CW00953473

Pots & Plays

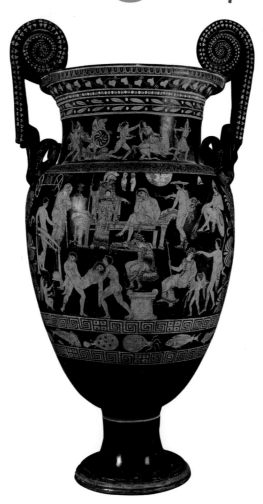

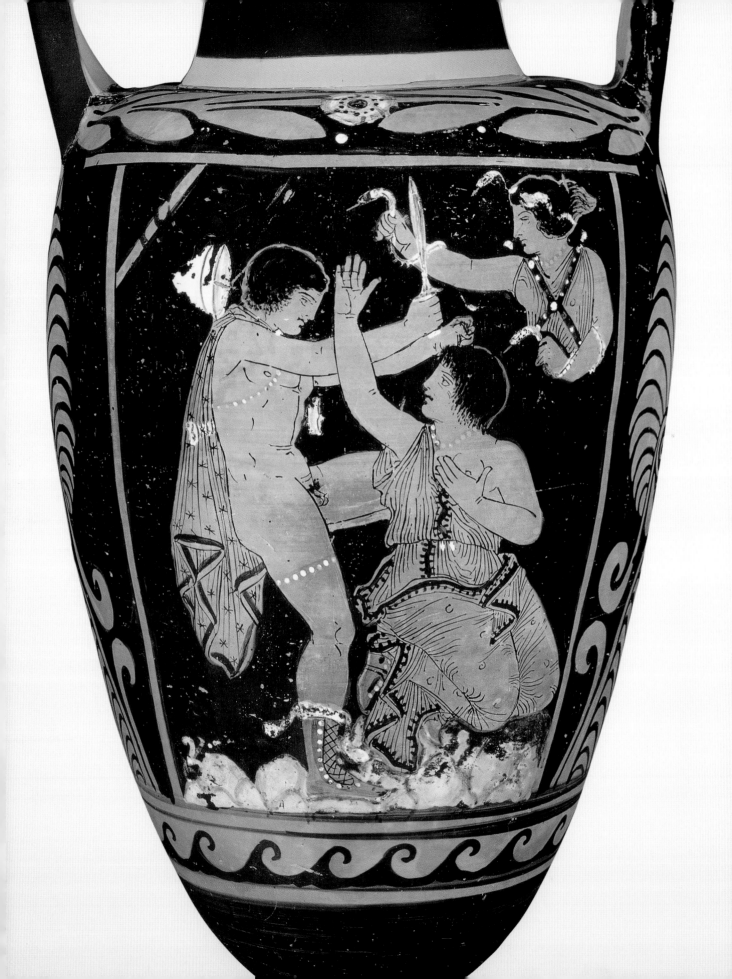

Pots & Plays

Interactions between Tragedy and Greek Vase-painting
of the Fourth Century B.C.

Oliver Taplin

THE J. PAUL GETTY MUSEUM

Los Angeles

© 2007 The J. Paul Getty Trust

Published by the J. Paul Getty Museum, Los Angeles

Getty Publications
1200 Getty Center Drive, Suite 500
Los Angeles, California 90049-1682
www.getty.edu

Printed by Imago, Singapore

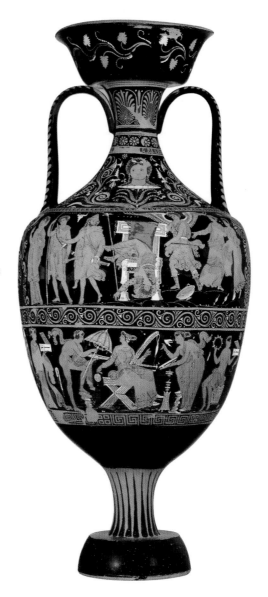

Library of Congress Cataloging-in-Publication Data

Taplin, Oliver.
 Pots & plays : interactions between tragedy and Greek vase-
painting of the fourth century B.C. / Oliver Taplin.
 p. cm.
 Includes bibliographical references and index.
 ISBN 978-0-89236-807-5 (hardcover)
 1. Vase-painting, Greek—Themes, motives. 2. Theater in art.
3. Greek drama (Tragedy)—Illustrations. I. Title. II. Title: Pots
and plays.
 NK4645.T377 2007
 738.3'820938—dc22
 2006033834

page i: More than likely related to Aeschylus' *Phrygians*, cat. 20
page ii: More than probably related to the second Orestes and
Klytaimestra scene in *Libation Bearers* (detail), cat. 5
page iv: Plausibly related to a tragedy about the death of Atreus,
cat. 95
page v: top, Possibly connected with a tragedy concerning a
larger-than-human figure in a wild landscape, cat. 98; middle,
Quite possibly related to Euripides' *Aigeus*, cat. 55; bottom, May
well be related to Aeschylus' *Europe* (or *Carians*), cat. 14
page vii: Detail of neck and mouth of Apulian loutrophoros,
cat. 89
page 1: New York Goose Play, fig. 5
page 47: More than likely related to the death scene in *Alkestis*
(detail), cat. 31

CONTENTS

PART 1

Setting the Scenes 1

PART 2

The Pots 47

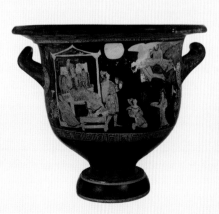

PREFACE & ACKNOWLEDGMENTS

POTS AND PLAYS sets out to explore an outstanding case of the interplay between theater and visual art, and between the arts and life—human life, that is, as lived and suffered and concluded. These interactions were, it is here claimed, particularly strong at a certain time and place—and are relatively well preserved. The time was (roughly) the fourth century B.C., when the stunningly successful art form of tragedy was vigorously spreading out through performances from its city of origin, Athens, to the whole of the widespread ancient Greek world. At the same time, the cultured and prosperous Greek communities in the West, in what we now call South Italy and Sicily, developed their own productive industry in painted ceramics. A significant type of this pottery consisted of large (sometimes very large), elaborately crafted vessels, made for funerals and covered with a great variety of mythological stories. It is the enrichment that tragic storytelling brings to these and its appropriateness to the occasion of mourning that lie at the core of this book.

All of the 109 pots discussed here in detail were painted between circa 420 and circa 310, especially between 350 and 320. And, except for the five painted in Athens, they were all painted in the Greek West, the great majority in what is known as Apulia, or (modern) Puglia. We do not have any other such powerful confluence of theater and visual art from another period or area of Greek antiquity. It is for this reason—and for reasons of coherence—that I have not included tragedy-related art from after 300 B.C., nor other (relatively patchily preserved) art forms, such as

terracotta figurines and marble reliefs, although they too certainly deserve study. I have excluded, except for a brief comparison in part 1, section J, comedy-related vase-painting, a very interesting but quite different phenomenon. And I have set aside Athenian art of the fifth century, except for the quick survey in section K: this is of great interest, certainly, but it is also relatively well known and problematic.

An astonishing number of the monumental mythological pots in question have been first published only in recent years, especially in the 1970s and 1980s. Nearly *half* of all those discussed in this book have been first published since the last major attempt to collect the material, in 1971. A great many receive here only their second serious study—and in some cases their first. Futhermore, many of the photos are the best yet published of the picture in question.

Pots and Plays also aspires to be a breakthrough because few of these major accessions have been previously discussed in any depth in connection with tragedy; nor have those known before 1971 been reconsidered in the light of the more recent discoveries. This "blockage" in interpretation has come about because in the last thirty-five years there has been a serious questioning of how art and literature relate, indeed whether they relate at all; and this has seriously inhibited the consideration of significant interaction. There are two, connected ways in which this book breaks through this deadlock (without prejudice to analogous questions in other times and places). One is that, with tragedy in the fourth century, we are not dealing with texts of limited access, but with

hugely popular, performed storytelling. Tragedy was very familiar to a large proportion of people in the Greek world and was one of the chief, if not the chief, forms of mythological narrating at this time. Second, the viewers of these vases were also viewers of the plays. They knew the tragic versions of the myths, and they brought that familiarity to their viewing of the pots. And the painters would have catered to their tastes; quite possibly they were even commissioned to recall certain specific plays.

The case will be made, then, that the viewers' appreciation of the painting was informed by the knowledge of particular tragedies; it was not dependent on it, but it was enriched by it. This approach through the sensibilities and associations of the viewers breaks out of the stalemated rivalry for priority between art and text. It also means that, in addition to the painting being related to the tragedy, the tragedy may be related to its envisioning through the painting. This two-way interaction is powerful and instructive for us today as well. Our appreciation of the pots is enhanced by bringing tragedy to bear; at the same time, our appreciation of tragedy is enhanced by knowing the pottery. While this concerns, above all, fifth-century Athenian tragedy as perceived and appreciated by Western Greeks of the next century, it can be very suggestive and enlightening for the fifth century as well. And for the twenty-first century A.D.

We see, again and again, how certain features of tragedy particularly appeal to the viewers: the spectacular costumes and stage properties; the scenes of threatened violence; scenes of entreaty and of taking refuge. We see how inextricably women, and often children, are caught up in these traumatic narratives; and how servants and bystanders "attend on" them, involved on the fringes and, like the theater audience, unable to do anything to prevent the outcome. We see, too, the presence of the gods, often on a separate level above the human events, powerful and beautiful yet seldom intervening, seldom even taking an active interest: The gods are part of the tragic universe, yet they do not dictate or explain it. And we see how these stories of horror and distress and disruption are nonetheless enacted with poise and physical beauty; and how they are arranged into meaningful compositions.

These and many other details of the ways in which the tragedies were perceived and understood are elicited in the course of the detailed pot-by-pot discussions. There are, however, few if any generalizations or universal rules that can be extracted or applied. There proves to be a great range of relationships between pot and play, and no invariables. To give an example, some pictures relate to a single incident in the tragic plot, some to several in combination, and some to events related in a messenger speech. There are, then, different ways in which the scene may be enriched by the tragedy, and with many and varying degrees of strength. The variety and complexity of the interactions are part of the fascination of the subject.

There is, though, one underlying question about human life and about the place of art within it: How are we to live confronted with suffering, bereavement, and death? The vases were undoubtedly painted to be viewed primarily at times of funeral. Why should the association of tragedy have been welcomed as appropriate? Why not simple scenes of comfort? There are also, indeed, paintings showing idealized visions of the dead persons in their prime, and there are scenes of happy times or of a hoped-for afterlife below. But why do we find so often scenes from the terrible stories of tragedy, so

full of grief and the ruin of settled life? That brings us close, I believe, to the great central questions about why the portrayal of suffering in art, including tragedy, affords "pleasure" and "comfort." These portrayals of the human condition are far from comfortable, and we are not pleased to witness them. And yet we are glad of the sense they give us that human life is not all meaningless cacophony, that we have the ability to salvage pattern and harmony.

I welcome this opportunity to acknowledge at least some of the debts of gratitude that I have accumulated over the more than ten years I have been working on this project. First I should name two monuments of scholarship without which the whole undertaking would have been impossible. One is the lifework of Arthur Dale Trendall, who catalogued, attributed, and dated almost every one of the more than twenty thousand painted pots known from the Greek West. The other is the product of the international collaboration of many scholars, the *Lexicon Iconographicum Mythologiae Classicae*, which collects and annotates almost every known artistic representation of ancient myth. I am also glad to name three scholars whose work I have found hugely and constantly helpful (even when disagreeing with them): Margot Schmidt (whose early death in 2004 is much lamented), Dick (J. R.) Green, and Luca Giuliani.

Colleagues and friends have been unstintingly generous with their time and advice. Jas Elsner and Robin Osborne read all of part 1 and much improved it (although there remain things they would not endorse); the two anonymous readers recruited by

Getty Publications read everything and made many constructive suggestions. I am also most grateful for various kinds of help and advice from Anna Banfi, Olympia Bobou, Eric Csapo, François Lissarrague, David Saunders, and Andreas Willi. Many others have given me time and support, especially my colleagues at Oxford in the Classics Faculty, at Magdalen College, and at the Archive of Performances of Greek and Roman Drama (a project financed by the Arts and Humanities Research Council). I thank all warmly.

Getty Publications have done this book proud—even though it has turned out much longer than first agreed. I thank Mary Louise Hart of the Getty Museum's Department of Antiquities, who originally made the link, and who has remained interested throughout; Monica Case, who did sterling work on obtaining the pictures; Abby Sider, who has been an extraordinarily diligent copy editor (any flaws that remain are due to me); Sandy Bell, who has conjured up this feat of typesetting and design; and Elizabeth Kahn, who oversaw the production of the volume and, in particular, the reproduction of its images. Coordinating all, Benedicte Gilman has remained a supportive and responsive, yet realistic, editor.

My deepest debt, finally, is to my wife and daughter, who have given me so much love and delight while this book has been in the making: Beaty and Charis, my two *charites*. I dedicate it to them.

O. T.
Great Haseley
September 2006

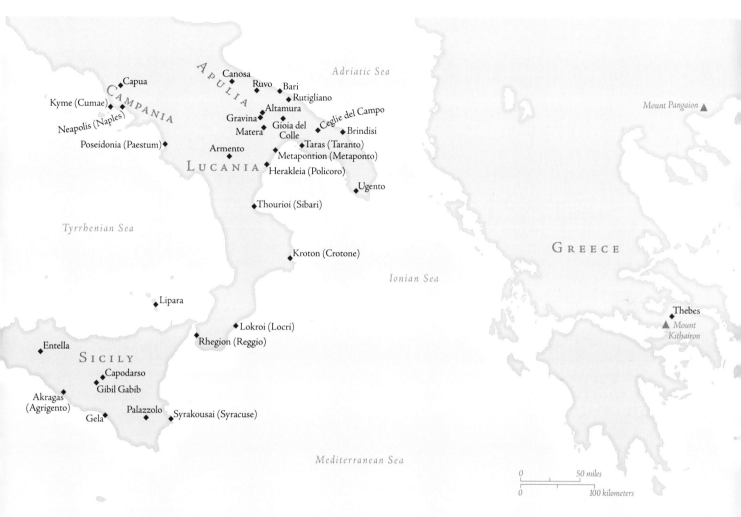

Canosa

Capua

Kyme (Cumae)

Neapolis (Naples)

Poseidonia (Paestum)

CAMPANIA

APULIA

Ruvo

Bari

Rutigliano

Altamura

Gravina

Matera

Gioia del
Colle

Ceglie del Campo

Brindisi

Taras (Taranto)

Armento

Metapontion (Metaponto)

LUCANIA

Herakleia (Policoro)

Ugento

Thourioi (Sibari)

Adriatic Sea

Mount Pangaion

GREECE

Tyrrhenian Sea

Kroton (Crotone)

Ionian Sea

Lipara

Thebes

Lokroi (Locri)

Mount
Kithairon

Rhegion (Reggio)

Entella

SICILY

Capodarso

Gibil Gabib

Akragas
(Agrigento)

Palazzolo

Gela

Syrakousai (Syracuse)

Mediterranean Sea

0 50 miles

0 100 kilometers

NOTE ON REFERENCES

Some of the publications cited most frequently in this book call for rather complicated systems of reference that should be explained.

First and foremost are the great compilations of A. D. Trendall, which list almost every known red-figure vase (over twenty thousand of them) from the Greek West. The most important is *The Red-Figured Vases of Apulia*, which is organized in rough chronological sequence, with each of thirty chapters covering a connected group of painters. Each pot in each chapter is numbered: for example, "*RVAp* 18/17" indicates number 17 within chapter 18. The two supplementary publications, *RVAp supp 1* and *RVAp supp 2*, follow the same chapter structure. Any additions to the first book are given a number that links them to a piece in the original collection. Thus, for example, "*RVAp supp 2*, 18/17a, 18/17b, and 18/17c" are three vases in chapter 18 of the second *Supplement* that relate stylistically to vase 18/17 in *RVAp*. Trendall's other two collections, *The Red-Figured Vases of Lucania, Campania and Sicily* (*LCS* and *LCS supp 3*) and *The Red-Figured Vases of Paestum* (*RVP*) are not given comparable internal divisions, and so references are given to the page and to the vase number found on that page. Thus "*LCS* 55/283" means vase number 283 on page 55.

Whenever any vase discussed is also included in Trendall and Webster's *Illustrations of Greek Drama* (Trendall-Webster 1971), a cross-reference is provided. Such references all begin with a roman numeral from I to V, referring to the five subdivisions of the book by types of drama, followed by the vase number within that section (II.2; IV.13, etc.). Part III on Tragedy is, however, subdivided into six sections, producing references such as III.2,8; III.3,47, and so forth.

The mighty international project *Lexicon Iconographicum Mythologiae Classicae* (*LIMC*) is published in eight double volumes, which follow the alphabetical order of the mythological names (with Greek spelling), although some entries are gathered in supplements that are later than the volume in which they should have appeared. Each of the volumes is divided into a first part, which gives the listings, and a second with a generous selection of photographs of the artifacts. An asterisk by an entry (such as "Medeia 35*") means that there is a picture in the associated second part.

For each of the 109 vases discussed in part 2 of this book, I have attempted to give a complete list of the relevant entries in *LIMC*. For all references to other pots, I have mentioned only those that are particularly relevant to the discussion. I have not specified the individual authorship or volume numbers for citations of *LIMC*.

La ceramica figurata a soggetto tragico in Magna Grecia e in Sicilia (*CFST*), the work of a team of scholars under the supervision of Luigi Todisco, is a valuable compilation and documentation, which includes most, though not all, of the vases discussed in this book. Reference is always made to the "Catalogue of Vases" on pages 361–523, which is subdivided by the abbreviations A (Attic), L (Lucanian), Ap (Apulian), S (Sicilian), P (Paestan), and C (Campanian), followed by a number in an approximate chronological order. Thus, for example, "Ap182" indicates number 182 in the Apulian section, where the vase is fully described along with a thorough bibliography. *CFST* also includes, among other indexes, etc., a small photograph of every vase included (there are about four hundred), arranged by the same numeration. There is also a useful collection and documentation of known provenances (pp. 527–71), which is referred to whenever relevant.

Primary references are listed first in citations; they are set off by a dash from the secondary references.

A word, finally, on the spelling of Greek proper names. There is no generally accepted system, and no way of pleasing everyone. I have as a rule employed Greek spellings, as in *LIMC*, such as Klytaimestra, Lykourgos, and so forth. There are, however, some names that are so familiar in their Latin spelling that I have stuck with that, such as Aeschylus (not Aischylos), Oedipus (not Oidipous). I have followed Trendall's naming of painters, which is often in Latin spellings, with the result that two spellings (such as Lykourgos and Lycurgus) can occur in close proximity. I have also retained some names that have very common anglicized spellings, such as Homer (for Homeros) and Syracuse (for Syracousai). Place names are, however, generally given in their Greek form (Taras, Metapontion), or, if that is unknown, in their modern Italian form (Ruvo di Puglia), not in the Latin (thus not Tarentum, Rubi, and so forth).

All translations are my own.

So why this avoidance of the subject? There are many contributory reasons. One has to do with complications of context. The vases do not, with a few exceptions, emanate from the same time and place as the initial productions of the plays, so there is a cultural gap to be constantly borne in mind. Second, a remarkably high proportion of the vases concerned have been first published since 1980, and it inevitably takes time for new accessions to be absorbed and disseminated.[2] It is, furthermore, only recently that we have had an accessible and complete (or very nearly complete) compendium of Greek mythology in art, the invaluable *Lexicon Iconographicum Mythologiae Classicae* (*LIMC*), published between 1981 and 1997. Last, and not least, experts have been traditionally trained as either scholars of language and literature (in some contexts known as "philologists") or scholars of material culture (usually called "archaeologists"). It may seem universally agreed that interdisciplinary explorations are highly desirable, but in practice the professionals have tended to remain territorial and partisan.

This last complication is all too relevant to what has proved to be the greatest inhibition, sometimes verging on a prohibition, against this subject in recent times. There has been serious and widespread questioning as to whether there is actually any serious interaction at all between literature and the visual arts. Many believe it to be more enlightening to treat them both as autonomous, and not in any way subject to the dilution of "debt" to one another. This is a relatively recent development. Up until around the 1970s, scholars, mainly philologists, tended to take it for granted that the two were related, and that the painted pottery was dependent on the preexistent and more important tragedies. Since then, the current has flowed very much in the other direction. Archaeologists and art historians have emphasized that the art does not need literature in order to be explained or understood; it holds good in its own right.

It is the aim of this part 1 to supply the factual and interpretative background to part 2. I attempt to find a way out of the impasse between philology and art

history and to suggest how it is impoverishing to treat their interests as separate worlds that run parallel to one another, rather than treating them as coexisting worlds in constant interaction. With this goal in mind, part 1 looks first at the plays and their contexts and then at the pots and their contexts, before bringing them together. Tragedy and painted vases were both, I hope to show, part of life for the Greeks who first commissioned and admired them. My goal is, then, to see how the ways that they relate to each other may throw light in both directions, both between the art forms, and between the past and the present.

In the main part of the volume, part 2, I have collected 109 individual paintings on ceramics and discussed each one for its possible bearing on the interaction of vases and tragedy. This is a selection of about one in three of those that might have been gathered in a more comprehensive collection, but it still aspires to cover all the most important aspects of the subject. I have tried to include every pot of unusual or of untypical, yet significant, interest; and I have selected representatives of all the relevant iconographies that occur in multiple examples. There are a few cases for which I conclude that, in the end, it is unlikely that the picture is related to tragedy at all: but they are included because they are test cases or exceptions that prove especially instructive. There are also some examples, but not all that many, at the other extreme, for which I feel it is as good as certain that the pot is closely related to a particular play. But most range in between probability and possibility (though by possibility I mean seriously possible, not merely remotely possible). And the kinds and degrees of their relationships are hugely various.

Some of the vases, about one third, I have related or attached to plays whose texts are complete. I have, however, included some pieces within those chapters that I conclude are not related to the surviving tragedy. I do so because they raise interesting questions closely connected with the play. Approximately another third (rather more) I relate, or consider the possibility of relating, to lost plays that we know something about.

And about one third (rather less) I relate to tragedy, but not to any tragedy that we know of.

It is important that each pot should be treated individually, in order to do justice to the great variety that we are dealing with. I am setting out the evidence and the discussion of each case one at a time also to avoid generalizations and doubtful groupings. This deliberately leaves it open to readers to draw their own conclusions about what kind of relationship with tragedy, if any, is to be recognized in each particular example. This may have the "drawback" of encouraging readers to disagree with my assessment, and to "know better," but I regard this as a price worth paying in order to address the complexity and the unavoidable inconclusiveness of the material.

B. WHAT WAS (IS) THE POINT OF TRAGEDY?

It is clear that the kind of finely crafted, often grand pottery that this book is concerned with was made primarily, if not exclusively, for funerals and to be buried with the dead. It is much harder to know what the paintings meant to those who commissioned and viewed them. I shall consider the inaccessible question of the cultural experience and "Greekness" of these people in section H, and I shall come to the deeper meanings of the vases for them in the concluding section, O. Setting the scenes thus shall, I hope, join up finally with the theme from which they set out: the significance of Tragedy.

Greek tragedy was originally Athenian tragedy. The genre was very much the innovative achievement of that city in its heyday, and Athens remained the metropolis of tragedy for the rest of ancient Graeco-Roman times. It developed rapidly from obscure origins (it was called "goat-song," but we do not know why) at the very time that Athens first established a protodemocratic constitution and rose to become the richest and largest city of the Greek world. The dramatic form seems to have been well developed and to have occupied a major annual festival of three or more days (the Great City Festival of Dionysos, or Great Dionysia), by about 490 B.C.; the surviving plays by the three great playwrights Aeschylus, Sophocles, and Euripides were all first composed between 472 and 406 B.C. The classic flowering was less than a century long; it is a mistake, however (promulgated by Friedrich Nietzsche), to suppose that tragedy died with the big three (let alone that Euripides killed it). It continued and flourished throughout the fourth century B.C.; the competition for new tragedies prospered (and indeed new tragedies continued to be composed, in a more desultory way, for another eight centuries). There were also regular occasions for the reperformance of the old tragedies from the fifth-century canon.[3]

Remarkably soon after its first official recognition as a distinct art form, tragedy was already taking up vast amounts of time, money, and effort at Athens. Why was it such a galloping success? Why was tragedy such an important part of Athenian life? I shall attempt to answer that huge pair of questions by distilling a personal overview into a very brief and dogmatic nutshell. In essence, tragedy took over the repertoire of the already powerful and varied Greek heroic myths, presenting them through direct enactment and with unprecedented immediacy before mass audiences. The effect was a complex and inextricable combination of strong emotion and fresh thought, experienced under intensely concentrated conditions.

The range of emotions goes far beyond the cliché formulation of "pity and fear"—although pity is certainly central. Any analysis should include grief, horror, indignation, disgust, affection, excitement, joy, elation, anguish, helplessness—all of them felt in anticipation and in the present and in retrospect.[4] As for the range of issues on which Greek tragedy provoked thought, a lapidary catalogue can do no more than suggest their complexity and breadth. Politics (in the sense of living in societies), power, persuasion, war, justice, revenge; the family, its bonds and conflicts, blood kin, marriage, bereavement; male and

female, public and interior, strength and weakness, love and hate, hurtfulness and protectiveness; emotions and their causes, their rationality and irrationality, their justification and their harmfulness; the workings of the mind, madness, the extent to which motives are conscious, the benefits and dangers of rationality; responsibility, free will, determinism, the extent of choice, the attribution of blame; the nature of truth, relativity, existence and seeming; the human sense of superhuman powers or gods, whether they are malign or benign, whether they have any sense of justice, whether they can be understood or are essentially incomprehensible; the meaning or meaninglessness of life, of suffering, of death. . . . In my view—though it is not a view that the reader has to share—that range of issues and that range of emotions are the fundamental reasons why Greek tragedy still speaks to us today, mutatis mutandis.[5]

It is of the essence that the experience of tragedy was (and is) pleasurable, and that this art form was (and is), in the broadest sense, *entertainment*. This was made possible because of the performance occasion and its communicative means. The narrative was enacted in a special space for performers, which was in turn situated within a special larger "viewing space" (the meaning of the Greek word *theatron*). The storytelling gripped attention through vivid visual means that included masks, costumes, stage properties, and painted scenery, and it was set into action by the bodily movements of individual actors, and by group movement including specially choreographed dance. The aural means that caught and enthralled audiences included the fine voices of the actors, the poetry of the spoken language, and the complex patterning of the lyrical language, its choral singing and music.

Within this special spatiotemporal containment, and through this disciplined enactment, Greek tragedy took its audiences into expanses of human experience that are rarely visited in everyday life—many of which one hopes never to experience in reality, or even cannot experience in reality. Vicariously the audience "plays the other,"[6] getting a taste of what it is like to be

(for those who are not) female, old, foreign, accursed, helpless, dying, bereft of family, reduced to a total misery, murderous, enslaved. And the audience has a vivid excursion into worlds in which the stability of society is overturned, the family is torn apart, the weak become powerful, freedom is destroyed . . . all that is most cherished and depended upon is disrupted or distorted or taken away. Tragedy draws its captive audience into the worlds of their worst fears, horrors, and fatalities. And yet—and this is crucial—and yet it has not really happened. It is all experienced within the strictly demarcated and formalized world of the theatron, within its special licensed space and time. At the end of the play, society has not been overturned, the family is not dispersed, the dead are not dead. Outside the theater, life goes on.

As all parties agree in Aristophanes' comedy *Frogs* (lines 1009–10), "poetry [specifically tragedy] makes people better in their societies." The special way in which tragedy enhances people's lives—instead of depressing or traumatizing them, as these experiences would do in reality—is indivisible from the special controlled time and place of the experience. The horrors are turned into a kind of benefit and beauty.[7] Out of apparently meaningless suffering comes meaning and form. And so the viewer is strengthened and enlarged in the experience of life.

C. THE SPREAD OF TRAGEDY FROM ATHENS

Although this momentous new arrival in the history of "entertainment" developed into a major art form in the city of Athens, nothing, or hardly anything, of the above in-a-nutshell account of tragedy is specific to Athens, or even exclusive to ancient Greece. Athenian tragedy could be considered, to use a deliberately paradoxical phrase, "universal, mutatis mutandis." Yet much of the most productive scholarship on ancient tragedy during the past thirty years has run counter to any such

claim of cultural nonspecificity, let alone of universality. It has concentrated on the "Athenianness" of tragedy, on its specificity and topicality for that particular society and that particular time. Scholars have related tragedy to the social structures, ideologies, sense of national identity, power relations, religious rituals, and social *rites de passage* of fifth-century Athens.[8]

This movement in scholarship toward particular cultural contextualization has been immensely enlightening and important; at the same time, it should not neglect or obscure the undeniable fact that tragedy did spread from Athens to the rest of the ancient Greek world (and thence to the Roman world, and thence…). This dissemination must have been thanks less to its Athenianness and more to its "universality," or—if that notion is too problematic—to its potential for adaptability. Thucydides, a product of the same era in Athens, set up (for his *History*) a disjunction between a "heritage for all time" and "a prize composition to be heard on a single topical occasion" (1.22). Tragedy has proved, I believe, to be both.

By about 330 B.C., Aristotle concludes his *Poetics*, a generalizing work of literary theory and criticism, by judging that tragedy is the greatest form of poetry, superior even to Homer and epic. From the time of Alexander the Great, in the late fourth century, until the end of Greek and Roman pagan antiquity (around the sixth century A.D.), tragedy is everywhere. The mask, symbol of the theater, is a ubiquitous motif, especially in Roman imagery; there are innumerable references, favorable and unfavorable, in poetry, oratory, and philosophy to what happens "in the theater."

This spread must have been thoroughly established before the time of Aristotle, and I think there are good reasons to suppose that it happened earlier and more widely than has been generally recognized.[9] In the first half of the fourth century, Plato is already speaking of tragedy as the most universally popular form of poetry, one that reaches wide audiences of all sorts. That is precisely why the elitist philosopher is so disapproving of theater. He refers to tragic performances traveling outside Athens and Attica in his

Laches (a work that probably dates from the 390s).[10] By the first quarter of the fourth century there was quite a list of playwrights and actors from well beyond Athens (for Sicily and the Greek West, see below). We know of some fourteen theaters from the fifth century, over half of these beyond Athens and Attica, and of many more from the course of the fourth century.[11]

Pushing back into the fifth century, the evidence is primarily about the leading playwrights themselves. The first and most striking fact is that Aeschylus composed a tragedy for a special occasion in Sicily in the mid-470s.[12] Thus tragedy was already celebrated well beyond Athens earlier than our earliest surviving tragedy, which is Aeschylus' *Persians* of 472 B.C. Soon after that *Persians* was reproduced at Syracuse, in Sicily, to great acclaim.[13] Aeschylus died at Gela, in Sicily, in 456 B.C., and "all those who devoted their lives to tragedy used to visit his tomb monument to pay homage, and to perform his plays."[14] Turning to Euripides, there are stories of his popularity within his own lifetime in Thessaly and in Macedon, where the king commissioned a special tragedy from him in about 408.[15] He was even said to have moved to Macedon toward the end of his life (the younger poet Agathon definitely emigrated to Macedon).[16] The most vivid evidence of his wide influence is the story (which goes back quite far) about Athenian prisoners of war in Syracuse in 413 B.C., who won their freedom by being able to recall and teach passages from Euripides' plays.[17]

We simply do not have the evidence to say just how this broad and rapid spread of tragedy to the rest of the Greek world happened in practical terms. Quite a plausible scenario can be reconstructed, however.[18] We know that tragedies were frequently performed around the villages and countryside of Attica, as well as in Athens itself (and in Piraeus, near Athens); and we know that in the fourth century, they were put on by troupes of traveling actors.[19] It is probable that "the same performers who worked the city festivals also worked the deme festivals … from as early as the

mid-fifth century."[20] Next, we have good evidence that there were plenty of non-Athenians present at the performances in Athens.[21] Furthermore, it was common practice for performers of various kinds of poetry to travel to celebrated (and no doubt sometimes lucrative) occasions, mostly festivals, throughout the ancient Greek world. So it seems quite likely, to pull the threads together, that before 400 B.C. Athenian troupes of players were traveling elsewhere in the Greek world to mount performances of tragedy. Possibly Athenian choruses traveled with them also, but it may often have been the case that locally trained choruses provided the songs, whether those of the original or detached interludes.[22] The report that the Athenian legislator Lykourgos tried to impose a definitive text on actors is also telling.[23] Thus, during the period from 450 to 350, tragedy went, piecemeal, from being primarily and predominantly Athenian to being shared—like epic, like sculpture, like music—throughout the whole Greek world. At the same time, it became the most familiar and popular way in which hundreds of thousands of Greeks came to know the great myths.

While we have much less evidence than we might like, there are still some impressive external pointers to this tremendous popularity of tragedy in the Greek world as a whole. One is the physical size of the theaters, built to hold many thousands—up to twenty thousand in the case of some, such as those in Megalopolis and Syracuse.[24] Second, there is the huge celebrity and wealth, and even political power, of actors such as Aristodemos, Neoptolemos, and Polos.[25] Third, there are the continuing complaints in Plato about how tragedy is accessible to everyone, and has too much influence over the people as a whole.[26] And then there is the evidence of other forms of literature—comedy, history, oratory (admittedly nearly all Athenian), literary and rhetorical theory, and so forth—which all refer to tragedy as something that is obviously well known to its readers and hearers. These indications all confirm that tragedy was known by very large numbers of people through performance.

Given the size of the theaters, we are talking about literally hundreds of thousands of spectators every year throughout the Greek world seeing tragedies performed.[27] On the other hand, there is no evidence to lead us to think that the reading of tragedy was usual, or that it was widespread beyond intellectual circles. Those who read Greek tragedy in the fourth century are likely to have been numbered in thousands, but not tens of thousands.

This is all related to the overarching question of how Greeks came to know their myths at any particular time and place, a question that has to be answered largely by conjecture. It is, however, a pretty fair conjecture that the main way throughout the Greek world in the fourth century was through tragedy—that sensational new kind of narrative that had swept the whole of the Greek heartland and diaspora by storm. So when we talk of "the story" or "the myth" as it is known in this period, this chiefly means, I suggest, the stories as told in tragedies. Of course, people will have encountered them in other forms of narrative as well. There was the performance—and the reading, especially at school—of traditional epic. Rhapsodes (performers of epic poetry) were still big business throughout the Greek world. And there was choral poetry, not least in the form of the circular dance for Dionysos, the dithyramb. There would also, no doubt, have been the reporting and discussion of these versions. The telling of stories at home—especially, it seems, by old women—was another sort of narrative context.[28] (But it would be anachronistic, as well as romantically sentimental, to suppose that these "old wives' tales" were the main form of storytelling.) Last but not least, stories were told through the visual arts, including vase-painting as well as wall painting and sculpture. The visual arts had their own narrative traditions; but, as I shall argue later (see sec. I below), it is an overabstracted and unrealistic position to suppose that the narrative in the visual arts and in verbal (or "literary") forms existed totally independently of each other, in rigid parallel without interaction.

D. The spread to Sicily and the Greek West

When we say that tragedy spread from Athens to "the rest of the Greek world," this refers to the far-flung communities of the ancient Greek diaspora, any community that shared the Hellenic linguistic, religious, and cultural heritage. These places were not only in mainland Greece and Asia Minor (present-day western Turkey), but dotted all around the Black Sea, the coast of Libya, the island of Sicily, and the coasts of southern Italy. The Greek presence in Italy was known as Great Greece (Megale Hellas, or in Latin, Magna Graecia): I shall call this, along with Sicily, "the Greek West."[29]

These cities were originally founded by settlers from mainland Greece and Asia Minor; they were known as "away settlements," *apoikiai*.[30] While they retained links and networks with their "mother cities," especially some religious cults, they were largely independent social, economic, and political entities. The settlers interacted with local non-Greek inhabitants and to some extent assimilated them. But they remained determinedly Greek in their language and culture, and they devoted considerable energies to participating in local and Panhellenic cults and festivals, above all, but by no means only, at Olympia and Delphi.[31]

These Greek cities in the West were very far from being backward, conservative, or marginal places: on the contrary, they were among the most prosperous and culturally enterprising communities in the ancient Greek world. As well as developing their own laws, coinage, festivals, and so forth, they produced thinkers, doctors, poets, painters, musicians, and other cultural specialists, who became renowned throughout the Greek world. The richest, most powerful, and best-known cities in the Greek West were in Sicily—and these are the most familiar in modern times also, since their remains are so well preserved. But

there were also fine cities all around southern Italy, from Neapolis (Napoli, Naples) on the western side down to Poseidonia (Paestum) and Rhegion (Reggio di Calabria) at the southern "toe"; then around to Kroton (Crotone) and up to Thourioi (near the site of the former Sybaris), and around the gulf of the "instep" to the great city of Taras (Taranto). In addition to the various named cities, there were other settlements, either Greek or thoroughly immersed in Greek culture, for which we do not even know the pre-Roman names. For example, a fourth-century theater has been excavated at Castiglione di Paludi to the north of Kroton. And at Ruvo di Puglia and Canosa di Puglia (also known simply as Ruvo and Canosa), both close to the Adriatic coast near Bari, tombs have been found that have quantities of very fine Greek pottery, including many works relevant to the subject of this book (see sec. H).

If any cities of the Greek diaspora were going to take up Athenian tragedy with enthusiasm, these cultural centers in the West were likely to be at the forefront. We do, indeed, have unusually strong evidence about Sicily. Dionysios, the aggressive despot of Syracuse for most of the first third of the fourth century, was a tragedy fanatic. He not only acquired the personal equipment of Aeschylus and Euripides (writing tablets, desk, lyre, etc.), but finally achieved his ambition of winning a prize at Athens (possibly awarded for diplomatic rather than literary considerations).[32] Fine, large theaters were constructed in stone throughout Sicily; in fact, there is a greater concentration of well-preserved ancient Greek theaters there than anywhere else.[33] Those that were constructed after the fourth century were probably in places where there was already a keen interest in theater, which had previously been performed in an architecturally less finished location.

And it is from Sicily that we have the two scenes on painted pottery that unequivocally and indisputably display tragedy being enacted on a stage: see numbers 105 and 106 for details. There are other Sicilian

vase-paintings that seem to come close to declaring their relation to the theater, notably numbers 65 and 22, which is probably representing no less a play than Sophocles' *Oedipus (the King)*.

E. How much was Athenian tragedy performed in Apulia?

Turning to the Greek cities on the mainland of Italy, the direct evidence is not as strong as for Sicily. But the extent to which tragedy was performed there is a crucial issue for this book, since the great majority of the vases discussed come from what we know as "Apulia" (on this label, see sec. G). The evidence needs to be considered in some detail, especially since no less an authority than Luca Giuliani has expressed serious doubts, even going so far as to claim that "we do not really know whether Attic tragedies of the fifth century were ever performed in the fourth century in Apulia."[34] Giuliani is an excellent scholar, a keenly observant art historian and contextualizer of art, who has made valuable contributions on the relevant vase-paintings.[35] It is important to decide whether his skepticism is justified or misguided.

Giuliani has developed a theory that the painters' public knew their myths through texts, mediated by experts, and not through the theater in the concrete and popular sense of the "watching place." I would claim, on the contrary, that by the time of the fourth century, theatrical performances were the main means through which people knew the myths. We cannot both be right on this particular issue. The questions about the cultural life and hellenization of the viewers of Apulian vases—especially those in the north, away from Taras—must be left for later (see sec. H). What is at issue, first, is the wider question of "whether Attic tragedies of the fifth century were ever performed in the fourth century in Apulia."[36]

1. Plato on audiences

There is one piece of evidence that comes close to being conclusive, although it does not finally prove that any of the plays performed were fifth-century Attic. This is a passage of Plato's *Laws* (659), the treatise of the mid-fourth century in which Plato sets up a perfect society (though rather more realistic than that in his earlier *Republic*). He insists that proper judges in the theater should not be influenced by the response of the vulgar audience: the judge is there to teach the people the proper pleasures, not to be instructed by them. This, he says, was the old Hellenic way, as opposed to "the custom in Sicily and Italy as practiced in these days" (*ho Sikelikos te kai Italikos nomos nun*), namely the custom whereby the mass of the audience awards the prize by popular vote. Plato knew what he was talking about: he went to Syracuse three times and was embroiled in politics there; he also visited Taras and its leader, Archytas, the nearest that the era produced to his ideal of a philosopher-king.[37] This passage is a reminder of how the cultural life of Greeks in Italy was closely similar to and interlinked with that of Greeks in Sicily (like their political history, indeed). It is beyond reasonable doubt that Euripides was performed, and often, in the Syracuse of Dionysios. There is no reason to think it was different in Taras or Thourioi.

2. Theater sites

It has to be conceded, however, that compared with Sicily, rather few physical remains of theaters have been discovered in Italy: only nine, and of them only one, Metapontion, is in Lucania or Apulia.[38] But no one could doubt, surely, that there was a theater at Thourioi, a foundation under heavy Athenian influence. Nor that the hugely prosperous Taras, with a population of a quarter of a million or more at its height, had a large theater—some sources say two.[39] Although the archaeology of Taras has been seriously hampered by the superimposition of the modern city,

there are many stories about the obsession of the Tarantines with theater. While such tales are largely the product of moralizing fiction, they would not make sense if theater had been only a marginal activity there.[40] The shortage of relics of stone theaters in this part of the world might result from the use of wooden seats on natural slopes rather than special constructions. The comic vases (see sec. J) certainly indicate that stages were normally constructed of wood, and they are a reminder that stone theaters were a relatively late development—even in Athens (as they were to be in Rome also). The traveling troupes probably set up their temporary stages and seating wherever the local city allowed.[41]

3. Playwrights and actors

While the concrete evidence for theaters is thin, the evidence for people active in the world of theater is stronger. We hear of a tragic playwright called Patrokles from Thourioi, and it is possible that he is mentioned in Aristophanes in the early 380s.[42] More interestingly, Alexis, one of the best-known and most prolific of all comic playwrights, was born at Thourioi in the 370s.[43] Like all Greek comedies, his plays contained allusion to tragic material. He spent most of his long life in Athens, but it seems highly implausible to suppose that he had never seen any Attic fifth-century tragedy before he left his native city. It is also surely significant that Rhinthon—the most famous exponent of a new generic transgression called "phlyakes," a mixture of tragedy and comedy in Doric dialect—was based in Taras at the end of the fourth century.[44] His titles that we know of are nearly all Euripidean, including two *Iphigeneias*, one *among the Taurians* and one *at Aulis*. Had Rhinthon never seen a play by Euripides performed at Taras?

A similar but even stronger argument applies to two tragic actors of the fourth century, the great age of star actors. One was Archias from Thourioi, who became sufficiently important to be involved in the downfall of Demosthenes, the great Athenian orator

and politician, in 332.[45] More significant and earlier was one of the most famous of all, Aristodemos of Metapontion.[46] His acting career spanned the entire middle half of the fourth century; he too became deeply involved in diplomacy and politics. Like Alexis, he spent most of his life at Athens; but can we really believe that he had never seen any Athenian classics before he left Metapontion? It is, on the contrary, likely that he began his acting career in the Greek cities of the West, playing the already established classics to local audiences there, before his reputation became so great that he was able to move his center of activities to Athens.

4. Actors on vases

There is painted evidence of an interest in tragic actors and in their symbol, the mask, even before these celebrities. From early in the history of Apulian vase-painting, there are pictures of a figure, sometimes Dionysos, sometimes a human actor, "offstage" (so to speak) and holding a mask, usually that of the role of a young woman.[47] The krater in figure 1 is one of the Tarporley Painter's early works, to be dated before 390; it shows Dionysos holding a mask.[48] The picture in figure 2 is also particularly interesting: the young man seems to be an actor looking at one mask of a young woman's role, while the woman to his right holds another ready for him to consider in comparison.[49] Figure 3, which is surely the most famous representation of an ancient actor, was painted at Taras in the mid-fourth century.[50] One of the attractive things about this picture is that the painter is so clearly interested in the actor as a person, and in the relation between him—with his stubbly beard, rather tired face, and graying hair—and the splendid (blond) tragic mask. This is, in fact, an unusually characterful portrait of an individual, and that individual is an actor carrying the symbol of his profession. Conceivably the great Aristodemos himself?

Satyr play might also be brought to bear. In Athens the satyr play was an integral part of the tragic

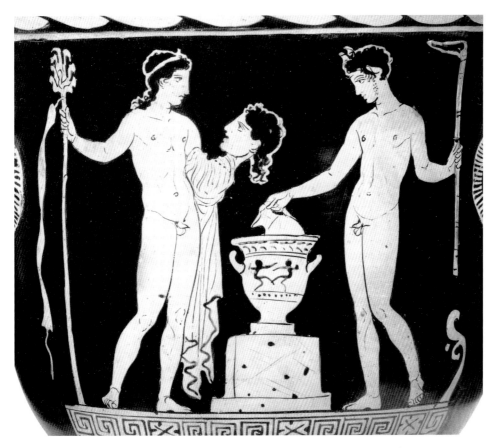

competition (see end of sec. K for discussion), and the practice there was that the actors and chorus members were the same. It is by no means sure that satyr plays fully took root in the Greek West, but there is one important picture of actors in satyr outfits, again by the Tarporley Painter, from back in circa 390s. In figure 4, three men are shown in typical satyr-costume shorts: two carry their masks, and a third, who has his on already, is getting into his dance steps.[51] Beyond this work, however, there are only a couple of satyr masks found on the Western Greek vases.[52]

So actors of tragedies (and perhaps of satyr plays) were familiar in Apulia in the fourth century, right from the start, about 400—which almost definitely means that plays were being staged. As Giuliani

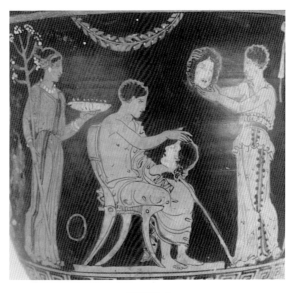

FIGURE 3
Portrait of actor with mask. Apulian Gnathia fragment,
attributed to the Konnakis Painter, ca. 350.
Height of fragment: 18.7 cm.
Würzburg, Martin von Wagner-Museum H 4600 (L832).

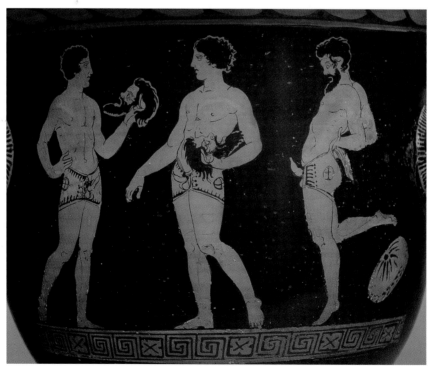

FIGURE 4
Actors of satyr play. Apulian bell-krater, attributed to the Tarporley Painter, ca. 390s.
Height of vase: 32.5 cm. Sydney, Nicholson Museum 47.05.

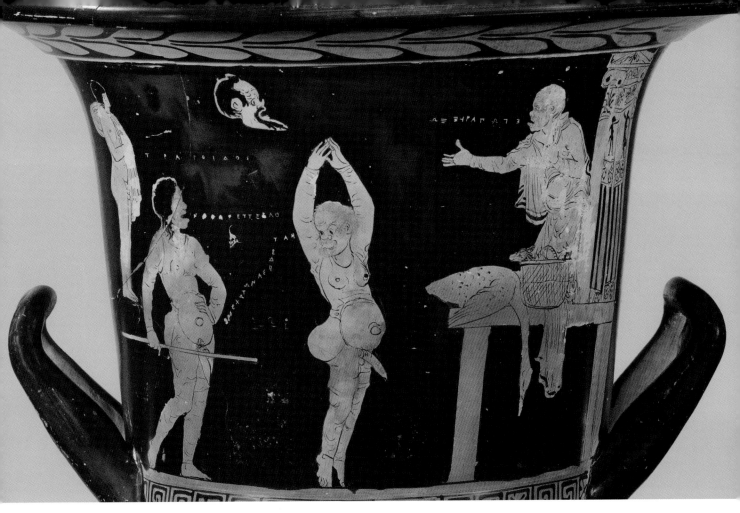

FIGURE 5
New York Goose Play. Apulian calyx-krater, attributed to the Tarporley Painter, ca. 390s. Height of vase: 30.6 cm.
New York, The Metropolitan Museum of Art 24.97.104.

insists, we cannot conclusively prove that any of the plays they performed were fifth-century Attic: it is theoretically possible that they were all the work of local dramatists, or that, if they were Attic, they were the work of contemporary fourth-century playwrights. But, given that the whole activity of tragic theater was the invention of Athens during the previous century, can it really be maintained with any credibility that the performances did not include fifth-century Athenian tragedy? It is rather more plausible to suppose, on the contrary, that the productions were often, or even predominantly, Athenian "classics."

5. The bearing of comic vases

Now, it is, of course, illegitimate to bring fourth-century serious mythological vase-paintings—the subject of this book—into this discussion of theater in Apulia, because it is precisely the nature and degree of their relationship, if any, to the tragic theater that is the question at issue. There is no reason, however, why we should not look at the comic vases—well over one hundred of them explicitly theatrical and performative.[53] Do they suggest that an awareness of Athenian tragedy was called for in order for their viewers to have appreciated them?

The first thing to note is that on those few vases that have inscriptions, these are, almost without exception, in Attic Greek and not in the local dialect, which at Taras, for example, was a strongly marked Doric.[54] The earliest and most interesting is the "New York Goose Play," an elaborately detailed calyx-krater by the (now familiar) Tarporley Painter (fig. 5).[55] The three characters all have words coming out of their

FIGURE 6
Würzburg Telephos parody. Apulian bell-krater, attributed to the Schiller Painter, ca. 370s.
Height of vase: 18.5 cm. Würzburg, Martin von Wagner-Museum H 5697.

mouths, in a convention not unlike that of modern cartoon bubbles, and (as far as we can tell) they are speaking Attic Greek, except that the left-hand young man is saying something unintelligible.[56]

More important for the question of Athenian tragedy is the "Würzburg Telephos" (fig. 6), an Apulian krater first published in 1980.[57] Eric Csapo (1986) and I realized independently and simultaneously that the correspondences between this scene and an episode in Aristophanes' comedy *Women at the Thesmophoria*, at 730ff., are so close and so multiple that the vase should be directly related to the Aristophanes without any intermediary comedy. Given that the comic vases are explicitly related to actual theatrical performances, this one presumably is as well. This connection has been almost universally accepted, even though it leads to a conclusion that would not otherwise have been seriously entertained: namely, that the Athenian comedy of Aristophanes—quite pos-

sibly with adaptations—was performed in the Greek West.[58] The conclusion that *Women at the Thesmophoria* was reperformed in the Greek West is suggestive, because it is largely about Euripides and expects quite a lot of acquaintance with Euripides' tragedy, including *Telephos*, the play parodied in the scene on the vase (see nos. 75–77). Comedy was a popular art form, and so the inference must be that Euripides' tragedies were both popular and performed—they had to be familiar for this vase to be appreciated by its viewers.

To conclude this discussion, it is not quite a hundred percent certain that "Attic tragedies of the fifth century were ever performed in the fourth century in Apulia," but it is extremely likely—perhaps ninety-nine percent? Indeed, it is almost inconceivable that they were not. Furthermore, the probability is that they were not only performed but performed often, and in front of large popular audiences. This is established, I hope, for Taras and the Greek cities around

the Gulf of Taranto. There still remains a question as to whether tragedies were much performed in the more remote parts of Apulia, particularly in the north, where many of the vases under discussion have been found. We shall return to this question, and to Giuliani's theory about it, in section H, after considering the wider phenomenon of vase-painting in the Greek West.

F. Vase-painting in the Greek West

The same place and time that saw the flowering of tragedy—Athens in the fifth century—was responsible for the heyday of red-figure vase-painting. This technique of decoration, which is widely perceived as the epitome of ancient Greek ceramic art, was invented in Athens in about 530 B.C.; for a century Athens had a virtual monopoly over its production. Attic red-figure has been found throughout the ancient Greek world and beyond: some one hundred thousand examples are known, and the total production must have been many millions. It was not an exalted art form, like sculpture or wall painting or metalwork, but it was a high-quality yet familiar accoutrement everywhere Greek in the fifth century.

Toward the end of the fifth century, during the course of the devastating Peloponnesian Wars, the Athenian fine ceramic industry began to decline. Production continued on through the fourth century, but in much smaller quantities and, with some exceptions, at a noticeably lower level of artistic quality. Yet there was only one region of the widely scattered Greek world that built up a truly substantial pottery production of its own, to make up for the diminishment of the Athenian monopoly: the Greek West.[59] This begins about the 430s with painting and potting that are closely similar to the Athenian and indubitably derived from it. It is widely supposed that the initial conduit was the Athenian-dominated foundation of Thourioi in 443. The earliest identifiable centers of production, however, were further up the gulf, in Metapontion and Taras. The industry then seems to have begun in Sicily in about 400, and to have spread from there northward to Paestum and to the Bay of Naples area around the 360s (see below). The great bulk of the production continued to be red-figure, although two other, more colorful techniques were developed, both in much smaller quantities: the so-called Gnathia at Taras and Centuripe in Sicily.[60]

There are at least twenty thousand Greek painted pots from the West now above ground.[61] Almost all of these, something like ninety-nine percent, were found in the areas of production; in other words, they were primarily made not for export but for local consumption. Although a great many are small and simply decorated with a hastily drawn conventional motif such as a woman's head or an Eros, a substantial number are larger, some very large. These grander works usually have less mass-produced scenes, whether funerary or mythological or both. At a rough guess, more than ten percent—i.e., more than two thousand—are on this scale. And of these a fair proportion, something between 300 and 450, may be reasonably (or at least not foolishly) claimed to be related to tragedy. The only modern attempt to compile a complete catalogue is *CFST*, which lists almost exactly four hundred claimants.[62] This is a thorough and sensible collection. While it includes some pots that are highly unlikely to have any significant tragic connections, and it does not include every serious candidate,[63] it is—taking into account "swings and roundabouts"—a fair estimate of the number in question here.

This very considerable body of painted pottery is generally known as "South Italian" (leaving aside the five percent that is Sicilian). I should explain why I am totally avoiding this common label (and the more obscure label "Italiote" as well). In my experience the term "South Italian" has the effect, if only subconsciously, of making people think that the pots are not really Greek, or at least that they are only marginally Greek. The names of the local subgroups (Apulian,

Campanian, and so forth) also tend to reinforce this impression of non-Greekness; they do, however, remain indispensable, however misleading, as will be explained in the next section.

There is, I suggest, another reason why the misleading label "South Italian" has stuck so fast to this pottery, a reason that is primarily aesthetic, a matter of taste. The most conspicuous and highly crafted Western Greek vases are very large—many taller than half a meter, and not a few even more than a meter high. They carry elaborate scenes and ornament on the neck as well as on the body, crowded with figures, often ten or more, and elaborated with extra colors, especially white and yellow and purple. They are undeniably "showy"—eye-catching display pieces, filled with attention-seeking detail. And they do not immediately appeal to all modern tastes, especially not to those trained to appreciate austere and understated clarity. They are an acquired taste, but, I suggest, a taste worth acquiring. Surely an eclectic modern (or postmodern) sensibility can see the appeal of this particular kind of ancient Greek art, without invidious comparisons.

I have heard fourth-century Western Greek vase-painting dismissed as "spät und schlecht" (late and lousy). This is clearly a judgment that takes Athenian painting, especially that of the early fifth century, as its ideal of Classical Art. This yearning for noble simplicity can be taken back to the eighteenth-century intellectual Johann Winckelmann; but in the appreciation of vase-painting, it was (Sir) John Beazley, the great connoisseur art historian, who did the most to canonize the Attic ideal. Beazley was generally supercilious about later and non-Athenian painting. While he was able to condescend to some Paestan painting as having "an agreeable tang of popular provincial art," he contrasted this with "the perpetual elegance of late Apulian vase-painting with its talent for trivialising even the noblest theme."[64] It is true that the limpid depth of high Attic painting is an artistic wonder (although there is also plenty of second-rate Athenian painting), but there is no obligation to idolize it to the exclusion

or dismissal of the very different Western Greek art of a century later.

In any case there is much more to the best of Apulian art than "perpetual elegance." Quite apart from the intellectual and cultural interest of many of the subjects, the compositions often display great artistry in the spatial and narrative relations of the figures to one another. Some of these artists are very fine draftsmen, fluent and expressive in detail.[65] There is a nice way of demonstrating this: broken fragments are often self-evidently of quality craftsmanship and easy to admire.[66] But when the painting is complete or near complete, the attractiveness of the detail and expression seems to become somehow lost within the multiplicity of the composition as a whole—the whole seems to add up to less than the sum of its parts. In my experience the best way to recover the quality of the detail within the whole is to look at the painting with careful, figure-by-figure attention, and then to return to the overall composition. The rewards of this approach may indicate that it echoes the way that the vases were perceived at the time of production.

I hope, then, that the latent fascinations and artistry of these works may be due for a reevaluation and appreciation, especially now that they have been fully catalogued and attributed through the lifework of Dale Trendall (who died in 1995).[67] And there is a further reason why fresh attention is called for. There has been a huge increase in the quantity of known vase-paintings in the last thirty-five years, especially during the 1980s. This was partly due to legitimate excavation, but largely through illegal "tomb robbing." In 1991 Trendall calculated that he had documented well over two thousand new Apulian vases between 1983 and 1991, many of them substantial and highly worked pieces.[68] It is indicative that of the 104 vases discussed in part 2 of this book (excluding the five that are Attic), a larger number have become newly known since 1970 (forty-eight) than were known before 1900 (thirty-eight). No fewer than twenty-nine of the pots were first published during the single decade of the 1980s, and a further ten in the 1990s.

verbal version of the story in order to have meaning. But it is my thesis that the viewers of these vases, with their experiences of mythological narratives, have to be brought into the picture. It is not the mentality of the producer/painter that is at issue so much as that of the perceiver. Once that is allowed, it should be registered that the interest for the viewer of some of the paintings in question is severely curtailed without a particular tragic narrative to inform them.

Take number 22: this is a pretty uninteresting picture unless it is brought to life by relating it to a specific scene in Sophocles' *Oedipus (the King)*. Or, if that pot is set aside as exceptional (no. 105 is even more so), then consider number 27. This is quite a nice picture, and someone with no knowledge of *Oedipus (at Kolonos)* will still recognize a vivid scene of suppliants at an altar. But it takes a particular narrative to explain why the old man sitting on the altar is blind, and to give a role to the two women with him and to the two men standing to either side. That story was told in the Sophoclean tragedy, and it is highly unlikely that viewers would have encountered it except through that play.

A more familiar example is the scene of Iphigeneia as a priestess handing over a letter to Pylades, who can then deliver it to its addressee, Orestes—there is a selection of this iconography in numbers 47, 48, and 49. No one disputes that Euripides, in his *Iphigeneia (among the Taurians)*, invented the story of Orestes being washed up in the Crimea and being recognized by his sister Iphigeneia through the delivery of a letter. So this scene ultimately derives from Euripides' play. But does it *need* the play to be appreciated? Could it not have become "simply the historico-mythical event"?[121] That disconnection is conceivable in theory—and it may have been the case for some viewers—but it has to be weighed against the high likelihood that *Iphigeneia* was a much-performed play in the fourth century, which means that the "event" for viewers would have been, in effect, the well-known Euripides play.

Lastly, number 87 supplies an interesting example.

This is one of six instances of the same iconography, which shows two young women suppliants in between a mature king and a young man. No one has yet been able to identify the story. It is a nice painting and it does not need a tragedy to be a self-sufficient work of art; it does not, strictly speaking, even need a mythological narrative. But surely the fourth-century Greek viewers were able to identify the myth, unlike us, and found the vase the more interesting and exciting for knowing it. And, while the informing narrative was not necessarily a tragedy, it is more likely to have been tragedy than not.

So we come to my crucial departure from the iconocentric position. The artistic language of the paintings—recurrent postures, etc.—may not need a particular version of the myth in order to engage a viewer, but the works are much informed by the narrative of the myth in question. The specific version makes the painting more powerful. If it is true that the performance of tragedy was one of the main means through which the viewers of these vases knew the myths, as I have argued in sections C–E, then their familiarity with the tragic telling would have, in at least some cases, informed their appreciation of the vase. It would have *enriched* its meaning for them. The vases are not, then, according to my approach, "banal illustrations," nor are they dependent on or derived from the plays. They are *informed by* the plays; they mean more, and have more interest and depth, for someone who knows the play in question. That is the core of what I mean by calling a vase "related to tragedy."

I shall try to give more substance to this idea of "enriching" or "informing" by means of a simplified analogy drawn from another period—I offer it for purely heuristic purposes and will not cite any actual manifestations. Suppose that we have a series of paintings that all evidently share the same basic iconography: they show a young man in black, with a white blouse, staring at a skull. Within that basic composition, which (let us suppose) draws on an iconographic tradition of contemplation scenes, there

are many variants. In most he stands, but occasionally he sits; in most, but not quite all, the man has a companion standing behind him; in nearly all, but not all, there is an open grave with earth and bones lying around it; and in most, but not all, there is a grave digger, and sometimes two grave diggers, down in the grave. In some of the pictures, there are indications of a church; in a few a boat can be seen on the sea in the distance; and in a few a funeral procession can be seen approaching. Now, at least some of these paintings are (again, let us suppose) fine works of art in their own right; they convey a vivid sense of youth and decay and of the prospect of death in life. They do not *need* the Hamlet story, let alone Shakespeare's text. But even a rudimentary recollection of the Shakespeare, whether from reading or performance, will surely inform and enrich the picture. "Alas, poor Yorick! I knew him, Horatio …" The grave digger identifies himself; but it is the Shakespeare that identifies the skull, the loyal Horatio, the funeral procession. It is important to register that none of these (imagined) paintings is presented as the play in performance: they include no painted scenery, lights, make-up, actors, and so forth. At the same time, one might note that the white blouse is drawn from a much-loved performance tradition; it is not essential to the scene and is not indicated by the text of the play. (I shall return to this matter of performance in the next section.)

The sine qua non of this iconography is the young man with the skull; the open grave is standard but not essential. If the man is old, then this is not Hamlet (it might be Saint Jerome). If he is looking at a decapitated head, it is not Hamlet (perhaps something to do with John the Baptist?). If he is looking at a leg bone, not a skull, then that is not Hamlet, unless perhaps it is some kind of secondary variant. The same would be true if the scene were set indoors. If the man is in colorful clothes, this is still presumably Hamlet, though it might jar with the picture that many have derived from the performance tradition. If Hamlet has two or more companions, that might also offend purists, but he is still presumably Hamlet; so too if he

is holding two skulls, one in either hand. These are the kind of variations and discrepancies that (mutatis mutandis) we shall encounter again and again in part 2 of this book. The pro- and contraindications have to be weighed against each other.

There are all sorts of ways in which this Hamlet analogy does not fully match the situation in the fourth-century B.C. Greek world, but I hope it makes clearer the basic point that paintings can be informed by plays. They mean more to those who recall the story as it is told in a particular play than they do to those who do not. The painting can be enjoyed through knowing some other narrative of the "myth," but it is less enriched. It is by coming at the issue through the *viewers* of the vases that I believe I have eluded the polarization between philodramatists and iconocentrics. Whatever it was that the viewers wanted from the mythological paintings, it was clearly not pictures of plays and not pictures of tragic performances. But, given the presence of tragic theater in their lives, there was no reason for them to keep these two art forms running separately along parallel lines.

J. Performance — and the contrast with comic vases

The most articulate attacks on the "old" philodramatist position in recent years have come from Luca Giuliani. He is not by any means a pure iconocentrist, however. He holds that the fourth-century vases (in contrast with earlier generations) are indeed informed by literature, including tragedy, although he is keen to detect the presence of other genres also, especially epic.[122] The crucial point for him (see sec. H above) is that the viewers of the vases did not know the literature directly for themselves, but had to have it mediated and explained by experts who knew it from reading texts. I have already attempted (in sec. E) to disprove his key claim that the public in fourth-century Apulia would not have seen Attic tragedies in performance. I shall now

consider the significance of another of his key arguments, which is that the vases never, or hardly ever, show the myths as plays in performance.[123] The only clear exceptions, he allows, are Sicilian: numbers 105 and (less indisputable) 22. This point is important and true: the great majority are paintings of mythological narratives, not of tragedies—however disappointing this may be to those interested in the practicalities of ancient Greek staging (as I am). I shall be arguing (in sec. M) that various elements of performance do actually "leech into" many of the vase-paintings, especially the later Apulian, although that should not be allowed to detract from the basic fact: these are not paintings of performances.

But granting this point does not mean, as Giuliani supposes, that the viewers of the paintings had not seen performances, any more than the viewers of the hypothetical Hamlet paintings never would have seen *Hamlet* performed. The paintings may still be deeply informed by tragedy, and the tragedy is still most likely to have been known in performance. But a painting that overtly displays and declares that it depicts a theater performance would no longer be a depiction of the myth: it would display the myth being performed by actors. The way in which a dynamic performance in the theater persuades the audience that it is "happening" cannot be transferred to a static picture of that performance. A picture cannot create a "dramatic illusion," quite simply because it is not drama.

This crucial point was made in slightly different terms in a seminal article by Green.[124] He starts from the observation that Greek tragedy does not openly declare its theatricality (*Hamlet* is different here). In a closely analogous way, Green argues, tragedy-related vase-painting does not overtly declare its theatricality. To put it in rather simplistic terms, tragedy does not "break the dramatic illusion," and tragedy-related vase-painting does not "break the mythological illusion."

Greek comedy, by contrast, is persistently meta-theatrical; it constantly makes play with the fact that it is a play (at least comedy of the period up to 400 and even 350 B.C.).[125] Comedy-related vase-paintings

draw attention to their theatricality in a closely analogous way. A brief look at the comic paintings will make the point.[126] I leave aside the Athenian evidence, which is hard to interpret and hotly disputed.[127] There are, however, Western Greek paintings in abundance from as early as 400 B.C., still well within the lifetime of Aristophanes, that display comedy clearly and incontrovertibly. There is great variety in these vases, and variety in their relationship to any performance of any particular play. They cover the whole range of dates and fabrics in Western Greek vase-painting, with their associated changes and differences, but the most important for present purposes are nearly all from Apulia in the period 400 to 360. In these scenes the narratives are quite explicitly *staged*. They are often taking place on a stage, and it is not rare for the pictures to include steps going up to the stage and/or stage doors. The participants in the scenes are conspicuously depicted as actors: they have comic (i.e., ugly) masks with open mouths, stage padding, costumes, and props. The actors of male parts sport the outsized (dangling) stage phallus. These paintings are not just images of funny stories, they are scenes of comedy in performance.

The earliest and most important picture, the New York Goose Play, has already been introduced (see fig. 5). The attention to staging detail extends to the decoration on the stage doors, and even to the strap that holds on the costume-belly of the old man. The unique "cartoon bubble" words emerging from the characters indicate beyond reasonable doubt (without going into details) that a particular moment, or at least a particular incident in a particular comedy, is being captured here. Another important painting is the fine and unprecedented Choregoi (Comic Angels) Vase, first published in 1991 (fig. 7).[128] Here we have all the standard features of performance: steps, stage, stage door (all showing the grain of the wood), masks, costumes, phalluses. And then, standing on the same stage, is a tall straight figure, finely dressed and with a handsome young face (mouth closed). Even without any further indication, we would take him to be a

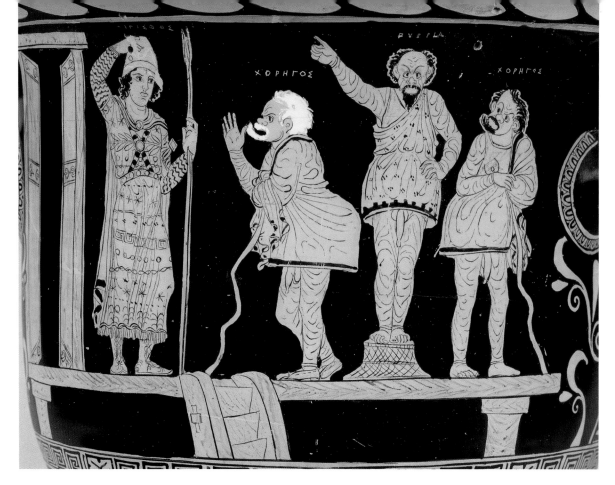

FIGURE 7
The Choregoi Vase. Apulian bell-krater, attributed to the Choregos Painter, ca. 390. Height of vase: 37.8 cm.
Malibu, J. Paul Getty Museum 96.AE.29.

figure from tragedy, who is for some reason involved in this comedy. This is confirmed by the name label above his head: ΑΙΓΙΣΘΟΣ. Aigisthos is a well-known figure from myth, who—both for his incestuous life story and for his involvement in the death of Agamemnon—makes an appropriate epitome of tragedy.[129] In fact, we can see Aigisthos as a baby on number 30, and as an adult complicit in murder on number 95. In neither of those tragedy-related vases is there in any explicit indication of theatrical performance: but here on this comic vase, he is standing firmly on the stage.

The core of the comic vases are, then, both pictures of comedy—they recapture a particular scene in a particular play—and pictures of its performance. The story of the comedy is not thought of as having a separate existence from the theatrical occasion in which it is enacted. The tragedy-related pictures, on the other hand, show a mythological story as a mythological story: they are paintings of a myth, not paintings of a play. But the fact that they are not pictures of performances does not mean that they are not related to tragedy. And it does not mean that they were not related to tragedies as known through performance, in the associations of their viewers in the Greek West of the fourth century.

K. PRECEDENTS AND PROBLEMS IN TRAGEDY-RELATED VASES FROM ATHENS

Before turning to the fourth-century vases—and the questions of how they might be related to tragedy, and how we might tell—it will be worth looking at Athenian fifth-century

painting, which tells a similar story in some ways, but with differences. Since this period in Athens was the great age of both tragedy and red-figure vase-painting, it remains a surprise—and in some ways, it cannot be denied, a disappointment—that tragedy has left so very little detectable trace in all those many thousands of pots. There have been several recent studies that have gone over the material with good sense and subtlety, but they are still not able to explain fully the lack of evident interaction between these two forms of depiction of myth and of life, which were both so active and creative simultaneously. Why this should be the case remains a question without a satisfying answer.[130]

Until recently there was just one known Attic painting showing, beyond any reasonable doubt, a scene of tragedy in performance. The krater in Basel (fig. 8), which dates right back to the 480s, has become well known since its publication in 1967.[131] It evidently shows six chorus members with almost uniform costumes and masks, dancing and singing in unison (whatever the other details of interpretation may be). This isolated "snapshot" of performance gives us a tantalizing glimpse of what we lack for both the fifth and fourth centuries. We do now, however, have a second—and, if anything, even more tantalizing and fleeting—glance: a scrap of pottery from the 420s, found at the Black Sea site of Olbia (fig. 9).[132] In the center stands the aulos player (the aulos was a double pipe with reeds) in full flow, and to either side is a chorus member, not in identical posture but with very similar costumes and masks. The way in which the profile mask is made clear in white is totally unparalleled.[133] These are, then, two pictures of performances, and they are quite distinct from the few we have that show an aulos player with a dancing figure, or actors putting on their costumes and masks.

A quite different but very interesting development

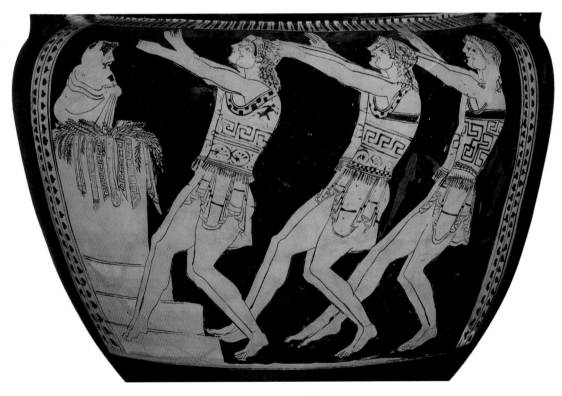

FIGURE 8
The Basel Dancers. Attic column-krater, unattributed, ca. 480s. Height of vase: 40.5 cm. Basel, Antikenmuseum BS 415.

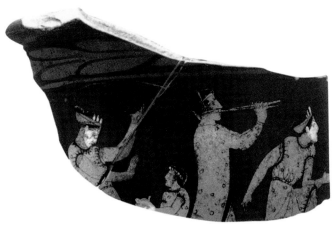

FIGURE 9
Kiev Chorus. Fragment of Attic bell-krater
(from Olbia), unattributed, ca. 420s.
Dimensions unknown (ca. 15 cm?). Kiev, Museum of
the Academy of Sciences, unnumbered.

one in a male role, the other female.[135] This painting
pretty clearly has something to do with a Dionysiac
celebration, perhaps set in his temple.

There is also a celebratory Dionysiac context to
the fullest, and by far the most important, theatri-
cal vase that we have, Athenian or any other: the
famous Pronomos Vase (fig. 12).[136] In addition to the
central presence of Dionysos himself with Ariadne,
there are the prize tripods (see sec. N2) under each
handle (scarcely visible in this photograph), for a
start. There is also a whole winning "team," including
the playwright (named as Demetrios), the lyre player

in the tragedy-related Athenian paintings
happens in the last decade or so of the
fifth century. We find paintings of actors
and chorus members "offstage"—in the
dressing room, so to speak. We have
already seen some examples of actors
with masks from Western Greek
vases (sec. E4), but the Athenian
forerunners are fuller and more
elaborate. They seem to be partic-
ularly associated with a fashion
in this period, exemplified by the
Pronomos Painter, for painting
highly ornamented fabrics—
indeed, it is possible that the paint-
er's delight in these goes beyond
anything that was actually seen in the
theater. Figure 10, said to come from
Taras, is a nice example, though unfortu-
nately very fragmentary:[134] it shows the mem-
bers of a female chorus (male performers, of course)
and their aulos player holding his instrument, which
has been taken apart into two separate pipes; there are
at least four masks, which the performers have taken
off (or not yet put on). On the bell-krater in figure 11,
of similar style and period, we seem to have Dionysos
and three of his companions surrounding two actors,

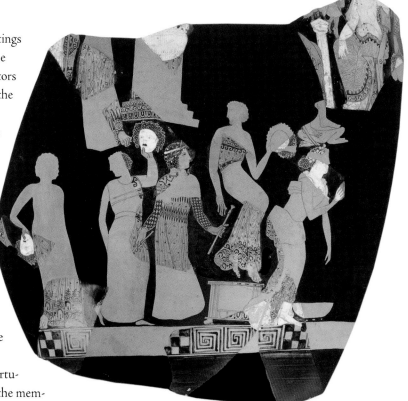

FIGURE 10
Female Chorus. Fragment of Attic krater
(found at Taras), attributed to school of the Pronomos Painter,
ca. 400. Height of reconstructed scene: 34.5 cm. Würzburg,
Martin von Wagner-Museum H 4781.

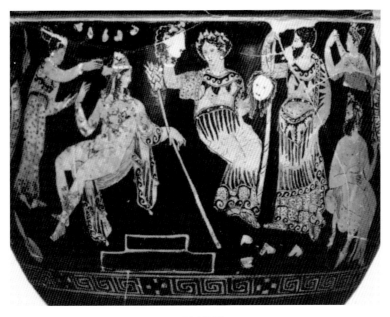

FIGURE 11
Dionysos and company. Attic bell-krater, unattributed, ca. 400. Height of vase: ca. 30 cm.
Ferrara, Museo Nazionale di Spina T 161C (inv. 20483) (from Spina).

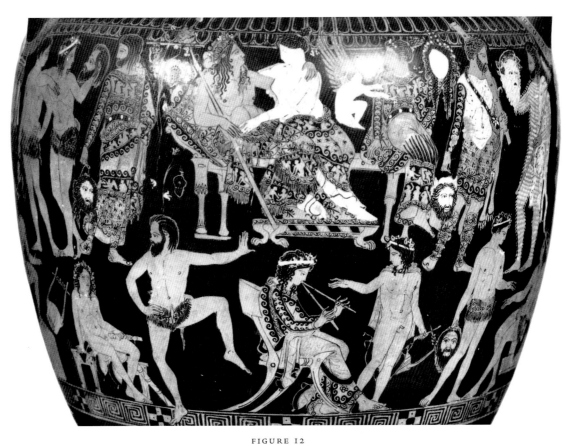

FIGURE 12
The Pronomos Vase. Attic volute-krater, by the Pronomos Painter, ca. 400s. Height of vase: ca. 75 cm.
Naples, Museo Archeologico Nazionale 81673 (H 3240) (from Ruvo).

(Charinos), and the central aulos player, Pronomos.[137] Furthermore, there are the actors, "fused" with their roles, and the chorus members in their satyr outfits, nearly all of them individually named with their real-life names.[138] This is not the place to go into the many intriguing details of this vase, which still, I suspect, has further insights to yield, even though it has been known for nearly two hundred years. There are, however, two particularly relevant points to make here. First, this is often treated as if it were of interest only for satyr play and not tragedy. But the team celebrated here will have put on three tragedies first; they are most likely shown in satyr outfits because that play was performed last. Perhaps it was only after the fourth play (i.e., the satyr play) that the cast took off their masks to face the applause, revealing their real faces—and only then could they hope to be judged victorious.

The second point is that, although this vase is now in Naples, it was found at Ruvo di Puglia.[139] At first glance this seems a very strange place to find an Attic vase with so much circumstantial detail. It would be easy to suppose that the picture meant nothing special in Ruvo, that it was just a curiosity picked up "via the second-hand market."[140] But, as has already been registered, an extraordinarily high proportion of the vases plausibly related to tragedy, whose provenances are known, come from this one site, an allegedly rustic and semibarbaric outpost. It seems likely (to me at least) that some of the inhabitants of Ruvo were fascinated by tragedy from early on, and that this is reflected by a passion for tragedy-related art in their tombs. It is not inconceivable that someone from Ruvo had actually been at Athens on the occasion of the victory in question, and had purchased (or even commissioned) this particularly intricate memento. I do not claim this as more than a possibility; but, to push the speculation further, it is not impossible that this very vase is a document in the hypothetically reconstructed story of how Athenian troupes were invited to travel elsewhere, and so spread tragedy (see pp. 6–7 above). It is also worth registering, more sol-

idly, that the Pronomos Vase is a volute-krater, a relatively uncommon shape in Athens, but one that was favored in Apulia from the start and which, with time, became the most favored shape of all for large-scale funeral vases. Maybe this is not a coincidence.

That, then, is a rapid survey of the chief Athenian vases that reflect the externals of tragic performance. It is interesting that the paintings of performers "offstage" are predominantly of choruses—in contrast to the Western Greek pictures, which are all of actors. This may suggest that the chorus was less central there than it was in Athens and throughout Attica. We see that Athenian mythological pictures never declare themselves to be theatrical performances, with the partial exceptions of the choruses in figures 9 and 10. This may be disappointing, but, as has already been maintained for the fourth century, they are pictures of myths, not of plays.

Deciding whether an Athenian painting is tragedy related is even more difficult than determining the connection in Western Greek vases, for Athenian vase-painters never, as far as we can detect, developed any system of implicit signals of theatricality. As we shall see in sections M and N, the vase-paintings of the Greek West developed a "lexicon" of signals that prompt the viewer to think of tragedy. But even without such signals in the Athenian fifth-century paintings, the question that remains is: are there any circumstances under which the viewer of a mythological vase-painting might benefit from thinking of a tragedy?

The only answer that has been offered is that some of the particular versions of myths that are told in the paintings are indebted to a particular tragic telling of that myth. But of the alleged cases, few are substantial enough to be taken seriously. It is a worrying danger sign that they nearly all concern plays that do not survive complete, so that there is an inevitable degree of speculation. One leading example is the veiled figure of Achilles that is claimed to be derived from Aeschylus' *Myrmidons* (see pp. 83–84). For all we know, some other telling may well have antici-

pated this feature of the Aeschylean presentation; it is indeed quite possible that the earliest of these paintings date from before Aeschylus' play. Second, it has been widely accepted, almost beyond dispute, that paintings of Andromeda in Oriental costume being tied between two posts are to be explained by Sophocles' play *Andromeda*. But we know next to nothing about the Sophocles play, and while the conjecture, which depends on inscriptions naming a son of Aeschylus, is not impossible, it is highly questionable (see pp. 175–76).

The strongest claims are, quite properly, based on surviving plays. There are two from the fifth century, and they are both related to Aeschylus' celebrated *Oresteia* trilogy. They are also related, interestingly, to the very first discussions in part 2 of this book, numbers 1 to 4 and 6 to 10. One scene is the meeting of Orestes and Elektra at the tomb of Agamemnon, which first appears on a mid-fifth-century vase. The other is a series of paintings from the second half of the century showing Orestes pursued by anthropomorphic Erinyes. It can hardly be coincidence that both cases have analogues, with both similarities and differences (more differences in the Erinyes scene), in the fourth-century paintings from the Greek West.

Apart from these two early cases, the three best candidates for Athenian mythological paintings connected with tragedy all come from the fourth century, not the fifth. Furthermore, they have quite close analogies from the West: in fact, in all three the scene is paralleled by more than one non-Athenian painting. Again, this can hardly be coincidence: it is, indeed, thanks to these similar iconographies from outside Athens that the case can be firmly made for the Athenian vases' connection with tragedy. The five Athenian paintings in this book include these three, all probably related to Euripides: 48 (380s) to *Iphigeneia (among the Taurians)*; 59 (390s) to *Andromeda*; and 75 (ca. 380s) to *Telephos*. The other two are *Oresteia* scenes: numbers 1 (from the 380s) and 6 (from ca. the 370s).

So there is not, to the best of my knowledge, a single fourth-century Athenian vase-painting that can

be strongly related to tragedy and yet has no Western Greek parallel. One is bound to wonder whether the influence may not have flowed in the reverse direction, i.e., that these later Athenian iconographies are imitating the much more theatrically informed artists from the Greek cities in the West.

Finally, this is the best place to consider the representation of satyr play in both Athenian and Western Greek vase-painting, since it seems to have been a particularly Athenian kind of drama and may not have transplanted well elsewhere. Satyr play was certainly an integral part of the tragic competition in Athens, and it was normal for every artist to produce one to follow each set of three tragedies.[141] In all probability this continued into the fourth century—a particularly nice later Attic picture of an actor holding a satyr mask is found in figure 13.[142] There are some Athenian paintings of actors offstage wearing ithyphallic satyr shorts and carrying satyr masks—the Pronomos Vase (see fig. 12) is the outstanding example. Satyrs are also pretty common presences within Athenian mythological paintings, but that does not prove that there was a corresponding satyr play. François Lissarrague has been a persistent iconocentrist here, pointing out, quite rightly, that there are other good

FIGURE 13
Satyr mask. Fragment of Attic cup, unattributed, ca. 380s. Height of fragment: ca. 12 cm. Dresden, Albertinum AB 473.

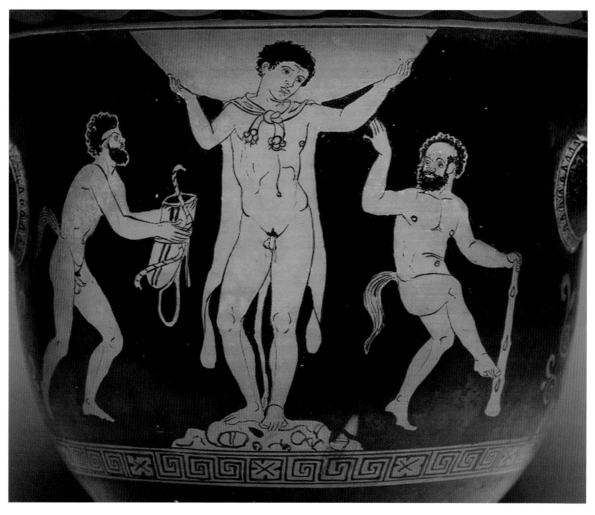

FIGURE 14
Satyrs with Herakles as Atlas. Apulian bell-krater, attributed to the Choregos Painter, ca. 380s. Height of vase: 33 cm.
Milan, Museo Civico Archeologico AO.9.285 (found at Ruvo).

cultural and iconographic reasons for including satyrs, without any need to appeal to a satyr play to explain their inclusion.[143] If the iconography of satyr play is at all like that of tragedy, however, then the same reservation about iconocentrism holds good: a picture may be informed by a play even though there is no explicit sign of theater as such. Thus, the fact that there are more than a dozen Attic vases of Prometheus offering fire to the satyrs makes it quite plausible that these paintings were informed, as has been suggested, by the Aeschylus satyr play that told the story.[144]

When we turn to the Western Greeks, there are thinner pickings. There is just one early painting (see fig. 4) that echoes the Athenian tradition of show-

ing actors in satyr shorts, and that is all. Satyrs in mythological scenes are also less common, although there are examples that raise the same kind of questions as those just discussed in relation to Athenian pots.[145] On slightly firmer ground, the scene in figure 14 shows satyrs, not in costume, making off with the famous weapons of Herakles, while he is preoccupied with supporting the whole globe in place of Atlas.[146] There is no positive indication toward the relevance of a satyr play, but it would not be surprising if there was one lurking behind the scene. The same is true for several scenes of satyrs reacting with terror to Perseus and the Gorgon's head. This iconography is found early, about 400, and happens to be in the upper

(minor) register of one of the finest of all early Western Greek paintings, the name vase of the Karneia Painter (fig. 15).[147]

So the presence of satyr play in Western Greek art is pretty thin and nearly all from the early years of the fourth century. In fact, only the Sydney chorus men give clear testimony that the genre accompanied tragedy at all in its export to the West. One must, therefore, be in doubt as to whether satyr plays followed tragedies in a similar way to the traditional program in Athens. Satyrs and their senior versions, silenuses, continued to be favorite figures throughout fourth-century Western Greek art, but not in association with satyr play as enacted in the theater.

L. ASSESSING HOW VASES ARE RELATED TO TRAGEDY: (1) THE NARRATIVES

Now that the backgrounds are in place, we can confront the central questions that underlie every picture discussed in part 2 and that explain the differing and often rather tentative headings to each entry. I believe that I have thus far established the following: (a) that tragedies, including the Athenian "classics," were performed, probably frequently and throughout the region, in the Greek West in the fourth century; and (b) that a mythological painting may be enriched and informed by the viewer's knowledge of a particular tragedy, without it being a picture of that tragedy, let alone of its performance. The question now is: how, in the case of any given mythological picture, are we to say that this one does appear likely to have sparked a connection with a tragedy for a perceptive viewer, while that one does not?

The answer might seem obvious: if the details of the narrative in the painting tally closely with those of a particular play, then it does relate to it, while if there are differences between them, then it does not. But there are at least two reasons why things are not so simple. One is that we know about only a small proportion of the tragedies that are likely to have been seen by the viewers of these vases. The number of tragedies in circulation may well have been in the thousands rather than the hundreds—the "big three" alone (Aeschylus, Sophocles, and Euripides) composed well over two hundred between them (not including satyr plays). While thirty-two tragedies

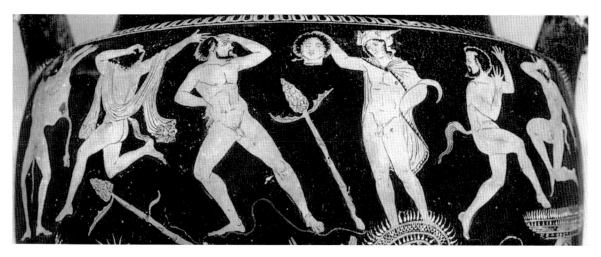

FIGURE 15
Karneia Perseus and Satyrs. Lucanian volute-krater, attributed to the Karneia Painter, ca. 400.
Height of vase: 72 cm. Taranto, Museo Archeologico Nazionale I.G. 8263 (from Ceglie del Campo).

survive, we know some details of perhaps another one hundred lost plays by them and by other dramatists, although much remains unknown even about these. Some statistics about the 109 pictures in part 2 will bring home the point. I have, of course, given special priority there to vases that may be related to the surviving plays, yet those still account for only thirty-nine entries.[148] Another forty-three are possibly related to lost plays by the big three, some only very speculatively so. This still leaves twenty-seven that I have reckoned to be plausibly tragedy related, even though we know little or nothing (else) about the play in question.[149]

Second, in connection with the plays that we do know about, a high score in correspondences between the painting and the play does not necessarily show that the viewer is being prompted to recall the tragedy, especially not with the relatively simple pictures. It is more a matter of the emphases on the various narrative elements within the picture, and whether they match the emphases of a particular play. No less importantly, discrepancies between the picture and the play do not by any means prove that they are *not* related. It is the task of the painter to arouse admiration and to suggest meaning for the viewer (a very simplified formulation for the time being—see further in sec. O): it is not to pay scholarly attention to the precise details of a text. And if the tragedy is brought to the mind of the viewer, then he or she will expect the play to inform and enrich the picture rather than be precisely copied by it. So it is, again, a matter of emphasis, a matter of pro- and contraindications, and the relative weighing of each. Are the pro-indications strong enough to prompt the association? Or are the contraindications strong enough to "block" the association? Neither is just a matter of a numerical totting-up: they are issues of quality, not quantity. The balancing of this kind of calculation has already been illustrated in a programmatic way by the Hamlet analogy.

Clearly this is a matter of judgment for the viewers, and, indeed, also a matter of the viewers' relevant acquaintance with tragedy. They may miss the association (and, it should be granted, still appreciate many aspects of the picture warmly). They may make a mistaken association, and yet not have their appreciation of the picture completely spoiled. A perfect match between the promptings of the picture and the responses of the viewers is an ideal more aspired to than achieved, but the notion of the "primary viewer" still stands valid. If the picture had been specifically commissioned, which may well often have been the case—we simply do not know—then the likelihood of a harmonious match would have been greatly increased.

And if it was a matter of competent judgment and informed association for the original viewers, then how much more so it must be for us. Every painting has to be taken by itself, and its emphases considered. Any possibly relevant tragedy that we have the good fortune to know about must be considered both as a text and as a potential performance. Reaching an assessment is always bound to be a matter of probability and possibility, plausibility and implausibility, seldom—if ever—total certainty. (Immeasurably more can be excluded than can be included.) Thus every picture in part 2 has a separate heading, which attempts to summarize my own assessment of its relationship to any tragedy or tragedies in question. In the end, however, I consider it more important to set out the issues than to draw firm conclusions from them.

The kind of considerations that we must constantly face may be best introduced by three briefly sketched examples of particular pots, fully discussed in part 2. In number 8 the central narrative tableau of Orestes at Delphi (rather like Hamlet and the skull) makes a strong case for claiming that this picture is informed by Aeschylus' *Eumenides*. Furthermore, the veiled figure would be inexplicable without knowledge of the dream-ghost of Klytaimestra in the tragedy. But there is a conspicuous contraindication to set against these pro-indications: Apollo is holding a purificatory piglet over Orestes' head, which never happens in Aeschylus' play as we have it. We might conjecture

that players added such a scene on their own initiative. Or the picture might have brought in the detail from the allusion to Apolline purification by sacrifice of a piglet at *Eumenides* lines 282–83. Either way, I conclude that the picture *is* related to and enriched by Aeschylus' tragedy.

My assessment of the balance tips away from a surviving play, however, in the case of number 26, which shows Philoktetes marooned on the island of Lemnos. The static Philoktetes, his cave, his bow and quiver, and the wild game hanging above all tally with Sophocles' *Philoktetes*; but we have no reason to think that these details were particular to his version. The most striking pro-indication is the way that Odysseus is shown as half behind the cave, holding his sword, as though hiding in an ambush. Turning to contraindications, however, Philoktetes is here fanning his diseased foot with a feather, whereas in Sophocles there is an emphasis on his repulsive bandages and no feather. More conspicuously, there are two female figures, Athena to the left and a beautiful young female on the right, who are not in any way explained or informed by the tragedy. These amount to major contraindications pointing the viewer away from Sophocles and toward some other telling of the story, quite possibly another tragedy.

The third example, number 43, is actually discussed by Moret as an exemplary illustration of "iconocentrism."[150] It happens to be the only artistic representation we have of the death of Neoptolemos, killed at the altar of Apollo at Delphi. This was a well-known story, but the only tragic telling to survive comes in the messenger speech in Euripides' *Andromache*. The whole issue hinges on the central figure with drawn sword who is lurking behind the omphalos stone, specifically identified as Orestes by an inscription. As far as we know, Orestes had never been involved in the story of Neoptolemos' death before Euripides' version. Moret claims that, according to Euripides, Orestes was not actually there at Delphi for the kill; but this is contrary to the clear indications of the text. Furthermore, in the tragic version Orestes

does not openly challenge Neoptolemos, like a heroic warrior, but stirs up the Delphians to attack him in ambush. The way in which the figure of Orestes hides behind the symbol of Delphi is, it seems to me, nicely informed by the Euripides play. So the play is not, as Moret claims, "a point of departure … only a pretext." I agree with him that "literary preoccupations" are not what matter to the painters—nor indeed to their public; but a vivid recollection of Euripides' tragedy is not the same as a literary preoccupation.

M. Assessing how vases are related to tragedy: (2) An index of signals

I have insisted that, with the rare Sicilian exceptions, the vases are not pictures of tragic performances. This is not, however, the same as saying that there are no signs or traces whatsoever of theatrical realities to be seen within the paintings. There are (or so I shall maintain) quite a range of features that may "leech in" from the painters' and viewers' familiarity with the visual dimension of theater. I shall not go as far as some who have claimed that one or another of these "signals," as I shall call them, is an infallible proof of the theatrical connection—although I do reckon that two of the entries in the following list, 4 and 6, are pretty strong prima facie indicators. All these features may have become assimilated with iconographies that are not theater related, especially later in the fourth century.

Here, then, is a list of the significant possible signals that I am aware of. I shall limit any illustrative examples to the 109 vases in part 2, although in most cases there are quite a few other examples of the signal in question. They are arranged in a convenient order, but not one of ascending or descending importance. I should emphasize that this is not a "tick box list": the strength of the signals is a matter of emphasis within pictorial context, not a matter of numerical accumulation. Several signals together do not necessarily

constitute a strong case for a related tragedy, although they would suggest that the picture is worth consideration. A single signal centrally deployed, especially in the earlier period, may constitute a strong indication by itself. Although these signals do not establish a certainty, they can contribute tellingly to the assessment of probabilities and possibilities.

1. Costume

There is plenty of evidence that tragic costumes for both male and female roles were splendid, and not at all like everyday wear. The two most obvious features were highly ornamented fabrics and long, tightly fitting sleeves (useful, apart from anything else, for playing multiple roles). These are clear in the Pronomos Vase and similar pieces (see figs. 10, 11, 12). There are also two particularly telling fourth-century illustrations that are unquestionably theatrical. First, there is Aigisthos on the Choregoi Vase (Apulian, ca. 390, fig. 7). The rows of varied ornamentation and the conspicuous sleeves are both characteristic of the costumes seen on many plausibly tragedy-related vases.[151] Second, the explicit performance scene on number 105 (Sicilian, ca. 330s) shows female characters with similarly ornamented robes and sleeves worn under a plainer chiton with border. Two other, comparable Sicilian vases (nos. 22 and 106) confirm that these are standard features of actual theater costumes.

Seldom do all the characters in a mythological painting wear such outfits, however. Young men are, on the contrary, usually shown as naked, in heroic fashion. It is clear that this kind of garb, even if it originated in the theater, was employed by painters for kings, Orientals, heroines, and others, even in paintings where there is no plausible question of a theatrical association. So this kind of costume is not by itself a sign of theater. On the other hand, Giuliani's dismissal of such outfits as irrelevant is going too far.[152] Although the costumes are not exclusively related to theater, they may still be signals within a larger

picture. They certainly do not count against a tragic connection.

2. Boots

The *kothornos* (buskin) became a kind of symbol of tragedy, second only to the mask. Worn for male roles, it was a high boot with a fairly soft thin sole (the high-soled buskin belongs to a later era).[153] On the vases they are often shown as laced up the front, as can be seen with Aigisthos in figure 7; alternatively, or in combination, they have ornate flaps or turned-over decoration at the top, often metallic looking, as with the Würzburg actor (see fig. 3).[154] Again, such boots, like the costumes, are by no means exclusive to tragedy-related scenes. They are found already in much earlier vase-painting, and they are far more widely associated with Dionysos and with travelers. It is striking, however, how many of the men on the likely tragedy-related vases do wear boots—sometimes even when they are wearing very little else! The boots are not a guarantee, but they may be a signal.

3. Porticoes

The standard background to a Greek theater set was a building with central doors (the *skene*). In tragedy this would usually represent a palace, sometimes a temple or a military tent. There is, of course, no background "set" in the vase-paintings. Yet, surprisingly often—in well over ten percent of the pictures in part 2—we do find a kind of portico, usually but not always central, usually supported by four slender pillars. As time goes by, less possible significance can be allocated to this, since the structure becomes conventional as a kind of minishrine on funeral vases to house an idealized image of the deceased.[155] But these "stagey" porticoes are spread throughout the period—number 14, for example, dates from as early as the 390s. So while the portico cannot count as more than a possible signal, there is no reason to disregard it.[156]

In view of the more strongly theatrical associations of some Sicilian vases, it is interesting to find columns on number 22 and an elaborate edifice on number 103. There are also architectural features, including doors, on the Paestan Herakles vase, number 45.[157] And there are more elaborate Apulian "sets" on numbers 69 and 71. Although we cannot assert it for sure, these may give out quite strong signals of associated theater.

4. The rocky arch

If any one of these signals comes close to being explicitly rather than implicitly theatrical, it is this not-very-common but highly recognizable feature. It was the convention to represent rocks by means of "squiggly" formations of paint; in the relevant instances, they are expanded to make a rock larger than the size of a person. This is nicely illustrated by number 18, which shows Prometheus bound to a rock that is painted as a kind of arch, rather than as solid. This feature is also found in several depictions (not all) of Andromeda, put out as a feast for the sea monster, as exemplified by numbers 60 and 61. On the former pot, a wool basket goes behind the right-hand edge of the rocky arch, showing that either it represents a cave, or the painter thinks of the "solid" rock as conventionally represented by an open archway.

It is a plausible conjecture that this rocky arch on the vases is based on a standard piece of portable stage set used by the acting troupes. If they wanted the *skene* door to represent a cave, they would put a painted arch in front of it. The vase-painters then borrowed this idea and so avoided the problem of how to represent a solid rock behind a figure. This theory has recently been confirmed by three examples, all later Apulian, of a rectangular "door-shaped" rocky arch, instead of the usual curved hoop. Two of these are in Andromeda scenes (see ch. 4, n. 36); the third (no. 98) is a mystery scene that seems to show a larger-than-human figure standing in a cave doorway. There are

also two quite early Sicilian scenes (nos. 26 and 65) that are set in cave mouths: in both of these, the arch is smooth rather than "squiggly," but here too we seem to be close to a stage set.

5. Anonymous witness figures

Many of the mythological vase-paintings include nameless companions, soldiers, maids, attendants, and so forth. They are not in themselves an indication of any relationship with tragedy, since figures of this sort are to be found in all kinds and periods of Greek vase-painting.[158] At the same time, it is an interesting (and not totally obvious) feature of tragedy that every single play includes anonymous, nonnoble characters.

These fall into three categories: silent attendants, choruses, and anonymous speaking roles.[159] The first of these is ubiquitous in both art forms and so cannot be treated as special. The second, the chorus, leaves notably little trace in fourth-century vase-painting. This is partly, no doubt, because multiple identical figures are not appropriate to this kind of painting, which avoids being heavily patterned. It may also be the case that in the Greek West the chorus was regarded as a secondary feature of the plays, unlike at Athens, where it had a central role. The best candidates for distant echoes of the chorus are probably the Erinyes in the Orestes-at-Delphi scenes on numbers 7–10, especially 9. Two recently published pairs of figures might also be claimed to invoke choruses because they are, unprecedentedly, given a combined label of identification. These are the two "maidservants" on number 95 and the two "Phrygians" (meaning Trojan soldiers) on number 96.

The third category is represented by a few solo figures who are given labels identifying them by their status or humble function and not by their names. In the case of the "herdsman" on number 68, there are good reasons to equate him with an anonymous speaking character in Euripides' *Melanippe (the wise)*. Other anonymous male characters are a "Phrygian" on

71, an "Aitolian" and a "servant" on 91,[160] a "tropheus" (male child carer) on 81, and a "paidagogos" (see next section) on 79. These labels are a prima facie indication of speaking characters within the associated tragedy. Among the mass of attendants, there is also a female figure whose role is particularly identifiable: a white-haired woman who is clearly associated with a high-status woman would be her "nurse" or "female child carer." She appears with a specific label ("trophos") on number 68. The nurse is a common figure both in tragedy and on the vases; but it would be unwise to claim her as a strong signal, since nurses appear in other forms of narrative as well.

6. The little old man (paidagogos figure)

In the vase-paintings there is one anonymous figure whose appearance is so distinctive that he is always easy to spot. While there are slight variations, the "family" of features generally show him as old and white-haired, stooped, with a crooked stick, a cloak, conspicuous tight sleeves (quite often white), and prominent boots, which often seem rather rich in comparison with the rest of his outfit. He begins to appear in Apulian painting in around the 350s (no. 33 is an incipient example), and he crops up frequently during the period of "high" Apulian. He appears in a remarkably large proportion of the plausibly tragedy-related vases—about twenty of those in part 2. It is highly significant that he also figures on numbers 22 and 105, the two Sicilian vases (ca. 330s) that are close to actual stagings: it is this Sicilian pair that clinches the claim that he has strong theatrical associations.[161]

In a valuable article, Green (1999) has collected and discussed fifty-one Apulian examples; he presses the claim that this persistent figure is a sure sign of a tragic association. The little old man is conventionally given the label of paidagogos (male carer, similar to the tropheus discussed above), but there are two reservations to make about that. First, there are paidagogoi in earlier paintings who are not represented in this way: examples are numbers 12, 34, and 35. Second, some of these old men are not child carers at all: the old Corinthian shepherd on number 22 is a clear exception; the herdsman on number 68 another. It is true, however, that the majority of them are associated with young or adolescent males who are under their care; and the paidagogos is not an uncommon role in tragedy. In some pictures of the abduction of young men, he may, however, have become nothing more than a conventional figure. One scene, for example, that occurs repeatedly in Green's list is the abduction of Ganymede: it might be rash to press for a tragedy behind all of those. Still, the stooped old man with his distinctive appearance is a first indication of a tragedy-related vase, even though he may not be knock-down proof. He might even be present as a signal without having any actual speaking role in the tragedy in question. This is the case, for example, on number 31, which is very likely related to Euripides' Alkestis.[162]

7. "Furies" and related figures

The Erinyes, or Furies, were ghoulish spirits of revenge and retribution. The very word "Erinys" becomes a sinister leitmotif throughout Greek tragedy. By the time of Aristophanes' Wealth (of 388 B.C.)—"perhaps she is an Erinys out of tragedy" (lines 422–24)—it appears that Erinyes are already especially associated with the tragic theater.[163] It seems to have been Aeschylus, in his Oresteia of 458, who first gave them visible anthropomorphic form. Only after that point do they enter the iconographic scene, first in fifth-century Attic pictures of the pursuit of Orestes, and then in fourth-century versions of his story. Orestes accounts for about half of their occurrences, but they turn up in a whole range of other myths as well.[164] While there are variables, the Erinyes are generally represented as quite good-looking females, with wings and with snakes around their arms and/or in their hair. They are sometimes in action, but often static, even calm.

Extending from the Erinyes themselves as a group, we occasionally find individual examples with alle-

gorical names such as Madness and Punishment.[165] Generally these figures introduce into the picture an element of what Christian Aellen called "cosmic order," particularly suggesting that murder and disruption will eventually be set to rights.[166] Crime, vengeance, and punishment are, of course, pervasive in Greek myth, and not only in tragic tellings of it. At the same time, it is striking how often there is an Erinys figure in the plausibly tragedy-related scenes in part 2. Even without including the Orestes scenes, there are more than ten of them.

Erinyes are by no means proof of a tragic connection, and there are counterexamples; but, taken along with other signals and considerations, they may well support the case for thinking that the viewer is being prompted to recall a tragedy. The presence of an Erinys on a tragedy-related vase should not, however, be taken to indicate that any Erinys appeared onstage; it need not even mean that the word was deployed in the play. What the Erinys does signify is that the story includes an element of retribution or psychic disturbance.[167]

8. Supplication scenes

Melodramatic scenes of violence, danger, rape, treachery—threatened or performed—these are the stuff of much of Greek myth, and not the special property of tragedy. Nonetheless, such scenes are characteristic of tragedy, and it would hardly be surprising to find them reflected in associated vase-paintings.

Two kinds of narrative are, perhaps, particularly "tragic." One is intrafamily killing, deliberate or in ignorance, intended or fulfilled. Such scenes, many featuring drawn swords, are seen in well over ten percent of the pictures in part 2, including stories such as those of Lykourgos and Medeia. Even more frequently we find supplication scenes, in which people throw themselves on the mercy of others or on the protection of a god (the word "asylum" is Greek in origin). There are at least eight vases in part 2 that show someone down on their knees pleading with another.

And number 105, set on a stage, confirms (if confirmation were needed) that this was a characteristic action of tragedy in performance.

Scenes with characters who have taken asylum at altars, where they either stand or more often sit, are even more common. About twenty such tableaux are included, even without including Orestes clinging to the omphalos (navel) stone at Delphi. An iconocentrist will point out that these altar scenes are all part of the stock-in-trade of the vase-painters, one of their "building blocks" for composition. This is quite true; but supplications and asylum scenes at altars are also part of the stock-in-trade of the tragedians. They are not only a recurrent scene type but are even central to several plays.[168] Both the tragedians and the vase-painters found this a particularly exciting and effective turn of events. It would not be surprising if there was interaction between the two—it might be more surprising if there were not.

It is noticeable how very common altars are on the likely tragedy-related pots, sometimes as a part of the story and sometimes not. About half of the vases include an altar in one part of the picture or another. Altars were, of course, everywhere in the life of the Greeks, not just in their stories, but I do wonder whether their frequency in these vases might have been encouraged by the stage altar in the theater. There is actually an altar, presumably a portable stage property, visible on the stage in the fragmentary Sicilian theater vase, number 106.[169]

N. ASSESSING HOW VASES ARE RELATED TO TRAGEDY: (3) TWO EXTRADRAMATIC SIGNALS

All of the possible signals discussed in section M, insofar as they might indicate a connection with tragedy, are shared with the play: that is to say, these features occur in appropriately different forms both within tragedies and within vase-paintings. I turn now to two features that

we find occasionally in vase-painting but which are connected to tragedy by external association, if they are connected to it at all.

1. Name labels in Attic dialect

A significant proportion of the vases in question, about a quarter even, have one or more name inscriptions on them. These occur throughout the fourth century, mostly on Apulian and Paestan vases. While some of the identifications are obvious (or seem obvious to us), particularly in the early decades, there are others that provide a key to narratives that would otherwise remain doubtful or obscure. And there are even a few narratives that we otherwise know little or nothing about. The Darius Painter seems to have particularly specialized in unfamiliar myths, and he frequently adds name labels as a clue or clarification: there are some fifteen examples of his inscribed work in part 2.

There is nothing intrinsically special or tragic about the inclusion of name labels: they are found in all sorts of pictures from throughout the history of Greek vase-painting (and other art forms as well). It is striking, however, that almost all of these inscriptions are in Attic dialect, or in forms that could be Attic; in quite a few cases, the forms are definitely not acceptable in Doric or Aeolic, the dialects of most of the Greek cities in the West (Taras was strongly Doric). Attic was the established dialect of the spoken iambic lines of tragedy and remained, as far as we know, the dialect of tragedy wherever it was produced. Over the course of the fourth and third centuries, a form of Attic (koine) became the accepted standard dialect throughout the Greek world, and it might be claimed that the Western Greek vase inscriptions are merely a manifestation of this development. But the Attic dialect is there from the start and is remarkably consistent. Furthermore, the widespread popularity of tragedy might well have been a factor in the eventual establishment of the Attic-based koine as the norm—which came first? I suggest that in the fourth century,

Attic dialect on vases might have "steered" the viewer toward an association with tragedy.

There are exceptions, but they are remarkably few. Two names repeatedly, but not invariably, use the Doric alpha instead of the Attic eta: Hermas (not Hermes) and Orestas (not Orestes). I note but cannot explain this. There is one vase among all those in part 2 that makes a conspicuous exception, perhaps the exception that proves the rule. This is number 91, a monumental volute-krater showing the story of Thersites killed by Achilles. No fewer than fourteen figures have identification labels, and four of those, including that of Thersites himself, are in forms that are definitely not Attic; none of the others are in a form that would be exclusive to Attic. This vase has widely been supposed to be related to a tragedy, but, in my view, this consistency of dialect puts a question mark over that. The Doric may "steer" the viewer away from relating the vase to a tragedy.

The generally consistent and scrupulous use of Attic is, I suggest, an indication of tragedy's centrality in the mythtelling of the fourth-century Greek West, especially in Apulia. The inclusion of an inscription in Attic does not, of course, necessarily indicate a tragic connection, but it can take its place among the index of signals.[170]

One further observation: It might be supposed that the accurate spelling and dialect of the name inscriptions suggest that they were copied from written sources. But an interesting detail contradicts this theory. While most of the letter forms are the same as those used in Athens in the fourth century (though not in the fifth), the cities of Western Greece, especially Taras, developed their own particular form of heta, which represents the sound of "h" (not included in the standard Greek alphabet used in modern times): this was "Ͱ."[171] It is employed throughout the fourth-century name inscriptions—not invariably, but in perhaps one-third of the possible opportunities. This seems to show that the vase-painters and their public were approaching the names from hearing rather than from reading them. In which case it is a

possible positive indication that they knew the plays from performance, not texts. Interesting, if true.

2. Tripods

Bronze tripods (large bowls supported by three legs) were a prestigious trophy and object of dedication from early days—Hesiod back in circa 700 won one as a prize for poetry. In Athens the tripod was especially associated with victory in the choral competition in dithyramb—there was even a Street of Tripods leading to the theater.[172] They did not presumably serve as tragic prizes; but the Pronomos Vase (see fig. 12) is still good evidence that they were associated with victory: beneath the two handles are festooned tripods, one on a pillar, one on the ground.

Tripods are not common on the Western Greek vases. As might be expected, they are most often found in settings with a sacred association, especially Delphi (e.g., nos. 7, 43).[173] While it is surprising to find two tripods on pillars behind the altar in number 27, they are probably there because the scene is set at the sacred grove at Kolonos. The single tripod on number 99 does not seem, on the other hand, to have any particular bearing on the scene. And, most strikingly, there are three pictures, all later Apulian, that have tall pillars carrying tripods at either end, pretty clearly framing the picture as a whole and not internal to it: these are numbers 40, 85, and 102. In the case of number 102, the rather "over-the-top" Medeia scene in Munich, there is every sign that the picture is tragedy related. The Parthenopaios scene on number 85 is also quite a likely claimant. It is in the scene on number 40, which I shall argue is related to Euripides' *Hippolytos*, that this signal, if it is one, makes the most significant difference to our assessment of the overall pro- and contraindications.

So, although there are only three, or possibly four, instances, these tripods do add up to quite a plausible connection with victory and dedication. And this relates to the picture as a whole, and not to any one element within it. Victory in a competition is the most

likely explanation. If that is right, then it shows, interestingly, that there were performances in Apulia, and that some of the vase-paintings were associated with particular successful occasions.

O. What was (is) the point of tragic vase-paintings for funerals?

To draw this setting of the scenes to a close, we should ask what the vase-paintings meant to the Greeks concerned, taken alongside the account in section B of what tragedy meant to them. And why did the two interact as they did?

I am now taking it as established (even if it is not quite one hundred percent certain) that during the fourth century, going to see tragedies in performance was an important, and indeed time-consuming, activity for Greeks and for highly hellenized non-Greeks everywhere, not least in the West. To resume section B briefly, tragedy worked in several ways, simultaneously and interdependently. It was entertainment, it gave pleasure by exciting and moving its audience; yet at the same time it prompted the viewers to think seriously about politics, the family, misfortune, mortality … the human condition. It also encouraged them to sense—without necessarily claiming any ultimate, metaphysical "truth"—that there are strengths and benefits to be recovered from the inscrutability and unpredictability and, all too often, grief of human life. Despite all the pain and disappointment, humans are still capable of courage, intelligence, generosity, celebration, and harmony. The splendor of the spectacle, the order and gracefulness of the movements and the music, the "rightness" and depth of the poetry, and the shaping of the form and plot all conspired to lead the audience of tragedy to feel that there might be meaning and beauty in life, and even in death, if they can only be "seen in the right way."

To turn now to the analogous question that has

not yet been faced: what did the painted ceramics mean to the people who commissioned, purchased, viewed, and appreciated them? Pottery came in all sorts of shapes and sizes, and at very varied levels of quality. Its uses ranged from everyday domestic chores to the formalized social drinking of the symposium, from religious rituals to weddings and funerals. We can declare with some confidence that the pots that interact with tragedy were made primarily for display at funerals and for the tomb, even if some were first given practical use at the symposium.[174] They are almost all at the highly crafted and costly end of the market, and the great majority of them are large, even very large, too bulky for any practical use. Some of the large kraters (wine-mixing vessels) have holes in the bottom that prove that they were never meant to hold liquid. Many of the larger pots also have explicitly funereal scenes on the side of the vase opposite the mythological picture. Lastly, all of those with known provenances were found in tombs. So the question comes into focus: why bring stories of suffering and disaster to the viewers' minds at a time of mourning, and why further infuse those stories with the recollection of tragedies?

These grand and conspicuous works of art might function both to honor the dead and to console and strengthen the living. The latter, the surviving mourners, have received most attention in recent studies, but it seems likely that the grave goods were at least partly chosen because they would please, or would have pleased, the dead person. It is widely held that the link between tragedy and funerals is the cult of the god Dionysos, but I am skeptical about such a facile "comfort." It is true that many Greeks in the West believed in the possibility of a blessed afterlife, opened up by initiation into mystery cults.[175] And these were often associated with Dionysos.[176] But there is no reason, as far as I am aware, to think that the tragic theater played any part in this afterlife, or was associated with it. The fact that theater was mounted under the auspices of Dionysos, and that he was involved in some hopes about an afterlife, does not strike me as a

sufficiently strong association to explain the appropriateness of tragic myths to funerals: these two aspects of the god are not that closely related. It is notable that only very rarely does Dionysos himself appear in the tragedy-related vases (in contrast to the comic vases); when he does, it is because he is part of the plot.[177] So the reflection of tragedy is more likely to be appropriate because the deceased, when alive, took pleasure in tragic performances. It may well be that sometimes the choice of the play on the pot was made in light of his or her specific tastes.

This train of thought is supported by the presence of comic vases in graves. The comedy-related pots are generally considerably smaller—typically 30 to 40 cm in height—and are most commonly bell-kraters for mixing wine. Unlike the monumental tragedy-related pieces, they were probably originally made and purchased for the symposium. Their scenes would certainly provide much entertainment, and it seems likely that the more elaborate pieces were specifically commissioned. They might, at first sight, seem too frivolous and grotesque to be placed in the tomb, but this makes sense if one thinks in terms of gratifying the dead. Someone who took great delight in comedy would not object to being buried with a comic scene, however rude and undignified.

But when it comes to "serious" mythological vases, the scenes on the funeral vases were in all likelihood primarily there to comfort the living.[178] This comfort would have been achieved especially through their display as part of the funeral celebrations. How, then, can the recollection of tragedy comfort the bereaved? I think that the answers to this are more complex and less naive than have usually been supposed.

Some tragic scenes offer in themselves comfort and hope, even amidst danger and death—or at least they do so at first sight. Orestes and Elektra are united at their father's tomb; Iphigeneia (among the Taurians) will be rescued from danger and united with her loved ones; Andromeda will be saved from the monster through love; Alkestis is restored to life for being the perfect wife. So far so good, but comfort

on this level has to remain pretty superficial. Orestes killed his mother, Andromeda was abandoned by her parents, Admetos agreed to let his wife die.... And, in any case, the majority of tragedies do not hold out any such easy solution: Their dark sufferings far outweigh their redemptions. What future happiness or reunion can cheer Niobe after the death of her children, or Oedipus after the truth is out, or Theseus who has condemned his own son to agonizing death? And what glimmer of hope can be extracted from the horrific story of how Medeia killed her children, or how Thyestes begot Aigisthos through incestuous rape, or how Klytaimestra butchered Kassandra? It is no good pretending that in the Greek tragedies, "everything will be all right in the end." Only a minority offer some kind of "happy ending," and even that usually comes about only after many trials. It is important to emphasize that, contrary to most consolations of modern religion, there is no salvation or afterlife standardly held out as transcending this mortal life. It seems to me that only a small proportion of all the tragedy-related vases can be regarded as showing scenes that will, in the long term, offer the comfort of compensation after suffering.

Generally speaking, the Greeks did not want their consolation rose-tinted. They respected the art forms that showed human tribulations without flinching. The thought that they salvaged from the tragedy-related scenes was this: if these great heroes and heroines of the past, for all their wealth and power and closeness to the gods, had to suffer, then so must we. We must be prepared to bear it with patience, and to live on, and to die.

Three illustrations will indicate how widespread this train of thought was in the ancient Greek world, even before speeches of consolation became formalized and commonplace. In the last book of the *Iliad* (24.602ff.), Achilles urges Priam to eat: even Niobe, he says, after all her children had been slaughtered by the gods, took food eventually. Both Priam and Achilles have been bereaved of their dearest, and yet they gather themselves, and eat, and sleep, and go on liv-ing. This is the archetypal consolation scene of Greek literature.[179]

Second, there is a fragment of comedy by Timokles, who was active in the second half of the fourth century.[180] The speaker observes that human life is full of sorrow and care, but that people have found ways to make this bearable, particularly by seeing that others are no better off, or even worse. The tragedians are cited as salutary benefactors of this kind. The illustrations given all have a touch of the absurd about them—this is comedy—but the basic idea is that the sufferings of the great heroes bring comfort to us ordinary mortals in the present.[181] "Every person can see that others have suffered misfortunes still greater, and so can bear their own troubles more easily," says Timokles' character. It seems to me that this perspective better accommodates the horrifying and unrelenting stories of tragedy than does a more sentimental association. It is not what happens or will happen to the characters that gives comfort, it is the recognition that such dark things come to everyone, even to them.

Third, there are two early Lucanian vases with mourners by a grave stele with the same inscription "spoken" by the tomb:[182] "On my back I grow mallow and thick-rooted asphodel: / in my bosom I hold Oedipus, son of Laios." Even Oedipus, the great king of Thebes, archetype of tragedy, experienced a catastrophic fall and descended into the deepest pit of horrors: yet ordinary plants grow on his tomb. We are not so different.

There is one further and final level of consolation that I would like to draw out from the paintings on these pots. This is a kind of "aesthetic" comfort, a suggestion that human lives, for all their muddle and misery, leave behind traces that are "beautiful." The stories of the myths are enacted by people who were grander and more splendid than we are, and they usually involve sufferings that are even worse, strokes of misfortune that are heavier, confusions that are deeper than those that we shall meet—at least if we are middling fortunate. And yet these stories are the stuff of

poetry, and the stuff of fine paintings. What the vase-painters do is to take these stories of "the worst in life" and turn them into pictures that have form and color, poise and shapeliness.[183]

It is not that the fourth-century paintings censor everything unpleasant. They still show grief and violence, wounds and corpses; but these subjects are always portrayed in a way that retains a certain distancing calm. However ugly the story, the painting is never ugly. This might be seen as a trivializing "perpetual elegance."[184] But I suggest that it does more justice to the works—seen within their context at funerals—to say that they draw out the human capacity to see form and color even in the worst of suffering, of violence, even in the bitterest depth of bereavement. That is why these vases relate to tragedy, and not to something more ordinary, beguiling, and comfortable. True comfort, if it is to go deep, needs something beyond what is merely comfortable.

In experiencing tragedy in the theater, people are taken to a prospect of the depths of horror, crises of instability, and trials of endurance, such as we hope that we shall seldom, if ever, meet in reality. Then, at the end of the play, no one in the theater is really dead or traumatized. And this experience of the abyss, this vision of the dark, this journey into disorder has been seen and heard in a form that has beauty. The poetry, dance, music, costumes, and voices, the fluency of sound and action have all conspired to make the experience strengthening, not weakening.

At the funeral the dead really are dead. Nothing, no amount of grief, will make them stand up again. And the dead person's life will have included, like all our lives, its disappointments and deceits, its ugly episodes, its griefs and anguishes. What the grand and graceful ceramics do is to distill some form out of all this human amorphousness. The vase-paintings and the tragedies alike, the pots and the plays, interact to provide us with renewed strength to persevere and not surrender to the clutches of the dark. This whole view of life, of death, and of art might be captured in the single word "humanity." It is a humanity that does not float in shallow optimism; it is firmly and deeply rooted in an awareness of human reality and suffering.[185]

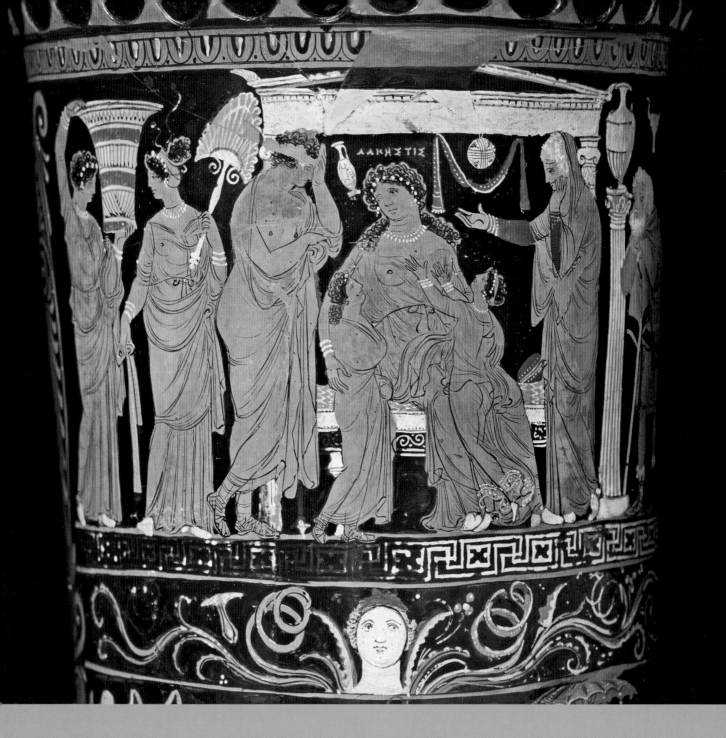

ΑΛΚΗΣΤΙΣ

PART 2

The Pots

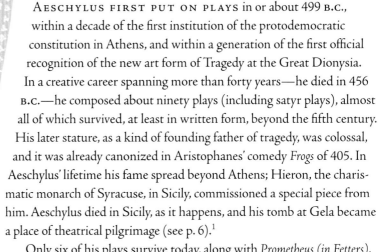

Chapter 1

Aeschylus

AESCHYLUS FIRST PUT ON PLAYS in or about 499 B.C., within a decade of the first institution of the protodemocratic constitution in Athens, and within a generation of the first official recognition of the new art form of Tragedy at the Great Dionysia. In a creative career spanning more than forty years—he died in 456 B.C.—he composed about ninety plays (including satyr plays), almost all of which survived, at least in written form, beyond the fifth century. His later stature, as a kind of founding father of tragedy, was colossal, and it was already canonized in Aristophanes' comedy *Frogs* of 405. In Aeschylus' lifetime his fame spread beyond Athens; Hieron, the charismatic monarch of Syracuse, in Sicily, commissioned a special piece from him. Aeschylus died in Sicily, as it happens, and his tomb at Gela became a place of theatrical pilgrimage (see p. 6).[1]

Only <u>six</u> of his plays survive today, along with *Prometheus (in Fetters)*, which is most likely from the "School of Aeschylus," quite possibly based on a script left unfinished and completed by his son after his death (see no. 18). Fortunately, three of those six are the tragedies of the *Oresteia* (the satyr play is lost), which are related to vase-paintings with a remarkable frequency and variety—indeed, more so than any other plays from Greek tragedy, it seems.

None of the other three have any reflections clear enough to earn inclusion here under Aeschylus' name. *Persians*, first performed in 472 B.C., was a special play drawing on recent events and contributing to the widespread celebrations of the great Greek victories over the Persian invaders in 490 and 480–79. Although there is a vase-painting with the title *PERSAI* (see no. 92), the play in question is definitely not the Aeschylean version. *Seven against Thebes* was the last play of a trilogy that Aeschylus produced in 467 B.C. There is a strange vase (no. 109) showing a possibly theater-related scene from the siege of Thebes, but, again, there is no good reason to connect it with Aeschylus' version. *Suppliants* (quite likely dating from 463 B.C.) also does not seem to be reflected in fourth-century art.[2] While *Prometheus (in Fetters)* appears not to have left any mark either, there is a very interesting painting (no. 18) related to *Prometheus (Released)*—the connection between the two plays remains open to debate.

Tragic trilogies in Aeschylus' time apparently quite often dramatized three "chapters" of a connected sequence. The *Oresteia*, however, seems

to have been the climactic finale of this type of monumental dramatic construction; Sophocles and Euripides, in the next generation, did not attempt to match or follow it. To judge from influence and citations, the trilogy—composed in 458 B.C., just two years before his death—was widely recognized as his masterpiece.[3] The first play, *Agamemnon*, shows the king returning fresh from his triumph at Troy, only to be killed by his wife, Klytaimestra. The second, *Libation Bearers (Choephoroi)*, tells how their son Orestes took vengeance on her and her lover, Aigisthos, but then was driven away by the Erinyes, the vengeful Furies of his mother's curse. Resolution is achieved in the third play, *Eumenides (Kind Goddesses)*, when Orestes flees to Athens, and Athena organizes a civic trial at which he is acquitted.

It is a measure of the *Oresteia*'s stature within Greek theater history that it is reflected in more vase-paintings than any other work we know of. To modern taste, the first (and longest) play of the trilogy may seem the most remarkable, yet it leaves no definite trace in later vase-painting.[4] Two particular scenes from later in the trilogy dominate: one is soon after the opening of the second play (nos. 1–4), and the other soon after the opening of the third play (nos. 6–10).

1–5 *Libation Bearers*

ALL BUT ONE (NO. 5) OF THE VASES discussed here exemplify an iconography—the children at the tomb—that is particularly richly represented; in fact, there are so many examples (fortunately) that it is not typical of the situation with other plays (unfortunately). *Libation Bearers* opens with Orestes and his close friend Pylades arriving at the tomb, where they hide while Elektra, Orestes' sister, and her company of maids arrive to offer libations; when Elektra has found a lock of hair and other traces of Orestes, he steps out to be recognized and reunited with her. The vases correspond to the action of Aeschylus' play in various ways while differing from it in others. There are about thirty-five of these paintings, spanning more than a century; they come from all the areas of Western Greek vase-painting, but are untypical in distribution in that relatively few are from the "heartland" of Apulia. It is also untypical that almost all of these tomb scenes are on small and ordinary vessels, especially hydrias, with hardly any on a grander or more ornate scale. This suggests that they were marketed as relatively inexpensive grave goods, carrying an appropriate scene of family mourning.

The key image that all these paintings have in common is the central tomb, usually adorned with funerary offerings, with a young man and

a young woman in mourning by it. He is nearly always accompanied by another youth (Pylades), and both are usually portrayed as travelers; she often has women in attendance, usually with libations or other offerings. Since the scene is so common, and so suitable to funeral art, the obvious question arises of whether this is a mythological rather than a generic scene, and of how far it is to be associated with the tragedy at all. As Green puts it: "Is there a clear point at which … a theatre-derived scene becomes merely the generic children at the tomb?"[5] The main argument for holding that the scene did, generally speaking, evoke the tragedy is the consistency of the specific details.[6] Furthermore, there are some cases of inscriptions that specify the myth (e.g., nos. 1 and 2), and the presence in others of Erinyes (e.g., no. 4) indicates that the mythological precedent (and thus possibly the tragic precedent) for the tomb scene is to be recalled. Bereavement befell even these great people of the heroic past, the picture suggests, so we too must bear our grief with dignity and patience (see pt. 1, sec. O).

1

Related to the tomb scene in Aeschylus' *Libation Bearers*

Attic pelike (fragmentary),
ca. 380s
Attributed to the Jena Painter
H: 28.7 cm
University of Exeter, unnumbered[7]

THE ICONOGRAPHY OF the children at the tomb, so common in the Western Greek vases, is also found in at least two Attic examples, one of which dates from as early as circa 440.[8] This Attic painting, however, is later than the earliest Western Greek examples, thus exemplifying the recurrent question of whether Athenian painting might have been "back influenced" by the theater-related pottery of the West (see pt. 1, sec. K). It is a pity that the pot is badly damaged, making some of the interpretation even more uncertain than usual. But, even without the conspicuous inscription of ΑΓ]ΑΜΕΜΝΟΝΟΣ (of Agamemnon) on the base of the tomb,[9] the mythological scene would be recognizable from the women with libations and the young man cutting his hair. Yet, while Orestes and Pylades are clear enough, some of the other figures are less easy to identify. The young man seated on the upper left is mysterious, for us at least: there is no clear sign that he is Hermes, who is found in some of these scenes (see no. 3), but he may make more sense as a detached divinity than as a human. The identification of the woman on the right, holding a hydria, as Elektra is confirmed by an inscription.[10] Therefore her similar companion further to the right is an attendant, as is the seated woman to the left of Orestes.

This painting is far from an exact replica of the text of Aeschylus' *Libation Bearers*. At the same time, there are positive signs that it is informed by a knowledge of the play; and these, I suggest, outweigh any discrepancies of detail. The most conspicuous pointer is the emphasis on Orestes cutting off a lock of his hair, which is what he does soon after the

1

opening of the play (6–7): "[I offer] this lock to Inachos for nourishing my life, / and this second lock as a token of my grief."[11] He does this before Elektra's entry and then hides from her. The painter, by bringing together Orestes' haircutting and the dejection of Elektra in a single composition, evokes the story as informed by the tragedy rather than the exact theatrical staging.[12] There is nothing in the picture, no contraindication, that is so at odds with the play that it directs the viewer away from recalling the Aeschylean version.[13] And those who do recall it will then know that the lock of hair will crucially bring together the brother and sister who are still so separate in the composition of the painting.

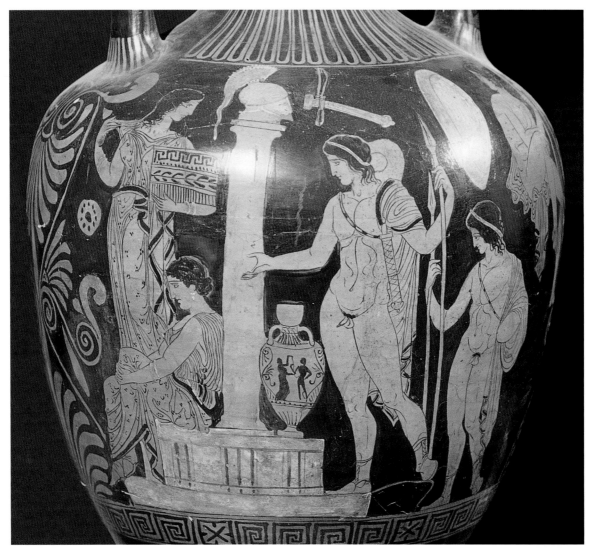

2

Related to the tomb scene
in Aeschylus' *Libation
Bearers*

Lucanian amphora, ca. 380
Attributed to the Brooklyn-
Budapest Painter
H: 66 cm
Naples, Museo Archeologico
Nazionale 82140 (H 1755)[14]

ON THIS PIECE of similar date to no. 1, but from the Greek West,
there are also inscriptions: ΑΓΑΜΕΜΝΩΝ (Agamemnon) on the grave
stele, and ΗΛΕΚΤΡ[(Elektra) above the seated woman's head.[15] The
tomb is marked as a warrior's by the helmet on top; note also the amphora
with the same funerary shape as the pot it is painted on. The woman
who accompanies Elektra carries a box of offerings rather than libations.
Although the figure behind Orestes is surprisingly small, it can hardly
be other than Pylades; again there is an extra, somewhat detached seated
figure, this time to the upper right. Orestes and Pylades are, in heroic
fashion, almost naked, yet they wear boots. The boots mark them as trav-
elers—though they may also indicate some affiliation to tragedy.

As emerges from the *LIMC* article on Elektra, more of the tomb

2

scenes on vases show Elektra sitting (nos. 1–23) than show her standing (nos. 34–41). This seems to have been the dominant iconographic tradition, employing the established image of the mourner sitting dejected. The text of the play implies that she is standing throughout, with her libation still unpoured, and at no point does it indicate that she is seated. Yet the sitting pose pictorially conveys the grief of her opening speech at *Libation Bearers* 84–105. It may even be that a performance tradition grew up with a seated Elektra; but it seems no less likely, if not more likely, that this was an iconographic tradition that was handed down by the artists.

3

Apparently related to the tomb scene in Aeschylus' *Libation Bearers*

Lucanian pelike, ca. 350
Attributed to the Choephoroi
Painter
H: 47 cm
Paris, Musée du Louvre K 544[16]

THIS VASE WAS PAINTED by a craftsman from the same tradition and locality as the previous artist, but some twenty or thirty years later. It is not common for a Greek vase-painter of this period to turn out multiple examples of the same iconography, but no fewer than five similar tomb scenes by this one artist survive (the others are all on hydrias); Trendall accordingly dubbed him the "Choephoroi Painter."[17] Each of the five is different, but they all show Elektra seated on the tomb in the center, with standing figures on either side. On this particular vase the tomb is especially fully adorned with pots and other offerings, but the standing figures are reduced to one on each side. On the left is Orestes, himself holding a libation (which he does not do in the Aeschylean text). He wears a traveler's hat and ornate boots. On the other side, where we might expect Pylades, a figure who is apparently Hermes stands in a relaxed pose. On one of these five vases, the figure balancing Orestes seems to be simply Pylades,[18] but in the other three, as here, he holds the *kerykeion*, the symbolic staff of the herald, especially of Hermes, the herald of the gods. Those who are intent on minimizing any connection between painting and drama may seize on this incompatibility and claim it as a definitive contraindication. But this might be hastily pedantic, seeing that Hermes is summoned by Orestes in the very opening lines of *Libation Bearers* (1–2), when only he and Pylades are onstage.[19] Furthermore, the chorus calls on Hermes to bring success to Orestes (812–18)—this motif may be reflected by the victory wreath that Hermes holds out in this painting. It is tempting to speculate that a performance tradition grew up in which Pylades was performed carrying a herald's staff as a prop, partly to reflect his role as Orestes' colleague and pious adviser, but also to associate him with Hermes. But that is not necessary in order to salvage the connection of these "Hermes" vases to the play, a connection of association, not of precise documentation.

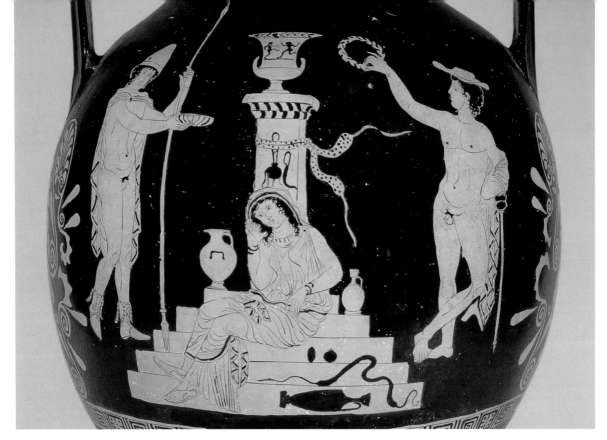

4

Plausibly related to the tomb scene in Aeschylus' *Libation Bearers*

Paestan neck-amphora, ca. 350s
Painter of the Geneva Orestes
H: 43.6 cm
Geneva, Musée d'Art et
d'Histoire HR 29[20]

THIS VASE WAS GIVEN ITS ONLY FULL discussion in Aellen-Cambitoglou-Chamay 1986. The tendency of that publication—admirable in other respects—is to play down, and even come close to denying, any connection between the vases and tragedy. Accordingly, the book drives a wedge between this painting and *Libation Bearers*. For the ancient Greek viewers, it is claimed, "it mattered little whether or not they identified the figures with Orestes and Elektra, or whether they stayed anonymous" (p. 268). This argument seriously undervalues, I would counter, the two winged figures who lurk above: the snakes in their hair and around the arm of one signal them clearly as Erinyes. Such figures, associated always with vengeance and punishment, become increasingly frequent in fourth-century vase-painting. While there is undeniably a free-standing artistic tradition in their representation, a high proportion of the scenes in which they appear may plausibly be connected with tragedy. The Erinyes even become a kind of emblem of the genre (see pt. 1, sec. M7).

The most important occurrence of the Erinyes in tragedy was, of course, as the extraordinary chorus of the third play of the *Oresteia* trilogy, summoned by Klytaimestra's curse to exact retribution from Orestes. They are continually evoked throughout the first two plays, and toward the end of *Libation Bearers* (1048–63) Orestes begins to see them, although they are still invisible to the chorus and to the audience. Their appearance as visible embodied figures in *Eumenides* is given a great buildup and

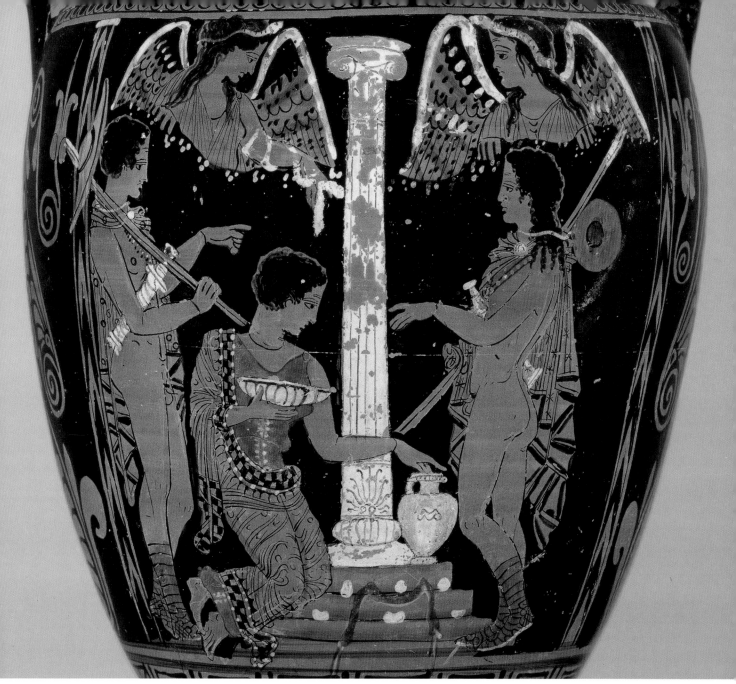

4

became a notorious coup de théâtre.[21] It is even likely that Aeschylus
was the first to give the Erinyes an explicitly anthropomorphic form; this
speculation is supported by the dramatic treatment of their appearance
in *Eumenides*, where they are spoken of as creatures never seen before on
earth. There is no artistic representation of them in human form before
458 B.C., and they invariably take on an anthropomorphic presentation
after that.[22] So, although Erinyes are found in representations of a wide
range of myths, there is good reason for them to occur most frequently in

connection with Orestes.[23] Thus the scene on this vase makes more sense to a viewer who knows the place of the Erinyes later in *Libation Bearers* and in the next play. In other words, it *does* make a difference to be able to identify the figures as Orestes and Elektra.[24]

Finally, Elektra is kneeling, while in all other examples of this scene she is either sitting or standing. She has evidently not yet noticed the two men; could there be a suggestion that she is seeing the lock of Orestes' hair? Moreover, her hair is cut short, as in mourning, and the man on the left has his hair cut in exactly the same way (while the man on the other side wears his long). This would seem to show that the man behind Elektra is her brother Orestes. In *Libation Bearers* the similarity of the siblings' hair is given special attention at 174–80.

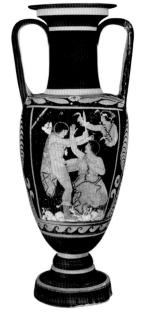

5

More than probably related to the second Orestes and Klytaimestra scene in *Libation Bearers*

Paestan neck-amphora, ca. 330s
Attributed to the Painter of
Würzburg H 5739
H: 34.5 cm (to top of body)
Malibu, J. Paul Getty Museum
80.AE.155.1[25]

UNTIL THIS POT was first published in 1982,[26] no painting could be plausibly related to any scene in *Libation Bearers* after the initial meeting at the tomb. The killing of Aigisthos by Orestes is not uncommon in early Greek art and in Attic vase-painting, often showing Klytaimestra wielding an axe; and it occurs occasionally in Western Greek painting.[27] But, while these pictures are often highly melodramatic, I am not aware of any that indicates a connection with the Aeschylean version of the narrative. It should be recalled that in Aeschylus the killing of Aigisthos is secondary and not reported or vividly envisaged; the attention is on Klytaimestra.

This painting has been recognized as showing the matricide of Klytaimestra by Orestes (note their similar hair); but the reasons for connecting it more specifically to *Libation Bearers* have not been given the attention they deserve. First and foremost, Klytaimestra is baring her breast and holding it out to Orestes.[28] In *Libation Bearers*, when Orestes first threatens his mother with death, she speaks these lines (896–98): "Hold there, my son. Take pity, child, before this breast of mine: / see, this is where you often used to suck in drowsiness / with baby gums the nourishment of mother's milk." Although it cannot be proved, it is very likely that this moment was an invention of Aeschylus.[29] It is effectively linked to his particular version of Klytaimestra's dream, in which she puts the snake that she has birthed to her breast.

The Getty vase may be the first known representation of this particular moment, but it should be noted that there is a silver seal dating from circa 400 that may be comparable.[30] It labels both Orestes and Klytaimestra, and shows her with a bare breast already wounded. On the seal she is not kneeling, but sitting on an altar—or might it be a clothes chest? She is not at the very moment of baring her breast, which is what makes the vase so striking.[31]

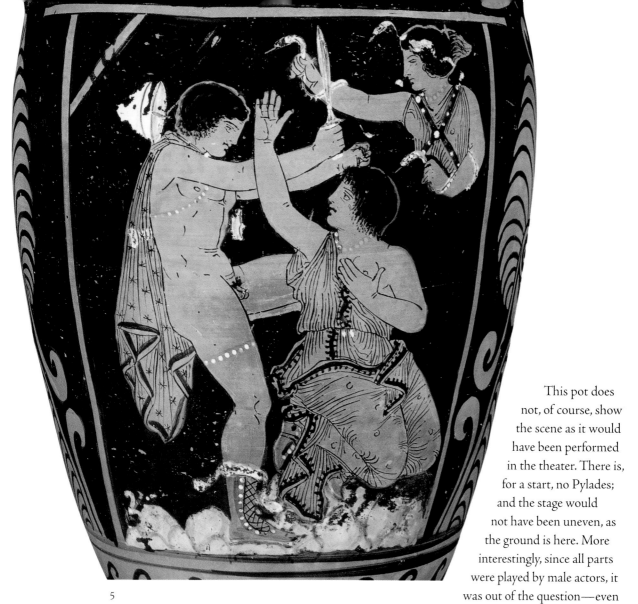

5

This pot does
not, of course, show
the scene as it would
have been performed
in the theater. There is,
for a start, no Pylades;
and the stage would
not have been uneven, as
the ground is here. More
interestingly, since all parts
were played by male actors, it
was out of the question—even
if decorum had allowed it—for the actor of Klytaimestra to bear a real
breast; this must have been conveyed by some histrionic gesture. But the
vase-painter is not similarly restricted and is able to display a shocking
realism.

Finally there is the Erinys in the top corner, with snakes in her hair
and around her arms. The Erinyes were not visible to the audience in *Liba-
tion Bearers*, but, as explained above, their threat is very much to the point.
They are invoked explicitly in the dialogue that immediately follows
Klytaimestra's baring of her breast. At line 912 she threatens Orestes with
her curses, and at 924 she warns him: "Look out, beware your mother's
angry dogs…" Later, when he sees the vision of the gathering Erinyes
after the murder, he understands her riddle: these clearly are his mother's
angry dogs (1054). In Aeschylus, both mother and son are tracked down
by revenge, both are vulnerable to the Erinyes. The painter possibly con-
veys this by having the Erinys direct one snake toward each of them.[32]

6–11 *Eumenides*

WHILE ONE VASE FROM THIS GROUP (no. 11) shows Orestes in Athens, the others are clearly set in Delphi. The protection of Orestes by Apollo and the sanction of his Delphic oracle for the killing of Klytaimestra both predated Aeschylus' version of the story, as did the trial of Orestes held in Athens.[33] It was very probably an Aeschylean innovation, however, to take Orestes to Delphi in between the murder and the trial. Furthermore, as noted above, Aeschylus was most likely the first artist in any medium to give the Erinyes anthropomorphic form. Thus the many fourth-century vases showing Orestes at Delphi threatened by Erinyes—about twenty-five of them in all—are plausibly related to the *Oresteia*.

While it is much disputed exactly how Aeschylus stage-managed the scenes, the fuller picture invoked by the text is clear.[34] The Pythia (the priestess of Apollo at Delphi), horrified by what she has seen inside the temple, describes the scene fully at *Eumenides* 34–59. She says that Orestes has taken refuge "at" or "on" the omphalos stone, his hands, which are still bloody, holding his sword and a suppliant branch. Before him are the Erinyes deep asleep on chairs—the priestess has never seen their like before. While they are still asleep, Apollo sends Orestes off to Athens to seek a trial (64–84); then the dream-ghost of Klytaimestra tries to arouse them from their vivid and noisy dreams. It is extremely unlikely that this sequence occurred somewhere other than Aeschylus' play; consequently, the paintings are most likely informed by its features in various ways.

Compared with the scenes of Orestes and Elektra at the tomb, most of these compositions are quite elaborate, in both figures and setting. They are all located, more or less explicitly, at Delphi; in most of them Orestes, drawn sword in hand, is kneeling at the egg-shaped object that conventionally represents the omphalos stone. The temple is often indicated by laurel, tripod, and altar, in various combinations. Apollo himself is almost always present in a protective pose. In some of the paintings, the Erinyes are sleeping; in some there is a fleeing Pythian priestess. We have, then, several pro-indications that link the works evocatively to the opening scenes of the Aeschylean play.

The representation of the Erinyes themselves does not, on the whole, match the Aeschylean description. They are, rather, assimilated to their conventional iconography in Western Greek vase-painting, where they are found in many other contexts as well (see pt. 1, sec. M7). They are invariably female and have snakes in their hair or around their arms, and usually both; this is their depiction in Aeschylus (*Choephoroi* [*Cho*] 1048–50; *Eumenides* [*Eum*] 48–54). They nearly always have wings, however, while

according to the text of *Eumenides* they do not (see line 51). In Aeschylus they have black robes (*Cho* 1049; *Eum* 52, 370), and possibly also black skin, but this is not usually the case on the vases (see no. 7 below). Last but not least, in virtually all of the paintings they are quite good-looking—in some of them they are even beautiful—whereas in Aeschylus there is repeated emphasis on their ugly faces and disgusting excretions (*Cho* 1058; *Eum* 52–54, 68, 192–93, 990–91).

The discrepancies between Aeschylus' picture of the Erinyes and the paintings of them might be explained by positing a narrative literary source other than Aeschylus. But the differences are much more likely accounted for by the growth of an iconographic tradition that perpetuated its own visualization. Given that, it is by no means inconceivable that the winged and beautiful Erinyes were prompted by, or promoted by, the development of a performance tradition of Aeschylus' play, at odds with the indications of the text and (presumably) with its first performance, in 458 B.C. After the initial shock of Aeschylus' horrible vision, it might soon have become more acceptable for the Erinyes, who became equated with the *Semnai* and other more conventional female divinities, to be assimilated to the ideal beauty that generally characterizes the portrayal of the divine in Greek art. It might also, like the title *Eumenides (Kind Goddesses)*, have been a way to placate them.

The six vases selected here are mostly from the fourth century, and one of them (no. 6) is Attic. We also have, however, no fewer than five Attic vase-paintings from the second half of the fifth century that show Orestes brandishing a sword in the presence of Apollo and of one or more Erinyes.[35] These paintings may well be following the precedent of Aeschylus' play in some respects, but they also notably diverge from it. In all five, Orestes is represented as kneeling, as if in exhaustion or taking refuge, on a pile of rough stones. The stones would seem to be a contra-indication, since there is nothing in Aeschylus' text to explain them. It has been claimed that they represent an altar at Delphi; but, in that case, why are they so rudimentary?[36] Furthermore, in some of these five vases the Erinyes are of rather indistinct gender, while in Aeschylus they are definitely, and significantly, female. Apart from the anthropomorphizing of the Erinyes and the habitual snakes, there would be no direct reason for connecting these earlier Attic paintings with Aeschylus at all.

6

Apparently related to the Delphi scene in Aeschylus' *Eumenides*

Attic pelike, 370s or 360s
Not attributed by Beazley
H: 30 cm
Perugia, Museo Etrusco-Romano, unnumbered[37]

THIS IS THE ONLY ATTIC representation of Orestes and the Erinyes from the fourth century.[38] In its three-figure simplicity, it is more like the Attic fifth-century paintings discussed above than the Western Greek iconographies, except that the stone at which Orestes has taken refuge is clearly the curved-conical omphalos. While it is not impossible that this feature of the paintings originated in Attic art and spread westward, the opposite—a kind of retro-influence—is more plausible. The Erinyes on this vase carry torches, which are not common in Orestes scenes (although they do occur elsewhere). Unique to this work are the long *peploi* (robes); Erinyes are normally shown with short skirts, suitable for rapid running. Maybe Trendall and Webster (1971, 45) are right to suggest that the painter is thinking of dancing, as in the tragedy, rather than of running?

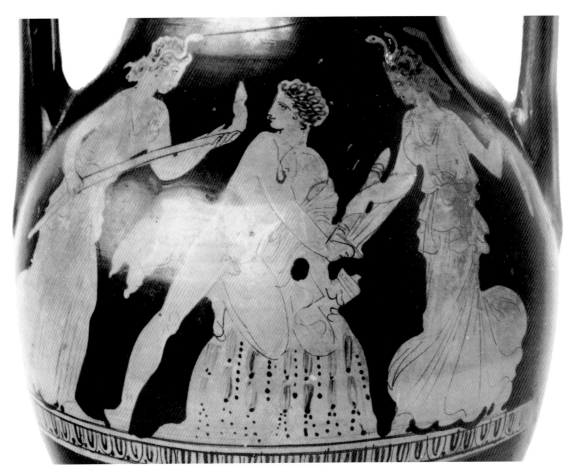

6

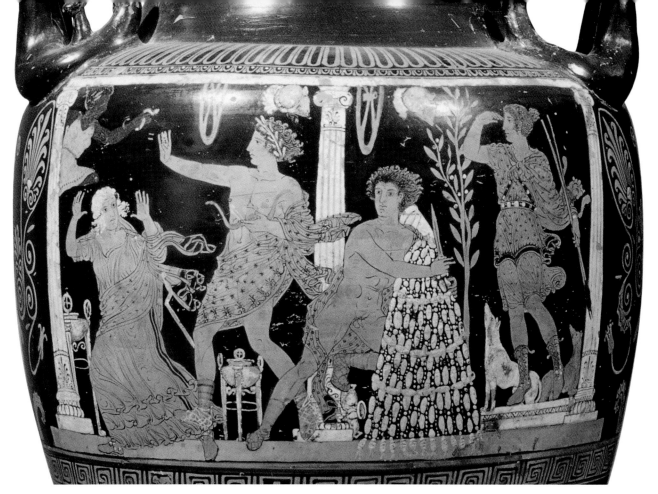

7

7

Related to the Delphi scene in Aeschylus' *Eumenides*

Apulian volute-krater. ca. 360s
The Black Fury Painter
H: 90 cm
Naples, Museo Archeologico
Nazionale 82270 (H 3249)[39]

UNLIKE THE PICTURES of Orestes and Elektra at the tomb, several of which go back to circa 400, and which are mainly on middle-range vessels, the pictures of Orestes at Delphi do not become common until the second quarter of the fourth century and are often on quite grand pots—the Black Fury Painter is, in fact, a forerunner of the great period of monumental ornate Apulian vases.[40] This painting is striking for its well-filled frame, lively movement, and use of color. It pulls out the stops in order to evoke the inner sanctum at Delphi: within the frame of Ionic columns we see the laurel tree, two tripods, and temple offerings, as well as the ornately decorated omphalos itself. Apollo wards off the threat (note his bow), while his priestess flees in such terror that she has even dropped her key, which is midway to the ground.[41]

This pot does not capture any one scene or any one point within the play. In Aeschylus the priestess runs away by line 63; Orestes clings to the omphalos between lines 64 and 93; Apollo addresses the Erinyes with invective at lines 179–234. But this kind of combinatory evocation is totally characteristic of these tragedy-related vases, as will be seen repeatedly. The single representative Erinys emerging from the top left-hand corner is striking, and, though solo, quite spooky. The use of the bright

yellow dress along with the white snakes and white underpainting has enabled the painter to show her as black skinned, even against the black glaze. The priestess at *Eum* 52 describes the Erinyes as "black"; while this might refer only to their clothing, it suggests that they may have been envisaged as having black faces and skin in the original Aeschylean production. There is, however, only one other example of this in all the many representations of this scene (see no. 9 below).[42]

But while the Erinys is alarming enough to justify the terror of the priestess and of Orestes himself, the painting as a whole is dominated by Apolline beauty and strength. This is reinforced by the presence of his sister Artemis on a low plinth to the right, dressed as a huntress with two hunting dogs. She is nowhere at all in the Aeschylean text, and it is unlikely that the performance tradition brought her on (unless to replace Hermes, who is instructed by Apollo at 89ff.?). So she is simply there, as in pictures of other narratives, as a kind of companion figure to Apollo.

8

Plausibly related to the Delphi scene in Aeschylus' *Eumenides*

Apulian bell-krater, ca. 380s
The Eumenides Painter
H: 48.7 cm
Paris, Musée du Louvre K 710[43]

IT IS REPEATEDLY ALLEGED in *Eumenides* that Orestes has been purified, although this is never accepted by the Erinyes, who are still able to track him by the trail of blood. He himself claims that he was purified both at Delphi and elsewhere, by the blood of suckling animals and by flowing water.[44] He says explicitly (282–83): "The blood-pollution was, when fresh, expelled back at the sacred hearth / of lord Apollo by purifying with a sacrificial pig." There is no sign whatsoever in the text that any act of purification was seen by the audience in the theater during the scene at 64–93. Yet there are four vase-paintings that show Apollo holding a piglet over Orestes while he is taking refuge at Delphi. In only two of these, however, are Erinyes also present: here and on a later, Paestan piece, where they are represented as busts above.[45]

Given that the scene did not occur in Aeschylus' production of *Eumenides*, there are three possible ways that it came to be represented on these vases: 1) There was an iconographic tradition, completely independent of Aeschylus' play, that showed Orestes taking refuge at Delphi and being purified by Apollo with piglet's blood. This might be supported by the fact that the earliest example has no Erinyes in it (Geddes A4:8, see n. 40). 2) A performance tradition of *Eumenides* grew up that, taking its cue from lines 282–83, presented Apollo bringing a piglet onstage during the prologue scene of the play. 3) The vigorous iconographic tradition of Orestes at Delphi under the protection of Apollo, variously related to Aeschylus' play, occasionally incorporated into the picture a purification scene, inspired by lines 282–83 of the play.

While all three explanations remain possible, it seems to me that the

8

third is by far the most plausible. This fine Louvre representation supplies the strongest arguments in favor of it. For here, in opposition to Orestes, Apollo, and Artemis (see no. 7 above), there are four female figures on the left-hand side of the composition. Three of them are wingless Erinyes: they have identical costumes and hair, with rather inconspicuous snakes. Their cross-banded short chitons and boots are all suggestive of traveling. The upper two are sleeping in a sitting position, which may suggest readiness for action. This fits *Eum* 47, where the Pythia describes the Erinyes as asleep "on chairs." The position of the third Erinys, only half out of the lower border of the picture, may be indicative of their connections with the Underworld (or might it suggest that she is still only half awake?).

It is very rare for Western Greek tragedy-related paintings to indicate anything like a chorus (see pt. 1, sec. M5); these three Erinyes may come closer than almost anything else we know. But what of the standing figure to the left with her head cloaked, reaching out to touch one of the sleeping

Erinyes? There can be no reasonable doubt that she is the dream-ghost of Klytaimestra, who was, of course, a character in the narrative as told by Aeschylus, and is most unlikely to have appeared in any other version. At *Eum* 94–139 she does her best to arouse the Erinyes from their deep sleep, while they noisily hunt Orestes in their dreams. They awake at 140–54, immediately after her departure. Without knowing this scene of the play, the viewer would not be able to make any particular sense of the veiled figure.

Thus in this single picture we see Apollo's protection of Orestes (*Eum* 64–93), but with the "intrusive" purificatory piglet, as well as the sleeping Erinyes, a waking Erinys (*Eum* 140–54), and the dream of Klytaimestra (*Eum* 94–139). The painting combines several features of the tragedy that were never seen together in an actual staging of the play. Yet, at the same time, it also interacts with the play quite closely.

9

Quite closely related to the Delphi scene in Aeschylus' *Eumenides*

Apulian calyx-krater, ca. 350s
Attributed to the Konnakis Painter
H: 51 cm
Saint Petersburg, State Hermitage Museum St. 349[46]

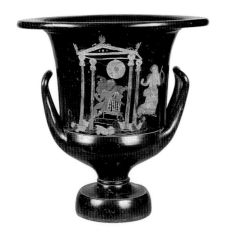

ORESTES AT THE OMPHALOS, sleeping Erinyes, and the fleeing priestess are all found elsewhere, yet this is an unusually striking representation of the Delphi scene. One reason is the architectural setting in a kind of "minitemple," which looks far more like an item of stage painting than any actual temple. This kind of "portico" reappears quite often in other tragedy-related scenes (see pt. 1, sec. M3).

Even more arresting are the no fewer than five Erinyes sleeping on the ground. They have identical costumes and appearance, and despite their supine state they are suggestive of a chorus. The representation of the Erinyes with white hair and black skin is especially notable. This skin color seems to be indicated by the text of Aeschylus (*Eum* 52) but is rare in the paintings, as discussed in the entries for vases 7 and 70. The pictorial impact here is even more striking than in those works because the figures are painted on the dark black background of the so-called Gnathia painting—a relatively rare technique compared with the usual red-figure.[47] Because of the totally black background, this method of painting was more polychrome and three-dimensional. It appeals to modern taste as particularly attractive and painterly; it was, indeed, widely exported from Italy back in the period around 300 B.C. The painter has shown the Erinyes' bodies mainly through the contrasting forms of their white dresses and white hair; there is also, it seems, some use of grey-black paint. It is worth noting that at *Eum* 69 Apollo calls the Erinyes "old women, ancient girls." If this line implies that in Aeschylus' own production the mask maker gave the Erinyes white hair, then this is the only painting that reflects that detail.

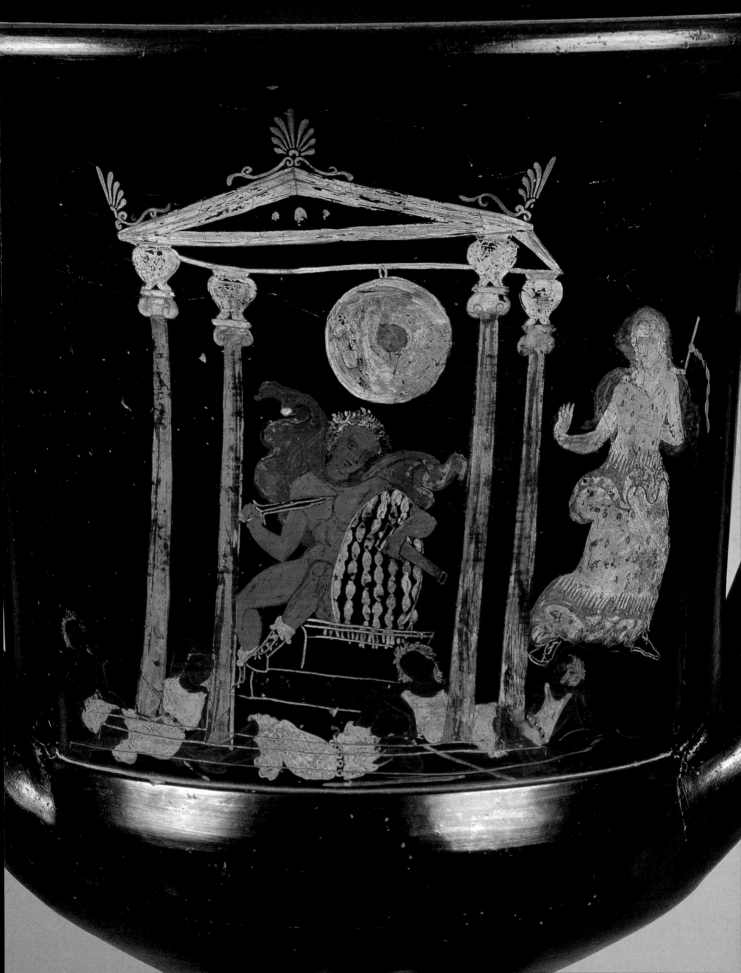

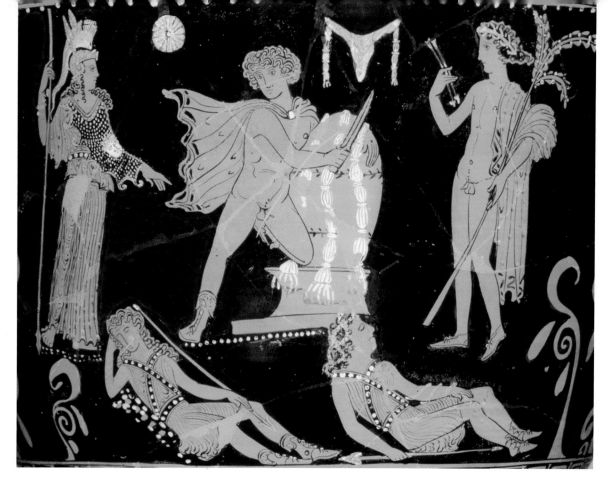

10

Related to the Delphi
scene in Aeschylus'
Eumenides

Apulian bell-krater, ca. 360s
Closely associated with the
Judgement Painter
H: 36 cm
Boston, Museum of Fine Arts
1976.144[48]

AS SEEN ABOVE, some of the Orestes-at-Delphi vases include
Artemis, even though she does not seem to have any particular reason
to be present. There is far more point to the presence of Athena, who
is found on five of the Western Greek representations, because the trial
of Orestes is to be held in her city and under her supervision.[49] Her
personal centrality to the story and her casting vote are very likely to have
been innovations of Aeschylus.[50] Thus her presence on this vase would
have made special sense to a viewer who knew the Aeschylus play and
recognized the role that she would have once Orestes left Delphi and
arrived in Athens.

 In *Eumenides* Apollo tells Orestes at Delphi that he should go to the
"city of Pallas" (a title for Athena) and clasp her image there (79–80), thus
suggesting the future protection that is made explicit in the paintings.
The Erinyes at that point in the play are still sleeping, whether or not they
were actually visible onstage. It is notable that in this painting Apollo,
with his arrows, and Athena, with her spear, are obviously superior to the
two Erinyes, fast asleep with their spears lying idle. In the first full discus-
sion of this vase,[51] Emily Vermeule suggested that their rather peaceful
depiction suggests their future conversion into "Kind Goddesses," and that
it is thus especially appropriate to funerary iconography. This may, I sus-
pect, be stretching rather too far to grasp at consolatory allegory.[52]

More than probably related to the scene of Orestes in Athens in Aeschylus' *Eumenides*

Apulian bell-krater, ca. 400s
Attributed to the Hearst Painter
H: 41 cm
Berlin, Antikensammlung,
Staatliche Museen zu Berlin
VI 4565[53]

WHILE THERE ARE MANY PAINTINGS of Orestes at Delphi, this depiction of him clinging to the statue of Athena is unique to date.[54] On either side of him is a winged, besnaked Erinys in movement. This is really quite close to the scene at *Eum* 254–396, which, as far as we know, was invented by Aeschylus. Apollo has told Orestes to sit and put his arms around the ancient statue of Athena in Athens (79–80). Orestes explicitly approaches the image at line 242; at 257–60, when the Erinyes find him there, they say (or rather sing): "And here he is: by taking sanctuary, / clinging round the statue / of the immortal goddess, / he hopes to stand trial / for the violence of his hands." They threaten him, while he holds on, until Athena herself arrives at 397.

Apart from the close correspondence of narrative, there is no other evident indicator of affinity with Aeschylus' *Eumenides* here. This pot does, however, date from the early days of Apulian vase-painting—the 390s at the latest[55]—before any repertory of "signals" was built up. It is interesting, though, that these two Erinyes appear quite unfeminine and even somewhat masculine.[56] Their appearance might possibly reflect actual performance, where the chorus members were, of course, male. But it is more likely to be explained simply by the less-than-delicate technique of this painter. His handling probably also explains the rather ugly face of the left-hand Erinys—although it is worth noting that there is a pair of conspicuously ugly Erinyes from about this period on a vase of the Medeia story (see no. 35).

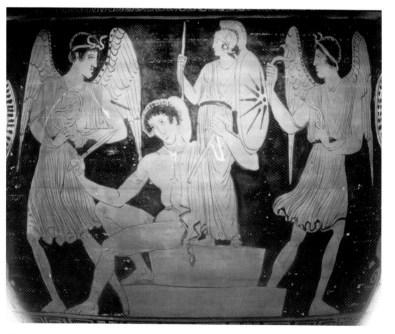

11

Other (Fragmentary) Plays

We know of the former existence of more than eighty plays by Aeschylus in addition to those that survive. It is attested that his works were reperformed in the fifth century, after his death, and he is widely quoted in Aristophanes and other comedians.[57] Fragmentary quotations from nearly all the recorded plays are evidence that the texts, or virtually all of them, survived to reach the great library at Alexandria. These several hundred quotations extend from a single word to ten lines. There are, in addition, a good handful of fragments of Aeschylus that have been discovered on ancient papyri within the last 120 years or so.[58] While there is no specific evidence of the restaging of Aeschylus during the fourth century, there is nothing implausible in supposing that reperformance was quite widespread and frequent for at least the most celebrated of his plays. His famous tomb at Gela might well indicate that he was especially favored in Sicily and the Greek West.

I have singled out for discussion those vases that I believe may be most plausibly connected with lost plays, or which are otherwise of related special interest for the subject. The order of discussion that follows is somewhat arbitrarily based on the alphabetical order of the Greek spellings of play titles.[59]

12–13 *Edonians*

Aeschylus put on a tetralogy known as the *Lykourgeia* (though we do not know when).[60] It is not clear just what narrative connection held the four plays together, but the first tragedy was called *Edonoi* and had a chorus of Edonians, the subjects of Lykourgos, and the satyr play was called *Lykourgos*. Lykourgos was a king in the area of Thrace by the river Strymon (which runs into the northern Aegean Sea) and was one of those figures in Greek mythology who made the mistake of resisting the newly arrived god Dionysos. We know from fragments that Dionysos was taunted onstage for his outlandish and effeminate appearance (as he would be much later in Euripides' *Bacchai*); and it is likely that (as in *Bacchai*) the palace was supernaturally shaken.[61] We know various versions of Lykourgos' punishment, but the most common and most redolent of tragedy was that he was driven mad and violently killed his own son Dryas or his wife or both, believing that he was chopping down Dionysos' vines.

There are several vase-paintings showing Lykourgos killing his family: the *LIMC* article collects nine certain examples and lists some eight

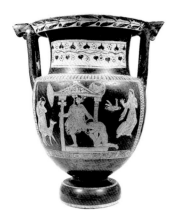

other possible instances as fragmentary or doubtful. Two are Attic of the later fifth century,[62] and the others are all Western Greek of the mid-fourth century. The madness and violence appear highly "tragic," and there are a few other signals to connect the scenes with the theater. There is, however, nothing that strongly connects the paintings with Aeschylus in particular. They are included at this juncture mainly because Aeschylus' *Edonians* was the most famous tragedy on this theme.[63]

12

May be related to a tragedy about Lykourgos, possibly Aeschylus' *Edonians*

Apulian column-krater, ca. 350s
Attributed to the Painter of
Boston 00.348
H: 41.3 cm
Ruvo, Museo Jatta 36955
(n.i.32)[64]

FRAMED IN THE CENTER, Lykourgos—represented, as nearly always, with a double ax—is about to strike Dryas, who supplicates him for mercy. A woman runs away to the right, dropping her sacrificial platter in alarm. These are standard features, but (while this is not a masterpiece of painting) there are three points of special interest here: the stylized "palace front"; the figure with the enfolding cloak above it, on the right; and the mourner on the left.

This kind of rather rudimentary "portico" is recurrent in possibly tragedy-related pictures (see pt. 1, sec. M3), and it might well have distant associations with theatrical scene painting. There is, as we have seen, some evidence for a seismic palace shaking in Aeschylus' play. Is there, then, anything to be said about the unusual, rather eerie figure above?

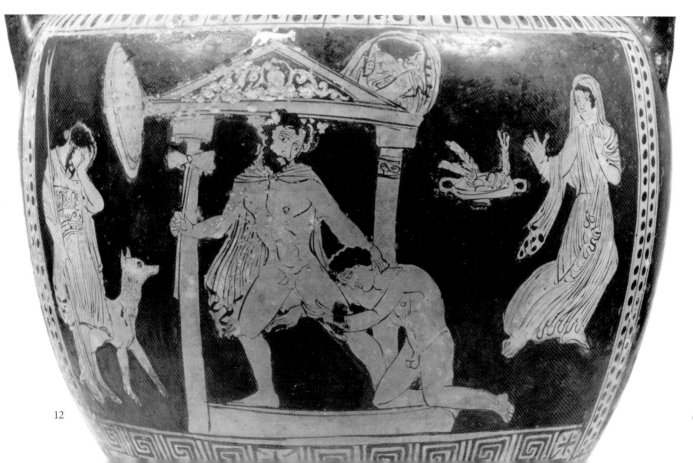

There is no evidence that an allegorical figure of Madness appeared or spoke in *Edonians*; Lyssa (her usual Greek personification) did, however, participate in another Aeschylean play about Dionysos-induced madness, probably concerning Pentheus, namely *Xantriai (Wool Carders)* (see fr. 169). She also appears above the palace before driving Herakles mad in the surviving Euripidean *Herakles*. So it would have been a plausible guess that the figure here represented Lyssa, even if she did not appear more explicitly in five other examples of the Lykourgos iconography (see below). There is also an example (in no. 65) of a figure appearing as a kind of "bust" above, where it very likely represents Hermes intervening "ex machina" (on the device of the *mechane*, see no. 14 below). Thus it is possible that this figure reflects an appearance of Lyssa "from the machine" in a Lykourgos play, whether that by Aeschylus or by another playwright.

The grieving figure to the left with spears and a dog is most plausibly interpreted as a hunting companion of Dryas. He might well represent his male carer, or paidagogos, and he might possibly have been a messenger figure within the tragedy, whether or not that of Aeschylus. It became the usual convention in Apulian vase-painting to represent the paidagogos as a little old man (see pt. 1, sec. M6); it so happens that there is such a figure in another Lykourgos scene (see no. 13).

It is worth comparing, finally, an Apulian tall jug of a late date, circa the 310s.[65] On it the central figure with the double ax is framed by a severely damaged palace; a woman and a boy to the left plead with him; and an old paidagogos runs up from the right. All this would fit well with the other Lykourgos pictures, except that the child he is about to kill seems to be a girl and not Dryas. Perhaps by this late date the sheer pathos and melodrama are more important than the precise narrative?

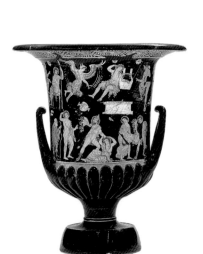

13

Probably related to a tragedy about Lykourgos, possibly Aeschylus' *Edonians*

Apulian calyx-krater, ca. 350s
The Lycurgus Painter
H: 58.4 cm
London, British Museum F271[66]

THE LYCURGUS PAINTER is an important forerunner of the great monumental mythological paintings of the Darius Painter and his associates. This picture displays one of the most characteristic features of its period and style: an upper register of divinities, calm above the turmoil of the human scene below. Here, however, there is also one interesting link between the two.

To take the human scene first: Lykourgos, who wears a Thracian cap, is about to deliver a second blow with his double ax to his unfortunate wife. Dryas is already dead, and two attendants carry his body off to the right. To the left is a young man who, it seems, is trying to remonstrate with Lykourgos; further to his left is an old paidagogos.[67] This figure, while not conclusive, is quite a strong indicator of an associated tragedy (see pt. 1, sec. M6), though not necessarily that by Aeschylus.[68]

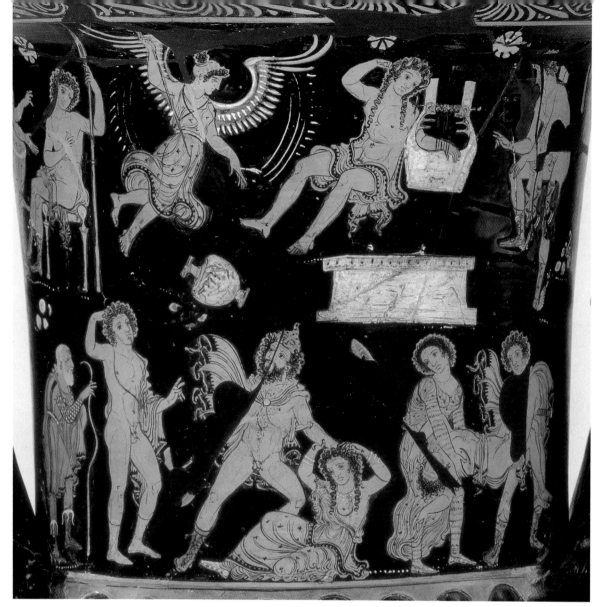

13

Among the gods above, Apollo is particularly prominent; the lighted altar beneath him might suggest that an uncompleted sacrifice figured in the story. To the right is Hermes, and to the left a seated male god with a spear and a standing female.[69] This painting is rather exceptional among those of Lykourgos for its absence of a prominent Dionysos.[70] As a kind of transferred representative of Dionysos, there is, instead, the beautiful, calm, and terrible figure of Lyssa (see no. 12). Her wings and snake-covered arm associate her closely with the Erinyes, but the sharp slender goad in her throwing hand is her special weapon. The striking "nimbus" around her is quite unusual, but it is found with Lyssa in two other examples of this very scene.[71] While the humans and the gods are otherwise strictly demarcated, Lyssa's goad is aimed at Lykourgos across the divine/human gap. As though with some apprehension of this, he glances upward before turning back to deliver his wife the coup de grâce.

14

May well be related to Aeschylus' *Europe* (or *Carians*)

Apulian bell-krater, ca. 390s
The Sarpedon Painter
H: 49.9 cm
New York, The Metropolitan
Museum of Art 16.140[72]

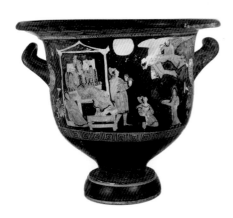

SARPEDON, SON OF ZEUS, is the greatest victim of Patroklos during his fatal day of glory in *Iliad* book 16. Hera and the other gods will not let Zeus rescue him from death, but they do concede that his body should be given the special privilege of being supernaturally removed from the battle, washed, dressed, and carried off for burial in his native land of Lykia, in southwest Asia Minor. This task is carried out by the winged twins, Hypnos and Thanatos, Sleep and Death.

The airborne cortege is known in at least eight Attic vase-paintings, including a particularly fine krater by Euphronios.[73] There are significant ways, however, in which this early Western Greek painting is different, ways that may be connected with a theatrical version of the narrative, maybe by Aeschylus. Immediately striking here are the figures on the ground looking up in astonishment at the sight of Sarpedon's corpse being miraculously transported. The standing man has an elaborate Oriental costume; the kneeling one is similar, though rather small.[74] The figure to the right with the platter is presumably a girl, perhaps a daughter of Sarpedon,[75] and the left-hand seated figure also seems to be an adolescent girl. Clearly, however, the main figure of the scene is the "queen," seated on a throne within a stagey structure and elaborately costumed in Oriental style, including tight sleeves. This depiction of the Sarpedon story is centered upon her.

Aeschylus produced a play (date unknown) called *Europe*, which was given the alternative title *Carians* (*Kares*), indicating that its chorus consisted of Carians and that it was very probably set in Caria (next to Lykia, and easily equated with it). The title and a few words were all that was known of the play until 1879, when a papyrus of twenty-three lines was published.[76] Clearly it is a tragic speech delivered by Europe, in which she tells how she has born three sons to Zeus and how she now fears greatly for the safety of her youngest, Sarpedon, who is away fighting at Troy. While it is not certain beyond question, this fragment is very probably from Europe's first speech in Aeschylus' *Europe*. In that case, the play is most likely to have included the return of Sarpedon's dead body to his grieving mother.[77] The other side of this krater shows another mythological narrative, also with elaborate costumes. Since it is evidently a scene set on Olympus, it seems fruitless to speculate on how the scene might have been connected with the tragedy, if all.[78]

Returning to the first side: once theater is brought to mind, the viewer is bound to think of a *mechane* scene. The *mechane* was the machine used for divine apparitions and for flying scenes, such as those involving the winged horse Pegasos. The body of Sarpedon in *Europe* may, then, have been flown into the spectator's view by use of this mechanical device. We have no surefire evidence that this machine already existed in Aeschylus'

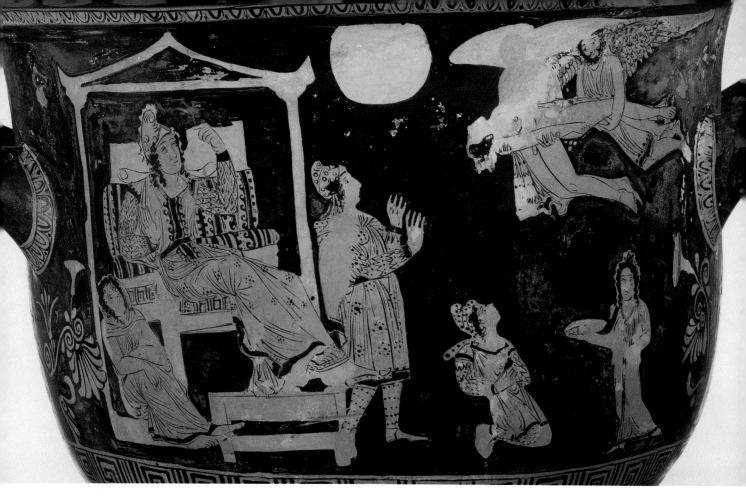

14

day, though many think it was the most likely staging for the arrival of Athena in *Eumenides* (397ff.). Given Aeschylus' theatrical inventiveness, it would be austere to rule this out.[79] Even if Aeschylus did not have the machinery available back in the time of the first performance of *Europe*, it could have been exploited later, in reperformances, once it was well established.

There is one other Western Greek painting of Sarpedon that may suggest the theater *mechane*. This is a Lucanian hydria of much the same date (ca. 400), one of the twelve large pots found together in a tomb at Policoro (Herakleia) in 1963, several of which have likely theatrical associations (see nos. 34, 37). On the shoulder Sleep and Death carry Sarpedon (labeled ΣΑΡΠΕΔΩΝ), while on the main body—with no apparent connection—there is a battle scene with a Greek warrior killing an Amazon.[80] There might be no particular reason to think of any connection with the theater and the *mechane*, were it not for the closely comparable spatial arrangement of the Medeia scene on another hydria by the same painter and from this same tomb (see no. 34 below). In that work the positioning of Medeia on the shoulder in her snake-drawn chariot, "out of reach" of Iason below, very likely reflects (I shall argue) the use of the *mechane* at the end of Euripides' famous play. So, to indulge a specula-

tive train of thought: if there was a messenger speech in Aeschylus' *Europa* describing how Sarpedon's body, on its way home, was flown clear of the battle raging down below, then the Policoro hydria might rather allusively recall that narrative, preceding his eventual arrival onstage by use of the *mechane*. But this is all rather a long shot.

15–17 *Niobe*

15

More than likely related to Aeschylus' *Niobe*

Apulian amphora, ca. 340s
Attributed to the Varrese Painter
H: 50 cm
Taranto, Museo Archeologico
Nazionale 8935[81]

NIOBE WAS ONE OF Aeschylus' best-known plays after the *Oresteia*. We know from Aristophanes *Frogs* 911–26 that Aeschylus brought the mourning Niobe on at the beginning and kept her in silence, seated and veiled, well into the play before she finally spoke. The play took place, then, after her children had been killed by Apollo and Artemis because Niobe had boasted that she was more fortunate than their mother, Leto.[82] This account fits well with a rough quotation in a late Greek lexicon illustrating the word for "brooding like a hen on eggs": "sitting she broods on the tomb of her dead children."[83] It was good luck, then, that this quote and another from the play were found within a papyrus fragment pub-

lished in 1933.[84] There has been much dispute over the interpretation of this fragment, but the majority view, which seems to me very probably right, is that it contains an explanatory speech from early in the play, delivered by a woman who is well disposed to Niobe and spoken in her presence while she remains sitting on the tomb. The speech predicts (line 10) that Tantalos, the father of Niobe, will arrive—presumably from Sipylos in Lydia (in west-central Asia Minor), where Niobe was raised before she moved to Thebes and married the king, Amphion. This tallies with a surviving fragment spoken by him (fr. 158), and with an indication that the play was set at the royal palace in Thebes (fr. 160).

The massacre of the Niobids was quite common on Attic vases, yet rare in Western Greek. The reverse is true of Niobe after the slaughter: while not found in Attic at all (to date), there are more than ten fourth-century Western Greek examples. Only in this one, however, is she shown in a pose that matches what we know of Aeschylus' play; in all the others, including two by this same Varrese Painter,[85] she is shown standing and turning into stone, an event that did not, as far as we know, figure in the Aeschylus version (but see nos. 16 and 17 below).

Here we see Niobe sitting on top of the tomb, which is unusually large, almost stagelike. Her head is veiled, in a posture of grief that might even be described as "brooding like a hen." On either side of her stands a tall funerary amphora, not unlike the one on which this scene is painted, except that they are ribbed rather than red-figure. Two figures with white hair, flanked by attendants, stand on either side of Niobe, holding out a hand to signify that they are addressing her—on the left an old man, on the other side an old woman. Niobe's face is turned down. This all fits remarkably fully with what we know of Aeschylus' tragedy. It is very likely, as has been discussed, that the speech on the papyrus was delivered while Niobe sat in veiled silence, spoken by an old nurse or by a female relation, such as her mother-in-law, Antiope. Since her elderly father also came and remonstrated with her, it seems more than plausible to suppose that someone viewing this vase is being invited to recall Aeschylus' play. This is an appropriate association for a funerary context, since, despite the element of divine punishment in the story, Niobe was an archetype of heroic grief.[86] Indeed, she was already cited in the *Iliad* (24.602–17) as someone who, despite the enormity of her grief, did eventually eat and thus assert the recognition that life must go on.

15

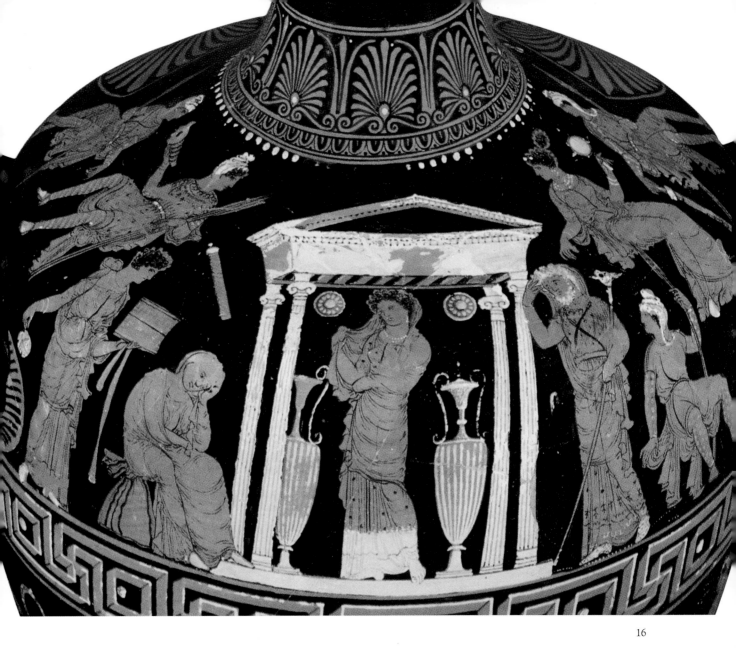

16

May be related to a
tragedy about Niobe,
possibly Aeschylus' *Niobe*

Apulian hydria, ca. 330s
Attributed to the Darius Painter
H: 62.7 cm
Geneva, Musée d'Art et
d'Histoire HR 282bis[87]

THE STORY OF THE GRIEVING NIOBE eventually being turned
into stone is found already in the *Iliad* book 24 (614–17). In that version
she became a rock with trickling water on Mount Sipylos, in Lydia; this
rock was, indeed, still visited by tourists centuries later.[88] This idea of
the mourner herself turning into the funeral monument seems to have
appealed to Western Greek vase-painters and their public. There are no
fewer than ten known examples of paintings depicting the story, most of
them from the "high" Apulian period of 350–325.[89] In all of these works,
Niobe's petrifaction is rendered by the use of white paint, usually only
below her knees, though in one case it has reached up as far as her waist.
In almost all she is veiled and looking down, and she is nearly always
inside a monument, sometimes explicitly set on top of a sepulchre.[90]

In these paintings, Niobe stands; this contradicts the emphasis on her sitting through much of Aeschylus' tragedy (see no. 15). There is no trace in any of the fragments that in the play, which was set in Thebes and not in Lydia, Niobe was turned into stone. While it remains possible that the petrifaction of Niobe was either reported or predicted later in Aeschylus' play, these factors militate against any significant relation between that work and these ten vases, at least at first sight. There might, indeed, be no reason to connect the iconography with tragedy at all, were it not for some of the figures who surround Niobe and her monument. In the majority of these pictures, there is an old king on one side and an old woman on the other; in several the man is clearly pleading with Niobe. These two figures are so like Tantalos and the Nurse (or Antiope) from the Aeschylus-related number 15 as to suggest that there may have been some connection with Aeschylus after all, either with his own play, or, perhaps more likely, a play under its influence.[91]

This large funerary hydria is in some ways characteristic of the petrifaction of Niobe scenes, though in others it is unusual. On Niobe's left is the usual old woman, but sitting, it seems, on a traveler's pack; on the right is the old king, presumably Tantalos. Flanking them are two women attendants and four Oriental soldiers. Despite the connections of Tantalos and Niobe with Lydia, it is rare to find Oriental features in the Niobe scenes.[92] These soldiers might suggest a scene set in Lydia rather than in Thebes.

The discussion in the first publication of this piece (Aellen-Cambitoglou-Chamay 1986) points out the discrepancies between this iconography and the Aeschylus tragedy and concludes that "the painters have followed a purely iconographic tradition" (153). But, while it is justifiable to react against a presumed connection between mythological vase-paintings and the great tragedians, and justifiable to insist on the importance of iconographic narratives, it is the "purely" that is too extreme a reaction. Tantalos and the grieving old woman may be derived ultimately from Aeschylus; and this painting may be informed by (but not dictated by) another, intermediate, and otherwise lost tragedy.

17

May well be related to
a tragedy about Niobe,
but probably not that by
Aeschylus

Apulian loutrophoros, ca. 330s
Attributed to the Darius Painter
H: 79.5 cm
Princeton University Art Museum
1989.29[93]

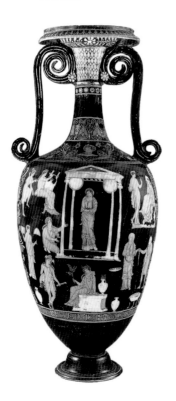

THIS GRAND VESSEL and a comparable piece in Zurich[94]—first published in 1990 and 1985, respectively—bring in new figures and complications, which seem to distance them further from the Aeschylean version than the previously known Niobe scenes.

On this vase there are no fewer than four notable variations: 1) Beneath Niobe sits a young woman who has taken asylum on a tomb, which is reported to be inscribed AMΦ[, in which case it is presumably the tomb of Amphion, Niobe's Theban husband.[95] Beside her stands the heroic figure of Niobe's brother, Pelops (labeled ΠΕΛΟΨ), with sword, winged Oriental cap, and "tragic" boots. It would make good sense for the sitting woman to be Chloris, a daughter of Amphion and Niobe, who was said (in contradiction of Homer) to have supplicated Apollo and Artemis—they are in the upper left of this picture. The story was that Chloris survived the massacre, going on to win at the first women's Olympic Games, held at the wedding of Pelops and Hippodameia.[96] 2) The woman pleading with Niobe is labeled "Merope" (ΜΕΡΟΠΗ), a figure not otherwise known in this story and hardly likely to have been the speaker of the Aeschylean fragment.[97] 3) On the right are an old nurse and an old paidagogos; they likewise stand by Niobe's right on the Zurich hydria. They are more likely to be attached to Niobe's children than to Niobe herself. Furthermore there is no Tantalos, since it is (I think) out of the question that the stooped figure with the bent stick could be equated with the stately king. 4) In the upper right is bit of rocky terrain where Pan stands before a seated figure in an Oriental cap. Fortunately she is labeled Σ[]ΠΥΛ[]Σ; in other words, she represents Sipylos, the mountain that was Niobe's homeland and where, according to the usual version, she ended up as a rock formation.

So we seem to have here a story that is far from number 15, and far from Aeschylus. It appears to have been concerned as much with the child or children who survived, and with Pelops, as with Niobe herself. And it involved an otherwise unknown Merope. It might be claimed that "in strict terms one could read it simply as a depiction of the myth, without intermediate connection with the theatre."[98] But it is hardly "the" myth when it includes so many variants; and it is surely not "simple." We cannot know how the viewers of this vase would have come to know this version of the story; but a theatrical version is the most likely guess. The supplication scene and the kneeling implorer are both characteristic tragic motifs (see pt. 1, sec. M8), as are the nurse and paidagogos (sec. M6).

There is one last possible pointer toward tragedy. The scene is presumably set in Thebes, where the tomb of Amphion was a well-known monument. So what is Sipylos doing here? I suggest that it is significant that she sits in a dejected pose suggestive of mourning. If the narrative

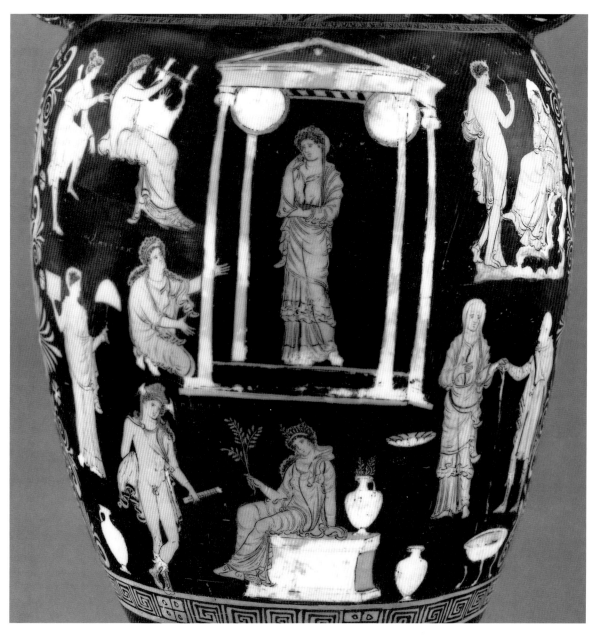

17

in question contained an aetiological prediction of Niobe's eventual pet-
rifaction as a rock on Mount Sipylos, that would explain the mountain
nymph's presence. But is that compatible with the incipient marmoriza-
tion of the central Niobe? It might be that this motif is simply taken from
the strong iconographic tradition; it might be symbolic rather than nar-
ratively literal. Or it might have been clear to a viewer who knew some
aetiological connection (from a play that is now lost to us) that was made
between Niobe at Thebes and her future stone figure on Sipylos.

18

More than probably related to the *Prometheus (Released)* by Aeschylus or School of Aeschylus

Apulian calyx-krater, ca. 340s
Attributed to the Branca Painter
H: 48 cm
Berlin, Antikensammlung,
Staatliche Museen zu Berlin
1969.9[99]

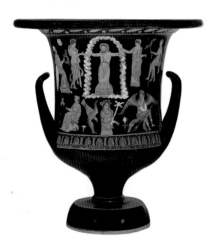

THE SURVIVING *Prometheus (in Fetters)* leaves no reflections in fourth-century painting. The play is in many ways different from what we know of the work of Aeschylus, so much so that the majority of modern scholars do not believe that it is Aeschylus' work, or at least not primarily his work—and I agree with this view. *Prometheus* was, however, handed down under Aeschylus' name and may have been based by a follower, such as his son, on an unfinished project. Antiquity also knew another *Prometheus*, differentiated by the subtitle *Released*, which was sometimes connected with it.[100] *Prometheus (Released)* was indeed a well-known play, and over thirty lines are preserved in quotations, along with a further twenty-eight lines of Latin, translated by Cicero.[101] It is clear from these texts that the two plays had a lot in common and contained several analogies or parallels. The central event of the latter play was the release of Prometheus from his bondage by Herakles, who first had to shoot the torturing eagle: "may Apollo of the hunt steer my arrow straight."[102] It is generally supposed that the two plays were part of a connected trilogy (or "dilogy," at least), and that either they are both the work of Aeschylus or neither is. I do not myself regard these assumptions as particularly cogent: it seems to me more than possible that *Prometheus (Released)* was an authentic play of Aeschylus, first performed with other, unrelated plays, and that *Prometheus (in Fetters)* was an "imitation" of Aeschylus, which owed much in form and content to the fully Aeschylean play.[103]

This fascinating picture is dominated by the flimsily clothed Prometheus, who is bound hand and foot to a rock. While this image would be a valid representation of a crag or rock on its own terms, the fact that a very similar rocky archway is found in other scenes of both binding and caves (see pt. 1, sec. M4) puts its connection with a standard item of stage scenery beyond reasonable doubt. It seems very likely that many theatrical companies had a painted rock arch that was put in front of the *skene* door when the play called for it. In a vase-painting this becomes a strong, if not conclusive, signal of a theatrical connection.[104]

Here a heroic Herakles approaches Prometheus to free him (traces of his bow in white are not well preserved); he has already shot the mighty eagle, which has fallen below with a bloody breast. The role of Apollo, who sits in the upper right, might have been nothing more than his invocation in fragment 200 (quoted above), though he may have been more prominent—like Herakles, he is a son of Prometheus' former oppressor, Zeus. Similarly, we have no other evidence of any involvement of Athena, Zeus' daughter; we might suppose her presence in the upper left of the painting to be merely conventional, were it not for the prominent garland that she holds forward. There is a testimony that in this play it was said that humans wear the garland in honor of Prometheus "as a requital of

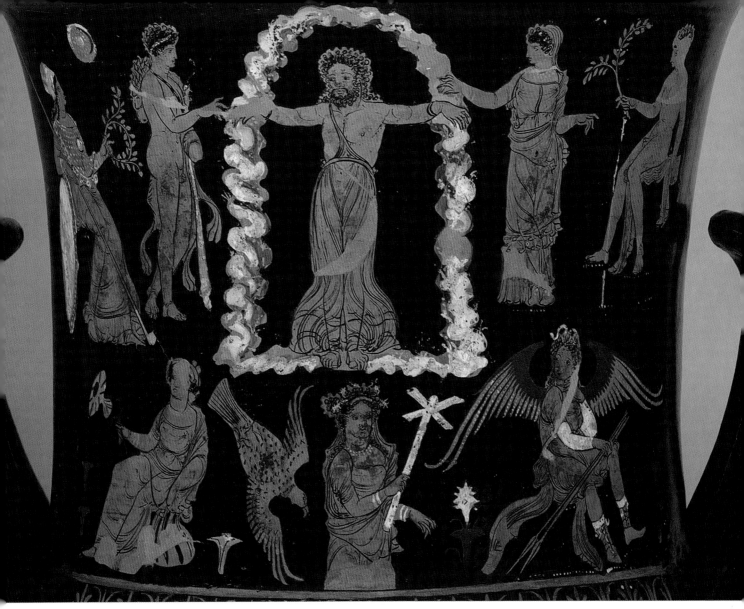

18

his fetters."[105] It is thus likely that the play included some kind of aetiology—though without this vase there would be no reason to suppose that the aetiology was established by Athena. The final figure in the upper register is the female to the right of Prometheus. It has been guessed,[106] on the strength of various reconstructions of the play, that she is Ge (Earth) or Themis, the mother of Prometheus. The truth is that the vase, while making it likely that this female was a speaking character in the play, gives no indication of her identity.

Of the three figures in the lower register, the right-hand seated one is clearly an Erinys—she has the full regalia of snakes, spears, wings, and boots (and note her tight sleeves).[107] The middle figure with the cross torch, half in and half out of the earth, would seem to fit the conventions for Persephone. Thus the left-hand figure holding a big flower is most likely her mother, Demeter.[108] Between them they add up to some sug-

gestion of the Underworld, of justice and of punishment; but, while they are evidence that these motifs were present in the play, they should not be used as specific evidence for its reconstruction.

Finally, the sharp eye of Trendall spotted that there are quite a few growing flowers scattered around the lower part of the picture, several of them painted in purple. In his poem about the journey of the Argonauts (3.845ff.), Apollonios (of Rhodes) told how a curative herb grows from wherever the eagle's blood fell on the ground; we are also told that the flower was called Prometheion. This intriguing painting (which is, of course, earlier than Apollonios) is evidence, good though not conclusive, that the flower was given an aetiology in *Prometheus (Released)*.

19

Possibly, but not probably, related to Aeschylus' *Phineus*

Lucanian volute-krater, ca. 400s
Attributed to the Amykos Painter
H: 57 cm
Ruvo, Museo Jatta 1095[109]

IN 472 B.C., Aeschylus put on a *Phineus* as one of the plays alongside *Persians*. The story was that Phineus was a blind prophetic king in Thrace, and for some reason he was plagued by the winged Harpies, who would steal and eat or befoul his food. The passing Argonauts asked him for advice, and, when the winged sons of the North Wind (called Zetes and Kalais) had chased off the Harpies, he told them details of their future voyage. We have very little idea, however, of how Aeschylus treated the story, how he put it onstage, and how (if at all) he made it "tragic."

There are several Attic representations of the story, which mostly date from the mid-fifth century and which might possibly have some connection with Aeschylus.[110] This is the only Western Greek representation, apart from a tiny fragment.[111] The painting goes all around the vessel (this plate does not include the two winged Harpies, apart from the feet at the right edge). There is no strong reason to connect it with Aeschylus, or even with tragedy, but it claims attention because it is a full, lively, and violent picture by an important early painter. Furthermore, Phineus' costume is ornate in the "theatrical" style, as is that of the Thracian soldier beneath him to the left of the table—or is he perhaps an Argonaut? If this picture is related to a play, it would seem a reasonable guess that the chorus consisted of the Argonauts themselves, since there are several spread around the picture.

The main interest here is that theatrical costume is already being assimilated by heroic narrative scenes, before 400 and possibly before 410. The Amykos Painter, who was active from circa 430 to 400, was central and influential, quite possibly working in Herakleia and interacting with "Apulian" painters who were working in Taras.[112] Given that the repertoire of "signals" indicating a theatrical connection does not develop until later, it is not out of the question that a tragedy, perhaps even that by Aeschylus, informs this piece.

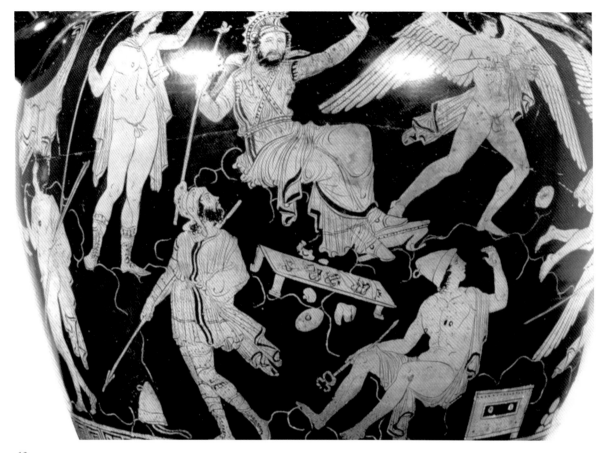

19

20–21 *Phrygians* (third play of the Achilles trilogy)

THE FACT THAT AESCHYLUS composed an Achilles trilogy that closely followed the structure of the *Iliad* is not given the recognition it should have in the history of tragedy.[113] While in some ways an homage to great epic model, it was bound to be no less an act of ambitious rivalry: tragedy can match epic, it says, and can even in many respects supersede and surpass it. It is not surprising that, to judge from citations, these were among Aeschylus's most celebrated plays, especially the first play, *Myrmidons*.

Much remains unknown, but we can sketch some features. The chorus of the first play was composed of Myrmidons, members of Achilles' crack troops. In the first part (half?) of the play, they and some Greek leaders plead with Achilles to rejoin the battle.[114] For a long time, like Niobe (see no. 15), he sits veiled and silent. All this derives from *Iliad* book 9, except that there Achilles is far from silent. The play goes on to

the death of Patroklos and Achilles' lamentation over his body, which matches *Iliad* 18, though Aeschylus made the notorious change of making Achilles' laments explicitly homoerotic. The second play was called *Nereids*, and these sea nymphs must have formed the chorus that accompanied Thetis when she brought Achilles his new armor (a blend of *Iliad* books 18 and 19). The play is likely to have included some reconciliation between Achilles and the Greek leaders, but there is no direct evidence of this. The third play, *Phrygians* (*Phryges*, also given the alternative title *Ransom of Hektor*), tells of how Priam came to Achilles' camp to ransom the body of his son—the great narrative of the final book of the *Iliad*.[115] The chorus consisted of Trojans who accompanied the old king Priam—in extreme contrast to the *Iliad*, in which Priam confronts his son's killer alone. We know that Achilles spoke briefly with Hermes at the start of the play but then sat—again—in veiled silence for a long time before eventually negotiating. In the *Iliad* Achilles had told the fatally wounded Hektor that he would not ransom his body at any price, not even if Priam were to offer his body's weight in gold (22.351–52). In the Aeschylus play, Priam did just that; while the staging of this scene remains uncertain, we are told that the gold was actually weighed out onstage.[116] Presumably, in contrast with Priam's surreptitious departure in the *Iliad*, the trilogy ended with a set-piece funeral procession.

Not only did Aeschylus boldly both follow and depart from the *Iliad*, he dramatized some of the epic's most crucial and memorable scenes. These were scenes that made a big impact on the visual arts—and had already done so well before the time of Aeschylus.[117] The embassy scene (in which the Greek leaders plead with Achilles) was particularly popular in early fifth-century Attic painting, but it is hardly found at all in Western Greek vases.[118] Nearly always Achilles is sitting unresponsively, with his head veiled, as we know he was in the Aeschylus play but not in the *Iliad*. This particular iconography goes back, however, to the 490s—the very beginning of Aeschylus' career—and it carries no theatrical signals. It must be regarded as possible, even probable, that the veiled Achilles predated Aeschylus.[119]

The scene of Thetis bringing arms to Achilles, with or without other Nereids, is also popular in sixth- and fifth-century Attic art. There is no reason to associate it with Aeschylus, except maybe in the one interesting case of a very fragmentary calyx-krater in Vienna dating from circa the 440s, which shows the Nereids in the upper register and a scene at Achilles' tent with a beast-drawn cart in the lower register.[120] It has even been claimed that these fragments show a scene from each of the three plays of the Achilles trilogy; but that involves a lot of speculation and is in danger of being circular.[121]

The Thetis episode occurs occasionally in fourth-century painting, and there is one late (ca. 310) volute-krater that has been claimed by Anneliese Kossatz-Deissmann as a candidate for an Aeschylean connection.[122] In this piece Thetis and another Nereid arrive below; Achilles sits centrally above, holding up a new greave, and he is surrounded by four male figures, identified by Kossatz-Deissmann as Odysseus, Talthybios, Automedon, and Antilochos. While the composition is reminiscent in many ways of the tragedy-related scenes of the high ornate period (the 340s and 330s), and while the male figures around Achilles are indeed interesting, there is nothing here that signals a theatrical connection sufficiently to make a strong case for it.

The arrival of Priam at Achilles' tent is also a favorite scene in both sixth- and fifth-century vase-painting. In the standard Attic iconography Achilles is reclining by a table of meat, with Hektor's corpse lying beneath his couch, while the balding old man advances with his arm outstretched. In none of the Attic paintings is there any discernable Aeschylean influence. There is, however, a so-called Melian relief from the mid-fifth century that shows Priam standing beside a huge set of weighing scales, with the body of Hektor lying below.[123] As with the *Libation Bearers* tomb scene, these reliefs may have been open to theatrical inspiration (see n. 8 in this ch.).

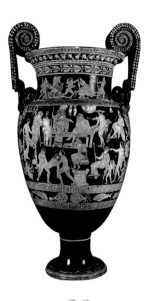

20

More than likely related to Aeschylus' *Phrygians*

Apulian volute-krater, ca. 350
Attributed to the Lycurgus
Painter
H: more than 100 cm
Saint Petersburg, State Hermitage
Museum B1718 (St. 422)[124]

THIS MONUMENTAL AND CROWDED SCENE, which includes several name labels, is different from the Attic iconography of the ransom episode in several ways, some of which seem to be positive pointers toward the Aeschylean *Phrygians*. In the upper register, Achilles sits veiled and grieving (not at his supper); by him stands Hermes (ΕΡΜΑΣ),[125] who spoke with Achilles at the start of the play, as noted above. The prominent figure of Athena also stands by Achilles, addressing him; we do not, however, have any (other) evidence that Athena had a speaking role in *Phrygians*. To the right sits Antilochos (labeled ΑΜΦΙΛΟΧΟΣ, a slight error), who in the *Iliad* becomes Achilles' favorite after the death of Patroklos. We have a fragment attributed to *Myrmidons* (fr. 138) in which Achilles addresses Antilochos, saying that his suffering is worse than that of the dead man. It is possible, I suggest, that the source of the quotation has used *Myrmidons* to refer rather loosely to the whole trilogy, and that Antilochos appeared in fact in the third play (perhaps while Priam was offstage with the body of Hektor?). The final figure to the left of the upper register is the old Nestor, who might be there simply to balance his son, Antilochos, rather than because he appeared in the play.

Turning to the lower register: Priam is seated, holding out a suppliant

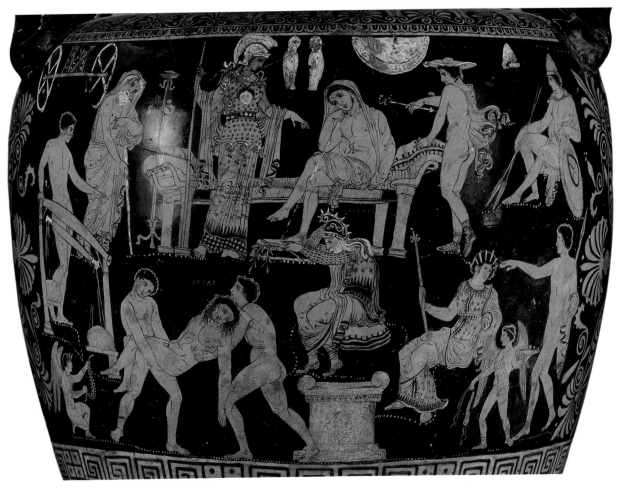

20

branch. He wears an elaborate Oriental costume with tight sleeves, and his hair and beard seem to be cut short in mourning. He appears to be giving attention not so much to Achilles as to the body of his son Hektor, which is being carried by two assistants toward—or is it from?—the large scales to the left. As mentioned above, we do know that the scales were one of the main features of Aeschylus' play (though this vase cannot be used as firm evidence for staging, of course). Finally, behind Priam is a richly costumed Thetis (labeled ΘΕ[) and a young warrior—neither of them necessarily figured directly in the play.

It seems fair enough to conclude that this picture is informed by *Phrygians*: in other words, that the viewer who knows the tragedy—the role of Hermes, the weighing of the body—will find the picture richer and more meaningful for that knowledge. This is a particularly suitable telling of the story for a grand funerary vessel. Two of the greatest bereaved figures of heroic myth are seen attempting to salvage some meaning and consolation from their bereavement, with the guidance of the gods. It may also be appreciated that Nestor will be bereaved of Antilochos and Thetis of

Achilles. If these great ones had to live under the yoke of mortality, and if poetry and song could be made out of their suffering, then so much the more must we lesser mortals attempt to find some comfort in our sorrow.

21

May be related to Aeschylus' *Phrygians*

Fragment of Apulian calyx-krater, ca. 390s
Attributed to the Black Fury Painter
H of fragment: 23 cm
New York, The Metropolitan Museum of Art 20.195[126]

THIS FRAGMENT IS UNFORTUNATELY too small to allow us to be confident in connecting the painting—from about half a century earlier than the previous vase—to Aeschylus' play. Priam's costume, however, is particularly elaborate in the theatrical style, which did not become merely conventional until later. Standing behind Priam is Hermes (note the winged boots), who wears an ornate cloak. As already seen, Hermes appeared in *Phrygians*, though not necessarily at the same time as Priam; the vase-paintings often combine elements from separate scenes. There are traces of another figure standing behind Hermes, and Achilles' elbow is visible in the top right-hand corner—it is clear that he is sitting, but not whether he is in a posture of mourning. The pillar behind Priam suggests that Achilles' tent was represented as a kind of stage-type portico.

It is hard to know whether the aesthetic and emotional appeal of this fragment would have remained as strong if seen within the entire picture, or whether—ironically—our perception benefits from the painting being fragmentary. The portrayal of Priam's face, his grief, and his cropped, disheveled hair and beard strike us as remarkably expressive.[127]

21

Chapter 2

SOME VASES THAT MAY BE RELATED TO Sophocles

SOPHOCLES FIRST PUT ON
TRAGEDIES in 468 and died more than sixty
years later, in 406. Over this extremely long period
of theatrical activity he produced at least 120 plays
(some thirty of them presumably satyr plays).

He was personally an attractive and popular
figure—"he was easy-going up here and
he's easy-going down there [in Hades]"[1]—
inspiring anecdotes about his love of the
symposium and its erotic opportunities,
and holding high political office now and
then throughout his life. His plays were very
successful, and some of them—most notably
Oedipus (the King) and *Antigone*—quickly became
central to the canon of Athenian tragedies of the
golden age.

Yet when we turn to fourth-century vase-
paintings, the picture seems quite different. There
are very few that can be associated with his plays
without strong doses of wishful thinking. There may,
indeed, be only two or three that can be connected
with any confidence. Out of Sophocles' seven surviv-
ing plays, four—including the celebrated *Antigone*—seem
to have left no clearly detectable mark in surviving paintings.
None of the many lost plays can be connected with surviving vase-
paintings with any probability, although a few interesting possibilities are
discussed below.

All this is in sharp contrast with Aeschylus, even though he belonged
to an earlier generation.[2] It is in even greater contrast with Sopho-
cles' great contemporary and rival, Euripides. Why should this
be so? At least part of the answer may be that Sophocles did
not "travel" as well as the other two. We have no stories of his
journeying elsewhere to put on his plays, and no evidence
that his plays were known in his lifetime outside Athens and
Attica. It is, however, hardly plausible to suppose that, while
Aeschylus and Euripides were much performed throughout the

rest of the Greek world, Sophocles remained unknown. We do have firm evidence that Sophocles was reperformed at Attic festivals in the fourth century.[3] Furthermore, when Aristotle (in about the 340s) picked *Oedipus* (*the King*) to stand as the epitome of the tragic art, he can hardly have been selecting a little-known playwright. Nonetheless, the paucity of Sophoclean reflections in Western Greek vase-painting seems to suggest that he did not speak as directly to the Greeks of that region and period as did Aeschylus, let alone their favorite, Euripides.

Little can be said with confidence about the chronology of Sophocles' plays. *Philoktetes* and *Oedipus* (*at Kolonos*) both come from his last four years; *Elektra* is likely to have been produced not long before them; and the other *Oedipus* probably was produced later rather than earlier in his career. *Aias* (Ajax is the Latin and Etruscan version of this name) may well have been a relatively early play; if so, it reflects a playwright who was innovative and adventurous from the start. The story of the disgrace of Aias and his subsequent suicide on his own sword is actually found more in pre-Sophoclean than in post-Sophoclean art.[4] An Attic red-figured lekythos (first published in 1976), which shows Aias praying before his planted sword blade, seems very much in keeping with the austere power of the Sophoclean tragedy, but it is dated to circa 460 and is likely to be earlier than the play.[5] The only fourth-century claimant to a connection with *Aias* is a group of small fragments by the Darius Painter, published in 1982. These happen to include four name inscriptions: Tekmessa, Eurysakes, Teukros, and Telamon.[6] Some scholars have leaped to connect the fragments with Sophocles' play, since Tekmessa, Eurysakes, and Teukros are all onstage at 1168–84. However, in the fragment Eurysakes seems to be larger than a child; and in any case Telamon is not a character in the Sophocles play. So I think that Trendall was too eager to make the tragic connection when he claimed that this is "probably from a scene to be associated with the *Ajax* of Sophocles."[7]

Trendall was also probably "over-optimistic" in hoping to relate two fourth-century paintings to Sophocles' *Trachinians*, the play set at Trachis in south Thessaly, which tells of how Deianeira fatally clothed her husband, Herakles, with a poison that she believed to be a love potion. One of these pots is, as it happens, another inscribed fragment by the Darius Painter.[8] Hyllos (the son of Herakles and Deianeira, his name is inscribed), who is old enough to wear a garland yet is clearly smaller than adult size, has raised a cattle skull (*boukranion*) above his head and is apparently about to attack someone with it; an adult youthful figure to the left is holding a cloth. This might conceivably reflect *Trachinians* in some way, but there is not enough evidence to make the possibility more than remote.

The other painting is a rather fine Sicilian calyx-krater of circa the 340s, which shows several of the characters in the story, all in rather sedate poses.[9] There are name labels identifying the youthful Herakles, who stands between the seated Deianeira on one side and Oineus, her father, on the other; above are a winged Nike (Victory) and the horned river god Acheloos, Herakles' rival for Deianeira's hand. Trendall repeatedly insisted that this would make an "admirable poster" for *Trachinians*. However, we have no evidence of pots being used as publicity for plays, and Oineus and Acheloos are not actually dramatis personae in Sophocles' play. While the arguments against a significant connection with Sophocles' play are too strong for the work to be included here, one can nonetheless see what prompted Trendall to favor the association. The reverse features a silenus and a satyr, figures associated with Dionysos, and the pot was found at Lipara (modern Lipari), a city in the Aeolian Islands off Sicily whose Greek inhabitants evidently had something of an obsession with the theater.[10] Furthermore, this is a Sicilian painting of a period and type that favored theater-related pictures (in fact, no. 22 is an outstanding example). But there are no theatrical signals on this particular piece.

22

Closely related to Sophocles' *Oedipus (the King)*, reflecting the scene with the old Corinthian, Oedipus, and Iokaste

Sicilian calyx-krater, ca. 330s
Attributed to the Gibil Gabib
Group, probably the Capodarso
Painter
H: 24 cm
Syracuse, Museo Archeologico
Regionale "Paolo Orsi" 66557[11]

UNTIL THESE FRAGMENTS were excavated in 1969, there was no vase-painting that could be plausibly related to this most canonical of tragedies.[12] Even though it is in less than good condition and the handles and the other side of the krater are lost, it is nonetheless a very interesting pot with an unusually strong relation to the tragedy—at least arguably so. It is one of a group of monumental Sicilian vases of the third quarter of the fourth century that are particularly close to the realities of theater.[13] Although this one was found at Syracuse, many are from relatively minor inland sites, including Gibil Gabib. Number 105 from Capodarso, quite possibly by the same painter as this work, is especially remarkable because it explicitly shows a theatrical stage (as is common in the comedy-related vases).

In this painting four figures (three visible in the photo) stand on a long strip of floor with pillars at the back, suggestive of a stage, but not a realistic representation of one. In terms of composition, the pillars serve to separate the four main figures, with two girls standing in between the three main figures. The two larger figures in the center have quite ornate garments, and all four have well-portrayed expressions of mood and emotion. From left to right, the first is a little man of the typical paidagogos type (note sleeves and boots), who stares fiercely forward in an unusually direct way and gestures toward his neighbor. This is a mature man (tight

22

sleeves) looking down to the left. Behind him, facing in the same direction, is an unhappy-looking woman who raises her cloak to her face; and finally there is a young woman, who is turned away from the others. The old man's words—whatever they might be—are disconcerting the others. There seems to be no clear pointer toward what narrative is being told—unless the two little girls offer a clue, since they are likely to be the daughters of the central figures. Yet this is surely not a generic scene without a story (contrast no. 23): in other words, the viewer is being challenged to supply the story (or else to remain puzzled).

Trendall put forward a narrative to explain the scene. This has been widely, though not universally, accepted, and I believe that it is very probably right. According to him, we have here a particular scene from Sophocles' *Oedipus (the King)*, the one in which the old man from Corinth (conventionally but rather carelessly known as the "Messenger") is telling Oedipus about his past, and about how he himself years ago received him as a baby up in the pastures of Mount Kithairon. This is all startling news for Oedipus, who has steadfastly believed himself to be the son of

the king and queen of Corinth. For Iokaste, however, this information is enough to make her realize that the man she has been married to since the death of her former husband, Laios, is in fact her own son, grown up from the baby that was sent away with an old shepherd to be exposed when it was three days old. When Oedipus turns to her at line 1054, she has already seen the truth. The text does not mark exactly when her recognition became evident to the audience, but a key line is 1042, in which the old Corinthian says that the shepherd he took the baby from was a slave of Laios. The vase not only shows the theatrically plausible "blocking" of Oedipus standing in between the other two, but also indicates an effective staging of Iokaste's silent recognition of the horrific truth.

It is no objection to this interpretation that the two little daughters are present during this scene, even though they would surely not have been in Sophocles' original staging (and are very unlikely to have been in any subsequent restaging). In the play they are, however, brought on to be reunited with their blind father/brother in a final scene of great pathos at lines 1462–1523. For anyone who knows the play, they are a memorable element; their presence here on the pot adds an extra emotional twinge to the scene. While this is unusually close to a picture of a scene, it is still enriched by the play as a whole. The only problem with this entire solution is the presence of the woman to the right, who is turned away from the main scene. But this objection is not insuperable: she may be thought of simply as a maid of Iokaste (or perhaps she would have been explained by the lost part of the vase?).[14]

This proposed interpretation makes good sense of an otherwise baffling scene. It is very interesting that the vase-painter has evoked a particular moment, one that is signaled by a rather subtle and far-from-spectacular action onstage—that is, the moment when Iokaste sees the truth. It is important within the dramatic fabric of *Oedipus* that she is the first to put the pieces together (the prophet Teiresias aside); Sophocles makes dramatic capital of her realization while the central focus for the audience is not on her but on Oedipus and the old man from Corinth. Aristotle in his *Poetics* (1452a24), a work that is more or less contemporary with the vase, picks this moment as a particularly effective recognition scene, because the Corinthian's apparently good news turns out to be bad.

This vase is especially telling, not only because it gives us striking evidence about costume and gesture, but also because it picks this powerful yet unmelodramatic scene. The work supposes quite a subtle appreciation on the part of the viewer. By showing Iokaste's wordless moment of horror, it surely appeals, not to someone who has read the play, but to someone who has seen it in performance.

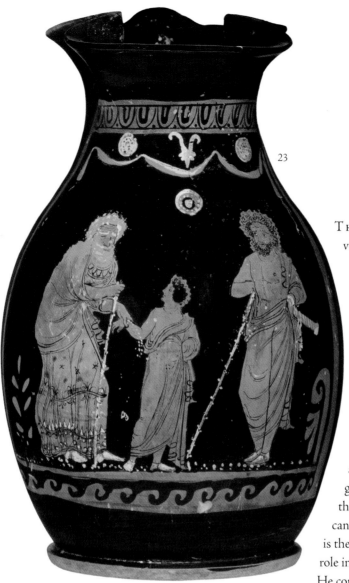

23

THIS WINE JUG, an unusually small vessel for the monumental Darius Painter, was published in 1982.[16] Its scene cannot, it seems, be related to any particular play, yet it has theatrical resonances. The old man on the left, though stooped, is quite clearly not a paidagogos figure: he is tall and has an ornate floor-length robe. He is evidently blind, led along by the boy or youth in the center. The figure to the right has a staff and sword, and is presumably a ruler, although he does not have particularly grand robes or accoutrements (e.g., there is no eagle on his scepter). There can be little doubt that the blind man is the celebrated seer Teiresias, who has a role in quite a number of Theban myths.[17] He comes onstage in four surviving tragedies and no doubt appeared in many more. In three of those four—*Oedipus (the King)* 300ff., *Antigone* 988ff., and Euripides' *Phoenician Women* 834ff.—he has a scene in which he advises and confronts the ruler, a scene not unlike this one. But I can detect no sign within this painting that it is pointing to any one of these three scenes (nor to any other that may have been known). *Phoenician Women* seems unlikely because in it Teiresias has with him both his daughter and Menoikeus, son of Kreon, but the painter need not be accurate in every detail. Schmidt raised the possibility that the youth might be Menoikeus rather than Teiresias' guide,[18] but he seems too small and immature to match the young man who has a substantial speaking part in that play. I conclude that we have here a general "Teiresias and king" scene, rather than a specific narrative—which makes an interesting contrast with the specificity of number 22.

23

Teiresias and a king, possibly related to Sophocles' *Oedipus (the King)* or *Antigone*, but not directly

Apulian oenochoe, ca. 330s
Attributed to the Darius Painter
H: 22 cm
Basel, Antikenmuseum BS 473[15]

24

Possibly related to
Sophocles' *Antigone*, but
more probably not related
to any tragedy

Apulian hydria, ca. 420s
Close to the Painter of the Berlin
Dancing Girl
H: 44.5 cm
Taranto, Museo Archeologico
Nazionale 134905[19]

ANTIGONE SEEMS IMMEDIATELY to have become a well-known
play. The story of the young princess facing death in order to bury her
dead brother—despite the edict of Kreon, her uncle and the new king of
Thebes—evidently struck a chord in Athens. Its influence can be detected
in Euripides' *Phoenician Women* and in the final, non-Aeschylean scene
of *Seven against Thebes*.[20] It is also quoted in a comedy by Eupolis, prob-
ably dating from 429.[21] In the fourth century, it was quoted at length by
Aristotle and by Demosthenes, who speaks of it being "often" performed
by famous actors (see n. 3 in this ch.). Yet there is not one single probable
reflection in fifth- or fourth-century art—although there is for another
Antigone story (see no. 64). This may be simply the result of bad luck; or
perhaps the play did not have the appeal in the Greek West that it enjoyed
in Athens.

There is one painting in the British Museum that is usually associated
with *Antigone*.[22] It seems to me, however, that there is a serious objection
to this identification of the scene; since that vase is already much repro-
duced, I have instead included here another pot that is, I reckon, no less
likely to be related to *Antigone*—although I cannot claim that it is any
more likely, either. On the British Museum vase, a young woman stands
on a rock between two youthful men with short chitons and spears, who
both stand in a rather relaxed way. Before them, to the left, sits a regal fig-
ure on a throne. There are no tight sleeves or ornate boots or other stan-
dard signals of a theatrical connection (see pt. 1, sec. M). There are only
two reasons to think of *Antigone:* One is that the first of the two "guards"
is addressing the king, as at *Antigone* 387–440—although it must be said
that he hardly fits the usual interpretation of a tough old soldier for this
role. The other argument is that the woman is looking down, thus fitting
Kreon's first address to Antigone when he has finished with the guard
(441–42): "You, yes you with your face turned down toward the ground,
/ do you confess, or do you deny, you did these deeds?" But these pointers
have to be set against the contraindications that the king is sitting, not
standing (not in itself a major objection), and that he is wearing a con-
spicuous Oriental headdress, which seems to have a sort of train hanging
from it. Advocates of the Sophoclean connection have to downplay this
signal,[23] yet it does pose a major obstacle to the identification. It is not
impossible that a performance tradition grew up of dressing the rulers of
the city of Kadmos (the Phoenician founder of Thebes) with Oriental
accoutrements, but that is a rather far-fetched explanation. Much as lov-
ers of the play may admire Antigone's defiance as she stares at the ground,
this contraindication outweighs the positive indication, in my view at
least.[24]

The iconography of this Taranto hydria is in some ways similar and in

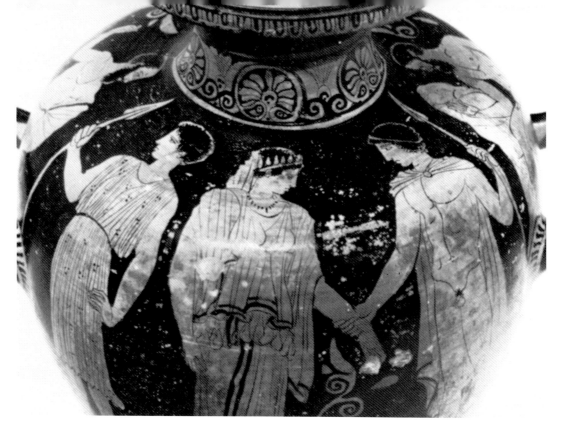

24a

24b

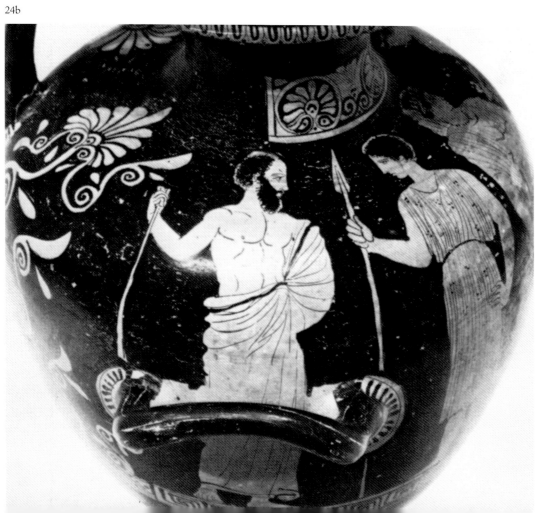

others different. It has been generally neglected, even though it dates from the early days of Western Greek red-figure vase-painting. Once again a dignified young woman, this time with a kind of crown, stands between two young men with spears. Again, they seemed to be approaching an older man, but in this painting he is slightly balding and has no headdress; he also holds a stick, though it is not straight like a royal scepter. Most unusually, he is standing within the loop of the handle. To the far right, above the other handle, is a satyr seated on a rock. Trendall observed that this picture "might well represent Antigone brought before Kreon by two guards."[25] In favor of this interpretation is the fact that (again) the woman seems to be looking down to the ground, but with her face turned away; in this case, however, the older figure is far from regal. It might be argued that his "isolation" under the handle reflects the role of Kreon within the play, but that might well be dismissed by the skeptical as fanciful special pleading. Furthermore, the right-hand young man holds the woman by the wrist, a gesture often associated with marriage rather than with custody. For Ingrid Krauskopf, this is the decisive objection to any *Antigone* connection.[26] If she is right to claim that their gazes are meeting, then this would indeed be a fatal contradiction; but, as far as I can see, the woman is looking lower than the man is, and more toward the ground. Overall, despite the rather attractive idea that this picture includes a kind of symbolic spatial representation of Kreon's unsympathetic stance in the play, it has to be conceded that we still lack a definite reflection of Sophocles' *Antigone* in all of fifth- and fourth-century art.

25

Plausibly related to the urn scene in Sophocles' *Elektra*

Lucanian bell-krater, ca. 350s
Attributed to the Sydney Painter
H: 31.5 cm
Vienna, Kunsthistorisches
Museum 689 (SK 195, 69)[27]

THE BASIC NARRATIVE of the reunion of Elektra and Orestes and of their revenge on Klytaimestra and Aigisthos is told in the two surviving *Elektra*s of Euripides and Sophocles, as well as in Aeschylus' *Libation Bearers*—and it was no doubt told in other, unknown tragedies as well. It was the meeting of the siblings in Aeschylus' version that dominated the response in vase-painting; the clear signal of that scene was the centrality of the tomb (see nos. 1–4). There are no paintings, as far as I am aware, reflecting Euripides' play, which is set at the poor farmstead of the peasant to whom Elektra has been married off. And there is only one (or possibly two) that may be related to Sophocles' play, which is set at the royal palace in Argos.

Sophocles' tragedy is woven around the gamut of emotions experienced by Elektra, including her belief during the central part of the play that Orestes is dead. The most famous scene was, and is, the one in which she laments over the urn that supposedly contains her brother's

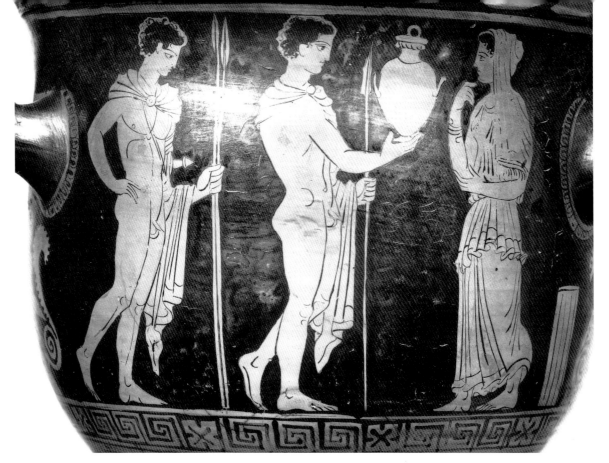

25

ashes, while he is in fact standing right beside her (1098–1170). Orestes and Pylades, posing as travelers from Phokis, bring on "the small urn of bronze" (757–58) with his alleged remains. This scene may be reflected on an earlier Lucanian hydria depicting a woman holding an urn while a man is sitting.[28] It is strange, however, that on that vase Orestes (assuming it is him) should be sitting, and that there is no Pylades; even stranger, there is a pillar inscribed with his name: ΟΡΕΣΤΑΣ. I suppose it might be possible, though it seems far-fetched, that this is a representation of his tomb as feared and imagined by Elektra. But any connection that pot may have had with Sophocles' play is much more remote than this rather crudely painted vase from a generation later.

Two similar men, both "heroically" naked (but with cloaks and spears, which indicate travel), advance with a funerary urn—a hydria, which was a standard vessel for ashes. The veiled woman before them makes a gesture that seems to suggest anxiety. This can hardly be any scene other than the "false urn," as dramatized in Sophocles' *Elektra*—and, as far as we know, unique to his version of the story. Despite a passing indication in the text that Sophocles had a plurality of people bringing the urn,[29] that discrepancy is trivial; the vase-painter wants an effective economy of narrative, not total fidelity to the text. Thus Orestes himself holds out the urn to his sister.

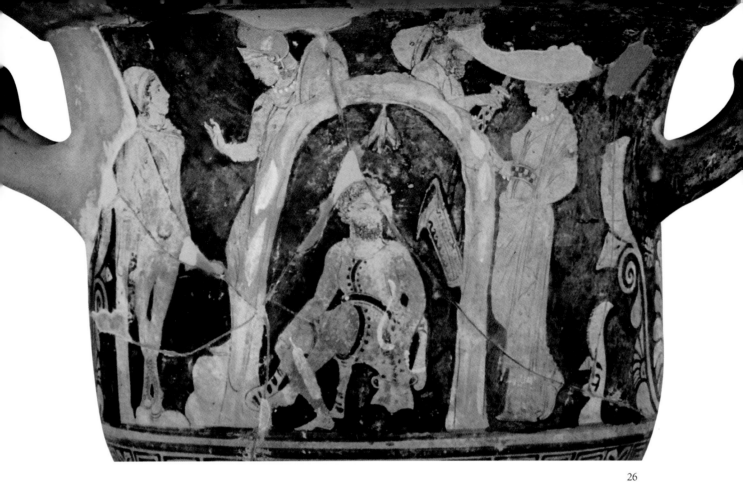

26

May be related to a
Philoktetes tragedy, but
apparently not that
of Sophocles

Sicilian bell-krater, ca. 380s
Attributed to the Dirce Painter
H: 43.5 cm
Syracuse, Museo Archeologico
Regionale "Paolo Orsi" 36319[30]

THIS INTRIGUING PAINTING is by an enterprising early Sicilian
painter,[31] who shows an interest in theater and who produced another,
similar composition that can be quite closely related to Euripides' *Antiope*
(see no. 65). Even though this work has at most a tenuous connection
with the Sophoclean version of *Philoktetes*, it seems worth including under
the heading of the known, surviving play.

Philoktetes himself sits centrally, yet isolated within the "hoop" of his
cave. To the left a young man (with fancy boots) stands rather noncha-
lantly by a tree; to the right is a beautiful young female. Half behind the
cave, to the left, Athena addresses the youth. Mostly behind (or rather
above) the cave, to the right and facing the young female, is a mature man
with a sword; given his place in the story and his characteristic *pilos* (a
type of hat), he can be identified as Odysseus. There are some ways in
which this painting tallies rather closely with Sophocles' play, but others
in which it is quite different. There are, in other words, both pro- and
contraindications to be weighed.

As in Sophocles, attention is given to Philoktetes' bow, which he is
holding, and to the wild birds that are hanging in his cave, sharing the
play's emphasis on his diet of raw game (e.g., lines 1146–62). On the
other hand, in Sophocles much is made of the filthy old bandages with
which Philoktetes binds his wound; they are not shown here, and he is

cooling the wound with a feather, which is not mentioned in the play.[32] The youthfulness of the figure to the left might make us think of Sophocles' Neoptolemos. We know from ancient sources that he was an innovation to replace the more usual Diomedes, who figured in Euripides' earlier *Philoktetes* version of 431. But, except perhaps for his clear separation from the Odysseus figure, there is nothing here to suggest that this young man is Neoptolemos rather than Diomedes, or indeed someone else.[33]

The biggest pro-indication is one that has not been given due attention: Odysseus, holding his sword, is largely "concealed" behind the cave. In Sophocles' play he twice leaps out suddenly in ambush (974–83 and 1293–1303) and makes it clear that he has been eavesdropping. At 1254–55 he threatens to draw his sword on Neoptolemos, and he may well be brandishing it at 1293–1303. It could be argued that the painting conveys this lurking and threatening behavior.

But there is a contraindication that outweighs this link: the conspicuous presence of Athena. She has no particular importance in Sophocles' play, in which the significant gods are Hephaistos, Zeus, and above all, Herakles. The way that Athena lectures the young man might suggest a "god from the machine" (the deus ex machina).[34] We do know that in Euripides' play Athena took care of Odysseus' disguise, but there is no clear evidence that she actually appeared in the play, let alone as the god from the machine. The female to the right also is not explicable in terms of Sophocles' play. It has been suggested that she represents the island of Lemnos—but how is the viewer to know that? Or, since she reaches out to touch the cave arch, might she be a nymph of the cave? If so, there is no hint of any such divinity in Sophocles. Pierre Vidal-Naquet has suggested that she somehow represents feminine guile; but he can arrive at that only by reading the vase in terms of conceptual oppositions, a kind of structuralist approach that can hardly rest on a single example, however ingenious.[35]

Until recently this was the only vase-painting showing the mission to fetch Philoktetes from Lemnos (so that he might fight against Troy), the subject of *Philoktetes* plays by Aeschylus and Euripides as well as Sophocles. But a fragment of Attic painting from circa 460 was published in 1996,[36] showing Odysseus, with someone's hand touching his arm from behind, watching the apparently oblivious Philoktetes (who has a name label). Between them is a twisty structure that might represent a cave or grotto, but may more likely be a tree; Philoktetes' bow and quiver are hanging from it.[37] Then, in 2000, a group of fragments in a Swiss private collection was published by Didier Fontannaz.[38] They are Apulian, probably dating from the 340s, shortly before the Darius Painter's time. Philoktetes sits inside a conventional wavy "cave arch" (see pt. 1, sec. M4); a dead

hare is hanging inside it, rather like the birds on the Syracuse vase. Outside the arch, to the right, is a figure with a *pilos* who is clearly Odysseus. To his right is a young man with shield and spear. While this might be Neoptolemos, he could well be simply a marginal attendant. On a small, separate fragment (fr. 3), there is another figure, who, Fontannaz insists, has a *pilos* pushed onto the back of his head and must be Diomedes. But the sherd is unfortunately too small to say anything with confidence, not even that the shape behind the figure is definitely his hat. So, while there is not enough evidence to say that these fragments are definitely not connected with a dramatized version of the Philoktetes story, there is also not enough to make any plausible case in favor of a connection.

27

Plausibly related to Sophocles' *Oedipus (at Kolonos)*

Apulian calyx-krater, ca. 340s
Close to the De Schulthess
Painter
H: 50.5 cm
Melbourne, Geddes collection
A 5:8[39]

IT WOULD NOT BE SURPRISING if *Oedipus (at Kolonos)* were not reflected at all in art outside Athens. It was one of Sophocles' last plays, first produced after his death, and it is especially Athenian. Set at Kolonos, Sophocles' own deme, a short distance northwest of the walls of Athens, it tells of how a hero cult of Oedipus came about there. (More than one place claimed the tomb of Oedipus, king of Thebes—the great enemy of Athens for most of the fifth century.) In this play he comes to a sacred grove, where he recognizes signs that he should die there. His two sons, Eteokles and Polyneikes, are fighting over the throne of Thebes, and an oracle predicts that he who recruits Oedipus will win. He refuses both sides and goes to a miraculous end. There was indeed a cult of Oedipus at Kolonos in later times, but we cannot be sure if that preexisted Sophocles or was founded in the wake of this play. Either way, the story is rather peculiar to Athens. Yet this vase, which was first properly published only in 2003 (it first came on the market in 1985), shows the Oedipus at Kolonos story with details that cannot be interpreted without knowledge of Sophocles' play. This cannot be what is often referred to as "simply the myth," because the myth was Sophocles' story.

In the picture an old man with a staff (*skeptron*), clearly depicted as blind, sits on an altar between two young women, one veiled and demure, the other more ornately attired. To the left stands a bearded king; to the right, a younger man (with fancy boots).[40] Above, to the right, sits an interested Erinys, with all the standard features.[41] Beyond a doubt, the old blind man is Oedipus taking refuge at Kolonos; on one side of him is his daughter Antigone, who accompanied him in his exile, and on the other is her sister, Ismene, who—in Sophocles' play (310–509)—arrives to tell them of the brothers' war and of the oracle. Before long (728–1043) Kreon arrives from Thebes, the villainous uncle representing the side of Eteokles. After he has been sent packing by Theseus, the good king

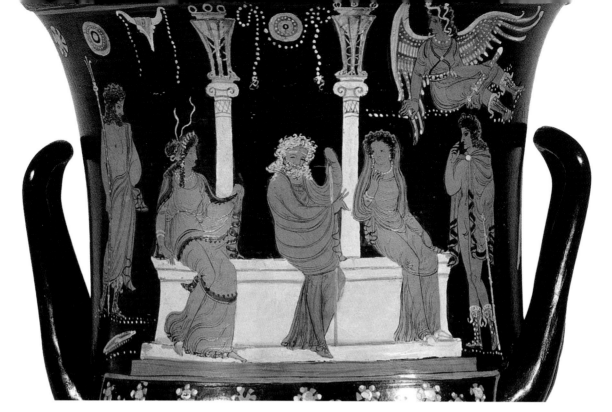

27

of Athens, there is a scene (1249–1446) with Polyneikes, who comes in
person. There is critical dispute over how sympathetic or unsympathetic
Polyneikes is, but since he has the support of Antigone, he is clearly not
as bad as Kreon. Oedipus curses him nonetheless, and the son departs
to certain death. It is the knowledge of these two rivals, pulling Oedipus
toward opposite sides, that makes best sense of the standing figures in this
painting: the confident Kreon to the left,[42] and the young, more hesitant
Polyneikes to the right.

Sophocles' play, which salvages some beauty and dignity from Oedi-
pus' end after a life of suffering, clearly has suitability for a funerary con-
text. While the vase can no doubt stand independently in its own right,
it means far more to a viewer who knows the particular play. The same is
true for the interpretation of the Erinys above. Instead of being merely a
general figure of punishment, this Erinys has a special significance, since
the grove where the play is set is especially sacred to the Erinyes under the
title of "Eumenides" (Kind Goddesses) (see lines 38–43, 84–110). When
Oedipus curses Polyneikes, he calls on "these goddesses here" (1391), and
so it makes special sense for the Erinys to be placed above Polyneikes'
head. It is also worth noting that there are several symbols showing that
this scene is set in a sacred space: the boukranion, the platters and fes-
toons. This could also explain the two pillars surmounted by tripods that
are set behind the altar. Since, however, there are other vases on which
tripods seem to be suggestive of victory in an artistic competition (see pt.
1, sec. N2), it is possible that here they carry a double significance.

To any but the most skeptical, this new vase must be regarded as strong evidence that Sophocles' *Oedipus (at Kolonos)* was reperformed in Western Greece in the mid-fourth century, and that its message of mortal consolation amidst the sufferings of human life was appreciated there.

Other (Fragmentary) Plays

WE HAVE EVIDENCE that certain now-lost plays by Euripides—and even by Aeschylus—were especially popular in the fourth century and in later antiquity. This is not the case with Sophocles: not one of his more than one hundred lost plays stands out for frequency of allusion in comedy or for frequent quotations.[43] And none indeed for reflection in vase-painting or other art forms. None of the three pots about to be discussed can be connected with plays by Sophocles with any confidence—again in contrast to Euripides and Aeschylus. It is not impossible that we are missing some instances through lack of evidence about the plays; but there does seem to be reason to think that Sophocles was either less appreciated after the fifth century and outside Athens than the other two or regarded as less appropriate for interaction with vase-painting.[44]

28

Directly related to a work titled *Kreousa*, probably but not definitely a tragedy, possibly the *Kreousa* of Sophocles

Apulian loutrophoros (or narrow amphora), ca. 330s
Attributed to the Darius Painter
H: 78.5 cm
Formerly Basel market[45]

THIS PAINTING—and a simpler version on a badly broken loutrophoros from Altamura, published a decade earlier, in 1978[46]—is closely related to a version of a Kreousa story that was previously unknown. They are both by the Darius Painter and probably date from within ten years of each other. Even without these similarities, the fact that both have an altar inscribed ΚΡΕΟΥΣΑ (Kreousa) with two snakes and a panther (or two) is enough to make them a distinctive pair. That "Kreousa" is the title of a work of narrative is made pretty certain by two other vases by this painter with comparable inscriptions: ΠΕΡΣΑΙ (*Persians*, see no. 92) and ΠΑΤΡΟΚΛΟΥ ΤΑΦΟΣ (*Funeral of Patroklos*).[47] Neither of these other two inscriptions refers to a character within the work (the latter is more likely to be reflecting some genre other than tragedy).

The five figures on the Altamura loutrophoros are essentially the same as those in the lower register here, as emerges from a quick comparison between them. In that work, however, the central woman with elaborately garlanded hair stands in front of a rectangular altar, instead of on top of a circular one. Two panthers and two snakes appear from behind it; the lion and the griffin below and the ring of sacred garlands with votive tablets are found only on this more elaborate piece. In the Altamura painting, the woman holds the olive branch in her left hand and a sacred chain

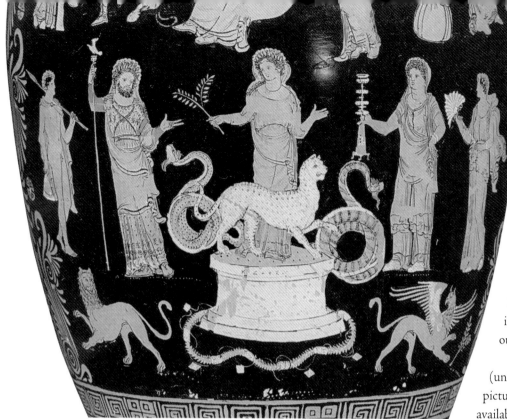

28

in the other; as here, she is turning toward the ornately costumed king (his robes and hair are even more embellished here). Behind him a young attendant carries a hat; balancing them on the other side are a woman and an attendant. In this more detailed painting, the nearer woman holds out an incense burner.

The upper row of figures (unfortunately cut off in this picture, which is the only one available) has no equivalent on the Altamura vase. The dominant divinity in the center is Apollo, with lyre, swan, and olive branch, which clearly mirrors the branch held by the woman below. The Eros above him indicates a love story. The obvious interpretation is, then, that we have here the story of Kreousa, the princess of Athens who was impregnated by Apollo with a son—the same story as that told in Euripides' surviving play *Ion* (see no. 46). All the sacred symbols around the altar strongly suggest that the scene is set at Delphi, as in Euripides. The central woman at the altar is thus most likely Kreousa herself (not the Pythian priestess, as Trendall maintained[48]). Although the king may well be Kreousa's husband, Xouthos, this vase cannot possibly be directly related to Euripides' *Ion*—not just because of the title *Kreousa*, but also because of the snakes, panthers, and olive branch, which are clearly part of the story in some way, yet not explained at all by the Euripidean version. Furthermore, the Ion of Euripides can hardly be the marginal youth with the hat to the left. In other words, there are decisive contraindications against Euripides' *Ion*, and there are pro-indications in favor of another, lost work.

It is the usual, though not invariable, convention in pictures of this period and composition for the figures in the upper row to be gods, or at least nonhuman. So it is strange that none of the four here, besides Apollo and Eros, have any clear markers of identity. The females to the right have a travel pack and a parasol, which might suggest that they are human visitors—rather like the chorus of Kreousa's attendants in Euripides. The sitting youth to the left has a bundle by him on the ground, and it has

been suggested that he is Ion with a pack of tokens left with him at birth, which will lead to his recognition.[49] While we cannot rule out these interpretations of the upper figures as human participants in the story, it must be recognized that in terms of iconographic composition, they would be unconventional.

The only known tragedy entitled *Kreousa* is that by Sophocles. We have eight fragments (ten, if two attributed to an *Ion* are from the same play), but they are so nondescript that we can say virtually nothing about the particulars of the play, except that the chorus was female (fr. 353). It has been generally supposed that it told a version of the same story as Euripides' *Ion*, about how Kreousa rediscovered her long-lost son by Apollo. But this is far from certain. If these two vases *do* reflect Sophocles' tragedy (a big "if"), then they suggest that there were more cultic details in that work, including some Apolline explanation of the snake and the panther(s).

29

May be connected to a *Tereus* tragedy, possibly that by Sophocles

Apulian loutrophoros, ca. 330s
Attributed to the Darius Painter (probably)
H: 92.5 cm
Naples, Museo Archeologico
Nazionale 82268 (H 3233)[50]

TEREUS WAS A KING OF THRACE, and Prokne his Athenian wife. He raped her sister, Philomela, cut out her tongue, and incarcerated her; she communicates with her sister through a tapestry message, and together they kill Itys, the son of Tereus and Prokne, and feed his meat to his father. When Tereus pursues them for revenge, they are all metamorphosed, and the gruesome story ends rather poignantly with him being turned into the hoopoe and the sisters becoming the swallow and the nightingale. Sophocles dramatized the story in his *Tereus*; although there are many more fragments than usual, and although the play was exploited for comic purposes in Aristophanes' *Birds*, we know very little of its particulars.

In this lively painting, full of movement, the lower scene—only partially visible in this plate—shows the two sisters (one or both reported to have name labels) escaping in separate chariots with charioteers.[51] Above, Tereus (labeled), in ornate Thracian costume, sets off on horseback, followed by two men (perhaps assistants, but they are not marked as Thracian), one with an ax. In front of Tereus stands a rather dignified female gesturing toward him. Without the name label, we could surely never have guessed that she is Deceit, or Trickery: ΑΠΑΤΑ (Apata). While the whole story is orchestrated through a series of deceits, the painting suggests a particular trick connected with the final pursuit—an event that in any tragedy would have to have been told through a messenger speech. But Deceit herself, along with Tereus' costume, supplies the only suggestion that this scene might be related to a tragedy at all. It is far from sure,

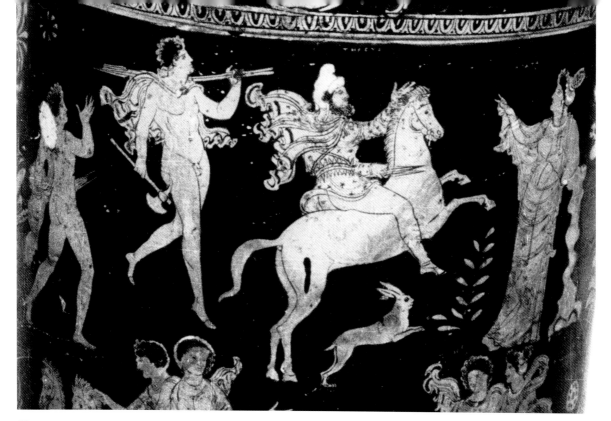

29

then, that this vase narrative does interact with tragedy; the spelling of "Apata" (not the Attic ΑΠΑΤΗ, "Apate") is a slight indication against.

In a fragment of Sophocles' *Tereus* (fr. 589), someone says that Tereus was crazy, but that the two women were even more so, since their cure was worse than the disease. This might have been spoken by a "god from the machine," commenting on their deceit. Might the speaker have been Apata herself? It is possible—but no more than that.

30

Quite likely reflecting a Thyestes tragedy, possibly the *Thyestes (at Sikyon)* of Sophocles

Apulian calyx-krater, ca. 330s
Attributed to the Darius Painter
H: 63.5 cm
Boston, Museum of Fine Arts
1987.53[52]

IN SOME OF THE REPRESENTATIONS of the sensational myths from this highly ornate period of Western Greek vase-painting, the picture is full of dynamic melodrama—swirling cloaks, brandished swords, galloping horses, and so forth. But no less often the picture is quite poised and restrained, with a few small details suggesting the passion of the story. This vase is a particularly fine example, suggesting a gruesome and perverted story through small, almost poignant touches, such as the baby's outstretched arm, the fallen staff, the nonchalant Erinys biding her time.

Fortunately, name labels identify the story. The central king is Adrastos, with the two main agents on either side of him: Thyestes (wearing a traveler's hat) to his left, and Pelopeia to his right. The standard version of this relatively little-known myth goes thus: after Thyestes had his murdered sons served to him at a feast by his brother, Atreus, he received an oracle that he would be avenged only if he had a child by his own daughter, Pelopeia. She had been sent away to Sikyon (in the northeast

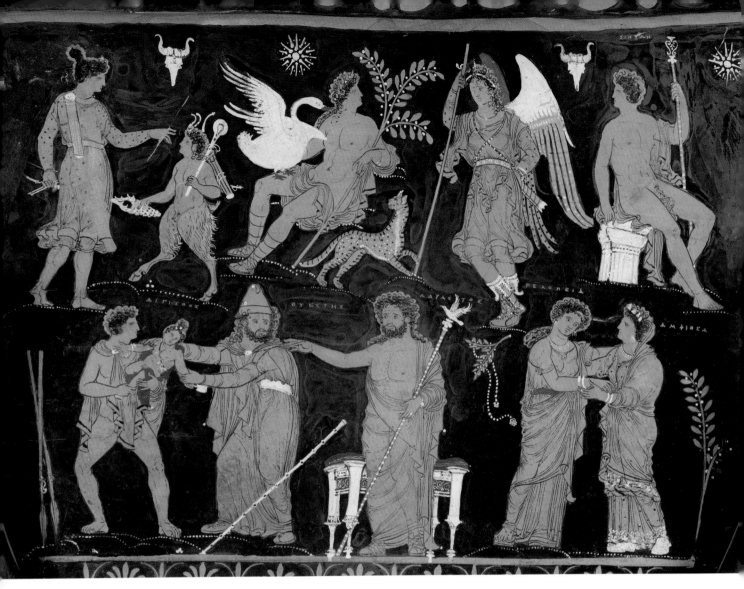

30

Peloponnese, not far from Corinth), where in some versions Adrastos was king at the time. Thyestes goes there and, hiding his identity, rapes her, leaving his sword behind. The resulting baby son, Aigisthos, is exposed in the wild and reared by goats and/or shepherds. He is eventually adopted by Pelopeia, who in the meantime has married Atreus. Once Aigisthos is grown-up, he and Thyestes recognize each other as father and son, and together they kill Atreus. This later episode is shown in number 95, which is also, as it happens, by the Darius Painter and also in Boston.

The juncture captured in this painting is when the bonny baby (given his own label of ΑΙΓΙΣΘΟΣ) is about to be taken away by the young servant to the left (unnamed). It is usually said that Thyestes is handing the baby over, but it looks rather as though he is trying to hold the baby back.[53] That interpretation would make more sense of Adrastos' insistent gesture: Thyestes (who has presumably not revealed his paternity) must, he insists, let the baby go. There is a yellow object in the baby's hand.

While I doubt that this is meant to be the sword (as was declared by Vermeule[54]), it is likely to be some token that is important within the story. Finally, to the right of the lower register, the unmarried mother is in distress, comforted by Adrastos' regal wife, Amphithea (also labeled).

In the center of the upper row sits Apollo, source of the oracle that gave Thyestes the terrible choice, in effect, of either raping his own daughter or of remaining unavenged. To the left is his sister, Artemis, and between them a little Pan, probably suggesting the wilds where the baby will be exposed.[55] To Apollo's right stands a typical Erinys, looking calmly down on the macabre human scene below. And finally, to the right is a youth sitting on a pair of columns, who is identified as a personification of the city of Sikyon (ΣΙΚΥΩΝ).[56]

There is little here that can be claimed to signal a clear connection with tragedy—perhaps nothing more than the Erinys and the Attic spelling of "Thyestes." Those who are firmly set against supposing such links could well claim that we have a pictorial narrative with no need of invoking a tragedy. Fair enough. The main reason in favor of supposing a connection is external rather than internal to the picture. Thyestes is widely regarded as an archetypal figure of tragedy, as is Aigisthos.[57] This story of revenge, oracular dilemmas, incest, recognition, and fratricidal strife is the very stuff of tragedy. It might be claimed by those who are not negatively predisposed that it is hard to see a representation of this myth without thinking of tragedy.

Sophocles composed two or possibly even three plays entitled *Thyestes*. There are few fragments, and we do not know which fragment belongs to which play.[58] The most relevant fact is that one of his *Thyestes* tragedies was given the subtitle *at Sikyon*, to distinguish it from the other(s). We cannot be sure just when such subtitles were allocated (they can be traced with certainty from about 300 B.C.), but the location of the play was important enough to supply the work's subtitle. The part of Thyestes' story that was set at Sikyon was, as told above, the rape of Pelopeia and the birth of Aigisthos. The Darius Painter considered the setting of his scene at Sikyon to be significant enough to give the city a presence—and a label—in the painting. So the connection between this vase and Sophocles' play should be regarded as at least a possibility. If it is right, then the play surely would have informed the viewer more fully about, for example, the attitude of Adrastos, the object in the baby's hand, and quite possibly other details that do not resonate with the uninformed viewer (such as the necklace on a branch to the left of Pelopeia?).

Chapter 3

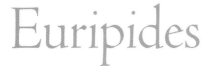

Euripides

EURIPIDES, in suspiciously symmetrical contrast to the genial Sopho-
cles, is traditionally portrayed as a difficult and nonconformist character.
There are many stories of his associations with the avant-garde, his mis-
anthropy, unpopularity, exile, and so forth.[1] He supplied Aristophanes—
and no doubt other comedians as well—with apparently inexhaustible
material about his plays and his private life. It seems to be a fact that he
won first prize only five times at the Athenian
Great Dionysia, and was often placed third out
of three. At the same time, we should set
against this caricature the probability that
the Athenians never refused him the
opportunity to
perform at the big
festivals; they were
happy to have whole
comedies made
around him and
his works (whereas
Sophocles hardly fig-
ures in comedy). By
the time that there was
an official annual show-
piece for "old" tragedies
in Athens (first in 386),
Euripides was evidently
a canonical master of the
genre, as is confirmed
by citations in fourth-
century orators and
comedians and by Aristo-
tle in his *Poetics*.

Euripides' fame spread
beyond Athens within his
own lifetime. His *Androm-
ache* seems to have been first
produced for a non-Athenian

audience; he was much admired in Thessaly (particularly Magnesia); and toward the end of his life he was invited to Macedonia by the king Archelaos and created a play for him (*Archelaos*) about his mythical forefather. There is also the famous story, which goes back at least to third-century Alexandria, that Athenian prisoners at Syracuse in 413 earned their freedom by teaching their captors passages of Euripides.[2] The story might even be true. And if the discussion of vase-paintings in this volume is not completely misguided, he had an early impact upon this art form and was by far the most frequently evoked of the tragedians throughout the fourth century.

Euripides was not (as is often wrongly implied) from the generation after Sophocles: he was a contemporary, some ten to fifteen years younger. He first put on plays in 455 and died at a good old age in 406, a few months before Sophocles, who was said to have paraded his chorus in mourning as a tribute to the tragedian who had been his great rival for nearly fifty years. During this time Euripides staged more than ninety plays; texts of some seventy-five of them survived to reach the library at Alexandria.[3] Seventeen tragedies and one satyr play (*Kyklops*) still survive, along with one tragedy, *Rhesos*, which, though transmitted under his name, is almost certainly the work of another (see pp. 160–61). We are able to date these tragedies fairly closely, thanks to a combination of external evidence and stylometric comparisons: only one comes from before 431, and eight date from 415 or later. I shall for convenience follow the chronological order in the consideration of surviving plays below.

Any summary generalizations have to be rough, in light of all the cautions and qualifications that one has to make about relating vase-paintings to plays. According to what follows, however, about half of the surviving plays have related pots. Some plays are quite widely reflected in art, especially *Medeia*, *Hippolytos*, and *Iphigeneia (among the Taurians)*; several others boast just a single surviving vase. So there is clearly a considerable element of chance involved. It seems that of the lost plays, between ten and fifteen can be plausibly related to vase-paintings. Thus, compared with Aeschylus and Sophocles, Euripides made a far greater impact on mythological pictures. Surely this must go hand in hand with his being more frequently performed, and with his making a greater impression on audiences. All the evidence appears to confirm Euripides as *the* outstanding tragedian in the eyes of fourth-century Greeks.

31

More than likely related to the death scene in *Alkestis*

Apulian loutrophoros, ca. 340s
Near the Laodamia Painter
H: 129 cm
Basel, Antikenmuseum S21[4]

EURIPIDES PUT ON *Alkestis* in 438, the same year as *Telephos* (see nos. 75–77), possibly his best-known play. It was the fourth play in a set, in the slot usually reserved for the satyr play. *Alkestis* is, however, in no way a satyr play, although it is lighter than a standard tragedy in some respects, especially the ending. There is a scene with a drunken Herakles, and, even more importantly, Alkestis is brought back from the dead, rescued by his derring-do; but in many ways *Alkestis* is a moving tragedy. In the story Apollo has granted Admetos, a king in Thessaly, a special favor: that someone else can die in his stead. His wife, Alkestis, offers herself, and the play is set on the fatal day. She dies onstage and is taken away for burial amidst much lamentation; Admetos returns bereft and full of remorse, until Herakles finally turns up with his "resurrected" wife.

If the grander painted vases were made for funerals in order to afford some comfort to the bereaved, one might expect *Alkestis* to be a favorite narrative: she is the model of a loving wife and mother, taken by death yet still cherished. Her death and return are, indeed, very popular in later art, especially Roman sarcophagi;[5] yet before this fine painting, composed on a grand scale, was published in 1971, there was no representation of the story in classical Greek art. Here the dying Alkestis, conspicuously labeled ΑΛΚΗΣΤΙΣ, sits centrally on her deathbed inside a portico. As Trendall describes the scene, "the emotions reflected in the features of the principal characters emphasise the sorrow and fear inspired by the nearness of death."[6] Alkestis is embracing her young son and daughter; the sorrowing man to her left must be Admetos. Behind him are two serving women, and correspondingly on the right-hand side are an old woman grieving and an old man of the typical paidagogos type. It is common to find a female and a male child carer together in scenes involving children, so they do not necessarily need to be explained by having speaking roles in the play (which they do not)—although there is a "maid" in Euripides who prepares for the appearance of Alkestis (136–212).[7] The whole painted scene is redolent of tragedy, also suggested by the portico and the paidagogos (see pt. 1, secs. M4, 6).

But is there any reason to associate it with Euripides in particular? There is at least one detail that tallies well: it is fairly clear, especially from lines 302–434, that Euripides brought on, as here, two children, one girl and one boy (he sings after his mother dies at 393). The chief reason, however, for associating this vase with Euripides' play is simply that, if all the allusions to it in Aristophanes are anything to go by,[8] *Alkestis* was a well-known play. This was highly likely to have been the best-known narrative of the story.

32

Possibly related to the ending of *Alkestis*, but not closely

Apulian large oenochoe, ca. 340s
Close to the Chamay Painter
H: 41.6 cm
Florence, La Pagliaiuola collection
116[9]

WHILE THIS COMPOSITION apparently displays the mainstream monumental form of a lower frieze of agents in the myth with a frieze of divinities above, it has to be said that it seems stilted and amateurish compared with the major products of this school. The figures stand too separately, and there is nothing to arouse the curiosity of the viewer about what is going on. It is in fact far from clear what story is being told. In the lower frieze are six adult figures and two children: from left to right, we see Apollo conversing with a man who holds an Apolline laurel branch; a relaxed Herakles talking with a regal woman who has a child on either side of her; a paidagogos (with sleeves and boots) gesturing to the children; and finally a seated woman (out of view in this photograph). The least unlikely interpretation that has been offered is that Apollo is saying farewell to his favorite, Admetos, and that Herakles is conversing with Alkestis, whom he has recently brought back from death. This is roughly, but only roughly, the situation at the end of Euripides' *Alkestis*. Furthermore, the paidagogos is a pointer toward the tragic connection, even though he does not have a speaking part in the play. On the other hand, there is little to evoke the particular spirit of Euripides' piece. There is nothing of the emotional bittersweetness of the scene in which Herakles reveals that the strange, veiled woman he has given to Admetos is in fact his lost wife. Instead, in this picture, Admetos has turned his back on both of them to address Apollo; yet Apollo, although he appears at the beginning of Euripides' play, is not even mentioned during the final scene.

Unfortunately the rather nondescript upper frieze does not seem to clarify matters. The figure with the torch to the right of the central altar may well be Persephone, who would fit the story of death and return (see *Alk* 852). Otherwise there is a Pan and a female divinity (Aphrodite?) to the left, and to the right a youth in boots and a satyr (out of view). It might be claimed that they somehow represent Tragedy and Satyr Play, but that seems to go well beyond anything that is indicated. The most interesting feature is, perhaps, the altar surrounded by a sacred band with a *boukranion*, which strongly suggests a ritual dimension to the story. This does not point to *Alkestis* in particular, but it is not in conflict with the play either, since at the very end Admetos declares the foundation of a new festival with dances and sacrifices in the region of Thessaly over which he rules (lines 1154–56).

32

33–36 *Medeia*

EURIPIDES' *Medeia* is a deeply disturbing tragedy. For much of the play Medeia herself is presented as a powerless and maltreated woman: she is a foreign exile at Corinth, and her spouse, the great Argonaut Iason, is leaving her for a rich royal marriage. She turns out to have a vengeful will so strong that she kills not only the king and princess but even her own sons in order to hurt Iason to the maximum. Finally, instead of sinking into despair or madness, she escapes triumphantly in a chariot lent her by her grandfather, the Sun. Far from being an ordinary woman and victim, she emerges as a semidivine being, who spurns human frailty and ruthlessly destroys the dethroned ex-hero.

Medeia epitomizes the story of the reception of Euripides. It was one of the plays that he put on in 431, when he was placed third (after Euphorion and Sophocles). Yet it rapidly became one of the most famous and influential of all Greek tragedies, and remained so in both ancient and modern times.[10] It is cited by Aristophanes and other comedians—there were even comedies called *Medeia*—and it evidently inspired or provoked several other tragedies.[11] In his discussion of the range of Medeia stories, the historian Diodoros of Sicily (first century B.C.) says (4.56.1), "there are such varied and different stories about Medeia generally because of the tragedians' search for amazing effects." This variety seems to be reflected in the vase-paintings, where we find at least two (nos. 94, 102) and probably three (no. 36) different stories, all reflecting Euripides' version in various ways, yet also distinctly departing from it.

Euripides evidently made major innovations in the preexisting story, changes that then shaped the whole future picture of Medeia. Before his play, the standard version had the Corinthians, or their king, Kreon's, relations in particular, kill Medeia's children in vengeance for her murder of their rulers. Indeed it is more than possible that Euripides was the first ever to have Medeia kill her own sons, the deed that became her defining action.[12] The play refers to the danger the children face from the Corinthians, a "false lead" characteristic of Euripidean innovation.[13] Euripides also very probably invented the astonishing escape at the end, when the audience is led to expect that she will be revealed in the doorway of the house with her dead children (1313–16), but she suddenly appears above in triumph. Her snake-drawn chariot became a central image of Medeia in both art and literature (see further below).

Euripides' play generally seems to have had a crucial impact on the presentation of Medeia in the visual arts. In Attic vase-painting and earlier art, she is seen only in other adventures, before and after her time in Corinth.[14] Then, from about 400 on, she begins to appear as the child

killer, quite probably within thirty years of Euripides' first production, and almost certainly in response to it (see nos. 34–35). It is highly unlikely that this picture of Medeia the filicide, which is recurrent through the rest of antiquity, began at this particular juncture independently of the impact of Euripides' tragedy.

33

Quite likely related to the messenger speech in Euripides' *Medeia*

Apulian bell-krater, ca. 350s
Not attributed by Trendall, but near the Ilioupersis Painter
H: ca. 40 cm
Naples, Museo Archeologico Nazionale, Santangelo 526[15]

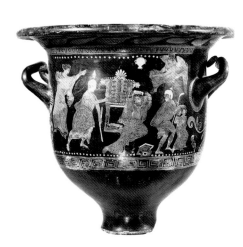

IN FRONT OF A THRONE a young woman falls to the ground, her hands reaching up to her ornate headdress; it seems that there are small flames licking from it.[16] An open casket lies by her. To the left an elderly king approaches, and a woman turns away gesturing in horror; on the other side an old paidagogos hurries two children away protectively.[17] An Erinys sits above, as often, with chilling calm.

This is clearly the same narrative as that in the vivid and particularly gruesome messenger speech at *Medeia* 1136–1230, related by a servant of Iason. He tells of how the princess accepted Medeia's gifts from her children, a headress and robe.[18] She can hardly wait to try them on; but they soon have their terrible effect, burning her head and tearing off her flesh. Her father, Kreon, arrives and embraces her corpse, only to find himself fatally enmeshed as well. At the same time, there are several ways in which this painting does not exactly match the details of the Euripidean messenger. In Euripides there is no casket mentioned (though this may well have been introduced in later performances); the children depart from the princess with Iason (1158), although they did return onstage with their paidagogos at 1002–18; furthermore, the princess lies dead before Kreon finds her. But these mismatches are, I suggest, far outweighed by the proindications, the features of the picture that do evoke the Euripidean version—in particular, the importance of the children as the bearers of the gift, and the violence with which the magic corrosives afflict the princess. Furthermore, Kreon's movement and gesture in the painting are close to his lament as told at *Medeia* 1206–10. And the woman to the left might well remind a viewer with good recall of the old servant who at 1171–77 raises a ritual cry, which then turns into a cry of distress as she realizes what is happening. As for the Erinys, she is very much at home in this scene.[19] Not only is this the vengeance of Medeia on the Corinthian royal house, which has offended her honor, but the children will in their turn become victims of her revenge on Iason.

There is another vase, a Lucanian bell-krater with four figures, that is often claimed to show this same scene of the princess trying on Medeia's poisoned robe.[20] There is indeed a princess with an ornate headdress, who has a maid with a casket and a robe standing nearby; on one side of the princess stands a king (not old); on the other a worried-looking male

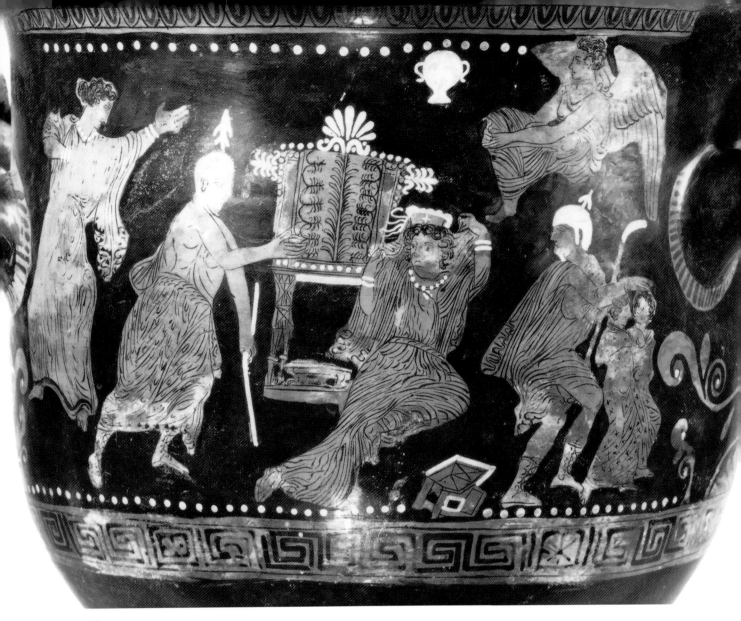

33

attendant. This painting is, however, considerably more at odds with the
Euripidean version than is the Naples krater, and it does not have the
positive indicators that are found here. In this other scene, there is no
sign of the poison or of the pyrotechnics, so it is too soon for Kreon to be
present. But if the king is supposed to be Iason, he either should have left
already with the children or should have them with him. The slave to the
right might possibly represent the servant of Iason who delivers the mes-
senger speech. I do not have any alternative narrative to offer, but it does
not seem to me that there are enough positive signals to the viewer to
bring Euripides' *Medeia* to mind.[21]

34

More than likely related to the final scene of Euripides' *Medeia*

Lucanian hydria, ca. 400
Attributed to the Policoro Painter
H: 44.3 cm
Policoro, Museo Nazionale della
Siritide 35296[22]

BEFORE TWO EARLY LUCANIAN VASES came on the scene, there was no visual representation from before 350 of Medeia escaping in the chariot of the Sun. This large hydria was excavated at Policoro in 1963; the even larger and more spectacular krater that follows (no. 35, now in Cleveland) was first published in 1983. The former, by the Policoro Painter, dates to about 400—in other words, it was conceivably painted while Euripides was still alive; the latter, by the same painter or an associate, may be a decade later. One normally expects mythological paintings from this early date to be relatively simple, compared with the more ornamented and expansive compositions in the later period. It is interesting that the Cleveland krater is already a considerably elaborated version of the plainer iconography on the Policoro hydria. At the same time, it is clear that they are essentially the same iconography. Whatever their relationship to Euripides, it is very much the same.

At least two of the twelve large figured pots that were excavated from a single tomb opened at Policoro on July 24, 1963, have plausible theatrical connections (see also no. 37 and pp. 73–74). It seems more than possible that the concentration of vases reflected a love of tragedy, especially perhaps of Euripides, on the part of the dead person whom the works honor. Three of them are hydrias by the same artist, given the name of the Policoro Painter from this find; these are very similar, and all take advantage of the virtually horizontal shoulders to divide the scene into an airborne register and an earthbound register. This division is most marked on this pot, which is dominated by Medeia (clearly labeled ΜΕΔΕΙΑ).[23] Her cloak and Oriental cap swirl about as she flies off in her snake-drawn chariot (her cap and sleeves indicate that there was originally more ornamental decoration on her costume). To either side of her are divinities. Beneath her, on the vertical side of the pot, Iason rushes up brandishing his sword, but it is clear that she is utterly beyond his reach. Directly below her lie the bodies of her two sons, lamented by a man who must be their paidagogos.[24]

Any modern viewer cannot help thinking at once of the final scene of Euripides' tragedy. A skeptic might well accuse this response of being hastily prejudiced by our obsession with our surviving literary sources. But the association is not, in fact, so naive: as explained above, it is highly likely that Euripides invented both the story of Medeia killing her children herself, and her escape from Corinth in a supernatural flying chariot. Thus the scene is not merely "the myth": it is Euripides' particular myth. In the play Iason comes on searching for Medeia at lines 1293–1305, threatening that she will have to hide beneath the earth or fly on wings to escape punishment. When he learns that she has killed their sons as well, he calls for the doors to be opened so that he can see the boys and

take revenge on her (1314–16). As all eyes are concentrated on the doors, in expectation of a revelation on the *ekkyklema* (the trolley that moved tableaux onto the stage), there is a voice from above (lines 1317–22): "Why shake and try to force these doors apart in your weak searching / for the bodies and for me, the one who did this thing? Abandon now / your efforts. If you want something from me, then you are free to speak, / though you shall never get me in your grip—thanks to this chariot, / gift of my grandfather, the Sun—defense against my enemies." This is not only a great coup de théâtre, it is a highly shocking turn of events. The great Argonaut is reduced to a helpless wreck, and the woman—or the female power, since she now turns out to be more than human—glories over him in triumph. Medeia not only destroys the primal bond that men unthinkingly take for granted, that between a mother and her children, she also escapes without punishment, scot-free. She is, in fact, the only transgressive or destructive female that we know of in Greek tragedy who is not brought low. It is this very moment of dramatic and cultural shock that the painter has captured.

But, once it has been established that the painting reflects in essence the final scene of Euripides, one must face that it is also at variance with the play as we have it. There are three significant mismatches (any further discrepancies seem trivial to me).[25] The first and most important is that the children's bodies are not with Medeia, but below on the ground. In the text Iason repeatedly pleads to be able to touch and mourn the bodies of his sons, and Medeia repeatedly refuses him even that cold comfort (1377–78, 1399–1404, 1410–12): she says that she is going to take them and bury them in a sanctuary of Hera (1378–81). It is beyond reasonable doubt that in Euripides' own production she had the bodies with her in the chariot—however that was staged in practice. It should not be denied that this is a major divergence between our text and the painting.

Second, the children are lamented by the paidagogos, who is not even present in the final scene of Euripides. This is not in itself such a serious discrepancy: once the bodies had been separated from Medeia, he is the obvious mourner. Throughout Euripides' play the loyal carer goes almost everywhere with the children and is often worrying for them (though the text does indicate explicitly that he is old—33, 63, 1013).

Third, Medeia's chariot is drawn by snakes or snaky dragons—as it is, indeed, in all fourth-century and many later representations, and also in many later literary sources. There is no indication of this in our text; there is nothing to contradict it, but there is also nothing to corroborate it. One might expect the chariot of the Sun to be drawn by horses (which would be pretty difficult to stage), but snakes are especially appropriate for the magical Medeia.[26]

How then might we best account for the fact that there are both significant similarities and dissimilarities between the painting and the final scene of Euripides' play? I can offer three possible explanations.

The first is that the painters have their own stories and their own story patterns, and there is no reason why they should be following any literary version. According to this approach, while the basic situation of the triumph of Medeia and the humiliation of Iason may have been derived from Euripides' recently performed play, the painter prefers for his own painterly reasons to show the dead children lamented below. For one thing it would be difficult to show them inside the chariot convincingly, and for another it makes a better and more pathetic composition if these elements are separated.[27] So too with the snakes, which are pictorially striking (perhaps derived from the traditional iconography of Tleptolemos); the painters do not need Euripides or the theater to justify them. This line of explanation is indeed tenable. But, within the whole cultural context, it raises a question: when Euripides' radical reformation of the myth was recent, and when this scene had first been enacted barely thirty years earlier, how likely is it that the contemporary viewers of the vase would have been able to look at it and totally shut out from their minds what they had heard about and had probably seen in the theater?

The second line of explanation might be that between 431 and the time of the painting of this pot, some other playwright put on a version of *Medeia*, and it is this work that is reflected here. There were indeed other dramatizations of the Medeia story, which, while inevitably influenced by Euripides, also departed from him. Some of these plays are probably reflected in vases that show more important divergences from Euripides (see nos. 36, 94, 102). Is it really plausible that a minor playwright could have made such an impact on Western Greek audiences that he displaced the epoch-making Euripides? Some might suggest Neophron, who clearly was quite close to the Euripidean version. Why should anyone think of the obscure Neophron over Euripides? This explanation, while not impossible, is hardly likely.

Finally, there is the possibility that actors in reperformances of Euripides' play had already introduced their own stagings, regardless of his original staging in Athens in 431. If the initial viewers of this pot had seen Euripides' play, it most probably had been in a local reperformance; this would have been adapted, no doubt, to suit available resources and strengths. I am inclined to take this theory seriously, because there are other variations that might be plausibly attributed to reperformance traditions rather than to any other proffered explanation (e.g., the iconography of Erinyes, see nos. 6–10). This would also be, I suggest, a reasonable explanation of the snakes: the actors' company would have introduced

them without actually contradicting the text—while perhaps adapting some stage props that they already had at their disposal. These snakes then proved to be a spectacular success with audiences, and became a standard part of Medeia's portrayal.

It might be objected that my preference for the third explanation—local variant restaging—is based on a belief in the centrality of theater performances in the experiences of Greeks of this time and place, a belief that is reconstructed more from probability than from direct evidence. I am bound to concede that this is true.

But could the staging be significantly changed without making changes to the text? This question arises especially over the placing of the children. Although our text clearly implies that Medeia has the children in the chariot, it does not explicitly say so: the emphasis is on the fact that Iason cannot touch them. Thus a restaging like that on the pot, with the children separate, would not be intolerably contradictory. In any case, it is not impossible that the actors did change the texts to suit other stagings. The text that we have is based upon an authoritative Athenian version that was supposed to be purged of actors' interferences.

What, finally, of the two figures on the same horizontal plane as Medeia? They do not need to be explained by any reference to stagings of the play. It quickly became a pictorial tradition, established early on, that divine figures—with only a supernatural or symbolic relevance to the narrative—are shown above, often completely detached from the tragic events. The goddess on the left with the mirror is surely Aphrodite: she is all too relevant to this story of sexual rivalry and revenge, and at one point the chorus even prays that she be favorable to them (628–44). The winged figure on the other side has usually been interpreted as Eros, who is indeed a standard companion of Aphrodite, though he is normally smaller and hovers close to her. Alternatively, this might possibly be an Erinys; unfortunately, any distinguishing features such as snakes would have been on the lost fragment of the pot. It does become standard for an Erinys to sit above the scene, as we have just seen in number 33; and we are about to see two seated Erinys-type figures in number 35. In Euripides' play Medeia herself is called an Erinys just before the murder of the children (1259–60); Iason prays that an Erinys may destroy her (1389–90); and not surprisingly there is yet more talk of avenging spirits (1333, 1371). But, despite all this, the bare legs seem to militate more in favor of Eros.

35

35

More than likely related to the final scene of Euripides' *Medeia*

Lucanian calyx-krater, ca. 400
Not attributed by Trendall, but close to the Policoro Painter
H: 51.4 cm
Cleveland Museum of Art
1991.1[28]

THIS SPECTACULAR MIXING BOWL is quite possibly by the same artist who painted the hydria just above, but at first sight it creates quite a different impression.[29] On closer scrutiny, this is more a matter of detailed ornamentation, the use of white paint, and the shape of the vessel rather than a matter of composition or subject, which are fundamentally the same. It is almost, indeed, as though this were the same painting, but consistently made more elaborate and more provocatively astonishing.

As before, Medeia is above in a snake-drawn chariot, whip in hand; but her Oriental outfit is more ornate, and the snakes are bigger and brighter—almost luminescent. She is surrounded by an amazing white "sunburst," and overall her power and freedom and semidivinity are made more explicit. Again Iason (fancy boots this time) runs up, but his powerlessness is even clearer—he doesn't even have a sword, only a staff. Here the dead children are not laid on bedding, but flung across an altar.[30] They are lamented by a white-haired female carer (nurse), as well as by the paidagogos figure behind her.[31] The significant addition is the altar, which brings in a suggestion of sacrifice and ritual. It might be argued that this reflects Medeia's declaration in Euripides' play that she is going to set up a cult for the atonement of the boys' death (1381–83).

It seems, then, that the correspondences and discrepancies between this painting and Euripides' play are very much the same as those discussed above, on number 34. The range of possible explanations also seems to be the same. It is quite clear that the explanation, whatever it might be, is the same for both paintings. That remains true regardless of the two strange, repulsive figures who lurk and leer in the upper corners. These two females have elaborate sleeves and leggings and very ugly faces; they are quite different from the two divinities on the hydria. While the positioning above is paralleled by quite a few instances of Erinyes, they are almost invariably represented as beautiful young women and almost always have snakes in their hair or around their arms, or both.[32] I think that these two figures should be regarded, not as Erinyes, but as horrible rapacious demons, who still suggest revenge and anguish.[33] In some ways they are reminiscent of Iason's claim about the dead children (1371): "they still exist as polluting vengeances [*miastores*] to fall upon you."

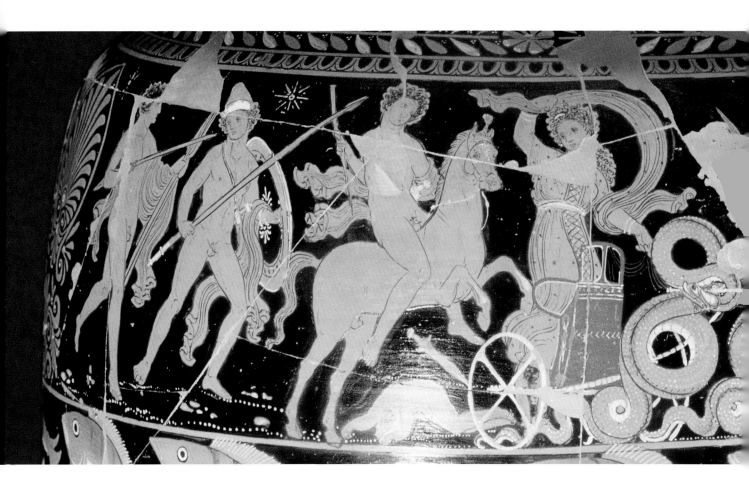

36

May be related to the
escape scene in a *Medeia*
tragedy, possibly that of
Euripides, but more likely
that of another tragedian

Apulian amphora, ca. 330s
Attributed to the Darius Painter
H: ca. 100 cm
Naples, Museo Archeologico
Nazionale 81954 (H 3221)[34]

AT FIRST GLANCE this work seems fairly similar to numbers 34 and 35: Medeia in her snake chariot, the dead sons, Iason in pursuit. But on closer inspection, there are, I think, some marked and instructive differences, which (like those in number 102, though less obvious) point firmly to a different version of the story, while one still influenced by Euripides.[35]

The picture forms the upper register of a monumental amphora. In the center is Medeia, in Greek dress this time, her cloak billowing in the wind as her serpent chariot sets off. To her right, in front of her path, is a female figure with torch and sword—an Erinys figure, or perhaps more specifically, Lyssa (Madness). To her right is a female with a nimbus riding a horse, apparently Selene, the Moon.[36] On the other side, close on Medeia's heels, is an armed man on horseback, followed by two others on foot. Although he is beardless, the mounted man is surely the vengeful Iason. The body of one of the sons has fallen out of the chariot and is under the horse's feet; there are traces of the other body still in the chariot.[37]

36

The whole dramatic dynamic is different from the Policoro and Cleveland pieces. The greatest single congruence between those two pots is that Medeia is above, superior and supernaturally invulnerable. But here her chariot runs on the ground, and it is not, it seems, fast enough to get clear away from the pursuer on horseback. There is no sign that it derives from the Sun; in this version of the story, it may be that Medeia has invoked the Moon to aid her magic (not even mentioned in the Euripides play). Furthermore, in the other two vases Medeia was in barbarian costume, reflecting Euripides' emphasis on her Eastern, non-Greek origins.[38]

So this Medeia is earthbound and is in danger of being caught. This might help to explain another feature that is significantly at variance with Euripides: the dead son who has fallen out of the chariot, lying rather shockingly in danger of being mutilated beneath the horse's hooves. This seems to me to be significantly distant from Euripides, no less so than the previous two vases, on which the corpses were at least intact and laid out for mourning. I offer an explanation for this detail that has not, as far as I know, been made before. There was a story about Medeia's escape with Iason from the Black Sea, when they were on their way to Greece, that involved her chopping up the corpse of her brother (usually called Apsyrtos) and dropping the pieces in the wake of their ship, the *Argo*, in order to hold up their pursuers, who felt bound to collect the bits for burial.[39] It looks as though the narrative on this vase may be some sort of reprise of that story: by dropping the body of one son, and then later perhaps the other, Medeia holds up Iason's pursuit. If there is anything to this speculation, then this version is in marked contrast to Medeia's possessiveness of the bodies in Euripides.

In conclusion, this scene may well reflect a tragic narrative, although there are no strong signals of the link.[40] If so, the tragedy in question deliberately exploited differences from the Euripides version (as does 102, even more spectacularly). If the account I have given is right, then this episode would, of course, have been the matter of a messenger speech and not been played out onstage, as in the final scene of Euripides. The incompatibilities between this narrative and that of Euripides, the contraindications, do serve instructively to bring out the strong Euripidean affinities and pro-indications of the Policoro hydria and the Cleveland krater.

37–38 *Children of Herakles*

HERAKLEIDAI— *Children of Herakles*—was first put on in about 430. It tells of how Herakles' family goes to Marathon, in Attica, after his death and has to beg for protection from persecution by Eurystheus, the villainous king of Argos. The Athenians nobly defend the family and even enable them to turn the tables. This drama of asylum seeking and revenge has generally not been considered among Euripides' better plays, even though it is from the same period as *Medeia* and *Hippolytos*; but it has recently been somewhat rehabilitated. *Herakleidai* is a particularly Athenian play, with explicit glorification of the great city. Had it remained unknown outside Attica, we should not have been surprised—though this supposes an attitude to local praise-poetry that may be more narrow and chauvinistic than was actually the case throughout Archaic and Classical Greece. In any case, there were no vase-paintings that could be plausibly associated with this tragedy until relatively recently,[41] when—within six years of each other (1963 and 1969)—two paintings from very much the same time and place were published. Both are from the area of Herakleia; both are the work of the same group of painters, probably local;[42] and both date to about 400. The pair clearly show the same central scene, yet with intriguing differences of detail and periphery.

These two pots provide early examples of the supplication scenes that will become very popular in Western Greek vase-painting, a scene type also widespread in tragedy (see pt. 1, sec. M8). Euripides' *Herakleidai* opens with a tableau of supplication set before the Temple of Zeus Agoraios at Marathon. Iolaos, a nephew of Herakles, represented in the play as an old man, is there with a number of Herakles' male children. He describes the situation in the prologue and explains how Herakles' mother, Alkmene, is inside the temple with the girl children. Then he suddenly says (48–49): "O children, children, here: take a firm hold upon my robes." He can see the agent of Eurystheus approaching. This man (not named in the play, but widely known as Kopreus) uses the cover and accoutrements of a herald to threaten violence. He is even putting that violence into action, knocking Iolaos to the ground, when the chorus of local elders arrives to the rescue (73–117), followed before long by Demophon, the king of Athens, at line 120.

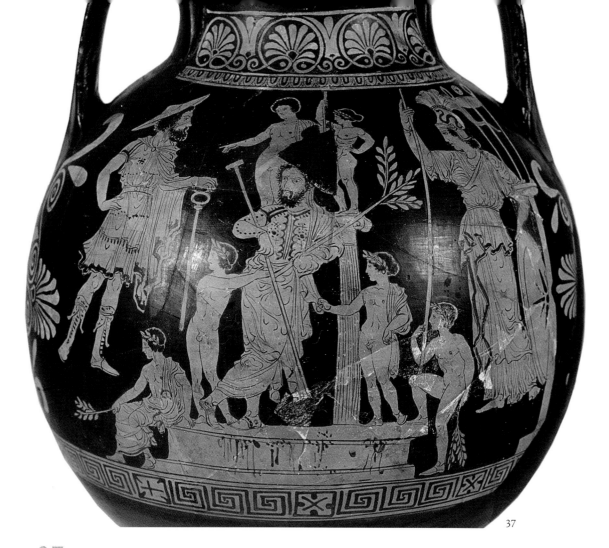

37

37

Probably related to
the opening scenes of
Euripides' *Children of
Herakles*

Lucanian pelike, ca. 400
Close to the Karneia Painter
H: 44.5 cm
Policoro, Museo Nazionale della
Siritide 35302[43]

IOLAOS, NOT AS AGED as suggested by Euripides' text, stands on
the altar with a suppliant branch. He has four garlanded boys with him,
two clutching his clothes. Above his right shoulder is what might be best
interpreted as a fifth boy, even though not garlanded, perched high as
a kind of lookout and pointing to the approaching herald.[44] The figure
on top of the pillar seems to be a statue, either Apollo, who has no obvi-
ous relevance, or perhaps Herakles.[45] On one side of the altar stands the
burly figure of Eurystheus' herald, complete with traveling hat, boots, and
kerykeion. Counterbalancing and potentially outweighing him on the other
side is Athena. Although she does not personally appear in Euripides' play,
she is repeatedly invoked and praised as a protective force (see 350–52,
770–75, 919–27). It is true that the setting of the play is the Temple of
Zeus, but, just as tragedy does not bring Zeus himself onstage, so the
painters of tragedy-related vases hardly ever include him in their pictures.
In sum, the pot captures evocatively the excitement of the story as told in
the play: attention is turned to the threat of the herald, but in the long run
Athena and her city will prevail.

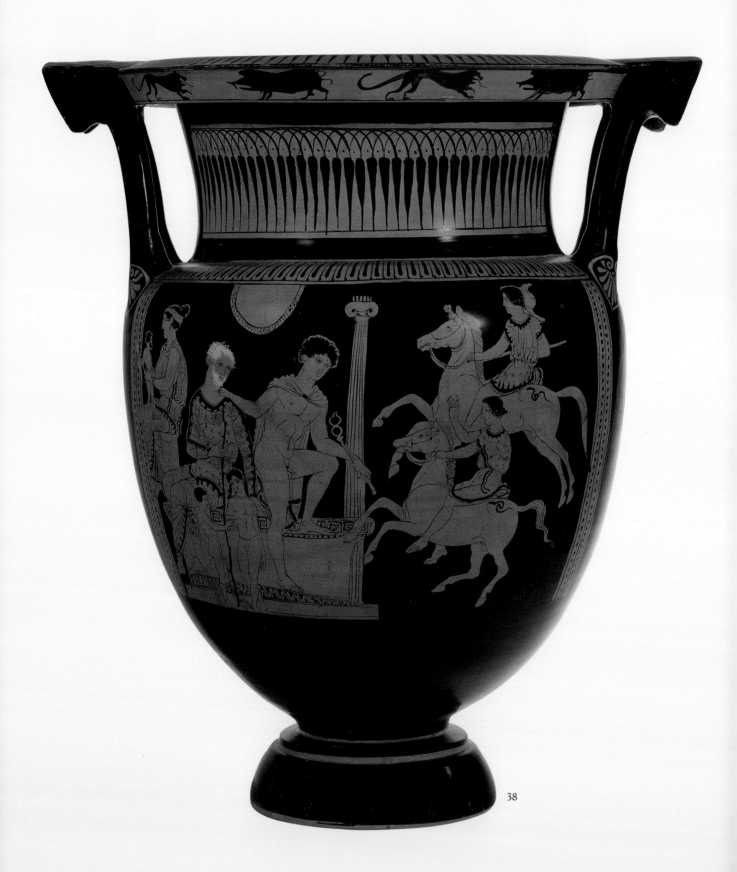

38

38

Probably related to
the opening scenes of
Euripides' *Children of
Herakles*

Lucanian column-krater, ca. 400
Close to the Policoro Painter
H: 52 cm
Berlin, Antikensammlung,
Staatliche Museen zu Berlin
1969.6[46]

HERE WE HAVE basically the same story and situation as in number
37: Iolaos and the boys at the altar are threatened by the herald, but with
indications that Athens will come to the rescue. These are, however,
not so much differently elaborated versions of the same picture (as was
argued for nos. 34 and 35) as different versions of the same dramatic situ-
ation. This time Iolaos, in ornate costume, sits holding a knobbly stick;
he is portrayed as old and decrepit, in closer keeping with Euripides' text.
The herald, on the other hand, is represented as youthful and fresh-faced,
not obviously in keeping with the assertive stance that he maintains in
the play; but here he has actually laid hands on Iolaos. The painting sug-
gests that he might even have started dragging him away by force, were it
not for the figures approaching on horseback. In the play the suppliants
are given protection by the king of Athens, Demophon (son of Theseus),
and his brother Akamas (who does not actually speak). Although there is
nothing explicit in Euripides' text about how they got to Marathon, it is
inherent in the situation that they come quickly in response to the suppli-
ants' call for help. This group of artists likes showing horses at the gallop;
this iconography exemplifies well how, when reflecting tragedy, painters
did not want to reproduce the actual staging, but rather turned the play
into pictorial terms.

To the left sits a woman, turned away, holding a statuette of Zeus.
Euripides' play makes sense of what might otherwise be a baffling fig-
ure. As Iolaos explains, Alkmene, the old mother of Herakles by Zeus,
is inside the temple (41ff.). She does not come onstage until much
later (642ff.), but she then has an important part in the closing scenes.
Although she is not portrayed here as aged, it is surely Alkmene, still off-
stage in the opening scenes of the play.

Thus it seems unreasonable to explain these two vases without any
reference to Euripides' *Children of Herakles*. While viewers might enjoy
them without knowing the Euripides play, they will appreciate them more
fully, more richly, if they do have experience of that particular telling in
his tragedy. All this strongly suggests that the play had been performed
in the Greek West within thirty years of its first performance in Athens.
A play about Herakles and his sons might have been particularly appreci-
ated in the city called Herakleia. On the other hand, Herakleia was a pre-
dominantly Doric city, associated with the Spartan "colony" of Taras, and
the play—in the course of being patriotically Athenian—contains some
strong anti-Peloponnesian material.[47] Some might be inclined to take the
ethnic biases of the play to be evidence against its being appreciated—or
even known—in Herakleia. I would advocate, on the contrary, that the
vases are good evidence that Greeks in the West (and indeed elsewhere)
were not as rigidly aligned in their attitudes toward art, music, and poetry

as they were in confrontational politics. Despite the constant conflict and warfare, cultural boundaries were permeable. Doric Greeks in the West appreciated readily and early that tragedy had far more to offer than narrow Athenian self-promotion. No doubt they had a certain cultural distance from the plays, unlike the Athenians, and responded differently to the political and ethnic alignments. But that need not mean that they refused to put them on, or to watch and appreciate them sufficiently to enjoy their reflection in vase-paintings.

One final speculation: the ages and physiognomies of Iolaos and of the herald are so different in the two paintings that it leads me to wonder whether the painters might have been influenced by two different performances, played by tragic troupes employing different masks for the roles.

39–42 *Hippolytos*

HIPPOLYTOS WAS FIRST PUT on by Euripides in 428, one of the rare years in which he won first prize. There are good reasons why this rich, disturbing dramatization of human attempts to behave right and of their failure remains central to the canon. The tragedy embraces quite a complex sequence of events in its first half, from Phaidra's efforts to suppress her burning love for her athletic and untouchable stepson, Hippolytos, through the meddling mediation of her nurse, to Hippolytos' misogynist outrage against Phaidra. In the second half of the play, her husband, Theseus, returns to find Phaidra's false accusations—that her stepson tried to seduce her—in her suicide note. This impels him to ask his father, Poseidon, to destroy Hippolytos, who departs into exile. Only after he has been mortally injured is the truth revealed, and father and son are reconciled just as Hippolytos dies.

While there are many reflections of this story in later art, especially in Roman wall paintings and sarcophagi, there is surprisingly little from the century after Euripides.[48] There is, however, a series of Western Greek vases, recently augmented, that relates to the messenger's narration of Hippolytos' fatal chariot journey (see nos. 41 and 42 below). It is not certain that we have any reflections of Phaidra's tormented love; but there are two possible candidates that are of special interest, whether or not the connection with *Hippolytos* is finally convincing.[49]

39

Possibly related to the first scene of Phaidra and the nurse in Euripides' *Hippolytos*

Apulian calyx-krater, ca. 350
The Laodamia Painter
H: 76 cm
London, British Museum F272[50]

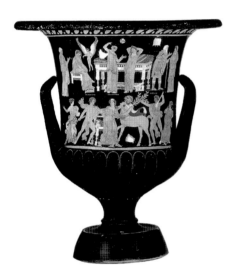

IT SEEMS TO BE A SHEER STROKE of bad luck that this is the only major piece to survive by this particularly fine draftsman and colorist. The narrative is ordered in two registers without any explicit bordering between them. We would be able to identify the lower story even without the three name labels (Peirithoos, Laodameia, Theseus): this is the bad behavior of the Centaur guests at the wedding of Laodameia to Peirithoos. There has, on the other hand, been no decisive interpretation of the upper scene. The lovesick Phaidra is certainly worth considering. It is an initial, though not fatal, objection that one might expect the upper scene to relate to the lower; the presence of Theseus at the wedding of Peirithoos does make a link, but not a close one.

Several features of this upper picture lure the interest of the viewer. There is the way in which the woman to the left sits disconsolate despite the attention of Eros; there is the rich central couch and the eroticism of the female figure standing by it. Last but not least, there is this early instance of the paidagogos figure, whose presence suggests that a young man figured in the story, and who probably signals a connection with a specific tragedy. It is not hard to see why people have thought of the Phaidra of our surviving *Hippolytos*. Despite her sexual desire, embodied by the Eros, she sits looking down and clasping her knees, struggling to resist. Meanwhile the old white-haired nurse remonstrates with her, as in the play. The old paidagogos on the other side can easily be associated with the slave who at the end of the prologue tries to give young Hippolytos some advice about respecting the gods, even Aphrodite, the goddess of desire and sex. There is, however, no one in the play to explain the woman with whom he is speaking—unless she is to be vaguely associated with the women of the chorus, who enter immediately after the scene with the old retainer.

Obviously, the key question for the association of this painting with *Hippolytos* is the identification of the two women who stand by the couch. It has been suggested that the voluptuous mistress on the right might be Phaidra herself, at the stage when she is giving in to the erotic urges that beset her. She does indeed command, just after her first entry, that she should be raised from her couch, and calls for her hair to be released and spread over her shoulders (197–201). In this interpretation, then, the seated Phaidra to the left is controlling herself, while the standing Phaidra has succumbed to her fantasies. The trouble with this, attractive though it might seem, is that in the vase-painting of this period, there is no convention of showing the same figure at two different stages of the story within the same picture.[51] Without some such convention, how is the viewer to arrive at this explication?

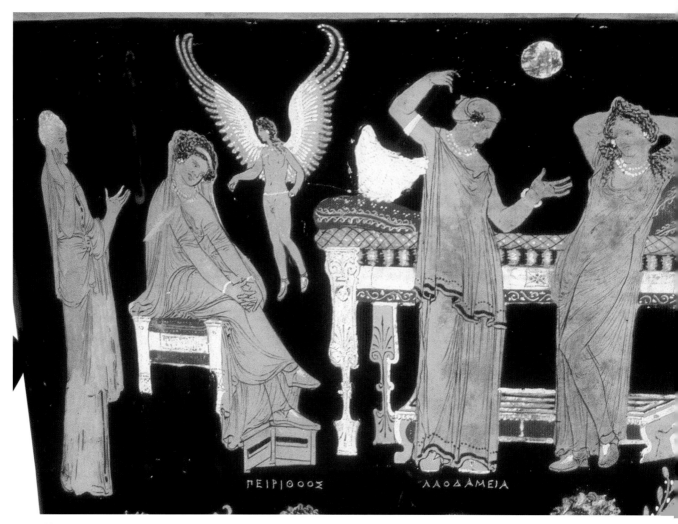

39

ΠΕΙΡΙΘΟΟΣ ΛΑΟΔΑΜΕΙΑ

If this picture is meant to reflect the Euripides play, then the female whose pose and dress are so erotically suggestive must surely be none other than Aphrodite. The attendant is then simply one of her retinue, perhaps Peitho (Persuasion). Aphrodite does, after all, speak the opening prologue of the play, and her statue was evidently onstage throughout. The goddess slightly regrets the agony of Phaidra (47–48): "She'll keep her reputation fine, but still shall die—yes, Phaidra dies." Of course, Aphrodite and Phaidra are never onstage at the same time; nor is the old manservant ever onstage with either of them. But, as has been seen repeatedly, the vases hardly ever attempt to reflect a particular moment of the play: instead, they tell the story in a way that is given an extra charge by the plot and emotion of the tragedy. That is, arguably, the relationship between this fine vase and Euripides' *Hippolytos*.

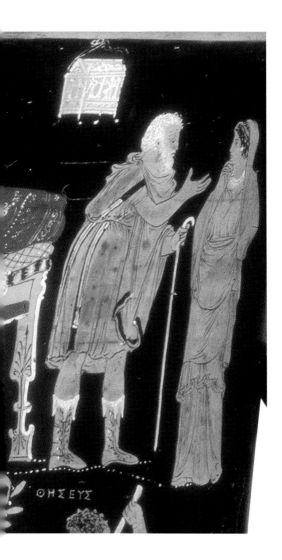

40

May well be related to the first half of Euripides' *Hippolytos*

Apulian calyx-krater, ca. 330s
Attributed to the Darius Painter
H: 50.9 cm
Geneva, Sciclounoff collection,
unnumbered[52]

CLEARLY THE UPPER REGISTER of this vase is divine and the lower human. Seated above are Aphrodite with Eros, Athena, and Hermes. In the scene below, the key enigma is the woman in the middle, who has pulled her clothing envelopingly around herself. To her left is a white-haired woman, probably a nurse figure, and to the right is a young man holding a long object; between them are an incense burner and an ornate stool. This intriguing painting was discussed in Aellen-Cambitoglou-Chamay 1986 (161) under the rubric of "scène enigmatique." But the enigma may be soluble.

There are not enough examples of full-frontal figures of this sort in this period to know at first sight how to interpret this feature.[53] But if she is seen as Phaidra, as was suggested by Schmidt,[54] then the portrayal does seem to make sense: caught between the encouragement of the nurse on one side and the aloofness of Hippolytos on the other, she can turn neither way. Instead she draws her garments tight around her in a kind of denial of her body's sexuality.

This interpretation seems to me to make better sense of the particularities than the other two that have been suggested, namely Paris and Helen at Sparta, and Iphigeneia being fetched from Aulis (see below). The gods above supply arguments both for and against the Hippolytos solution. Aphrodite and Eros are all too appropriate; Athena does not figure directly in *Hippolytos*, but her city of Athens is very relevant and is invoked several times, including in the closing lines at 1459–61 (see also 30, 974, 1094, 1123); as it happens, she holds a similar position in number 42. Hermes, however, has no particular appropriateness to Euripides' tragedy. It is true that the nurse acts as a go-between, a role that might be associated with Hermes, but he is never actually mentioned in the text. His presence is not a fatal objection to this interpretation, but it has to be conceded that he is a slight contraindication.

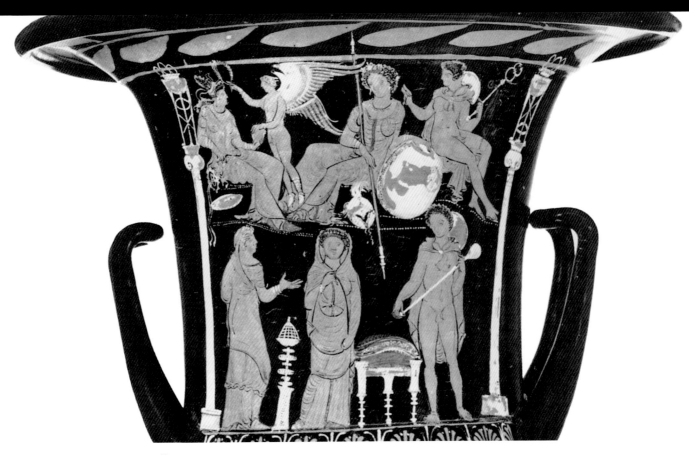

40

What is the youth holding? Aellen, noting that he is dressed just like the Hermes above him, insisted that he must be a herald as well, and that the object must be ("doit être") a trumpet.[55] This led to the suggestion that he is fetching Iphigeneia from Aulis. But I have found no other heralds with trumpets (their sign is a *kerykeion*). When trumpets appear in Western Greek vases, it is nearly always in a battle scene, and the instrument is held by a figure in Oriental dress. (For a clear example, see no. 101).[56] When Trendall introduced this vase, he took the object to be a *lagobolon*, the heavy-headed stick carried by herdsmen and hunters in the wild, used both to control flocks and to throw at game, especially hares. The Darius and Underworld Painters show them quite often, especially wielded by young hunters and by Pan; sometimes a little Pan has a little *lagobolon*.[57] It seems very appropriate to the Euripidean Hippolytos that he should be represented as a young hunter (see lines 18, 109, 1093, and Phaidra's fantasy at 215–31). If this young man is indeed holding a *lagobolon*, then it is quite a strong marker in favor of this interpretation.

Finally, there are the two columns with tripods on either side, rather like side frames, stretching all the way from the ground to the top line and slightly above it. It might be that they somehow indicate the setting of the play (which does not fit *Hippolytos* particularly); but it seems more likely that they indicate a victory in an artistic competition (see pt. 1, sec. N2). If so, then the art form is likely to have been tragedy, and the tragedy Euripides' *Hippolytos*.

41

Plausibly related to the messenger speech in Euripides' *Hippolytos*

Apulian bell-krater, early fourth century
Not attributed by Trendall
H: ca. 40 cm
Bari, Museo Archeologico Provinciale 5597[58]

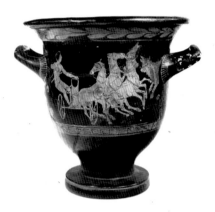

THE GREAT MESSENGER SPEECH in *Hippolytos* (lines 1173–1254) is memorably vivid and distressing—a virtuoso piece for the actor. Hippolytos has been condemned to exile by Theseus, who also used a curse granted by his father, Poseidon, to call for his son's death. The messenger tells Theseus of how Hippolytos' grieving friends took farewell of him as he set off westward along the shore in his racing chariot, accompanied by loyal servants. They see and hear a huge tidal wave, and a monstrous bull emerges from it. The horses rush about in panic, and, despite Hippolytos' charioteering skills, the bull drives them relentlessly toward the rocks until the chariot is smashed and Hippolytos fatally mutilated.

We do not know whether this story was told before Euripides—probably not. In any case, it leaves no trace in Attic art, and before 1965 there was only one known example in Western Greek art (no. 42). John Oakley (1991) has valuably documented the six further examples (and one fragment[59]) that have surfaced since then, including two that were too recent to gain inclusion in the *LIMC* article. Six of the seven total works date from after 350; the seven include one Sicilian vase and one Campanian, as well as five Apulian. Presumably, it is simply chance that there should have been such an increase in examples of this particular scene; it is a warning that iconographies of which we happen to have only one or two examples may not have been rarities in their own time.

But why should this scene have been especially popular? If the choice was made for consolatory associations at times of bereavement, it is not an obvious candidate. It is true that we have here the sad death of a fine, athletic prince, which might seem suitable for the funeral of young men. But the implications of the story, especially for the parents, are more than usually inappropriate. An alternative is that this play was very popular, and that the messenger scene was a much-loved virtuoso piece within it. In that case, it would have been chosen to match the delights of the mourned person when he or she was alive. I find this explanation more plausible.

This vase is by far the earliest and the simplest representation of this scene. In five of the six other examples, Hippolytos wears a charioteer's outfit, and in all but one, Aphrodite—the divine agent of his downfall—is also included.[60] In the four other Apulian pictures there is a "Fury" figure, but all we have here is Hippolytos, the panicking horses, and the bull. The way in which the bull has only half emerged from the handle, so to speak, is vividly suggestive of its supernatural epiphany. The animal is more threatening and alarming than in the other, later representations.[61] Its approach directly in front of the rearing horses is quite close to the messenger's description (lines 1226–29): "But if he tried to steer and shift

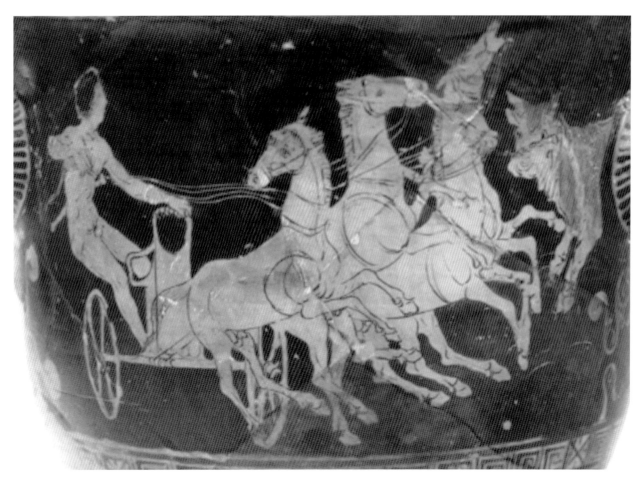

41

their course toward the softer ground, / it would appear in front of them, so as to turn them back, the bull, / driving the four-horse team quite mad with terror..." The pot makes a fine dramatic painting in its own right, but it is enriched for the viewer who recalls the play. We seem to have here, then, a good example of an early Western Greek vase-painting that relates to a tragedy quite closely, but without any signal whatsoever of the link. It is left entirely for the viewer to bring the supporting power of the tragedy to bear. In the later, more elaborate paintings—such as no. 42—there are signals that suggest that the particular tragedy will throw fuller light on the picture. Paradoxically, the early paintings have a closer relationship to the tragedy in some ways, while not including any indications of the connection.

42

Related to the messenger speech in Euripides' *Hippolytos*

Apulian volute-krater, ca. 340s
Attributed to the Darius Painter
H: 108 cm
London, British Museum F279[62]

THOUGH SAID TO BE an early work,[63] this vase shows many of the Darius Painter's characteristics: the use of white and color, the careful composition, and the combination of action and balance; also typical are the human drama below and the serene gods above. Hippolytos is portrayed using both reins and goad to try to control his racing horses, but the terrifying bull emerges beneath their front hooves.[64] Directly in front of them, touching one horse's head, is a female figure with snakes on her head and arms, a torch, and fancy boots—a typical Erinys. One might ask whether she and similar figures on three of the other vases represent an Erinys or Lyssa, but I think that there is no need to make a sharp distinction, because the figure has multiple, overlapping significances. This is a story of revenge, the revenges of Aphrodite and of Phaidra on Hippolytos; but it is also the story of the curse granted by Poseidon that Theseus calls down upon his son. The bull—the embodiment of that curse—terrifies the horses (1218ff.), maddening them (1229–30). There is, of course, no explicit personification within the Euripidean messenger speech, but in the visual terms of the painting, this demonic figure is full of apt meaning.

Lastly of those on the human register, there is the old paidagogos gesticulating in alarm behind Hippolytos. He does not appear in any of the other six vases (though he is in no. 39, if that is to be associated with *Hippolytos*). Those who know the play will immediately think of the old retainer who remonstrates with Hippolytos early in the play, and who tries to warn him of the dangers of spurning Aphrodite. He acts within the picture as a kind of helpless witness figure. It might be claimed that he is also the messenger who will return and tell the story, the story that is being narrated in the painting. That does not, however, tally particularly well with the Euripidean text: the messenger there is an attendant and a groom (1151–52, 1173–80), and one of those who run to keep up with Hippolytos before the bull appears—in other words, he seems to be young rather than old. But, then again, it is possible that in the later performance tradition he was played by an actor with the same mask and costume as those of the old paidagogos of the prologue. In any case, he seems to be a signal toward Euripides' tragedy.

Turning to the gods above, Aphrodite (with Eros) is nearly always included in these Hippolytos scenes, present at the hour of her triumph. To the right is Poseidon, father of Theseus, who is also shown on the Naples krater (see n. 64). In the center stands Athena, in her only appearance in a painting of Hippolytos' fatal ride (though we have also seen her in no. 40). Her prominence is by no means out of keeping with the play, though it does suggest quite careful attention to the tragedy's nuances and its Athenian dimension. To her left is Apollo. His presence does not necessarily need a specific explanation from within the play, but he might

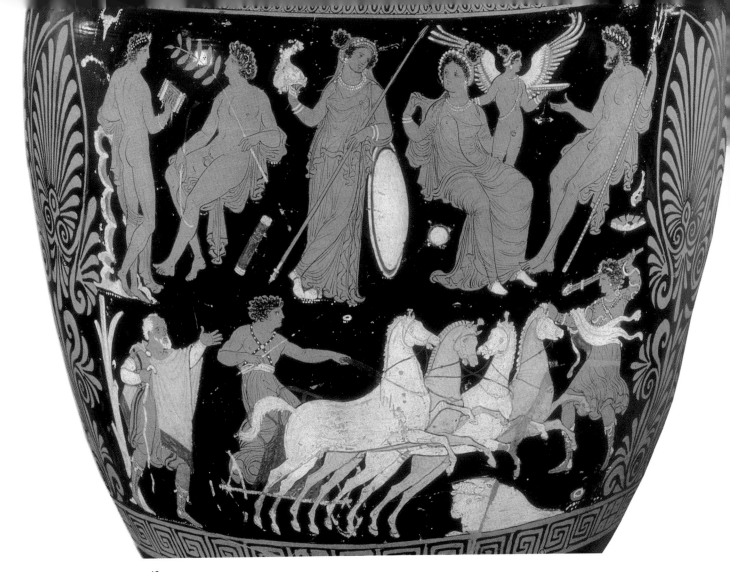

42

be thought of as a surrogate for Artemis. Although she is very important
in the play, perhaps it was considered inappropriate to show her at the
moment of her rival's assertion over her.[65] Lastly, to the left, there is a Pan
figure leaning on a rock and holding a syrinx and a curved *lagobolon*. As is
often the case in the vase-paintings of this period, he represents the wild
countryside, the kind of places where Phaidra imagines herself hunting
with Hippolytos. It is most striking that these divinities are all uncon-
cerned, paying no attention to the danger and imminent death below.
Athena looks down, but even this seems to be in mild regret, rather than
because she is actually watching. The gap between the human and the
divine is wide: the gods are present, but that does not mean that they are
active or moved on behalf of the humans. They are on a different plane—
as is often the case with the gods of tragedy.

43

Plausibly related to the messenger speech in *Andromache*

Apulian volute-krater, ca. 360s
Attributed to the Ilioupersis Painter
H: 57 cm
Milan, Collezione H. A. (Banca Intesa Collection) 239[66]

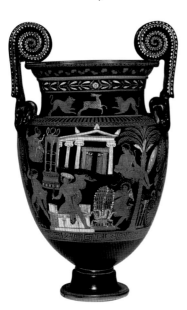

THE ILIOUPERSIS PAINTER was a prolific and influential artist, who was an important intermediary between the relatively simple early Apulian paintings and the high monumental pieces of the next generation.[67] This vase and the closely comparable number 47 exemplify two main features of the artist's work that will become standard: the volute-krater form and the division, not fully developed here, into a lower register of suffering humans and an upper register of calm divinities. An element that seems more particular to these two paintings is the emphasis on sacred and cultic elements. Here, in addition to Apollo (labeled ΑΠΟΛΛΩΝ) with his bow, and to the Pythian priestess with her temple key, there are two tripods, an altar, an ornate omphalos, and a spectacular palm tree.[68] Looming above the whole scene is the Temple of Apollo, partly hidden behind a sort of hill. All told, there is special attention given to the sacred setting, and to Delphi in particular.

The three figures below are involved in violent action. Neoptolemos (ΝΕΟΠΤΟΛΕΜΟΣ)—on the altar, cloak swirling and sword in hand—has already sustained a serious wound. Orestes (ΟΡΕΣΤΑΣ[69]) lurks behind the omphalos—presumably his hidden hand holds a sword. Lastly, the youth on the left has no name, but is pretty clearly about to attack Neoptolemos with his spear.[70] It is remarkable that this is the one and only representation of the death of Neoptolemos at Delphi to survive in visual art. It was a famous episode, told with important variations about who was involved and about the guilt or innocence of Neoptolemos himself.[71] There was even an expression, "Neoptolemean revenge," referring to the way that Apollo killed him at the altar at Delphi, just as Neoptolemos had killed Priam at the altar during the Sack of Troy. In surviving tragedy, however, the story is told only in the messenger speech of Euripides' *Andromache*.[72] Is there any good reason to connect this painting with the Euripides play, or is it rather the mythological story without any literary affiliations?

The role of Neoptolemos in *Andromache* is to be away at Delphi and to appear onstage only after he is dead. The play is set in his kingdom in Thessaly, where he lives with Andromache, widow of the Trojan Hektor, with whom he has an infant son. He is, however, married to Hermione (daughter of Helen and Menelaos), who is childless and deadly jealous. In the course of the play, her cousin Orestes arrives, declares his love for her, and tells of how he has arranged a plot for the assassination of Neoptolemos at Delphi (993–1008). Although there is an unrealistically short time for Orestes to get back to Delphi, it seems clear from the messenger's speech that he is there for the kill (1114–16):[73] "But men with swords were lurking there in ambush for him in the shade / of laurel trees. And one of these, the crafty planner of all this, / was Klytaimestra's son..."

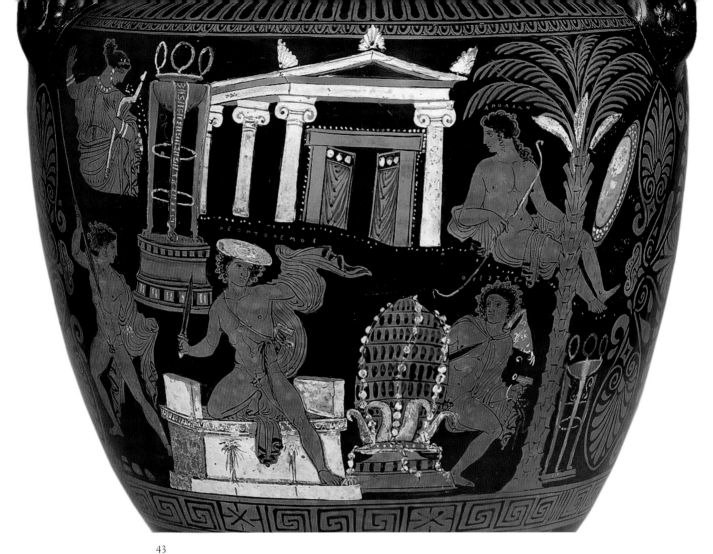

43

The messenger relates how Neoptolemos was inside the sanctuary when ambushed by the Delphian conspirators (1111ff.); they wound him easily, as he has no armor; he then seizes some armor that is hanging nearby (does the shield to the right of the palm tree allude to this?) and leaps onto the altar. He is bombarded with weapons, and in the end embarks on a kind of fully armed dance of death—the origin of the Pyrrhic dance.

The painting tallies with much of this, but not with all. The most telling pointer toward an informing familiarity with the Euripides is, I think, the presence of Orestes and his stealthy position lurking behind the omphalos. There is no evidence whatsoever that Orestes was involved with the death of Neoptolemos before Euripides' play, and this is likely to have been a Euripidean invention. It is important, and in keeping with the sympathies of the rest of the play, that instead of facing him in man-to-man combat, Orestes conceals himself inside a group in order to attack an unarmed man. This unscrupulous cowardice is effectively suggested—while not, of course, exactly reproduced—by the portrayal of

Orestes lurking behind the sacred stone, while the Delphian to the left is at least more overt.

Moret's discussion has both the strengths and failings of his "iconocentric" approach.[74] With characteristic acuity and detail, he shows how all the poses are taken from the artistic repertoire as found in many other scenes. He concludes that this is enough to explain the entire scene without any appeal to the tragedy, which was no more than a "point of departure." He also insists that the picture does not correspond properly with Euripides: either Orestes should not be there at all,[75] or he should be among the other attackers. But this is, I suggest, a kind of selective pedantry: Orestes' position in the painting captures his surreptitious role in Euripides' *Andromache* far more effectively than if he were out in the open with a group of Delphian attackers.

44

Related to the scene of the blinded Polymestor in *Hekabe*

Apulian loutrophoros, ca. 330s
Attributed to the Darius Painter
H: ca. 100 cm
London, British Museum
1900.5-19.1[76]

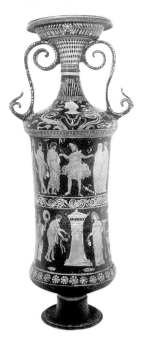

THE UPPER BAND on this tall loutrophoros has five figures, who at first sight may seem fairly innocuous and unspecific. It is only when one takes a closer look at the central figure, who stands between two men and two women, that one realizes that it shows a particularly gruesome incident from the story of Hekabe ("Hecuba" in Latin), the former queen of Troy and wife of Priam. This man wears an ornate but short knee-length robe with a cloak and an Oriental cap that seems to be slightly awry. He stands in a clumsy way with his feet apart and his arms awkwardly held out. The horrible detail that explains everything is that he has just been blinded.

As far as we know, it was Euripides in his *Hekabe* (late 420s) who made up the whole story of how Polymestor, a king in Thrace, was entrusted with the care of Polydoros, the young son of Priam and Hekabe, and then treacherously murdered him for his gold.[77] The tragedy is set in his kingdom, a short way across the Dardanelles from the freshly sacked Troy; it tells of how Hekabe, now a prisoner and slave, discovers the truth and exacts a terrible revenge. She lures Polymestor and his two sons into her tent, and with the help of other Trojan women, kills the boys and blinds the father. He reemerges, blindly stumbling and groping around for violent revenge (lines 1056–83). Agamemnon, the Greek leader, hearing the commotion, acts as an adjudicator between the pleas of Polymestor and of Hekabe, finding in her favor. That the opening of this scene is quite closely reflected here is beyond reasonable doubt: to the left stands Agamemnon with an attendant; to the right, Hekabe, with white hair and stick, and a younger companion. The incapacitated Polymestor stands between them, blindly feeling in front of him.

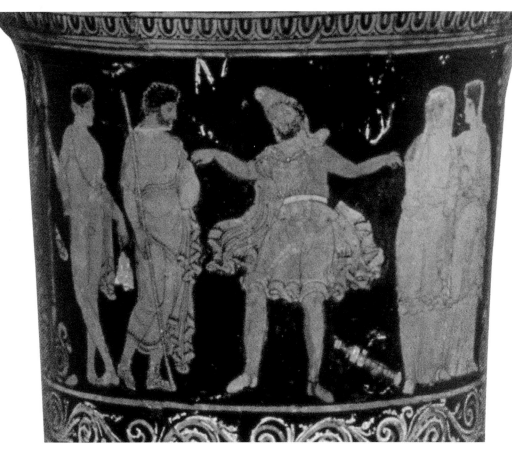

44

This painting is the only representation of the Polymestor episode
in all of surviving ancient art. It does not correspond with the play in
every detail (why should it?). In the Euripides play, the bodies of the two
boys are revealed when Polymestor emerges; and there is no mention
of any fallen sword. But the point is that the play is needed in order to
make full sense of the picture. This is certainly not always the case with
tragedy-related paintings; but here a viewer who does not know the story,
as invented and narrated by Euripides, is going to find this scene impos-
sible to interpret with any detail.

And why, finally, should anyone want such a cruel and vengeful scene
on a large, ornate loutrophoros? Perhaps it was painted for the funeral of
someone who liked this particular play by Euripides? The melodrama of
Hekabe was much appreciated in the Renaissance, not least for this very
episode; this pot would seem to be evidence that it had that appeal already
in the middle of the fourth century B.C.

45

Evidently related to a tragedy about the madness of Herakles, not that of Euripides, but quite likely under its influence

Paestan calyx-krater, ca. 350s
Signed by Assteas
H: 55 cm
Madrid, Museo Arqueológico
Nacional 11094 (L369)[78]

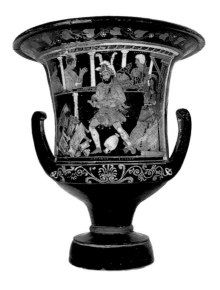

THIS PIECE, signed by the painter Assteas, is perhaps the most theatrically tragic of the two thousand or so surviving pots from Poseidonia. Above all there is the pity- and fear-laden subject matter: Herakles in the grip of the madness that drives him to kill his own children. There are also the ornate costumes and theatrical architecture, especially the porch and half-opened door to the right. The "windows" above, with figures in them, probably do not reflect any actual theater architecture but are found in other theater-related pictures. The most plausible explanation is that they were a device to include other characters who are important in this particular narrative of the story. In this case the three are all labeled: from left to right, they are Mania (Madness); Iolaos, the young nephew of Herakles; and Alkmene, Herakles' white-haired mother.[79]

To the left of Herakles is a heap of domestic furniture and utensils piled up and already on fire[80]—an effective portrayal of a prosperous household in the process of being disastrously overturned. His wife, Megara (inscribed ΜΕΓΑΡΗ[81]), flees with a gesture of horror toward the doorway. Herakles, wearing greaves and an ornate helmet with feathers—but no lion skin, bow, or club—is carrying a small child toward the fire, and is clearly, despite the boy's pleading, about to immolate him. This is the one and only painting of this narrative to survive, and it has some striking correspondences to the mad scene in Euripides' tragedy *Herakles* (sometimes subtitled *Raging in Madness*), first produced not long before 415. At the same time, however, it displays some important differences.

First, a brief résumé of the story in the Euripides play. Herakles returns from his last labor just in time to save Megara and his three sons from being executed by the local tyrant. No sooner are they safely reunited at home than Iris and Lyssa appear, sent by Hera to "punish" Herakles. A messenger relates what happened (922–1015). The family—including Herakles' old father, Amphitryon—are all standing by the sacrificial altar of Zeus in the courtyard, when Herakles begins to suffer a fit of delusions. He imagines himself setting off for Mykenai to wreak revenge on his foe Eurystheus; then he absurdly enacts himself dining and then participating at the Isthmian Games, before he eventually draws his bow on his own children, imagining them to be the children of Eurystheus (967–1000). He shoots the first with gloating triumph; when the second comes close and clasps his chin, he smashes the boy's skull with his club. Megara seizes the third son and locks herself inside with him; but Herakles breaks down the door and shoots both mother and child with a single arrow. Finally, Athena intervenes to stop the carnage before Herakles can kill his old father as well.

It seems very likely to me that in this painted version, Herakles' madness has similarly taken the form of delusions: this would explain why he

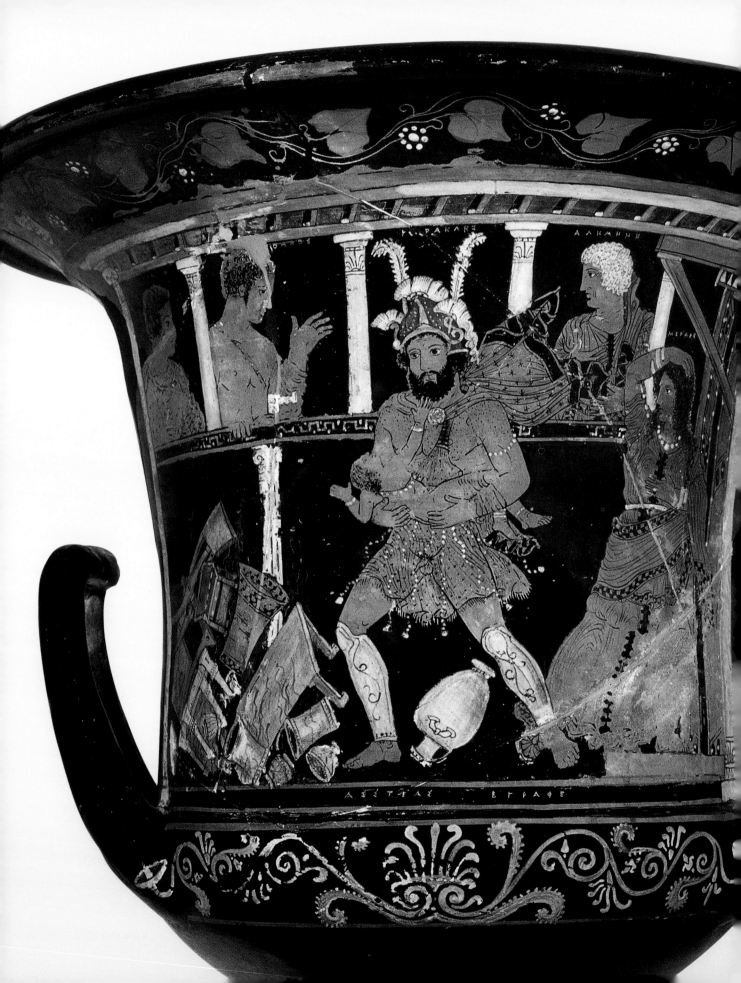

is wearing the helmet and greaves, and why he has built a pile of stuff and set it alight. Perhaps he imagines that he is sacking a city? This painting resembles the Euripidean dramatization, but with variations. Some of these may have drawn on other, preexistent versions of the myth. There was a story, going back to a time before Euripides, in which he burned his sons;[82] there were also versions in which Megara survived the slaughter, as seems to be suggested here by her flight (not protecting a child). Another significant divergence from Euripides is that Herakles is not using his bow and club in the slaughter. Furthermore, there is no sign of Amphitryon here, while the figures above indicate that Alkmene and Iolaos may have been characters in this particular play.

So this picture should not put the viewer in mind of the Euripides play. Anyone who is tempted at first glance will be turned back by several clear contraindications. Yet there are signs that encourage the recall of a tragic version. In theory this might have been a pre-Euripidean tragedy; but, as far as we know, his was the first tragic treatment of the story. The whole rather macabre idea of Herakles killing his sons while acting out some delusionary exploits is likely to have been a Euripidean invention. In addition, the figure of Mania looks like a post-Euripidean variant on his Lyssa. If this vase does reflect a later tragedy, it looks as though that work took on some variants that preexisted Euripides and that may have been more traditional—the child fire and the escape of Megara.

One last clarification is called for: Trendall gives half support to the suggestion by Margarete Bieber that it is not a straight tragedy that is reflected here but some local form of tragicomedy, or "hilaro-tragedy."[83] Apart from the general lack of evidence for any such Western Greek or Italian dramatic forms in the fourth century (forms that Bieber was keen to promote), there is nothing in this picture that is comic in any appropriate sense of the word. In Euripides, when Herakles first goes mad, the onlookers are not sure how to respond (950–52): "The servants were inspired by fear and laughter all at once; they glanced / at one another, and one said: 'Is Master playing games with us / or has he gone stark mad?'" Once he starts attacking the children, there is no longer any laughable element left. The dynamic of this scene looks similar. Bieber believed it funny that the bonfire includes nonflammable metal objects; but this is more likely to be the result of Herakles' delusions over what he is burning. It is also possible that he has put on women's clothing beneath his armor—his garment is oddly transparent. If so, then again it is likely to part of his macabre fantasy rather than a sign of comedy. Finally, Bieber found the feathers on Herakles' helmet most amusing; but this kind of ornament was widespread in the fourth century, all the way from Samnite Italy to the new power of Macedonia.[84]

45

46
May well be related to *Ion*

Apulian volute-krater, ca. 350
Attributed to the Lycurgus Painter
H: 98 cm
Ruvo, Museo Jatta 1097
(36822)[85]

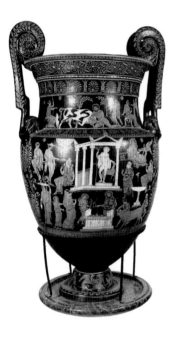

GIVEN THAT THE SURVIVING Euripidean plays from the 430s and 420s have left quite a few marks in fourth-century vase-painting, there are surprisingly few from the numerous later plays that survive. There is the outstanding exception of *Iphigeneia (among the Taurians)*, which is richly reflected (see nos. 47–50), along with some other "escape plays" from the years 414 to 408, most notably *Andromeda* (see nos. 59–63). There are, though, no plausible cases to be made, as far as I am aware, for pots related to *Suppliants*, *Elektra*, *Trojan Women*, *Phoenician Women*, or *Orestes*, even though we know that some of these remained very popular in theater. There may well, of course, be a strong element of chance involved here. Until Margot Schmidt (1979) published her learned and persuasive interpretation of this vase, there were not thought to be any paintings related to Euripides' *Ion*. Yet this piece was already in the collection of the Jatta family in Ruvo by 1869.

Ion, which probably dates to 414 or 413, is often treated dismissively as a lightweight happy-ending romance; but in fact the twists and turns of its plot include much that is dark as well as bright. In the end Kreousa, the princess of Athens, returns home from Delphi along with her long-lost son, to the accompaniment of prophesies from Athena that he, Ion, will be the founding father of the Ionians, who will in future generations inhabit both Europe and Asia. But there has been much anguish and anger and danger on the way; the play evokes with a special poignancy both Ion's experience as a temple slave with no family, and Kreousa's barren years since the day when, as an unmarried mother, she had to expose her baby sired by Apollo, and left him for dead.

It is not easy to put the variegated plot in a nutshell. Kreousa comes to Delphi with her non-Athenian husband, Xouthos, to consult the oracle about their infertility. There she meets and builds up a fellow-feeling with the temple slave, who is in fact the son that she bore after Apollo had raped her, all those years before. Apollo had made Hermes whisk the baby from the cave under the Athenian Acropolis, where she had left him, and deposit the cradle at Delphi for the Pythian priestess to find. The oracle tells Xouthos, more than half falsely, that the young lad is his son; he names him Ion, and tells him that he will be the prince of Athens. This only turns the knife in Kreousa's wound and compounds her resentment against Apollo's treatment. Her jealousy and family pride lead her and her loyal old servant to plot to poison Ion. When Ion uncovers this and tries to have her put to death, the situation is saved at the last minute by the intervention of the old Pythian priestess, who has preserved tokens that identify Ion as Kreousa's baby. So Apollo is vindicated; yet his past behavior is dubious enough for Athena, rather than him, to appear as the "god from the machine" to declare the final dispensation.

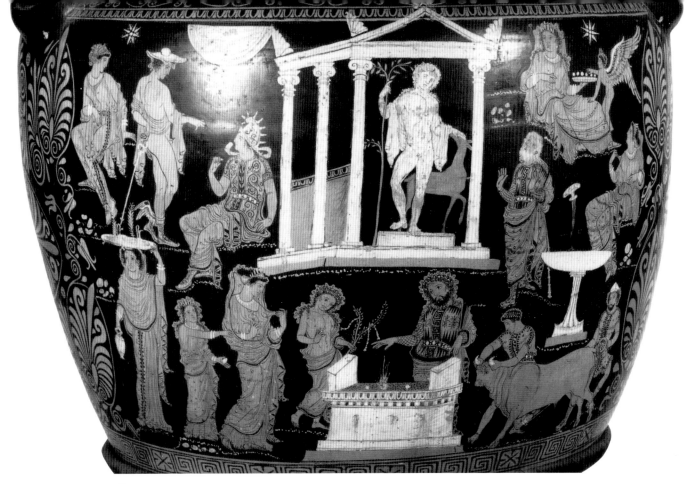

46

Trendall described this painted scene simply as "Sacrifice to Apollo."[86] And so it is, but the painting rather clearly evokes a particular story, not just a generic scene. The great strength of Schmidt's interpretation is that it satisfactorily explains all the major figures—or nearly all. She proposes that this is not a specific scene from Euripides' *Ion*, but—as is so often the case—a more combinatory evocation of several of the leading characters and themes. The scene is dominated by a statue of Apollo inside the shrine (there is even a small strut beneath its raised foot); the figure is appropriate enough to *Ion*, in which the Temple of Apollo is constantly important, but the god himself never appears onstage. Beneath the Apollo is his lighted altar, tended by a long-haired youth, bigger than a boy, but smaller than a man, who holds Apolline laurel boughs—all apt to Ion himself.

On the other side is an ornately dressed man, who would be Xouthos. To the right two attendants are bringing up a bull for the sacrifice. In Euripides' play, when Xouthos has met and named Ion, he arranges a big feast so that Ion can say farewell to all his Delphian friends (651–67, especially 664, "with the pleasure that accompanies the sacrifice of an ox"); later on, this feast is fully described (1122–1214, especially 1168–76).

This scene of sacrifice, and especially the Apolline boy/youth, seems to capture rather well the Euripidean version of Apollo's "gift" of his son to Xouthos. The play also makes sense of the apprehensive, rather downcast stance of the regal, half-veiled woman who stands to the left. Xouthos' gain is not good news for Kreousa, and her feelings will swell into murderous anger. Behind her are an attendant and a woman carrying offerings; for one who knows *Ion*, they might evoke the chorus of women who have accompanied Kreousa to Delphi.

There are two readily identifiable deities above, who also fit well with the proposal that Euripides' play is the key to this scene. To the left is Hermes, who was entrusted by Apollo with the task of carrying the baby from Athens to Delphi, and who delivers the prologue. To the right are Aphrodite and Eros, appropriate to this story in which Apollo's desire for Kreousa is so important—he took her "without shame, doing what gratifies Kypris," as she puts it (895–96).[87] To the extreme of both sides sit females who need not be specifically identified (perhaps they are nymphs of Parnassos?).

Yet to be explained are the two figures at the intermediate level on either side of the temple. To the right is an old man looking toward Apollo. The first person to come to mind, working from the play, is the old carer/ paidagogos, who remains utterly loyal to Kreousa and her royal line, and who is indeed crucial in the plot. But there are problems with this interpretation: first, he is not shown as close to Kreousa, as might be expected; second, he is not a bent old man with a short chiton and crooked stick, like the standard paidagogos; he is more upright and dignified.[88] What then of the balancing figure, apparently a seated divinity in ornate costume, with a spectacularly crenellated Oriental headdress? Schmidt put forward an ingenious suggestion that I find very attractive: that she is a personification of Asia.[89] Hermes, who is gesturing toward her, predicts in the prologue that Apollo will cause the unnamed boy to be named throughout Greece (74–75) as "Ion, founding father of the Greeks who live on Asian land."[90] If this is right, then the old man might also be some symbolic or genealogically significant figure—but in that case, the Euripides play does not seem to supply any answer.[91]

In conclusion there is, I think, much to be said for Schmidt's *Ion* theory—many details of the painting that are otherwise inexplicable become meaningful to the viewer. The identification of the "Asia" figure is, however, quite a big leap of association to be demanded. And if the old man is to be thought of as Kreousa's retainer, he is strangely positioned within the picture. But who else might he be?

47–50 *Iphigeneia (among the Taurians)*

In his *Women at the Thesmophoria* of 411, Aristophanes derived much comic material from a recent type of Euripidean tragedy that involved danger, resourcefulness, and in the end, escape. The two plays that he particularly picked on were *Helen* and *Andromeda*. It does indeed seem to be true that in the period between 414 and 408, Euripides produced something of a cluster of "saved-from-danger" tragedies. Two that are strikingly similar survive, *Helen* (412?) and *Iphigeneia* (413?),[92] subtitled *among the Taurians* and known by the abbreviation *IT*, to distinguish it from the *Iphigeneia* subtitled *at Aulis* and known as *IA*. *Andromeda* was clearly another—and was popular in vase-paintings (see nos. 59–63). It seems that *Hypsipyle* (no. 79) and *Antiope* (nos. 65–66) also belonged to this general category. *Ion* is both similar and different (see no. 46 above).

There does not seem to be one single artistic representation from ancient times of Helen in Egypt, let alone one related to Euripides' play. It may be that this counterversion of the central myth of Helen at Troy was too ludic and literary to appeal to the visual artists? *IT*, on the other hand, is more widely reflected in fourth-century art than any other surviving narrative of Euripides, except perhaps *Hippolytos*. At least two scenes are recalled, and in a range of wares—Attic, Apulian, and Campanian—stretching from circa 380 to circa 320. This might seem surprising at first glance, since *IT* is not rated particularly highly in the modern canon. It is a salutary corrective, therefore, to find *IT* repeatedly cited as a good model in Aristotle's *Poetics*, second only to Sophocles' *Oedipus*. It was probably with this play, rather than *IA*, that the great Neoptolemos won the actors' competition in Athens in 341; and in the early third century, the Western Greek poet Rhinthon composed tragicomic plays in Doric that took the titles of both *IT* and *IA*.[93]

If we ask why this particular play should have been so popular, the answer may lie partly with its beautifully and complexly constructed plot, but partly also perhaps with its appeal to Greeks who lived in the more far-flung cities of their scattered world. It is set in the territory of the Taurians, on the southeast coast of the Crimean peninsula, a part of the world where there were several Greek settlements at the more commodious sites. Among the many legends of the Black Sea Greeks was one in which Iphigeneia, the daughter of Agamemnon and Klytaimestra, had been rescued by Artemis from being sacrificed and was whisked away to the land of the Taurians. Reports told that the locals celebrated ritual human sacrifice in her honor. It is as good as certain, however, that it was a purely Euripidean invention to bring Iphigeneia's brother, Orestes, to

that remote place, and to have her rescued and brought back to mainland Greece.[94] So any artistic representations of this story are bound to be derived, more or less closely, from the Euripidean play.

All the vases show a fascination with the chilling role of Iphigeneia as the priestess of the remote and macabre cult of Artemis. Nearly all of them (no. 47 is an exception) give special prominence to one or both of two special objects within the story, which are also stage props within the play. One is the cult image of Artemis, which Orestes has been sent by Apollo to bring back to Attica; he must do this in order finally to throw off the pursuit of the Erinyes. With Iphigeneia's help, he succeeds in the end, of course. The other is a letter. Iphigeneia agrees to spare one of the two Greeks (Orestes and Pylades) who have been captured if he will take a letter back to her brother, in Argos. Pylades, the ever-faithful companion of Orestes, swears to deliver the letter to the priestess's brother, provided that she promises him safe passage (727ff.). To make doubly sure that the message gets through, Iphigeneia reads it out loud (769ff.). After that, Pylades can simply deliver the letter to Orestes, with its lines that are both poignant and on the verge of laughter (788–92): "Oh, you have bound me with an oath that's easy, and have sworn the best. / I shall not take excessive time to carry out the oath that I have sworn. / I bring this letter and—see this—deliver it to you, Orestes, / a message from your sister here."

IT has much more sweetness than bitterness, but there are sinister touches, especially the dark practices of the local cult. The excitement of the escape plot and hoodwinking of the local Taurian king, Thoas, involves several thrilling twists and turns, before Athena finally appears "from the machine" and settles everything, explaining how both the image and Iphigeneia herself will initiate separate Artemis cults in Attica.

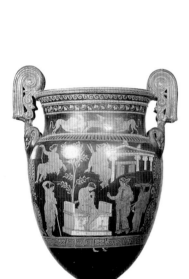

47

Evidently related to the meeting of Orestes and Iphigeneia in Euripides' *IT*

Apulian volute-krater, ca. 360s
Attributed to the Ilioupersis Painter
H: 62.6 cm
Naples, Museo Archeologico Nazionale 82113 (H 3223)[95]

THIS SEEMS TO BE ALMOST a companion piece to the *Andromache* volute-krater, number 43. As in that vase, the scene here is crowned by a half-concealed temple and has divinities above the human characters as they act out their dangerous story below. In this case, however, the humans are caught at a more pensive and less violent moment. Orestes sits centrally on the bloodstained altar, holding his staff and looking down. The laurel tree, which presumably is appropriate to this sanctuary of Apollo's sister, divides him from the standing Pylades. Before him stands Iphigeneia in an ornate costume, holding the large temple key that is the usual sign of a priestess—she is clearly addressing Orestes. All three of them are labeled.[96] Behind Iphigeneia is an (unnamed) attendant with ritual accoutrements. Above—and, as usual, not paying direct atten-

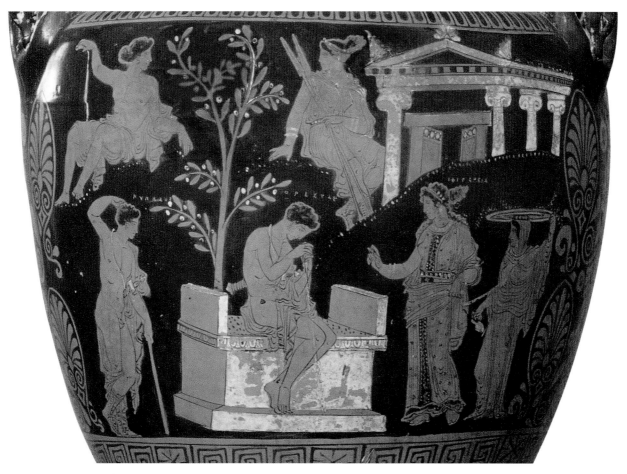

47

tion—are Artemis and Apollo holding a conversation across their shared
laurel tree.

It might seem at first glance that this picture evokes *IT* generally, not
any particular juncture in it. But for someone who knows the play well,
or has it fresh in mind, there is a moment and a memorable frisson that
fits this picture quite closely. Iphigeneia has had the idea of the letter, and
Orestes has insisted, much to her admiration, that Pylades should be
the one to survive (578–616): this helps to explain why the two men are
shown in such different attitudes. At this point (617–27) Orestes asks
for details of how he will be slaughtered, and of what will happen to his
corpse. Iphigeneia offers what comfort she can and then goes inside the
temple to get the letter, giving instructions that the prisoners should be
kept unbound (628–42). It is not necessary for the viewer to recall this
exact exchange in order to identify and enjoy the picture; but the work is
perhaps given an extra tinge of horror and poignancy for one who does.
If this interpretation is right, then it is interesting that a scene has been
selected for its dialogue rather than for its action.[97]

48

Related to the recognition scene in Euripides' *IT*

Attic calyx-krater, ca. 380s
The Iphigenia Painter
H: 50 cm
Ferrara, Museo Nazionale di
Spina T1145 (3032)[98]

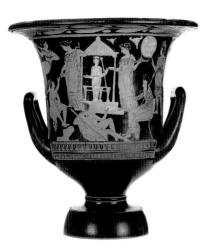

THE SCENE OF IPHIGENEIA about to hand over the letter to Pylades is one of those, like the petrifaction of Niobe (see nos. 16 and 17) and the chariot crash of Hippolytos (see nos. 41 and 42), whose iconography has been augmented in recent years. There have indeed been three interesting new vases, substantial Apulian pieces that were unknown before 1990, to add to the five already known.[99] It is a vivid moment in the play, and the suggestion of the imminent reunion of brother and sister might have been considered appropriate to funerary gatherings. It may also be that the bond of their Greekness, epitomized by the literacy of the message, would have had a special appeal in the more far-flung parts of the Greek world—though obviously of more immediate appeal to Pontic Greeks than to those in the West.

This particular vase is one of the few fourth-century Attic paintings that are relevant to this study. It is earlier than the Western Greek examples of this scene, so it raises once more the question of whether there was a lost Attic tradition that spread to the West, or whether the influence was in the other direction. The details are sufficiently close to several of the Apulian pots to make it most unlikely that the two iconographies are unconnected rather than the product of some sort of interaction.

This picture is dominated by the shrine containing the ancient statue of Artemis. On one side stands Iphigeneia, with key and letter, and on the other is a temple attendant, both with quite ornate "theatrical" costumes.[100] Iphigeneia is handing the letter to Pylades, who for some reason is sitting down; Orestes semireclines below.[101] Since, at this stage, Orestes believes that he's going to be left behind to be slaughtered, it is not inappropriate that he should be sitting separately.[102] One of the other vases (Saint Petersburg, see n. 99 in this ch.) has several figures in Oriental costume, which marks them as Taurians (or Scythians, not strictly the same). The figure of King Thoas sitting grandly on his throne, however, is unique to this painting; a richly costumed attendant fans him. Thoas does not, of course, have any place in the actual letter scene and does not come onstage until later in the play (1153–1489). As is often the case also in Western Greek iconographies, the painter wants to bring on disparate elements that evoke the play, rather than stick narrowly to one particular moment.

There are (it is reported[103]) figures in the upper corners of the painting, which seem to be marginal and unexplained. The female sitting to the left above Iphigeneia is perhaps best regarded simply as Artemis, who is found in all of the Apulian representations (demonstrating that there is no problem with having her present in the same picture as her image). It is odd, however, that she does not have any of the characteristic signs that would readily identify her.[104] If she is not Artemis, this figure must be simply an attendant—such as those who constitute the chorus of the play.

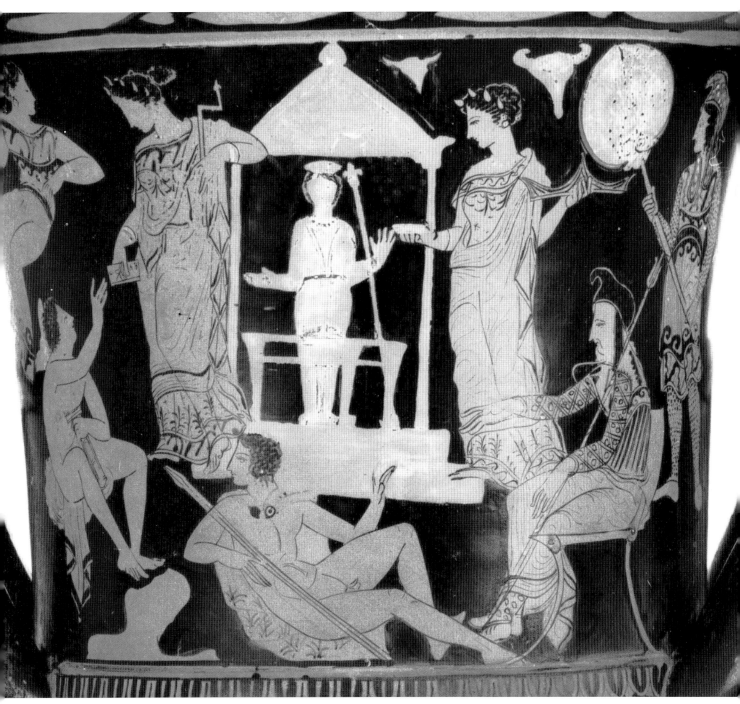

48

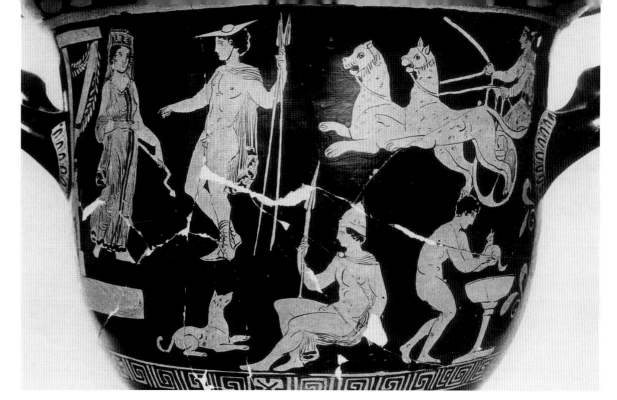

49

Related to the recognition scene in Euripides' *IT*

Apulian bell-krater, ca. 350s
Attributed to the Painter of
Boston 00.348
H: ca. 35 cm
Virginia, private collection 22
(V9105)[105]

THIS RELATIVELY EARLY PAINTING has most of the usual elements of the *IT* iconography: shrine, statue, key, letter, the image of Artemis. What makes it striking and unusual is the placing of the shrine at the left-hand edge, putting the whole scene in profile. The resulting effect of a kind of "porch" is not common and is perhaps reminiscent of the way that the stage building is sometimes shown in profile on comic vase-paintings (see pt. 1, sec. J).[106] Half protruding from the doorway is the small statuette of Artemis (holding a bow?)—small enough to be portable, as it has to be in *IT*. Iphigeneia, who is splendidly clothed, is about to hand the letter to Pylades (with traveling hat and boots). Orestes sits rather detached below (see no. 48 above). In front of him is a dog, and behind him a youth holds a cat over a washing bowl—perhaps the animals suggest the cult of Artemis? It is worth recalling that the play makes repeated reference to Iphigeneia's task of sprinkling lustral water on the heads of human victims about to die (see lines 244–45, 622, 644–45, 1190). There is a lustral bowl on at least one of the other vases as well,[107] which leads me to wonder whether there might have been a performance tradition of having such a prop onstage.

Finally there is the very striking portrayal of Artemis, wearing an animal skin and riding at full tilt in her panther chariot. While this does not, of course, correspond with anything that was actually seen by the spectators of Euripides' play, it may convey a dramatic and rather frightening impression of her outlandish Taurian cult far in the north of the Black Sea.[108]

50

Probably related to the escape scene of Euripides' *IT*, but only loosely

Campanian neck-amphora,
ca. 330s
Attributed to the Ixion Painter
H: 62.2 cm
Saint Petersburg, State Hermitage
Museum B2080 (W1033)[109]

THIS PIECE IS FAIRLY TYPICAL of the best of Campanian mythological vase-painting (probably from Capua) and of its most important artist, the Ixion Painter. Enlivened by the use of color, rather like that in the Attic Kerch style,[110] the scene is exciting, violent—even somewhat cinematic. Three figures emerge with swift movement from the open doors of the architecturally detailed temple. One man advances with a drawn sword, the other looks around cautiously—Orestes and Pylades. Between them is Iphigeneia, with no key but with the statuette of Artemis. The story is unmistakably the escape from the Taurian temple; and, to clinch it, there is a severed head stuck on a pole fixed to the temple above, just as indicated by the text of *IT*.[111]

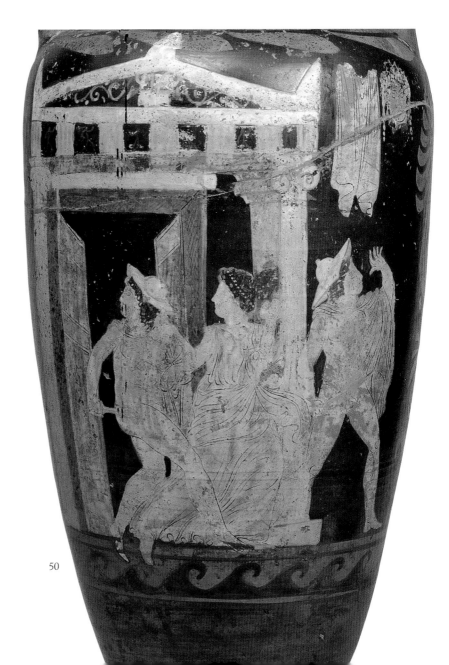

50

Yet, while the painting vividly evokes the excitement and danger of Euripides' play, it does not correspond at all closely with any actual scene within it. It might even seem discordant to someone who knows the play well or who has it fresh in mind.[112] In Euripides' plot Iphigeneia comes out by herself, carrying the image of Artemis, and sets about deceiving Thoas (1156–1221). Then at 1222–33 Orestes and Pylades are bought out, bound and veiled, to form a silent procession, with attendants carrying torches and sacrificial animals. This is all very different from what we have here on this vase. So much so that some might wish to argue that the picture is following a different version of the narrative, whether that version was another, derivative play or an independent tradition built up by the visual artists. I myself am more inclined to think that the artist evokes the sense of theater and the general excitement of Euripides' play, but without encouraging in the viewer any close recall of the dramatic embodiment in *IT*.

51

Possibly related to the account of Pentheus' death in Euripides' *Bacchai*

Apulian phiale, ca. 350
Close to the Thyrsus Painter
H: 12 cm
London, British Museum F133[113]

THE MODERN ESTIMATIONS of any individual Greek tragedy bear no regular relationship to its reflection—or lack of reflection—in fourth-century vase-painting, as we have repeatedly seen. While there is rather more relation to the popularity of the play in ancient times, there is no firm correlation there either. *Phoenician Women* and *Orestes* were among Euripides' best-known plays (especially *Orestes*), yet neither has, as far as I know, left any distinct mark on surviving vase-painting. *Bacchai* (*Bacchant Women*), one of the plays that Euripides left unperformed at the time of his death in 406, was also celebrated and much cited throughout antiquity. In modern times it has been one of the most studied and most performed of all. Yet it has left little or no trace in fourth-century painting. This hastily and rather poorly drawn plate is the best that I can offer.[114]

The story of how the young ruler Pentheus rejected Dionysos when the god came to his mother's city of Thebes, and his consequent dismemberment (*sparagmos*) by the Theban bacchant women on Mount Kithairon, was popular enough with artists; it is the Euripidean version that is not. The ten or so Attic paintings of the tale, which usually show the gruesome *sparagmos*, are in any case earlier in date than the Euripidean tragedy.[115] The eleven Western Greek pictures, nearly all Apulian, show Pentheus surrounded by maenads and in imminent danger.[116] I am disinclined to connect any of these pictures even remotely with Euripides, for they all include a central contraindication, and many have two. The main one is that Pentheus is openly male: he is painted as a "heroic nude," and in most of the pictures his genitals are openly visible. Furthermore, in nearly all of the representations he is armed with either a sword or two spears.[117]

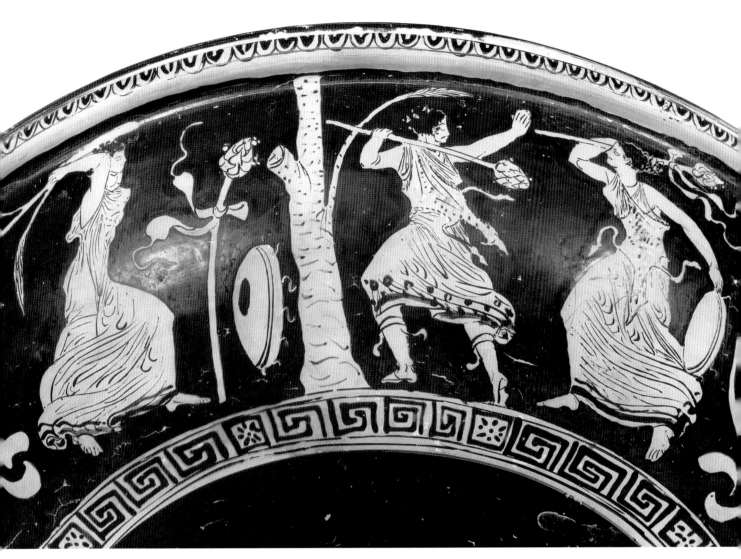

51

In Euripides' *Bacchai* Pentheus disguises himself as a maenad woman and goes to the mountain without any soldiers or weapons. This is crucial to the play and in direct contradiction of the vase-paintings. As Jenny March (1989) has shown, Euripides' play repeatedly invokes and refers to what was presumably the usual version of the myth, in which Pentheus set out to attack the maenads openly and with military force. Characteristically, Euripides does this in order to accentuate the novelty and peculiarity of his remake of the story.

Pentheus' disguise is central to the Euripidean version, but this would not be easy for a painter to represent. The painting would need to indicate that the maenad who is being attacked by the others is actually a man in disguise. This may be, I suggest, what we have in this sketchy picture. The thyrsi and tympani show we certainly have a maenadic scene—in the official British Museum catalogue, it is described as "three maenads in a Bacchic orgy."[118] It was Trendall who made the crucial observation that

"the central figure may well be intended to represent Pentheus dressed as a maenad, since the other two figures are clearly attacking."[119] That observation is, I suggest, supported by another: that the central figure is wearing boots. Maenads are almost invariably represented in art as having bare feet, like the outer two here; and there is indeed a reference to this in *Bacchai*, in which the chorus sings of their "white feet" (862–65): "Am I ever, then, to set my white feet dancing / in all-night bacchic revels, / baring my neck to the dewy air...?"

So there is a case for proposing that this painting evokes the particular Euripidean story for the alert viewer. But is the central figure supposed to have female breasts? If so, then that would of course be a fatal objection. The poor draftsmanship does not allow a definite decision, but the folds of the central figure's clothing are clearly not like the profile breasts of the other two. Even allowing this, it has to be said that there are quite a few details that do not exactly match the Euripides text; but I do not think any one of them is so conspicuous that it cancels out the pro-indications. In *Bacchai* Pentheus wears a headband (929), and his dress is ankle length (935–38). Also the messenger relates how he has fallen to the ground when the maenads begin to tear him apart; and there is even a reference to a body part with a shoe rather than a boot (1134). But the biggest mismatch is that in Euripides' version the maenads pelt Pentheus when he is sitting at the top of a pine tree (1063ff.), so that they can get at him. Although that is not what we have here in the painting, there is the large tree in between the central and the left maenad figures. This is a proper tree, unparalleled by the lesser foliage on other fifth- and fourth-century paintings. This tree is arguably a positive sign of the connection with *Bacchai* that outweighs the mismatched details. Furthermore, the left-hand maenad has torn off a branch to attack, which is what some bacchants do at *Bacchai* 1098.

In the end it is a matter of weighing pro-indications and contraindications—a judgment that is not helped by the poor quality of the drawing. I am inclined to tip in favor of the Euripidean connection (but then I would, wouldn't I?).

52

Possibly related to a
tragedy about the sacrifice
of Iphigeneia, possibly
a version of Euripides'
unfinished *Iphigeneia (at
Aulis)*

Apulian volute-krater, ca. 360s
Close to the Ilioupersis Painter
H: 70 cm
London, British Museum F159[120]

LESS THAN A DECADE after his *IT*, Euripides embarked on another
Iphigeneia, eventually to be subtitled *at Aulis (IA)*. This play told of how
she was sacrificed by her father, Agamemnon, in order to get the Trojan
expedition on its way from the bay of Aulis, where it was becalmed.
We know that it was produced by Euripides' son, also called Euripides,
within five years of his death. It was evidently unfinished, however, and it
is quite likely that his son filled out the missing portions. Moreover, the
play seems to have been quite extensively patched and elaborated after
that—perhaps because there was no definitive text by Euripides himself
in his archive.[121] It is generally agreed that the last sections of the play,
from about line 1510 to the end, contain a lot of later material. Unfortu-
nately, this means that we do not know how Euripides meant the play to
end; nor indeed how it ended in the first production soon after his death.
Above all, we do not know whether in its early form the play ended with
the actual death of Iphigeneia, or whether, as in *IT*, Artemis substituted
a deer for her at the last moment. This is also what happens in the final
messenger speech of *IA* as we have it, a passage that is of uncertain origin,
and much of it of dubious quality. In this surviving narrative, Iphigeneia

willingly gives herself for sacrifice, the priest Kalchas readies the knife, and Agamemnon and the rest look down to the ground (1577–89). They all hear the knife strike, but when they look up, there is a deer in Iphigeneia's place.

This painting is especially eye-catching and unusual in the way it depicts the transformation from human to animal: the painter has achieved a kind of "double exposure" that conveys the idea vividly. The vase captures the very moment when the central figure is about to strike, watched from above by Artemis and Apollo. The scepter in the left hand of the man about to strike Iphigeneia strongly suggests that he is meant to be Agamemnon; there were versions of the story in which he struck the fatal blow, slaughtering his own daughter. That would, however, be completely inconsistent with the *IA* messenger speech as we have it. So too is the way in which the young assistant and the woman (Klytaimestra?) on the left are watching the sacrifice. Green and Handley (1995, 47) say that this vase "surely reflects Euripides' *Iphigenia at Aulis*." This seems an overstatement: it does not reflect the version that we have. In fact, as far as I can see, we cannot even say confidently that it reflects a tragedy at all, since there are none of the standard indicators. But, given the pathos of the story, it is quite probable that the viewer is being encouraged to recall a tragic messenger speech. It is even possible that the speech belonged to a version of *IA*. If so, it was not the version that has come down to us.

53–54 *Rhesos* (probably not by Euripides)

THE THRACIAN KING RHESOS came with his troops to help the Trojans against the besieging Greeks; but he had scarcely arrived when he was slaughtered in his sleep, the victim of an opportunistic nighttime "commando raid" by Odysseus and Diomedes. We have the story from two poetic sources, which agree on some details and diverge on others: the earlier is a kind of digression in the course of the *Iliad*—book 10, or the *Doloneia*—and the other is the surviving tragedy called *Rhesos*. It seems that Euripides produced a tragedy called *Rhesos* early in his career, but the one we have can hardly be his, since it contains many features and techniques that are the product of a later era in the development of the genre. The majority of scholars believe—and I do not hesitate to agree with them—that the tragedy we have is the work of another playwright, producing not long after the death of Euripides. In other words, *Rhesos* is our only surviving fourth-century tragedy (and one of only two we have that are anonymous—the other being *Prometheus*). This makes the play no less interesting, and in some ways more so. It is a most unusual tragedy,

set on a battlefield in the dark of night; it makes quite realistic attempts to create some of the alarm and confusion of its setting. Not least, it involves the chorus in the submilitary action in a way that is so different from Euripides (and Sophocles) as to seem to be a reaction against what had become the conventional inaction of the chorus. Somehow this tragedy became incorporated into the Euripidean corpus, possibly through some confusion with Euripides' own *Rhesos* play, which seems to have been lost early. If, as seems likely, there is at least one fourth-century vase-painting (no. 54) that reflects the surviving play, then it seems possible that it was already believed to be the work of Euripides well within a century of his death.

53

Possibly associated with (anon.) *Rhesos*, but not closely or clearly

Apulian volute-krater, ca. 360s
The Rhesus Painter
H: 99 cm
Berlin, Antikensammlung, Staatliche Museen zu Berlin
VI 3157[122]

WHILE THE CENTRAL STORY of *Iliad* 10—the fate of the Trojan spy Dolon—is narrated relatively often in visual art, the death of Rhesos is surprisingly rare, as emerges from the useful *LIMC* article. There are, however, three Apulian paintings; their relation to the tragedy has been the subject of a perceptive and thought-provoking article by Giuliani (1996). This monumental and quite elaborate painting is probably the earliest.[123] As Giuliani emphasizes, it poses some awkward narrative problems, whether or not it has anything to do with our tragedy. The central sleeping Thracian with his beard and ornate headdress must be Rhesos himself. But there is no sign that he is dead yet; nor indeed that any of the five sleeping Thracians are dead, except for one, the twisted body at the top left. There has been cause for alarm, however, since a wide-awake Thracian flees to the left. It might seem tempting to equate him with the messenger in our *Rhesos* tragedy (728–803). But there are two conspicuously memorable features of the tragic character—he is a charioteer, and he is seriously wounded—and neither of these figures on the vase.

Given that Rhesos is still alive, the Greek with a sword approaching him from the lower right must, beyond any reasonable doubt, be Diomedes. There is a clear differentiation of tasks: Diomedes does the bloody work of the killing, while Odysseus takes care of Rhesos' superb white horses. This division of labor is both in the *Iliad* (10.488–502) and in *Rhesos* (622–26—see further below). In that case, who is the Greek at the lower left, who seems—to judge from his flowing cloak and his posture, which closely echoes the Thracian above him—to be running away? There is no explanation of him in either the *Iliad* version or the tragic: on the contrary, in both, Odysseus and Diomedes are explicitly a daring duo who have set out on a covert mission. There is no place, then, in the story for another Greek. The solution offered by Giuliani is that the painter has included figures who represent two alternative positions for Diomedes,

53

one attacking, one escaping. "The image arises," he claims, "from a largely autonomous process of iconographic montage."[124] The problem with this idea is that the "montage" results in a narrative that does not make sense as a story; it amounts to iconographic incompetence. Any viewer who brings curious attention to bear on the picture will be baffled and frustrated. Giuliani does himself go on to acknowledge that such a disjunction of picture and narrative is "extremely unusual within Apulian vase-painting."[125] And it is true that the great majority of the paintings, especially the grander monumental pieces (such as this), pay remarkably close attention to narrative coherence and to a "sense of plot," as it might be called.

I can see only one way to rescue this painter from the charge of unusual incompetence: to suppose that this picture is actually reflecting another version of the Rhesos story, one that is otherwise unknown to us. If this speculation is right, then it would seem that in this variant Odysseus and Diomedes had a third companion; and probably that they intended, at least at first, to steal the horses by stealth without killing any

of the Thracians. So it was important in this story that a Thracian awoke and raised the alarm. The narrative might have been in another tragedy, or it might have been in some other form. This does not, initially, seem to be a very plausible scenario. But the alternative would also be strange: an iconographic mythological narrative that includes several self-defeating incoherencies.

54

May be plausibly related to the surviving (anon.) *Rhesos*

Apulian volute-krater, ca. 340
Attributed to the Darius Painter
H: 82 cm
Berlin, Antikensammlung,
Staatliche Museen zu Berlin
1984.39[126]

THIS FINE EARLY WORK by the Darius Painter uses his favorite two-level composition, but unlike his later paintings, it does not differentiate by mutual exclusion between the humans below and the divine above—as is immediately indicated by the two sleeping Thracians to the left, one on each level. Between them lies the distorted corpse of a colleague, clearly the victim of Diomedes, who is creeping forward to attack the comfortably bedded central figure with his royal scepter resting across him—readily identifiable even without the inscription of ΡΗΣΟΣ above. Below, reflecting the same division of labor seen in number 53, Odysseus is holding the two white horses, ready for escape after the slaughter. Giuliani makes the nice observation that they have no harnesses, an unusual detail for Western Greek paintings (which often depict horses).[127] Odysseus holds them each with a simple halter through the mouth, as it is nighttime, and they have been unharnessed. The flickering campfire, which illuminates the scene, so to speak, is also an enterprising piece of artistry, both in terms of technique and of atmospheric suggestiveness.

The nonhuman figures are all to the right-hand side of the picture. Athena is, however, a participant in the central narrative. She holds out her hand, gesturing to Diomedes across the sleeping Rhesos: this clearly signifies that she is giving Diomedes special guidance. Although Giuliani describes her pose as one of "superhuman indolence," she is shown as taking more of an active interest than is usually the case with the standard upper-frieze divinities. To her right is a female, veiled in grief, sitting on a rocky seat.[128] Below her, between two rocky outcrops, is a male with horns holding a shell and a (papyrus?) reed: he is pretty clearly a river god—and perhaps the rocks are his banks? Without further mythological information, these two figures make no evident sense except as decorative fillers; but someone who knows the play *Rhesos* will not stay in the dark. The tragedy repeatedly emphasizes the genealogy—not in Homer, and very likely a novelty—of Rhesos' father being the river Strymon (279, 346–54, 394, 919–20, 929).[129] His mother is "one of the Muses"—the play carefully avoids naming which. The chorus at 351–54 celebrates in lyric verse how the river swirled around her virgin body and made her pregnant. She appears at the end of the play as the "god from the machine"

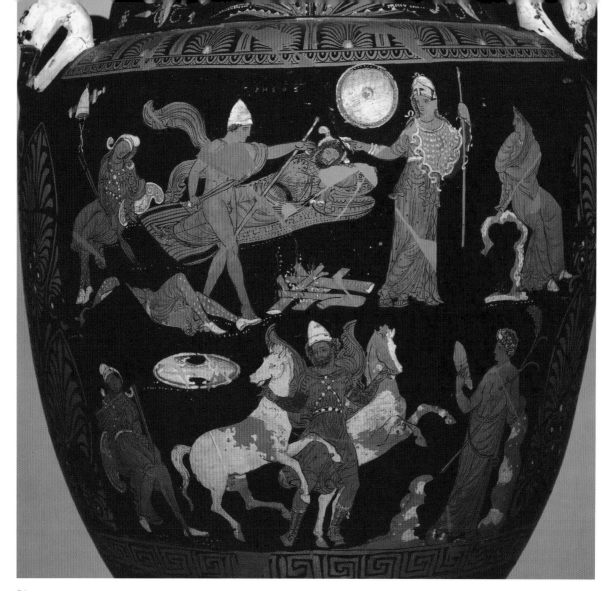

54

(891–982) to lament her son and to carry his body away to Mount Pangaion, where he will be a "man-god." She also recalls with sorrow (917–31) her crossing of Strymon, and how she threw the baby into his father's waters (Strymon rescued Rhesos and had him brought up by the local nymphs). This explains the pair of figures, the river god and the grieving mother.

There are other features in this painting that fit well with a knowledge of the tragedy; and there are, as far as I can see, no serious contraindications. In the play Athena plays a prominent role as the guardian deity of Odysseus and Diomedes: she tells them about the arrival and vulnerability of Rhesos (595–639), distracts Paris while they are doing their killing and horse rustling (642–64), then calls out for them to get a move on (665–74), before she finally disappears as both the Greek pair and the chorus return onstage (675–91).[130] The painting translates this guidance into pictorial terms.

Furthermore, turning to more external indicators, Odysseus' costume is more than usually "theatrical." With his conspicuous sleeves as well as the boots and cross-banding, he is kitted out similarly to the "model" tragic costume of Aigisthos on the Choregoi Vase (see pt. 1, sec. M1).[131] Lastly, there is the placing of the "Rhesos" inscription above. Instead of being close to the person identified, as is usual, it is above Diomedes; thus it may be better seen as a title for the whole picture, rather than as simply a name label.

Now that I have argued that this painting reflects the tragedy more than usually closely, I turn finally to Giuliani's counterclaim that the painting draws on Homer as well as tragedy, leading him to insist that "what the image tries to represent is not epic and not tragedy, but quite simply the story of Rhesos' death."[132] But his arguments for the reflection of the *Iliad* are not nearly as strong as those that have just been made for the reflection of tragedy. First he insists that the division of labor between Odysseus and Diomedes is more thoroughgoing in the epic than in the play. This is true, but the arrangement as they go off—"I shall do the killing, while you take care to subdue the horses" (*Rh* 625)—is quite enough to justify the picture. The fact that they are together when they return later at 675–91 does not contradict this. Second, Giuliani argues that Rhesos' furrowed forehead and skewed headdress show that Athena is inducing a nightmare in him, recalling the nightmare, whether literal or figurative, at *Iliad* 10.496–97. This is probably reading too much into a frowning brow, since this feature is common in the Darius Painter's portrayal of older figures (including Odysseus here). But if there were something to this extremely subtle interpretation, how could any viewer be expected to detect it? Giuliani answers this by recourse to a speculative theory that the viewers of these vases had never seen or heard the literary narratives, but that they had the pictures interpreted for them by professional funeral orators who were literate readers of epic, tragedy, and poetry. I have discussed my objections to this scenario in part 1, section H.

In conclusion, there are conspicuous pointers in this painting toward the tragedy, and little or nothing toward epic. The vase makes good sense, I would claim, to someone who had seen our *Rhesos*, whether they thought they were seeing a tragedy by Euripides or by someone else. The painting does not "represent" tragedy (as Giuliani rightly insists); but there is a good case for saying that it is made for people who know the tragedy, and who could reflect on it to enrich their appreciation of the pictorial narrative's excitement, atmosphere, and pathos.

Chapter 4

SOME VASES THAT MIGHT BE RELATED TO FRAGMENTARY PLAYS BY

Euripides

ON ANY CALCULATION, a striking number of the lost plays by Euripides may be more or less plausibly related to vase-paintings, especially when compared with Aeschylus, and even more so with Sophocles. This amounts to good evidence of Euripides' high popularity in the fourth century (and even in the late fifth).[1] Only a few of the vases, however, can be connected with a Euripides play with a strong degree of confidence, and many cases are at best speculative.[2] Furthermore, there is a methodological danger lurking here: the temptation to build the evidence of the vase-painting (consciously or unconsciously) into the reconstruction of the lost play, and then to claim that the resultant reconstruction confirms the connection with the vase. It is only when independent evidence, best of all in actual preserved quotations, tallies significantly with the vase-painting that the connection can be claimed as truly well based. This is by no means to insist that vases cannot be used at all to pose conjectures about the lost plays; but it is important to remember that they do not by themselves constitute firm or direct evidence.

The previous chapter on the surviving plays of Euripides followed a fairly secure chronological sequence. There are, however, too many uncertainties about the dating of the lost plays for that to be possible here also. I shall therefore follow an alphabetical order of titles; and, since the fragments are gathered in the standard editions in the alphabetical order of the titles in Greek spelling, I shall follow that, even though it does not always coincide with the spelling of the English titles.[3]

55

Quite possibly related to Euripides' *Aigeus*

Apulian bell-krater, ca. 370s
The Adolphseck Painter
H: 38.8 cm
Adolphseck, Schloss Fasanerie
179[4]

EURIPIDES' *AIGEUS*, which concerned a disreputable episode in Medeia's story in Athens, very probably dated from before the surviving *Medeia* of 431. After leaving Corinth, she got married to Aigeus, King of Athens. When Theseus, his young son (by Aithra), arrived in Athens, Medeia recognized him, while his father did not. Out of jealousy she persuaded Aigeus to send the youth on a perilous mission against the Bull of Marathon. When Theseus succeeded, she then plotted with Aigeus to poison the young man. As Theseus was about to drink, he gave his sword to Aigeus, who then recognized him as his own son. Medeia had to go into exile yet again.

This relatively early Apulian vase might well be telling this story,[5] although the only overt reason for connecting it with tragedy is the choice of a highly melodramatic moment combined with the ornate outfits of the two outer figures. The half-veiled woman on the left looks alarmed, and it seems that she has just dropped the jug that is falling to the ground. The old king on the right, with white hair and beard (unfortunately the white paint has come off) has an elaborate scepter and is holding a sword, its scabbard, and a *pilos*. The youth in the center is wearing a garland (from his victory over the bull?) and holds a club.[6] He is pouring liquid from a cup, which would normally signify a libation; but it is possible that, within this story, he is pouring away the poison—or perhaps he is doing both things at once? So the picture does fit what we know of the tragedy rather well, and the costumes are a possible indicator. If the painting does indeed reflect the play, then it is evidence, though far from firm, that the attempted poisoning and recognition took place in a sacred setting.[7]

55

56

56

Possibly related to Euripides' *Aiolos*

Lucanian hydria, ca. 410s
Attributed to the Amykos Painter
H: 52 cm
Bari, Museo Archeologico
Provinciale 1535[8]

THIS IS AN UNUSUALLY HARROWING SCENE from an otherwise typical work by this prolific early Western Greek artist. It was probably painted before 410, well within Euripides' lifetime, that is. The main body of the high-shouldered hydria shows a miscellany of young men and women; here, up on the high shoulder, there are ten further figures, five to the left of the central couch and four to the right (not all visible). On the couch lies a woman with a fatal wound beneath her bare breast, clearly self-inflicted by the sword that is still gripped in her hand (the scabbard is on the pillow). To her left stands a distressed young man with another behind him, who is either tying or untying his hands behind his back. The three women further to the left seemed detached, as is the one on the extreme right. On the right side of the couch, an old man points his staff accusingly. Behind him an old woman, heavily muffled, is sitting on an altar,[9] and the spear carrier behind her seems to be responsible for keeping her under guard.

The narrative, which is quite specific and disturbing, will only make sense to a viewer who knows the myth of the suicide of Kanake, daughter of Aiolos.[10] This was the subject of a notorious play by Euripides (probably dating from the mid-420s)—notorious because it sympathetically dramatized the incestuous love of brother and sister. While there are variants of detail, the central story was that from among Aiolos' six sons and six daughters, Makareus fell in love with his sister Kanake and got her pregnant; she concealed the baby, with the help of her nurse. Meanwhile Aiolos drew lots to pair off his sons and daughters, but unfortunately Kanake was not allocated to Makareus. She killed herself with a sword (sent to her by Aiolos himself, it seems). In the telling on the vase, it would appear that Makareus has been arrested on some accusation connected to Kanake's death, and that the old nurse is also in trouble.

There is no signal here to point the viewer toward Euripides' tragedy, but then there seldom is at this early period. On the other hand, there is nothing that contraindicates what we know of the tragedy; and, to judge from the recurrent references to it in comedy, Euripides' play made a big impact.[11] If the viewer of this painting is being invited to recall Euripides' play, then it is not an episode as fully enacted onstage. The nurse's refuge at the altar is unlikely to have been in the same scene as Aiolos' accusation of Makareus; and the actual death of Kanake would have occurred indoors and offstage, probably—though not necessarily—reported by a messenger. It is, however, quite possible that her body was revealed on the *ekkyklema,* and that there was a confrontation between father and son in the presence of her corpse. Such a scene would have been closely similar to the events in the surviving *Hippolytos* of about the same period.

If this vase is indeed related to the Euripidean tragedy, then it is interesting that such a scandalous play was taken up outside Athens, and that it made enough impact to be reflected on a vase within twenty years of its first performance in Athens. If, as is likely, this was a funerary vessel, it would seem that the most plausible explanation for such a horrible scene in such a context is that the dead man (or woman) had a particular liking for this play. Another conceivable attraction might be the connection of Aiolos with the "Aeolian Islands" to the northwest of Sicily. On the other hand, that is quite a long way from the part of Italy where this vase was painted, and even further from Canosa (where it was probably found), near the northern, Adriatic coast of Apulia.

57–58 *Alkmene*

WHILE AMPHITRYON WAS AWAY at the wars, Zeus took his physical form and deceitfully usurped a supernaturally prolonged night with his wife, Alkmene. The outcome was non-identical twin boys, Herakles by Zeus and Iphikles by Amphitryon. When the real husband returned home, he became suspicious of his wife's fidelity. She tried to take refuge at an altar, but he built a pyre around her; she would have been burned to death but for the intervention of Zeus through the agency of rain clouds that extinguished the flames. It sounds more like the stuff of comedy than tragedy, and there were indeed comedies made of the story, including the Greek model(s) of Plautus' *Amphitruo*.[12] But there were also several tragedies, including one by Euripides. Although we have nearly twenty fragments from this work, they allow us to assert next to nothing about the details of the play, except that the prologue was probably spoken by a god, and that the violence of the flame-dousing storm became proverbial.[13] Any further reconstruction tends to work back from the vase-paintings.

There are no fifth-century vase-paintings of this story, but there are—with the addition of the most recent and most complex (no. 58)—six Western Greek vases, extending from one painted about 400 (no. 57) to two Campanian pieces from the third quarter of the century.[14] It is not implausible to suppose that it was Euripides' play that brought about this popularity, although that is far from sure.

Despite the fact that hardly anything is shared by all of the pictures, except for the figure of the endangered Alkmene herself, it is worth tracing some of their family resemblances. On five out of the six, she is sitting on or by an altar, and in all but one of these, there is also a pile of logs. Amphitryon appears on five out of the six, and in all but one of those (no. 57), he has lighted torches. Hermes is present on three; Zeus on either two or three (and as an eagle on no. 58). Three of the vases have some sort of rainbow effect, and two have cloud nymphs emptying pitchers of water.[15] There are, in other words, enough similarities to argue for a common literary reference—in which case Euripides' play is the prime candidate. But, at the same time, there is also enough variety to claim that there is either more than one literary narrative or a degree of mythmaking by the painters themselves. It would certainly be rash to go far along the road of reconstructing Euripides' tragedy by trying to patch together these part-convergent, part-divergent pictures. I would not agree, then, with the opening sentence of Séchan's discussion: "There is no better example to be derived from illustrated sources for the reconstruction of lost tragedies."[16]

57

Quite possibly related to Euripides' *Alkmene*

Fragmentary Apulian calyx-krater, ca. 400
Attributed to the Painter of the Birth of Dionysus
H: 23 cm
Taranto, Museo Archeologico Nazionale 4600[17]

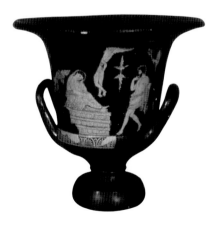

IT IS A GREAT PITY that this vessel is so fragmentary, since it seems a fine piece of craftsmanship, and it might well have contained more of interest. On several other vases, Alkmene lifts her hand in appeal to Zeus, but here she sits veiled with a kind of sad resignation. If she is sitting on an altar, then it is entirely hidden by the logs of the pyre. These are already alight, which will explain why Amphitryon (labeled ΑΜΦΙΤΡΥΩΝ[18]) does not hold a torch. He approaches with a gesture of uncertain significance—perhaps he is already somehow aware of the intervention of Zeus, which is symbolized by the thunderbolt that is pictured directly in front of him.

There are traces of three deities in the upper field of the painting. To the right is Hermes; in the center above the pyre, Eros; and to the left is a seated figure with a scepter, who is generally assumed to be Zeus. If this composition does recall Euripides' tragedy for the viewer, it does not do so literally, of course: the burning pyre must have happened offstage and been reported by a messenger, as is true of the great storm (though perhaps it was heard onstage?). It has been speculated (e.g., by Trendall-Webster) from the presence of Hermes on this and other vases that he spoke the prologue of the play; there is nothing implausible about that. It has also been claimed that Zeus spoke the "epilogue," presumably meaning that he was the "god from the machine." This idea is more dubious, since in the whole of known tragedy there is no incontrovertible appearance of Zeus in person onstage.[19] In conclusion, this painting may have invoked a knowledge of Euripides' *Alkmene*, but the connection is far from sure. It would be risky to infer anything from the vase about the details of the play.

58

Possibly related to Euripides' *Alkmene*

Apulian calyx-krater, ca. 330s
Attributed to the Darius Painter
H: 56 cm
Boston, Museum of Fine Arts
1989.100[20]

THIS WELL-FILLED yet still well-composed painting of the Alkmene story raises interesting questions about its possible tragic connections. The first and most basic must be whether it shows fundamentally the same form of the narrative as the other five Alkmene vases, or whether this work is not only more elaborate but also significantly different. The most prominent feature that it has in common is the central figure of Alkmene (with a name label) sitting on the altar. In three of the others (including no. 57), logs are neatly stacked around her, whereas here some are untidily lying around on the ground, while more are being brought by the young attendants to the left and right. Alkmene is circled by a rainbow nimbus in red, yellow, and white; there is a suggestion of a rainbow in two of the other paintings.[21] As in three of the others, Amphitryon holds a lighted torch; here he also has an assistant holding another. The lower row of figures includes, finally, a personage with a spear and sword who does not appear in any of the other versions: he is labelled ΧΡΗΩΝ, which is apparently a form of "Kreon."[22] He does not seem to be portrayed as the local king, but rather as a fighting companion of Amphitryon. His posture suggests anxiety.

Now to turn to the upper frieze of figures. On the right are Aphrodite and Eros; although they are not in any of the other vases, their appropriateness to the story is obvious. Facing them is Hermes, who does figure in two of the other paintings (including no. 57). Over on the other (left) side sits the blind, white-haired Teiresias (labeled), along with the youth who cares for him.[23] He has elaborate robes and a scepter surmounted by a curious miniature shrine or picture. Given that the figures in the upper range of such iconographies are usually divinities, it is interesting to find Teiresias elevated to this kind of semidivine status. There is one more numinous creature in this upper register: flying above the human scene between Amphitryon and Alkmene is the eagle, a representation of the power of Zeus. And there is a final suggestive touch, one that strikingly crosses between the two levels. In his left hand, Amphitryon holds (rather unrealistically) a long spear that extends right up across the painting of the eagle. This possibly suggests Amphitryon's attempt to thwart the will of Zeus by force—an attempt that is bound, of course, to fail.

In this particular painting there is, perhaps, only one distinct pointer toward tragedy, and that is the figure of Teiresias. His recurrent role in tragedy as the wise adviser of the headstrong kings of Thebes (endorsed by his costume) suggests that the painter is inviting the viewer to let a particular tragedy inform this scene. This possibility would fit with the cumulative case that can, I believe, be made for claiming that the Darius Painter often draws on tragedy in detailed and subtle ways for his monumental mythological scenes. If there is a tragic interaction, then it is quite

58

likely the same tragedy as that which informs the other paintings in this "family" of fourth-century representations of this episode. The combination of altar and pyre, the presence of Hermes (who may have been the prologue speaker), and the rainbow (which may have been given some sort of aetiology) all suggest the same version. This vase strongly suggests that Teiresias intervened in the tragedy, where he no doubt gave sound advice that Amphitryon rejected. Kreon may also have been a character, but he may have only been alluded to. It is no serious objection that these two do not appear in any of the other pictures, since this one is considerably fuller and more inclusive. The depiction of the logs—not piled neatly, but still strewn around the altar—is a touch of realism, rejecting the more conventional and more easily painted piling of a formal pyre. In fact, what we have here may well be closer to the detailed description in a messenger speech. Lastly, given my reservations above (on no. 57) about whether Zeus ever appeared in person onstage, I think the symbolic representation of his presence and power by the eagle is more likely to reflect his intervention as conveyed in a tragedy (his part in this story is, after all, of somewhat dubious virtue if thought of anthropomorphically). In conclusion, I think it is quite likely, though still far from certain, that this vase would have been enriched for the viewer who had seen a tragic performance—more likely than not the *Alkmene* of Euripides.

59–63 *Andromeda*

EURIPIDES' TRAGEDY *Andromeda* of 412 B.C. got off to a sensational start. Instead of the normal prologue, there was a chanting young woman exposed to the mercies of a vengeful sea monster, with the nymph Echo in the caves as her only companion. Before too long the hero Perseus comes flying in with the aid of his magic sandals, falls in love with her at first sight, and heads off to slay the monster. It is not surprising that Aristophanes made comedy out of this in his *Women at the Thesmophoria* the next year; nor is it surprising that it became one of Euripides' best-known and most quoted tragedies—we have some forty fragments. The bound Andromeda and the romantic Perseus also became a favorite subject in Western Greek vase-paintings, mainly (as usual) Apulian. There were sixteen when Konrad Schauenburg compiled his fine *LIMC* article (1981); the extraordinary flood of new material in the 1980s may be measured by the fact that he could add six more by the time he came to his article on Andromeda's father, Kepheus.[24] The question of how much, or how little, these vases reflect Euripides' *Andromeda* is intriguing; this may be a case of an iconography that starts from a play but then takes on a life of its own.

But first, the depiction of Andromeda's binding and exposure in Attic vase-painting requires discussion. There are seven examples, six of them earlier than Euripides' play (only no. 59 is later).[25] In all six she is bound or about to be bound to poles; in some she has Oriental clothing (even trousers); and in some there are "negroid" Ethiopian attendants. Five of them date to about 450 or soon after, and it has become something of an orthodoxy that they drew their inspiration from an early play by Sophocles, also called *Andromeda*.[26] This is questionable, as it is largely based on the analogy of the post-Euripidean paintings, which involves reading back into the Attic fifth-century artistic context the quite different priorities and conventions of the West in the fourth century. Apart from the general point that these vases may have drawn on some narrative form other than tragedy, we know next to nothing about Sophocles' play—not even that it definitely dealt with the binding, nor even that it was a tragedy rather than a satyr play.[27] There is just one external point that is used to back up this hypothesis: one of the vases has an inscription by the figure of Perseus in praise of "Euaion son of Aeschylus."[28] He is similarly inscribed on two other mythological vases (showing Aktaion and Thamyras), and it is inferred that all three paintings reflect a tragic scene in which Euaion had acted onstage. It is a nice idea, but a house of cards.[29]

While there are numerous variants among the twenty-four or so Western Greek vases, some features are shared by many. In the majority Andromeda is in a richly ornamented Greek dress and wears an elaborate headdress, which may suggest that she is decked out as some sort of "bride of death."[30] Perseus usually has winged shoes and sometimes a winged hat, and he carries his special hook blade, which he had used to decapitate Medusa. Andromeda's father, the Ethiopian king Kepheus, figures in many of the paintings, distinguished by his barbarian costume.[31] Kepheus had received an oracle saying that sacrificing his daughter was the only way to assuage the anger of the deities of the sea. In the usual version of the myth, they had been offended by his wife Kassiepeia's boasts that either she or her daughter was more beautiful than the Nereids (sea nymphs). Kassiepeia is also depicted in some of the vases (see no. 63). The most curious and interesting variation is the object that Andromeda is bound to. The most common fixture is a rock, often the kind of "rock arch" that seems to owe something to theater scenery (see pt. 1, sec. M4). But she is also found in several paintings bound between two trees; she is occasionally bound to two columns, and in one case to a kind of shrine.

And what relevant information can be gleaned from the fragments of Euripides? There is unfortunately nothing clear about Andromeda's costume, but Perseus certainly had his winged shoes (fr. 124). We know that she was joined before too long by a chorus consisting of her friends

and contemporaries (fr. 117), and that a messenger told of how Perseus vanquished the monster (fr. 145). It is also clear that Kepheus became opposed to Andromeda going off and marrying her Greek rescuer, while she remained staunchly loyal to her new love. It may well be that Kassiepeia had a part, also in opposition to Perseus; but there is no trace of a role in the play for Phineus, Andromeda's disappointed affianced in some versions of the story. It is very likely that in the end, a "god from the machine" intervened on Perseus' behalf, probably predicting that Perseus, Andromeda, Kepheus, Kassiepeia, and even the monster (Ketos) would eventually become constellations. Some late astronomical sources indicate, though far from conclusively, that Athena was the final dispenser of this celestial future.[32]

Finally, in view of the variety of bindings in the vase-paintings, it is worth wondering how Euripides represented this scene, since we know that the play began with Andromeda already bound in place, ready for the monster.[33] In fragment 125, Perseus describes Andromeda as being on a "mound surrounded by the foam of the sea." So the setting was the seashore, and Andromeda was somehow to be imagined as bound to a rock or cliff. But, however this was presented in the original Euripidean production, that staging was not necessarily followed by later productions in other parts of the Greek world (see further below). If some kind of "stage rock" was available, which could be fixed in front of the stage door, then this would have been an obvious occasion for its use (see no. 60).

59

May well be related to Euripides' *Andromeda*

Attic calyx-krater, ca. 390s
Near the Pronomos Painter
H: 28 cm
Berlin, Antikensammlung,
Staatliche Museen zu Berlin
VI 3237[34]

THIS VASE, produced in Athens but reportedly found in Capua, was painted within twenty years of the first production of Euripides' play. It does not have anything much in common with the pre-Euripidean Attic vases, except perhaps Andromeda's being marked as non-Greek by her "Oriental" headdress. On the other hand, the composition shares one main feature with many of the post-Euripidean Western Greek paintings, namely that Andromeda is fixed to a rock. The rock's outline is not marked very strongly (nor are the bonds), but it has various bits of foliage growing from its surface. Andromeda's highly ornate robes and tight sleeves, similar to the outfits that characterize the Pronomos Painter, do not prove a connection with tragedy, but they certainly do not militate against it. Something else in keeping with Euripides' version is the opposition between Kepheus, who sits with his scepter on one side (is his hand proprietarily laid on his daughter's foot?), and Perseus, with his Gorgon sickle on the other. Perseus does not have winged shoes, which is contrary to Euripides, but he is being crowned by Aphrodite, emphasizing his erotic feelings for Andromeda and his eventual nuptial success. Balancing

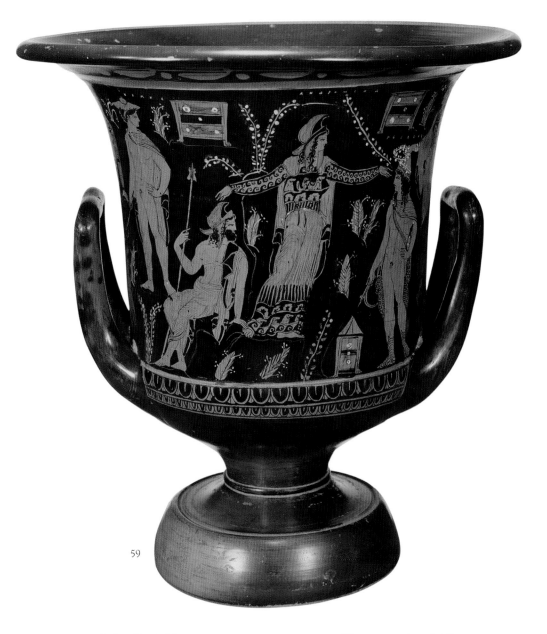

59

Aphrodite is Hermes—present as a protector of Perseus, perhaps? All four figures have name labels. Up in the top left-hand corner, finally, is an ornately costumed Ethiopian girl; in the top right-hand corner is a lighted altar (not visible in this photograph).

This vase may well have evoked Euripides' play for a contemporary viewer. There are no conspicuous contra-signals; the big pro-signal, apart from Andromeda's tragic-style outfit, is the wild rock that she is fixed against. On the other hand, it could not and should not be claimed that the play was essential to the appreciation of this striking painting.

60

May be related to
Euripides' *Andromeda*

Fragmentary Apulian pelike,
ca. 370
Attributed to the Felton Painter
H: 40.5 cm
Würzburg, Martin von Wagner-
Museum H 4606[35]

ALTHOUGH FRAGMENTARY, this is a nice piece of painting, and it
shows particularly well how the rocky archway is related to a doorway or
a cave mouth.[36] Andromeda is bound to it, yet the arch has a band hung
over it and a wool basket partly behind it (these are presumably symbols
of womanhood put out with Andromeda, which are found in several of
the paintings). She is dressed, as in several other vases, with a kind of
crown and an ornate robe with a conspicuous decorated stripe down the
front. These elements may well suggest that she is dressed up as a bride, a
detail that is not explicit in our surviving fragments of Euripides but that
could have figured in the play.[37] To her left are two attendants, perhaps
like the Euripidean chorus; any figures to the right are lost except for one
hand.

Directly below the rock is the sea, but there is dry land on either side.
To the right Kepheus, in ornate barbarian costume, is lifting his hand up
to plead with Andromeda; but she is looking down at the opposite figure,

who is also lifting an arm toward her: Perseus, here complete with winged boots and hat. Thus the competing claims and Andromeda's choice are made clear. The pensive woman behind Perseus might be an attendant, or she might more likely be Kassiepeia. She would in turn connect with the Nereid on a sea horse who is riding through the waves beneath Andromeda. If this painting is related to Euripides' play with any detail, it may suggest that Kassiepeia and her boast somehow figured in the tragedy. But this is pretty speculative.

The main signal toward the theater is undoubtedly the rocky archway. While it is not a bad pictorial device for representing a rock, its arched (rather than irregular) shape and its depiction as not being solid both suggest theatrical stage scenery to the viewer who has an eye for such things.

61

May be related to a tragedy about Andromeda, possibly that by Euripides

Apulian loutrophoros, ca. 340s
Attributed to the Metope Group
H: 87 cm
Malibu, J. Paul Getty Museum
84.AE.996[38]

MANY OF THE FEATURES here have already been seen: Andromeda with crown and finery, fixed to the rock arch; Kepheus with his scepter to the right, represented as rather older than usual. Unusually, there are three "Oriental" soldiers all wearing similar outfits. If these figures were supposed to suggest a chorus,[39] then any play in question is not that by Euripides, whose chorus members were friendly young women (frs. 117–20); but I see no indication of any chorality. The women to the left and the right also seem to be decorative rather than choral, and there is no strong reason to equate either with Kassiepeia.

In many ways the center of attention in this composition is the sea monster, which is putting up a good fight against Perseus, who has kept to the dry land.[40] It makes an exotic and colorful figure with its finny "legs" and crocodile-like jaws. We do not know how the creature was described by Euripides, except that it was moving swiftly through the sea (fr. 145); but it is unlikely that this marine fantasy owes much to the tragedy. The crowning touch—which is surely a fancy of the painter's—is the Nike riding on the monster's back like some sort of jockey. The Nike is, however, urging the monster on to defeat rather than victory, since the beneficiaries are going to be Perseus and Andromeda.

Assuming that a vessel of this size and ornamentation must have been made for funerary use, why should this scene be thought appropriate? It is a story of true love and the triumph of love and courage over all opposition. There may well have been some sort of sentimental consolation to be appreciated by the mourners. Another factor, though, could have been the popularity of Euripides' play, appreciated by the dead person and the mourners alike.

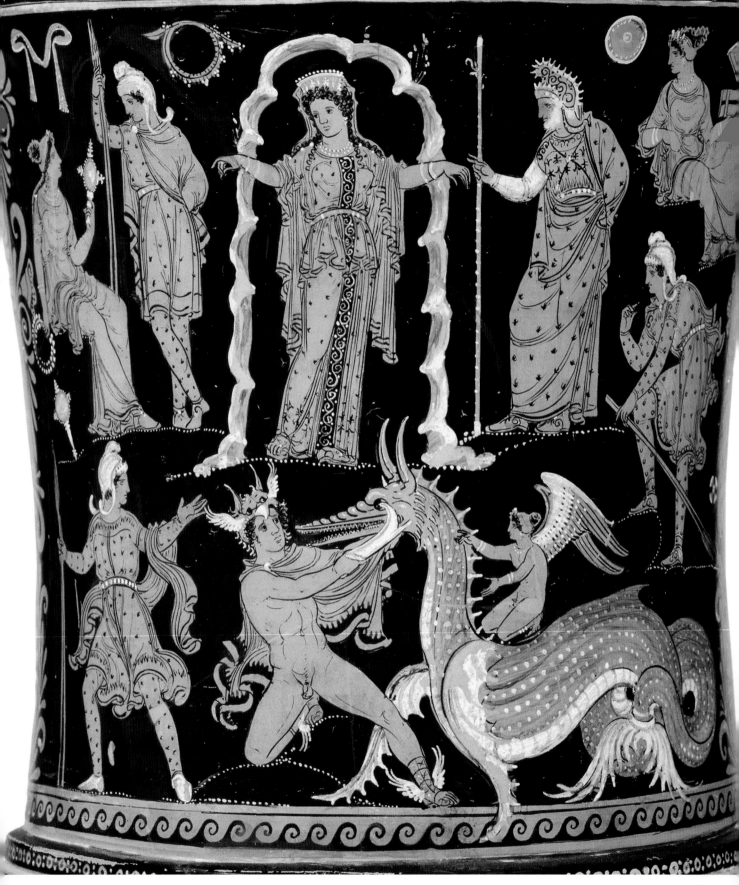

62

Possibly related to Euripides' *Andromeda*

Apulian volute-krater, ca. 400s
Close to the Sisyphus Painter
H: 63.3 cm
Malibu, J. Paul Getty Museum
85.AE.102[41]

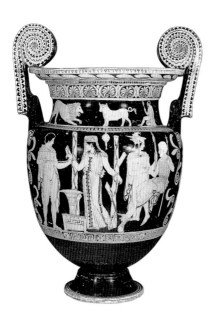

UNTIL THE PUBLICATION of this vase in 1986, the Attic krater in Berlin (no. 59) was the earliest post-Euripidean Andromeda painting; but this large and ambitious Western Greek piece dates to within ten years or so of Euripides' first production. So far, more attention has been given to its aesthetic quality than to its narrative content. The usual observation has been simply that Andromeda is being tied to tree trunks, and that this iconography thus aligns itself with the Attic examples of the alleged "Sophoclean" version (see pp. 174–75).

There are objections to this claim. First and foremost Perseus and Kepheus are together, joining hands: presumably Kepheus is agreeing to give Perseus his daughter if he succeeds in killing the monster, an agreement that he will then renege on. But this cannot be happening while Andromeda is being bound for exposure. One way of avoiding this contradiction is to divide the two halves of the picture and to think of them as not showing simultaneous scenes.[42] It seems to me far more likely, however, that the picture shows Andromeda being *un*bound rather than bound—in other words, Perseus has already rescued her, and the story is moving on.[43] If so, then this is quite distinct from the "Sophoclean" iconography.

Second, Andromeda is being bound to trees and not to posts, as in all the earlier Attic paintings. This might seem a trivial distinction, were there not four other Apulian paintings, all from more than half a century later, that clearly show her being bound to two trees.[44] It seems, then, that there was a narrative tradition, whether purely iconographic or taken from a literary source, in which Andromeda was bound to trees rather than to a rock or posts or anything else.

One could take this vase to be related to Euripides' play, but for one apparent contraindication, the trees. It is always supposed that in Euripides' staging she was fixed directly to the rock; but the main reason for this assumption is, in fact, the vase-paintings (such as nos. 58–61) rather than any textual evidence. It is true that as Perseus approached he saw Andromeda fixed on a "mound" (or headland or crag—*ochthon*, fr. 125), but it is by no means impossible that it was further specified that she was bound to two trees on that mound. In that case, however, there would seem to be a contradiction with the majority of pictures, which show her without any trees, usually on the "rock arch." This is a problem, but not insuperable if we are willing to accept that a variety of performance practices grew up in fourth-century replayings of the great "classics." It may be that in Euripides' text she was bound directly to the rock, but that some revivals tied her between two convenient stage trees. Or it may have been the other way around (trees in Euripides, but directly on the rock in the theater). Since the painted rock arch seems to have been familiar in

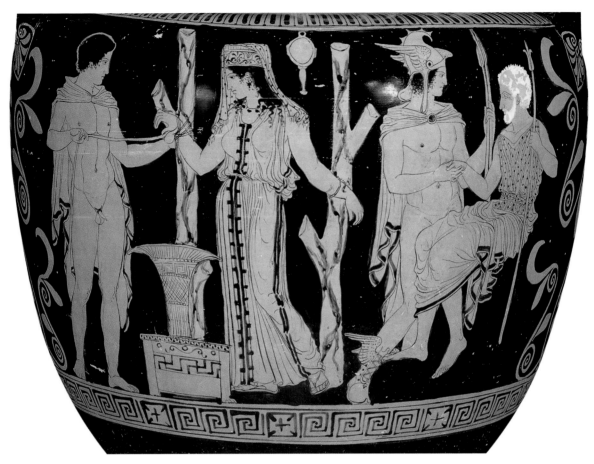

62

fourth-century theater, it would easily have become accepted for stagings of *Andromeda*, even if the scenery slightly contradicted the text.

On our present evidence, I find it a finely balanced question as to whether or not this vase may be plausibly related to Euripides. If, in fact, it was not related, then it is interesting that several of the motifs found later are already there: Andromeda's costume, the wool basket, the tension between Kepheus and Perseus. If it was, then the vase offers particularly interesting evidence for how very soon Euripides' most popular plays were transferred to the Greek West, and how greatly they were appreciated there.

63

May well be related to an *Andromeda* tragedy, quite possibly that of Euripides

Apulian pelike, ca. 330s
Attributed to the Darius Painter
H: 61 cm
Malibu, J. Paul Getty Museum
87.AE.23[45]

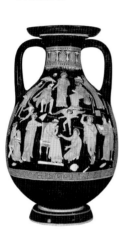

ALTHOUGH THIS PAINTING narrates an episode from later in the story, it has pretty much the same cast (helpfully labeled) as that in the series of vases depicting the bound Andromeda. The bottom row is flanked on the right by an Ethiopian attendant and on the left by a maidservant; between them, from right to left, we have: Kepheus, old and regally robed as usual; Perseus; and Kassiepeia (ΚΑΣΣΙΕΠΕΙΑ), who is kneeling in front of her daughter. Andromeda herself is sitting on a fine throne and is dressed in the usual bridal outfit (is she holding something in her left hand?). Above them both is an Eros with a love charm. Clearly, then, Andromeda has been vindicated, and her mother is begging for forgiveness for having tried to thwart the course of true love. Andromeda's rich throne is unlikely to be merely ornamental, and it probably had some significance in the final dispensation. This may be confirmed by the elaborate empty throne that awaits Andromeda on a nice calyx-krater in Matera, which evidently shows an intermediate stage in the story.[46]

The nonchalant figure with the fan who stands behind Andromeda's throne could be seen as merely an attendant, were there not a winged figure above her head, apparently a Nike, and an inscription that explains all. She is OMONOIA, Homonoia, which means "Agreement" or "Concord." We clearly have the closing scene of the Andromeda story, when all are reconciled. There are a couple of indicators that might point to a theatrical version: Kepheus' costume and the pose of the kneeling pleader, which is found in other probably tragedy-related scenes. If there is such a connection, then Homonoia is more likely to have been invoked verbally than to have been an actual speaking character.

The shape of this vessel does not allow a lot of space for figures in the upper register. Here, apart from the central deity, we seem to have four ordinary humans. There are two Ethiopian men to the left, one civilian, one military. One of the two attendant women on the right has a traveling bag, which might possibly suggest that Andromeda's maids will end up going to Greece with her and Perseus. But the central upper emphasis is on Aphrodite. This strongly suggests to me that, if this scene is related to a play, she delivered the final "god from the machine" speech, no doubt commending Homonoia, telling everyone what to do, and predicting the future immortality of the participants as constellations. The fact that Aphrodite is given the label ΚΥΠΡΙΣ (Kypris, meaning "Goddess from Cyprus") points in the same direction. This is a distinctly more poetic title than the usual "Aphrodite" (which does appear in at least one fourth-century vase inscription), so the painter may have taken this title from the text of the play. It is worth noting that Euripides uses the name "Kypris" much more frequently than "Aphrodite" (including in her self-naming in *Hippolytos* line 2).

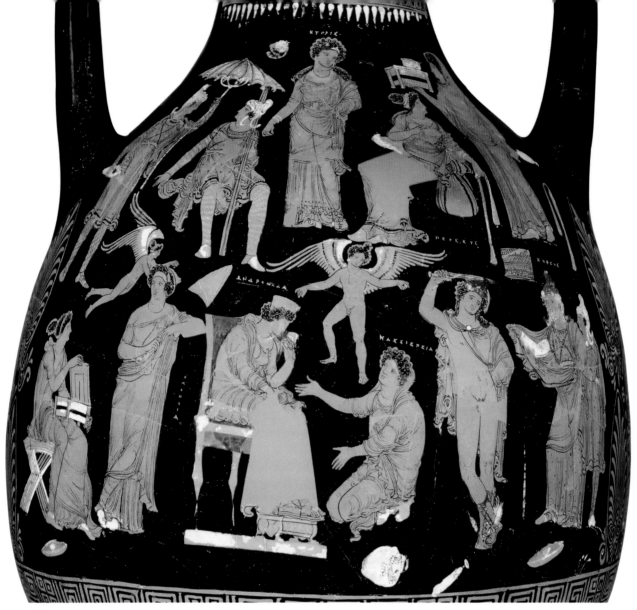

63

In the only comment that I have encountered about the possible relationship of this vase to tragedy, Trendall wrote, "one wonders whether either or both of these [viz. Kypris and Homonoia] might have spoken the prologue or epilogue in a late drama of Andromeda."[47] He does not give his reasons for saying that the play should be "late" rather than that by Euripides. One reason might have been the personification of Homonoia: she seems to have emerged as a divine force only toward the end of the fifth century.[48] But it is possible that the word was used with a small "h" in the play and was turned into an independent personification by the painter. Second, some late sources about the constellations

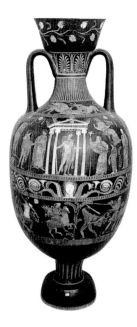

(*katasterismoi*) suggest that they were disposed by Athena, making no mention of Aphrodite.[49] It is by no means certain, however, that this detail goes back to Euripides; it is, alternatively, always possible that Aphrodite reported future constellations that were in some way the responsibility of Athena. Aphrodite would undoubtedly have made an appropriate epilogue "god from the machine" for the Euripides play. Thus it may be relevant that she also appears on number 59, the Attic krater in Berlin, and on the calyx-krater in Matera, which is closer to the closing scenes than to the opening scenes of the story (see above).

In conclusion, if any of the vases that have been discussed here in relation to Euripides' *Andromeda* are rightly associated with that play—a case that is cumulatively pretty plausible, although still by no means certain—then this painting probably is as well. It may be characteristic of the Darius Painter that, rather than showing the usual Andromeda on the rock, he shows this unusual scene of her, now safely rescued, being asked for forgiveness by her own mother.

64

May well be related to an *Antigone* tragedy, possibly that by Euripides

Apulian amphora, ca. 350s
The Group of Ruvo 423
H: ca. 100 cm
Ruvo, Museo Jatta J423 (36734)[50]

WE DO NOT KNOW a lot about Euripides' *Antigone*. It was produced a good few years after Sophocles' famous play, and, knowing Euripides, we would expect it to have been provocatively different. This pot, which seems to point toward tragedy through its costumes and central porch, might be a plausible candidate for a reflection of this play. It all depends, however, on how you interpret the evidence given in an ancient commentary on Sophocles that "it was the same story [*mythopoiia*]" in Euripides, except that Haimon stole Antigone away and they had a son called Maion.[51] There were also ancient stories, possibly derived from Euripides, about Antigone and her son being concealed by shepherds but eventually handed over to Kreon. The disputed question is whether the same *mythopoiia* means exactly the same episode of the story—the narrative in which Antigone dies immediately after burying her brother—or the same set of characters, but not necessarily the same set of events.

Most of the characters in this painting are labeled. One conspicuous exception, however, is the richly clothed boy, who looks as though he should be Maion. An old woman (a nurse?) stands behind him; in front of him (with label) is his regal old grandfather, Kreon. Above them both, holding an open box (which might well have held recognition tokens), is Ismene, Antigone's sister.[52] On the other side of the central shrine is Antigone, her hands bound, escorted by a guard. Behind them, veiled in dejection, is Haimon. The central figure, who dominates the picture, is easily recognizable as Herakles, even without the inscription reportedly on the lintel of the "shrine." He looks very much the divine hero here, and one

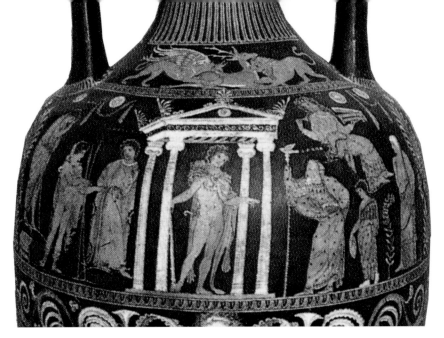

64

might well suppose that he has the role of the "god from the machine."[53]

There is a rather damaged amphora in Berlin that shows much the same story.[54] Antigone has been brought on bound again, but there both the boy and Herakles stand in between her and Kreon, who is enthroned and rather younger. Behind Kreon there is a soldier with a wreath, and a distressed young man, presumably Haimon. There is no suggestion on the Berlin vase of any divinity or transcendent status for Herakles—although the wreath may suggest some kind of victory or resolution.

It seems pretty likely to me that both these vases reflect an *Antigone* tragedy, but it is far from sure that this was Euripides' version, especially since there is no evidence that Herakles was a character in that play.[55] Some scholars have preferred to relate them to a fourth-century *Antigone*; they point to the evidence from an inscription that the famous Astydamas won with three plays, including an *Antigone,* in 341 B.C.[56] According to Trendall's dating, however, this Ruvo amphora should predate that first performance by a decade or more. Given that in Euripides' play Antigone and Haimon had a son, I am inclined to take the debatable reference to *mythopoiia* rather loosely, and to keep open the possibility that his *Antigone* is reflected here. If the love of Antigone and Haimon was somehow vindicated, then that might make the tragedy rather suitable for a funerary amphora.

65–66 *Antiope*

THIS COMPLEX AND EXCITING PLAY of revenge and rescue was very well known.[57] We had unusually numerous fragments (nearly fifty), even before a sizable papyrus was published in 1891, giving us much of the final scene (fr. 223). The play did not actually center on Antiope herself so much as on her twin sons fathered by Zeus, Amphion and Zethos. They will, according to this tradition, become the future founders of the great city of Thebes. The ideological debate between Zethos, the industrious man of action, and Amphion, the thoughtful artist, was already being quoted by Plato in his *Gorgias*.[58] The play is set in the area of Oinoe and Eleutherai, high on Mount Kithairon, the borderland between the territories of Athens and Thebes. Although Eleutherai was closely connected with the Athenian cult of Dionysos, the myth was, as far as we know, entirely Theban. It was in this remote spot that Antiope gave birth, and the sons have been reared by a kindly herdsman. She, meanwhile, has been the maltreated prisoner of the local king Lykos and his wife, Dirke. In the play Antiope escapes but is found out by Dirke, and is about to be cruelly punished when her maternal relationship with the two young men is somehow recognized. They take revenge on Dirke by tying her to the horns of a bull, which drags her to her death. They are then about to kill Lykos also, in order to escape punishment, when Hermes intervenes and predicts their future and the future of Thebes. This includes throwing Dirke's ashes into one of the two local rivers, which will thereafter bear her name.

Much of this plot was probably the invention of Euripides; no other Greek dramatized the story, as far as we know. Queen Dirke and her horrible death were likely his creation entirely.[59] This gory fate must have been reported in a vivid messenger speech, which included fragment 221: "Wherever it could twist around, it dragged along behind with it / the woman, boulders, branches, as it constantly rampaged about…" It was this narrative that especially appealed to later artists; we have three Western Greek vases showing the scene. Each is different in many respects, and together they make an interesting study in how tastes and narrative techniques changed between circa 400 and circa 320.[60]

The earliest of the three is by far the simplest, and the most brutal; were it not for the Euripidean myth and the later analogues, there would be no reason to connect the work with tragedy. This Lucanian pelike of circa 400 was one of the group of mythological vases found at Policoro in 1963.[61] Amphion and Zethos hold goads and cords; the terrified Dirke, with her clothing all awry and breasts bare, lies on the ground, clutching the bull's front leg with one hand and reaching up with the other in a plea

for mercy. Above her steps a very male bull. While the stony ground gives an idea of her imminent mutilation, there may also be a macabre suggestion of bestial rape. It is a shocking scene of violent revenge—and it does not need Euripides' tragedy to convey that. It does seem quite likely, however, that without any knowledge of the Euripides play, the viewer in circa 400 would not have been able to identify any of the particulars of the myth being narrated. And why, in any case, should this myth be thought suitable for the tomb of what was probably a wealthy local person? Cumulatively, the finds from this tomb suggest that she (or he) and her mourners had quite a taste for tragedy, and particularly for Euripides.

65

Plausibly related quite closely to the later scenes of Euripides' *Antiope*

Sicilian calyx-krater, ca. 380s
The Dirce Painter
H: 52 cm
Berlin, Antikensammlung,
Staatliche Museen zu Berlin
F 3296[62]

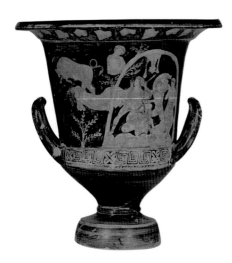

FOUND NEAR SYRACUSE in 1875, this pot gave its name to the Dirce Painter, whose workshop was to prove influential in the spread of red-figure vase-painting to Paestum and, more widely, to Campania. It is quite a skillfully and elaborately composed picture. Dirke and the bull are no longer central, but move away to the left. The trampling, the rocky ground, and the sexualized brutality are still there, however. Dirke is clearly already dead, her lolling head tangled with a broken branch (the white paint of the cords tying her to the bull's horns has not survived well).

The right-hand side of the picture is framed by an arch; the panther skin hanging above, the branches that grow from the arch, and the rocky floor all suggest some kind of primitive cave dwelling (compare Philoktetes' cave by the same painter on no. 26). This fits with the setting of Euripides' play: the shepherd's dwelling is referred to as both a home and a cave.[63] Within the arch the youthful twins (wearing tragic-style boots) have their swords drawn and cloaks flying, as they threaten Lykos, who has been brought to his knees (note his ornate sleeves and cross-banding). A woman—presumably their mother, Antiope—flees in alarm to the right. Finally, the central figure above is the upper half of Hermes, indicated by his *kerykeion* (nearly all the white paint is now lost).

All this is really quite close—in fact, unusually close—to the play as we have its text (somewhat damaged) in the papyrus fragment. The exact sequence within the fragment is as follows: Antiope and the twins go inside the cave just before Lykos arrives searching for her (17ff.).[64] The old herdsman persuades him to go inside, after sending away his bodyguards (57–73); very soon Lykos' cries are heard, and he is revealed at the mercy of the two young men (79ff.). As they (or one of them) tell Lykos that he can join his wife among the dead and can ask her who they are, Hermes intervenes to stop the slaughter at the last minute (96ff.). Lykos (at 133ff.) accepts all the god's commands, including giving up the

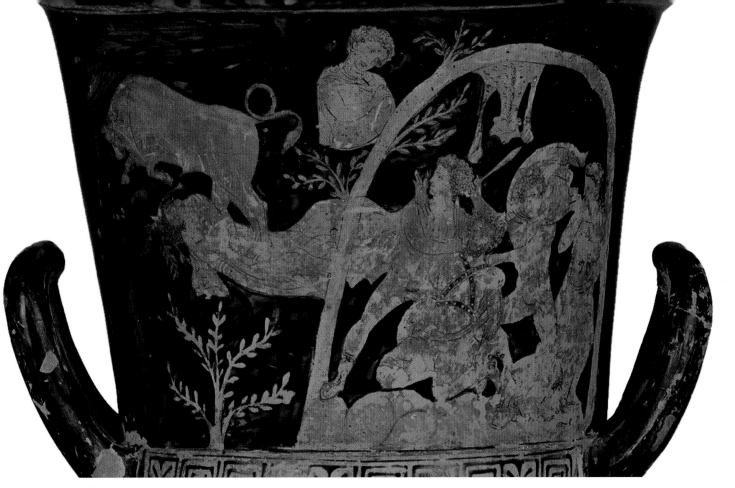

65

rule of the city to the two sons of Zeus and scattering his wife's ashes into what will become the Dirke River. The papyrus then stops shortly before the end of the play. There is no textual indication that Antiope was present during this final scene; presumably, the painter includes her because of her role in the story as a whole. Otherwise, the revelation of the near assassination in the cave mouth and the divine intervention of Hermes reflect the text closely. However the original was staged, this painting strongly suggests that in a production in Sicily the *ekkyklema* was used for the human scene (in which Lykos is revealed), and the *mechane*, the flying machine, for the epiphany of Hermes.[65] That is to say that the vase reflects contemporary performance practice. There is no reason why it should concern itself with Euripides' original staging, which may or may not have been the same.

While it does not hesitate to include both Antiope and the (reported) death of Dirke within the picture, this pot is, on the whole, unusually close to the theater. This closeness of vase-painting to performance may have been particularly cultivated in Sicily.

66

Related to the later scenes of Euripides' *Antiope*

Apulian calyx-krater, ca. 320s
Attributed to the Underworld
Painter
H: 66 cm
Melbourne, Geddes collection
A 5:4[66]

THIS POT, which is half a century later than number 65, recognizably tells the same story, though with significant differences of style and emphasis. While this later painting may have more obvious theatrical signals, it is in other ways more distant from the Euripides play.[67] Along with the multiplication of figures, the greatest difference is that while the Sicilian composition put the death of Dirke and the near murder of Lykos within the same compositional frame, here they are distinctly divided into two levels, both containing human and nonhuman figures. Thus the viewer must work out, for instance, that the dead woman at the bottom is the wife of the king at the top.

To take the upper level first: to the left of the central violent action are a Pan, marking the setting as wild, and an older and a younger female. Their calmness may suggest that they are gods, but there are no clear signals. At the right-hand end are Aphrodite and an attendant, perhaps Peitho (Persuasion); they probably signify Zeus' desire for Antiope. Amphion and Zethos are much as before (in no. 65). But Lykos (note scepter as well as regal outfit), instead of being in the mouth of the cave, is sitting like a suppliant on an altar. This does constitute a slight contra-indication against the Euripides play, but the introduction of this iconographic cliché is far outweighed by the positive signs. Distinctly unusual is the physical intervention by Hermes: he holds back one brother while he points his *kerykeion* at the other. This scene effectively conveys the urgency with which he steps in to stop the killing at the last minute. It is, however, quite different from the spatial relations of the theater—and of the Berlin krater. This physical involvement of the god is unusual for later Apulian painting.

The lower scene with the fate of Dirke shows some new features that derive from iconographic conventions, as well as others that seem to have drawn on the report in the play. To the left a young woman, not obviously explained, runs away. To the right is the little old man, a conventional *paidagogos* figure, who is often equated with the messenger. But since the old shepherd foster-father was actually a character in the play and spoke the prologue, in addition to helping in the plot against Lykos (see above), this is surely him (and his dog!). It is not impossible that he also acted as the messenger, but we do not have any clear evidence of this.[68] The prancing white bull is a great deal less bulky and frightening than the animal on the Policoro pelike, or even the one on the Berlin krater, but there are still the tell-tale cords hanging from its horns, which lead the eye to the horribly broken body of Dirke.

There are figures, not found in the other two vases, both in front of the bull and behind it. In front is a fairly typical winged Erinys figure, holding a whip (are there vestiges of a snake in her hair?); by this stage of

66

the fourth century, any vase narrative of a revenge story had to include an
Erinys. The male figure whipping the bull from behind is less standard.
He has snakes in his hair, wears an animal skin, and holds what looks
like a *lagobolon*. He seems, then, to be some sort of rural spirit of frenzy,
spurring on the bull. There is no reason to suppose that he or the Erinys
actually appeared onstage in the play; it is quite likely, however, that the
messenger said something figurative about the wild behavior of the bull
(see fr. 221, quoted on p. 187), and that this language suggested these fig-
ures to the painter.

There is one nice final touch to be registered. Near Dirke's feet lies a
tambourine, and beneath her is a thyrsus with a little bell attached—sym-
bols of Bacchic rites. We happen to have evidence that in Euripides'
Antiope Dirke came out to Eleutherai to celebrate rites of Dionysos, and
that she probably had with her a subchorus of fellow bacchants.[69] There
is even some disputed evidence that she was accused of wearing Bacchic

paraphernalia without the proper right to do so.[70] If, as all this seems to suggest, Dirke was a devotee of the important cult of Dionysos at Eleutherai, then she is not likely to have been presented as a pure villainess; and maybe Antiope was not untainted by the guilt associated with her horrific death. So, while much in this Melbourne krater is little more than elaboration of what can already be seen fifty years earlier, there is an extra element of religious complication, which is unlikely to have come from anywhere other than Euripides' play.

67

May be related to a tragedy of Danae on Seriphos, possibly Euripides' *Diktys*

Apulian volute-krater, ca. 360s
Attributed to the Ilioupersis
Painter
H: ca. 70 cm
Princeton University Art Museum
1989.40[71]

AN OLD MAN and a younger woman have taken refuge at an altar within a "portico edifice" signifying the Temple of Poseidon, as is explicitly marked by his statue. The indicators of a possible tragic connection are the costumes (especially sleeves) and the whole situation of suppliance. We can at least be sure of which myth is being narrated. Polydektes, king of the island of Seriphos, became enamored of Danae, who had been rescued there along with her infant son, Perseus. Once the boy had grown up, Polydektes sent him off to face Medusa, the Gorgon; in his absence Danae—protected only by Polydektes' brother, Diktys (who in some versions was a fisherman)—took refuge at "the altar."[72] Perseus rescued her on his return and turned the lustful Polydektes into stone. Clearly Polydektes is the king to the left here; Diktys is the old man reassuring Danae at the altar; and Perseus, with a "Phrygian cap" and his trademark sickle and Gorgon bag, approaches to the rescue.[73]

Above, to the left, are Aphrodite and Eros, while the two females to the right remain unexplained. It is tempting to think that they may reflect the chorus; but this pair is different from the more probably choral pair of maids on number 95 in two significant ways: they are on the higher, divine level, and they are not looking toward the human action. They are more likely to be marginal Nereids.[74]

Ioanna Karamanou has made a good case for relating this vase to Euripides' tragedy *Diktys*. We do know that the play was set on Seriphos, and that Diktys and Danae were characters (see fr. 332); and it probably dealt with the return of Perseus and the punishment of Polydektes. There may well have been other dramatizations of the story, but the tragedy that Euripides produced in the same year as *Medeia* (431) is likely to have been by far the most celebrated.

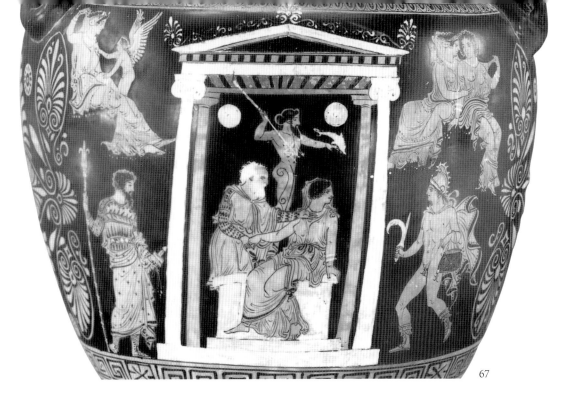

68

Very plausibly related to
Euripides' *Melanippe (the
Wise)*

Apulian volute-krater, ca. 320s
Attributed to the Underworld
Painter
H: 80.5 cm
Atlanta, Carlos Museum, Emory
University 1994.1[75]

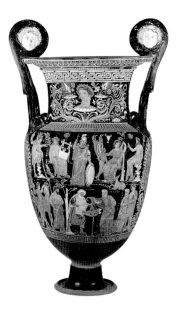

THIS WELL-CRAFTED, colorful, and intriguing piece goes some way
toward defending the Underworld Painter against Trendall's dismissive
remark that his subjects "cover a far less interesting and original range
than do those of the Darius Painter."[76] Although the upper gallery of calm
divinities takes up more than half the surface, it is the lower, human gal-
lery that captures the viewer's interest with unusual details and an effec-
tive portrayal of the characters' emotions.

Some of the names of those caught up in this story have grand genea-
logical associations, so it is a nice touch that the central figure of the entire
lower composition should be an anonymous old peasant, explicitly labeled
as such: BOTHP (Herdsman). Although his costume is more ornate than
the norm (and his boots are particularly splendid), he is clearly a typical
"little old man" (paidagogos). He shares the spotlight with the occupants
of the skin blanket-pouch that hangs from his stick: a pair of twin babies
with cute little bonnets. He is showing them with an anxious demeanor
to the fierce-looking old man, Hellen (ⱵΕΛΛΗΝ),[77] who in the standard
genealogies was the founding father of the Hellenes. On the other side of
the herdsman, separated off by a tree, stands the king Aiolos, son of Hel-
len, who gave his name to Aiolis (meaning Thessaly and Boiotia). To the
right-hand side is the young Melanippe, looking nervous, shielded protec-
tively by her old white-haired nurse, who is labeled as such—ΤΡΟΦΟΣ
(written vertically, which is unusual). The frieze is balanced to the left by
the only figure whose attention is not concentrated on the twin babies:
this is the young Kretheus, who is doing something very strange, namely
putting a garland on a horse that he is holding with his other hand.

The story of Melanippe and her twins was not told in many versions

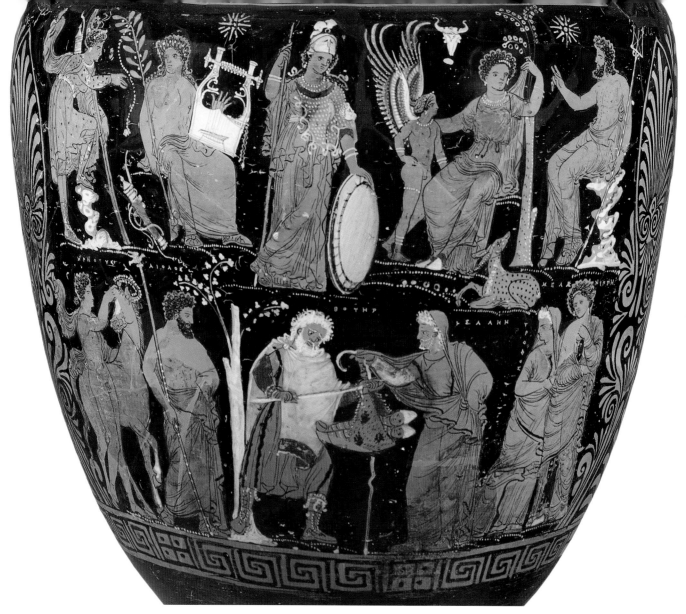

68

and was best known from the two *Melanippe* tragedies of Euripides, one
of them subtitled *the Wise*, and the other, *in Fetters*. The latter was set in
Western Greece and told of an episode in which the sons were young
adults;[78] it was *Melanippe (the Wise)* that told of the boys' infancy.[79]

This vase seems to be highly characteristic of tragedy-related paint-
ings, as is suggested most obviously by the typical figures of the nurse and
herdsman.[80] There are several pro-indications—and, as far as I can tell, no
contraindications—that the tragedy in question was Euripides' *Melanippe
(the Wise)*.[81] Although there are few fragments (and several fragments
attributed simply to *Melanippe* might belong to either play), we do fortu-
nately have part of an ancient plot summary and the first twenty-two lines
of the prologue spoken by Melanippe herself.[82] Between them, these two
sources tell us that her father was Aiolos and that her mother, daughter of
the Centaur Cheiron, has been transformed into an oracle in the form of a

horse called Hippo (or Hippe). Melanippe was impregnated by Poseidon, and, in fear of her father, gave the resultant twins to her nurse to put out in the cattle sheds, as Poseidon had instructed. Some of the cowherds saw the babies being reared by cattle and took them to be unnatural prodigies. They were taken to Aiolos, who, on the advice of Hellen, decided they should be incinerated. Melanippe dressed them in funereal wrappings before delivering a great speech in their defense, drawing on cosmogonic wisdom learned from her mother (fr. 484). It was this speech that earned her the title "the wise." The textual evidence does not take us far beyond that point, except that it may be safely supposed that the twins' true paternity and maternity were somehow revealed; and that they were given the dynastic names of Aiolos and Boiotos (fr. 489).

If we now turn to the question of what this vase may tell us about Euripides' *Melanippe (the Wise)*, we must always remember that we are on insecure ground and in the realm of suggesting rather than asserting. But since, for example, the old nurse had a part in the fate of the babies, it is more than likely that she had a speaking role in the play—and the vase confirms that. And since "some cowmen" saw the babies with the cattle and brought them to the king, it becomes very likely that one particular herdsman, our *boter*, actually did the talking; to judge from the portrayal, he expressed anxious concern for the babies. It is fairly plausible on the evidence that there was some tension between Aiolos and Hellen, and that Hellen was the more aggressive, as is again now confirmed by the picture. The irony is then that he wants to destroy the very grandchildren who are going to give their names to the future regions of Hellas.

And it must be beyond reasonable doubt that the crowned horse somehow represents Hippo—she is already being talked about in Melanippe's prologue (fr. 481, lines 13–22). It would seem that Kretheus was her son (contradicting some other versions), but that does not necessarily mean that he actually appeared or spoke within the play. Given her powers of prophetic wisdom, Hippo would be a good candidate for the deus ex machina. Her equine form might seem to be a serious obstacle, were there not a later catalogue of special masks that actually includes "Cheiron's daughter Hippe turned into a horse in Euripides."[83]

If Hippo delivered the "epilogue" speech, then it is unlikely that any of the gods in the upper frieze had a speaking role in the play. We do not know whether Artemis and Apollo (to the left) were even mentioned. Poseidon, to the right—sitting above his human beloved, Melanippe, but totally detached from her—was of course the father of the twins; and that alone is enough to justify Aphrodite and Eros. The most challenging figure is Athena, who stands, ornately caparisoned and central. It might be tempting to associate her with Athens as the metropolis of tragedy, a

kind of acknowledgment of the nursery of the genre. The chief problem with this idea is that Athena does not appear all that frequently in the tragedy-related vases—in fact, I suspect that she appears less frequently than Aphrodite or Apollo. It may be more to the point to recall the comparably central Athena on the Hippolytos vase (no. 42); her presence there apparently reflects the relevance, even though not central, of Athens to the play. Lines 9–11 of Melanippe's prologue might suggest something similar: she relates how another of Hellen's sons, Xouthos, went to "celebrated Athens" and there married Kreousa, who gave birth to Ion on the Acropolis. While this story is changed in Euripides' *Ion*, where Xouthos is only Ion's stepfather, it alludes to the same myth of Athens' association with Ionia through Ion. It may well be that this Athenian dimension was further mentioned toward the end of the play; but, even if this was the only reference, these lines, coming so near the beginning, make Athena's presence on the vase more than purely decorative.

69

Possibly related to Euripides' *Meleagros*

Apulian volute-krater, ca. 340s
Close to the Lycurgus Painter
H: 57 cm
Naples, Museo Archeologico
Nazionale 80854 (Stg. 11)[84]

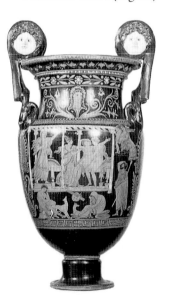

WE KNOW VERY LITTLE for sure about Euripides' *Meleagros* (probably a late play). There are bits of evidence that suggest that the plot covered rather too much material for one tragedy: preparations for the hunt of the monstrous boar that was ravaging Kalydon; the hunt itself; Meleagros' infatuation with the virginal huntress Atalante; his award of the boar's hide to her; the opposition of his maternal uncles; Meleagros' murderous response; the revenge by his mother, Althaia, who extinguishes his life flame and so brings about his death; and finally, her suicide. The fragments do make it quite clear that disputes between Meleagros, Althaia, and Atalante about the suitability of the love match were an important element.

Largely because of the lack of any detailed corroboration, there are no vase-paintings that can be connected to this play with any confidence. There are four paintings by an early fourth-century Attic painter, known as the Meleagros Painter, that show Atalante and other hunters, apparently before the hunt.[85] But their ornately patterned hunting "shorts" are the only indicators of any possible tragic connection. There are two Western Greek paintings that are rather suggestive of a particular play, whether or not that by Euripides. One is the upper frieze of an amphora by the Darius Painter,[86] in which Meleagros—in the center, wearing a sun hat and fancy boots—is handing over the boar pelt to a seated Atalante, who wears quite an elaborate huntress costume, including cap, ornate sleeves, and boots. Eros hovers above, and Aphrodite shows interest behind Atalante; to the right are two attendant huntsmen. Thus far there is nothing apart from the inconclusive costumes to associate this scene with tragedy.

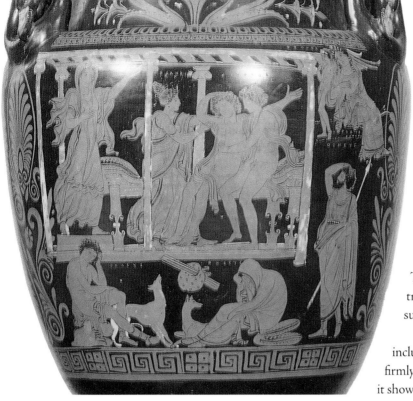

69

To the left, however, we have two tell-tale figures: an Erinys with a torch, and a kind of paidagogos figure, although he is rather younger than usual and wears a sun hat. These are prima facie indicators of the story of revenge that lurks behind the romantic scene, and of the well-disposed witness-messenger. Thus this pot might reflect Euripides' tragedy, although this remains far from sure.

This striking Naples krater is included not so much because it can be firmly connected with Euripides as because it shows an intriguing scene of high pathos, with a range of labeled characters, and the main scene is happening within an interesting architectural edifice. Quite a few Western Greek mythological paintings include a central shrinelike edifice, which is common in funerary art of this period and is arguably "stagey" (see pt. 1, sec. M3). Generally speaking, the structures are higher than they are wide and have a portico above; they do not normally take up much of the picture's total space. So this long "room" here, which has both a floor and a ceiling, and which leaves only a narrow band on two sides, is distinctly unusual. Trendall compares it with the Herakles scene on number 45, in which "the background to the scene on the vase seems to be definitely of stage inspiration."[87] In this painting, however, the main action is taking place inside the edifice, not outside of it. Given that tragic messenger speeches so often tell of terrible and violent events that have happened inside the palace, this work might be a painter's attempt to convey a scene that was reported in a messenger speech in the play.

All the figures on this vase are given name labels, except for the two main characters, who apparently do not need identification. The young man who is collapsing on the couch, evidently in his death throes, must be Meleagros; he is being tended by his siblings, Deianeira and Tydeus. The woman rushing up on the left with a gesture of alarm must be Althaia: she seems to be regretting the extinguishing of her son's life, but too late. A scene like this might well have been reported in Euripides' *Meleagros*, in which Althaia was a major character, and in which Tydeus probably also had a role.[88] The two figures who mourn at the bottom of the scene, Peleus and Theseus, are unlikely, however, to have been speaking char-

acters; they are marked simply as fellow huntsmen by their dogs and the bundle of nets and stakes used in boar hunting. To the lower right stands Oineus, Meleagros' father, with a gesture of sorrow.

Lastly, rather squeezed into the upper-right corner is Aphrodite, along with a winged boy. She is not the usual uninterested deity, for she looks down wistfully at Meleagros, no doubt in regret for the unhappy conclusion to his love for Atalante. We would have unhesitatingly taken the winged boy simply to be Eros, were he not given a name label: ΦΘΟΝΟΣ, "Phthonos," which means "Envy" or "Jealousy." This variant on a highly conventional iconography conveys with an effective twist how this love story has been utterly spoiled by Althaia's jealousy against Atalante and her own son.[89] One needs an attentive—and literate—eye to appreciate this touch. While the figure makes good sense in purely pictorial terms, it could also owe something to a tragic text, as the trope of "good has been turned into harm" is common in tragedy. Did Euripides' play, perhaps in a chorus, contain something about desire being blighted by jealousy?

70

Possibly related to Euripides' *Oineus*

Paestan hydria, ca. 340s
Attributed to Python
H: 44 cm
London, British Museum F155[90]

THE COSTUMES AND THE SINISTER ERINYS emerging from the ground are both suggestive of tragedy, but by this period both may be such standard features of mythological vase-painting that they do not constitute definite signals. The narrative is striking but not obviously recognizable, and it is unlikely that anyone would have rightly conjectured it without the inscription (no longer visible) that identified the figure on the altar as ΑΓΡΙΟΣ, "Agrios."[91]

The story of Oineus was that the aged king had been dethroned and humiliated by Agrios and his sons. When Oineus' grandson Diomedes returned from the wars, he restored his fortunes and took bloody revenge. The armed young man in the center must be Diomedes, and the sad-looking old man, Oineus; the woman might be his wife, Periboia. *Oineus* was one of Euripides' notorious "kings-in-rags" plays, so if the painting is related to the play, the incident it depicts took place after he was rescued and reinstated. Agrios in this picture is sometimes described as a "suppliant" at the altar, but that does not fit with his bound hands and immobility: he is more like a sacrificial victim who has been placed there. It looks as though Diomedes may be offering Oineus the option of being the one to cut Agrios' throat—potentially a sacrilegious deed in this sacred space? If that interpretation is right, this scene could hardly have been enacted onstage.

The Erinys, as always, marks a story of punishment and revenge. Two things are of special interest about her. One is that she seems to be emerging from the ground, suggesting her chthonic nature; the other is

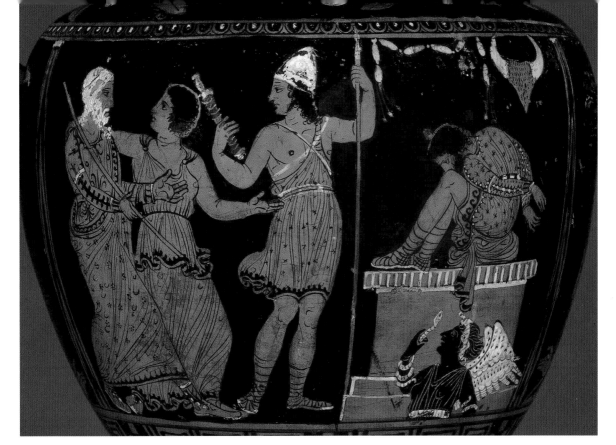

70

that she has both black robes and black skin—the color is accentuated by the contrast with her wings and snakes. Although there are references in Aeschylus' *Oresteia* to the Erinyes having black cloaks or skin, it is very rare to find this reflected pictorially (see nos. 7 and 9 above). If this picture does indeed evoke Euripides' play, then it is possible that there was something in that text that suggested this unusual representation to the painter (but that is a big "if"!).

71

Possibly related to Euripides' *Oinomaos*

Apulian situla, ca. 360s
Attributed to the Painter of Athens 1714
H: 27 cm
Rome, Museo Archeologico Nazionale di Villa Giulia 18003[92]

IT WAS A FAMOUS STORY: Oinomaos challenged all comers to a chariot race for the hand of his daughter, Hippodameia, and Pelops from Asia Minor eventually succeeded by enlisting the treacherous charioteer Myrtilos and then killing him. The story was quite a favorite with the Apulian vase-painters, who narrate both the lead-up to the race and the race itself.[93] Several of the vases are mildly suggestive of tragedy through their actions and costumes, and four of them include an Erinys;[94] but, as far as I know, the truth is that we have no good reason to relate any of them to any particular tragedy. Although both Sophocles and Euripides produced an *Oinomaos*, we know very little detail about either. I have included this Villa Guilia situla because it has the most interesting collection of features, but there is no particular reason to connect it to Euripides rather than Sophocles, if indeed it had any significant connection with either.[95]

There are five such paintings, showing Proitos handing over the letter to Bellerophon in the presence of a woman who must be Stheneboia. We know that her lust and its rejection were important early in the play (frs. 661–65); if she was present in a scene in which Proitos believes that he is sending Bellerophon to his death, this would have made for a tense piece of theater. It is interesting that the letter as a physical object attracts particular attention, as it did in the representations of *Iphigeneia (among the Taurians)* (see p. 44). It was evidently felt to be a small but powerful stage object, packed with potential significance.

72

May well be related to a scene early in Euripides' *Stheneboia*

Apulian stamnos, ca. 400
Attributed to the Ariadne Painter
H: 30 cm
Boston, Museum of Fine Arts
1900.349[98]

THIS PAINTING IS RELATIVELY EARLY (390 at the latest); in fact, there is an even earlier, but less interesting, pot with the same composition of figures.[99] To the right Pegasos is raring to go; Bellerophon has just at this moment taken the life-threatening letter in his hand. Proitos, with his showy scepter, stays calm, but there is a subtle hint of unease conveyed by the reassuring hand that Stheneboia lays on his arm.

There is a further feature of this painting, which has not, I think, received the attention that it deserves: the doorway from which Stheneboia is emerging. Why should that be included when it does not apparently contribute anything to the visual narrative? A possible answer—and a plausible one, it seems to me—is that it alludes to the door of the theater *skene*, which was such an important threshold in many scenes of tragedy.[100] It would unobtrusively nudge the viewer to think of tragedy. If this suggestion is correct, the play can hardly be other than Euripides' *Stheneboia*.

72

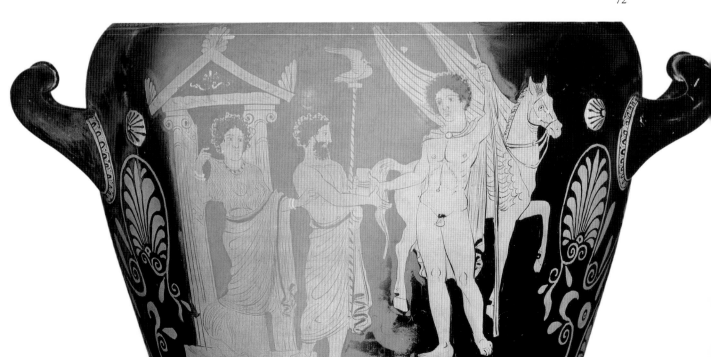

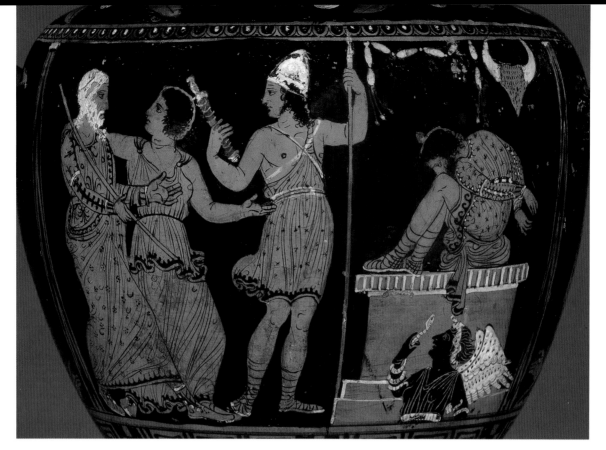

70

that she has both black robes and black skin—the color is accentuated by the contrast with her wings and snakes. Although there are references in Aeschylus' *Oresteia* to the Erinyes having black cloaks or skin, it is very rare to find this reflected pictorially (see nos. 7 and 9 above). If this picture does indeed evoke Euripides' play, then it is possible that there was something in that text that suggested this unusual representation to the painter (but that is a big "if "!).

71

Possibly related to Euripides' *Oinomaos*

Apulian situla, ca. 360s
Attributed to the Painter of
Athens 1714
H: 27 cm
Rome, Museo Archeologico
Nazionale di Villa Giulia 18003[92]

IT WAS A FAMOUS STORY: Oinomaos challenged all comers to a chariot race for the hand of his daughter, Hippodameia, and Pelops from Asia Minor eventually succeeded by enlisting the treacherous charioteer Myrtilos and then killing him. The story was quite a favorite with the Apulian vase-painters, who narrate both the lead-up to the race and the race itself.[93] Several of the vases are mildly suggestive of tragedy through their actions and costumes, and four of them include an Erinys;[94] but, as far as I know, the truth is that we have no good reason to relate any of them to any particular tragedy. Although both Sophocles and Euripides produced an *Oinomaos*, we know very little detail about either. I have included this Villa Guilia situla because it has the most interesting collection of features, but there is no particular reason to connect it to Euripides rather than Sophocles, if indeed it had any significant connection with either.[95]

There are five such paintings, showing Proitos handing over the letter to Bellerophon in the presence of a woman who must be Stheneboia. We know that her lust and its rejection were important early in the play (frs. 661–65); if she was present in a scene in which Proitos believes that he is sending Bellerophon to his death, this would have made for a tense piece of theater. It is interesting that the letter as a physical object attracts particular attention, as it did in the representations of *Iphigeneia (among the Taurians)* (see p. 44). It was evidently felt to be a small but powerful stage object, packed with potential significance.

72

May well be related to a scene early in Euripides' *Stheneboia*

Apulian stamnos, ca. 400
Attributed to the Ariadne Painter
H: 30 cm
Boston, Museum of Fine Arts
1900.349[98]

THIS PAINTING IS RELATIVELY EARLY (390 at the latest); in fact, there is an even earlier, but less interesting, pot with the same composition of figures.[99] To the right Pegasos is raring to go; Bellerophon has just at this moment taken the life-threatening letter in his hand. Proitos, with his showy scepter, stays calm, but there is a subtle hint of unease conveyed by the reassuring hand that Stheneboia lays on his arm.

There is a further feature of this painting, which has not, I think, received the attention that it deserves: the doorway from which Stheneboia is emerging. Why should that be included when it does not apparently contribute anything to the visual narrative? A possible answer—and a plausible one, it seems to me—is that it alludes to the door of the theater *skene*, which was such an important threshold in many scenes of tragedy.[100] It would unobtrusively nudge the viewer to think of tragedy. If this suggestion is correct, the play can hardly be other than Euripides' *Stheneboia*.

72

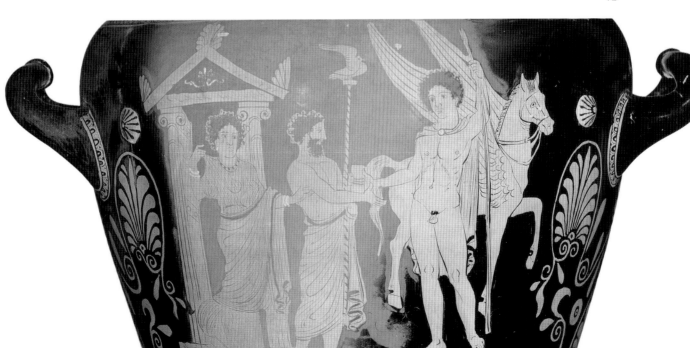

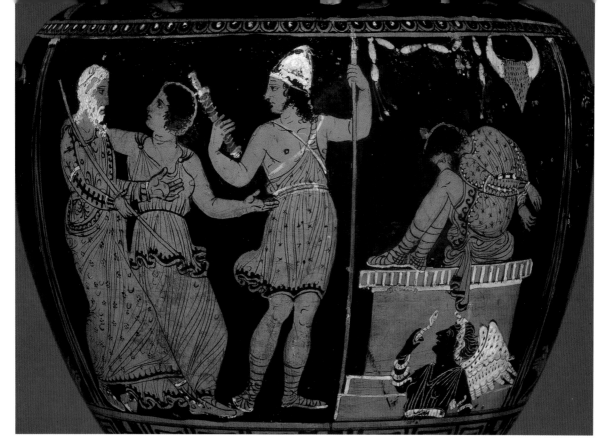

70

that she has both black robes and black skin—the color is accentuated by the contrast with her wings and snakes. Although there are references in Aeschylus' *Oresteia* to the Erinyes having black cloaks or skin, it is very rare to find this reflected pictorially (see nos. 7 and 9 above). If this picture does indeed evoke Euripides' play, then it is possible that there was something in that text that suggested this unusual representation to the painter (but that is a big "if"!).

71

Possibly related to Euripides' *Oinomaos*

Apulian situla, ca. 360s
Attributed to the Painter of Athens 1714
H: 27 cm
Rome, Museo Archeologico Nazionale di Villa Giulia 18003[92]

IT WAS A FAMOUS STORY: Oinomaos challenged all comers to a chariot race for the hand of his daughter, Hippodameia, and Pelops from Asia Minor eventually succeeded by enlisting the treacherous charioteer Myrtilos and then killing him. The story was quite a favorite with the Apulian vase-painters, who narrate both the lead-up to the race and the race itself.[93] Several of the vases are mildly suggestive of tragedy through their actions and costumes, and four of them include an Erinys;[94] but, as far as I know, the truth is that we have no good reason to relate any of them to any particular tragedy. Although both Sophocles and Euripides produced an *Oinomaos*, we know very little detail about either. I have included this Villa Guilia situla because it has the most interesting collection of features, but there is no particular reason to connect it to Euripides rather than Sophocles, if indeed it had any significant connection with either.[95]

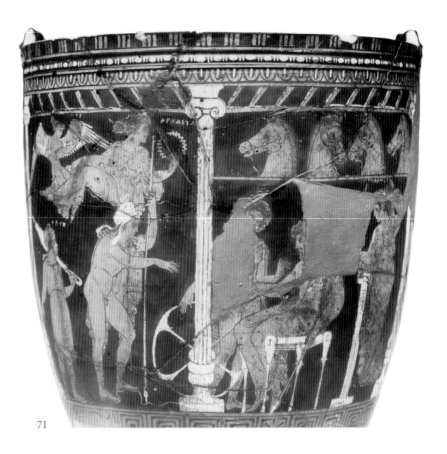

71

This is one of those scenes set inside an architectural edifice, and this may in itself prompt a connection with tragedy. The column down the center bisects the picture rather awkwardly, and the four horses of the racing team looking over a kind of stable door are rather charming, but they are not an example of great pictorial composition. Below them sits the king Oinomaos; behind him, slightly alienated by a smaller column, is Hippodameia.[96] In front of him the charioteer Myrtilos is portrayed, as is usual, holding a wheel: this is a reminder that he will dispatch Oinomaos by misfitting a hub. On the left of the column stands Pelops, heroically naked but for his boots, cloak, and Oriental cap. Behind him is a servant labeled ΦΡΥΞ, "Phrygian," signifying that he comes from Pelops' home- land (strictly Lydia but often subsumed under the rough area of Phrygia). The labeling of anonymous figures is quite rare and, in at least some cases, indicates their role within a tragic narrative (see pt. 1, sec. M5). If this vase is to be related to a tragedy, then the inscription might suggest that a nameless Phrygian had a speaking part. Finally, above Pelops is Aphrodite with Pothos, or "Longing"—Eros by another name. Aphrodite holds a crown, which is a symbol of Pelops' victory both in love and in the chariot race. There is nothing here in the end, then, that points strongly to tragedy; but the architectural setting and the anonymous Phrygian are unusual touches that might be there partly to remind the viewer of a par- ticular tragic version of the story.

72–74 *Stheneboia*

THE STORY OF STHENEBOIA'S illicit love for Bellerophon, and of her punishment, was a favorite among Western Greek artists in the fourth century. Recent additions have brought the tally up to about twenty paintings of various incidents, on vessels large and small, from a variety of areas and spread across the duration of red-figure painting in the region.[97] There are the usual problems about assessing which of these pictures—if any—are related to Euripides' play, *Stheneboia*, and how. It is significant, however, that this story was not featured in earlier vase-painting and then became popular in the fourth century; also that we do not know of any fifth-century narratives of the story, apart from Euripides' play. *Stheneboia* was probably produced around 430; innovating from any previous version, it probably added Pegasos to the tale and changed Stheneboia's fate. The play became notorious for its portrayal of adulterous lust. Thus there is at least a prima facie case for supposing some influence on the vases from the tragedy.

We are told quite a lot about Euripides' tragedy thanks to a plot summary and several fragments. Between them, however, we have what seems to be too much material, spread over too long a time span, to have been included within a single tragedy. The plot summary covers the following sequence of events: Bellerophon is a guest of Proitos, king of Tiryns; Proitos' wife, Stheneboia, has fallen in love with him. When rejected, she makes false accusations against him, and Proitos sends Bellerophon off to his father-in-law, Iobates, in Caria with a sealed letter asking him to get rid of the young man. He survives being sent against the monster Chimaira, however, and returns to Tiryns, only to be plotted against once more. This time he deceives Stheneboia, takes her off on the winged horse Pegasos, and then drops her in the sea off Melos. Fishermen return her body to Tiryns, and Bellerophon finally explains to Proitos how he and his wife have been justly punished. Even allowing for Pegasos' supernatural speed, and for Greek tragedy's generally flexible handling of time, this seems too much to contain within a single play. Those events would require one or even two explicit lapses of time. While it is not totally impossible that Euripides included such lapses, it would have been contrary to the usual conventions (the "unity of time"). Alternatively, it is possible that the play began during Bellerophon's second stay at Tiryns, although this is hard to reconcile with the opening thirty lines of the prologue, which are preserved (fr. 661). Also, for what it is worth, the departure of Bellerophon with the treacherous letter is a favorite scene with the vase-painters.

There are five such paintings, showing Proitos handing over the letter to Bellerophon in the presence of a woman who must be Stheneboia. We know that her lust and its rejection were important early in the play (frs. 661–65); if she was present in a scene in which Proitos believes that he is sending Bellerophon to his death, this would have made for a tense piece of theater. It is interesting that the letter as a physical object attracts particular attention, as it did in the representations of *Iphigeneia (among the Taurians)* (see p. 44). It was evidently felt to be a small but powerful stage object, packed with potential significance.

72

May well be related to a scene early in Euripides' *Stheneboia*

Apulian stamnos, ca. 400
Attributed to the Ariadne Painter
H: 30 cm
Boston, Museum of Fine Arts
1900.349[98]

THIS PAINTING IS RELATIVELY EARLY (390 at the latest); in fact, there is an even earlier, but less interesting, pot with the same composition of figures.[99] To the right Pegasos is raring to go; Bellerophon has just at this moment taken the life-threatening letter in his hand. Proitos, with his showy scepter, stays calm, but there is a subtle hint of unease conveyed by the reassuring hand that Stheneboia lays on his arm.

There is a further feature of this painting, which has not, I think, received the attention that it deserves: the doorway from which Stheneboia is emerging. Why should that be included when it does not apparently contribute anything to the visual narrative? A possible answer—and a plausible one, it seems to me—is that it alludes to the door of the theater *skene*, which was such an important threshold in many scenes of tragedy.[100] It would unobtrusively nudge the viewer to think of tragedy. If this suggestion is correct, the play can hardly be other than Euripides' *Stheneboia*.

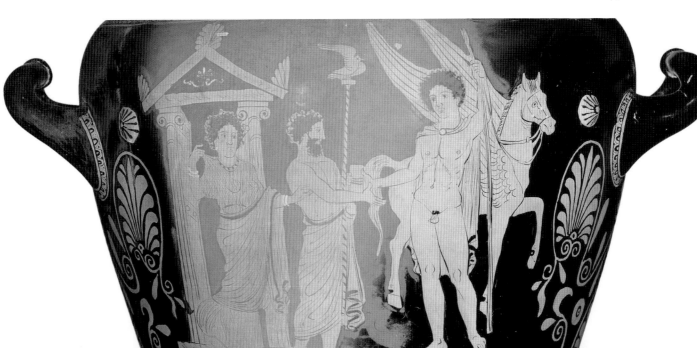

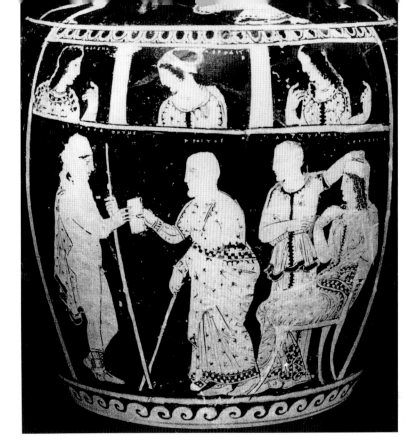

73

73

May be related, but not closely, to Euripides' *Stheneboia*

Paestan hydria, ca. 340s
Signed by Assteas
H: 62.7 cm
Paestum, Museo Archeologico
Nazionale 20202[101]

IN SOME WAYS THIS PICTURE is closer to the theater than the other examples of this iconography, but in others it is more distant. The clearest theatrical signal is the ornamentation of the costumes, most extremely Proitos' sleeves. There are also three figures in "windows" above, which are quite like the Assteas Herakles krater (no. 45), though the architecture there is more explicitly stagelike. These features do not in themselves prove any theatrical connection, but they make a strong case when taken in combination with the other examples of this scene (such as no. 72), which strongly suggest that it was Euripides who made this story popular in Western Greece.[102]

As in most of the pictures, the painter has caught the tense moment in which the letter changes hands; again this is in the presence of Stheneboia. She is being reassured by her nurse, who—we know from the prologue (fr. 661, lines 10–14)—acted as a go-between (as in *Hippolytos*). Assteas gives her the name label "Astyanassa" (ΑΣΣΤΥΑΝΑΣ[). It is extremely unlikely that she had any name in Euripides' play. As Moret says,[103] the artist is probably being "overzealous" with his name labels; but I do not think that need mean, as he supposes, that there is no connection whatsoever with Euripides. The same is true for the three figures above: Aphrodite, between two Erinyes, one named Alekto.[104] While they are all highly appropriate to the story of lust and revenge, there is no reason to suppose that any of them actually figured directly in the play. It is likely that the naming of the Erinyes is the zealousness of Assteas once again.

Finally, there is no Pegasos here, although he is found in all other pictures of the scene. This has led to the general assumption that Bellerophon had the horse with him onstage for the letter scene in Euripides, however that was staged.[105] The flying machine (*mechane*) was popular in the fourth century, and it seems likely that the audiences in Paestum would have relished it. If the *mechane* was used to introduce Pegasos, then that is yet another way in which this vase has departed from the original version of the play. So while Moret goes too far in totally rejecting any "literary origins" for this vase, he is right to point to the disjunctions as well as conjunctions.

74

Possibly related to Euripides' *Stheneboia*, but only remotely

Apulian calyx-krater, ca. 330s
Attributed to the Darius Painter
H: 57.8 cm
Fort Worth, Kimbell Art Museum
15[106]

OTHER ADVENTURES OF BELLEROPHON were also popular in Western Greek vase-painting, especially his arrival at the court of Iobates in Lykia, and his battle with the Chimaira.[107] As Bellerophon arrives on Pegasos, the letter again features on several vases, in a kind of mirror reflection of the departure from Proitos. Since Euripides' *Stheneboia* was set in Tiryns, this episode, if it was recounted at all, would have been in a messenger speech or reported by Bellerophon himself. We know that he did recount his battle with the Chimaira (fr. 665a).

This vase has been selected from the paintings of the arrival in Lykia for two reasons: one is the tragedy-type costumes, especially that of the king, and the other is the image of Bellerophon and Pegasos sailing through the sky much to the amazement of those on the ground. This kind of configuration, which is already found as early as the New York Europa (no. 14), seems likely to owe something to the use of the flying machine in the theater. The machine was very probably used in *Stheneboia*, which may thus have influenced this composition. This theory is a long shot, however, and it fails to explain the woman who is running away in alarm: she seems to be too integral to the narrative to be merely an anonymous attendant. There is, however, no problem with the inclusion of Poseidon, since he was Bellerophon's father, and his son has just come flying over his domain.

There is a more dramatic and unusual Bellerophon scene that also includes Poseidon, on an early Apulian amphora (ca. 420s), excavated at Gravina in 1974.[108] Bellerophon looks down from Pegasos as Stheneboia falls headlong into the sea (which contains various marine life). On one side are Aphrodite and Eros, who are in some ways the losing gods in this story, and on the other Poseidon and a triton (decoratively costumed). This scene might possibly owe something to Euripides' still-recent play, but that remains a remote speculation on present evidence.

74

75–78 *Telephos*

IF ALLUSIONS IN ARISTOPHANES are anything to go by, then
Telephos, first produced in 438, may well have been Euripides' best-known
play.[109] Not only are there frequent references, there are extensive paro-
dies in both *Acharnians* of 425 and *Women at the Thesmophoria* of 411. This
strongly suggests that *Telephos* was a favorite for reperformance, as the
parodies would have been largely lost on audiences who had not seen it.
We also have no fewer than five separate ancient papyri of this play, and
more plays called *Telephos* were produced in the fourth century. Aeschy-
lus and Sophocles also produced plays with this title, but it seems, as
usual, to have been Euripides who dominated perceptions of the story's
dramatization.

The vase-painter's favorite is the hostage scene, the very one that is
parodied at length in Aristophanes—which can hardly be coincidental.[110]
Briefly, Euripides' story is as follows: Telephos was a son of Herakles who
had become king of Mysia, in Asia Minor. In a false start to the Trojan
expedition, he had been wounded in the leg by Achilles; following an
oracle from Apollo saying that he could be cured only by the one who had
wounded him, he came disguised as a beggar to Argos. In order to ensure
that he is given a hearing, he seizes the infant Orestes and, taking refuge
at an altar, threatens to kill him.[111] His desperate persuasiveness succeeds
in the end; he is cured and undertakes to guide the Greeks to Troy. We
know from art that Euripides was not the first to make Telephos a sup-
pliant with the child;[112] but it is only after Euripides that the incident
becomes violent, with Agamemnon threatening force and Klytaimestra
trying to restrain him. The notion that this hostage scene at the altar hap-

pened offstage and was reported by a messenger has been surprisingly widely entertained—surprisingly because it is so unlikely that Aristophanes would physically parody an incident, even quoting lines from it, that had been only reported and not seen.[113]

75

Related to the hostage scene in Euripides' *Telephos*

Attic calyx-krater, ca. 400–375
Not attributed by Beazley
H: 50 cm
Berlin, Antikensammlung,
Staatliche Museen zu Berlin
VI 3974[114]

THIS IS ANOTHER CASE of a single Attic example having quite close analogies with a Western Greek iconography, and the question arises of which influenced which. This painting even includes the pose of "kneeling on the altar," which is so familiar in Western Greek painting.[115] As is usual, Telephos (note his boots) has his sword in one hand and the child held in the other arm. Agamemnon runs up with his spear (or scepter?); Klytaimestra is on the other (left) side of the altar, turning around as she runs away.[116] The unusual feature in this particular piece is the emphasis on the sanctuary of Apollo. Elsewhere the cult of the altar is not specified, whereas here we see a laurel tree with votive tablets and Apollo himself sitting above.[117] As already noted, Telephos had traveled in response to an oracle from Apollo, and in one fragment (700) he calls on Apollo. So it may well be that the god was sufficiently invoked in the play to give the painter the idea of including him and his cult signs.

75

76

Plausibly related to
the hostage scene in
Euripides' *Telephos*

Lucanian calyx-krater, ca. 400
Close to the Policoro Painter
H: 51.4 cm
Cleveland Museum of Art
1999.1[118]

THIS PAINTING, our earliest representation of the hostage scene as
violent, has the spectacular Medeia sunburst scene (no. 35) on the other
side. This is not the only pot for which it might be claimed that both sides
show scenes that are related to tragedy, but it is by far the most likely.[119]
And it may even be significant that both plays are by Euripides, and that
both include in some sense the "exploitation" of children.[120]

Telephos is "heroically" nude except for his bandage. Agamemnon,
who draws his sword with a sweeping movement, has a defensive cloak
wrapped around his other arm, a pair of ornate boots, and nothing else
(these boots are arguably a signal of theatrical connection). Klytaimestra
rushes up behind him with her arms held out in a gesture that mirrors
that of the little Orestes. Although more simple and less nuanced than
the *Medeia* scene on the other side, this vigorous painting strongly evokes
a moment that by 400 B.C. was probably already regarded as one of the
most memorable episodes in Euripidean tragedy.

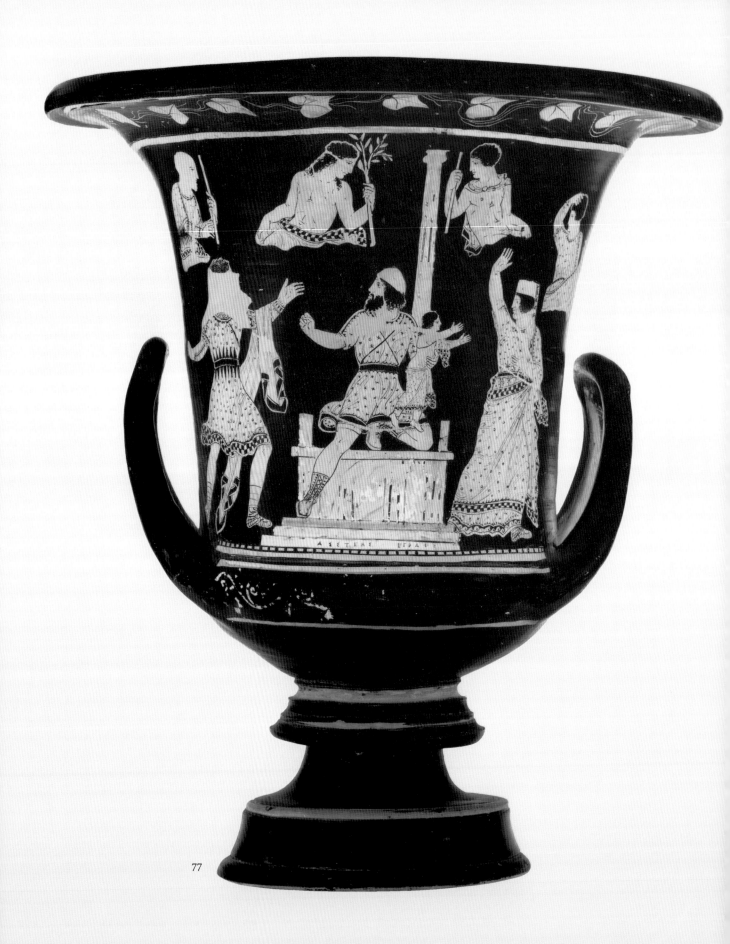

77

77

Plausibly related to the hostage scene in Euripides' *Telephos*

Paestan calyx-krater, ca. 340s
Signed by Assteas
H: 56.5 cm
San Antonio Museum of Art
86.134.167[121]

THIS LIVELY YET NOT OVERCROWDED PIECE, proudly signed by Assteas on the altar, seems to have "theater" written all over it, through both the melodramatic situation and the ornate costumes (and even boots); this connection is confirmed by the familiar Telephos iconography. There are, however, some unexpected figures above the main scene. All are labeled, though the white paint has been badly abraded—as it has on the sword in Telephos' hand and the tripod on top of the pillar.

Telephos' *pilos* and short robe are not typical, but short robes like this recur elsewhere in Paestan paintings and might possibly reflect the fashion in theater costumes in Paestum.[122] But the bandaged leg, the raised sword, and the little Orestes holding out his arms to his mother are all mainstream features. This is true also of Agamemnon approaching threateningly, and Klytaimestra retreating in horror, turning her back.[123] So far so good. Of the figures above, Apollo, who looks down with interest, is straightforward and was seen in quite a similar placement on the Attic krater 75. Hermes may be there simply as Apollo's brother, or he may evoke the element of travel and subterfuge in the story.[124] The other two figures are more surprising. First there is the white-haired old man at the top left, who is identified as the seer of the Greek expedition, Kalchas. It is interesting to note that, like Teiresias in number 58, the prophet is placed on the superhuman rather than the human level. We have no trace of the participation of Kalchas in any of the fragments or testimonia for Euripides' *Telephos*. A skeptic might seize on this to argue that some other version of the story is being reflected here; but that runs against the main iconography. It is not, in any case, out of the question that Kalchas made a speech in *Telephos*, resolving the impasse that had been reached; and it is quite likely that he was at least referred to.

The most puzzling figure, however, is not so much Kalchas as the female to the right, slightly below the level of Apollo and Hermes and represented, like them, as a half figure. She has long sleeves and an ornate costume (like Kalchas), and she seems to be responding with strong emotion. Her label says ΘΡΙΣΑ, "Thrisa," an otherwise unknown name. She might be Orestes' Thracian nurse, a slave called "Thraissa"; but her positioning suggests that she is not a mundane human. She remains an enigma. It is conceivable that she is nothing more than a figment of Assteas' zeal for name labels (see no. 73).

78

May well be related to a *Telephos* tragedy, probably not that of Euripides

Apulian volute-krater, ca. 310s
Attributed to the White Sakkos Painter
H: 110 cm
Geneva, Sciclounoff collection, unnumbered[125]

AFTER THE HEYDAY of the Darius and Underworld Painters in the 340s and 330s, the tradition of monumental mythological paintings continued for a while in Apulia, particularly in the North, it seems. A considerable number of works have come to light recently, especially by the Baltimore and White Sakkos Painters, who—while not as fine as the previous generation of artists—were by no means despicable. This huge volute-krater has a separate mythological scene on the neck;[126] on the main body, seven young warriors are preparing to arm, positioned around the central portico—presumably all Greeks about to set out for Troy. Only the figure in the middle left, with his foot on an Ionic column, is paying attention to the central action; he is likely to be Agamemnon. At this late period, any mythological scene—theater-related or not—may have some features that earlier would have been likely signals of theater, such as the portico and ornate costumes and boots. Nonetheless, this particular scene has a dramatic tension about it suggestive of a play—we simply cannot be certain.

Telephos reclines on a rich couch, supporting his bandaged leg at ease. He is holding an unusually elaborate lance with the point directed down toward himself. There can be no doubt that this is the spear of Achilles, which wounded him in Mysia and is destined to be the means of his cure. A young man stands before him as a prisoner with his arms bound behind his back. The third figure seems to have the task of being the guard and is looking to the leading outside warrior as if for reassurance. This makes me wonder whether the prisoner might be Achilles after he has put up resistance to handing over his spear.[127] In this version perhaps Agamemnon had to have him arrested in order to secure his compliance? It might seem unlikely that Achilles would submit to this, but in a tragedy he need not have been as fearsome and independent a figure as in the *Iliad*.[128]

It is generally accepted that Achilles was a character in Euripides' *Telephos*. There is a papyrus fragment (727c) in which he arrives to join the Greek army and complains to Odysseus about their prevarication. It has been conjectured that other fragments come from a scene or scenes in which Achilles is urged to help after he resists the idea of benefiting a barbarian.[129] But there is nothing to suggest that he had to be "arrested" in order to force the handing over of his spear. Therefore, while this painting might be reminiscent of Euripides' tragedy, it probably tells another version of the Telephos story. We know that there were other *Telephos* tragedies, and this vase might well reflect one of them.[130]

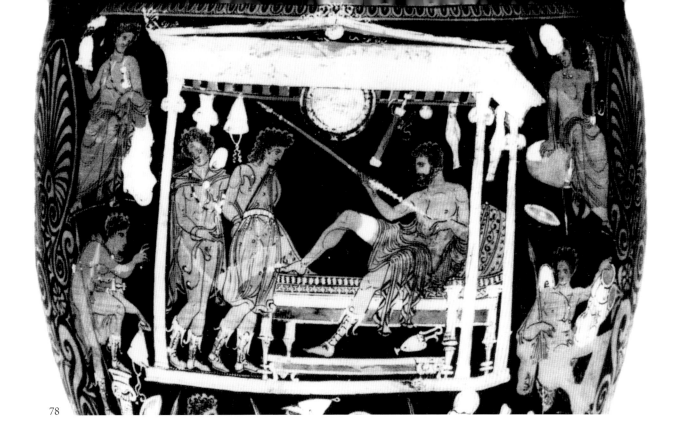

78

79

Plausibly related to Euripides' *Hypsipyle*

Apulian volute-krater, ca. 330s
Attributed to the Darius Painter
H: 142 cm
Naples, Museo Archeologico
Nazionale 81934 (H 3255)[131]

THIS HUGE AND CROWDED VESSEL—standing 1.42 meters in height, with more than fifteen figures in its central scene—seems well suited to Euripides' *Hypsipyle*, a complex play of more than 1,700 lines in length, dating from the same period (ca. 410–407) as the long and episodic *Orestes* and *Phoenician Women*. There was not a lot that could be said about the play until the publication in 1908 of *Oxyrhynchus Papyrus* (*POxy*) 852, which preserved parts, many very fragmentary, of several hundred lines, mostly from the first half of the play. Patient work on the positions of these fragments in the original roll has led to a fairly secure reconstruction of much of the tragedy, now presented in the two excellent editions by Martin Cropp and Richard Kannicht.[132]

Hypsipyle had been a princess on the island of Lemnos, where she bore twin sons, Euneos and Thoas, to the glamorous Iason. She has, however, come down in the world and is now separated from her sons and employed as a nursemaid to the baby Opheltes, child of the priest of Zeus at Nemea (in the northeast Peloponnese) and his wife, Eurydike. Bringing Hypsipyle to Nemea was very probably the invention of Euripides, and so, in that case, were most of the details of the play. The two lost youths turn up near the start, when they encounter Hypsipyle but are not recognized (of course). They are then offstage throughout the central part of the drama, until they eventually compete in the newly founded Nemean Games and, victorious, are reunited with their mother.

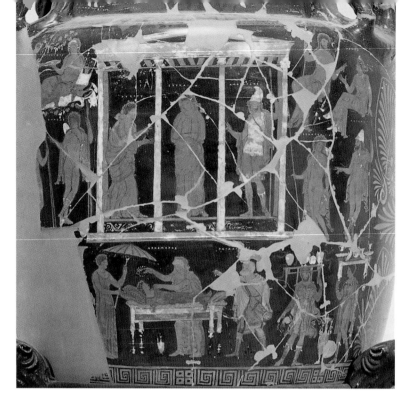

79

The middle section of the plot, meanwhile, is precipitated by the
arrival of the famous expedition of the Seven on their way to attack
Thebes. They are guided by the wise but doomed seer Amphiaraos. At
his request Hypsipyle shows him the way to the spring for water. But
while there she puts the baby down, and he is killed by the monstrous
serpent that lurks by the spring. Hypsipyle returns distraught and is soon
confronted by Eurydike, who accuses her of killing the child deliberately
and insists on her death. Amphiaraos returns just in time to save her.[133]
Eurydike relents when Amphiaraos declares the foundation of a festival
in honor of Opheltes, who is to be renamed Archemoros—though it is
possible she later reneges on this. Not much survives from the scenes
between this point and the preserved scene near the end of the play in
which Hypsipyle is reunited with her sons.[134] Dionysos, Hypsipyle's
grandfather, appeared finally as the "god from the machine." Both plots,
then, look toward the establishment of the Nemean Games in honor of
Zeus and of the dead Opheltes/Archemoros.[135]

There is a lively vase-painting in Saint Petersburg that shows the fatal
incident with the serpent;[136] but there is no strong sign to connect it with
Euripides' play, in which the story was probably reported by Hypsipyle
herself, and not through a messenger. Opheltes, who is actually shown as
a youth rather than a baby (contrary to Euripides), lies dead beneath the
spring and its tree. The serpent coiled around the tree is being vigorously
attacked by three warriors, while a fourth, maybe Amphiaraos, stands by.
A distraught woman rushes toward the boy's body. If she is to be recog-

nized as Hypsipyle, then that detail would correspond with the Euripides version; if the vase reflects another narrative, she might be Eurydike.[137]

The central narrative on this Naples krater is, by contrast, one that we know was at the heart of Euripides' play. Furthermore, all main figures are helpfully labeled and confirm the connection. Inside the three-bay portico, Eurydike stands in the center in a hesitant pose. On one side of her is Hypsipyle (ϜΥΨΙΠΥΛΗ), who is pleading; on the other Amphiaraos makes what looks like a gesture of advice or admonition. This pretty closely reflects the situation and the dynamic of the scene in fragment 757, in which Eurydike is eventually persuaded to relent. This precise composition would surely mean considerably less to a viewer who did not know that particular scene. This is not "simply the story," but Euripides' dramatization of the story.

To the left of the "palace portico" are Euneos (ΕΥΝΕΩΣ) and an arm of a figure (broken) who must have been Thoas. Above them is their great-grandfather Dionysos—eternally youthful, of course—with a lyre and vines. To the right stand Parthenopaios and Kapaneus, two of the Seven against Thebes. They are unlikely to have been characters in the play, but quite likely to have been named. Finally, at the top right sits Zeus himself, at whose shrine the play is set.[138] He is in conversation with the seated Nemea (ΝΕΜΕΑ), the personification of the place, who not only is decorative but also reflects that the aetiology of the Nemean Games was central to the play.

All of this would have been quite enough to fill most vases, but this mighty vessel has room for a further frieze below the main scene. This scene is concerned with the funeral preparations for Opheltes, who has already been given the title of ΑΡΧΕΜΟΡΟΣ, "Archemoros." He is laid out on an ornate bier. A servant woman shades his head, and an old woman lays a wreath on it; she should perhaps be thought of as a funeral attendant rather than as the child's nurse, since Hypsipyle herself was the nurse. At the foot of the bier, a typical old male carer approaches carrying the boy's lyre. This is the only painting in which a figure of this kind is explicitly labeled as being the paidagogos (ΠΑΙΔΑΓΩΓΟΣ), and the label may indicate that he had a speaking role in the play, possibly as a messenger. We do not actually have any other evidence for this, however. Behind him are two attendants carrying tables on their heads loaded with funerary offerings. The balancing figures on the left are missing. In the surviving fragments of the text of *Hypsipyle*, there is no reference to the body onstage; we simply do not know if it was bought on during Euripides' play. We might have expected such a scene, but it is not at all clear how this can be reconciled with the play as reconstructed from the fragments.[139] There was surely, however, some kind of report—perhaps delivered by the

paidagogos?—of both the funeral and the first games, in which Euneos and Thoas competed. The connection of this lower frieze with Euripides' tragedy need not have amounted to more than that.

Nonetheless, this lower frieze makes the narrative particularly suitable for a funerary vessel, perhaps for an infant burial. A child dies, a cause for much grief, but from his mortality will be salvaged glory and beauty. Amphiaraos' speech of consolation to Eurydike in Euripides was much cited by ancient Stoics and others. Fragment 757 (lines 920–27) includes the following: "There is no human born who knows no pain: one buries children, then / gets others to renew the line. And then we die ourselves. We grieve, / we humans, at returning earth to earth—yet it's necessity. / We are life's reapers, like the farmers of a fruitful harvest-home: / one lives, another is no more. Why should we weep at things like these, / when it's our very nature to live through them and then die?" In view of these poignant lines, it is surprising only that there are not more funerary vases reflecting *Hypsipyle*—unless perhaps consolation was not such a prime motive for the selection of narratives, as has often been claimed?[140]

80

Quite possibly related to Euripides' *Phoinix*

Fragment of Apulian calyx-krater, ca. 330s
Attributed to the Darius Painter
H of fragment: 13.5 cm
Oklahoma, Stovall Museum
C/53-4/55/1[141]

PHOINIX IS MOST FAMILIAR as Achilles' aged mentor. In the *Iliad* (9.444–82), he tells the story of how as a young man he was alienated from his father, Amyntor, over a matter of sexual jealousy and came for refuge to Achilles' father, Peleus. Euripides' dramatization of this story was evidently distinctive for having Amyntor blind his own son.[142] Peleus eventually took the blind Phoinix to the Centaur Cheiron to be cured. There are two main figures (both named) in this painted fragment, and they seem to be set in a rural landscape.

The mature Peleus, who wears a wreath, is addressing the young seated Phoinix, who is clearly portrayed as blind. This is the only vase-painting we have of this myth. It might well be related to Euripides' tragedy, but both the vase and the play are too fragmentary to assert that connection with any confidence.

80

81
Plausibly related to Euripides' *Phrixos* (the First Version)

Apulian volute-krater, ca. 330s
Attributed to the Darius Painter
H: 102 cm
Berlin, Antikensammlung,
Staatliche Museen zu Berlin
1984.41[143]

THIS TWO-LEVEL PAINTING of fifteen figures (and a sacrificial ram) shows the Darius Painter at his most ambitious and subtle—the work is monumental, populous, and full of unpredictable touches. There are at least three indicators that alert the viewer who is interested in such things to a connection with a particular tragedy.[144] There are the costumes, especially that of the king in the center with his boots, cross-banding, and conspicuous red sleeves. Second, there is the familiar old paidagogos figure, who is explicitly given the anonymous label of "child carer," ΤΡΟΦΕΥΣ. Third, the name labels are all in Attic forms, including those that would be different in other dialects (see pt. 1, sec. N1).

There may have been other tragedians who told the story of Phrixos' near sacrifice by his own father, Athamas, but the most famous was Euripides. Evidence from highly fragmentary plot summaries on papyrus has established that he produced two plays called *Phrixos*, subtitled *the First Version* and *the Second Version*. Most of our fragments might belong to either play, and it is now accepted that both plays dealt with the same portion of the Phrixos story (see *TrGF* 5.2, 856). It has not, however, been pointed out (as far as I know) that there is a reason for associating this vase with the first rather than the second *Phrixos*: we have evidence that Dionysos was significant within the play of *Phrixos (the Second Version)*,[145] and while there are no fewer than seven divinities in the upper register here, Dionysos is not one of them.

The basic story was that Athamas had two children, Phrixos and Helle, born from Nephele, who was later somehow deified as a cloud goddess. He then married Ino, daughter of Kadmos and aunt (and in some versions, nurse) of Dionysos. Exemplifying the role of the jealous stepmother, she first engineered a crop failure and then falsified a Delphic oracle to say that Athamas had to sacrifice Phrixos. Nephele intervened and saved her children by supplying a magic ram with a golden fleece, which flew them off to safety (though Helle fell off into what became the Hellespont, i.e., Dardanelles). This painting seems to have several features that call for knowledge of one particular telling of the story in order to appreciate them fully. We should be cautious, however, about assuming that Euripides' play would have explained everything. There is more likely to have been some kind of combination or interplay between the dramatic version and the painter's own narrative creativity.

In the center the young Phrixos (labeled), standing above the altar, holds a sacrificial sheep—the conspicuous brightness of its fleece suggests that it is the ram of the Golden Fleece. The animal has sacrificial ribbons on its head, and so, significantly, does Phrixos himself. Athamas (labeled) raises his sword for the sacrificial blow. At the same time he points a finger at Ino (labeled), and Phrixos turns back toward her. She looks

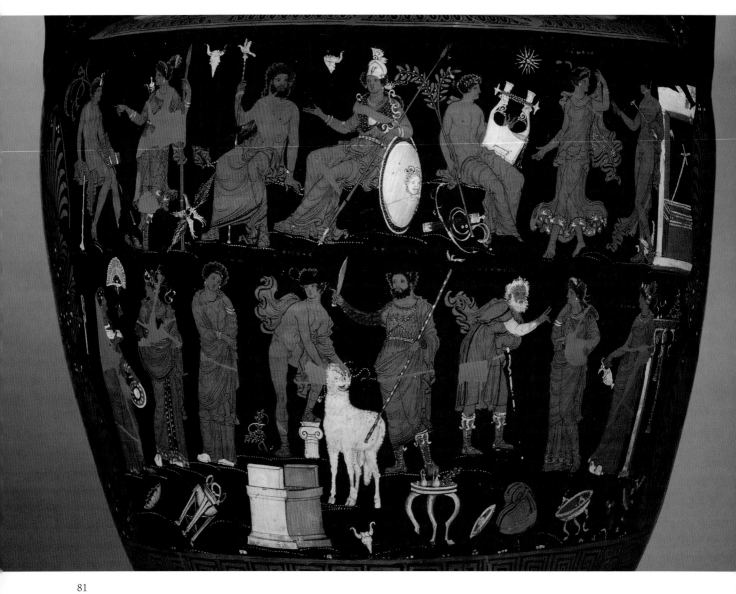

81

apprehensive. All this suggests that Phrixos had believed it was the ram, not himself, that was to be sacrificed, but at the last minute both he and Athamas had some reason to suspect Ino's treachery.[146] The two women behind Ino do not have labels, but the front one seems to be too ornately attired to be a mere attendant; it may be that the play explained her, but if so, that explanation is lost to us. On the other side of the central event, the old male carer is warning or instructing Helle.[147] We do not know if either had a speaking role in Euripides' play, though the vase suggests that they did. Finally, to the right is a relaxed figure who would remain unidentified if she did not have the label E]ΥΦΗΜΙΑ, "Euphemia." This word, meaning something like "auspicious voice," is most familiarly used to refer to the ritual silence that should accompany a sacrifice.[148] Her personification here could suggest that in the tragedy, ritual observance somehow prevented the murderous and impious sacrifice from happening. There is no reason to suppose that Euphemia was actually evoked as a personification in the play; indeed, the word may not have been used at all and might be the painter's elaboration of the dramatic moment.[149]

The serene divinities in the upper register show no great interest in the tense events that are being enacted below—they live on a different plane from that of struggling mortals. They are all easily identifiable except for one, and she is the only divinity to get a label: ΝΕΦΕΛΗ, "Nephele." In the center is Athena, flanked by Zeus and Apollo. It was Apollo's oracle that was tampered with, and Phrixos was on the point of being sacrificed to Zeus.[150] While Athena might possibly signify the Athenian origin of the tragedy, it is more likely that she was somehow brought into the mythical narrative.[151] To the left are Pan and the huntress Artemis; they simply indicate that the story, or part of it, took place in the wild countryside. To the right Hermes stands with a torch by an edifice that may well have been identifiable to well-informed viewers of this painting. According to Apollodoros it was Hermes who gave the golden ram to Nephele. Here he is communicating with her as she moves gracefully; the painter has taken trouble to convey her eternal youth and beauty.[152]

There is much to appreciate in this painting without recourse to any tragedy. It does not need Euripides or any other narrator in order to be enjoyed. At the same time, there are quite a few details that seem to allude to narrative specifics, nearly all of which are lost on us. It is plausible to suppose that an appreciative viewer of the vase knew a particular telling that further informed and enriched the viewing. In light of the Darius Painter's liking for tragic myths, the interaction may well have been with Euripides' *Phrixos (the first version)*.[153]

82

Probably related, if remotely, to Euripides' *Chrysippos*

Apulian bell-krater, ca. 330s
Attributed to the Darius Painter
H: 60 cm
Berlin, Antikensammlung,
Staatliche Museen zu Berlin
1968.12[154]

APULIAN VASE-PAINTING was particularly keen on four-horse chariot scenes. And frequent among these are scenes of abduction or rape. Green (1999, 51) suggests that Ganymede, Kephalos, and Chrysippos, all youths taken away for love, might have been popular motifs for the art made to accompany funerals of young males (although, as shall be seen, there are some far from comforting associations). There are seven examples of the abduction of Chrysippos by Laios, three of them by the Darius Painter, and three by the later Baltimore Painter.[155] They are all largely similar, and it seems that this iconography may have been a case of something approaching the "mass production" of a favored scene.

It is widely held, though not universally agreed, that Euripides invented this particular story in his tragedy *Chrysippos* (probably a fairly early play). If so, then all these vases must, in a sense, derive from that play; but the link may still be pretty remote. In Euripides' version Chrysippos was the son of Pelops and Hippodameia; Laios, while in exile and visiting them, became pederastically enamored with the lad and carried him off, perhaps during the chariot race at the Olympic Games. Chrysippos killed himself for shame, and Pelops cursed Laios—who was, of course, to be killed in due course by his own son, Oedipus.

In the vases Laios has the boy, portrayed as distinctly immature, with him in the chariot. Sometimes an Eros flies overhead; sometimes there are one or more figures in front of the horses, as here; and sometimes Pelops (in Oriental costume) pursues, as in this painting. In none of them is there any pressing indicator of theatrical connection. Most notably, perhaps, there is no sign of an Erinys, even though this is a story of revenge: the emphasis is rather on Eros. The nearest thing to a theatrical signal is the presence in this and one other painting of an old paidagogos figure.[156] Green (1999) has argued that such figures are invariably markers of a theatrical connection; they are, however, pretty commonplace in these "rape" scenes, especially those with Ganymede. Their bearing on scenes of the abduction of young charges is obvious: it is their task as child carers to stop this kind of thing from happening. Once the paidagogos iconography had become conventional, by about 340, they might possibly have appeared within such events without necessarily signaling any theatrical link.

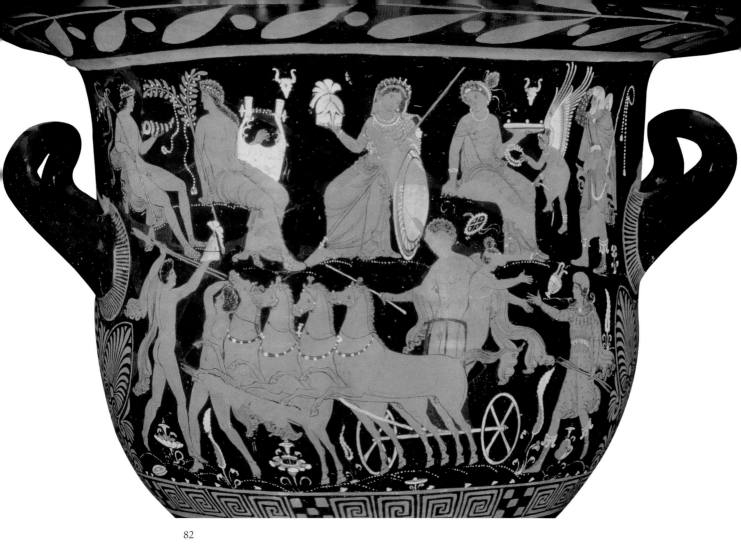

82

Strangely, the paidagogos in this particular picture is at the right-hand end of the upper register of divinities,[157] instead of being in the lower register with the other humans. The easiest explanation of this placement is that the chariot takes up so much of the lower register that, given this relatively small vessel, there is simply insufficient space for him below. This theory does not, however, give much credit to the compositional skills of the Darius Painter, who is usually a meticulous artist. In fact, this "displacement" of the paidagogos might be used as argument against any close relationship with theater.

SOME VASES THAT MAY BE RELATED TO OTHERWISE

Unknown Tragedies

SOME OF THE VASES DISCUSSED in the chapters on the three great playwrights are, as has been registered, more likely to be related to tragedies by other playwrights. Examples include numbers 17 (*Niobe*), 26 (*Philoktetes*), 36 (*Medeia*), and 45 (*Herakles*). In some cases a plausible explanation of the affinities and disparities between the picture and a known tragedy is that the play depicted dated from the fourth century and incorporated some influences from one of the canonical tragedies of the fifth-century "golden age." I have found, however, in surveying the material, that there are a significant number of other vases—perhaps as many as one hundred altogether—that show signs of being related to a tragedy for which we have little or no idea about the authorship or provenance. This is a category that has been rather marginalized in previous studies.[1]

It is not at all surprising that quite a few pots from the fourth-century Greek West should be related to plays and playwrights that we cannot identify. Even for the fifth century—assuming (perhaps wrongly) that all major tragedies were first staged at the Great Dionysia in Athens—we know something, on an optimistic estimate, of three hundred out of more than one thousand tragedies; in many cases all we know is the title.[2] The annual competition for new tragedies continued to be a major and prestigious event throughout the fourth century in Athens, and it is more than likely that further competitions were set up in other Greek cultural centers for both new and old tragedies. Playwrights such as Karkinos, Chairemon, Theodektes, and Astydamas may be little more than names to us, but in their day they were celebrities.[3]

In this section I have arranged the entries by the vase's area of origin and, within that category, by approximate date. The great majority are Apulian, followed by a handful of Sicilian and Campanian works.[4] Furthermore, most of the vases in this section come from the second half of the fourth century, with hardly any from the first quarter of the century. This is not merely a quirk of my selection. If a vase is related with any plausibility to an otherwise unknown play, it will need to include distinct signals alerting the viewer to its theatrical connection. But signals of this

kind only became a standard phenomenon after about 370 (see pt. 1, sec. M). There are quite a few vases included elsewhere in this book from earlier than 370, but their inclusion rests primarily on the relation that they have—or at least may have—to plays that we know about from literary sources. There may well be vases from that earlier period that are related to unknown plays, but if so we are not in a position to identify them. We would, in any case, expect them to be less thick on the ground in the early decades when the theatrical scene was dominated by the still-recent "greats," especially Euripides.[5]

A significant group of vases in this chapter—some eight out of twenty-seven—date from around the 330s and are by the hand of a single dominant painter, the Darius Painter. This also is not mere coincidence. In this period there clearly was a taste among those commissioning and/or purchasing monumental funerary vessels for detailed versions of unusual myths. The Darius Painter was the most skilled and prolific artist to cater to this taste. Furthermore, the very substantial number of Apulian mythological vases that came onto the market in the 1970s and 1980s derived predominantly from the decades between 340 and 310. This phenomenon can be clearly seen from the two hugely augmented chapters in the second supplement to *RVAp*: chapter 18 ("The Circle of the Darius and Underworld Painters") and chapter 27 ("The Baltimore and Stoke-on-Trent Painters"). It is in those later years that one would expect painters to extend their repertoire from the great fifth-century classics to other, more recent—and possibly more local—playwrights.

83

May well be related to a tragedy about the daughters of Kekrops

Apulian calyx-krater (fragmentary), ca. 380s
Close to the Black Fury Painter
H: 36.6 cm
Malibu, J. Paul Getty Museum
77.AE.93[6]

ATHENS WAS NOT VERY RICHLY ENDOWED with local myths; compared with Thebes or Argos or Troy, its stories did not supply an especially privileged source of tragic material. In fact, only one surviving tragedy, Aeschylus' *Eumenides*, is actually set within the city of Athens, although Euripides' famous tragedy *Erechtheus* was also set there.[7] This painting, which is impressive despite its damaged condition, is one of the fairly few representations of Athenian myth we have from the Greek West. While the claim that "the scene … was undoubtedly taken from a now lost Attic tragedy based on the myth" might be too definite,[8] the connection is more likely than not.

The center of the scene is dominated by two figures in highly decorated outfits. The higher, Athena, advances assertively, while the young woman below, as though protected by the goddess, is sitting with her arm resting on an unusual box or casket. There can be no doubt that this is Pandrosos, one of Kekrops' three daughters who were entrusted with the task of looking after the closed casket that contained the snake-baby

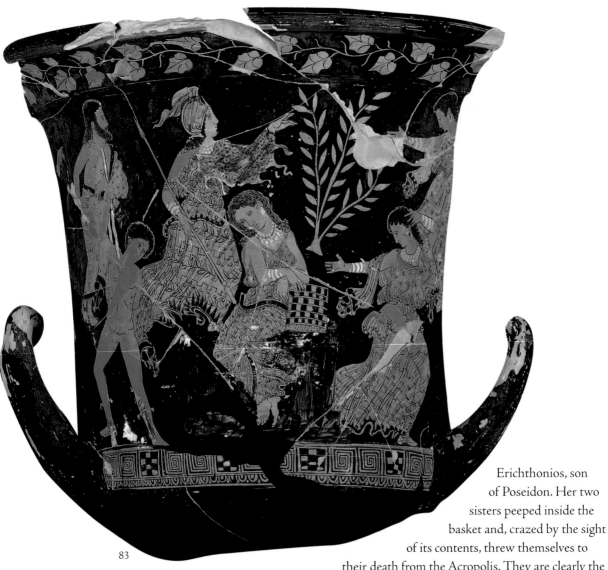

83

Erichthonios, son
of Poseidon. Her two
sisters peeped inside the
basket and, crazed by the sight
of its contents, threw themselves to
their death from the Acropolis. They are clearly the
two rushing away to the right; the olive tree recalls the sacred tree on the
Athenian Acropolis. The king to the left is, then, Kekrops, represented
here as purely human (he often has a half-snake form). Below him is
probably the (damaged) figure of his son, Erysichthon: it seems that he
was fighting with a serpent (white and nearly all gone, unfortunately),
most likely the serpent that was guarding the casket. Pandrosos is sitting
on an altar, which was painted white and has now almost disappeared.

The costumes and "atmosphere" appear to invoke tragedy, and the
Athenian subject matter is most likely tragic; the scene might well relate
to various aetiologies established at the end of the play.[9] The recalcitrant
fact remains, however, that we have no other trace whatsoever (as far as
I know) of the tragedy in question. In view of the intense interest in the
"Athenianess" of tragedy in recent years, this painting serves as a reminder
of how little we know.

84

Probably related to an unidentified tragic scene of suppliants

Apulian krater (no volutes),
ca. 360s
Attributed to the Ilioupersis
Painter
H: ca. 60 cm
Vatican Museums 18255 (AA2)[10]

THE ILIOUPERSIS PAINTER has been encountered before as an artist who pioneered the monumental two-register volute-krater, and who made interesting artistic use of tragic associations in his work. For anyone who is not impenetrably resistant to any interplay between art and literature, the scene on this vase signals a tragic connection loud and clear. In addition to the "dramatic" scene of suppliants at the altar, there are the costumes (note the sleeves of all three men of widely differing ages), and there is a tell-tale Erinys in the top right-hand corner—this one has a snake and a torch, but not wings.

There are enough details here to make it obvious that a particular myth is being narrated. The young woman and the old man with a sword (daughter and father?) have taken refuge; the young man with two spears to one side and the mature king to the other both have an interest in them. To the left, above the young man, is a female divinity without any clear identifying sign; Aphrodite and Eros in the middle suggest an erotic interest in the story, perhaps between the king and the young woman. And the Erinys indicates a story of revenge or punishment or both. Last but not least, there is the tall, conspicuous palm tree. This image is clearly saying something: it might signify an African setting, or it might signal Artemis or Apollo, as it does on the same painter's scene at Delphi in number 43.

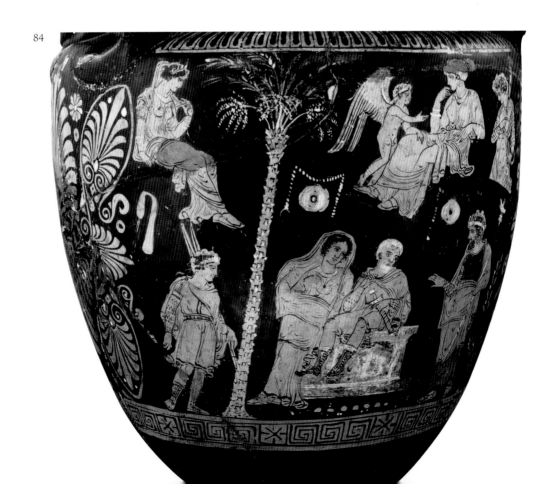

84

Despite all these signals, however, no one has been able to specify a convincing mythical key, and hence any particular tragedy. The overall composition is quite like the *Oedipus at Kolonos* scene on number 27, and that play has, indeed, been suggested as one interpretation. But the old man here is not blind, and Aphrodite is quite inappropriate to that narrative. It may well be, however, that there was some kind of competition or conflict over the fate of the suppliants, as in that play. The sword has made some think of the Thyestes and Pelopeia story, but there is much that does not fit that either (contrast no. 30).[11] The stories of Daidalos and Pasiphae on Crete, and of Danae on Seriphos, have also been advocated.[12] Neither is impossible, but it seems more realistic to admit that, on present evidence, this is a mythological story that we cannot identify, and that it recalls a tragedy that we cannot specify.

There is, by the way, another evidently tragedy-related picture by the Ilioupersis Painter (or someone closely associated with him) that we know definitely deals with a myth that is otherwise unknown to us, because it has name labels.[13] Melanippos falls dying behind a tripod; to his left Merops rushes up with a sword, while Klymene gestures behind him (these two were the parents of Phaethon). On the other side of Melanippos, a young man, Stornyx, otherwise totally unknown, kneels on a altar with drawn sword; behind him a woman runs away. It is all very exciting, but the story is completely lost on us.

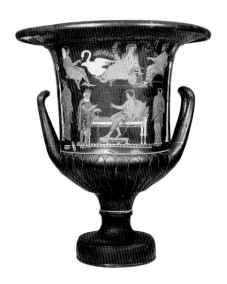

85

Plausibly related
to a tragedy about
Parthenopaios

Apulian calyx-krater, ca. 350s
Attributed to the Lycurgus Painter
H: 62 cm
Milan, Museo Civico Archeologico
St. 6873[14]

THIS NICELY COMPOSED two-tier painting suggests dramatic tension between the young man and the old man, and quite likely between the two regal women on either side. That this tension reflects the narrative of a tragedy, now lost to us, is confirmed both by the old paidagogos figure, who is elaborately costumed, and by the two pillars surmounted by tripods that frame the picture on either side (see pt. 1, sec. N2).

It is most unlikely that anyone would have been able to begin to guess what myth was being narrated here, were there not some name inscriptions—above all, the central identification of the young man on the couch as Parthenopaios. He was a young prince who was one of the seven leaders of the ill-fated expedition against Thebes. A name label identifies the woman to the right as his mother, Atalante. She was very probably opposed to her son's participation in the expedition. It may well be that the woman on the other side was somehow in favor of his going, but we have no idea who she is or what part she played. The old man does not have a name label, either. Some have identified him as Adrastos, the king of Argos and organizer of the Seven, but that is surely wrong: this stooped old man with his short robe and crooked stick is not a king, but

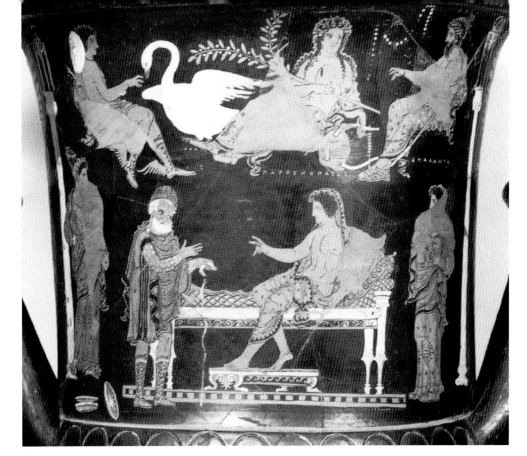

85

an anonymous character, probably a slave. He may be acting as a kind of
intermediary, who has the task of persuading Parthenopaios to partici-
pate; but the sadness of his expression is more likely to be seen as that of
some well-wisher, perhaps Parthenopaios' former child carer, who has bad
premonitions and is trying to persuade him not to go.

There are three gods above. Apollo is in the middle—his oracle may
have been somehow involved in the story. To his left is Hermes; to his
right is a figure who might have been taken as Zeus, were he not identi-
fied with a label, ΑΡΗΣ, "Ares."[15] Some sources said that Ares was the
father of Parthenopaios, which could have been the case in this version.

A father and son named Astydamas were both Athenian playwrights.
There were stories that the elder indulged in excessive self-praise after a
victory with his *Parthenopaios*.[16] On the other hand, we happen to have
solid epigraphic evidence that the younger Astydamas was victorious with
a *Parthenopaios* in the year 340.[17] That victory is likely to be the origin of
the anecdote, and it is at least ten years later than the painting on this pot.

This is an attractive painting in its own right. Much of its potential
power is, however, lost on us because we cannot interpret all its implied
narrative, in particular the sad old man and the woman to the left. View-
ers were probably being reminded of a particular tragic telling of this
story, and the recollection would have given the painting much more
depth and strength.

86

May well be related to a tragedy of unknown subject

Apulian calyx-krater
(fragmentary), ca. 350
Attributed to the Lycurgus
Painter
H of fragment: 12.4 cm
Bonn, Akademisches
Kunstmuseum 147[18]

WE MIGHT HAVE BEEN able to attribute a myth to this suggestive fragment, if only we had more of the pot. The tension of the situation and the female dress (note the sleeves) are suggestive of tragedy—but there is very little to go on. The young man to the left is holding a rope, evidently tying the richly costumed woman to a tree. Thus far, this is reminiscent of some of the Andromeda scenes; but that story does not seem to account for the very dejected bearded man who is sitting with his hands tied behind his back. He has a partial name label above him—]ΙΣΣ[—but no one has been able to suggest a satisfactory completion of that. Finally, to the right stands a figure who apparently holds a scepter, probably the king who is in command of the situation. It seems more than likely that the man and the woman are both in custody, accused of some joint misdemeanor, and that an unknown tragedy is lurking behind this.

86

87

Probably related to an unidentified tragedy involving two suppliant women

Apulian volute-krater, ca. 350
Attributed to the Painter of Bari
12061
H: 93 cm
Geneva, Musée d'Art et
d'Histoire 24692[19]

THIS PAINTING SEEMS TO TELL quite a distinct story, which makes it surprising that no one has come up with a convincing myth, let alone a tragedy, to relate to the vase. It is all the more surprising because there are no fewer than five other examples of what is clearly the same iconography—in other words, this was a popular narrative. This particular vase is probably not the earliest example, but it is especially fine, and it is the focus of the best discussion of the subject.[20]

The tally of features that all the scenes have in common is quite substantial. All have two young women who have taken asylum at an altar; on one side is a mature king who approaches aggressively, usually with a drawn sword; and on the other is a young (unbearded) man, often with a *pilos,* a sign of travel. Furthermore, they all emphasize the sacred space of the setting with various combinations of suppliant branches, tripod, urn-

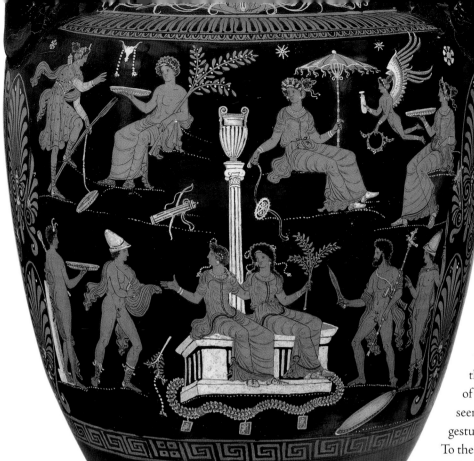

87

topped column, and, in this case, the sacred band with votive tablets that makes a kind of "magic circle" around the altar. Only one painting adds another clearly significant figure: an amphora in Saint Petersburg by the Darius Painter has an ancient priestess intervening to restrain the attacking king.[21] On this vase the figure to the right may be a companion of the other young man—he seems to be making a significant gesture, but its meaning is unclear. To the left-hand end is a Pan holding a bowl and a *lagobolon*: as in other works, this suggests that the scene, or at least a good part of the story, was played out in the countryside.

This krater has a classic upper tier of divinities, who display no direct interest in the passionate human scene below. On one side of the central pillar are Apollo and Artemis, and on the other, Aphrodite, Eros, and attendant divinity (such as Peitho). We might have hoped that the choice of divinities would have given us a clue toward the interpretation of the human scene. It is a problem, however, that two of the other paintings also have divinities, and not one is shared among all three vases: two have Aphrodite, two Apollo, and two Athena.

Various myths have been proposed, but all of them run up against contraindications that are stronger than any pro-indications they can offer. If, for example, the young women were the Locrian Maidens, there should be signals that the scene is set at Troy; if they were Prokne and Philomela, there should be signs of a Thracian setting and some other indication of the horrific story. The most favored solution has been the daughters of Danaos, and the tragic narrative offered for them has been Aeschylus' *Suppliants*.[22] But there are always two women and never more, and they show no sign of any connection with Egypt, whereas in Aeschylus' play they are explicitly in Egyptian garb. Similarly, supposing the older man to be Pelasgos, the king of Argos, the younger man should be conspicuously Egyptian, if he is to fit the Danaid plot. This vase suggests, on

the contrary, that the younger man may be some kind of friend or rescuer: it is the older king who threatens the safety of the two suppliants. This is the exact reverse of the situation in Aeschylus.

Aellen offers the fascinating suggestion that this story was the tragic template for the comedy by Diphilos that was turned into Plautus' *Rope* (*Rudens*), in which two shipwrecked young women are protected by a priestess who turns out to be their mother.[23] Maybe someone will be able to come up with the mythological solution to this popular picture, but no one has managed it to date.

88

Apparently representing a scene of an unidentifiable tragedy

Bell-krater in Gnathia technique (fragmentary), ca. 350s
Attributed to the Konnakis Painter
H: 22.5 cm
Würzburg, Martin von Wagner-Museum H 4698 and H 4701[24]

THIS ATTRACTIVE POLYCHROME FRAGMENT, widely known as the "Würzburg Skenographie," is frustratingly broken. It looks, however, like an attempt to reproduce perspective scene painting on the surface of a pot. The portico and half-open double doors with the figure emerging from them seem to call out "theater!" It further appears that there is a play actually in performance within this setting. In addition to the woman in the doorway, we see a sad-looking young man in a traveler's hat and (probably) an old man holding a ritual bowl.[25]

But this is not likely to be a "production photo," so to speak, or even something close to that. There are no masks; the costumes are monochrome, without ornament; and the young man's drapery does not look realistic. Furthermore, if any scene building was actually constructed like this, it would seem that it had two main side doors and no central door (assuming it is symmetrical), or at least no main door in the center. While this is not an impossibility in the real theater, it goes against frequent implications in the texts that call for a dominant central door. There also seems to be evidence of the central door in the archaeological remains of several important theaters, such as those at Epidauros and Eretria. It seems fruitless to try to identify a play. The miniature of Bellerophon and Pegasos represented by the acroterion (building ornament) on the roof does not amount to serious evidence in favor of Euripides' *Stheneboia*, although an amusing idea. Iason's arrival in Iolkos and confrontation with his uncle, King Pelias, is less unlikely, but still highly speculative.[26]

88

89

Possibly related to a tragedy about Leda, but more probably not

Apulian loutrophoros, ca. 340s
Attributed to the Painter of
Louvre MNB 1148
H: 90 cm
Malibu, J. Paul Getty Museum
86.AE.680[27]

THIS FASCINATING, almost mesmerizing vase combines myth with religious and cosmic symbolism. Undoubtedly it had messages of funerary meaning and consolation for its original viewers, but these are now hard to decipher.[28] Although the vase includes some features that are found in tragedy-related paintings, such as the portico and the Erinys-like figure in the top left, the truth is that there is little to alert the viewer to any theatrical connection, except perhaps for the inscriptions, since "the Attic dialect of the labelling of the figures and the particularity of the representation prompt one to think of theater."[29]

It is true that there are particularities, but it is not clear how a play might have thrown light on them. The central human figure below is Leda (ΛΗΔΑ), who was impregnated by Zeus in the form of a swan: here the lovemaking is evidently about to begin. Sleep (ΥΠΝΟΣ) is ready to tap her—presumably postcoitally. To the left a richly costumed woman flees: she looks like a maid who has been playing ball with Leda before the swan

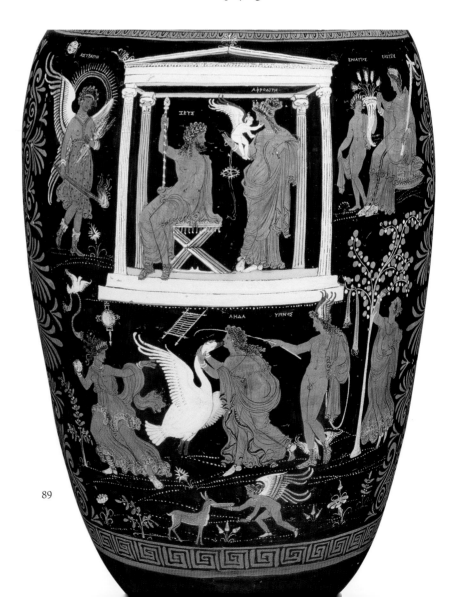

89

came along. Behind Sleep a woman plucks an apple from a tree (in the Garden of the Hesperides?). None of this could have been seen onstage, and it is not at all obvious how a messenger would have told such an erotic story, or would have been able to account for the variety of figures.

The divinities above conform with the standard spatial composition, although three of the six are very unusual. Zeus himself is not a frequent presence in these pictures, but here he sits in the portico with Aphrodite and Eros. He is placed more or less above his swan manifestation in the world below—a striking emblem of the stark division between the human and divine worlds. To his left is Lightning (ΑΣΤΡΑΠΗ). She has some of the attributes of an Erinys figure—wings, boots, torch—but has a nimbus and holds the lightning bolt of Zeus (which he does not want just now). To the right is an iconography quite like that of Demeter and her son, Ploutos, in Attic vase-painting;[30] but here she is explicitly labeled as "Eleusis," and the boy with the cornucopia of grain as ΕΝΙΑΥΤΟΣ— "Anniversary," or "Year-cycle." The cosmic suggestiveness is clear: we have crops, the seasons, storm, sleep, love, fertility—and perhaps death. The beliefs of the mystery cult of Demeter very probably supplied some of the keys to this symbolism; but it hard to see how a tragedy would have unlocked it.

Why, then, the Attic dialect? This might be best put down to the Eleusinian connection—the great cult center was, after all, in Attica. Or it may be that by this period of Apulian painting, Attic had become the conventional dialect for all vase inscriptions, even though it would not have been the dialect of most of the viewers (who would have said Aphrodita rather than Aphrodite). If so, then that would be witness to the power of tragedy in the whole realm of mythtelling, though not necessarily in this particular painting.

90

Possibly related to a play of Daidalos, possibly Euripides' *Cretans* (*Kretes*)

Fragment of Apulian calyx-krater, ca. 340s
Tentatively attributed to the Branca Painter
H of fragment: 13.3 cm
Basel, Cahn collection HC 225[31]

THIS FRAGMENT, WHICH IS ONE OF THREE, suggests an unusually fine and intriguing painting.[32] We would be lost without the inscription ΔΑΙΔΑ[(with a trace of Λ between his calves?) by the seated dejected figure, who wears an artisan's hat and short robe: Daidalos, then. The terrified youth who crouches by him must be his son, Ikaros. Daidalos, the master craftsman, got into deep trouble with Minos, king of Crete, once he found out about the help that Daidalos had given to Minos' wife, Pasiphae. First, he made her a cow casing, so that she could consummate her desire, inflicted by Poseidon, for a god-sent bull. Second, he constructed the famous labyrinth to house the monstrous progeny of this union, the Minotaur. As Schmidt argues, this narrative context makes it very likely that Pasiphae is the woman sitting, probably seeking asylum,

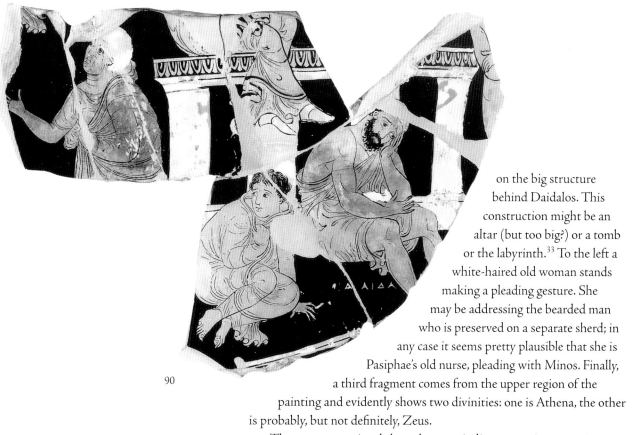

90

on the big structure behind Daidalos. This construction might be an altar (but too big?) or a tomb or the labyrinth.[33] To the left a white-haired old woman stands making a pleading gesture. She may be addressing the bearded man who is preserved on a separate sherd; in any case it seems pretty plausible that she is Pasiphae's old nurse, pleading with Minos. Finally, a third fragment comes from the upper region of the painting and evidently shows two divinities: one is Athena, the other is probably, but not definitely, Zeus.

There are some signals here that may indicate a tragic connection: apart from the scene of stress and fear, there is the asylum motif, and the stock type of the old nurse. We know that Euripides' *Cretans* told of Minos' discovery of Pasiphae's unnatural impregnation. It was a fairly early work and probably contributed to Euripides' growing reputation as a dramatist who did not hesitate to encroach upon taboo subjects. In a substantial papyrus fragment, published in 1907 (fr. 472e), Pasiphae boldly defends her "bestial" sexuality and blames her husband for what has happened; he commands that she and her "accomplice" (the nurse?) should be shut away (45–49). We do not, however, have conclusive evidence that Daidalos and Ikaros figured in this tragedy at all. It has usually been thought likely, if only to add enough complication to the story. There is also some possible indication of their inclusion in Aristophanes' *Frogs* (849–50), in which "Aeschylus" accuses "Euripides" of collecting "Cretan monodies" and bringing "unholy sexual unions" into his work. An ancient commentator on this says that Ikaros performed a rather daring monody in *Cretans*.[34] The most likely reconstruction is that Ikaros sang some song of terror at the prospect of being forced to fly with wings made by his father, their only chance of escape from imprisonment and punishment on Crete. So, while the connections claimed between these painted fragments and the textual fragments of Euripides' play are inevitably speculative, they do make quite good sense. The story is at least one worth telling.

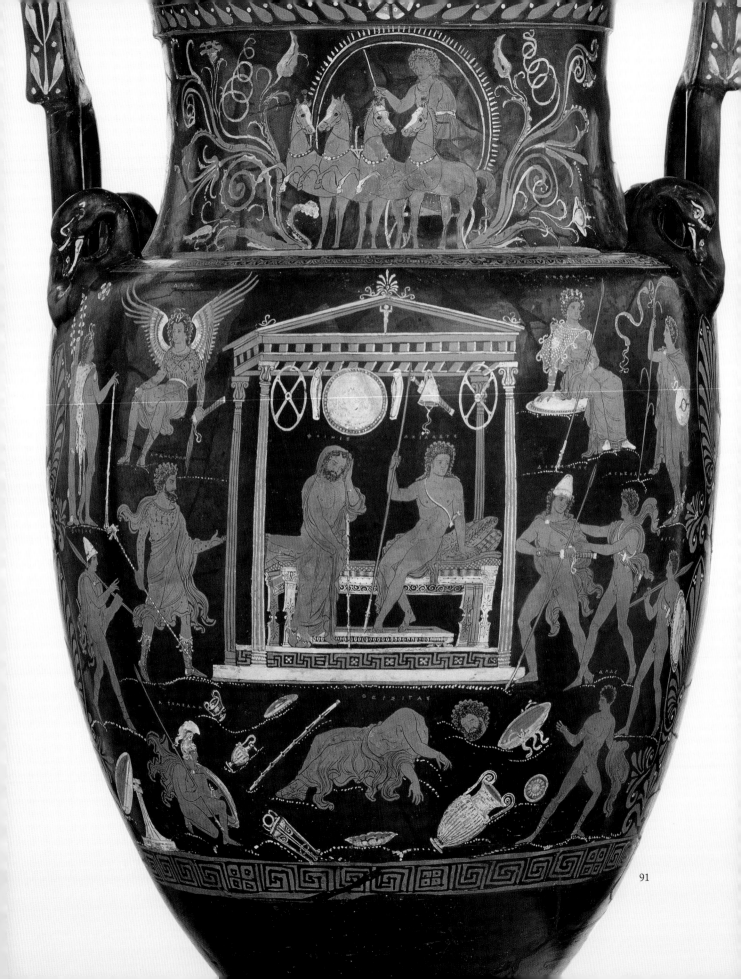

91

Possibly related to a tragedy about Achilles and Thersites, perhaps the *Achilles* of Chairemon

Apulian volute-krater, ca. 340s
Close to the Varrese Painter
H: 124.6 cm
Boston, Museum of Fine Arts
1900.03.804[35]

THIS VESSEL FROM THE PEAK PERIOD of Apulian monumental painting stands 1.25 meters high; its main picture includes no fewer than four divinities and ten men, every one neatly labeled. This is one of the most celebrated of fourth-century vases, and with good reason. It is finely drawn, with expressive faces, tense action, and nice narrative touches. Only someone who is incurably prejudiced against this style of painting could resist being drawn into its details. And those details turn out to tell an unusual story of the Greek army at Troy, with some pro-indications of tragedy and some possible contraindications. If it does mean to bring a tragedy to mind, then it does so, as often, through several scenes and aspects of the play, not through any one scene as enacted onstage.

First a brief account of the scenes. The composition is on three levels, the uppermost belonging to the gods. The middle part of the upper two levels is taken up with the portico edifice, a very ornate "tent" where Achilles sits aloof in the company of his distressed old mentor, Phoinix. This center forms a kind of statuesque defiance, surrounded on three sides by violent action. Yet the figure that draws the eye with fascinated horror is the decapitated body that lies in the narrowest register beneath the portico: this is Thersites (ΘΕΡΣΙΤΑΣ). His head with eyes closed is lying some way from his trunk, surrounded by the debris of a violent struggle. To the left of the body crouches the armed Automedon, a close companion of Achilles; on the other side is a servant with the anonymous label ΔΜΩΣ (*dmos*), "Servant," retreating in horror from the body.[36] Turning to the middle level: to the left of Achilles and Phoinix, Agamemnon (spelled ΑΓΑΜΕΜΜΩΝ) is making a regal approach, while on the right a youthful Diomedes (ΔΙΟΜΗΔΗΣ) is drawing his sword but being restrained by Menelaos. Behind and below Agamemnon is a warrior labeled "Phorbas," a common heroic name, but otherwise unknown in the Trojan context; behind and below the pair on the right is a warrior anonymously labeled "Aitolian," ΑΙΤΩΔΟΣ. Finally, on the upper level there are, from left to right, four divinities: Pan with his lagobolon signifies a wild setting for at least some of the story; he is common in these pictures but only here actually named as ΠΑΝ. The seated Erinys has the full repertory of characteristics—boots, snakes, spear, and drawn sword—and she is specified as ΠΟΙΝΑ (Poina), "Punishment," or "Revenge." To the right of the portico are Athena and Hermes, spelled ΑΘΑΝΑ (Athana) and ΕΡΜΑΣ (Hermas).

This was not a very well-known story, but we do have various sources that fill in some of the details.[37] Thersites was not always portrayed as a commoner, as in *Iliad* book 2, but sometimes as a scion of the royal house of Aitolia, as was Diomedes—hence his threatened violence. Thersites

taunted Achilles for his ill-fated passion for the Amazon queen, Penthesileia, or he felt sympathy for her, and Achilles in anger killed him. This caused a quarrel among the Greeks, which eventually obliged Achilles to go away and make appeasement.

Some of the standard indicators of tragedy are scattered around this picture, although it has to be reiterated that they do not amount to a conclusive proof of a tragic connection. The main three are: the portico, Agamemnon's costume, and the Erinys figure. I think that the anonymous *dmos* might well be another: his reaction to what has happened suggests that he might have been the messenger who told of Thersites' gruesome death. On the other hand, it seems less likely that the anonymous Aitolian was yet another speaking character. Against a tragic connection, it might be argued that there are too many named figures to all be included in any cast list. It is possible, however, that Automedon and Phorbas were only referred to in the tragedy, without actually making speaking appearances; the same might even be true for Menelaos. There is one further contraindication militating against tragedy, one that has been generally neglected: those name labels that are susceptible to dialect variation do not take their Attic forms, as is usual in the most likely tragedy-related vases.[38] One might counter that three of four incontrovertible Doric forms are among the gods—namely "Poina," "Athana," and "Hermas"—and that a vase-painter might have more readily reverted to his own dialect for these figures, especially if none of them was actually a character in the play. On the other hand, the inscription of the Doric form "Thersitas" (not "Thersites") is conspicuous in the center of the painting, beneath the feet of Achilles.

So, on internal grounds, the evidence is fairly finely balanced for and against. It might be tipped in favor of a tragic connection by the fact that we do know of quite a celebrated tragedy on this very subject. This was by Chairemon and was probably first performed, presumably in Athens, in the second quarter of the fourth century, within twenty years or so of this painting.[39] We have one line cited from his *Achilles*, and one from his *Achilles (Slayer of Thersites)*, in all likelihood the same play.[40] We know the play was still being performed a century later, since we have the epitaph from an actor (and boxer) from Tegea, who singled out eight victories from his tally of eighty-eight, one of which was in the *Achilles* of Chairemon at the Naia festival at Dodona.[41]

While we remain far from certain about the interpretation of this vase, it raises an interesting nexus of questions. This scenario is rather appropriate to such a sensational and detailed artwork.

92

Possibly, but far from definitely, related to a tragedy called *Persians*

Apulian volute-krater, ca. 330s
The Darius Painter
H: 130 cm
Naples, Museo Archeologico
Nazionale 81947 (H 3253)[42]

ALTHOUGH THIS VASE is by no means his best work, in my judgment, it is hardly surprising that the mighty krater (1.30 meters high) gave the Darius Painter his name. It was found along with several other pieces by his hand in 1851. Among the host of colorful figures sits no less than Dareios, king of the Persians (Darius is the Latin spelling), with his name inscribed clearly beside him—a key figure in both Persian and Greek history, and namesake of the king who came to the Persian throne in 336 (only to be brought low by Alexander the Great).

It is also not surprising that the vase has been connected with tragedy, since right in the center, in front of Dareios, is a little old man in the characteristic paidagogos outfit, standing on a plinth inscribed ΠΕΡΣΑΙ— "Persai," or "Persians." This is presumably the title of the whole painting; it is also the title of a surviving play by Aeschylus, and of a lost play by Aeschylus' older contemporary Phrynichos.[43] But this picture has nothing directly to do with Aeschylus' play, in which Dareios appears as a ghost

92

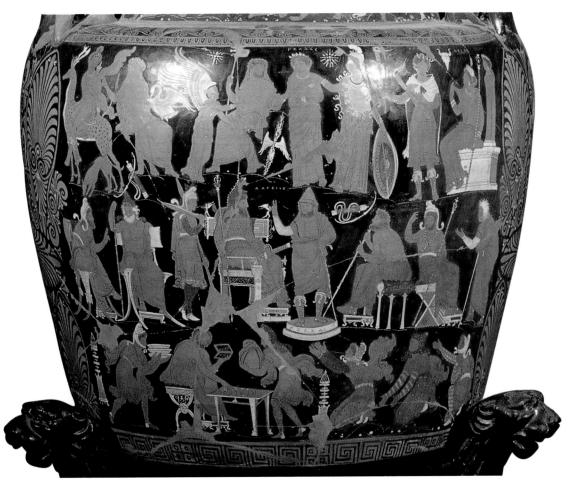

from the tomb. Apart from the "messenger," there is remarkably little in the way of pro-indications toward tragedy. The possibility should not be ruled out that he is wearing this tragic outfit because old anonymous figures were conventionally portrayed like this by 330 B.C., whether or not they had anything to do with tragedy.

The composition is arranged in three rows with no direct contact or interaction between them. At the bottom is a scene of tax or tribute gathering, with various Oriental figures, cash in hand or pleading empty-handed, around an accountant. While evocative, this could have no more than the most tangential connection with anything in a tragedy—possibly a choral ode might have dwelled on the taxation of the Persian Empire? The upmost row consists of divinities along with four "allegorical" figures. From left to right we have: Artemis, Apollo, Nike, Zeus, Greece (Hellas, or ҺΕΛΛΑΣ), Athena, Deceit,[44] and finally, Asia (ΑΣΙΑ). Since this last figure looks Greek, not Oriental, she may well represent what we call Asia Minor, rather than the land mass to the East.[45] Athena is guiding Greece toward Zeus, while Deceit, who takes the form of a fully equipped but wingless Erinys figure, is turned toward Asia, who seems to have taken refuge at an altar. There does, indeed, seem to be a distinct narrative behind this allegorical gathering. In Aeschylus' *Persians* (181ff.) the Persian queen tells of her dream about two sisters, one in Persian and the other in Dorian clothes, one allocated the land of the Barbarians, the other the land of Hellas. This passage of Aeschylus may have influenced the narrative reflected here on the Dareios vase, but that does not mean that the story behind it was a tragedy; in fact, it is not obvious how all this could have been incorporated into a tragedy.

In the central row, the only figure who is named is Dareios himself. His rich outfit no doubt owes much to theatrical tradition and certainly does not militate against a tragic connection; the same is true of the Persian bodyguard behind him. Thus the three figures in the very center of the composition suggest tragedy. So does the title on the plinth, since plural titles taken from the identity of the chorus were common for tragedy. This convention was, however, extended to other genres, as is most relevantly illustrated by the famous late fifth-century dithyramb by Timotheos, called *Persians*.[46]

But the tragic indicators do not extend to the other five figures in the central row, four of them sitting, one not, three of them Persian, two apparently not. At first glance they may seem like a chorus, but they are too varied in appearance and too diverse in their conversations and directions of attention. Although we are told that the Persian-themed play by Phrynichos began with a eunuch spreading seats for the Persian councillors, surely they did not actually sit on seats onstage?[47] As Schmidt

has insisted, these councillors or plotters look individualized, almost as though they are drawn from a historical narrative.[48] She may well be right that the narrative behind this vase was perceived to have some bearing on Greek relations with the Persians, and with their king, at the time of the painting, in the 330s.

In conclusion, the two central figures, Dareios and the old man (who might be some kind of agent of the deceit?), are strong pro-indications toward tragedy, but there is little else to support that initial impression. If the narrative behind this work is not tragic, but from some other kind of poetry or even from prose, then it is interesting that by this stage in the history of Western Greek vase-painting—the peak of the Darius Painter's period—some of the central conventions of the iconography of tragic indicators could be assimilated into other contexts without danger of confusion.[49]

93

May be related to a tragedy about the departure of Amphiaraos

Apulian volute-krater, ca. 330s
Attributed to the Darius Painter
H: 102.5 cm
Cleveland Museum of Art 88.41[50]

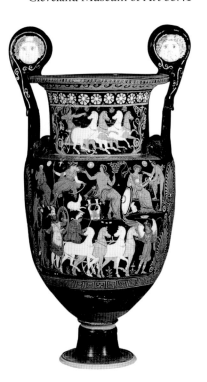

THERE CAN BE LITTLE DOUBT that the narrative in this scene is the departure of the wise and prescient king Amphiaraos as one of the leaders of the ill-fated expedition of the Seven against Thebes, where he knows he is doomed to die.[51] There is a closely similar picture of the scene in Saint Petersburg, and a fragment in Boston, both by the Darius Painter.[52] The basic story was that Amphiaraos' wife, Eriphyle, was bribed to get him to go, despite his premonitions, and that he made his two young sons swear to take vengeance on her.

This situation explains the melancholy stare of the departing warrior and the distress of the youth who stands by him with a jug for the parting libation. The youth above him with hoop and ball seems as yet oblivious (on the Saint Petersburg krater, both boys are immediately behind the chariot). Although she is on a level with the gods, the white-haired woman above him is most likely to be their loyal old nurse. Next to her, Apollo—patron of Amphiaraos' prophetic power—is the central deity. Amphiaraos' charioteer was apparently Oriental, to judge from his cap here and on the Boston fragment.

There are various possible indicators of tragedy scattered among the paintings. On this Cleveland krater, in addition to the costumes and the old nurse, there is an Erinys in front of the horses, marking the story as one of revenge. In Saint Petersburg the Erinys is in the top left (Apollo is central again), and beneath her is a distressed old paidagogos.[53]

We know of tragedies called *Eriphyle* and *Amphiaraos* by various playwrights, but we know next to nothing about their handling of the story. If these three pieces by the Darius Painter are related to a tragedy, we are not in a position to say which.[54]

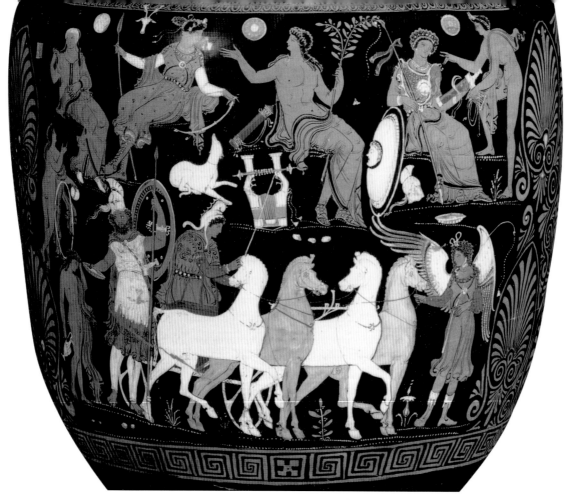

93

94

May well be related to a play about Medeia at Eleusis

Apulian volute-krater, ca. 330s
Attributed to the Darius Painter
H: 100 cm
Princeton University Art Museum
1983.13[55]

THIS ENIGMATIC VASE may have as much to do with mystery cult as with tragedy, but it does concern Medeia, who became a kind of emblematic figure of the genre. It also has two of the most typical signals in the center: the paidagogos figure, with his characteristic stance, outfit, and boots; and the two boys who have taken asylum at the altar below. Without two inscriptions, we would know even less than we do about what on earth is going on. One, very unusually, identifies the location: written on the lintel of the "portico," which is festooned with votive offerings, is "Eleusis: The Sanctuary" (ΕΛΕΥΣΙΣ: ΤΟ ΙΕΡΟΝ). And the woman inside it with the old man is identified as ΜΗΔΕΙΑ, "Medeia."

Medeia came to Athens after her misadventures in Corinth; but no other narrative associates her with Eleusis, a town on the Attic coast in the direction of Corinth, which was best known for its initiation cult of

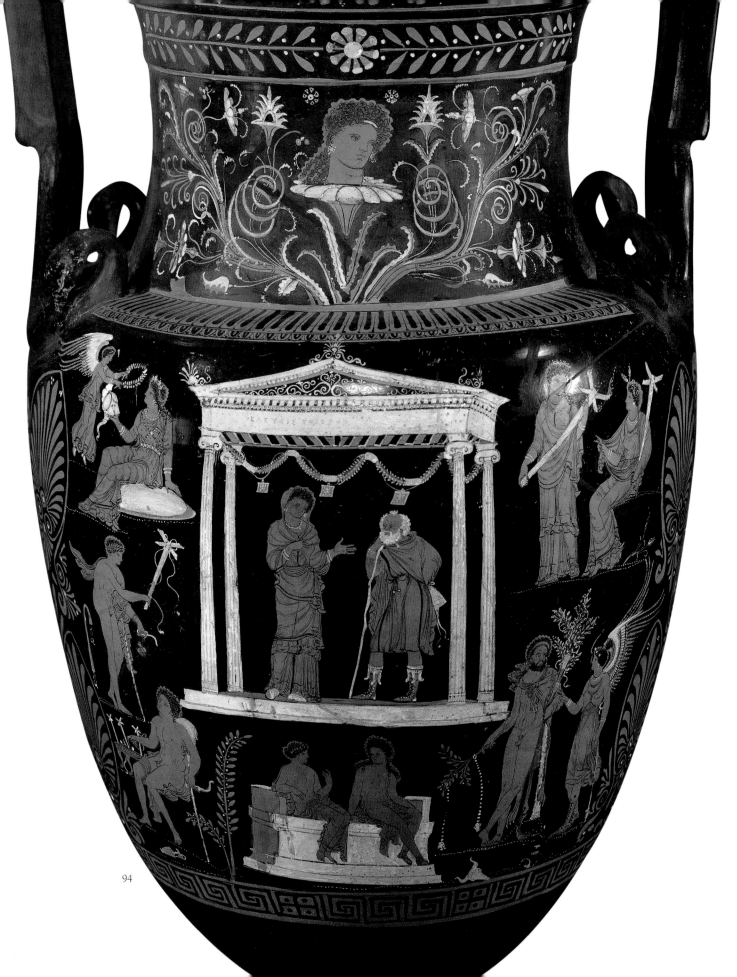

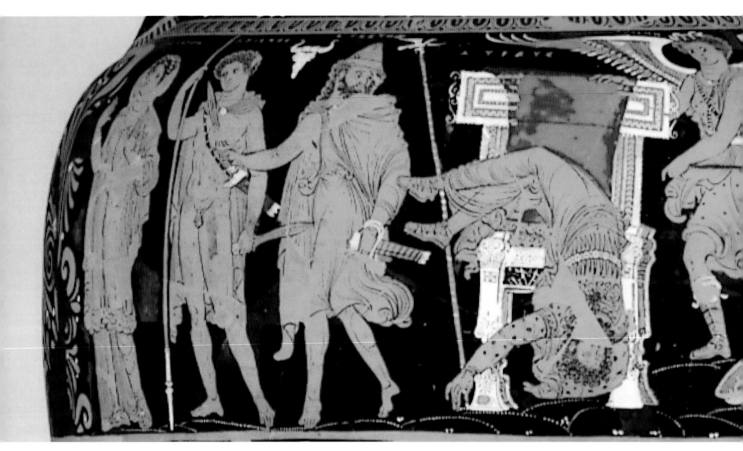

95

The Darius Painter sometimes takes special care in portraying the
direction in which eyes are turned—as with Aigisthos in this picture.
Poine is clearly looking toward the two women on the right. What might
this signify? They are evidently two serving maids, similarly but not
identically dressed; they have both dropped their spindles and are look-
ing and gesturing toward the central carnage—this much is clear even
without the label above their heads: ΔΜΩΙΑΙ, "maidservants." Singular
or anonymous labels such as "Shepherd" and "Nurse" or even (on no. 91)
ΔΜΩΣ, "Servant," have been encountered already (see also pt. 1, sec. M5).
They might be an indicator toward tragedy, in which anonymous speak-
ing characters are a standard feature. But a plural noun identifying a pair
is very unusual; in fact, the only clear parallel is on the next—and closely
similar—vessel, number 96.[64] I argue in Taplin (forthcoming) that in both
cases, the pair of figures may well be representative of the chorus of a trag-
edy. It seems significant that they are explicitly labeled, and that they are
both looking at the central action: this suggests the "group witness" func-
tion of a chorus. Perhaps Poine looks toward them because it is the role
of the chorus to draw out or underline the larger patterns that are exem-
plified by the plot? The chorus of this Atreus tragedy may have dwelled

on the long-term impact of Vengeance on human affairs, especially in the tangled history of the great mythical dynasties. This can remain no more than a guess, but it is, I hope, an interesting guess.

There were *Thyestes* tragedies by Sophocles (see no. 30) and by Euripides, but we have no particular reason (as far as I am aware) to associate this particular vase with either of them, rather than with an unknown tragedy, quite possibly by a later tragedian.

96

May well be related to a tragedy about Hesione

Apulian amphora, ca. 330s
Attributed to the Darius Painter
H: 87.5 cm
Geneva, Musée d'Art et
d'Histoire (on loan)[65]

This amphora and number 95—published in 1995 and 1991, respectively—are two of the most recent additions to our stock of Apulian mythological iconography. They are so similar in dimensions and overall composition as to make one wonder if they might have come from the same find-spot. Furthermore, both display unusual and unprecedented mythological narratives. Indeed, Priam is so familiar as the aged king of Troy that it is something of a shock to see him here as a very young man.

In the center of the seven-person, upper-level composition stands a statuesque Herakles (with label). Kneeling in supplication to his right side is the young, unbearded Priam (also labeled). The bag at his feet might suggest that he has been traveling; the pillar with an urn might suggest a sacred site, or possibly a tomb (the ground is marked as uneven). Balancing Priam on the other side is his white-haired, rather weary father, Laomedon (labeled), clearly marked as a king but reduced to abasing himself. Behind Laomedon stands his daughter Hesione[66] and behind her is an attendant (unlabeled). An Eros above Laomedon gestures toward Herakles; to judge from the way that Herakles' eyes are turned toward Hesione, it would seem that he takes an erotic interest in her.

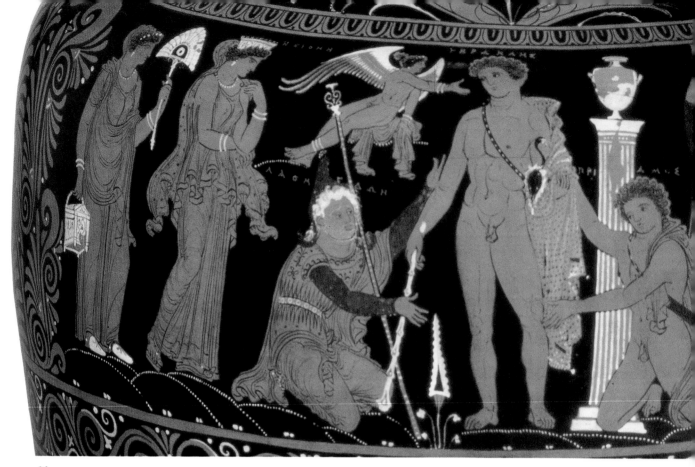

96

This love interest is the painting's main divergence from an other-
wise familiar story, a kind of Trojan version of the Andromeda story.
Laomedon failed to reward Poseidon and Apollo properly for their help
in fortifying the walls of Troy. The consequence was a sea monster, and a
command that the king must offer Hesione as appeasement. Like Perseus
in the other story, Herakles rescues the maiden. But in the usual version,
he stipulates as his reward some special Trojan horses, not the hand of
the young princess. Laomedon reneges on this promise; Herakles kills
him and all his sons except for the youngest, Priam, who is spared at the
request of Hesione. Herakles gives her as bride to his friend Telamon
(their son was Teukros). So Priam, the only royal survivor, becomes the
king of Troy, prosperous until the great expedition of the Trojan War
arrives.

Clearly the narrative here is some variation on this myth. In addition
to the desire of Herakles for Hesione, it seems to have involved some kind
of rival pleas made to Herakles by Laomedon and Priam. Maybe Herakles
will spare only one, and each has to plead his case? There would appear
to be some good material for a tragedy here, and the tableau of kneeling
suppliants is probably an even stronger indicator toward that than Laom-
edon's costume.[67]

There is one further possible pro-indication. To the right-hand end are two Trojan soldiers, similarly but not identically costumed in fine Oriental gear, both looking quite calmly toward the central scene of pleading. They share the label ΦΡΥΓΕΣ, "Phrygians," a common poetic term for Trojans from the early fifth century onward. This is remarkably similar to the maidservants on the Boston Atreus amphora, number 95. If they were rightly interpreted as representing the chorus of a play, then the same is surely true of these two Phrygians.[68] It is even possible that their rather calm, detached air reflects something of the way that the chorus was handled in the play in question.

97

Possibly related to a tragedy about Rhodope

Apulian calyx-krater, ca. 330s
Attributed to the Darius Painter
H: 65 cm
Basel, Antikenmuseum und
Sammlung Ludwig S34[69]

HERE, ONCE AGAIN, we have the Darius Painter telling a recherché myth—so recherché that it is otherwise unknown to us—and a narrative with a likely, but not incontrovertible, connection with a tragedy. Were it not for the name inscriptions, it is doubtful that anyone would have been able to identify the six human figures in the lower frieze, apart from Herakles. Even with the labels, we are reduced to guessing what is going on. In fact, it is safer to begin with the gods above. From left to right, they are: Pan (with *lagobolon*), Apollo, Artemis in hunting gear sitting on an altar beside a statue of herself, and finally, Aphrodite with Eros. It is puzzling, however, that Artemis, who looks disgruntled, has resorted to her own altar, almost as though she were a human suppliant. Maybe she is making clear to her brother, Apollo, just how offended she is by something that is happening in the human world below?

Turning to the humans, the central figure is Rhodope, a nymph of Thrace, associated with the main mountain range in that part of the world. The only clue to her story here is that she holds a writing tablet in her hand. She stands in front of the ornate throne of a young king named Skythes, who, while he is recorded to be the son of Herakles and to have given his name to the Scythians, is sufficiently off the beaten track for this vase to be his one and only entry in *LIMC*. Behind him is an anonymous young soldier. Rhodope stands in between Skythes and a stern-looking

97

Herakles, to whom she seems to be offering the sealed tablet. The two figures behind Herakles add yet more enigmas. The woman is labeled Antiope, and she lays her hand protectively on the shoulder of her little boy, Hippolytos (who is, unusually, portrayed with his face fully frontal).[70] Hippolytos' father was Theseus, who went with Herakles to attack the Amazons in what was to become Skythia, where he took Antiope (sometimes called Hippolyta) and made her pregnant.

So the makings of a possible story begin to emerge. It is set in the North, in either Thrace or Skythia, even though none of the characters is in non-Greek clothing.[71] It looks as though the narrative involved some kind of dispute, possibly with Herakles as the arbitrator, quite likely some kind of quarrel or rivalry between Rhodope and Antiope. Possibly the tablet has something to do with the paternity of the boy? Clearly Artemis is somehow central to the story, and probably she is offended. While Antiope is not represented as an Amazon huntress or a warrior, this scene is very likely connected to the story of how Hippolytos will grow up to be a devotee of Artemis, as was most famously portrayed in Euripides' surviving *Hippolytos*. Because of that play, it is worth wondering whether the decision in this scene has something to do with his upbringing. While there is nothing here, in conclusion, that strongly indicates a connection with tragedy, there is the tantalizing suggestion of a link through Artemis and Hippolytos with Euripides' celebrated play, in which a message written on a tablet has a crucial and terrible place within the tragedy.[72]

98

Possibly connected with a tragedy concerning a larger-than-human figure in a wild landscape

Apulian calyx-krater, ca. 330s
Attributed to the Darius Painter
H: 49.5 cm
Germany, private collection[73]

THIS STRANGE PICTURE can hardly be claimed to be among the Darius Painter's finest works; it finds inclusion here almost solely because of the rectangular "cave mouth" that dominates the composition. This rocky rectangle is closely comparable to the rounded rocky arches found elsewhere, which are plausibly supposed to reflect a standard piece of theater scenery that went in front of the *skene* door (see pt. 1, sec. M4). This theory seems to be confirmed by this new addition, where the rounded arch has apparently been squared off so that it would more exactly fit the stage door, even though this is at the expense of realism. Furthermore, there are two recently published Andromeda scenes where she is bound to a rectangular rock—again, most likely based on this standard piece of stage equipment.[74]

This scene is clearly marked as a wild place by the divinities above, who are seated on uneven ground. The female with a bowl may well be a nymph; in the center above the "door" is a little half-goat Pan with both

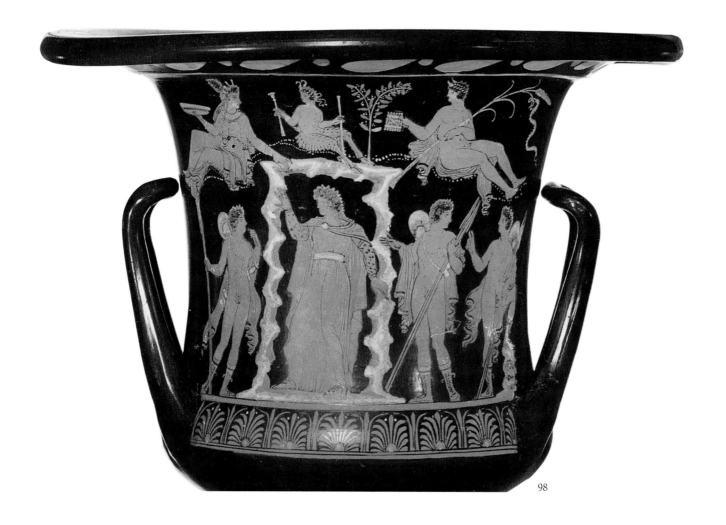

98

a *lagobolon* and, it seems, a trumpet;[75] and to the right is either an adult Pan or a river god, holding out a reed-pipe syrinx. Turning to the lower scene, outside the door we find three young men who are represented as heroic nudes but all with boots, hats, and spears. They might be hunters or soldiers, and perhaps the fact that two have swords suggests the latter. The narrative may be that they have traveled to visit the person in the cave or grotto. He is the great mystery. He is young and quite burly, with luxuriant hair and a full robe with cape and sleeves. It seems clear, and is presumably significant, that he is physically larger than the other three. In Hamburg Museum 1995 (63), he is identified as possibly being a god, namely Dionysos, perhaps making an epiphany from the Underworld; but I see none of the familiar signs that might mark him as Dionysos.

One final suggestion: is it possible that the figure in the doorway is represented as blind? There is no clear depiction of an open eye; this would explain why his hands are on the sides of the cave door in a rather strange manner. The figure who then inevitably comes to mind is Polyphemos, the blinded Kyklops, whose story from *Odyssey* book 9 is so celebrated. In that case the soldiers would probably be three of Odysseus' men. But this does not, in the end, seem to be a very likely solution. There is no sign that the "giant" has been recently blinded, and there are no signs of the pastoral life that characterizes Polyphemos in the *Odyssey* and elsewhere.

99
Possibly related to a tragedy, possibly about Amphion and Tantalos

Apulian monumental lekythos, ca. 330s
Attributed to the Darius Painter
H: 83.6 cm
Geneva, Musée d'Art et d'Histoire
HR 134[76]

THIS IS THE ONLY EXAMPLE we have of the Darius Painter adapting this traditional shape, and it is a work of high quality. The single handle allows for the two rows of figures to go most of the way around the entire pot. In the absence of helpful name labels, the competing scenarios for identifying the scenes are complex; since any connection with tragedy is far from sure, it would not be appropriate to explore them here in full. Apart from any tragic "feel" about the figures or atmosphere, which is (to put it mildly) subjective, the main possible indicators are probably the "nurse" figure in the lower picture and the tripod pillar at the right-hand end of the upper picture (not visible in this plate), which might indicate an artistic contest (see pt. 1, sec. N2), but equally well might indicate a religious location.

The king in the center of the upper scene has an Oriental headdress, and the two soldiers at the left end of the frieze are fully Oriental. Furthermore, the handsome young man below, who is carrying off a noblewoman, apparently against her will, has an Oriental cap (and little else besides his "tragic" boots). These similarities suggest that the two registers tell related stories, although they do not prove it. The most favored inter-

99

pretation has been that this is Paris abducting Helen, and that the king above is Priam, with either Paris or Apollo himself playing the lyre. This Trojan nexus is not out of the question, but I find that the alternative put forward by Margot Schmidt (1990) has more to be said for it. According to her, the king is the Lydian Tantalos, and the handsome lyre player is Amphion, who will marry Tantalos' daughter, Niobe. She, then, is the figure standing behind Amphion (and hence the Aphrodite and Eros behind Tantalos). Amphion was famed for his musicianship, and was even said to have learned and assimilated Lydian harmonics. This, says Schmidt, explains the positioning of his hand on the top of the lyre—which would indeed be the kind of nice touch that the Darius Painter likes to include. In this scenario, the scene beneath is likely to be Pelops, son of Tantalos and brother of Niobe, taking off his Greek bride, Hippodameia, from Olympia.

There are other details that remain to be explained, such as the box held by the nurse, the female with branch and spindle at the top right, and the figure—a river?—in front of the horses (not visible here). It is possible that a particular tragedy would have explained all these elements for the original and primary viewers of the vase.

100

May well reflect a tragedy that included the death of a child

Apulian volute-krater, ca. 320
Attributed to the Group of
Taranto 7013
H: ca. 80 cm
Paris, Musée du Louvre K 66
(N3147)[77]

IT IS NO GOOD PRETENDING that Apulian vase-painting did not go downhill in the last quarter of the fourth century, after the high period of the Darius Painter and his contemporaries. Nevertheless, the central tableau here of the queenly woman lamenting the dead child conveys a pathos that is difficult to resist. It strongly suggests tragedy, the prime genre of lament, although there are not really any other telling signals. There has actually been quite widespread agreement about which myth this narrates, and even which tragedy it reflects: namely, that it relates to Euripides' *Hypsipyle* and shows Eurydike, the mother of Opheltes (to become Archemoros), lamenting her son, who has been killed by the serpent at Nemea. In that case, it is claimed, the warrior in armor is Amphiaraos, looking quite similar to his appearance in the Naples *Hypsipyle* vase, number 79. The other young warriors who stand around the place are then seen as other members of the Seven against Thebes.

The problem with this interpretation, which was authoritatively advocated by Séchan, is that it does not take into account the new knowledge that has been acquired about *Hypsipyle* in the years since the publication of the big Oxyrhynchus papyrus in 1908 (see no. 79). It seems pretty clear now that there was no scene in that play in which Eurydike delivered a personal lament for her child; all her grief and anger are expressed in the presence of Hypsipyle, who is consistently the center of dramatic

100

attention. So without a further pointer, such as Hypsipyle herself or the serpent, there do not appear to be sufficient pro-indications evoking Euripides' narrative of the Opheltes story.

Another possible narrative that comes to mind is that of the little Astyanax, thrown from walls of Troy; the armed soldier would then be a Greek such as Menelaos or Talthybios. The surviving play that dramatizes that event and features Astyanax lamented onstage is Euripides' *Trojan Women* (of 415 B.C.). There is, however, a serious contraindication against that association also. The woman who laments Astyanax (at 1156–1206) is his grandmother, Hekabe, and there is much emphasis on her old age. Furthermore, the shield of Hektor is important in that particular scene, while the shield held by the warrior here appears to be his own. It is a further discrepancy if, as it appears, the child has a wound in the breast. It remains just possible, however, that this is supposed to be Andromache lamenting for Astyanax, her son (less likely than Eurydike lamenting for Opheltes); in which case the scene might be related to a play under the influence of Euripides' *Trojan Women*, but not that play itself. This unknown play might have thrown some light on the figures above, of Hermes and of Dawn (Eos) in her chariot (not visible in this photo).

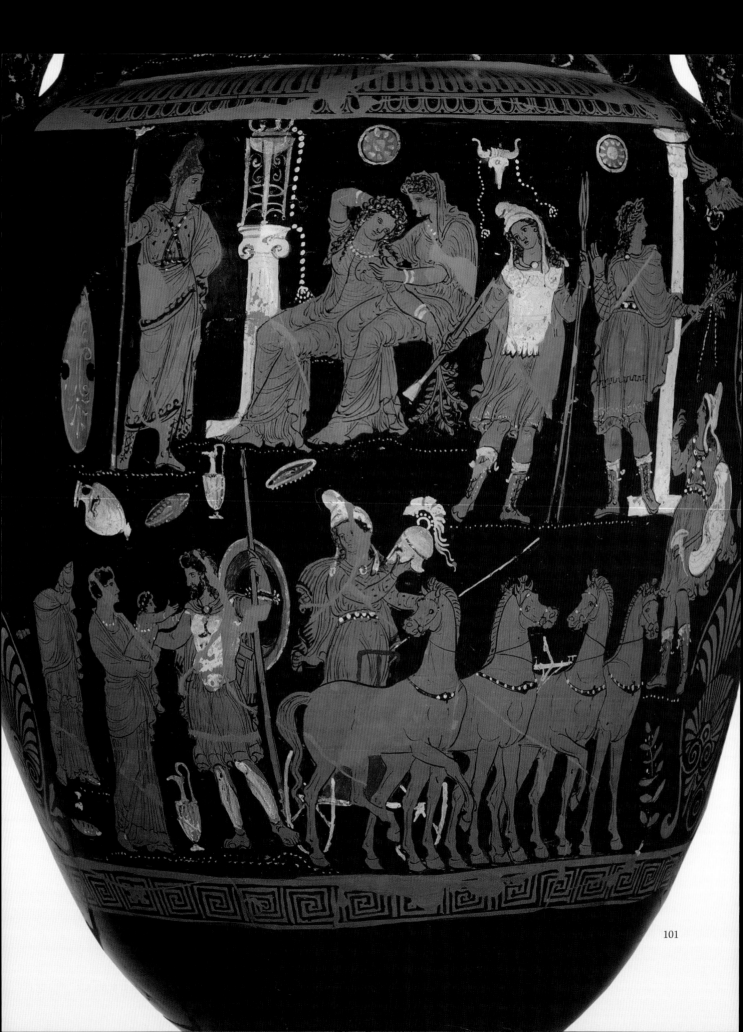

101
Plausibly related to a
tragedy about Hektor,
quite possibly the *Hektor*
of Astydamas

Apulian volute-krater, ca. 320
Attributed to the Underworld
Painter
H: 107 cm
Berlin, Antikenmuseum,
Staatliche Museen zu Berlin
1984.45[78]

IT IS IMMEDIATELY CLEAR that this scene has an Eastern set-
ting: there are no fewer than four figures with "Phrygian caps" and ornate
sleeves. It is just as clear that the lower scene is the farewell of Hektor,
who is taking his leave of Andromache and his baby son, Astyanax, the
moving episode immortalized in *Iliad* book 6 (390–502). Yet, as soon as
the great epic scene is recognized, a viewer who knows the poem will see a
contraindication signaling that this is not precisely the Homeric narrative.
Hektor's charioteer is holding the famous helmet, which is positioned,
shining brightly, right in the center of the composition. In Homer, Hek-
tor is at first wearing it, but then, when he holds out his arms to his son
and the child cries, he takes it off and lays it on the ground (6.466–73). At
the end of the meeting, Hektor picks up his helmet himself and sets off
on foot. Given that this picture is not following Homer exactly, it is more
likely that the woman holding the baby is Andromache herself, rather
than the nurse (who holds the baby in the *Iliad*).[79] The figure of a woman
standing behind her is unfortunately incomplete; it might have decisively
signaled that she was either Andromache or, more probably, the nurse
(with white hair).

Turning to the upper register, it clearly consists of humans, not of
gods. There can be no doubt about the identity of the central woman
holding a branch in a kind of swoon: this must be Kassandra in a fit of
prophesying. In that case the tripod would seem to signify a prophetic
affinity with Apollo (rather than an artistic victory). The older woman
taking care of her is most likely her mother, Hekabe; the king to the left
is probably Priam, although he is not as aged as usual. The soldier to her
right seems to be simply a trumpeter, probably signifying the imminence
of battle, though he might be specifically Paris (or Deiphobos?—see
below). The figure to his right is given clearer signals: he holds a sacred
branch and wears a wreath, and in all likelihood he is Helenos, the
prophet brother of Hektor and Kassandra. This is corroborated by the
bird of omen in the top right, which is flying with a snake in its claws. The
column separates it off as a manifestation of the divine and perhaps sug-
gests that Helenos sees the omen from a temple.[80]

So a group of narrative episodes are combined into a single composi-
tion: the departure of Hektor to battle, dire prophecies by Kassandra,
and the interpretation of an omen by Helenos. These add up to just the
kind of sequence of scenes we might encounter in a tragedy. If there was a
tragedy that drew on the story of Hektor in the *Iliad*, it would very likely
have leaped over almost all of the intervening Iliadic narrative that comes
in between the departure of Hektor in book 6 and his death in book 22,
and would have included the death and probably the mourning over his
corpse.

Now, it so happens that we know of a tragedy called *Hektor* by the leading fourth-century playwright Astydamas. And it so happens that we have a fragment from it in which Hektor says, "take my helmet, servant, so that this boy shall not be frightened."[81] This departure from the Homeric detail (of the helmet being put on the ground) does tally remarkably closely with the vase. Astydamas' *Hektor* was probably a well-known work. This celebrity would be confirmed if one or more of the four papyrus fragments that have been attributed to it did in fact come from that play. At least two of the fragments fit this vase remarkably well, suggesting that it relates to their source play. "The seer Helenos" is actually named in one fragment (fr. 1h, line 12); in another a king, who must be Hektor, calls for his armor to be brought, including the shield of Achilles (fr. 1i, 5ff.). The other two fragments are less easy to incorporate into the same play; although they both deal with the death of Hektor, they do so in different ways. In one (fr. 2a) there seems to be a conventional messenger's report of the fatal duel between Hektor and Achilles.[82] But in the fourth fragment, we have Kassandra caught up in a vision, set in lyric dialogue, reminiscent of her visions in Aeschylus' *Agamemnon*.[83] In dialogue with Priam, she "sees" the fate of Hektor and then expresses surprise at the arrival of Deiphobos, whom she "saw" on the battlefield. It is generally thought that this complex scenario is unlikely to come from a fourth-century tragedy, and hence that it is not from Astydamas; but it is striking how this scene fits rather well with the painting.[84] So, while it would be a mistake to make too much of it, at least three, if not all four, of these papyri are remarkably consistent with the picture on this vase.

There is, then, a surprisingly strong case for claiming that this painting was meant to evoke Astydamas' *Hektor* in the mind of the informed viewer, although, given the tattered evidence, it remains far from sure. Giuliani is very insistent on the presence of Homeric epic in the perception of this picture and even gives that connection prominence over any possible link with Astydamas. This is all part of his larger claim that the painters did not reflect any particular literary version of any story, but put together an eclectic mix of narratives. I suggest that this may underestimate how important it was for a new tragedy to set itself against earlier versions of the story, both reflecting and rejecting them. This would have been especially true of those few tragedies that had the temerity to retell episodes from the great *Iliad* itself; Aeschylus' Achilles trilogy (see nos. 20 and 21) and *Rhesos* (see nos. 53 and 54) are the two examples already encountered. Clearly Astydamas' *Hektor* was another—indeed, this was probably one of its claims to fame. Thus some of the features in this picture that draw on Iliadic material—the baby, the helmet, the eagle-and-snake omen—might well have been integral to a single tragedy that

was setting itself up in a kind of "rivalry" with Homer. In other words, the bearing of Homer on this painting is not as a direct "source," but as a canonical version that has been deliberately changed and mediated through a tragedy.

102

Plausibly related to a *Medeia* tragedy, but not that by Euripides

Apulian volute-krater, ca. 320
Attributed to the Underworld
Painter
H: 117 cm
Munich, Staatliche
Antikensammlungen 3296[85]

THIS HUGE KRATER, 1.17 meters high with nineteen figures in the main picture, is perhaps the most celebrated and most often reproduced of all Western Greek pots.[86] It is far from the best, falling well short of the subtlety and draftsmanship of the Darius Painter, and even of some of this same painter's work, such as the Melanippe vase (no. 68). Nonetheless, it has a wealth of intriguing detail and is almost a textbook repository of the signals that tell the viewer that a painting should be enriched by the knowledge of a certain tragedy.

The multiple tragic indicators include the central portico, occupying two of the three levels of figures and carrying the inscription of five names (in Attic dialect). Second, there is the violent and melodramatic action

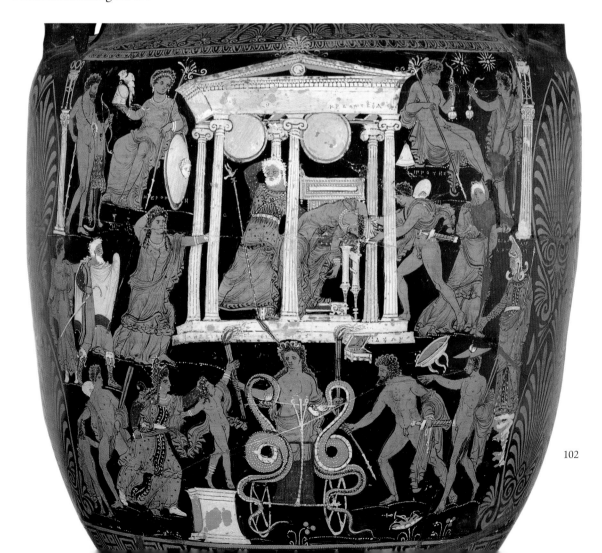

within the portico: the dying princess, with her mother (labeled Merope) rushing up from one side, while her brother (labeled Hippotes) comes from the other side, trying—too late—to wrench the poisoned crown from her head.[87] Third, there are the costumes (although they include only one pair of tragic boots), especially that of the king, Kreon, and the Oriental outfits of Medeia herself and of her father's ghost (see below). To the left of the central scene is, fourth, a typical paidagogos, who in this instance may well have played the part of a messenger. The white-haired figure fleeing apprehensively to the right looks very much like his female equivalent, the nurse—possibly in this play she was the one who brought the fatal presents (note the open casket that lies beneath the princess)? Certainly there is a contrast with number 33, where the paidagogos hurries Medeia's two sons away in a manner quite close to Euripides' narrative.

Then, fifth, there is the serpent chariot conspicuously placed in the center of the bottom row. It is pretty clear that by this time, the chariot has become a symbol of the tragic Medeia, following the iconography— though not the text (as we have it)—of Euripides' play (see nos. 34 and 35). The figure in the chariot here, however, is not Medeia herself, as it is in all the other representations, but ΟΙΣΤΡΟΣ (Oistros, or "Frenzy"), a kind of male Erinys complete with snakes and torches. The statuesque Oistros, while suggestive of vengeance, does not seem to stand directly for Medeia's passion in this version;[88] perhaps his separation of Medeia from Iason to the right is more symbolic of the whole changing relationship between those two.[89] Oistros was not necessarily a speaking character but was probably alluded to within the play. To the left of the chariot, Medeia herself ruthlessly grasps one of her sons—who has taken refuge on an altar—and is about to stab him with her other hand. Sixth and last—and "outside the play," so to speak—is the pair of tripods on pillars to either side of the four divinities in the upper row (Herakles, Athena, Kastor, and Polydeukes). This may be the most persuasive example of such tripods suggesting an artistic victory (see pt. 1, sec. N2). Perhaps the dead man of the tomb, which also contained bronze armor, had bankrolled a successful production of this spectacular play?

Two of the most interesting features of the whole composition are placed rather inconspicuously on the fringes, whether or not purposefully. To the extreme right, apparently on a rock, is the Ghost of Aietes (Medeia's father), explicitly labeled as such (ΕΙΔΩΛΟΝ ΑΗΤΟΥ).[90] While it is possible that his ghost was evoked during the central part of the play, it seems more plausible that he either spoke the prologue or delivered some kind of "god from the machine" speech toward the end. Second, in the very bottom left, Medeia's other son is attempting to make an escape,

apparently aided by a young man with hat and spears (looking quite like the one behind Iason). Neither the boy nor the man is given a name label, and it remains a possibility that this escape was foiled by the murderous Medeia. But, given the great variety of Medeia stories, each played off against the great archetype of Euripides, and no doubt to some extent against each other, it seems quite likely that in this version one of the two sons escaped, perhaps to found some future dynasty.

It seems that this is yet another vase-painting, the third discussed, that reflects a Medeia play that is under the influence of Euripides, but not actually his work. If so, the vase-painters reflect the different tragic versions that were expressly noted by Diodoros of Sicily (quoted on p. 114). In the narrative in number 36, she has killed both sons, but her triumph over Iason seems less overwhelming and her escape more hazardous. In number 94 it may be that she does not kill the two boys but somehow leaves them protected at Eleusis. And in this variant here, finally, she kills one while the other escapes. The painter has marked this Medeia tragedy as quite distinct from that of Euripides, but at the same time, through the iconographic centrality of the dragon chariot, he has marked it as responding to as well as departing from that great iconic challenge.

103

May well be related to a tragedy concerning Adrastos and his daughters

Sicilian calyx-krater, ca. 340s
Belonging to the Adrastos Group
H: 39.8 cm
Lipari, Museo Eoliano 10647[91]

SEVERAL OF THE BEST monumental pieces from the later flourishing of Sicilian vase-painting (ca. 340 to 320), mainly calyx-kraters, display scenes that seem to have rather close connections with the theater.[92] They include two of the most significant scenes of all, the Oedipus vase in Syracuse (no. 22) and the Capodarso scene explicitly set onstage (no. 105). Unfortunately, many of them are in rather poor condition, but this pot is a striking exception, with its colors and detail still nice and clear. The floor on which the scene takes place and the half-open door to the left are both highly suggestive of theater. It is interesting that all the action is happening in front of the supporting columns, and none of it "inside." It is worth asking whether the columns and elaborate ceiling are to be perceived as an actual architectural setting, or as a painted perspective background. At the same time, this scene of extreme violence and physicality involving five figures could hardly ever actually have occurred onstage: it is much more likely to have been related in a messenger speech. The painter has, then, put the scene in a setting that reminds the viewer of its theatrical affiliation.

A mythological narrative has been offered for this scene, and it is surely right. Adrastos, king of Argos, had received an oracle that he would marry his two daughters to "a lion and a wild boar who fight," or words

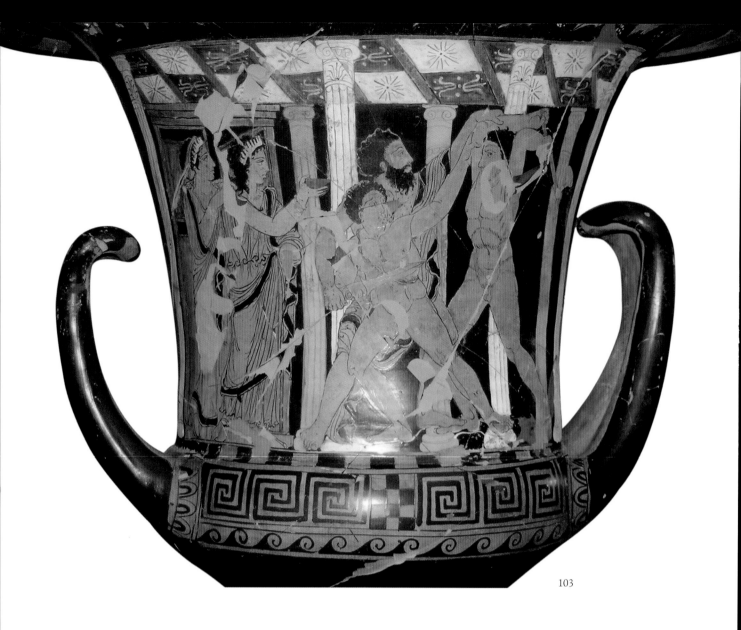

103

to that effect. Two young exiles turn up in Argos, Polyneikes and Tydeus, and promptly start fighting, probably over some amour. When Adrastos finds them locked in deadly combat, he stops them and marries them off to his two unfortunate daughters. These three men will become the core of the Seven against Thebes. There are a couple of passages in surviving Euripides in which this episode is recalled (*Suppliants* 140ff., *Phoenician Women* 408ff.); but, if there is a tragic background to this painting, it would surely have been a full-blown messenger narrative and not merely some dialogue résumé.

Those who are resistant to allowing any relationship between vase-painting and tragedy will point out that the architectural setting is far from a conclusive indication, and that there is nothing else that is obviously theatrical. That is quite right: the link is far from certain—but it still remains fairly plausible.[93]

May be related to a tragedy, or tragedy-related performance, about Odysseus and Maron

Sicilian calyx-krater, ca. 330s
The Maron Painter
H: 40.2 cm
Lipari, Museo Eoliano 2297[94]

THIS SICILIAN VASE, of similar shape and date as number 103, has more overt signs of theatricality, and yet its connection with tragedy is probably more questionable. All four figures, all labeled,[95] stand on a distinctly stage-like floor, and their costumes are all suggestive of tragedy. The question mark hangs over the doubtful tragic potential of the incident, and over the two female allegorical figures who frame the two men in the middle.

The two central figures are identified as Odysseus and Maron. Odysseus has his characteristic *pilos* and fine tragic-type boots. Maron is in a full Oriental—or more precisely, Thracian—outfit. He is handing over a full wineskin. This episode is not directly narrated in the *Odyssey* but is recalled by Odysseus as he later sets off to the Kyklops' island, taking a skin of Maron's dark wine with him (*Od.* 9.196–215). He tells of how he and his men raided the Kikonians in Thrace, their first landfall after leav-

104

ing Troy, and how he spared Maron, the priest of Apollo (no sign of that priesthood here) and his family. In gratitude Maron gave him treasures and twelve jars (not just one skin) of his special vintage. This picture is not, then, very close to the *Odyssey*: it is more like a simplified, dramatized version of it.

While the wine is much praised in the *Odyssey*, there is no particular suggestion in the text to inspire either of the female figures. The one on the left holding a garland is ΟΠΩΡΑ, "Harvest-time."[96] She is, as it happens, a nonspeaking allegorical figure accompanying Peace in Aristophanes' comedy *Peace* (in which she was probably portrayed by a man as an exaggeratedly well-endowed sex object). The other, holding a horn (of plenty?) is identified as ΑΜΠΕΛΟΣ, "Grapevine."[97] As has been seen elsewhere, the naming of figures on a tragedy-related vase, including allegorical figures, does not necessarily imply that they had a speaking role; but it does make it likely that the idea was directly alluded to in the play.[98]

If these two figures actually appeared onstage, as seems to be indicated by the composition here, then we are probably not dealing with a conventional tragedy, as we know it. The painting seems more suggestive of some kind of masque or pageant. We do not, however, have external evidence of any such genre at this period in Sicily (or anywhere else in the Greek world). Trendall and Webster raised the possibility of a *hilarotragoidia*, or tragicomedy, of the kind that would develop later into the mixed-genre "tragic *phlyakes*" of Rhinthon.[99] I do not, however, see any sign of hilarity here, nor of the distortion or ugliness that is characteristic of comedy. On the contrary, the expressions are serious and the poses decorous. I am more inclined to believe that, although they tread on the same floor as Odysseus and Maron, the two personifications were verbally but not incarnately invoked within a tragedy.

Another possible objection against a tragic reference might be that Maron and his gift of wine are not a very promising subject matter. But that point underestimates the aspirations of tragedy to remodel and outbid the great epic archetypes. This rivalry goes right back to Aeschylus' Achilles trilogy in the early days (see nos. 20 and 21); but it can also be seen in the fourth-century example of the *Hektor* of Astydamas (see no. 101). It is by no means inconceivable that a solemn pact between Odysseus and the Thracian, ratified by the blessings of the harvest and the vine, was followed by some distressing turn for the worse; or, possibly, that this pact was achieved only after the disruption and upsets of a tragedy.

105

Closely related to the actual performance of an unidentified tragedy

Sicilian calyx-krater, ca. 330s
The Capodarso Painter (Gibil
Gabib Group)
H: 46 cm
Caltanissetta, Museo Civico
1301bis[100]

ALTHOUGH THIS PAINTING is in poor condition and was found at a remote site high in central Sicily,[101] its importance can hardly be overemphasized. The four figures are clearly shown as treading on a temporary wooden stage platform of the kind that is familiar from comic vases. Whatever its relation to any particular moment in an actual performance, the painting openly declares its theatricality, and that theatricality is clearly tragic. At the same time, it draws the line short of actually reproducing masks with open mouths—though the little old man at the right seems to be close to a caricatured face.

The fact that we have here a picture that aims to evoke a tragedy in performance for the viewer, rather than the usual invocation of a mythi-

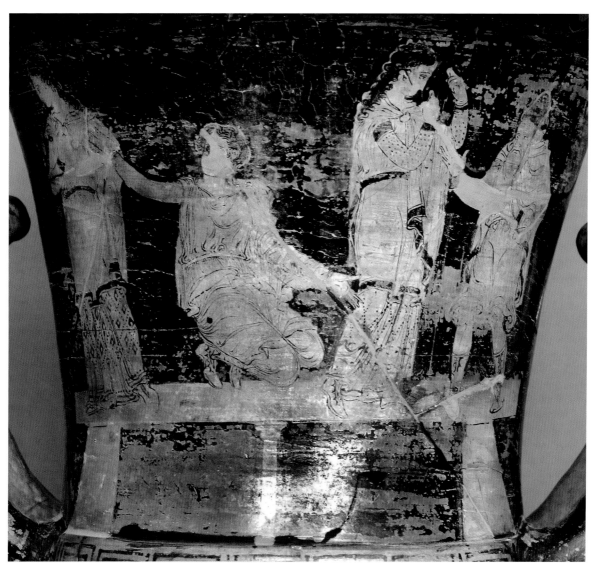

105

cal narrative informed by tragedy, enables us to derive at least three firm inferences. The first is about costumes. Even if this work represents the efforts of a minor traveling troupe in the interior of Sicily, the costumes of two of the three women are quite ornate and elaborate, and the right-hand one also has ornate sleeves. The plainer dress and short hair of the kneeling woman may then be significant for the plot. Second, the painting confirms—hardly a surprise—that scenes in which a character kneels in pleading are thought of as typical of tragedy (see pt. 1, sec. M8). And third, it confirms that the little stooped old man with the cloak, boots, and—as often—traveling hat is indeed a recurrent figure in tragedy. It is striking that he also figures on the Oedipus vase that is probably by the same painter (no. 22).[102]

There does not seem to be any particular indication of what play or what story we are dealing with here. As with the comic vases, this picture appears to be intended for a viewer who can be relied on to identify the play in question. Thus Sophocles' *Oedipus (the King)* makes sense of the otherwise enigmatic number 22; here, on the contrary, we must remain in the dark unless we can fit this scene to a play that we already know. This was attempted by Trendall and Webster (1971), who suggested the scene in Euripides' *Hypsipyle* in which the messenger tells Eurydike of the death of her child, while the nurse Hypsipyle pleads for mercy. A probably fatal obstacle to this, however, is that it is next to certain from the papyrus fragments that Hypsipyle herself reported the death of the child—in other words, there was no little old messenger in that episode.[103]

Although the characters are on the same stage and even overlap each other slightly, there is an objection to taking this simply as a single actual moment in a tragedy: there are four of them, and all four seem to be actively participating. Quite apart from any "rule" specifying a limit of three actors, it becomes confusing in masked theater if more than three characters speak in a single scene. I would not rule out the possibility that the artist has put two separate scenes on this stage simultaneously, perhaps combining two separate pairs. It is worth recalling that in the Oedipus painting, the two little girls were "interpolated" by association from a later scene in the play. There is also a fourth figure there, but she is turned away and does not interact with the other three—none of the four figures here can be detached in the same way.

Therefore, while there can be no reasonable doubt that this picture evokes a tragedy in performance, it may not represent a single scene. In that case we have a combination of the conventions of the comic vases, which are as a rule "scene specific," and of the tragedy-related vases, which are quite happy to combine different parts of the play within a single composition.

106

Closely related to the actual performance of a tragedy, just possibly Euripides' *Alkmene*

Fragment of a Sicilian krater (probably), ca. 330s
Attributed to Lentini-Manfria Group
H of fragment: 14.8 cm
Contessa Entellina, excavations of 1988 E856[104]

THIS FRAGMENT IS FROM the same era of Sicilian vase-painting as numbers 22 and 105; as it happens, it is also from a remote ancient site in the uplands of Sicily—toward the western end, in this case. Enough survives to make it virtually certain that we have another scene explicitly set on a stage, like that in number 105. At the right-hand edge, a woman sits on an altar, probably with her hands held up in alarm. To her left a male figure seems to be stepping off a small podium, holding in his hand a sacred chain and an object said to be a torch, although I can see nothing to prove that it is not a sword.

If it is true that he is holding a torch, then one can see why Monica de Cesare (1992) thought of *Alkmene*. In the usual iconography (see nos. 57 and 58), which may well be related to Euripides' tragedy, Alkmene takes refuge at an altar, while her husband, Amphitryon, turns it into a pyre and threatens to set fire to it. There are some problems with this identification here, although they are not necessarily fatal. One is that the altar is usually surrounded by logs ready for igniting; it might be countered that in actual stage practice, these may have been left to the imagination.[105] Second, one would expect the altar to be center stage rather than at one edge. And third, connected to that, the man is apparently moving away from the altar and not toward it.

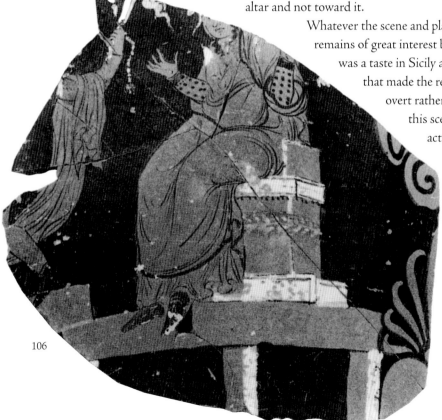

106

Whatever the scene and play portrayed, the fragment remains of great interest because it confirms that there was a taste in Sicily at this period for vase-paintings that made the relationship to performed tragedy overt rather than covert. And, given that this scene is something close to an actual performance, it is worth noting that the woman's costume is very similar to that of the right-hand woman on number 105, including the decorated sleeves. Furthermore, the man has a dark costume, even darker than that of Iokaste on number 22. Lastly, the altar here is not a mythical "reality," but a stage property. The painting further confirms what we knew already: that scenes of refuge at an altar were a favorite incident in tragedy.

107

Probably related to an unidentifiable tragedy

Campanian fragment (unknown vessel), ca. 330s
Attributed to the Caivano Painter
H of fragment: 18 cm
Dresden, Albertinum ZV 2891[106]

IT IS QUITE REASONABLE that we should be inclined to associate painted scenes of domestic violence, especially those set just inside or outside palace doors, with tragedy. Gruesome stories of family slaughter are a basic stuff of the genre. Prime examples already encountered include the stories of Lykourgos (nos. 12, 13), Herakles (no. 45), Meleagros (no. 69), and Atreus (no. 95). There are several other vases for which the myth cannot be confidently identified, and yet the scene has tragedy written all over it, so to speak. There are two good examples in Trendall-Webster 1971: one, which is complete, shows the imminent slaughter by a youth of a mature man in tragic-type costume; the other, which is a fragment, has a bearded man in tragic costume crawling through a door, fleeing from someone else who is stepping on a pile of overturned domestic furniture.[107]

It should not be denied that Campanian red-figure vase-painting is generally inferior, both in technique and sophistication of the treatment of myths, compared with contemporary painters to the south, including Paestum, and to the east, especially northern Apulia. There is a taste for blatant violence, especially scenes of stabbing, and several paintings that draw on tragic myths and their related iconographies seem remote from tragedy in their open carnage.[108] The Caivano Painter shares this taste for violence—see especially number 108—but he shows rather more subtlety and quality of draftsmanship than most.[109]

On this lively and well-drawn fragment, a bearded man is in violent movement in front of half-open doors: he has evidently just emerged from them. He has a sword in his right hand (paint largely lost). A woman flees to the left, and probably another to the right, to judge from the clothing that is visible. It has been proposed that the myth in question is that of Tereus, Prokne, and Philomela, subject of a famous play by Sophocles (see no. 29); but there is really so little to go on, in both the pot and the play, that such tenuous speculation becomes unprofitable. What does seem likely is that we have here a painting that, for the informed viewer, would have been enhanced by the knowledge of a particular tragedy.

107

108

Possibly related to a tragedy, possibly including the sacrifice of a young woman

Campanian neck-amphora,
ca. 330s
Attributed to the Caivano Painter
H: 60 cm
Geneva, Musée d'Art et
d'Histoire HR 411[110]

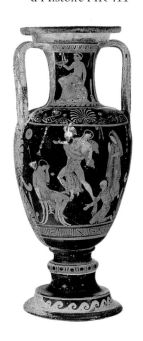

THIS UNUSUAL AND DISTURBING SCENE seems at first sight to be redolent of tragedy; yet on closer inspection it reveals several puzzles, as was well brought out in its first publication. The central action is the warrior carrying off a fair maiden; to the right are a distressed woman and an old king on his knees pleading, in all likelihood the victim's parents. The young man sitting on the chair to the left seems to be distressed but helpless. One might, therefore, think of the violent rape of a princess after the defeat of a city, or some scenario of that kind (although in that case why is the young man not resisting to the death?).

The young woman has a wound beneath her right breast, marked by a stream of blood running down and onto the warrior. This led Aellen, Cambitoglou, and Chamay (1986) to suggest that this betokens that she is going to be killed as a human sacrifice; furthermore, that her bared breasts indicate, with a touch of macabre eroticism, that she will be stripped for the sacrifice. There is a passage of tragedy that comes straight to mind: the report of Polyxene's sacrifice in Euripides' *Hekabe* (559–65): "from her shoulder the whole way to her waist she ripped her covering robe, / laying her breasts and torso bare, most beautiful and statue-like; / and sinking to her knees she spoke these bravest words: look, look, young

108

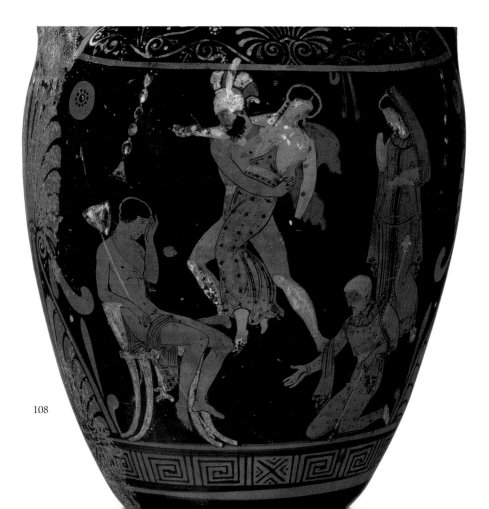

man, / here, if you want to strike my breast, then stab me here; if you desire / my neck, then here's my throat stretched out for you."

There is indeed something of a fascination with human sacrifice in Greek tragedy, and sometimes the victim is a beautiful young virgin, as in Euripides' *Children of Herakles* and *Iphigeneia (at Aulis)*—see number 52—as well as in *Hekabe*. But none of those plays fits the combination of figures on this vase. And, more importantly, in all of them the maiden goes to the sacrifice willingly in the end: there is no case of her being taken off to death by brute force, as here.[111]

Given the Campanian taste for explicit violence, it is not so surprising that this scene should be found on a vase-painting from Campania. This particular painter seems to have rather specialized in scenes of the sacrifice of beautiful maidens, since two other examples survive—both only slightly less shocking than this one. On a bell-krater in Schwerin, a young woman lies dead, partially naked, mourned by a king and an old man sitting on an altar;[112] on a hydria in Naples, a woman with her hands tied behind her to a stake is confronted by a young man who is drawing his sword.[113]

In conclusion, it might be a mistake to suppose that there is a tragedy behind this painting, despite the costumes, the kneeling king, and the general atmosphere. On the other hand, it would not be amazing if a taste developed in later fourth-century Campania for tragedies that were more explicitly bloodthirsty than those of fifth-century Athens. We do not, however, have any corroborating evidence for this local trend.

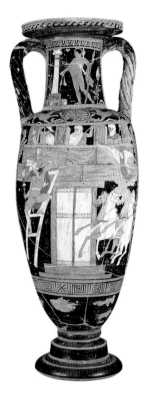

109

Just possibly related to some kind of performance about the Seven against Thebes, but probably not a tragedy

Campanian neck-amphora, ca. 330s
Attributed to the Caivano Painter
H: 63.4 cm
Malibu, J. Paul Getty Museum
92.AE.86[114]

THIS LIVELY AND COLORFUL SCENE is unlike anything else known and poses some baffling questions. It is not difficult to describe, but it is very difficult to interpret. In the center is one of the mighty gates of Thebes, closed against the besiegers. Above them are the monumental blocks of the city walls, and in the crenellations are three figures: two defending warriors and a white-haired king.[115] It is easy to identify the warrior who scales the walls holding his shield in one hand and a flaming torch in the other: this is Kapaneus, who notoriously boasted that not even Zeus could stop him from burning and sacking Thebes. In the top left, Zeus' thunderbolt is already on course to strike him down.

But there is no such easy explanation of the team of four horses that prances in from the other side, with their charioteer "offstage," so to speak, on the right-hand side of the picture. They are clearly victorious horses, however, since a Nike with a garland and ribbon hovers above them. They would be a very odd way of representing the victory of the defenders inside the walls. On the other hand, none of the seven attacking

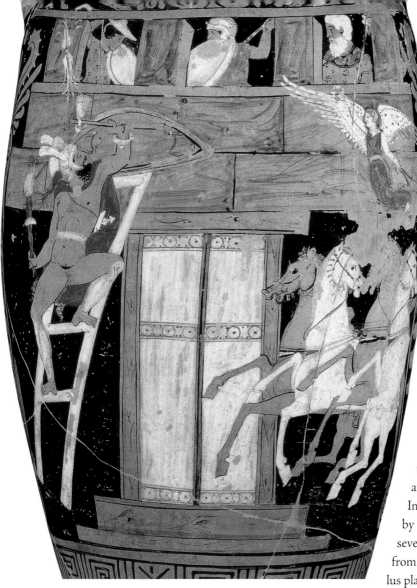

109

warriors are victorious, unless one counts the miraculous disappearance of Amphiaraos beneath the earth as a kind of victory?[116]

The striking down of Kapaneus would never, of course, have been enacted onstage in a tragedy—at least not in a tragedy as we know the genre from our fifth-century Athenian examples. The incident is foreseen in Aeschylus' surviving *Seven against Thebes* (of 467 B.C.), but not actually narrated. Before the attack, the reconnaissance scout reports Kapaneus' boast (lines 423–34). Eteokles, the brave leader, replies that he is confident that Zeus will strike the arrogant attacker down with his bolt (444–46). In Aeschylus' play the battle is fought by man-to-man combat at each of the seven gates—not, as in this painting, from the battlements. And the Aeschylus play offers no clue to the victorious four-horse chariot. I see no reason, then, to connect this vase directly with Aeschylus' *Seven against Thebes*, nor, in the absence of any pro-indications, with any other tragedy.

We would confidently conclude that the vase represents the myth and not any mimetic performance, were it not for one detail: the walls of Thebes seem to be deliberately shown as made of wood. It might be that this kind of streaking effect using dilute glaze is meant to represent the grain of stone, but elsewhere this is the technique used for wood. If this is so here—and I think it remains a big if—then the painting suggests some kind of temporary construction made by carpentry rather than mythical walls of stone. But we have no other evidence from this period (as far as I know) for the reenactment of mythical battles in some kind of pageant, and this idea seems a far-fetched explanation in order to rescue one detail of pictorial technique. Nonetheless, it cannot be out of the question that this vase is a trace of some kind of strange "war games" performance about which we are otherwise ignorant.

VASE CONCORDANCE

Adolphseck, Schloss Fasanerie 179 no. 55
Atlanta, Carlos Museum, Emory University
 1994.1 no. 68
Bari, Museo Archeologico Provinciale
 1535 no. 56
 5597 no. 41
Basel, formerly market no. 28
Basel, Antikenmuseum
 BS 473 no. 23
 S21 no. 31
 S34 no. 97
Basel, Cahn collection HC 255 no. 90
Berlin, Antikensammlung
 F 3296 no. 65
 VI 3157 no. 53
 VI 3237 no. 59
 VI 3974 no. 75
 VI 4565 no. 11
 1968.12 no. 82
 1969.6 no. 38
 1969.9 no. 18
 1984.39 no. 54
 1984.41 no. 81
 1984.45 no. 101
Bonn, Akademisches Kunstmuseum
 147 no. 86
Boston, Museum of Fine Arts
 1900.349 no. 72
 1900.03.804 no. 91
 1976.144 no. 10
 1987.53 no. 30
 1989.100 no. 58
 1991.437 no. 95
Caltanissetta, Museo Civico 1301bis no. 105
Cleveland Museum of Art
 88.41 no. 93
 1991.1 (side A) no. 35
 1991.1 (side B) no. 76
Contessa Entellina, excavations of 1988
 E856 no. 106
Dresden, Albertinum ZV 2891 no. 107
Exeter, University, unnumbered no. 1
Ferrara, Museo Nazionale di Spina
 T 1145 (3032) no. 48
Florence, La Pagliaiuola collection
 116 no. 32
Fort Worth, Kimbell Art Museum
 15 no. 74

Geneva, Musée d'Art et d'Histoire
 (on loan) no. 96
 HR 29 no. 4
 HR 134 no. 99
 HR 411 no. 108
 24692 no. 87
 282bis no. 16
Geneva, Sciclounoff collection,
 unnumbered no. 40
 unnumbered no. 78
Germany, private collection no. 98
Lipari, Museo Eoliano
 2297 no. 104
 10647 no. 103
London, British Museum
 F133 no. 51
 F155 no. 70
 F159 no. 52
 F271 no. 13
 F272 no. 39
 F279 no. 42
 1900.5-19.1 no. 44
Madrid, Museo Arquológico Nacional
 11094 (L369) no. 45
Malibu, J. Paul Getty Museum
 77.AE.93 no. 83
 80.AE.155.1 no. 5
 84.AE.996 no. 61
 85.AE.102 no. 62
 86.AE.680 no. 89
 87.AE.23 no. 63
 92.AE.86 no. 109
Melbourne, Geddes collection
 A 5:4 no. 66
 A 5:8 no. 27
Milan, Collezione H. A. 239 no. 43
Milan, Museo Civico Archeologico
 St. 6873 no. 85
Munich, Antikensammlungen 3296 no. 102
Naples, Museo Archeologico Nazionale,
 Santangelo 526 no. 33
 81954 (H 3221) no. 36
 82268 (H 3233) no. 29
 80854 (Stg. 11) no. 69
 81934 (H 3255) no. 79
 81947 (H 3253) no. 92
 82140 (H 1755) no. 2
 82270 (H 3249) no. 7
 82113 (H 3223) no. 47

New York, The Metropolitan Museum of Art
 16.140 no. 14
 20.195 no. 21
Oklahoma, Stovall Museum
 C/53-4/55/1 no. 80
Paestum, Museo Archeologico Nazionale
 20202 no. 73
Paris, Musée du Louvre
 K 66 (N3147) no. 100
 K 544 no. 3
 K 710 no. 8
Perugia, Museo Etrusco-Romano,
 unnumbered no. 6
Policoro, Museo Nazionale della Siritide
 35296 no. 34
 35302 no. 37
Princeton University Art Museum
 1983.13 no. 94
 1989.29 no. 17
 1989.40 no. 67
Rome, Museo Archeologico Nazionale
 di Villa Giulia 18003 no. 71
Ruvo, Museo Jatta 1095 no. 19
 1097 (36822) no. 46
 J423 (36734) no. 64
 36955 (n.i.32) no. 12
San Antonio Museum of Art
 86.134.167 no. 77
Saint Petersburg, State Hermitage Museum
 B1718 (St. 422) no. 20
 B2080 (W1033) no. 50
 St. 349 no. 9
Syracuse, Museo Archeologico Regionale
 36319 no. 26
 66557 no. 22
Taranto, Museo Archeologico Nazionale
 4600 no. 57
 8935 no. 15
 134905 no. 24
Vatican Museums 18255 (AA2) no. 84
Vienna, Kunsthistorisches Museum
 689 (SK 195, 69) no. 25
Virginia, private collection 22 (V9105) no. 49
Würzburg, Martin von Wagner-Museum
 H 4698 and H 4701 no. 88
 H 4606 no. 60

NOTES

PART I: SETTING THE SCENES

1 Publication date is 2003, but I was already well advanced with this work before I was able to obtain a copy toward the end of 2004. I have done my best to integrate it throughout, nonetheless. While the authors' approach is very different, the chapter by Carmela Roscino, "L'Immagine della Tragedia" (223–357), overlaps in many particulars with my concerns here.

2 Only 41 of the 109 pots in part 2 are in Trendall-Webster 1971. It is also a consideration that two of the three most important publications of relevant new vases—Aellen-Cambitoglou-Chamay 1986, on vases in Geneva, and Giuliani 1995, on vases in Berlin—are both, in different ways, inclined to play down the connections of the vases with tragedy. (The third, more amenable to tragedy, is Padgett et al. 1993, on vases in Boston.)

3 Easterling 1993 was important for opening up this disregarded chapter in the history of Greek tragedy; see also Xanthakis-Karamanos 1980.

4 I am deliberately avoiding the term "catharsis," which I regard as too ill-defined and overused to be of great value.

5 *Mutatis mutandis* is an extremely useful phrase—something like "making due adjustment for the factors that need to be adjusted"—since it allows for the validity of such factors and due allowances, without getting bogged down in specifics.

6 This invaluable phrase was coined by Zeitlin (1996).

7 In Wilson-Taplin 1993, we suggested that the incorporation of the terrifying Erinyes, the Furies, into the city of Athens at the end of Aeschylus' *Oresteia* trilogy is a model for the whole tragic experience.

8 Prime examples of such approaches are Vernant and Vidal-Naquet 1972, 1986; contributors in Winkler-Zeitlin

1990; and Easterling 1997. Areas of concentration have included the praise of Athens, the anxieties of empire, the Athenian pre-play displays, and the ideology of Athenian democracy.

9 See Taplin 1999, 33–57; Dearden 1999; there is a good study of the subject from the perspective of the acting profession by Csapo (2004); see also Imperio 2005.

10 *Laches* 182d83—see Taplin 1999, 39; Csapo 2004, 70–71; see also Plato's *Republic* 475d for traveling theater fans.

11 For a useful list, see Csapo 2004, 56 n. 13, 66–67.

12 This was his *Women of Aitne*, produced to celebrate the foundation of the new city beneath Aitne (Etna) by Hieron, the monarch (or "tyrant") of Syracuse. We have four lines from the play (*TrGF* 3, fr. (fragment) 6): they are in Attic dialect and are about a local Sicilian cult.

13 I have argued in Taplin (forthcoming A) that *Persians* was a calculated attempt to put tragedy on the Panhellenic map by contributing to the widespread celebrations in the 470s of the great victories over the Persians in 490 and 480/79.

14 *Life* of Aeschylus, lines 46–47 (p. 35) in *TrGF* 3.

15 We have quite a lot of fragments and information about this play, *Archelaos*; see *TrGF* 5.1, 313ff., frs. 228–64.

16 *TrGF* 5.1, T (Testimonia) 112–20 (101–4).

17 *TrGF* 5.1, T189a and b (129–30); see Taplin 1999, 42–43.

18 See Dearden 1999, 229–32.

19 See sources in Csapo-Slater 1995, 124–32.

20 Csapo 2004, 64.

21 Csapo-Slater 1995, 124–32.

22 Aristotle complains about these interludes (*embolima*). The practice of putting the words "choral song" in the play scripts, rather than writing out the specific lyrics, may well have grown out of this tradition of allowing for local choruses.

23 See Csapo-Slater 1995, 10, sec. 14.

24 For Syracuse, see Polacco 1981, 1990.

25 Passages collected in Csapo-Slater 1995, 231–38.

26 If women were in the audience in other parts of the Greek world, even if not in Athens itself, that would help to explain why Plato claimed that tragedy's great reach was harmful even to them.

27 Here is a speculative calculation. Suppose that three tragedies were being performed in a day on two days a year in 100 locations throughout the Greek world. That would make 600 play performances a year. If each location had an average capacity of 4,000, and the average spectator spent one day a year at the theater (watching three tragedies), that would suggest that close to a million Greeks saw tragedies each year. So even a cautious pruning of these cautious figures will still arrive at hundreds of thousands.

28 See Buxton 1994, 18–21 and notes.

29 The term should, strictly speaking, include Greek settlements in Sardinia, Corsica, and southern France, above all the prosperous and cultured city of Massilia (Marseilles).

30 The usual term is "colonies," but I shall not use this word because it brings with it a lot of baggage, much of it inappropriate.

31 Sicilian Greeks took special pride in their successes in the chariot races at the great Panhellenic games, for instance.

32 Syracuse also produced two tragic playwrights later in the century, Achaios and Sosiphanes. See *TrGF* 1, 79, 92.

33 Todisco (2002, 167–92) catalogues and discusses twenty theaters from Sicily; see Moretti 1993, 78–88.

34 Giuliani 1996, 73.

35 Especially in Giuliani 1995.

36 I shall include the neighboring coastal areas of "Lucania" in this discussion, since they were culturally indistinguishable from Apulia (see sec. F below).

37 See Huffman 2005, esp. 32–42.

38 See Mitens 1988; Moretti 1993, 88–89;

39 One is explicitly attested at Polybios *History* 8.30.7, as well as in various later sources.

40 Giuliani (1995, 160 n. 28) criticizes credulousness about these anecdotes; see also Purcell 1994, 389–90.

41 The closest to direct evidence of this is Plato's *Laws* 817b–c, which talks of players "fixing up their stages in the agora." Hughes (1996) has shown that most of the scenes on the comic vases would belong in permanent theaters; cf. Csapo 2004, 58.

42 See *TrGF* 1, 57 fr. 2. The scholion on Aristophanes' *Ploutos* 84 says the Patrokles named there was a tragic poet but also says he was Athenian. It is quite conceivable that they are the same Patrokles.

43 Evidence collected and discussed in Arnott 1996, 12–15.

44 See Taplin 1993, 48–52; *PCG* I, 264.

45 See Ghiron-Bistagne 1976, 315; Stephanis 1988, 95–96; also Easterling 2002, 336–38.

46 Ghiron-Bistagne 1976, 156, 312, 364; Stephanis 1988, 76–77.

47 On this subject see Taplin 1993, 92–93, with bibliography. Throughout this discussion I am omitting consideration of terracotta masks and statuettes: for recent accounts of them, see Green 1994, 34–37; Todisco 2002, 31, 55–61, 101–4.

48 Apulian bell-krater, ca. 400; New York L 63.21.5; *RVAp* 3/2 and pl. 13; *RVSIS* ill. 102. On another, similar piece, the youth holding the mask is apparently human: London F163; *RVAp* 3/12. For a complete survey of vases with masks, including other earlyish Apulian examples, see Trendall 1988.

49 Apulian bell-krater, ca. 370; Brindisi, Faldetta Collection; *RVAp supp 2*, 4/210a—Trendall 1991, 156 and pl. 63; Taplin 1993, 92 and pl. 22.117. The woman standing behind him has Dionysiac attributes, but there is no indication that the seated person is himself Dionysos.

50 Apulian Gnathia fragment, ca. 350; Würzburg H 4600 (L832); *CFST* Ap95 (incongruously in *CFST*, since the scene must be set offstage); and Froning 2002, 79 and fig. 95.

51 Apulian bell-krater, ca. 390s; Sydney, Nicholson Mus. 47.05; *RVAp* 3/15; *RVSIS* ill. 104—Trendall-Webster 1971, II.2; for a good recent discussion with bibliography, see Green 2003, 40–41, no. 12.

52 In a particularly beautiful painting of Dionysos and Ariadne, there is a satyr or silenus mask on the ground: this is an Apulian calyx-krater, ca. 340; Basel Antikenmus. BS 468; *RVAp* 18/13 and pl. 170.3 and pp. 479–80. There is also an interesting Campanian amphora from the 330s, which apparently shows an actor with his satyr mask pushed back on top of his head: Kiel, private coll.; *LCS supp 3*, 158/792a; *RVSIS* ill. 287. (For a comic actor with his mask pushed back, see Richmond, VMFA 82.182 (Apulian mid-century); *RVAp supp 1*, 10/23a.)

53 The subject of my book Taplin 1993.

54 See Cassio 2002.

55 Apulian calyx-krater, ca. 390s; New York 24.97.104; *RVAp* 3/7; *RVSIS* fig. 105—*PhV²* 84; Taplin 1993, 30–31 and ill. 10.2. Two recent contributions on this, which both make interesting points, are Schmidt 1998, 25–28, and Marshall 2001.

56 There is also an inscribed word, ΤΡΑΓΟΙΔΟΣ (tragedian), in the upper left. As Schmidt (1998, 27–28) has pointed out, this is likely to be a label for the ugly man beneath it, and not for the boy to the left, who is probably a non-player attendant. See the similar unmasked boy in the Cheiron comedy on London F151; *RVAp* 4/252—*PhV²* 37. There is also, interestingly, a similar figure on the new Attic fragment of a chorus in Kiev, see fig. 9.

57 Apulian bell-krater, ca. 370s; Würzburg H 5697; *RVAp* 4/4a; *RVSIS* fig. 109 (too recent for *PhV²*)—Taplin 1993, 36–40 (with bibliography) and ill. 11.4; Trendall 1991, 165–66, pl. 68.

58 The only significant dissenter I know of has been none other than Giuliani (2001, 37 n. 39), who maintains that "no comic scene in Apulian iconography shows a demonstrable relation to a given Attic comedy." He is evidently well aware that the Würzburg Telephos

is not good news for his position on tragedy in the Greek West.

There is, or rather was, one other vase to corroborate this interpretation, a rather rough painting formerly in Berlin and probably destroyed in the Second World War, corresponding to the opening of Aristophanes' *Frogs* sufficiently for the link to be probable: formerly Berlin F3046; *PhV²* 22; Taplin 1993, 45–47 and ill. 13.7. Other vases that might possibly be connected with known Attic comedies are inevitably more speculative, see Taplin 1993, 41–44.

59 Far and away the most informative introduction to this subject is by Trendall in his *RVSIS*.

60 Both continued down into the third century. For a concise introduction to these, see Green 1982a (including p. 282); on Gnathia, see also De Juliis 2000, 121–22. Two Gnathia paintings are included in part 2 of this book as nos. 9 and 81; see also fig. 3 in part 1.

61 Trendall (*RVSIS* 7) calculated "approaching 20,000" red-figure vases. His totals are roughly recalculated by *CFST* 100ff. at 25,000 (Lucanian 2,000, Apulian 15,000, Sicilian 1,000, Paestan 2,000, Campanian 5,000).

62 A previous attempt was Webster 1967, but he himself recognized the severe limitations of the appendix gathered at 137–70. I have not attempted to include reference to this work, which is not user-friendly and is largely superseded by *CFST*.

63 Nearly all those included in this book that are not found in *CFST* have been published since 1980, and so are not representative of the overall picture. They are nos. 5, 16, 49, 89, 93, 98, 99, 108, 109 (and some of these, especially 89, 98, and 109, are long shots for tragic affiliations). Others not in *CFST* are nos. 24, 51, 97, 104.

64 Beazley 1944, 365.

65 There is a good appreciation of artistic qualities in Giuliani 1995, 66–72.

66 The splendid publication of H. A. Cahn's collection of fragments, Cambitoglou-Chamay 1997, illustrates this well.

67 Trendall largely followed Beazley's methods for grouping and allocating works to painters. This means that the

68 *RVAp supp 2*, vii.

69 Nearer to 2,000 and 15,000, respectively, according to *CFST*.

70 Bibliography and so forth in *LCS supp 3*, 3.

71 E.g., *RVSIS* 17–18; cf. Giuliani 1995, 159 n. 3.

72 For a valuable survey of Lucanian pottery, treating it as distinct, see Siebert 1998, 100–118.

73 Excellently published by Degrassi (1967). On the provenances of Lucanian tragedy-related vases, see Gadeleta in *CFST* 142–66; De Juliis 2001, 205–20. For more general material on provenances, see Robinson 1990, esp. 183–84.

74 *RVAp* 185–92, *RVSIS* 79.

75 They are nos. 33, 43, 47, 52, 53, 67, 84.

76 See *RVAp* 413–15; *RVSIS* 80–81. Lycurgus Painter in part 2: nos. 13, 20, 46, 69, 85, 86.

77 See *RVAp* 482–95; *RVSIS* 89–90; also Schmidt 1960; Aellen-Cambitoglou-Chamay 1986.

78 These are nos. 16, 17, 23, 28, 29, 30, 36, 40, 42, 44, 54, 58, 63, 74, 79–82, 92–99.

79 Represented by nos. 18, 27, 31, 39, 61, 90, 91.

80 The best was the Underworld Painter: see nos. 66, 68, 101, 102.

81 This is discussed with reference to known provenances by Robinson (1990).

82 See Gadeleta in *CFST* 166–94, esp. 171–72; De Juliis 2000, 104–19. Pots from Taras include no. 57, which dates back to circa 400.

83 On Canosa, see the excellent volume Cassano 1992. Ruvo has been less well documented, but an idea of the amazing finds of Greek pottery there may be gained from Andreassi 1996.

84 All this makes it very interesting, rather than a puzzling anomaly, that the celebrated Pronomos Vase, an Athenian work of circa 400, was found at Ruvo—see further discussion on pp. 21–22 below.

85 These are nos. 22, 26, 65, 103–6. Several others might well have been included, e.g., Lipari 9405 (*LCS supp 3*, 272/29d; *CFST* S12 (Alkmene)—Trendall-Webster 1971, III.3,7); Siracusa 47038 (*LCS* 602/102 and pl. 236.1); Lipari 340bis (*LCS*

supp 3, 275/46h; *CFST* S16 [Hippolytos]—Trendall-Webster 1971, III.3,23). On tragedy and Sicilian vases, see also Keuls 1997, 361–70.

86 See the series of studies by Bernabò-Brea, esp. Bernabò-Brea 1981; Bernabò-Brea and Cavalier 2001.

87 In general, see Cipriani-Longo-Viscione 1996.

88 Aristoxenos fr. 124, cited at Athenaios 632a–b; see Purcell 1994, 394.

89 It is, in fact, uncertain whether no. 4, classified as Paestan, was produced in Paestum or in Sicily.

90 In addition to the three entries in part 2 (nos. 45, 73, 77), at least two others of the nine entries under his name in *CFST* are quite likely to be tragedy related.

91 I have deliberately not included the famous and much-reproduced Orestes-at-Delphi scene on London (1917.12-10.1, *RVP* 145/244; *CFST* P12—Trendall-Webster 1971, III.1,11). Even Trendall (*RVP* 146) is negative about its artistic merit and almost endorses Beazley's judgment that it is a "monstrosity."

92 These are San Antonio 86.134.168 (*RVP* 85/133; *CFST* P4) and Paestum 4794 (*RVP* 109/142; *CFST* P7—Trendall-Webster 1971, III.1,12).

93 There are even odder inscriptions on some later vases, e.g., "Ieus" for Zeus on London F149 (*RVP* 139/239; *CFST* P15) and "Alēktra" for Elektra in an Orestes-at-Delphi scene on Tampa Bay NI 4.1.89 (*RVP* 245/971; *CFST* P18—Taplin 1993, 24 and pl. 3.106).

94 For example, Iphigeneia hands over the letter without Pylades present (Sydney, Nicholson Mus. 51.17; *LCS* 406/305; *CFST* C23—Trendall-Webster 1971, III.3.30b); Telephos holds Orestes at the altar with no Agamemnon threatening (Graz, Landesmuseum Joanneum 8641/2; *LCS* 269/278; *CFST* C19).

95 See *LCS* 335–37; *RVSIS* 161; *CFST* C35–48.

96 See *LCS* 305–7; *RVSIS* 160; *CFST* C28–33.

97 The standard history of Taras is still Wuilleumier 1939; for more recent contributions, see Purcell 1994; De Juliis 2000. On Archytas himself, see Huffman 2005.

98 For a helpful study of Greeks and non-

Greeks in the area of Lucania (Basilicata), see d'Agostino 1998.

99 The chief local pottery shape that was assimilated was the nestoris, or "trozzella"—see *RVSIS* 10. It has been claimed that the inscription on the Campanian oenochoe London F233 (*LCS* 238/94) is in Oscan: see Taplin 1993, 40–41. But, if so, it remains exceptional.

100 See *RVSIS* 15–16 and Trendall's bibliography on p. 276; Robinson 1990, 186.

101 Purcell (1994, 396) characterizes them as "a competitive, hierarchical, image-conscious, aggressive, militaristic elite." There are good remarks on cultural assimilation, as opposed to political attitudes, by d'Agostino (1998, 47–49).

102 Greek mirrors made expressly for the Etruscan public make a striking contrast—see de Angelis 2002.

103 This is in contrast with Paestan—see p. 19.

104 Giuliani 1996, 71.

105 Most clearly in Giuliani 2003, 231–61.

106 Has Giuliani, to some degree, read the elitism of classical philologists in the nineteenth and twentieth centuries back into the fourth century B.C.?

107 See Giuliani 1995, 18–19 with notes, esp. n. 44; Giuliani 2003, 243–48. As is now generally recognized, there was, in reality, no overnight revolution between 401 and 399: the transition from orality to literacy was a piecemeal process that happened in fits and starts between circa 550 and circa 250—and it was not even complete before or after those two dates—see, e.g., Thomas 1992, passim. When Aristotle claims that tragedies can be appreciated equally well through reading, he is not stating the accepted view, and he is not stating the obvious—see, e.g., Taplin 1977, 477–79.

108 Giuiani 1995, 152–58 and notes; also briefly in Giuliani 1996, 86.

109 It has been recently exemplified in a highly polarized form by Small (2003). Her title (*The Parallel Worlds...*) says it all: the point of parallels is that they never touch each other. For a similar approach to Homeric epic and visual art, see Snodgrass 1998.

110 If I sometimes adopt a somewhat polemical tone against the "new" orthodoxy, it is because it still tends to pose as an embattled minority position and

to adopt a contemptuous tone against alternatives.

111 Giuliani 1996, 72; in Taplin 1993, 21, I called these advocates "philologist-iconographers."

112 For some bibliography, see Giuliani 1996, 72 n. 4.

113 On the title page, "Études sur la tragédie grecque" is printed in a far larger font than "dans ses rapports avec la céramique."

114 Giuliani 1996, 74–75; in Taplin 1993, 21, I called these advocates "autonomous iconologists."

115 Notably Robert 1881; cf. Metzger 1965.

116 Moret 1975, further exemplified by Moret 1984 on the iconography of Oedipus and the Sphinx.

117 The "interpretation" sections by Christian Aellen in Aellen-Cambitoglou-Chamay 1986 are particularly important because they reject, or do not even raise, any connection between tragedy and the vases published there, which were collected at that time in Geneva. Several are important for this work, and no fewer than eight of them will be discussed later: these are nos. 4, 16, 39, 68, 88, 93, 99, 108.

118 Aellen in Aellen-Cambitoglou-Chamay 1986, 268, slightly paraphrased.

119 Those "original" stage directions were a central subject of Taplin 1977 and 1978.

120 Thus, of those pictures in part 2 that are variously related to surviving plays of Euripides (nos. 31–54), more than a third connect with messenger speeches.

121 The phrase of Green (1994, 52).

122 In two cases I argue that he overemphasizes Homer and underemphasizes tragedy: nos. 54 and 101. I see the Homeric material as mediated and transformed by the tragedy.

123 Most fully explored in Giuliani 1995, 16 with notes; see also Giuliani 1996, 73–74.

124 Green 1991a, misunderstood, despite its clarity, by Small (2003, 68–70).

125 See Taplin 1986. I may have overstated the case there, since there are ways in which tragedy can be self-conscious, but at the same time there does remain a deep-seated contrast with comedy.

126 This was the subject of Taplin 1993. The most important contribution since then has been Schmidt 1998; see also Csapo 2001, 23–24.

127 Schmidt (1995, 65–70) has even placed a question mark over the best-known claimant, the "Anavyssos Perseus" (Athens, formerly Vlastos coll. [now in the National Museum?]; ARV² 1215—Trendall-Webster 1971, IV.1; Taplin 1993, 9 and pl. 8.25). There are, by the way, some very interesting new fragments of a mid-fourth-century Attic jug with a comic chorus: Athens, Benaki Mus., published by Pingiatoglou (1992).

128 Apulian bell-krater, ca. 390; Malibu 96.AE.29; RVAp supp 2, 1/124 (too recent for PhV²)—Trendall 1991, 164 and pl. 67; Taplin 1993, 55–63, bibliography, and pl. 9.1. There is no consensus on the interpretation. I am still inclined to believe the solution proposed in Taplin 1993, 55–63, that he somehow "represents" Tragedy as opposed to Comedy (which is counterrepresented by Pyrrhias, the slave standing on the wool basket).

129 On the citation of Aigisthos as an archetype of tragic perversions, see Wilson 1996, 316, 319–20.

130 They include Pickard-Cambridge 1968; Green 1991b, 1994, 16–48; Taplin 1997, 69ff.; Csapo 2001, 17–38; Froning 2002, 71–82; Imperio 2005.

131 Attic column-krater, ca. 480s; Basel BS 415; BAD 260; published by Schmidt, 1967, 70–78, pls. 19.1, 21.1; see Green 1994, 18 and fig. 2.1.

132 Fragment of Attic bell-krater from Olbia, ca. 420s; Kiev, Museum of the Academy of Sciences, unnumbered; published by Froning, 2002, 73 and pl. 88. This is the only publication known to me, and I am much indebted to her.

133 The role of the smaller boy, also in costume (and singing?), is not obvious. He might be compared to the attendants occasionally found on comic pots (see n. 56 above), but he seems to be participating.

134 Fragments of Attic krater, found at Taras, ca. 400; Würzburg H 4781; ARV² 1338; CFST A72.

135 See Green 1982b, 237–48. This is an Attic bell-krater (ca. 400 from Spina) Ferrara inv. 20483 (no ARV² or BAD)—Green 1994, 81 and fig. 3.18; Froning 2002, 76 and fig. 92. The female is holding their two masks, and it seems that their faces are "fused," so to speak, with their dramatic roles. We

are left with several open questions; for example, is the actor on the right still wearing her/his mask?

136 Attic volute-krater, ca. 400s, from Ruvo; Naples 81673 (H 3240); ARV² 1336.1; CFST 27 n. 142—Trendall-Webster 1971, II.1; Krumeich-Pechstein-Seidensticker 1999, 562–65; Froning 2002, 83–84 and pls. 105–6.

137 Demetrios is known only from this vase. Pronomos of Thebes, on the other hand, was a celebrated performer.

138 For a study of these, see Junker 2003, 317–35.

139 According to Gadeleta in CFST 173, 544–45, it came from a group of tombs excavated in 1835, which contained objects from a wide chronological spread from the sixth century down to the mid- or later fourth.

140 Trendall-Webster 1971, 3; they do also suggest a local "theater-lover" as an alternative.

141 Alkestis was put on as a fourth tragedy by Euripides in 438, and so shows that the rule was not invariable.

142 Fragment of Attic cup, ca. 380s; Dresden, Albertinum AB 473; see Sparkes 1988, 133–36, fig. 14.1; Froning 2002, 85 and pl. 110.

143 See especially Lissarrague 1990, 228ff. For a less skeptical survey, see Green 1994, 38–46; Krumeich-Pechstein-Seidensticker 1999, 41–73.

144 See Beazley 1939; Simon 1982; Trendall-Webster 1971, II.4.

145 Thus, for example, a badly damaged midcentury Lucanian volute-krater seems to show Prometheus with the satyrs again: this is Copenhagen inv. Chr. VIII 1; LCS 121/613, pls. 62.1–3.

146 Apulian bell-krater, ca. 380s, found at Ruvo; Milan AO.9. 2841 (former Moretti coll.); RVAp supp 2, 1/123—Trendall-Webster 1971, II.13. There is a very nice comic scene on the other side, the "Milan cake-eaters."

147 Lucanian volute-krater, ca. 400: Taranto Mus. Naz. I.G. 8623; LCS 55/280 and pl. 24; RVSIS ill. 23. While all of these should, I suggest, be allowed as real possibilities, I am inclined to think that the balance tips in the other direction with a vase that has often been claimed to reflect our one and only surviving satyr play, the Kyklops of Euripides. The well-known early Lucanian calyx-krater from the 410s (London 1947.7-14.18;

LCS 27/85; *RVSIS* ill. 9—Trendall-Webster 1971, II.11), which may well be earlier than Euripides' play, shows Odysseus and his men about to blind the drunken Kyklops with a huge tree trunk, while two satyrs, not in costume, prance up from the right. Only a dedicated philodramatist would put money on this one.

148 And serious doubt hangs over the allocation of at least five of them, for various reasons—I have in mind nos. 24, 26, 32, 40, 47.

149 Two of these might well be related to plays by other playwrights: no. 94 to Karkinos and no. 101 to Astydamas.

150 Moret 1975, 176–77, deployed but not fully endorsed by Giuliani (1996, 72–75).

151 His *pilos* (hat) and cross-banding are conventional indications that he has been traveling.

152 Giuliani 1995, 160 n. 32; 1996, 74 n. 14.

153 When *kothornoi* are found on females, they are associated with travel and/or hunting, e.g., on Erinyes.

154 While his costume has the usual tight sleeves, it has no patterned ornamentation. But in view of the fancy fringe at the bottom, along with his grand boots and mask, I take this to be the crimson robe belonging to the role of a king.

155 This is usually known as a *naiskos* (little shrine)—this term should not be extended to mythological theater-related paintings, however.

156 There is also an early painting, no. 71, that has some doors without any building, a feature associated more with the explicitly theatrical comic vases, as in figs. 5 and 7. The doors on nos. 43, 47, and 50 are rather different; the doors on no. 109, even more so.

157 See Gogos 1983.

158 See Schulze 1998.

159 This is based on the discussion in Taplin (forthcoming B).

160 I have some doubts, however, as to whether no. 91 is related to tragedy rather than to some other narrative form.

161 This evidence should be set against the iconocentric skepticism of Moret (1975, 147, 272), echoed by Giuliani (1995, 161 n. 35).

162 The name vase of the Darius Painter (no. 92) might be a cautionary example, though. A typical little old man is

standing right in the center; and yet (according to my discussion) there are serious reasons for wondering whether the narrative behind this work was, in fact, a tragedy.

163 On this passage, and on Aischines' *Against Timarchos* 190–91, see Wilson-Taplin 1993, 176 with notes.

164 *LIMC* Erinyes is very good as far as it goes, but there are quite a lot of additions to be made (some of them published more recently). From the vases in part 2 alone, there are nos. 5, 27, 30, (34?), 66, 84.

165 Paestan vases tend to give Erinyes individual names.

166 Aellen 1994 is a fine study of allegorical figures, especially but not only Erinyes, in Western Greek painting. He generally takes an iconocentric position, however, and pays no particular attention to tragedy.

167 The same caveat applies to other allegorical figures, such as Homonoia on no. 63 and Euphemia on no. 81.

168 For example, Euripides' *Children of Herakles*, reflected in nos. 37 and 38. The classic study of supplication remains Gould 2001, first published in 1973.

169 There are two other substantial props that recur quite frequently in the paintings: thrones and couches, often highly ornate.

170 There are very few overall "titles" included in the paintings, and they are not necessarily the titles of tragedies. Thus, two of the Darius Painter's best-known monumental pieces have the titles *Funeral of Patroklos* and *Persai*: the former is almost certainly not tragedy related, and the latter may not be; see no. 92. Two recently published paintings are both entitled *Kreousa*; see no. 28 for discussion.

171 It is first recorded on the New York Goose Play (see fig. 5), ca. 390s; see Jeffery 1990, 29.

172 See, in general, Wilson 2000, 200ff.

173 Thus the tripod beside Kassandra on no. 101 signifies her prophetic power.

174 For a study of the distinction between mythological scenes for symposiatic and for funerary use in Athenian art, see Junker 2002.

175 See, for example, Burkert 1987. These beliefs are also reflected by Underworld scenes and scenes of Orpheus on the vases; see Moret 1993.

176 These cults also leave many traces in smaller vase-paintings; see Giuliani 1995, 143ff.

177 An example is the Lykourgos story; see nos. 12 and 13.

178 See Keuls 1978. This increasingly has been the view taken in recent studies and is particularly well explored and exemplified in Giuliani 1995, especially 152ff.

179 This same idea infuses Achilles' speech to Priam earlier (*Iliad* 24.534ff.): his father, Peleus, might seem to have every good fortune, but even he has sorrow mixed in because of his single "untimely" son. See also the lines from Euripides' *Hypsipyle*, quoted on p. 214.

180 *PCG* fr. 6, quoted by Athenaios 223c. On this motif, see Kassel 1958.

181 The list is: Telephos (comfort for the poor), Alkmaion (for the diseased), the sons of Phineus (for the blind), Niobe (for those who have lost a child), Philoktetes (for the lame), and Oineus (for misfortunes in old age).

182 Louvre CA308 (*LCS* 110/572 and pls. 56.5–6) and Naples 2868 (inv. 81735) (*LCS* 114/592).

183 This is the opposite of the traditions of realism that have been much more powerful in modern art forms, which tend to say that what is horrific and ugly and cruel should be shown as horrific and ugly and cruel.

184 See Beazley, quoted on p. 16 above.

185 I take the words of this sentence from Macleod 1982, 16.

PART 2, CHAPTER I

1 The Testimonia (the ancient testimonies about Aeschylus' life and work) are all gathered in *TrGF* 3, 31–108. For plays in Sicily, see sections Gd and Ge. See *Life*, paragraph 11 (p. 35) for his tomb as a focus for tragic artists.

2 But see Kossatz-Deissmann (1978, 45–62), who makes a case (see no. 87 in this book). There is a judicious assessment by Schmidt (1979, 159–62).

3 It is worth noting the recollection of Elektra at Aristophanes' *Clouds* 534–36 and the detailed allusions to the opening of *Libation Bearers* at *Frogs* 1123–69, where it is treated as familiar.

4 The well-known "Oresteia krater" (Boston 63.1246; *ARV²* 1652—BAD 2752;

Knoepfler 1993, 53–54, 56 and pls. 7, 8) is earlier than Aeschylus' play, probably painted in the 460s; furthermore, it makes Aigisthos, not Klytaimestra, the central figure on both sides. An Attic cup of circa 430 (Ferrara, T 264 [2.482]; *ARV²* 1280.64, 1689—BAD 216252; Knoepfler 1993, 51–52 and pl. 6), which shows Klytaimestra attacking Kassandra with an axe, is often used to "illustrate" *Agamemnon*, but it has no signals of any connection with Aeschylus' tragedy.

It is also worth registering an intriguing early Lucanian fragment in the Cahn collection, in Basel (HC 1331; *CFST* L13—Cambitoglou-Chamay 1997, 14–17, no. 3; Knoepfler 1993, 55, no. 37). This shows a queen laying hold of a seminaked man—Klytaimestra and Agamemnon? She does not, however, have a weapon, and there seems to be another hand grasping the man's head as well, both details inconsistent with the Aeschylean version.

5 Green 2002.
6 Note, as a contrast, that on Naples 3126 (inv. 81736) (*RVP* 37/76 and pl. 8d), there is a similar scene but with only women—presumably not related to *Libation Bearers*. There are other tomb-offering scenes that do not prompt any connection, e.g., Trieste 1814; *LCS* 407/313, pl. 161.1.
7 Jena Painter; *ARV²* 1516, 80; *LIMC* Elektra I, 1—BAD 231036; Kossatz-Deissmann 1978, 92.
8 Copenhagen 597; *ARV²* 1301.5; *CFST* A46; *LIMC* Elektra I, 34*—BAD 219000; Trendall-Webster 1971, III.1,2; Knoepfler 1993, 59–60 and pl. 40. This early painting is unparalleled in that it shows Elektra and her maid on one side of the cup and Orestes and Pylades on the other. There are also five "Melian" terracotta reliefs that appear to show the scene. These are fully discussed by Prag (1985, 51–57, 146–47 F 2–6; *LIMC* Elektra I, 24–25, 42–43). See also the same subject on the Cretan relief *LIMC* Elektra I, 26. The date of the earliest of these is claimed by some to be pre-458, but this is disputed.
9 The early Copenhagen skyphos has AGAMEM[on the stele itself—see Prag 1985, 54.
10 I am grateful to Richard Seaford for first alerting me to this.

11 The text of the prologue is unfortunately incomplete, but these lines must have come soon after the beginning.
12 In one fine but fragmentary painting (Cahn coll. HC 284; *RVAp* 2/14a (on p. 436); *CFST* Ap30; *LIMC* Elektra I, 3*), Elektra is holding a lock of hair and looking at it—cf. *Libation Bearers* 167–204.
13 Kossatz-Deissmann (1978, 92) is strictly correct in saying that this vase is not a "proper illustration," but few if any of the paintings are illustrations in that strict sense. Insofar as she is attempting to drive a wedge between the Attic and the Western Greek representations, I think that is probably misleading.
14 Brooklyn-Budapest Painter; *LCS* 115/597 ("much repainted"); *CFST* L23 (from Basilicata); *LIMC* Elektra I, 6*—Knoepfler 1993, 61 and pl. 9; Séchan 1926, 88 and fig. 26. Known by 1853.
15 Not visible in this photo. Trendall (*LCS* 115) judges these inscriptions ancient while condemning others on this vase as modern additions. Moret (1979, 236–39) surveys such inscriptions on pillars; he questions whether they point to plays or are merely generic.
16 Choephoroi Painter; *LCS* 120/599; *CFST* L47; *LIMC* Elektra I, 7*—Trendall-Webster 1971, III.1,5; Knoepfler 1993, 64 and pl. 11. Known by 1898.
17 *LCS* 120/599–603; *LIMC* Elektra I, 7–11 (*LCS* 621 and 631 have the same scene but treat it differently). *CFST* 398–402 (L39–50) catalogues twelve vases by this artist that may be connected with tragedy.
18 Naples H 2856; *LCS* 120/601; *LIMC* Elektra I, 9*; *CFST* L42.
19 Hermes is also called upon by Elektra at lines 164–65 (usually transposed to stand as 124a–b—there are textual problems). For discussion of Hermes' recurrent importance in the play, see the references given in the index to Garvie 1986, especially p. 201.
20 Painter of the Geneva Orestes; *RVP* 56/1 and pl. 15; *CFST* P1; *RVSIS* figs. 346–47; *LIMC* Elektra I, 19a*—Aellen-Cambitoglou-Chamay 1986, 264–69 and pl. on p. 28; Knoepfler 1993, 64 and pl. 12. First published 1984.

In *RVP* Trendall shows how the art of red-figure vase-painting was bought

to Paestum from Sicily. He is not certain whether this particular piece was painted in Sicily or in Paestum but thinks the latter to be more likely, in which case it is one of the earliest surviving Paestan vases. It is worth noting that the checkered hem becomes common in Paestan tragedy-related paintings; also that this iconography was popular at Paestum, with some ten examples surviving.
21 See Taplin 1977, 371–74.
22 See *LIMC* Erinys, pp. 839–42. The later travel writer Pausanias (1.28.6) says Aeschylus was the first to show them with snakes in their hair. He adds that their artistic representations are not fearsome.
23 This is roughly indicated by the fact that of the 119 entries in *LIMC* Erinys, no fewer than 59 are connected with Orestes.
24 There are two other, quite late representations of the tomb scene with the Erinyes above. One is also Paestan: Boston 99.540, ca. 320s; *CFST* P20; *RVP* 255/1004; *LIMC* Erinys 37— Trendall-Webster 1971, III.1,6; Kossatz-Deissmann 1978, 94 and pl. 14.1; Padgett et al. 1993, 183–85, no. 105, color pl. 18. The other is Campanian: Hamburg, Termer collection, ca. 330s; *CFST* C52; *LCS supp 3*, 208/495a; *LIMC* Erinys 38—Kossatz-Deissmann 1978, 94–95 and frontispiece.
25 Painter of Würzburg H 5739; *RVP* 183/418 and pl. 129; *RVSIS* fig. 382; *LIMC* Klytaimestra 31*—Aellen 1994, 24–25 and pl. 15. Not in *CFST*. First published 1982.
26 In Mayo 1982, 229–30, no. 105.
27 See *LIMC* Aigisthos; also Prag 1985, ch. 3 and pls. 6–21; Knoepfler 1993, 66–69; Kossatz-Deissmann 1978, 98–101.
28 Not covering it, as said by Trendall (*RVP* 184).
29 There is a distant reminiscence of the scene in the *Iliad* (22.79–89), in which Hekabe tries to draw her son Hektor from danger by appealing to his respect for her mother's breast. More disturbingly, this gesture might also recall the erotic story of Helen stopping Menelaos from killing her at the Sack of Troy by exposing her breast. But this detail is not explicitly attested before Euripides' *Andromache* 629–31.
30 Ioannina 4279; *LIMC* Klytaimestra 32,

with drawing; see Prag 1985, 40–41, pl. 28c.

31 There is an Attic kalpis of circa 440 in Nafplio (Nauplia 11609/180; *ARV* 1061.154—BAD 213785) that shows a young man attacking a woman who is on an altar. While the condition of the vase is too poor to confirm the image from photographs, the woman is said to be exposing her breast with her left hand. For useful discussion and the best photographs available, see Prag 1985, 40 and pl. 27.

32 See Aellen 1994, 24–25.

33 See Sommerstein 1989, 1–6.

34 In Taplin 1977 (363–74), I argued that in the scene beginning at 64, only Orestes and Apollo were seen by the audience, and that the Erinyes did not make themselves visible until after they awoke, in the scene beginning at 140. I would no longer so confidently maintain that staging. In any case, it might well be later restagings, not the original, that influenced the representations on the fourth-century vases.

35 They are *LIMC* Orestes 7–10 and 22, usefully discussed by Prag (1985, 48–51 and pls. 30–32) and Knoepfler (1993, figs. 61–65); see Giuliani 2001, 2003.

36 Prag (1985, 49) (cf. Knoepler 1993, 8–9, 80) suggests that the unworked stones on the Athenian Areopagus hill, described by Pausanias at 1.28.5, may be alluded to in the paintings—this seems quite possible.
 Giuliani (2001, 29), who assumes that this must be Delphi, claims that the Attic vases "underline the dynamics of flight and pursuit"; but, since in all of them Orestes is static, I do not see how this is the case. There are, by way of contrast, three fourth-century Western Greek vases that do show something more like the pursuit in action: these are *LIMC* Erinys 68–70. One of them (Naples 82124 [H1984]; *CFST* L24; *LCS* 113/588) has Orestes between two threatening Erinyes; but it is much repainted, and François Lissarague warns me that the face of Klytaimestra in the mirror is modern.

37 Not in *ARV²* (or BAD). This is *LIMC* Orestes 28; Erinys 45*—Trendall-Webster 1971, III.1,9; see Knoepfler 1993, 72 and fig. 55; see also Metzger 1951, 47, 295–97.

38 It is in the so-called Kerch style, the

label given to a lively and colorful type of mid-fourth-century Attic pottery, made mainly for export (the name is taken from an area of Ukraine where there have been numerous finds).

39 Black Fury Painter; *RVAp* 7/13; *CFST* Ap23 (from Ruvo); *LIMC* Orestes 12; *LIMC* Erinys 50—Kossatz-Deissmann 1978, 107 and pl. 22.1.; Knoepfler 1993, 75 and pl. 19; Séchan 1926, 95–96 and fig. 31. Known by 1839.

40 The earliest representation of Orestes at the omphalos, perhaps as early as 400, is probably the bell-krater by the Tarporley Painter (Melbourne, Geddes coll. A4:8), first published by Trendall (1990, 213–17, pl. 36). It is *RVAp supp 2*, 3/4a; *CFST* Ap33—Knoepfler 1993, 75 and pl. 56. Pictures of Orestes and the Erinyes remained popular until late in the fourth century—see, for example, Berlin 3164; *LCS* 340/803—and it is found even on a very small vessel (one Fury only): Capua 7549; *LCS* 324/726; *CFST* C34.

41 For this recurrent iconography, see Moret 1975, 137–47.

42 The only other clear representation of a black-skinned Erinys is in a Paestan painting of a quite different myth, no. 70. There is another possible example in a fragment in the Allard Pierson Museum, Amsterdam, 3525A; *RVAp* 7/7 and pl. 53.3.

43 Eumenides Painter; *RVAp* 4/229; *CFST* Ap44 (may be from Armento); *LIMC* Orestes 48*; Erinys 63—Kossatz-Deissmann 1978, 107–11 and pl. 20.2; Knoepfler 1993, 72–73 and pl. 18. Known by 1842.

44 See esp. lines 280–85 and 445–52 with Sommerstein (1989) 131–32, 160; also Parker (1983) 386–88; Dyer (1969).

45 Paestum 4794; *RVP* 109/142 with pl. 62a; Trendall-Webster (1971) III.1.12; *CFST* P7. These four vases are discussed by Trendall (1990) 212–14: one of them, *RVAp* 4/230 (formerly Milan market) is not in *LIMC* Orestes; and he reports one in Brindisi (p. 213 n. 11) that remains unpublished. Trendall also documents (213 n. 13) two vases that show Apollo purifying Orestes with sprinklings from a laurel branch; one of these (Hermitage 298 [St 1734]; *RVAp* 4/127; *CFST* Ap45; *LIMC* Orestes 51*) includes an Erinys.

46 Konnakis Painter (Gnathia technique);

CFST Ap93 (from Ruvo); *LIMC* Erinys 46—Trendall-Webster 1971, III.1,10; Kossatz-Deissmann 1978, 105–6 and pl. 21.1; Knoepfler 1993, 75–76 and fig. 57; Séchan 1926, 95 and fig. 30; Aellen 1994, fig. 23b; Dyer 1969, 53, no. 7, pl. 5.7. Known by 1863.

47 "Gnathia" seems to have been invented in Apulia at about the period of this vase (its label derives from early finds at Egnatia) and to have been produced for about one hundred years. For a valuable survey, see Green 1982a, 252ff.

48 Close to the Judgment Painter; *RVAp* 10/33 and pl. 87.5; *CFST* Ap50; *LIMC* Orestes 24*; Erinys 49—Vermeule 1979, 185–88, pl. 51; Padgett et al. 1993, no. 17 (74–78) and color pl. 6. First published 1978.

49 *LIMC* Orestes 23–27. She is also on one of the fifth-century Attic vases that show Orestes at the pile of stones: this is Louvre K343; *ARV²* 1117.7; *LIMC* Orestes 22—BAD 214783.

50 See Sommerstein 1989, 4–6.

51 Vermeule 1979, 185–88.

52 The painter is indeed not a wonderful draftsman; see *RVAp* 261 on the deterioration of the Judgment Painter's technique.

53 Hearst Painter; *RVAp* 1/32; *CFST* Ap4; *LIMC* Orestes 61; Erinys 74; Athena 116*; *RVSIS* fig. 43—Kossatz-Deissmann 1978, 113–14 and pl. 23.2; Knoepfler 1993, 104–5 and fig. 90; Dyer 1969, 53, pl. 5.8. Known by 1932.

54 The pose is modeled on scenes of Kassandra taking refuge at the Palladion during the Sack of Troy; see Moret 1975, 103–34.

55 *RVAp* 9 dates the Hearst Painter to the last quarter of the fifth century and adds that his later works—of which this is one—might date from after the turn of the century.

56 As they tend to be in the fifth-century Attic representations (see above). Trendall (1990, 214) also notes that the Erinys on London F166 (ca. 370; *RVAp* 4/232; *CFST* Ap43) is of "rather masculine aspect."

57 The evidence is in the ancient *Life* and other sources collected by Radt in *TrGF* 3, 56–58. This includes a rather optimistic list of comic citations.

58 The standard edition of the fragments is *TrGF* 3. In an appendix to vol. 2 of the Loeb edition (1957), the papyrus

fragments known at the time were valuably edited with translation and notes by Lloyd Jones.

59 The book on this subject by Kossatz-Deissmann (1978) makes a case for reflection of the following plays that are not included here: *Women of Aitne* (the play commissioned by Hieron); *Tox-otides* (*Archer-Nymphs*); *Myrmidons* and *Nereids*, the first two plays of the Achilles trilogy (see nos. 20 and 21 below). Séchan (1926) claimed to detect possible vase-paintings based on *Pentheus*, *Phorkides*, *Telephos*, and *Thracians*. For *Philoktetes*, see no. 26.

60 Aristophanes *Thesm.* 135, with scholion.

61 The evidence for this is fr. 58: "The house is inspired by the god, the building dances as a bacchant." Attribution to this play is not totally certain.

62 These are *LIMC* Lykourgos I, 12* (Rome, Villa Giulia 55707; *ARV*² 1343—BAD 217561), a Dionysiac revel around a decapitated Dryas; and *LIMC* Lykourgos I, 26* (Krakow, Czartoryski Museum 1225; *ARV*² 1121.17—BAD 214835; Trendall-Webster 1971, III.1,13), where Dionysos is stately and bearded.

63 Kossatz-Deissmann (1978) does not include the *Lykourgeia* in her book, even though she tends to be optimistic about Aeschylean connections. Farnoux in *LIMC* Lykourgos I, p. 319, is studiously noncommittal on the relation of texts and images.

64 Painter of Boston 00.348; *RVAp* 10/50; *CFST* Ap48; *LIMC* Lykourgos I, 14*; Lyssa 10—Séchan 1926, 70 and fig. 19; Aellen 1994, no. 23, pl. 27; Sichtermann 1966, K 48, pls. 80–81. Known by 1874.

65 Schauenberg (in Hamburg Museum 1995, no. 14, 45–46) attributes it to the White Sakkos Painter. This was published too recently to be included in *RVAp*, *LIMC*, *CFST*, or Green 1999.

66 Lycurgus Painter; *RVAp* 16/5 and pl. 147; *CFST* Ap96; *LIMC* Lykourgos I, 28; Aphrodite 1521; Apollon 927; Ares 92*; Lyssa 8*; Sterope I, 2—Trendall-Webster 1971, III.1,15; Séchan 1926, 71–72 and fig. 21; Aellen 1994, no. 25, pl. 30; Deichgräber 1939, 295–96, pl. 4; Green-Handley 1995, 43, 69–70, and fig. 19. Known by 1845.

67 Green 1999, 57, no. 18.

68 The picture on the reverse (see *RVAp*

pl. 147.2) shows another scene of myth, Pelops before his chariot race. It includes a high column surmounted by a tripod. While this might possibly signify an artistic victory (see pt. 1, sec. N2), it is more likely to suggest Pelops' mythical victory.

69 This pair might possibly be Dionysos and Ariadne, but if so there is no clear signal. See *LIMC* Lykourgos I, 28 on p. 313.

70 Especially as he is present on another, fragmentary piece by the same painter (Amsterdam, Allard Pierson Museum 2563; *RVAp* 16/29; *LIMC* Lykourgos I, 30*; *CFST* 270 n. 199). Though the piece is sadly broken, the double ax and the nimbus make its identification pretty certain. Dionysos sits there calmly, cup in hand.

71 *LIMC* Lykourgos I, 30* (see n. 70), 27* (Naples 82123; *LCS* 114/593; *CFST* L19—Trendall-Webster 1971, III.1,16). See also the useful *LIMC* Lyssa article by Kossatz-Deissmann, which lists no fewer than six appearances in Lykourgos scenes, as nos. 7–12.

72 Sarpedon Painter; *RVAp* 7/1; *CFST* Ap36; *LIMC* Europe I, 221, 222*; Pasithea II, 2*; Sarpedon 14*; Thanatos 10—Trendall-Webster 1971, III.1,17; Kossatz-Deissmann 1978, 66–74 and pl. 8.1 (and 7.2). First published 1916.

73 These and other possible examples are nos. 3–12 in the valuable *LIMC* article by Von Bothmer (the Euphronios is no. 4).

74 Most non-Greeks from the East are represented in ancient art with a pointed cap and, usually, ornate sleeves and leggings.

75 There is no artistic convention in this period of showing low-status people as smaller. Since the painter is "an admirable draughtsman" (*RVAp* 163), the figure's size should not simply be explained as artistic botching.

76 *TrGF* 3, fr. 99—a schoolboy dictation exercise and full of errors.

77 Robertson (1988, 109ff.) gives an excellent discussion of this vase. He also ingeniously interprets an Attic mug of circa 425 (Port Sunlight 5060 (X 2250); *LIMC* Sarpedon 12*— BAD 17489) as showing Sleep and Death with Sarpedon on one side and Europe among Carians on the other, thus connecting it with Aeschylus. But the piece is so

badly damaged that this must remain an intriguing speculation.

78 It is reproduced and discussed in Trendall-Webster 1971, III.1,17, and Kossatz-Deissmann 1978, 72. The winged youth might be Hypnos, but if so he is rather small. If the female to his left is Europe, she is not in Oriental costume on this side.

79 In saying this I am contradicting, or at least qualifying, Taplin 1977, 446 n. 2.

80 This is Policoro 35294; *LCS* 57/285 and pls. 26.2, 27.2; *CFST* L7; *RVSIS* 27—Trendall-Webster 1971, 52, 54; also Kossatz-Deissmann 1978, 72–73 and pl. 8.2; I should add that *CFST* includes several vases showing Europe and the bull, but I am not aware of any good reason to relate them to Aeschylus' play.

81 Varrese Painter; *RVAp* 13/4 and pl. 109.1; *CFST* Ap114; *LIMC* Niobe 10*; Tantalos 2—Kossatz-Deissmann 1978, 86–87 and pl. 10; Trendall 1972, 315, fig. 5; Schmidt-Trendall-Cambitoglou 1976, 40–50, pl. 33a; Keuls 1978, 87, pl. 36.7. Found with over four hundred objects in the Varrese Tomb in Canosa in 1912 (cf. *CFST* 549–57).

82 They were, however, killed during the course of Sophocles' *Niobe* play—see Lloyd-Jones 1996, 226–35. For an admirable survey of the mythographic evidence, see *LIMC* Niobe pp. 908–9. Ruvo J424 (36735) (*RVAp* 27/24; *CFST* Ap205) is a highly "dramatic" late calyx-krater depicting the slaughter of the Niobids, but there is no particular reason to relate it to the Sophocles play.

83 Hesychius ε 5579; *TrGF* 3, fr. 154a (6–7).

84 *TrGF* 3, fr. 154a (7). The papyrus reads ΕΠΟΙΜΩΖΟΥΣΑ (groaning), which is, beyond reasonable doubt, a corruption of some form of ΕΠΩΙΖ– (brooding).

85 Numbers 12* and 16* in Schmidt's invaluable *LIMC* article.

86 See Keuls 1997, 169–99.

87 Darius Painter; *RVAp* supp 2, 18/63e; *LIMC* Niobe 13*; Tantalos 4—Aellen-Cambitoglou-Chamay 1986, 150–57, color pl. 23. Not in *CFST*. First published 1986.

88 Pausanias 1.21.3.

89 Only four of these were known before 1970. This suggests a certain homogeneity in some of the tombs where the

great number of new Apulian vases were found in the 1970s and 1980s (not documented, of course). There is a valuable survey of the vases by Trendall (1985, 133–39); see also Keuls 1997, 159–65.

90 On Naples 82267 (H3246) (*RVAp* 13/22; *CFST* Ap130; *LIMC* Niobe 12* [Varrese Painter]), this is especially elaborate.

91 See good note with bibliography in Green 1999, 60–61 n. 17.

92 There are, however, three other instances of an Oriental presence. Two of these—which include Niobe's brother, Pelops—are no. 17 below and Zurich University 4007, documented in note 94 below. The third is a late Apulian plate, which unusually has a second myth, that of Andromeda, within the same frame: this is Taranto 8928; *RVAp* 28/97, pl. 363.1; *CFST* Ap238; *LIMC* Niobe 14—Kossatz-Deissmann 1978, 87–88, pl. 12.1. On this piece Tantalos is in Oriental dress; see Keuls 1997, 165–66.

93 Darius Painter; *RVAp supp* 2,18/56b, pls. 36.2–3; *CFST* Ap142; *LIMC* Niobe 20*; Pelops 59; Sipylos 2*—Green 1999, no. 32 and fig. 14; Trendall 1991, 178, fig. 73; Aellen 1994, 127–30, no. 92, figs. 114–15. First published 1990.

94 Zurich University 4007; *RVAp supp* 1, 18/11a (reallocated to the Ganymede Painter in *RVAp supp* 2, 25/17-2); *CFST* Ap194; *LIMC* Niobe 19*; Pelops 58; Tantalos 6*—Green 1999, no. 42 and fig. 13.

95 See *LIMC* Niobe pp. 912, 914.

96 Pausanias 5.16.4 with 2.21.10. There are further complications on the Zurich krater, where one of Niobe's daughters stands beside her mother and is also turned into stone; see Schmidt 1986a, 256. Two other figures, on the upper left, might well be the surviving Niobids; Pelops himself stands right beside Niobe.

97 It might seem tempting to dismiss this inscription as an error, perhaps for Antiope. But the Darius Painter rather specializes in particular and often little-known versions of the myths, and takes special care with name labels.

98 Green 1999, 45–46.

99 Branca Painter; *RVAp* 18/6 (and p. 477); *CFST* Ap129 (from Sibari?); *LIMC* Apollon 928; Athena 627; Deme-ter 472*; Dike 13*; Erinys 21; Persephone 341; Prometheus 72*; Themis 25; *RVSIS* 192–93—Trendall-Webster 1971, III.1,27; Kossatz-Deissmann 1978, 136–41 and pls. 26.1–2, 27.1; Trendall 1970, 168–74; Aellen 1994, 49–50, no. 31, pls. 38–39. First published 1970.

100 The standard subtitles in English are *Bound* and *Unbound*, but this makes the pairing speciously explicit.

101 *TrGF* 3, fr. 193; VIII Griffith 1983.

102 *TrGF* 3, fr. 200; IX Griffith 1983.

103 I was already advocating this in Taplin 1977, 463–64; I have to confess that it has not been widely accepted.

104 DeVries (1993, 517–23) makes an ingenious case for another Prometheus on a rock arch, on a fragment of the fifth-century Attic pot found at Gordion (now in Philadelphia); but this reads too much into a poorly preserved sherd.

105 *TrGF* 3, fr. 202; XVIa Griffith 1983, 303.

106 *LIMC* Themis 25.

107 She is missing from the *LIMC* Erinys article.

108 Kossatz-Deissmann (1978, 139–40) makes an interesting case for this figure as an Underworld Dike (Justice); cf. *LIMC* Dike 13*. See also Aellen 1994, 49–50.

109 Amykos Painter ("much repainted"); *LCS* 47–48/243 and pl. 19; *CFST* L2; *LIMC* Argonautai 11; Boreadai 11*; Harpyiai 17*; Hermes 896; Phineus I, 13*—Trendall-Webster 1971, III.1,26; Kossatz-Deissmann 1978, 121–24, pl. 25.2. Known by 1843.

110 See, e.g., Trendall-Webster 1971, III.1,24 and 25; for a catalogue, see *LIMC* Phineus I, 1–11 and 19–21.

111 Amsterdam, Allard Pierson Museum 2534; *RVAp* 1/44; *CFST* Ap5; *LIMC* Phineus I, 12; Boreadai 10*—Kossatz-Deissmann 1978, 127, pl. 25.1.

112 See especially *LCS* 29–32.

113 There can be no reasonable doubt about this trilogy, even though it lacks explicit external confirmation.

114 Fr. 132 is evidence that Phoenix was one of them.

115 In the *Iliad* Phrygians are distinct from Trojans and came from further south; at some date, probably about the time of the great Persian invasions of 490 and 480, they became easily equated; see Hall 1989, 73–74.

116 Evidence for all this is in *TrGF* 3, 365.

117 In the monumental and invaluable *LIMC* Achilleus article (by Kossatz-Deissmann), the embassy scene is section XII; the bringing of the arms is Section XVI; and the ransom of Hektor is XXI (more than sixty entries!). The author is, however, rather too ready to suppose Aeschylean connections.

118 The fine early "Apulian" fragments (Heidelberg 26.87; *RVAp* 7/5; *LIMC* Achilleus 457*—Trendall 1938, 27, 41, no. 85, pl. 29) seem to be expressly close to the *Iliad*, and not to Aeschylus; see Kossatz-Deissmann 1978, 13; Giuliani 2003, 241–43.

119 See Giuliani 2003, 233–41.

120 Vienna University 505; *ARV*² 1030.33; *LIMC* Achilleus 524, see also 480, 660—BAD 213416; Trendall-Webster 1971, III.1,18–19 (a useful presentation); Kossatz-Deissmann 1978, 20–21.

121 For example, fr. 9 seems to show Briseis returning to find the corpse of Patroklos; but this is unlikely to have been seen in *Myrmidons* (though not out of the question). The Nereids are given individual names, furthermore, which is never done for a tragic chorus.

122 Louvre K67; *RVAp* 28/115, pls. 365.1–2; *CFST* Ap227; *LIMC* Achilleus 527*. See Kossatz-Deissmann 1978, 19–23 and pl. 1.

123 Toronto, Royal Ontario Museum 926.32; *LIMC* Achilleus 662*—Trendall-Webster 1971, III.1, 20; Kossatz-Deissmann 1978, 24–25. Published and well discussed by Graham (1958).

124 Lycurgus Painter; *RVAp* 16/55; *CFST* Ap104 (from Ruvo); *LIMC* Achilleus 664; Amazones 374; Amphilochos 15; Antilochos I, 16*; Argonautai 21*; Boreadai 23; Gigantes 61d*; Hektor 92; Herakles 2796; Iason 39; Nestor 30—Kossatz-Deissmann 1978, 25–32 and pl 2.2; Séchan 1926, 118–19 and pl. III. The vase is reported to have been "much repainted" (*RVAp* 424)—in particular, there was tampering with the scale pans and the addition of the two Erotes (cupid figures) and of the altar beneath Priam. Known by 1840.

125 This Doric form of the name is found elsewhere on vases that have otherwise Attic spellings.

126 Black Fury Painter; *RVAp* 7/8; *CFST*

Ap21; *LIMC* Achilleus 665*; Hermes
582; *RVSIS* 134—Trendall-Webster
1971, III.1,21; Mayo 1982, 14, 84–86;
Kossatz-Deissmann 1978, 28–29 and
pl. 2.1. First published 1938.

127 For the short hair and beard, see no.
20 and the fragment of polychrome
Gnathia krater New York 10.210.17A
(*LIMC* Achilleus 666*—Kossatz-
Deissmann 1978, pl. 3.2; Mercier 1995).
A character in comedy (*PCG* Com.
Adesp. 414) says, "I shall get myself
Priamed," meaning that he will get his
hair and beard cut short.

PART 2, CHAPTER 2

1 Aristophanes *Frogs* 76.

2 It also contrasts with the Athenian ora-
tors, who often quoted Sophocles (and
Euripides) rather than Aeschylus; see
Wilson 1996, 315.

3 We have anecdotes about a particular
performance of Sophocles' *Oinomaos*
(lost), for example, and of "frequent"
performances of *Antigone*; see Dem-
osthenes *De Corona* 120, *On the False
Embassy* 247. There are also stories of
famous actors in the roles of Elektra
and Aias.

4 Examples include the great Exekias
painting of Aias planting his sword
(Boulogne 558; *LIMC* Aias I, 104*)
and the picture of Tekmessa taking the
cloth off his body, which anticipates
Aias 915–16 (Malibu 86.AE.286; *LIMC*
Aias I, 140*—*Para*² 367.1bis; *BAD*
275946).

5 Basel Museum on loan; *LIMC* Aias I,
105*—published by Schefold (1976,
71–78).

6 Pulsano, Guarini coll. 135–37; *CFST*
Ap140; *RVAp supp 2*, 18/65f—Todisco
1982, 180–89 and pls. 58–59; Todisco
argues (183–84) that the inscription
might have said ΤΕΛΑΜΩΝ[ΙΟΣ
ΑΙΑΣ (Aias, son of Telamon), but no
other such name label I know of gives
more than the simple name of the char-
acter. (These fragments seem to have
been overlooked by *LIMC*.)

7 *RVAp supp 2*, 18/65f, 151.

8 Cahn coll. HC 229; *RVAp* 18/90; *CFST*
Ap163; *LIMC* Hyllos I, 6*—Trendall-
Webster 1971, III.2,12. It was first
published by Schmidt 1967, 182–84
and fig. 59.4. She makes the case for

Trachinians and hazards a reconstruc-
tion of the lost picture; but it remains a
long shot. There is a cautious discussion
in Cambitoglou-Chamay 1997, no. 104,
243–45.

9 Lipari 9341 D; *LCS supp 3*, 275/46f;
CFST S18; *LIMC* Acheloos 259a*;
Herakles 1682; *RVSIS* fig. 428 and pl.
236—Trendall-Webster 1971, III.2,11
(no picture); Rasmussen-Spivey 1991,
172–73 and pl. 70.

10 See Bernabò-Brea 1979, 135–37.

11 Gibil Gabib Group; *LCS supp 3*,
276/98a; *CFST* S14; *LIMC* Oidipous
83*; Antigone 1*; Iokaste 5; Ismene I, 1;
RVSIS fig. 429 and pl. 236—Trendall-
Webster 1971, III.2,8; Green-Handley
1995, no. 20; Green 1994, fig. 3.6 and pl.
61; Green 1999, no. 50; Pelagatti-Voza
1973, no. 332, p. 98, pls. 22–23; Bertino
1975, 17–28. Excavated at Syracuse in
1969; published 1970.

12 Séchan (1926, 143–45 and fig. 45)
makes a case for a painting that was
already lost by 1926, but it is not a
strong one; cf. Schmidt 1982, 241.

13 They are collected by Trendall (*LCS*
593–625) under the headings of the
Manfria Group, the Lloyd Group, and
the Gibil Gabib Group; there are addi-
tions in *LCS supp 3*, 273–77. Some of
these are found elsewhere in this book
(see nos. 103–6).

14 Trendall and Webster (1971, 69)
write that "she turns her head away
in despair"—but she has no reason to
know what Iokaste knows, and hence
no reason to despair.

15 Darius Painter; *RVAp* 18/73a; *CFST*
Ap162; *LIMC* Oidipous 84*; Kreon
10; Menoikeus 2; Teiresias 12—Taplin
1997, 85 and fig. 16; Schefold-Jung
1989, 66, fig. 46. First published 1982
(see n. 16).

16 Schmidt 1982, 236–43 and pls. 53.1,
2—a characteristically thorough and
subtle discussion.

17 There is a Teiresias on no. 58, but he is
on the upper, "superhuman" level—see
discussion there.

18 Also explored by Krauskopf in *LIMC*
Menoikeus 2.

19 Close to Painter of Berlin Dancing Girl;
RVAp 1/18; *LIMC* Antigone 22 ("to be
rejected"). Not in *CFST*. From Ugento.
First published 1970.

20 Its authenticity is much disputed, but

the influence—and hence priority—of
Antigone seems to me to be clear.

21 *PCG* 5, fr. 260, lines 22–26; see also the
later Antiphanes in *PCG* 2, fr. 228.

22 This is the lower band of a rather sim-
ple "Lucanian" nestoris (or trozzella, a
local Italianate shape that lends itself to
two bands of decoration), which dates
from circa the 370s: London F 175; *LCS*
103/539; *CFST* L32; *LIMC* Antigone
11* (where it is accepted)—Trendall-
Webster 1971, III.2,4; Séchan 1926,
141–42 and fig. 43.

23 E.g., referring to it as "a kind of
(theater-costume) tiara," *LIMC* Anti-
gone 12*, p. 822.

24 I should confess that in Taplin 1993,
83–88, I cited in favor of the *Antigone*
hypothesis the very strange comic vase
at Sant'Agata dei Goti (*RVAp* 4/224;
*PhV*² 44, no. 59 and pl. 4a; *RVSIS* 115;
LIMC Antigone 13*—Taplin 1993, pl.
22.22), which seems to be related in
a parodic way to the British Museum
iconography. But this is a tenuous and
speculative train of connections.

25 *RVAp* 8; see also Dearden 1999, 237.

26 *LIMC* Antigone p. 824.

27 Sydney Painter; *LCS* 128/650 and
pl. 63.1; *CFST* L38; *LIMC* Elektra I,
48—Trendall-Webster 1971, III.2,5;
Knoepfler 1993, 65 and pl. 13; Séchan
1926, 142–43 and fig. 44. Known by
1813.

28 London F92; *LCS supp 3*, 70/BB43
(re-allocated from *RVAp* 10/15); *CFST*
L21; *LIMC* Elektra I, 47*—Knoepfler
1993, 64 and fig. 45.

29 "You [plural] who carry it" at line
1123—though it is hard to think how
this was staged.

30 Dirke Painter; *LCS* 204/32 (also *RVP*
25/8); *CFST* S7; *LIMC* Lemnos I, 96;
Philoktetes 56; Neoptolemos p. 776—
Séchan 1926, 489–93 and fig. 144 (in
the chapter on Euripides); M. Flashar
in Schadewaldt 1999, 155–58 and
fig. 6. Excavated in 1915 at the Fusco
necropolis, Syracuse (see *CFST* 571).

31 Trendall (*RVP* 22) maintains that both
Campanian and Paestan red-figure
painting descended from this Sicilian
school. But the Dirke Painter himself
does not seem to have left Sicily.

32 This motif is found again in later art;
see *LIMC* Philoktetes 34–37.

33 Fontannaz (2000, esp. 56–57) insists
that in the iconographic tradition any

figure with Odysseus on Lemnos "must" be Diomedes. But the evidence for this rare iconography is not sufficient to sustain such dogmatism. He insists also on a continuity from Attic to Western Greek iconography; but a look at the *LIMC* articles on any of the better-represented stories shows that in some cases there is continuity, while in others there is striking disjunction.

34 The *Antiope* painting by the same artist (no. 65) shows Hermes "from the machine" above the scene.

35 Vidal-Naquet (in Vernant and Vidal-Naquet 1972, 180–84) argues that there is a contest for Philoktetes' affiliation between masculine hoplite values represented to the left and female trickery to the right. He is rather good at disposing of other interpretations, but his own can call on only minute touches to support it—in other words, it is built on the detection of encrypted clues rather than on any sustained principles of iconography. Fontannaz (2000, 62) favors this interpretation but does not bring any iconographic arguments to bear.

36 Cahn coll. HC 1738; *LIMC* Philoktetes 55a* (published in Simon 1996, 35)—Fontannaz 2000, 56, no. 1, fig. 10.8.

37 It so happens that Aeschylus *Philoktetes* fr. 251 speaks of hanging the bow from a tree—though I hasten to add that this is not enough to claim a direct connection.

38 Fontannaz 2000; this article supplies a "mise au point" (exemplification) of the kind of polarized monodisciplinarian attitude that I'm hoping to put behind us. For him the interpreters of vases are divided into those who are "purely philological" and those who believe in an "entirely independent iconographic tradition" (64). He maintains that dichotomy mainly by polemical rhetoric rather than reasoned argument.

39 Close to the De Schulthuss Painter; *RVAp supp 2*, 17/81, pl. 33.4; *CFST* Ap131; *LIMC* Ismene I, 2*; Oidipous 91; *RVSIS* 200—Green 2003, no. 1, 27–29; Taplin 1997, 84–85 and fig. 1; Aellen 1994, 37–38, cat. 29, pl. 29. First published 1989.

40 There has been some repainting, including—according to Trendall (*RVAp supp 2*, 136)—all of this younger man's face.

41 This Erinys needs to be added to the list in *LIMC* Erinys.

42 Green (2003, 28) thinks this is more likely to be Theseus, suggesting that the painting reflects solely the later scene of the play, rather than its overall narrative form.

43 The standard edition is *TrGF 4*, edited by Radt. There is also a very useful collection by Lloyd-Jones (1996); pp. 4–9 give a convenient list of the known plays. Fortunately, they follow the same numeration.

44 This pessimism is not shared by Séchan (1926) nor by Trendall and Webster (1971), though they admittedly include fifth-century vases as well. Trendall and Webster add to those plays that are discussed here possible "illustrations" of *Andromeda* (see here, pp. 176–77), *Nausikaa*, and *Thamyras*. Séchan (1926) adds *Laconians*, *Laokoon*, *Niptra* (*Washing*), *Helen's Return*, *Scyrians*, *Troilos*, and *Tyro*. If any of the paintings of the Oinomaos story relate to a tragedy, it is almost as likely to be that of Sophocles as that of Euripides; see no. 71.

45 Darius Painter; *RVAp supp 2*, 18/59c, 149–50, pl. 37.1; *CFST* Ap141; *LIMC* Ion 5b; Kreousa I, 8* (useful discussion by Berger-Doer); Xouthos 3*—Schauenburg 1988, figs. 1–3. First published 1988.

46 Now Altamura Mus.; *RVAp* 18/57 and pl. 179.1; *CFST* Ap169; *LIMC* Ion 5a; Kreousa I, 7*; Xouthos 2*.

47 Naples 3254 (inv. 81393); *RVAp* 18/39; not included in this volume because there are insufficient signals that it is related to tragedy.

48 *RVAp supp 2*, 149–50.

49 Ibid.

50 Probably Darius Painter; *RVAp* 18/62; *CFST* Ap177; *LIMC* Apate 2*—Aellen 1994, no. 5, pl. 8. Excavated (with no. 79) at Ruvo in 1834 (see *CFST* 546).

51 Unfortunately, *LIMC* simply refers its Tereus entry to Prokne and Philomela, and that article does not include this vase. So it appears in *LIMC* only under Apate.

52 Darius Painter; *RVAp supp 2*, 18/65c and pl. 37.4; *CFST* Ap144; *LIMC* Pelopeia 1*; Sikyon 1*; Thyestes 1—Vermeule 1987; Padgett et al. 1993, 110–14, no. 41, and color pl. X; Trendall 1991, 174–76 and fig. 72; Aellen

1994, 76–77, no. 48, pls. 60–61. First published 1987.

53 As is rightly pointed out by Green (1995, 117).

54 Vermeule 1987.

55 He has a shell, a bow and arrows, and a throwing stick, a *lagobolon*; on this object, see p. 133.

56 The columns presumably indicate the city proper; on this figure, see Aellen 1994, 104, 147. Two other place figures in the upper right of large pots by the Darius Painter are Sipylos on no. 17 and Nemea (near Sikyon, as it happens) on no. 79.

57 Thyestes at Aristotle *Poetics* 1453a7ff. and 18ff. Aigisthos is named along with Oedipus as the archetype of incest stories at Andokides *On the Mysteries* 129; (anon.) *Against Alkibiades* 22; see Wilson 1996, 316, 319–20.

58 Fr. 247 may be about how oracles should be obeyed, however horrible they seem. But this is disputed.

PART 2, CHAPTER 3

1 There is now a compendious collection of Testimonia by Kannicht in *TrGF* 5.1, 39–145. There is a valuable short survey of the material by Kovacs in the Loeb Euripides I (Kovacs 2001), 1–36.

2 See *TrGF* 5.1, T189a and b; see also Taplin 1999, 42–43. The evidence that Euripides was once an ambassador to Syracuse (T96) is not necessarily false.

3 The lost plays seem to have been mainly satyr plays. It appears that Euripides may have taken these less seriously than did his seniors.

4 Close to Laodamia Painter; *RVAp* 18/16 and pl. 171.4; *LIMC* Alkestis 5*; *CFST* Ap121; *RVSIS* 196—Trendall-Webster 1971, III.3,5; Schmidt-Trendall-Cambitoglou 1976, 78–93 and pls. 19–22 and color opp. pl. 78; Green 1994, 54 and fig. 32; Green 1999, no. 5 and fig. 3. First published 1971.

5 See *LIMC* Alkestis, esp. 543 (Schmidt).

6 Trendall-Webster 1971, 75.

7 Green (1999, 40) says that the paidagogos "will report these events later." Does this imply that he takes the related play to be another, not that by Euripides?

8 See Rau 1967, index on p. 215.

9 Close to the Chamay Painter; *RVAp*

16/68 and pls. 158.1–2; *CFST* Ap110; *LIMC* Admetos I, 11*; Alkestis 18; Apollon 940—Saladino 1979, 99–101 and figs. 1–3; Green 1999, no. 12. First published 1976.

10 For ancient reception, see Mastronarde 2002, 64–66; Hunter 1983, 29; for modern, see Hall-Macintosh-Taplin 2000, passim.

11 There was a *Medeia* by one Neophron (otherwise virtually unknown), which seems to have been particularly close; there were even stories that Euripides' play came after this one and was much influenced by it. But the substantial fr. 2 (*TrGF* 1, 15 fr. 2) is clearly responding to Euripides, rather than the other way around. Mastronarde's full discussion (2002) cautiously reaches this same conclusion.

12 Thus, two rather crude Campanian vases show her in the act of killing, but they do not invite any particular recognition of Euripides' play. On Paris, Cabinet des Médailles 876 (*LCS* 325/739; *CFST* C18), she is killing both children; on Louvre K300 (*LCS* 338/786 and pl. 131.3; *CFST* C45), she is killing one.

13 See Mastronarde 2002, 51, within a good discussion of the whole myth (44–57).

14 See *LIMC* Iason and Peliades; also Sourvinou-Inwood 1997, 262–66; the good *LIMC* Medeia article by Schmidt is devoted to the Corinth episodes.

15 Attributed to circle of the Ilioupersis Painter (but not in *RVAp*); *LIMC* Kreousa II, 16; Merope II, 2; *CFST* Ap77 (may be from Pomarico)—Séchan 1926, 400–402 and fig. 118; Page 1938, lviii; Mastronarde 2002, 68 n. 114; Green 1999, no. 26. Known by 1833.

16 See *LIMC* Kreousa II, 123.

17 This kind of paidagogos figure belongs far more to the next period of Apulian painting, that of the Darius Painter in the 340s and 330s. This makes me wonder about the attribution that puts this painting as early as the 350s.

18 Mastronarde (2002, 56) thinks that the use of the poisoned robe as the means of death may well have been an invention of Euripides'.

19 Another to add to the *LIMC* Erinys entry.

20 Louvre CA2193; Dolon Painter, ca.

390s; *LCS* 100/517, see *LCS supp 3*, 56/D4; *CFST* L30—Trendall-Webster 1971, III.3,35 ("must have been inspired by Euripides' play"); cf. *LIMC* Kreousa II, 1* ("uncertain"); Séchan 1926, 398–40 and pl. 7; Mastronarde 2002, 68 n. 114.

21 Schmidt (1970a, 826), pointing to arguments against *Medeia*, supports the Tereus story.

22 Policoro Painter; *LCS* 58/286 and pls. 26–27; *CFST* L9; *RVSIS* fig. 28; *LIMC* Aphrodite 1412*; Iason 70*; Kreousa II, 24; Medeia 35*—Trendall-Webster 1971, III.3,34; Taplin 1993, 22–23 and pl. 2.103. Excavated at Policoro (ancient Herakleia) in 1963; see *CFST* 533–34.

23 The standard spelling became ΜΗΔΕΙΑ, with an *eta* for the long first vowel. It is possible, however, that at this early date "E" was still used for the long as well as the short vowel. This is confirmed by the spelling ΣΑΡΠΕΔΩΝ (Sarpedon) on another vase from the same tomb (Policoro 35294; *LCS* 57/285 and pls. 26–27; *CFST* L7).

24 The standard paidagogos figure (see pt. 1, sec. M6) is a feature of vases of the second half of the fourth century (see Green 1999). At this early date, he has not yet become a pictorial stereotype.

25 Small (2003, 47–52) makes a lively case for totally disconnecting this vase and no. 35 from Euripides. She deploys a rather indiscriminate mix of good and bad arguments.

26 See Mastronarde 2002, note on line 1317.

27 As argued by Sourvinou-Inwood (1997, 271). It is worth noting that in an Etruscan-related (Faliscan) vase-painting in the Hermitage (b 2083), the boys' bodies are in the chariot carried by Medeia: this is *LIMC* Medeia 39*.

28 Close to Policoro Painter (not in *LCS*); *CFST* L14; *LIMC* Erinys 101; Iason 71; Medeia 36*—Taplin 1993, pl. 1.101; Tompkins 1983, 76–79; Neils 2003, 217–18 and color pl. 17; Shapiro 1994, 179; Revermann 2005. First published 1983.

29 Trendall never published an attribution but is reported to have thought the work to be by the Policoro Painter or a close associate. Apparently he had doubts at first about the authenticity of this piece but was later convinced. There are indeed some oddities, but

they are surely outweighed by the detailed touches that would never have occurred to a forger (unless the forger had access to a body of important authentic vessels that are unknown to us).

30 According to Hardwick (1999, 179–200), the altar is of a triglyph type particular to Corinth.

31 The paidagogos is strangely ugly. I wonder if this was one of the details that aroused Trendall's suspicions? The nurse has Thracian-type tattoos on her arms, an unusual detail in Western Greek art—suggested by theatrical sleeves, perhaps? But see Schulze 1998, 20, 64–65, for a different opinion.

32 See Revermann 2005, 10–11. He suggests the possible influence of Etruscan Underworld iconography.

33 See Schmidt (*LIMC* Medeia 36*): "hässliche Daemoninnen."

34 Darius Painter; *RVAp* 18/43 and pl. 178.1; *CFST* Ap158; *LIMC* Medeia 37*; Amazones 383*; Astra 28; Iason 73*—Séchan 1926, 404–5 and fig. 121; Moret 1975, 180–84, pl. 94; Aellen 1994, 39–42, no. 42, pl. 52. Excavated in 1851 from the "Darius Painter Tomb" at Canosa; see *CFST* 557–58.

35 I note, however, that Giuliani and Most (forthcoming) do not see anything here that does not fit: "all this corresponds very closely to the Euripidean tragedy."

36 There are parallels for Lyssa with a nimbus around her head (cf. no. 13); but, if it was there, it is not conspicuous. On Selene, see Aellen 1994, 124–25.

37 Confirmed by Schmidt (*LIMC* Medeia 37*, p. 392).

38 Sourvinou-Inwood (1997, 288–94) argues that in Euripides' play Medeia appeared dressed as a Greek until her final epiphany, when she was in full Oriental finery. This is an attractive possibility, though not provable.

39 The story was already in the work of fifth-century mythographer Pherekydes; see Mastronarde 2002, 47–48.

40 While the Darius Painter often does make conspicuous connections with tragedy, it so happens that none of the five monumental pieces by him, which were found at Canosa in August 1851, do so obviously (see also no. 92).

41 An interesting case was made by Schmidt (1967, 174ff. and pl. 59.1) for the scene on a Campanian krater

(Schwerin, Staatliches Museum 719; *LCS* 307/566; *CFST* C33—Séchan 1926, 212–13). This shows two men, one on an altar, mourning a dead girl—it remains, however, a stretched chain of conjectures. Another possibility that has been offered is a supplication scene on a Paestan amphora (Würzburg H5739; *RVP* 174/379 and pl. 118; *CFST* P17). Simon, in Beckel-Froning-Simon 1983 (148, no. 67), is surely right that it is not a scene of Orestes and Elektra at the tomb; but there is little to indicate children of Herakles either. Schmidt (1970a) also made a case for the badly damaged and repainted volute-krater Bari 3648 (*CFST* Ap84; *RVAp* 8/144), which shows two men carrying the corpse of a young woman, but, interesting though the scene is, it is hard to make the connection with the Euripides play.

42 Trendall (*LCS* 50–51) dubbed them the PKP Group, meaning Palermo, Karneia, and Policoro Painters.

43 Close to Karneia Painter; *LCS* 55/283 and pls. 25.5–6; *LIMC* Alkmene 20; Apollon 241*; Athena 628; Herakleidai 2*; Kerkyeion 4*; Kopreus 1*; *CFST* L5—Trendall-Webster 1971, III.3,20; Gogos 1984, 32–35 and fig. 5. Excavated at Policoro in 1963 (see *CFST* 533–34).

44 As discussed by Schmidt (*LIMC* Herakleidai 2*). This youth cannot possibly represent the old men of the chorus, as has been suggested. It has also been proposed that he represents the future rejuvenation of Iolaos; although that is an ingenious idea, it is without any basis in the contemporary conventions of iconography.

45 See Allan 2001, 76.

46 Close to Policoro Painter; *LCS supp* 2, 158/291a, *supp 3*, 20/291a; *CFST* L15; *LIMC* Herakleidai 3; Akamas and Demophon 20*; Alkmene 21*—Trendall-Webster 1971, III.3,21; Gogos 1984, 28–32. First published 1969.

47 Some of the most effusive Athenian material is in the choral songs. I do wonder when it became customary for the choral songs of the original to be replaced by other texts, rehearsed and performed by a local chorus (see Taplin 1999, 38). This kind of adaptation might have already started in the fifth century.

48 There was an earlier dramatization by Euripides, also called *Hippolytos*, subtitled *Veiling Himself* to distinguish it from our play, which was subtitled *Carrying a Garland*. In that version Phaidra was much more shameless in declaring her desires to Hippolytos. It does not seem to have left any clear traces in fourth-century art. An unusual pyxis lid by the Darius Painter has been offered: this is in Altamura (formerly in Taranto); *RVAp* 18/73; *CFST* Ap170—Trendall-Webster 1971, III.3,22. But apart from the melancholy face of the woman, there is no clear indication of tragedy, let alone of which tragedy.

49 Two other possibilities are worth registering: (1) A Lucanian squat lekythos, ca. 360 (Naples 81855[H2900]; *LCS* 166/925 and pls. 72.5–7; *CFST* L52); this shows a pensive regal woman on a throne with an approaching Eros; (2) A Campanian neck-amphora, ca. 320s (New York 06.1021.239; *LCS* 339/795 and pls. 131.8–9; *CFST* C36). Here one woman offers a plate to another, who is seated; a youth (nude) stands behind, and a large Erinys sits above.

50 Laodamia Painter; *RVAp* 18/14 and pls. 171.1–3; *CFST* Ap120 (reportedly from Anzi); *LIMC* Phaidra 11*; Theseus 271*; *RVSIS* fig. 195—Séchan 1926, 329–33 and fig. 96; Green 1999, 57. Known by 1886.

51 For bibliography on this "rule," see Giuliani 1996, 78 n. 36.

52 Darius Painter; *RVAp supp 1*, 18/64b, p. 74, and pl. XIII.1–2; *CFST* Ap186; *LIMC* Hermes 680*; Hippolytos I, 77; Aellen-Cambitoglou-Chamay 1986, 161–65; Schmidt 1986, 256. First published 1983.

53 Compare, e.g., Naples, private coll. 108; *RVAp* 18/59 and pl. 179.2. A reader advises that "in Attic vase-painting the convention should show love or grief, or here possibly both."

54 Schmidt 1986, 256.

55 In Aellen-Cambitoglou-Chamay 1986, 164.

56 Also see, e.g., Ruvo 1088; *RVAp* 2/23; *RVSIS* fig. 57.

57 See, e.g., Basel BS 468 (*RVAp* 18/13 and pl. 170.4, 18/48); Richmond 81.55 (*RVAp supp 1*, 18/281b—Mayo 1982, no. 51); Boston 1987.53 (no. 30); German private coll. (no. 98; in Hamburg Museum 1995, 63, no. 24, this is

wrongly identified as a trumpet—why should Pan have a trumpet?).

58 Never attributed by Trendall (and not in *RVAp*, though known to Trendall and Webster [1971, 88]); *CFST* Ap20—Oakley 1991, 67–68 and fig. 1. First published 1991.

59 Cahn coll. HC 237; *RVAp* 5/42; *CFST* Ap40—Oakley 1991, 68 and fig. 2. I shall not include this in the following discussion.

60 The exception is a variant in other ways as well: this is New York, White-Levy coll. 231; *RVAp supp 1*, 18/20a; *CFST* Ap145—Oakley 1991, 69–70 and figs. 4–6. There Hippolytos is turning around, distracted from his horses, and even from the bull, by the assertive Erinys.

61 They all have the bull, except the Sicilian calyx-krater (Lipari 340bis; *LCS supp 3*, 275/46h; *CFST* S17—Trendall-Webster 1971, III.3,23; Oakley 1991, 72–73 and figs. 13–15). In that picture the chariot is already smashed, and the bull has gone.

62 Darius Painter; *RVAp* 18/17; *CFST* Ap148 (from Ruvo); *LIMC* Aphrodite 1528*; Athena 630; Hippolytos I, 105*; Lyssa 29; Poseidon/Neptunus 129—Trendall-Webster 1971, III.3,24; Oakley 1991, 68–69 and fig. 3; Séchan 1926, 335–37 and fig. 99; Aellen 1994, no. 33, pl. 41; Green 1999, 57 and figs. 4–5. Known by 1848.

63 *RVAp* 18/17.

64 It is an interesting feature of Naples, private coll. (1) 488 (*RVAp supp 1*, 18/293a and pl. 17.4; *CFST* Ap215; *LIMC* Hippolytos 103*—Oakley 1991, 70 and fig. 7) that the bull is represented as inside a kind of seething wave. On Toledo, Orr coll. (*RVAp supp 2*, 27/23h, pl. 7; *CFST* Ap202; Oakley 1991, 70–72 and figs. 8–12), there is a tripod in between the horses and the bull—does this represent their past record in chariot competitions?

65 She is on the Toledo krater (see n. 64), riding on a deer, and perhaps rather awkward next to Aphrodite.

66 Ilioupersis Painter; *RVAp* 8/4 and pl. 60.3; *RVSIS* ill. 140; *LIMC* Neoptolemos 25; Apollon 890*; Machaireus 1; *CFST* Ap72—Trendall-Webster 1971, III.3,9; Séchan 1926, 253–55 and fig. 75; Moret 1975, 176–77 and pl. 51/1. Known by 1868.

67 See *RVAp* 188–92; *RVSIS* 79–80.

68 The palm is probably thought suitable simply through association with the cult of Apollo on Delos, where there was a sacred tree beneath which he and Artemis were supposed to have been born. The omphalos is a more ornate version than those in the *Eumenides* scenes; see nos. 6–10.

69 A more common spelling than the Attic ΟΡΕΣΤΗΣ. This and the spelling ΕΡΜΑΣ for "Hermes" are sometimes found among otherwise Attic forms.

70 I had wondered if he might be a servant escaping (cf. the servant on no. 102), but the position of the spear and the cloak wrapped around his forward arm are clear indications that he is attacking.

71 See Allan 2000, 25ff.

72 First performed in the mid-420s. There was no trace of it in the official records in Athens, so it is widely supposed that it was first performed elsewhere; see Allan 2000, 149ff.

73 See lines 1074–75, 1115–16; see Lloyd (1994) on 1008; Allan (2000, 76–77) contradicts Lesky (1966), who tried to argue on grounds of realism that Orestes never returned to Delphi.

74 Moret 1975, 176–77; cf. Giuliani 1996, 75.

75 This is the unconvincing claim by Lesky (see n. 73), which is eagerly embraced by Moret (and Giuliani) because it suits his case better.

76 Darius Painter; *RVAp* 18/19 and pl.174.1; *LIMC* Hekabe 59; Agamemnon 86*; Polymestor 1; *CFST* Ap173 ("from Basilicata")—Trendall-Webster 1971, III.3,19; Séchan 1926, 321–22 and fig. 95. Known by 1834.

77 See Mossman 1995, 29–31.

78 Assteas; *RVP* 84/127 and pls. 46–47, discussed on 89–90; *RVSIS* ill. 355; *LIMC* Herakles 1684; Alkmene 18*; Herakleidai 8; Mania 1; Megara I , 2; *CFST* P6—Séchan 1926, 524–26 and fig. 155; Aellen 1994, no. 8, pl. 12. Excavated at Paestum in 1864.

79 Two details are worth noting: Mania has a whip, which does not appear in the standard drawing of the picture (as in *LIMC* Herakles 1684, e.g.); and Iolaos is spelled correctly in Greek, not in the form ΙΟΛΗΟΣ, as recorded in *RVP*.

80 Trendall (*RVP* 89) reports that Herakles' name label reads ΝΡΑΚΛΗΣ. But

the first letter seems to be a *heta* (Ⱶ) followed by an oddly formed "H" (or perhaps an "A"?).

81 The Attic spelling should be ΜΕΓΑΡΑ.

82 Pherekydes fr. 14; see Fowler 2000, 284.

83 *RVP* 89–90; see Bieber 1961, 130.

84 See *RVP* 89 and n. 9. For large feathers in a perfectly serious depiction, see, e.g., Achilles and Penthesileia on *RVAp* 8/260 (fully published in Aellen-Cambitoglou-Chamay 1986, 62–69).

85 Lycurgus Painter; *RVAp* 16/16; *LIMC* Apollo 326*; Ion 2; Aphrodite 1532; Chyses I, 14; Eros 928; Herakles 2346*; Iolaos 36; Kreousa I, 4; Ladon I, 3; Xouthos 1*; *CFST* Ap102 (from Ruvo)—Schmidt 1979, 163–69 and pl. 42. Known by 1869.

86 *RVAp* p. 417.

87 "Kypris" refers to Aphrodite, the "Goddess from Cyprus."

88 Green (1999) does not include this vase. This is, in fact, rather early for the standard paidagogos figure.

89 Schmidt 1979, 164.

90 See also Athena at 1586. Schmidt (1979, 164) collects some interesting material, including passages of Isokrates, about Greek attitudes toward Asia in the mid-fourth century. She suggests that the scenes elsewhere on the vase, concerning the Hesperides and Herakles, bring in all the known world.

91 Simon (*LIMC* Ion 2) thinks of Hellen, the eponymous ancestor of the Hellenes and, in some versions, the father of Xouthos. But he is never mentioned in Euripides' *Ion*, where Xouthos' father is explicitly Aiolos.

92 On the date, see Cropp 2000, 60–62.

93 See *PCG* 1, 264.

94 On the myths and cults, see Cropp 2000, 43–56.

95 Ilioupersis Painter; *RVAp* 8/3; *LIMC* Iphigeneia 18*; Artemis 1380; *CFST* Ap73—Trendall-Webster 1971, III.3,28; Séchan 1926, 382–84 and fig. 111; Cambitoglou 1975, 59. Excavated at Ruvo in 1836 (see *CFST* 543–44).

96 With the non-Attic spelling ΟΡΕΣΤΑΣ—although ΠΥΛΑΔΗΣ has his Attic *eta*.

97 Another, rather less interesting painter picked the more obvious scene, in which Orestes is first brought in as a prisoner (456ff.). This is an Apulian bell-krater of similar date, Pavia, Mus. Civ. (unnumbered); *RVAp* 5/265; *CFST*

Ap53. There are only three figures: Orestes is brought before the priestess (with key) by a Taurian guard (no Pylades).

98 Iphigenia Painter; *ARV²* 1440.1 (*Add²* 377); *LIMC* Artemis 1376; Elektra I, 55; Iphigeneia 19*; Thoas II, 1—BAD 218096; Trendall-Webster 1971, III.3,27; Cambitoglou 1975, 58–59; Shapiro 1994, 170–71.

99 The two new accessions, besides no. 49, are: (1) Matera, Mus. Arch. (formerly Bari market), volute-krater, ca. 330s; *RVAp supp 2*, 14/126b and pl. 19.2; *LIMC* Iphigeneia 24*. Not in *CFST*. (2) New York market, calyx-krater, ca. 330s; *CFST* Ap134 (to which I owe knowledge of its existence). Not in *RVAp* or *LIMC*. The two previously known Apulian vases are: (3) Moscow, Pushkin Mus. II 1b 504; *RVAp* 18/8; *CFST* Ap192—Trendall-Webster 1971, III.3,30a. (4) Saint Petersburg, Hermitage B1715 (St. 420); *RVAp* 27/18; *CFST* Ap208—Trendall-Webster 1971, III.3,29.

I am leaving out a lost piece (lost before 1926), formerly in the Buckingham coll. (*LIMC* Iphigeneia 20 (with drawing); *CFST* Ap125), which has some odd (suspicious?) features. I am also leaving aside, despite its interesting architecture, the Campanian bell-krater Louvre K404 (*LCS* 321/702; *CFST* C51—Trendall-Webster 1971, III.3.31). It is not at all clear to me that the figure in the left-hand door is the statue of Artemis (too big); and the right-hand figure has neither key nor letter.

100 In three of the other vases—Moscow (n. 99, no. 3), Saint Petersburg (no. 4), and Matera (no. 1)—Iphigeneia is inside the shrine along with the statue.

101 Trendall and Webster (1971, 92) think that this evokes the report of the herdsman who tells of how Orestes and Pylades were sitting on the shore when they were first seen (264ff.)—but this seems far-fetched.

102 As he is on no. 47 and on the new New York vase (n. 99, no. 2), where he is sitting on a column drum. On the Matera vase (no. 1), he stands with one knee raised. It may not be surprising that Orestes is not present at all on the Campanian neck-amphora in Sydney (Nicholson Mus. 51.17; *LCS*

406/305 and pl. 160.4–5; *CFST* C23—Trendall-Webster 1971, III.3,30b), since this is such a simple two-figure composition. It is disconcerting, though, that he is not on the Moscow krater (no. 3).

103 Trendall-Webster 1971, III.3,27.

104 Only one of the pictures—Saint Petersburg (n. 99, no. 4)—includes Athena, who is the "god from the machine" in *IT*.

105 Painter of Boston 00.348; *RVAp supp 2*, 10/48a; *LIMC* Iphigeneia 21*. Not in *CFST*. First published 1992.

106 It is worth noting that the Dionysiac scene on the reverse has a "suspended profile female mask," according to *RVAp supp 2*, 63.

107 Namely the Saint Petersburg krater (n. 99, no. 4); on the Matera vase (no. 1), there is a bowl with four feet (so not simply a tripod).

108 In several of the other pictures, she has the more conventional spears, bow, and hunting boots. On the new New York vase (n. 99, no. 2) Artemis stands holding a deer, which is a common attribute but which might also be a reminder perhaps of the substitution that she made for Iphigeneia at Aulis?

109 Ixion Painter; *LCS* 338/790 and pl. 131.6; *LIMC* Iphigeneia 29*; *CFST* C39—Trendall-Webster 1971, III.3.32; Cambitoglou 1975, 64. Known by 1868.

110 See *LCS* 335.

111 Especially lines 72–76. This gruesome detail is also in Herodotos' account of the Taurians (4.103). It does not, however, figure in any of the other vase-paintings.

112 Yet Trendall and Webster (1971) make no complaint. Cambitoglou (1975), who is generally trying to drive a wedge between the Iphigeneia vase-paintings and Euripides' play, is in this case quite right to insist on the incompatibility. Throughout the article, however, he refers to "the story" as though it existed in total independence from the play. Yet the story was Euripides' own creation.

113 Close to Thyrsus Painter; *RVAp* 10/190—Taplin 2004. Not in *LIMC* or *CFST*. Known by 1896.

114 Trendall (*RVAp* 274) characterizes the Thyrsus Painter as "a productive but rather inferior artist."

115 See *LIMC* Pentheus 2, 24–25, 39–44.

116 These are *LIMC* Pentheus 6–16, to which should be added the frag-

ment Boston, MFA 1986.263; *RVP* 255/1003a, later reclassified by Trendall as Apulian rather than Paestan (see Padgett et al. 1993, 133, no. 54); *CFST* P19.

117 The closest to a possible exception is an early Apulian bell-krater, Lecce, Mus. Arch. 638; *LIMC* Pentheus 3*; *CFST* Ap19 (not in *RVAp*). To the left of two maenads with drawn swords is a seated figure with a branch. It is not distinctly clear whether this is a male or female, but, if it is taken that this is Pentheus, as *LIMC* claims, then here he is not obviously masculine. But can this single branch possibly represent his hiding in the trees? It looks much more like a conventional token, such as Apollo's laurel bough.

118 Walters 1896, 67.

119 *RVAp* 281. He never registered this in his index, and it has not been recorded anywhere else (including *LIMC*).

120 Close to Ilioupersis Painter; *RVAp* 8/104; *LIMC* Agamemnon 30*; Artemis 1373; Iphigeneia 11*; Kalchas 23; *CFST* Ap79 ("from Basilicata")—Séchan 1926, 372–78 and fig. 108; Green-Handley 1995, 47–48 and fig. 22. Known by 1833.

121 Diggle (1994) expresses doubts about the Euripidean authorship of much of the play—"may be Euripides" is the most optimistic category!

122 Rhesus Painter (assoc. with Ilioupersis P.); *RVAp* 8/102a on p. 441; *LIMC* Rhesos 3; Odysseus 47*; *CFST* Ap68—Trendall-Webster 1971, III.5,8; Giuliani 1996, 78–79 and pl. 18. Known by 1889.

123 The simplest of the three paintings is Naples 81863 (H 2910), an Apulian situla of circa the 350s by the Lykurgus Painter; *RVAp* 16/18; *CFST* Ap100 (from Ruvo, 1836)—Trendall-Webster 1971, III.5,7; Giuliani 1996, 77 and pl. 16. It is not (contra Trendall-Webster 1971, 113) simply a less elaborate version of the same iconography, and it does not include anything within the painting itself that particularly evokes or indicates the surviving tragedy, nor does it even single out Rhesos. It shows only two living figures, Diomedes and Odysseus, escaping with Rhesos' prize horses, while above them lie three very dead Thracians in highly ornate and

outlandish costumes with emphasis on their zigzag sleeves and leggings.

124 Giuliani 1996, 79.

125 Ibid.

126 Darius Painter; *RVAp supp 2*, 18/17a, pl. 35.1; *LIMC* Rhesos 4*; Odysseus 49; Strymon 2*; Mousa, Mousai 155; *CFST* Ap147—Giuliani 1988, 77–78 and pl. 17; Giuliani 1995, cat. 2, 31–33, 94–102; Aellen 1994, no. 83, pl. 99. May be from Canosa, see *CFST* 557. First published 1988.

127 Giuliani 1996, 80.

128 Giuliani (1996, 81) says that she is sitting "on the edge of a small pond." Is this because the left edge is not complete?

129 It seems much less pointed to take the river as merely the Skamandros, as does Aellen (1994, 145).

130 The Muse even upbraids Athena and her city of Athens for ingratitude (938ff.). It is not inconceivable that in the original staging real horses brought on Rhesos' chariot at his first entrance; see Taplin 1977, 77. The chorus call the Greeks "robbers" (678–79); I now wonder whether, at least in later fourth-century productions, Odysseus and Diomedes brought the horses back on at 675–91?

131 I do not think that *LIMC* Rhesos p. 1046 is right to say that Odysseus is "disguised in an oriental tunic."

132 Giuliani 1996, 85. Cf. Giuliani 1995, 102.

PART 2, CHAPTER 4

1 For a survey of the wider evidence, see Xanthakis-Karamanos 1980, 28–34.

2 There are several plays discussed in Séchan 1926 and in Trendall-Webster 1971 that are not included here. I have restricted myself to those for which I feel there is a case of some substance to be made (and, of course, I have restricted myself to the fourth century). Even so, there are still some very interesting lost plays that seem to have left no trace in fourth-century vase-painting, e.g., *Archelaos*, *Erechtheus*, *Phaethon*. I might mention particularly that Policoro 35304 (*LCS* 55/282; *CFST* L6), showing Poseidon and Athena on opposite sides, has been claimed as related to *Erechtheus*; but any

3 Fortunately we now have the benefit of the amazingly learned, helpful, and comprehensive edition by Richard Kannicht, *TrGF* 5.1 and 5.2 (2004). I have also derived great help from the two selective volumes of fragmentary plays, *EfrP* 1 and *EfrP* 2.

4 Adolphseck Painter; *RVAp* 4/51; *RVSIS* ill. 110; *LIMC* Aigeus 23*; Theseus 168*; *CFST* Ap41—Trendall-Webster 1971, III.3,3; *TrGF* 5.1, 151–52. Known by 1938.

5 Some Attic vases (none of them showing this particular episode) have been connected with Euripides' play—see Shefton 1956 and *TrGF* 5.1, Tiii (151–52). These fall outside the scope of this study, both in terms of chronology and because of their lack of tragedy-related signals.

6 Unless perhaps this is the young hunter's *lagobolon*? (See no. 40).

7 This notion does not fit with the usual story (see *TrGF* 5.1, 151) that these events took place at a feast.

8 Amykos Painter; *LCS* 45/221 and pl. 18; *LIMC* Aiolos 1*; Kanake 1*; Amphithea II, 1; *CFST* L4 (probably from Canosa)—Trendall-Webster 1971, III.3,4; *TrGF* 5.1, 160–61. Known by 1883.

9 I wonder whether she is possibly meant to be shown as concealing a baby in her robes?

10 Some have thought of the Hippolytos story, but there are several contraindications, at least against the surviving play: the sword (as opposed to noose), the absence of the suicide letter, and the binding of the accused young man.

11 See *TrGF* 5.1, Tiv and viii (159–61).

12 There is also a Paestan comic vase: Vatican 17106; *LIMC* Alkmene 2*—Trendall 1959, no. 65; Trendall-Webster 1971, IV.19.

13 Provided the papyrus fragment 87b is rightly allocated to this play. For the storm, see Plautus *Rope* (*Rudens*) 83–87 (see *TrGF* 5.1, Tiia (219)).

14 There is also a possible Sicilian example (no. 106), set on a stage, but this is so fragmentary that I have not included it in this discussion.

15 Only no. 58 includes Teiresias and Kreon in the "cast" (see below). Just one vase has Amphitryon helped by an otherwise unknown character called Antinor: this is London F149, a midcentury Paestan bell-krater signed by Python; *RVP* 139/239 and pl. 88; *LIMC* Alkmene 5; *CFST* P15—Trendall-Webster 1971, III.3,8. I cannot help wondering whether this Antinor is a figment of Python's quasilearned invention. Or perhaps he should be equated with the Kreon on no. 58?

16 Séchan 1926, 242. He was referring mainly to the Python krater (see n. 15). Neither no. 57 nor no. 58 was known at that time.

17 Painter of the Birth of Dionysus; *RVAp* 2/11; *RVSIS* ill. 55; *LIMC* Alkmene 4; Amphitryon 1; Eros 81; *CFST* Ap15 (from Taranto)—Trendall-Webster 1971, III.3,6; *TrGF* 5.1, Tiib (219). First published 1956.

18 *CFST* wrongly reports the spelling as ΑΝΦΙΤΡΥΩΝ.

19 See Taplin 1977, 431–32.

20 Darius Painter; *RVAp supp 2*, 18/65b; *RVSIS* ill. 206; *LIMC* Kreon I, 9*; Teiresias 4; Hermes 457; *CFST* Ap146—Padgett et al. 1993, 119–21. First published 1989.

21 The Paestan krater (see n. 15), and the Campanian neck-amphora, London F193; *LCS* 231/36; *LIMC* Alkmene 6*; *CFST* C5.

22 Or it could be an otherwise unknown "Chreon"? The Darius Painter is normally very careful about spellings, but this does not seem to be a philologically possible form.

23 *LIMC* Teiresias 4 says that he has "Oriental costume," but this is not specific (it is also inaccurate to describe the scene as "death of Alkmene").

24 *LIMC* Kepheus I, 6 (= no. 62), 9–10, 12–14, 15a. There are also two new cases of Andromeda without any Kepheus. These are, for the record: Rome, private coll., *RVAp supp 2*, 15/44-1 and pl. xxiv; and Germany, private coll., *RVAp supp 2*, 27/43f. For this happy-ending story as an example of consolatory material, see Keuls 1997, 164–66.

25 *LIMC* Andromeda 2–7, all with photos; 2–6 are also listed in Green 1994, 177 n. 10.

26 See Trendall-Webster 1971, 65–66, and Green 1994, 20–22; cf. *LIMC* Andromeda I, p. 787.

27 See *TrGF* 4, 156–60; Lloyd-Jones 1996, 50–53; *EfrP* 2, 143 (Gibert).

28 A white-ground calyx-krater found at Agrigento in Sicily, Agrigento AG7; *ARV²* 1017, 53; *LIMC* Andromeda 5*—BAD 214231; Trendall-Webster 1971, III.2,1.

29 The fullest case is made in Krumeich 2002 (see also his bibliography).

30 She is naked only on the Campanian hydria, Naples, Stg. Spinelli 1952; *LCS* 245/138; *LIMC* Andromeda 20*. I wonder if this is meant to be a comic painting? It is hard to take seriously!

31 His outfits seem generically Oriental rather than African or Occidental (although the Euripides play was set in Ethiopia, which was thought of as the far West).

32 Sources in *TrGF* 5.1, Tiiia (233–34). It is not impossible that Aphrodite conveyed Athena's disposition for the constellations (see further below).

33 This may have been staged by use of the *ekkyklema*. Or it may have been a "cancelled entry," i.e., she simply came on and was bound in view of the audience, who were then expected to treat this as not part of the play (see *EfrP* 2, 141–2).

34 Comparable with but not by the Pronomos Painter; *ARV²* 1336, 1690; *LIMC* Andromeda I, 8*; Kepheus 5*; Aithiopes 21*; Perseus 179; *CFST* A71 (prob. from Capua)—BAD 217501 (see *Para²* 480 on attribution!); Trendall-Webster 1971, III.3,10; Séchan 1926, 258 and fig. 76; *TrGF* 5.1, 236; *EfrP* 2, 139–40 (Gibert); Green 1994, 22–24.

35 Felton Painter; *RVAp* 7/70; *LIMC* Andromeda 1.10*; Kepheus 7*; Neireides 460; *CFST* Ap58 (reportedly from Taras); known by 1932.

36 Two recent additions to the Andromeda iconography actually have a rectangular rock rather than an arched one. This would seem to be even more clearly a stage prop to fit in front of the doorway. They are Rome, private coll., *RVAp supp 2*, 15/44-1 and pl. xxiv (not in *LIMC*), and New York market, *RVAp supp 2*, 16/64a and pl. xxv, 3, *LIMC* Kepheus 9.

37 Fr. 112, lines 1–2 and 6–7, alludes to girls' choruses and marriage songs, but it is hard to know how much of this is made up by Aristophanes and how much is genuine Euripides.

38 Metope Group; *RVAp supp 2*, 18/16g; *RVSIS* ill. 182; *LIMC* Kepheus 10*; Per-

seus 189*; Phineus II, 3*; CFST Ap118. First published 1989.

39 As suggested in *CFST* 443.

40 Several other paintings show Perseus in combat with the monster—in one it takes the form of a huge fish! This is Berlin 3238; *LCS* 227/8, pls. 89.1–3; *LIMC* Andromeda I, 19*; Perseus 190*; Kepheus I, 21; Echo 2*.

41 Close to the Sisyphos Painter; *RVAp supp 2*, 1/90a; *LIMC* Kepheus 1.6*; Perseus 180; Phineus II, 1; *CFST* Ap9. First published 1986.

42 Thus Green 1994, 178 n. 13: "The painter has shown the general effect rather than any individual moment."

43 In that case the man on the left is presumably simply an attendant. He has been taken to be Andromeda's thwarted suitor, Phineus (see *LIMC* Phineus II, 1); but I see no good reason to suppose that.

44 These are (1) Naples 82266 (H 3225); *RVAp* 18/58; *LIMC* Andromeda I, 13*; *CFST* Ap181—Trendall-Webster 1971, III.3,11; (2) Naples Stg. 708; *RVAp* 18/306; *LIMC* Andromeda I, 14; *CFST* Ap218; (3) Taranto 8928; *RVAp* 28/97; *LIMC* Andromeda I, 17*; *CFST* Ap238; (4) Matera 12538; *RVAp* 18/65; *LIMC* Andromeda I, 64*; *CFST* Ap172—Trendall-Webster 1971, III.3,12.

45 Darius Painter; *RVAp supp 2*, 18/69a and pl. 38.2; *LIMC* Homonoia 2; Kassiepeia 13; Kepheus I, 14*; Perseus 217*; Phineus II, 4; *CFST* Ap143—Trendall 1991, 178 and pl. 74; Aellen 1994, 168–69, 181–82, no. 111, pls. 138–39. First published 1988.

46 For details of this pot, see no. 4 in n. 44 above; see also Lo Porto 1991, 94–97.

47 Trendall 1991, 178.

48 See *LIMC* Homonoia pp. 476–77. The word does not occur in surviving Euripides.

49 *TrGF* 5.1, Tiiia (233–34).

50 Group of Ruvo 423 ("repainted"); *RVAp* 15/41 and pl. 142.4; *LIMC* Antigone 14*; Herakles 381; Ismene I, 9; *CFST* Ap89 (probably from Ruvo)—Séchan 1926, 274ff. and fig. 85; *TrGF* 5.1, Tc9 (262). Known by 1836.

51 See *TrGF* 5.1, Tiia and notes (261–62); see also Xanthakis-Karamanos 1980, 50–53.

52 ΙΣΜΗΝΗ (Ismene) is in good Attic. "Kreon" is peculiarly spelled ΚΡΑΩΝ.

53 It should be registered, though, that

this is not his role in Hyginus' version of the story (*TrGF* 5.1, 262), in which Kreon does not follow Herakles' advice to spare Haimon and Antigone. It also does not tally with the evidence, far from conclusive, that Euripides fr. 177 was addressed to Dionysos as the deus ex machina in *Antigone*.

54 Berlin F3240 (early Darius Painter, 340s); *RVAp* 18/23; *CFST* Ap136; *LIMC* Antigone 15.

55 There is a papyrus fragment (*POxy* 3317; *TrGF* 5.1, fr. 175) that has been attributed to this play, with a reference to "the house of Herakles" or something similar. I am inclined, however, to follow those who hold that this fragment belongs to *Antiope* rather than to *Antigone* (see n. 70).

56 *TrGF* 1, DID (*didaskalia*, or ancient production record) A 2a (26).

57 This rescue story fits with the well-attested date of circa 408, as such stories were popular at that time. Metrical criteria suggest a date of ten or more years earlier, however.

58 For more on early reception, see *EfrP* 2, 270–71.

59 Before Euripides she seems to have been simply the nymph of the spring (see *LIMC* Dirke p. 635).

60 I have already discussed this topic in Taplin 1998.

61 Policoro 35297 (Policoro Painter); *LCS* 58/288 and pl. 27.4; *RVSIS* ill. 29; *LIMC* Dirke 4; *CFST* L11—Trendall-Webster 1971, III.3,14; Degrassi 1967, 223–25; Taplin 1998, 33 and pl. 8.1.

62 Dirce Painter; *LCS supp 3*, 99; *RVSIS* ill. pl. 61; *LIMC* Antiope I, 6*; Dirke 5; Lykos I, 1; *CFST* S5 (from Palazzolo)—Trendall-Webster 1971, III.3,15; Séchan 1926, 305–7 and fig. 88; Csapo-Slater 1995, 60–62 and pl. 3; *EfrP* 2, 265–66; *TrGF* 5.1, 277; Taplin 1998, 35 and pl. 8.2. Known by 1878.

63 For example, fr. 223, lines 19, 58, 68–70. The panther skin might suggest the local cult of Dionysos, and fr. 203 may refer to some cult pillar of the god inside the cave home.

64 There are two current systems for the line numbering of this fragment. I follow that of *TrGF* 5.1, which is that of the actual papyrus.

65 See Csapo-Slater 1995, 61–62.

66 Underworld Painter; *RVAp supp 2*, 18/318a; *RVSIS* ill. 211; *LIMC* Dirke

6*; Hera 491; Lykos I, 2*; Lyssa 19; Oistros 2*; *CFST* Ap214—Trendall 1986, 157–65; *EfrP* 2, 265–66; *TrGF* 5.1, 277; Taplin 1998, 35–37 and pl. 9; Green 1994, 58 and pl. 3.4; Green 1999, 41 and fig. 6 (cat. 23); Aellen 1994, no. 53, pls. 68–69. First published 1986.

67 The subject of Taplin 1998.

68 It is worth noting that the old shepherd on no. 68 is also the work of the Underworld Painter.

69 See *TrGF* 5.1, Tiiia (276), Tv (277).

70 This is *POxy* 3317, lines 6–8. Kannicht (in *TrGF* 5.1, fr. 175 [see n. 55]) is one of those who allocate this fragment to *Antigone* (see n. 55 above). I am inclined to side with those, including Collard (in *EfrP* 2, 282–84, 311–12), who think that it fits *Antiope* much better.

71 Ilioupersis Painter; *RVAp supp 2*, 8/6a and pl. 6; *LIMC* Polydektes 6; *CFST* Ap67—Karamanou 2002–3, 167–75; Kannicht in *TrGF* 5.2, 1160–61 (addenda to *Diktys*). First published 1990.

72 Thus Apollodoros *Mythical Stories*; *TrGF* 5.1, T1a (381).

73 Perseus is more usually shown with a special winged hat, but there are other examples of him with this kind of Oriental cap.

74 Thus Karamanou 2002–3, 170.

75 Underworld Painter; *RVAp supp 2*, 18/283d; *LIMC* Hellen 1*; Kretheus 1; Melanippe 1; Poseidon 194*; *RVSIS* ill. 210 (and pp. 263–64); *CFST* Ap221—Aellen-Cambitoglou-Chamay 1986, 190–99; Green 1994, 54–65, fig. 33; Green 1999, cat. 2, 42–43, and figs. 7–8; *EfrP* 1, 241–42; *TrGF* 5.1, Tiv (528). First published 1986.

76 *RVAp* 532. To be fair, this comment is already somewhat qualified in *RVAp supp 2*, 161.

77 For this form of *heta* (the sound of "h"), see p. 42.

78 It was probably set at Metapontion, one of the cultural centers of the very part of the Greek world that produced these tragedy-related vases. It seems disappointing, then, that we find no evidence that it was popular in this part of the world; see Allan 2001, 85–86 and n. 75.

79 The date of this play is uncertain, but it is most likely to have come from the period of 425–416.

80 I suggest (in Taplin forthcoming B) that the labeling of anonymous figures

81 Even Aellen-Cambitoglou-Chamay 1986, which tends to be skeptical about tragic connections, allows this case (193). Green has repeatedly said that the *Melanippe* in question is not that of Euripides (e.g., Green 1994, 55; 1995, 116). This seems to be entirely on the alleged grounds that in Euripides the twins were some kind of genetic monstrosity, while here they are normal little chaps. This seems to be a misunderstanding of the ancient plot summary (*TrGF* 5.1, 526, line 19), which says that they were believed to be monstrous because they were thought to have been born from the cow that is suckling them; it does not say that they were physically teratomorphic.

82 The "hypothesis" is *TrGF* 5.1, 525–26, the prologue fr. 481 (*EfrP* 1, 248–51).

83 Pollux 4.141; *TrGF* 5.1, Tva (528). Aellen (in Aellen-Cambitoglou-Chamay 1986, 195) argued strongly that the honorific crowning suggests her further transformation into a constellation.

84 Close to Lycurgus Painter ("restored"); *RVAp* 16/54; *LIMC* Althaia 4*; Meleagros 42; Oineus I, 49; Phthonos 26*; Theseus 307*; Aphrodite 1278/1524; Eros 1014; Orpheus 199; Peleus 42; *CFST* Ap106 (from Armento)—Trendall-Webster 1971, III.3,40; Séchan 1926, 431–33 and fig. 123; Aellen 1994, no. 113, figs. 142–43; *TrGF* 5.1, Tiiid (555). Known by 1867.

85 *LIMC* Meleagros 37*, 38*, 39, 40; Atalanta 41*; two are included as Trendall-Webster 1971, III.3,37 and 38.

86 Bari 872; *RVAp* 18/44; *CFST* Ap171—Trendall-Webster 1971, III.3,39.

87 *RVP* 90 (the reference in 90 n. 16 to *RVAp* 8/140 should be to 8/149—which is no. 71 below).

88 Fr. 537, probably spoken by the god from the machine, predicts his future (inhumane) behavior.

89 There are some nice remarks in Aellen 1994, 160–62, 180–81.

90 Attributed to Python; *RVP* 149/249; *LIMC* Agrios 1*; Oineus I, 55; Erinys 105; Diomedes I, 6; Periboia III, 1; *CFST* P13 (probably from Paestum)—Trendall-Webster 1971, III.3.41; Séchan 1926, 444–46 and fig. 125; Handley-Green 1995, 25 and fig. 25; Aellen 1994, no. 74, pl. 87; *TrGF* 5.2,

Tiiic (584–85). Acquired by the British Museum in 1772.

91 There have been doubts about this inscription, but Trendall (*RVP* 149) reports that it has been confirmed by infrared photography. This is the only surviving representation under *LIMC* Agrios.

92 Painter of Athens 1714; *RVAp* 8/149; *LIMC* Hippodameia 4*; Myrtilos 1*; Oinomaos 2; Aphrodite 1277*; Eros 1016; Pelops 4; Pothos I 8; *CFST* Ap86 (probably from Ruvo)—Séchan 1926, 450–51 and fig. 126. Known by 1912.

93 The former are *LIMC* Oinomaos 2, 7–13; the latter 17–21 (plus 22, which is Campanian). There has been only one recent minor addition to those surveyed by Séchan back in 1926.

94 *LIMC* Erinyes 106–8 (including 106a).

95 It is worth noting that the Oinomaos picture on London F271 (*RVAp* 16/5 and pl. 147; *CFST* Ap96) is the reverse side of the Lykourgos painting on no. 13.

96 All the figures are given name labels (several misprinted in *CFST*). Only OI[is preserved from Oinomaos' name. In the engraving in Séchan 1926 (451, fig. 126), Hippodameia's name seems to have an initial heta.

97 Unfortunately *LIMC* is not as helpful as usual for surveying the myth. There is no article on Bellerophon, but simply a cross-reference to Pegasos (even though there is at least one picture of Bellerophon without Pegasos—see no. 73). Then the article on Pegasos, in turn, cross-refers to Proitos (as does that on Stheneboia) and to Iobates. I should add that I am not including here the "Würzburg Skenographie," which is discussed as no. 88.

98 Ariadne Painter; *RVAp* 1/104; *LIMC* Proitos 3*; *CFST* Ap3 (said to be from Gela)—Trendall-Webster 1971, III.3,45; Padgett et al. 1993, no. 8, 62–64 and color pl. 2 (the red color is the result of misfiring in the kiln). Known by 1900.

99 Lucanian amphora, ca. 410s; Naples 82263 (H 2418); *LCS* 44/218; *CFST* L3.

100 It may then be significant that there is also a doorway on a bell-krater in Naples showing a similar scene but without Proitos: Naples 81662 (H 1891); *CFST* L26 (does not seem

to be in *LCS*). There is another similar door in a *Telephos* scene on Bari 12521; *LCS supp* 3, 35/F6 (416d); *CFST* L35.

101 Signed by Assteas; *RVP* 86/134, disc. pp. 98–99 and pl. 55; *LIMC* Proitos 5*; Erinys 88*; *CFST* P5 (from Agropoli, near Paestum)—Trendall-Webster 1971, III.3.44; Aellen 1994, 51–52, no. 1, fig. 1. Excavated 1967 (see *CFST* 535–37).

102 Moret (1972, 100–102) is able to pick holes in any overstated case for connecting this vase closely with Euripides' play (see further below). But, in doing this, he does not take account of the earlier examples, in which the relationship is closer: they are not sufficiently different to justify the suggestion that they tell "a different version of the legend" (102).

103 Moret 1972, 102.

104 Spelled ΑΛΛΕΚΟ. The name of the other (if it was ever there) has disappeared.

105 Some suppose that a stage-property horse was attached to the flying machine; others that a real horse with property wings was employed (see *EfrP* 1, 82). Since the former device is parodied in Aristophanes, while the latter is not, this inclines me to think the machine was more likely to have been used.

106 Darius Painter; *RVAp* 18/64a (501); *LIMC* Iobates 1*; *CFST* Ap156—Tompkins 1983, no. 15. First published 1982.

107 As may be seen from *LIMC* Iobates, there have been several recent additions to this iconography.

108 Gravina 177005 872; *RVAp* 2/2 and pl. 8.3; *CFST* Ap12. There is (or was) a strikingly similar polychrome painting in the Hermitage (Séchan 1926, 500–1 and fig. 148), which has been suspected of being a modern forgery—see *RVAp* 32 (perhaps this needs to be reassessed?).

109 See Rau 1967, index on p. 217.

110 *LIMC* Telephos (nos. 51–53, 55–60, 62–66) seems to list four Attic examples, three Etruscan, and seven Western Greek. This is, however, a singularly difficult and un-user-friendly article, since it cross-refers rather than catalogues. It is also begrudging of any comment on relations between the iconography and Euripides' celebrated play.

111 On the advice of Klytaimestra, accord-

ing to the version of the story as told in Hyginus (*TrGF* 5.2, Tiiic [681]), unless it means after her warning (see Keuls 1990, 91).

112 See the mid-fifth-century Attic pelike London E382; *ARV*² 632; *LIMC* Agamemnon 11*—BAD 207332.

113 See the good sense in *EfrP* 1, 24–25. Strauss (*LIMC* Telephos p. 869) seizes on this theory to distance the iconography from the theater. Yet he does not deny that the comic "Würzburg Telephos" is closely related to a scene enacted onstage in *Women at the Thesmophoria* (Würzburg H 5697; *RVAp* 4/4a, discussed in, among other places, Taplin 1993, 36–40).

114 Not in *ARV*². It has been suggested that the pot might be Boeotian, but its Attic credentials are unquestioned in the Beazley Archive Database (no. 6980). It is *LIMC* Agamemnon 13*; Apollo 875; Telephos 55*—Trendall-Webster 1971, III.3.47; Keuls 1990, 91–92.

115 "Agenouillé," see Moret 1975, 101ff.

116 For her identification as Klytaimestra, see below. She is running away rather similarly on Bari 12521; *LCS supp 3*, 35/F6 (416d); *CFST* L35. The woman fleeing to the right is clearly of lesser status.

117 It was these cultic details that prompted the unlikely idea that this scene occurred offstage in Euripides. But that is reading too much into them.

118 Close to the Policoro Painter (not in *LCS*); *CFST* L14; *LIMC* Agamemnon 14a; Telephos 59*—Taplin 1993, 37–38 and pl. 1.102; Tompkins 1983, 76–79; Neils 2003, 217–18, no. 17. First published 1983.

119 Other possibilities raised in *CFST* are L45; Ap13, 36 (no. 14 here), 74, 96 (no. 13 here), 171, 241; and S12.

120 See Neils 2003, 217.

121 Signed by Assteas; *RVP* 84/128, 90–92 and pl. 48; *LIMC* Kalchas 4*; Telephos 57; Thrisa 1; *CFST* P2 (reportedly from Paestum, see *RVP* 90 n. 17)—Shapiro-Picon-Scott 1995, 233–35, no. 118. First published 1983.

122 Keuls (1990, 92) points out that Aristophanes' *Acharnians* 439 refers to the beggar Telephos having a "little *pilos* hat."

123 The name label ΚΛΥΤΑΙΜΗΣ[finally disposes of the doubts that used to

124 *CFST* 499 reports that his name is spelled with a heta, but this is not confirmed by *RVP* 92.

125 White Sakkos Painter; *RVAp* 29/2a (961); *RVSIS* ill. 256; *LIMC* Telephos 89; *CFST* Ap232. First published 1983.

126 Two women suppliants are being threatened (see no. 87).

127 Trendall (*RVAp* 962) put forward a rather far-fetched theory that the painter has confused Telephos with Philoktetes, and that the prisoner is the Trojan seer Helenos.

128 On the "pre-Iliadic" Achilles in tragedy, see Michelakis 2002, 172–85.

129 See the notes on frr. 716–20 and 724 by Kannicht (*TrGF* 5.2, 699–703) and Cropp (*EfrP* 1, 51–52).

130 See *TrGF* 5.2, 686.

131 Darius Painter; *RVAp* 18/42; *LIMC* Hypsipyle 15; Euneos et Thoas 1*; Archemoros 10*; Nemea 15*; Kapaneus 7*; Parthenopaios 9; Septem 14*; *CFST* Ap179— Trendall-Webster 1971, III.3.26; Séchan 1926, 360–64 and fig. 103; Aellen 1994, 148–49, no. 86, pls. 106–7; *TrGF* 5.2, Tvi (741); *EfrP* 2, 180; Green 1999, no. 27, 43, and figs. 11–12. Excavated in Ruvo in 1834 (same tomb as no. 29, see *CFST* 546).

132 *EfrP* 2, 169–258; *TrGF* 5.2, 736–97.

133 At this point we are at fr. 757, line 54, which we know from a marginal annotation was line 853 of the original play.

134 This is fr. 759a, which includes line 1600 of the original.

135 It may be that Dionysos also had details to offer about Athens and Lemnos, and about the Athenian family of the Euneidai (see *EfrP* 2, 176–79 [Cropp]).

136 Hermitage B 1714 (St. 523); *RVAp* 16/12; *CFST* Ap101; *LIMC* Archemoros 8*— Trendall-Webster 1971, III.3.25.

137 It is a pity that a vivid Paestan fragment now in Bari is so incomplete. In this picture the boy is still alive, with one arm swallowed by the huge serpent while he reaches with the other toward a woman in a tragic-type costume who seems to be running away. If only we had more of the image, we might be able to gauge its relation to the tragedy. This is Bari 3581; *RVP* 144/242 and pl. 93a; *CFST* P16; *LIMC* Hypsipyle 2; Archemoros 2*.

138 Only]ΥΣ is preserved from his label.

139 See *EfrP* 2, 175 (Cropp).

140 Two other vases have been connected with *Hypsipyle*, but for insufficient reason, it seems to me. (1) It is true that the warrior on no. 100 (Louvre K66) is similar to this Amphiaraos, but that does not seem to warrant an identification (and the paintings are not by the same artist). Also, there is no reason to suppose that Eurydike lamented her child onstage in *Hypsipyle*. (2) Naples 81944 (H 1766; *RVAp* 16/67 ["heavily repainted"]; *CFST* Ap109) has six figures who have been identified with those in the Hypsipyle story; but I see no good indicator of this, and no theatrical signals either. (*CFST* [546] claims this "probably" came from the same tomb as the Naples *Hypsipyle* krater, but this is tenuous.)

141 Darius Painter; *RVAp* 18/7; *LIMC* Phoinix II, 2; Peleus 229*; *CFST* Ap167—Trendall-Webster 1971, III.3, 42; Mayo 1982, no. 49, p. 127. Known by 1961.

142 See *TrGF* 5.2, Tiii (846) and fr. 816.

143 Darius Painter; *RVAp supp 2*, 18/41b, pl. 35.4; *LIMC* Nephele II, 2*; Phrixos et Helle 1*; Euphemia 1; *CFST* Ap159— Giuliani 1988, 6–10 and plates; Giuliani 1995, cat. 1, pp. 26–31, 88–94; Aellen 1994, 165–66, no. 112, and pls. 140–41; Green 1999, no. 7, figs. 24–25; *TrGF* 5.2, 856. First published 1988.

144 Yet in his first publication, Giuliani (1988), who points to many fine details, never even mentions tragedy or Euripides.

145 See the plot summary in Tiia in *TrGF* 5.2, 861.

146 There is a similar interpretation by Giuliani and Most (forthcoming).

147 Labelled ΕΛΛΗ—no heta, as reported by Trendall (*RVAp supp 2*, 147).

148 See Aellen 1994, 165–66.

149 See similar questions with Homonoia on no. 63.

150 See Tiia and b in *TrGF* 5.2, 857–59.

151 A speculation: Helle fell into the sea near Sigeion (see Apollodoros in Tiib in *TrGF* 5.2, 859), a city at the mouth of the Dardanelles that was of strategic importance for Athens.

152 Giuliani and Most (forthcoming) interpret her movement quite differently as conveying distress.

153 There is a lively Paestan krater, signed

by Assteas, but unfortunately badly worn, that shows Phrixos and Helle flying on the back of the Golden Ram: this is Naples 82411 (H 3412); *RVP* 84/126, discussed on pp. 87–88 and pl. 45; *CFST* P3. To the left their mother protects them; to the right Dionysos rides a panther. If this is related to a tragedy at all, it is likely, in view of the presence of Dionysos, to have been another play, possibly *Phrixos (the Second Version)*. No other vase-painting of the Phrixos story shows any sign of being related to the theater.

154 Darius Painter; *RVAp* 18/66; *LIMC* Chrysippos 2*; *CFST* Ap164— Trendall-Webster 1971, III.3,16; Aellen 1994, no. 82, pl. 98; Green 1999, no. 6 and fig. 26. First published 1970.

155 Collected in *LIMC* as Chrysippos I, 1–5 (with three entries under 4).

156 The other is Naples 81942 (H 1769); *RVAp* 18/48; *CFST* Ap176—Trendall-Webster 1971, III.3,17; Green 1999, no. 28.

157 Their identities are obvious except for the figure to the left with the shell. Aellen (1994, 148) suggests plausibly that he represents the local river, the Alphaios.

PART 2, CHAPTER 5

1 Séchan (1926, 521–33) has a brief (for him) chapter on "secondary poets." Trendall and Webster (1971) include two pots by minor named tragedians (III.4,1–2); eight (including two of *Rhesos*) by "unidentified tragedians" (III.5,1–8); and five with "unidentified subjects" (III.6,1–5).

2 This is based on the estimate made by Knox (1979, 8–9).

3 For this era, see e.g. Seeck 1979, 185–94; Easterling 1993.

4 It is probably not of great significance that no Paestan pots appear in this chapter (there are six in the other sections). There is only a limited number that may be related to tragedy in any case—and of the twenty-six candidates listed in *CFST* (499–507), ten are attached to one play, Aeschylus' *Libation Bearers*.

5 It could be argued that all of the vases from the Policoro tomb are related to tragedy, since some of them are very

likely to be (see nos. 34, 37). But that is probably to push our luck too far. Among the earlier vases that I have considered for inclusion in this chapter, the most interesting candidates are: (1) Ruvo 10963 (*RVAp* 1/52 and pl. 5.1; *RVSIS* pl. 35), a lively and ornate painting of the rape of the Leukippidai. But this cannot be close to any scene enacted on stage. (2) Taranto from Rutigliano (*RVAp* 1/12a (435); *CFST* Ap2) might be related to a tragedy about Memnon, but, without more evidence, there is little to build on. (3) Bari 6254 (*LCS* 103/536, pls. 51.9, 53.2; *CFST* L28—Trendall-Webster 1971, III.6,4) apparently has a scene in which a woman and a boy have taken refuge at an altar, with a young soldier on one side and a friendly woman on the other; certainly a situation redolent of tragedy.

6 Close to the Black Fury Painter; *RVAp* 7/22a (1074); *LIMC* Erechtheus 31; Erysichthon II, 2*; Kekrops 14; *CFST* Ap28—Mayo 1982, no. 18, pp. 88–89. First published 1982.

7 See *EfrP* 1, 148ff.; *TrGF* 5.1, 391ff.

8 Mayo 1982, 89.

9 As at the end of *Erechtheus*; see *LIMC* Erysichthon II, p. 20.

10 Ilioupersis Painter; *RVAp* 8/13; *LIMC* Danae 71*; Alkmaion 19; Atreus 3; Oidipous 91; Pan 36*; Pelop(e)ia I, 3; Thyestes 4; *CFST* Ap69—Séchan 1926, 209–10 and fig. 65; Aellen 1994, 52–53, no. 19, pls. 24–25. Known by 1813.

11 Séchan (1926, 209–10) rightly rejects this identification.

12 For Daidalos, see Aellen 1994, 52–53—but can the palm tree really signify Crete? In favor of Danae, see *LIMC* Danae 71*. The recently published no. 67 has suggestive similarities, but the big difference is that the young man there is specifically Perseus.

13 This is on the neck of a volute-krater, Bari 3648; *RVAp* 8/144 (the scene is "almost entirely overpainted"); *CFST* Ap84—Trendall-Webster 1971, III.5,5; Kossatz-Deissmann in *LIMC* Klymene II, 1*; *TrGF* 2, fr. 5h (12–13). There is an interesting discussion of the whole vase by Schmidt (1970b, 71–72 and pls. 71–72).

14 Lycurgus Painter; *RVAp* 16/6 and pl. 148.1–2; *LIMC* Adrastos 21; Apollon 802, 939; Atalante 91*; Parthenopaios

8*; *Septem* p. 735; *CFST* Ap97— Trendall-Webster 1971, III.4,1; *TrGF* 2, fr. 8e (17); Green 1999, no. 24. Known by 1963.

15 According to *CFST* (434), Apollo and Hermes are also labeled, but I can make out no trace of this.

16 See *TrGF* 1, 60T2.

17 See *TrGF* 1, DID A2,21 (26).

18 Lycurgus Painter; *RVAp* 16/9 and pl. 149.3; *CFST* Ap98—*CVA* Bonn 3, Germany 59, p. 35. Known by 1850.

19 Painter of Bari 12061; *RVAp supp* 2, 14/126a and pl. 19.1; *RVSIS* pl. 179; *LIMC* Pelasgos 8*; *CFST* Ap119— Aellen-Cambitoglou-Chamay 1986, 71–83 and color pl. 17; Green 1995, 118–19. Published in 1986.

20 Aellen-Cambitoglou-Chamay 1986, 71–83. The earliest example is probably Ruvo J414; *RVAp* 15/68 ("much repainted"); *CFST* Ap92 (probably wrongly included as *Lokrides* in *TrGF* 2, fr. 5f). At first sight Naples 82125 (H 1760; *LCS* 14/589 ["hideously repainted"]; *CFST* L18) might seem to be related, but it has conclusive differences. It is, however, yet another supplication scene, and might well be related to tragedy.

21 This is Hermitage B1705 (St. 452); *RVAp supp* 2, 18/47a ("much repainted"); *CFST* Ap149—good picture in Aellen-Cambitoglou-Chamay 1986, 75.

22 Including Kossatz-Deissmann 1978, 45–62.

23 In Aellen-Cambitoglou-Chamay 1986, 77–80.

24 Konnakis Painter; *LIMC* Iason 2*; Pegasos 240*; Peliades 1; Pelias 7; Proitos 13*; *CFST* Ap94—Trendall-Webster 1971, III.4,3; Bulle 1934; Csapo-Slater 1995, 62–63; Moraw and Nölle 2002, 67, fig. 77. Known by 1923.

25 The reconstruction by Otto in Simon 1982a, 23, shows another woman symmetrically balancing the one to the left. This seems to be based on a further fragment that is not usually visible in photos.

26 See Simon 1982a, 24.

27 Painter of Louvre MNB1148; *RVAp supp* 2, 20/278-2 and pl. 47.2 (for dating, see 179–80); *RVSIS* pl. 184; *LIMC* Ploutos 12*; Astrape 5*; Eniautos 1; Hypnos 2; Keryx 9; Leda 17*—Aellen 1994, no. 85, pls. 101–4, pp. 104–5,

125–27, 149–53, 157–60, 175–76, 182–84. Not in *CFST*. First published 1986.

28 This painting is in many ways the central theme of Aellen 1994; his conclusions are brought together on 182–84.

29 Green 1995, 120.

30 See *LIMC* Ploutos 420.

31 Branca Painter? (see next note) (not in *RVAp*); *CFST* Ap155—Schmidt 1992, 306–11 and pl. 69; Cambitoglou-Chamay 1997, no. 94 (220–26) and front cover; *EfrP* 1, 78; *TrGF* 5.1, Tiiic (503). First published 1992.

32 Attributed by Schmidt (1992) to the Branca Painter, a talented forerunner of the Darius Painter; the interesting Prometheus vase (no. 18) is by him. The Cahn catalogue inclines to the Darius Painter himself, see Cambitoglou-Chamay 1997, no. 94, p. 220.

33 Schmidt (1992) suggests that it may represent some kind of blending of two or all three. She points to Niobe on no. 15 for a comparable tomb.

34 The evidence is collected as *TrGF* 5.I, fr. 472g (516).

35 Close to Varrese Painter; *RVAp* 17/75; *LIMC* Achilles 794*; Agamemnon 61; Poine 8; Thersites 3*; Automedon 48; Dike p. 391; Helios 20; Menelaos 40; Phoinix II, 15; Phorbas IV, 1; *CFST* Ap135—Trendall-Webster 1971, III.4,2; *TrGF* 1, 71 fr. 1c; Séchan 1926, 527–33 and fig. 156; Padgett et al. 1993, no. 38 (99–106); Morelli 2001, passim. Found at Ceglie del Campo (near Bari) in 1899.

36 This label is mistakenly associated with *demos*, "the people," in Padgett et al. 1993, 105.

37 The material is collected and discussed by Morelli (2001, 23–72).

38 The spelling of "Diomedes" may be Doric as well as Attic.

39 On Chairemon, see Collard 1970. The textual evidence is fully documented by Morelli (2001, 77–85), who has a very full discussion of every aspect of this lost play. This work is, however, far from satisfactory on the subject of this vase, as is pointed out in the review by Green (2002).

40 These are *TrGF* 1, 71 frs. 2 and 3.

41 This is *IG* V.2118; *TrGF* 1, DID B11,13.

42 Darius Painter; *RVAp* 18/38; *RVSIS* p. 98, pl. 203; *LIMC* Asia 1; Hellas 5*; Apate 1*; *CFST* Ap182—Trendall-Webster 1971, III.5,6; *TrGF* 2, fr. 8f; Aellen 1994, 109–17, no. 4, lines 5–7. Excavated at Canosa in 1851 (see *CFST* 557–58).

43 This was, we are told, called *Just Men* or *Persians* or *Councillors* (see *TrGF* 1, 3T1 [= fr. 4a]). This evidence is rather suspicious, however, as the triple title is listed only by a late encyclopedia (the *Suda*), but not one word of it survives; and, while double titles—*A* or *B*—serve to distinguish a play from others with one of the same titles, there is no point to more than two alternatives.

44 The inscription ΑΠΑ[might have been completed ΑΠΑΤΗ or ΑΠΑΤΑ.

45 Aellen (1994, 110) is insistent that Hellas is shown as intimidated and Asia as haughty. But this does not seem so clear to me.

46 This was an elaborate lyric narrative song and dance performed by a large chorus. We can be sure that this was not the narrative behind the vase, since it told of the defeat of Xerxes in the sea battle at Salamis.

47 This is *TrGF* 1, 3 fr. 8, attributed rather puzzlingly to a play called *Phoenician Women*. This cannot, by the way, be the play in question here, since it told of the defeat of Xerxes (after the death of Dareios).

48 Schmidt (1982, 505ff.) turned to Herodotos on the Ionian Revolt; this is discussed but not accepted by Aellen (1994, 112–15).

49 It is worth registering that another monumental piece from the same 1851 tomb shows a "dramatic" scene entitled ΠΑΤΡΟΚΛΟΥ ΤΑΦΟΣ, *Funeral Rites of Patroklos* (which unlike *Persians* would not be a standard tragedy title). This is Naples 81393 (H 3254); *RVAp* 18/39. Although some of the costumes are tragic-looking, it has seldom been claimed to have any close connection with drama, and rightly so: its narrative has far more affinities with epic.

50 Darius Painter; *RVAp* 18/41 and pl. 177; *LIMC* Amphiaraos 74a; Erinys 86*—Aellen-Cambitoglou-Chamay 1986, 111–17 and color pl. 19; Aellen 1994, no. 41, pl. 49.l. Not in *CFST*. First published 1982.

51 Despite the caution expressed in *LIMC* Amphiaraos pp. 702–3.

52 These are: (1) Hermitage B1710 (St. 406); *RVAp* 18/21 ("heavily repainted");

CFST Ap174; and (2) Boston 61.113; *RVAp* 18/74—Padgett et al. 1993, no. 44, p. 122.

53 Detail in Aellen 1994, pl. 47; he is no. 38 in the catalogue in Green 1999. It so happens that a crooked stick is preserved on the Boston fragment, which very likely also belongs to a paidagogos figure. The fragment also includes a tall Ionic column surmounted by a tripod; since there is no particular indication of a sacred setting in the other two paintings, this may signify an artistic victory (see pt. 1, sec. N2).

54 The discussion in Aellen-Cambitoglou-Chamay 1986 never even uses the "T-word"!

55 Darius Painter; *RVAp supp* 1, 18/41a and pl. 12; *LIMC* Demeter 468; Herakleidai 9*; Herakles 1409*; Iris I, 153*; Medeia 68; Persephone 342; *CFST* Ap165—Trendall 1984, with color covers; Schmidt 1986b; Giuliani and Most forthcoming; Green 1999, no. 31. First published 1983.

56 These two are often taken to be the Dioskouroi (Kastor and Polydeukes).

57 Giuliani and Most (forthcoming) ingeniously suggest that this is encouraged by the cross torches.

58 See Giuliani and Most (forthcoming).

59 Ibid.

60 This is *TrGF* 1, 70 fr. 1e (212); see Trendall 1984, 13–14.

61 Darius Painter; *RVAp supp* 2, 18/47b and pl. 36.1; *CFST* Ap137—Padgett et al. 1993, 42, 115–18, color pl. XI; Aellen 1994, no. 10, pls. 16–17; Taplin (forthcoming B). First published 1991.

62 Padgett et al. 1993, 115.

63 The Attic spelling contrasts with ΠΟΙΝΑ on no. 91.

64 There are fragments of an Orpheus in the Underworld scene with a pair of Eumenides (]ΜΕΝΙΔΕΣ). This is different, however, since they are representatives of a standard group of female divinities (Ruvo, formerly Fenicia coll. [not in *RVAp*]; *CFST* Ap66—Aellen 1994, no. 6); there appears to be no photograph published, only an old drawing.

65 Darius Painter (too recent to be in *RVAp supp* 2); *LIMC* Hesione 1*; *CFST* Ap185—Birchler and Chamay 1995, 50–57 and pls. 13–16; Taplin (forthcoming B). First published 1995.

Aeolian Islands A group of islands off the northeast coast of Sicily. The most important Greek settlement was at Lipara (modern Lipari).

aetiology An explanation of the origin or cause of a phenomenon, a "just-so story." This is a favorite feature in Greek mythological narratives, including tragedy, linking the past with the audience's world.

altar Greek altars were sacred blocks of stone, usually near temples, where animals were sacrificed and fires lit to cook the meat. They commonly figure in tragic plots, often as a place of *supplication*.

Amazons A matriarchal race of warrior women who were believed to have lived somewhere beyond *Skythia*. They are variously implicated in Greek heroic mythology.

amphora A long two-handled storage jar, often with a narrow neck. Tall amphoras made for funerals developed a shape with long slender foot and neck.

Apulia The name given by the Romans to the "heel" of Italy (modern Puglia). It was extensively settled by Greeks around the Gulf of Taranto in the south and, more sporadically, along the Adriatic coast to the north. "Apulian" is the label conventionally given to the large production of pottery made in this area.

Asia(tic) A rough label given to lands and their peoples to the east of the ancient Greek mainland. "Asia" thus encompasses, among other areas, Caria, *Lydia*, *Persia*, and Phrygia. The term *Oriental* is sometimes used with similar vagueness.

Asia Minor The name conventionally used to refer to the Roman province of "Asia," which more or less covers the west of what is now Turkey.

Attic(a) The entire territory surrounding and including the city of Athens and its demes. The demes were local subdivisions of Attica, and many held their own festivals of Dionysos, including performances of drama. "Attic" is commonly (and properly) used as an epithet for Athenian matters. This is the usage for locally produced pottery; also for *dialect*.

aulos A musical instrument constructed with two joined pipes with separate reeds (sometimes misleadingly translated as "flute"). It had a piercing sound and was well suited for outside performances, including accompanying the *lyrics* of tragedy. The aulos player (*auletes*), who wore an ornate costume, was fully visible to the audience.

bacchant, see *maenad*.

bell-krater A *krater* shaped like an inverted bell. A common medium-sized pot shape in the Greek West.

boots Calf-length boots are common in many contexts in Greek art and particularly in Dionysiac contexts. The *kothornos*, a fancy boot with a thin flexible sole, was worn by performers in tragedy (not comedy); they are often represented in associated vase-painting.

boukranion The skull of a sacrificed ox. Often shown hanging in sacred contexts.

calyx-krater A kind of *krater*, usually taller than a *bell-krater*, with straighter sides opening out at the top (like the calyx of a flower). Much favored in the Greek West, especially Sicily.

Campania The region of Italy around Naples and Capua. Although the coast was settled by Greeks, this area was more (and sooner) affiliated with the Italians to the north.

cap The term usually used for the headwear depicted as characteristic of a wide range of *Asiatic*/Eastern people. It is not straight-sided, but bends, usually back, to a peak. The degree of ornament varies.

choregos This term can mean "chorus leader," but in connection with theater, it usually refers to a rich citizen who undertook the organization and expense of training the chorus.

chorus (adj.: choral) A rehearsed group who sang and danced together. Common in many contexts of ancient Greek life and always an integral part of drama. In tragedy the chorus, numbering fifteen in Athens, always had a shared place within the world of the play, and wore very similar masks and costumes.

chthonic Associated with the *Underworld*.

column-krater A type of *krater* whose handles are in a straight line from the shoulder to the rim.

cross-banding Diagonal bands worn on the upper body, crossed at the front. They are a sign of travel and/or exertion (such as hunting).

Delphi One of the two most important *Panhellenic* cult centers, on the slopes of Mount Parnassos on the north side of the Corinthian Gulf. The most important of its several cults was that of Apollo, and his temple, with its oracle, was at the core of the sacred area. Common symbols of Delphi are the *omphalos* stone, *tripods*, and laurel trees. "Pythian" is a common epithet of Delphic matters, as in the Pythian Games, and of the priestess, the *Pythia*.

deus ex machina, see *god from the machine*.

dialect During the Classical period, there were many variations in the dialects of Greek spoken throughout the Greek world, although these are usually classified by philologists into a few main groups. The distant cities of the diaspora generally spoke a dialect derived from that of their founding mother-city. Thus, for example, the citizens of Taras spoke a *Doric* dialect based on that of Sparta. The spoken parts of tragedy were always in *Attic*, the dialect of Athens, a distinct variant of Ionic. The choral parts were in a poetic dialect colored by *Doric* forms.

didaskaliai Official records of the annual dramatic competitions (names of playwrights, plays, etc.) were kept in Athens. They were known as *didaskaliai* from the word *didaskein*, meaning to "produce" plays. A few are fortunately preserved in written sources or inscriptions on stone.

Dionysia The "Great" or "City" Dionysia was the spring festival of Dionysos in Athens, at which theater was put on in the god's honor. The association was maintained outside Athens throughout the Greek world, although it also became the practice to mount plays at the festivals of other gods.

Doric The Greeks believed that they were derived from a small number of different ethnic

125–27, 149–53, 157–60, 175–76, 182–84. Not in *CFST*. First published 1986.

28 This painting is in many ways the central theme of Aellen 1994; his conclusions are brought together on 182–84.

29 Green 1995, 120.

30 See *LIMC* Ploutos 420.

31 Branca Painter? (see next note) (not in *RVAp*); *CFST* Ap155—Schmidt 1992, 306–11 and pl. 69; Cambitoglou-Chamay 1997, no. 94 (220–26) and front cover; *EfrP* 1, 78; *TrGF* 5.1, Tiiic (503). First published 1992.

32 Attributed by Schmidt (1992) to the Branca Painter, a talented forerunner of the Darius Painter; the interesting Prometheus vase (no. 18) is by him. The Cahn catalogue inclines to the Darius Painter himself, see Cambitoglou-Chamay 1997, no. 94, p. 220.

33 Schmidt (1992) suggests that it may represent some kind of blending of two or of all three. She points to Niobe on no. 15 for a comparable tomb.

34 The evidence is collected as *TrGF* 5.I, fr. 472g (516).

35 Close to Varrese Painter; *RVAp* 17/75; *LIMC* Achilles 794*; Agamemnon 61; Poine 8; Thersites 3*; Automedon 48; Dike p. 391; Helios 20; Menelaos 40; Phoinix II, 15; Phorbas IV, 1; *CFST* Ap135—Trendall-Webster 1971, III.4,2; *TrGF* 1, 71 fr. 1c; Séchan 1926, 527–33 and fig. 156; Padgett et al. 1993, no. 38 (99–106); Morelli 2001, passim. Found at Ceglie del Campo (near Bari) in 1899.

36 This label is mistakenly associated with *demos*, "the people," in Padgett et al. 1993, 105.

37 The material is collected and discussed by Morelli (2001, 23–72).

38 The spelling of "Diomedes" may be Doric as well as Attic.

39 On Chairemon, see Collard 1970. The textual evidence is fully documented by Morelli (2001, 77–85), who has a very full discussion of every aspect of this lost play. This work is, however, far from satisfactory on the subject of this vase, as is pointed out in the review by Green (2002).

40 These are *TrGF* 1, 71 frs. 2 and 3.

41 This is *IG* V.2118; *TrGF* 1, DID B11,13.

42 Darius Painter; *RVAp* 18/38; *RVSIS* p. 98, pl. 203; *LIMC* Asia 1; Hellas 5*; Apate 1*; *CFST* Ap182—Trendall-Webster 1971, III.5,6; *TrGF* 2, fr. 8f; Aellen 1994, 109–17, no. 4, lines 5–7. Excavated at Canosa in 1851 (see *CFST* 557–58).

43 This was, we are told, called *Just Men* or *Persians* or *Councillors* (see *TrGF* 1, 3T1 [= fr. 4a]). This evidence is rather suspicious, however, as the triple title is listed only by a late encyclopedia (the *Suda*), but not one word of it survives; and, while double titles—*A* or *B*—serve to distinguish a play from others with one of the same titles, there is no point to more than two alternatives.

44 The inscription ΑΠΑ[might have been completed ΑΠΑΤΗ or ΑΠΑΤΑ.

45 Aellen (1994, 110) is insistent that Hellas is shown as intimidated and Asia as haughty. But this does not seem so clear to me.

46 This was an elaborate lyric narrative song and dance performed by a large chorus. We can be sure that this was not the narrative behind the vase, since it told of the defeat of Xerxes in the sea battle at Salamis.

47 This is *TrGF* 1, 3 fr. 8, attributed rather puzzlingly to a play called *Phoenician Women*. This cannot, by the way, be the play in question here, since it told of the defeat of Xerxes (after the death of Dareios).

48 Schmidt (1982, 505ff.) turned to Herodotos on the Ionian Revolt; this is discussed but not accepted by Aellen (1994, 112–15).

49 It is worth registering that another monumental piece from the same 1851 tomb shows a "dramatic" scene entitled ΠΑΤΡΟΚΛΟΥ ΤΑΦΟΣ, *Funeral Rites of Patroklos* (which unlike *Persians* would not be a standard tragedy title). This is Naples 81393 (H 3254); *RVAp* 18/39. Although some of the costumes are tragic-looking, it has seldom been claimed to have any close connection with drama, and rightly so: its narrative has far more affinities with epic.

50 Darius Painter; *RVAp* 18/41 and pl. 177; *LIMC* Amphiaraos 74a; Erinys 86*—Aellen-Cambitoglou-Chamay 1986, 111–17 and color pl. 19; Aellen 1994, no. 41, pl. 49.l. Not in *CFST*. First published 1982.

51 Despite the caution expressed in *LIMC* Amphiaraos pp. 702–3.

52 These are: (1) Hermitage B1710 (St. 406); *RVAp* 18/21 ("heavily repainted"); *CFST* Ap174; and (2) Boston 61.113; *RVAp* 18/74—Padgett et al. 1993, no. 44, p. 122.

53 Detail in Aellen 1994, pl. 47; he is no. 38 in the catalogue in Green 1999. It so happens that a crooked stick is preserved on the Boston fragment, which very likely also belongs to a paidagogos figure. The fragment also includes a tall Ionic column surmounted by a tripod; since there is no particular indication of a sacred setting in the other two paintings, this may signify an artistic victory (see pt. 1, sec. N2).

54 The discussion in Aellen-Cambitoglou-Chamay 1986 never even uses the "T-word"!

55 Darius Painter; *RVAp supp 1*, 18/41a and pl. 12; *LIMC* Demeter 468; Herakleidai 9*; Herakles 1409*; Iris I, 153*; Medeia 68; Persephone 342; *CFST* Ap165—Trendall 1984, with color covers; Schmidt 1986b; Giuliani and Most forthcoming; Green 1999, no. 31. First published 1983.

56 These two are often taken to be the Dioskouroi (Kastor and Polydeukes).

57 Giuliani and Most (forthcoming) ingeniously suggest that this is encouraged by the cross torches.

58 See Giuliani and Most (forthcoming).

59 Ibid.

60 This is *TrGF* 1, 70 fr. 1e (212); see Trendall 1984, 13–14.

61 Darius Painter; *RVAp supp 2*, 18/47b and pl. 36.1; *CFST* Ap137—Padgett et al. 1993, 42, 115–18, color pl. XI; Aellen 1994, no. 10, pls. 16–17; Taplin (forthcoming B). First published 1991.

62 Padgett et al. 1993, 115.

63 The Attic spelling contrasts with ΠΟΙΝΑ on no. 91.

64 There are fragments of an Orpheus in the Underworld scene with a pair of Eumenides (]ΜΕΝΙΔΕΣ). This is different, however, since they are representatives of a standard group of female divinities (Ruvo, formerly Fenicia coll. [not in *RVAp*]; *CFST* Ap66—Aellen 1994, no. 6); there appears to be no photograph published, only an old drawing.

65 Darius Painter (too recent to be in *RVAp supp 2*); *LIMC* Hesione 1*; *CFST* Ap185—Birchler and Chamay 1995, 50–57 and pls. 13–16; Taplin (forthcoming B). First published 1995.

66 Spelt ΗΣΙΟΝΗ, without a heta, while Herakles has one—ⱵΡΑΚΛΗΣ.

67 See pt. 1, sec. M8. Birchler and Chamay (1995, 54–55) go so far as to say that this kind of supplication is "always" found in scenes that have tragic inspiration.

68 See Taplin (forthcoming B).

69 Darius Painter; *RVAp* 18/64; *LIMC* Amazones 782*; Apollon 941; Artemis 1391*; Herakles 2807*; Hippolytos I, 7*; Rhodope 1; Skythes I, 1*— Schmidt-Trendall-Cambitoglou 1976, 94–108 and pls. 23–26. Not in *CFST*. First published 1976.

70 All names are given Attic spellings, but neither Herakles nor Hippolytos has a heta.

71 Schmidt (in Schmidt-Trendall-Cambitoglou 1976, 106–8) raises some intriguing speculations about the possible relevance to this picture of the activities of Philip II of Macedon in Thrace at about this time. The mountains of Rhodope are close to Philip-popolis (modern Plovdiv), the city he founded in 342/1.

72 Ibid., 105–6.

73 Darius Painter; *RVAp supp 2*, 18/65e and pl. 38.1—Hamburg Museum 1995, no. 24, pp. 62–63 (the attribution and dating there are presumably superseded by Trendall). Not in *CFST*. First published 1992.

74 See pt. 2, ch. 4, n. 36.

75 Not, as described in Hamburg Museum 1995 (63), a long and a short trumpet.

76 Darius Painter; *RVAp supp 2*, 18/70a; *LIMC* Hekabe 5*; Helene 174*; Kassandra I, 25; Niobe 2*; Priamos 9; Tantalos 20—Aellen-Cambitoglou-Chamay 1986, 136–49 and color pl. 22; Schmidt 1990, pl. 42. Not in *CFST*. First published 1986.

77 Painter of the Group of Taranto 7013; *RVAp* 28/36 and pl. 350; *CFST* Ap193; *LIMC* Archemoros 9*; Astyanax I, p. 935; Eos 35; Euneos et Thoas 33; Hermes 437*; Septem 15*—Séchan 1926, 358–60 and fig. 102; *EfrP* 2, 180. (There is an incised inscription saying "Lasimos painted this," but Trendall [*RVAp* 913] reckons that this is modern.) Known by 1886.

78 Underworld Painter; *RVAp supp 2*, 18/283a; *LIMC* Hekabe 17a; Hektor 21*; *CFST* Ap213—Giuliani 1988, 18–24; 1995, 43–45, 122–23; Kannicht

1991, 60 fr. 1h (138–39). First published 1988.

79 Contra Giuliani 1988, 20; 1995, 44, 126.

80 There is also an eagle omen in no. 58, and see the early Apulian battle scene of Herakles and Kyknos on Ruvo 1088; *RVAp* 2/23.

81 *TrGF* 1, 60 fr. 2. The exact text is not certain, but it is universally agreed that this is the sense of what it said.

82 These three fragments are edited as *TrGF* 1, 60 frr. 1h, 1i, and 2a; see also Xanthakis-Karamanos 1980, 162–69.

83 This is *TrGF* 2, adespota (unattributed) fr. 649. This remarkable lyric fragment, which is *POxy* 2746, contains repeated directions saying "song," which seem to give the actor freedom to improvise, see Hall 2002, 18–19. In the first publication of the fragment, Coles (1968) expressed caution about attributing it to Astydamas' play. But the vase-painting has changed the situation.

84 Extrapolating from Athena's impersonation of Deiphobos at *Iliad* 22.226ff., might Deiphobos be the man with the trumpet?

85 Underworld Painter; *RVAp* 18/23; *LIMC* Medeia 29*; Kreousa II, 17*; *CFST* Ap219—Trendall-Webster 1971, III.5,4; Séchan 1926, 405–8; Morelli 2001, 101–34; Aellen 1994, 40–41, no. 78, pl. 90; Green 1999, no. 25; Shapiro 1994, 181–82; Kannicht 1991, adespota fr. 6a (246–49). Excavated at Canosa in 1813, and acquired by Ludwig of Bavaria for his showpiece museum in Munich.

86 It is the subject of a kind of cadenza in Roberto Calasso's *The Marriage of Cadmus and Harmony* (English trans., London: Cape, 1993, 328–30).

87 Trendall (*RVAp* 532) says that flames "spring up out from her diadem"; but I have not been able to confirm this. Neither Merope nor Hippotes was a necessary speaking character in the play: they may have been only named in a messenger's report.

88 See Aellen 1994, 40–41.

89 Rather as his name label comes in between their two names inscribed on the base of the portico.

90 We cannot know whether this form of his name, "Aetes" rather than "Aietes," was actually used in the play.

91 Painter of Adrastus Group; *LCS supp* 3, 275/46e; *LIMC* Adrastos 2*; Argeia

1*; Tydeus 8; *CFST* S17; *RVSIS* ill. 427—Trendall 1991, 173–74 and pl. 71. Excavated at Lipari in 1971 (see *CFST* 570). Published in 1977.

92 These include Syracuse 47038; *LCS* 602/102 and pl. 236.1, "one of the finest of all Sicilian vases," according to Trendall. This work also has a violent scene in an elaborate architectural setting—it might have been included here, had it been in better condition.

93 As well as the general "ambience," it is worth noting that Adrastos was a standard tragic persona. Although he has a significant role in only one surviving tragedy (Euripides' *Suppliants*), he is one of those nominated in a catalogue of familiar tragic figures in a fragment of the comic playwright Antiphanes. Fragment 189 in *PCG* gives two examples of tragic stories familiar to everyone: the family of Oedipus and the story of Alkmaion, where "Adrastos will come on in a bad temper and will go away again."

94 Maron Painter; *LCS supp* 3, 275/46g; *LIMC* Maron 2*; Odysseus 66; Opora 4; *RVSIS* ill. 430—Trendall-Webster 1971, III.6,2; Aellen 1994, 138–39, 192, no. 100, pl. 124. Not in *CFST*, but see 271 and n. 201. Excavated on Lipari by 1957, published in 1965.

95 There seems, unfortunately, to have been some flaking of the glaze, which has lost some of the lettering. The labels, however, are clear on earlier photographs.

96 Attic spelling, not, as in Homer, ΟΠΩΡΗ.

97 The inscription is always reported as the rarer form ΑΜΠΕΛΙΣ, but the O seems clear to my eye. It makes little difference to the sense.

98 See, for example, Oistros on no. 101, Homonoia on no. 63, and Euphemia on no. 81. Closer to Opora (Harvest-time), but less likely to be related to tragedy, is Eniautos (Year-cycle) on no. 89. For a complete catalogue, but without consideration of possible relations to tragedy, see Aellen 1994, 202–11 on Furies and related figures, and 212–17 on other personifications.

99 See Taplin 1993, 48–52.

100 Gibil Gabib Group (Capodarso Painter); *LCS* 601/98 and pl. 235.2–3; *CFST* S13—Trendall-Webster 1971, III.6,1; Taplin 1993, 27–29 and pl.

6.111; Panvini 2003, 266. Excavated at Capodarso; published in 1967.

101 Capodarso, between Enna and Caltanissetta, was deserted by the end of the third century B.C.

102 See Green (1999), who does not actually use these two vases to confirm his already strong case.

103 See no. 79. It is true, however, that Hypsipyle's pleading with Eurydike in fr. 757 would well fit the two women to the left hand of this scene.

104 Close to Lentini-Manfria Group (too recent for *LCS*); *CFST* S15. Excavated at Entella in 1988; first published discussion in 1992; de Cesare 1992, 979–83 and pl. LV.2. I warmly thank *CFST* for drawing my attention to the existence of this interesting fragment.

105 There do not seem to be any logs in London F193 (Campanian); *LCS* 231/36 and pl. 90.7; *LIMC* Alkmene 6*; *CFST* C5.

106 Caivano Painter; *LCS* 309/585; *CFST* C30 (from Paestum). Known by 1891.

107 These are, respectively, Bonn 2667 (*LCS* 113/584 and pls. 59.1–2; *CFST* L22—Trendall-Webster 1971, III.6,3); and Sydney 53.10 (not in *RVAp*; *CFST* Ap105—Trendall-Webster 1971, III.6,5).

108 Examples include Medeia stabbing her children on Paris, Cab. Méd. 876 (*LCS* 325/739; *CFST* C18) and Orestes stabbing Aigisthos on Berlin VI 3167 (*LCS* 338/785 and pl.131.2; *CFST* C40).

109 At one time Trendall thought he might have been a Paestan artist (*LCS* 305–7) but later concluded that he had interacted with Paestan workshops. This particular fragment was found at Paestum, and the decorations on the costumes have affinities with Paestan painting (see pt. 2, ch. 1, n. 20).

110 Caivano Painter (not in *LCS* or *CFST*); see Aellen-Cambitoglou-Chamay 1986, 252–58, where it was first published.

111 The nearest that comes to mind is the chorus' recollection of Iphigeneia's sacrifice in Aeschylus' *Agamemnon* 238ff., in which she is lifted and held over the altar with a gag over her mouth.

112 Schwerin 719; *LCS* 307/566; *CFST* C33. Schmidt (1967, 185) connects this with Euripides' *Children of Herakles* (see pt. 2, ch. 3, n. 41).

113 Naples, from Caivano T5; *LCS*

308/572; picture in Elia 1931, 589–90 and pl. 9.

114 Caivano Painter (not in *LCS* or *CFST*); *LIMC* Kapaneus 12a; Septem 42*. First published 1993 (no discussion yet published).

115 Possibly this alludes proleptically to the usual version in which Kreon will become king of Thebes after the mutual slaughter of the sons of Oedipus.

116 Iconography of this sort usually represents a victory in a chariot race, but that seems to be incongruous here.

GLOSSARY

Aeolian Islands A group of islands off the north-east coast of Sicily. The most important Greek settlement was at Lipara (modern Lipari).

aetiology An explanation of the origin or cause of a phenomenon, a "just-so story." This is a favorite feature in Greek mythological narratives, including tragedy, linking the past with the audience's world.

altar Greek altars were sacred blocks of stone, usually near temples, where animals were sacrificed and fires lit to cook the meat. They commonly figure in tragic plots, often as a place of *supplication*.

Amazons A matriarchal race of warrior women who were believed to have lived somewhere beyond *Skythia*. They are variously implicated in Greek heroic mythology.

amphora A long two-handled storage jar, often with a narrow neck. Tall amphoras made for funerals developed a shape with long slender foot and neck.

Apulia The name given by the Romans to the "heel" of Italy (modern Puglia). It was extensively settled by Greeks around the Gulf of Taranto in the south and, more sporadically, along the Adriatic coast to the north. "Apulian" is the label conventionally given to the large production of pottery made in this area.

Asia(tic) A rough label given to lands and their peoples to the east of the ancient Greek mainland. "Asia" thus encompasses, among other areas, Caria, *Lydia*, *Persia*, and Phrygia. The term *Oriental* is sometimes used with similar vagueness.

Asia Minor The name conventionally used to refer to the Roman province of "Asia," which more or less covers the west of what is now Turkey.

Attic(a) The entire territory surrounding and including the city of Athens and its demes. The demes were local subdivisions of Attica, and many held their own festivals of Dionysos, including performances of drama. "Attic" is commonly (and properly) used as an epithet for Athenian matters. This is the usage for locally produced pottery; also for *dialect*.

aulos A musical instrument constructed with two joined pipes with separate reeds (sometimes misleadingly translated as "flute"). It had a piercing sound and was well suited for outside performances, including accompanying the *lyrics* of tragedy. The aulos player (*auletes*), who wore an ornate costume, was fully visible to the audience.

bacchant, see *maenad*.

bell-krater A *krater* shaped like an inverted bell. A common medium-sized pot shape in the Greek West.

boots Calf-length boots are common in many contexts in Greek art and particularly in Dionysiac contexts. The *kothornos*, a fancy boot with a thin flexible sole, was worn by performers in tragedy (not comedy); they are often represented in associated vase-painting.

boukranion The skull of a sacrificed ox. Often shown hanging in sacred contexts.

calyx-krater A kind of *krater*, usually taller than a *bell-krater*, with straighter sides opening out at the top (like the calyx of a flower). Much favored in the Greek West, especially Sicily.

Campania The region of Italy around Naples and Capua. Although the coast was settled by Greeks, this area was more (and sooner) affiliated with the Italians to the north.

cap The term usually used for the headwear depicted as characteristic of a wide range of *Asiatic*/Eastern people. It is not straight-sided, but bends, usually back, to a peak. The degree of ornament varies.

choregos This term can mean "chorus leader," but in connection with theater, it usually refers to a rich citizen who undertook the organization and expense of training the chorus.

chorus (adj.: choral) A rehearsed group who sang and danced together. Common in many contexts of ancient Greek life and always an integral part of drama. In tragedy the chorus, numbering fifteen in Athens, always had a shared place within the world of the play, and wore very similar masks and costumes.

chthonic Associated with the *Underworld*.

column-krater A type of *krater* whose handles are in a straight line from the shoulder to the rim.

cross-banding Diagonal bands worn on the upper body, crossed at the front. They are a sign of travel and/or exertion (such as hunting).

Delphi One of the two most important *Panhellenic* cult centers, on the slopes of Mount Parnassos on the north side of the Corinthian Gulf. The most important of its several cults was that of Apollo, and his temple, with its oracle, was at the core of the sacred area. Common symbols of Delphi are the *omphalos* stone, *tripods*, and laurel trees. "Pythian" is a common epithet of Delphic matters, as in the Pythian Games, and of the priestess, the *Pythia*.

deus ex machina, see *god from the machine*.

dialect During the Classical period, there were many variations in the dialects of Greek spoken throughout the Greek world, although these are usually classified by philologists into a few main groups. The distant cities of the diaspora generally spoke a dialect derived from that of their founding mother-city. Thus, for example, the citizens of Taras spoke a *Doric* dialect based on that of Sparta. The spoken parts of tragedy were always in *Attic*, the dialect of Athens, a distinct variant of Ionic. The choral parts were in a poetic dialect colored by *Doric* forms.

didaskaliai Official records of the annual dramatic competitions (names of playwrights, plays, etc.) were kept in Athens. They were known as *didaskaliai* from the word *didaskein*, meaning to "produce" plays. A few are fortunately preserved in written sources or inscriptions on stone.

Dionysia The "Great" or "City" Dionysia was the spring festival of Dionysos in Athens, at which theater was put on in the god's honor. The association was maintained outside Athens throughout the Greek world, although it also became the practice to mount plays at the festivals of other gods.

Doric The Greeks believed that they were derived from a small number of different ethnic

groups or ancestors. One particularly important group was the Dorians, who were settled especially in the Peloponnese. Their *dialect* group was Doric.

ekkyklema A conventional piece of machinery (meaning, literally, "the roll-out") in the Greek tragic theater (parodied in comedy), on which scenes that were to be thought of as indoors could be wheeled out on a platform through the central doors of the *skene*. It was used especially to reveal groups and tableaux, e.g., scenes of carnage.

epic Before the development of theater, the main form of narrative of Greek heroic myth was long poems in hexameter performed by a solo reciter (rhapsode). While quite a few of these epics were in circulation in Classical times, the most prestigious were already the *Iliad* and the *Odyssey*, both attributed to Homer.

Erinyes (singular: Erinys; Latinized English: Furies) These were thought to be gruesome female spirits from the *Underworld* who pursued vengeance, especially in response to curses and to family offenses. It may have been Aeschylus' play *Eumenides* in 458 B.C. that first gave them human form ("Eumenides" is a placatory name meaning "Kind Goddesses"). After that point they are quite common in art, always wreathed in snakes, often with wings. They became especially associated with tragedy.

Eros Personified god of sexual desire, son of Aphrodite, and usually envisaged as a winged boy. There could be a plurality of them (Erotes).

Eumenides, see *Erinyes*.

Furies, see *Erinyes*.

Gnathia A new and attractive technique for decorating pottery, developed at Taras in the mid-fourth century, in which polychrome painting was applied to a black-glaze background.

god from the machine It was quite frequent in tragedies, especially in those of Euripides, for a divinity to appear near the end of the play. The god would sort out remaining problems and predict the future (often including an *aetiology*). It became standard for them to appear on the flying machine (see *mechane*); and, whether or not this was much used in the fifth century, they became known as the *theos apo mechanes*, or in Latin, the deus ex machina.

Hades The god of the *Underworld*. His realm itself became known simply as "Hades."

Hellas The Greek for "Greece," meaning, in effect, all Greeks (Hellenes) throughout the diaspora.

hero cult In addition to the immortal gods above, there were believed to be powerful spirits of the dead—known as "heroes"—in the *Underworld* below. They included many of the great figures of myth. They had to be placated by cult observances, particularly *libation*s and athletic competitions. Hero cults were mainly local, often at the believed site of the hero's tomb.

heta A letter making the sound of "h," present in many *dialect*s of Greek but not included in the canonical alphabet. It was sounded in *Attic* and is often found as a letter in Athenian inscriptions. It was also employed in the Greek West and was quite often, but far from invariably, found in the *label*s on Western Greek vases.

hydria A jar with narrow neck and three handles for carrying water. This vase shape was especially associated with funeral and tomb offerings.

iambic Ancient Greek meter was patterned by the length of syllables rather than by stress. The spoken lines of tragedy were constructed of three sets of four syllables, with a basic shape of "short-long-short-long" (the "iambic trimeter"). There were many possible variations on this basic pattern, however.

iconography The study of the recurrent or related pictorial ways of representing particular narratives or types of scene.

Ionia The central stretch of the western coast of *Asia Minor*, and the associated islands of the central Aegean. The inhabitants of this area were known as Ionians and spoke the Ionic *dialect*. Athens was closely associated with the Ionians.

Italiote A term, going back to ancient Greek, used of the Greeks who were settled in Italy.

kalpis A particular form of *hydria*, with a continuous curve from foot to lip.

Kerch style An ornate and colorful variant of *red-figure* vase-painting developed by Athenian

artists in the fourth century, particularly for export. It is named after an area in the northern Black Sea where quantities have been found.

kerykeion A special form of staff carried by heralds and official messengers, and by Hermes, messenger of the gods.

kothornos, see *boots*.

krater A substantial vessel with a wide mouth for mixing wine and water at the *symposium*, but also adapted for funerary use. Its various forms—*bell*, *calyx*, *column*, and, above all, *volute*—provide the most favored vase shapes for showing tragedy-related mythological scenes.

Kypris A frequently used alternative name for Aphrodite, derived from her association with the island of Cyprus.

label/name label Greek vase-painters, including those in the West, sometimes added (with paint or by scratching) the written names of some of the figures in their mythological paintings. This is particularly helpful when the myth is relatively obscure.

lagobolon A stick, usually knobbly and sometimes curved at the end, that hunters and rustics would use as a throwing weapon, especially against hares. It was probably also an aid to herding flocks.

lekythos A tall, narrow jug with one handle, originally for oil but often associated with funerals.

libation An offering of liquid, usually wine, poured on the ground, either in honor of a god or to placate the dead.

loutrophoros A tall, slender vessel with a narrow neck, originally for carrying water for a marriage ceremony; adapted for funerals, especially for unmarried girls.

Lucania The name given by the Romans to the southwesternmost area of Italy, between *Campania* and *Apulia*, known in modern times as Basilicata. One of the varieties of Greek pottery, closely allied to Apulian, is known as "Lucanian." There is no reason, however, to think that the ancient Greeks regarded Apulia and Lucania as separate areas.

Lydia An area of *Asia Minor*, inland from *Ionia*. Although it was not Greek, there was much interaction between Lydia and the Greeks, including mythological connections.

lyric Poetry for singing, usually in complex meters. The main lyrics in tragedy were the set-piece choral odes, but there were also lyric dialogues between an actor and the *chorus*.

Lyssa Goddess personifying madness or frenzy; she occasionally was portrayed onstage in tragedy. Similar to an *Erinys*.

maenad Woman inspired to an ecstatic state by the cult of Dionysos (Bacchus). Groups of maenads, often also called bacchants, would roam over the mountains; their cult practices included tearing animals apart (*sparagmos*).

Magna Graecia (Greek: Megale Hellas) This became the conventional label for the Greek territories in the south of Italy.

mask All participants in Greek plays, tragedy and comedy, actors and chorus, would wear masks. Made of lightweight material, they would incorporate hair as well as the whole face, and were put on over the head.

mechane Greek tragedy made use of a crane (parodied in comedy) that would lift and transport characters who were to be thought of as in the upper air. This was known as "the device" (*mechane*). It was employed for human characters in flight, e.g., Perseus on Pegasos, but was especially associated with the *god from the machine*.

messenger speech A conventional element found in most tragedies, in which an eyewitness reports in a long solo speech some catastrophic events, often violent, that have occurred off-stage. The speaker may be any appropriate witness (attendant, nurse, shepherd, soldier, etc.); collectively, they are known as "the messenger." These speeches were evidently a virtuoso opportunity for actors, and they are often reflected in vase-painting.

mystery cult A cult that required some sort of initiation ritual before the participant (*mystes*) was admitted. Such cults promised special benefits to initiates, including advantages after death. Mystery cults, especially those associated with Orpheus and with Dionysos, were widespread among the Greeks in the West.

naiskos A term meaning "little shrine," which is conventionally applied to the small built structures often found represented on Western Greek vases, especially to house an idealized figure of a deceased person. I have preferred the term *portico* in tragedy-related context.

Nereids Nymphs of the sea, deriving their name from Nereus, an old sea god.

nestoris (Italian name: trozella) A wide-mouthed jar, usually with handles that come up higher than the lip. This was the only local Italian pot shape that was significantly taken up and adapted by Greek potters.

Nike Personified goddess of victory. She is always represented as winged, often carrying a victory wreath.

nimbus A supernatural circle shown surrounding a divine figure, usually just the head (rather like a halo).

nurse Blanket term used to refer to female child carers (the male equivalent is *paidagogos*). Mythological (and other privileged) children, especially girls, were thought of as having such carers, who would often remain loyal to their charges for life. Nurses are quite frequently found in tragedies; in the vase-paintings they are conventionally shown with white hair standing near their mistress.

nymphs Loose term used to refer to minor female deities, especially those associated with natural phenomena such as rivers and mountains.

oenochoe A jug for wine.

Olympia (adj.: Olympic) Great *Panhellenic* sanctuary in the Alphaios Valley in the western Peloponnese, sacred primarily to Zeus Olympios ("Olympian," a title derived from Mount Olympos, home of the chief gods). The Olympic Games, which attracted huge numbers of visitors from all over the Greek world, were held there every four years.

omphalos Meaning, literally, "navel," this term was used especially (though not exclusively) for the sacred oval-shaped stone in the shrine of Apollo at *Delphi*, which was held to be the navel of the whole world.

orchestra A place for dancing. In the Greek theater, this refers to the large flat area, usually circular, in front of the stage building.

oracle A term referring both to the place where humans would ask questions and advice from a divine source, and to the reply itself. The most celebrated oracle (of many) was that of Apollo at *Delphi*.

paidagogos Male child carer allocated to a privileged child, usually a boy (equivalent of a *nurse*). He would look after the boy, at least until adulthood (hence the rather misleading translation sometimes used: "tutor"). A paidagogos sometimes has a speaking role in tragedy and is quite often represented on related vases. From the mid-fourth century, he is given a distinctive costume and appearance. This "little old man" figure may sometimes represent old men in other non-noble roles.

Paestum Italian name for the large Greek city of Poseidonia, on the west coast, south of Naples. Under Italian control in the fourth century, it still maintained a vigorous localized Greek culture, including a distinctive kind of *red-figure* pottery.

Pan A somewhat anarchic god (occasionally plural: Panes) who haunted wild places. He is always represented with horns, and sometimes with the lower half of a goat. Little Pans (*paniskoi*) are also found. In many vase-paintings the inclusion of a Pan signals an association with wild places.

Panhellenic Term meaning something shared by all Greeks, wherever they might live throughout the diaspora. The word also has associations of the unification of Greeks as opposed to other races.

papyrus Sheets of strong material used as the equivalent of paper, made from the pith of the papyrus reed, which was obtained above all from Egypt. Many ancient Greek documents written on papyrus, including tragedies, have been excavated from the sands of Egypt, but almost all are in very tattered and fragmentary condition.

Persia The most powerful country in the East during the Classical period of Greece, more or less equivalent to modern Iran. The Greeks were much fascinated by the Persians while also fearing and despising them.

phlyakes A hybrid type of drama, developed in the Greek West in about 300 B.C., that combined elements of both tragedy and comedy in *Doric dialect*. The label used to be attached

to comic vases of the fourth century, but most scholars have now abandoned this inaccurate usage.

pilos A conical brimless hat worn by men, particularly when traveling.

portico Term used for the small built structures in tragedy-related pictures (sometimes also known as *naiskos*). These are usually supported by four slender columns and may possibly owe something to theatrical sets.

Poseidonia, see *Paestum*.

Puglia, see *Apulia*.

Pythia Title of the priestess of Apollo at *Delphi*.

red-figure(d) The technique of vase-painting most favored in the Greek West. It was first developed in Athens in the decades before 500 and was produced in the West from about 430 until 300. Basically, the figures are left in the natural red color of the clay and are painted around in black; a variety of lines, shading, and other colors (white, purple, etc.) are added to the figures for detail.

reperformance The practice of putting on a play again at a later date, and usually in another place, from the original first performance.

rock arch A painted "squiggly" arch found on some Western Greek vases, representing a large rock or a cave mouth. It is plausibly related to an item of painted theatrical scenery.

satyr play It was the convention in Athens for each tragedian and his troupe to put on a burlesque fourth play after their three tragedies. This had a chorus of satyrs, roaming followers of Dionysos, who sported some animal characteristics, including a horsetail and priapic phallus. Satyr plays usually figured Pappasilenos, the old father of the chorus. It is unsure how widespread satyr play became in the Greek West.

scepter (Greek: *skeptron*) Monarchs in Greek vase-painting are usually represented as holding scepters, which take the form of a long, straight, slender staff, often surmounted by a miniature eagle.

scholion (plural: *scholia*) It was common for ancient Greek literary texts to be accompanied by copious commentary and annotations,

known as "scholia." Some of these survive into modern times.

skene Meaning, literally, "tent," this became the standard word for the stage background building in the theater. It normally had central double doors.

Skythia Very roughly speaking, the area of modern Romania and Ukraine; the Scythians were thought of by the Greeks as quite distinct from Asiatics.

South Italian This is the term usually used to distinguish the pottery (and culture in general) produced by the Greeks settled in southern Italy (*Magna Graecia*). I have preferred to use the term *Western Greek*.

subtitle Two plays of the same title by the same playwright were distinguished by use of a subtitle, probably the work of later bibliographers. These pairs might take the form of additions, such as *Iphigeneia (among the Taurians)* and *Iphigeneia (at Aulis)*, or might be simple ordering as with *Phrixos (the First Version)* and *Phrixos (the Second Version)*.

suppliant, supplication (or suppliance) People who were in serious trouble, especially in danger for their lives, might take the desperate step of throwing themselves on the mercy of (supplicating) either a powerful human or a god. This is a favorite scenario in tragedy and most commonly displays the suppliants taking refuge at the *altar* of a god. Anyone who did them direct violence, while they remained at the altar, was in danger of incurring the anger of the god.

symposium Drinking party for a limited number of men who are linked by social bonds—a basic institution of social coherence, especially for the wealthy. Various cultural and erotic activities would enliven the party; and it was an occasion for the use of fine pottery.

terracotta(s) While it may be extended to pottery and anything made of baked clay, this term is used especially of models and figurines. Mold-made terracotta figures of actors, especially from comedy, were produced in quantity in the fifth and fourth centuries (and later).

testimonia The term used for the collected bits of evidence for some particular matter; for example, for the life and works of a tragic poet.

theatron Literally a "watching place," thence extended to mean "theater."

Thrace Roughly the area of modern Bulgaria. Thracians, although not Greek, are caught up somewhat in Greek mythological stories.

trilogy/tetralogy In Athens it was the standard practice for a tragedian to produce three tragedies at the *Dionysia*, a trilogy; along with the satyr play, these works formed a tetralogy. In the days of Aeschylus, the plays were often linked by subject, but this practice did not continue. We do not know whether tragedies were presented in threes outside Athens.

tripod A large bronze bowl supported by three legs, often highly ornamented. While originally for boiling water over a fire, their chief use in classical times was as prestige objects to dedicate in sanctuaries and/or to display as tokens of a victory, including victory in artistic events.

tyrant The Greek word *tyrannos* was originally used of any absolute ruler or monarch; but during the fifth century, the word came to acquire negative connotations of dictatorial behavior. Modern uses of the word with reference to ancient Greece tend not to distinguish the neutral from the negative applications.

Underworld The land of the dead from which there was no return (except in a very few cases), conceived of as a sunless realm beneath the earth, ruled over by Hades. It was usually taken to be a shadowy, insubstantial, and joyless place; adherents of *mystery cults*, however, nourished hopes of a blessed afterlife. Some mythological figures who had committed special crimes were subjected to perpetual punishments.

volute-krater A form of *krater* that became particularly favored for decorated monumental vessels by *Apulian* vase-painters. The neck, and even the foot, became places for elaboration, as well as the large body; the tops of the handles were attached to the lip with elaborate volutes, which were sometimes decorated with faces (mascaroons). The very large volute-kraters, which were undoubtedly produced for funerals, particularly tend to figure tragedy-related mythological narratives.

Western Greek This term should, strictly speaking, apply to all the diaspora west of the Greek mainland. I have tended to use it more particularly, to refer to the Greeks in southern Italy and Sicily.

BIBLIOGRAPHY

Bibliographical abbreviations

Add²	*Beazley Addenda —Additional References to ABV, ARV² and Paralipomena*, 2nd edn.
AJA	*American Journal of Archaeology*
AK	*Antike Kunst*
ARV²	*Attic Red-Figure Vase-Painters*, 2nd edn.
BAD	Beazley Archive Database
BerlWPr	*Winckelmannsprogramm* (Berlin)
BICS	*Bulletin of the Institute of Classical Studies*
CFST	*La ceramica figurata a soggetto tragico in Magna Grecia e in Sicilia*
CVA	*Corpus Vasorum Antiquorum*
EfrP 1	*Euripides, Selected Fragmentary Plays*, Vol. 1
EfrP 2	*Euripides, Selected Fragmentary Plays*, Vol. 2
IG	*Inscriptiones Graecae*
JHS	*Journal of Hellenic Studies*
LCS	*The Red-Figured Vases of Lucania, Campania and Sicily*
LCS supp 2	*The Red-figured Vases of Lucania, Campania and Sicily: Second Supplement*
LCS supp 3	*The Red-Figured Vases of Lucania, Campania and Sicily: Third Supplement (Consolidated)*
LIMC	*Lexicon Iconographicum Mythologiae Classicae*
Meditarch	*Mediterranean Archaeology*
NumAntCl	*Quaderni Ticinesi Numismatica e Antichità Classiche*
ÖJh	*Jahreshefte des Österreichischen Archäologischen Institutes in Wien*
Para²	*Paralipomena, Additions to Attic Black-Figure Vase-Painters and to Attic Red-Figure Vase-Painters*, 2nd edn.
PCG	*Poetae Comici Graeci*
PhV²	*Phlyax Vases*, 2nd edn.
POxy	*The Oxyrhynchus Papyri*
RA	*Revue Archéologique*
RVAp	*The Red-Figured Vases of Apulia I/II*
RVAp supp 1	*First Supplement to The Red-Figured Vases of Apulia*
RVAp supp 2	*Second Supplement to The Red-Figured Vases of Apulia*
RVP	*The Red-Figured Vases of Paestum*
RVSIS	*Red Figure Vases of South Italy and Sicily: A Handbook*
TrGF	*Tragicorum Graecorum Fragmenta*
TRI	*Theatre Research International*

Add²
Carpenter, T., T. Mannack, and M. Mendoça. *Beazley Addenda —Additional References to ABV, ARV² and Paralipomena*. 2nd edn. Oxford: Oxford Univ. Press, 1989.

AELLEN 1994
Aellen, C. *A la recherche de l'ordre cosmique: Forme et fonction des personnifications dans la céramique italiote*. 2 vols. Zurich: Akanthus, 1994.

AELLEN-CAMBITOGLOU-CHAMAY 1986
———, A. Cambitoglou, and J. Chamay. *Le peintre de Darius et son milieu: Vases grecs d'Italie méridionale*. Geneva: Association Hellas et Roma, 1986.

ALLAN 2000
Allan, W. *The "Andromache" and Euripidean Tragedy*. Oxford: Oxford Univ. Press, 2000.

ALLAN 2001
———. "Euripides in Megale Hellas: Some Aspects of the Early Reception of Tragedy." *Greece and Rome* 2nd series 48 (2001): 67–86.

ANDREASSI 1996
Andreassi, G. *Jatta di Ruvo: La famiglia, la collezione, il Museo nazionale*. Bari: Adda, 1996.

ARNOTT 1996
Arnott, W. G. *Alexis: The Fragments; A Commentary*. Cambridge: Cambridge Univ. Press, 1996.

ARV²
Beazley, J. D. *Attic Red-Figure Vase-Painters*. 2nd edn. Oxford, Oxford Univ. Press, 1963.

BAD
Beazley Archive Database. http://www.beazley.ox.ac.uk.

BEAZLEY 1939
Beazley, J. D. "Prometheus Fire-Lighter." *AJA* 43 (1939): 618–39.

BEAZLEY 1944
———. "A Paestan Vase." *AJA* 48 (1944): 357–66.

BECKEL-FRONING-SIMON 1983
Beckel, G., H. Froning, and E. Simon. *Werke der Antike im Martin-von-Wagner-Museum der Universität Würzburg*. Mainz: von Zabern, 1983.

BERNABÒ-BREA 1979
Bernabò-Brea, L. *Il castello di Lipari e il Museo Archeologico Eoliano*. Palermo: Flaccovio, 1979.

BERNABÒ-BREA 1981
———. *Menandro e il teatro greco nelle terracotte liparesi*. Genoa: Sagep, 1981.

BERNABÒ-BREA AND CAVALIER 2001
———, and M. Cavalier. *Maschere e personaggi del teatro greco nelle terracotte liparesi*. Rome: "L'Erma" di Bretschneider, 2001.

BERTINO 1975
Bertino, A. "Scene di soggetto teatrale sui vasi a figure rosse." In *Archeologica: Scritti in onore di Aldo Neppi Modona*, ed. N. Caffarello, 17–28. Florence: Olschki, 1975.

BETTS-HOOKER-GREEN 1988
Betts, J. H., J. T. Hooker, and J. R. Green, eds. *Studies in Honour of T. B. L. Webster II*. Bristol: Bristol Classical Press, 1988.

BIEBER 1961
Bieber, M. *The History of the Greek and Roman Theatre*. 2nd edn. Princeton Univ. Press, 1961.

BIRCHLER-CHAMAY 1995
Birchler, P., and J. Chamay. "Hésioné en Apulie: Un chef-d'oeuvre de la peinture apulienne." *AK* 38 (1995): 50–57.

BULLE 1934
Bulle, H. "Eine Skenographie." *BerlWPr* 94, 1934.

BURKERT 1987
Burkert, W. *Ancient Mystery Cults*. Cambridge, MA, and London: Harvard Univ. Press, 1987.

BUXTON 1994
Buxton, R. *Imaginary Greece: The Contexts of Mythology*. Cambridge: Cambridge Univ. Press, 1994.

CAMBITOGLOU 1975
Cambitoglou, A. "Iphigeneia in Tauris." *AK* 18 (1975): 56–66.

CAMBITOGLOU 1979
———, ed. *Studies in Honour of Arthur Dale Trendall*. Sydney: Sydney Univ. Press, 1979.

CAMBITOGLOU-CHAMAY 1997
———, and J. Chamay, eds. *Céramique de Grande Grèce: La collection de fragments Herbert A. Cahn*. Zurich: Akanthus, 1997.

CASSANO 1992
Cassano, R., ed. *Principi Imperatori Vescovi: Duemila anni di storia a Canosa*. Bari: Marsilio, 1992.

Cassio 2002
Cassio, A. C. "The Language of Doric Comedy." In *The Language of Greek Comedy*, ed. A. Willi, 51–83. Oxford: Oxford Univ. Press, 2002.

CFST
Todisco, L., ed. *La ceramica figurata a soggetto tragico in Magna Grecia e in Sicilia*. Rome: Giorgio Bretschneider, 2003.

Cipriani-Longo-Viscione 1996
Cipriani, M., F. Longo, and M. Viscione, eds. *Poseidonia e i Lucani*. Naples: Electa, 1996.

Coles 1968
Coles, R. A. "A New Fragment of Post-Classical Tragedy from Oxyrhynchus." *BICS* 15 (1968): 110–18.

Collard 1970
Collard, C. "On the Tragedian Chaeremon." *JHS* 90 (1970): 22–34.

Cropp 2000
Cropp, M. J. *Euripides: "Iphigenia in Tauris."* Warminster: Aris & Phillips, 2000.

Csapo 2001
Csapo, E. "The First Artistic Representations of Theatre: Dramatic Illusion and Dramatic Performance in Attic and South Italian Art." In *Theatre and the Visual Arts*, ed. G. S. Katz, V. Golini, and D. Pietropaolo, 17–38. Toronto: Legas, 2001.

Csapo 2004
———. "Some Social and Economic Conditions Behind the Rise of the Acting Profession in the Fifth and Fourth Centuries B.C." In *Le statut de l'acteur dans l'antiquité grecque et romaine*, ed. C. Hugoniot, F. Hurlet, and S. Milanezi, 53–76. Tours: Presses universitaires François-Rabelais, 2004.

Csapo-Slater 1995
———, and W. J. Slater. *The Context of Ancient Drama*. Ann Arbor: Univ. of Michigan Press, 1995.

d'Agostino 1998
d'Agostino, B. "Greeks and Indigenous People in Basilicata from the Eighth to the Third Century B.C." In *Trésors d'Italie du Sud: Grecs et Indigènes en Basilicate*, 24–57. Exh. cat. Milan: Skira, 1998.

de Angelis 2002
de Angelis, F. "Specchi e miti: Sulla ricezione della mitologia greca in Etruria." *Rivista di Antichità* 15 (2002): 37–73.

de Cesare 1992
de Cesare, M. "Alkmena ad Entella: Ceramografi sicelioti e campani nel IV secolo A.C." *Annali della Scuola Normale Superiore di Pisa* 22.4 (1992): 979–83.

De Juliis 2000
De Juliis, E. M. *Taranto*. Bari: Edipuglia, 2000.

De Juliis 2001
———. *Metaponto*. Bari: Edipuglia, 2001.

Dearden 1999
Dearden, C. "Plays for Export." *Phoenix* 53 (1999): 222–48.

Degrassi 1967
Degrassi, N. "Meisterwerke frühitaliotische Vasenmalerei aus einem Grab in Policoro-Herakleia." In *Archäologische Forschungen in Lukanien II: Herakleiastudien*, ed. B. Neutsch, 193–231. Heidelberg: Kerle, 1967.

Deichgräber 1939
Deichgräber, K. "Die *Lykurgie* des Aischylos: Versuch einer Wiederherstellung der dionysischen Tetralogie." *Nachrichten der Akademie der Wissenschaften zu Göttingen*. Historisch-Philologische Klasse. I: Altertumswissenschaft. New Series 3, 8 (1939): 231–309.

Descoeudres 1990
Descoeudres, J. P. *ΕΥΜΟΥΣΙΑ: Ceramic and Iconographic Studies in Honour of Alexander Cambitoglou*. Sydney: Sydney Univ. Press, 1990.

DeVries 1993
DeVries, K. "The *Prometheis* in Vase Painting and on the Stage." In *Nomodeiktes: Greek Studies in Honor of Martin Ostwald*, ed. R. M. Rosen and J. Farrell, 517–23. Ann Arbor: Univ. of Michigan Press, 1993.

Diggle 1994
Diggle, J. *Euripidis Fabulae*. Vol. 3. Oxford: Oxford Univ. Press, 1994.

Dyer 1969
Dyer, R. R. "The Evidence for Apolline Purification Rituals at Delphi and Athens." *JHS* 89 (1969): 38–56.

Easterling 1993
Easterling, P. E. "The End of an Era? Tragedy in the Early Fourth Century." In *Tragedy, Comedy and the Polis*, ed. A. H. Sommerstein, S. Halliwell, J. Henderson, and B. Zimmerman, 559–69. Bari: Levante, 1993.

Easterling 1997
———, ed. *The Cambridge Companion to Greek Tragedy*. Cambridge: Cambridge Univ. Press, 1997.

Easterling 2002
———. "Actor as Icon." In *Greek and Roman Actors: Aspects of an Ancient Profession*, ed. P. Easterling and E. Hall, 327–34. Cambridge: Cambridge Univ. Press, 2002.

EfrP 1
Collard, C., M. J. Cropp, and K. H. Lee. *Euripides, Selected Fragmentary Plays*. Vol. 1. Warminster: Aris & Phillips, 1995.

EfrP 2
———. *Euripides, Selected Fragmentary Plays*. Vol. 2. Warminster: Aris & Phillips, 2004.

Elia 1931
Elia, O. "Regione I.VIII: Caivano; Necropoli pre-romana." *Notizie degli scavi di antichità*, 1931, 577–614.

Fontannaz 2000
Fontannaz, D. "Philoctète à Lemnos dans la céramique attique et italiote: Une mise au point." *AK* 43 (2000): 53–69.

Fowler 2000
Fowler, R. L. *Early Greek Mythography: I Texts*. Oxford: Oxford Univ. Press, 2000.

Froning 2002
Froning, H. "Masken und Kostüme." In Moraw and Nölle 2002, 70–95.

Froning-Hölscher-Mielsch 1992
———, T. Hölscher, and H. Mielsch, eds. *Kotinos: Festschrift für Erika Simon*. Mainz: von Zabern, 1992.

Garvie 1986
Garvie, A. F. *Aeschylus: "Choephori."* Cambridge: Cambridge Univ. Press, 1986.

Ghiron-Bistagne 1976
Ghiron-Bistagne, P. *Recherches sur les acteurs dans la Grèce antique*. Paris: Les Belles Lettres, 1976.

Giuliani 1988
Giuliani, L. *Bildervasen aus Apulien*. Berlin: Mann, 1988.

Giuliani 1995
———. *Tragik, Trauer und Trost: Bildervasen für eine apulische Totenfeier*. Berlin: Staatliche Museen, 1995.

Giuliani 1996
———. "Rhesus between Dream and Death: On the Relation of Image to Literature in Apulian Vase-Painting." *BICS* 41 (1996): 71–86.

Giuliani 2001
———. "Sleeping Furies: Allegory, Narration and the Impact of Texts in Apulian Vase-Painting." *Scripta Classica Israelica* 20 (2001): 17–38.

Giuliani 2003
———. *Bild und Mythos: Geschichte der Bilderzählung in der griechischen Kunst*. Munich: Beck, 2003.

Guiliani-Most (forthcoming)
———, and G. Most. "Medea in Princeton." In Kraus et al. (forthcoming).

Gogos 1983
Gogos, S. "Bühnenarchitektur und antike Bühnenmalerei: Zwei Rekonstruktionsversuche nach griechischen Vasen." *ÖJh* 54 (1983): 59–86.

Gogos 1984
———. "Das Bühnenrequisit in der griechischen Vasenmalerei." *ÖJh* 55 (1984): 27–53.

GOULD 2001
Gould, J. "Hiketeia." In J. Gould, *Myth, Ritual, Memory and Exchange: Essays in Greek Literature and Culture,* 22–77. (Reprinted from *JHS* 93 (1973): 74–103.) Oxford: Oxford Univ. Press, 2001.

GRAHAM 1958
Graham, A. "The Ransom of Hektor on a New Melian Relief." *AJA* 62 (1958): 313–19.

GREEN 1982a
Green, J. R. "The Gnathian Pottery of Apulia." In Mayo 1982, 252–59.

GREEN 1982b
———. "Dedications of Masks." *RA* 2 (1982): 237–48.

GREEN 1991a
———. "Notes on Phlyax Vases." *NumAntCl* 20 (1991): 49–56.

GREEN 1991b
———. "On Seeing and Depicting the Theatre in Classical Athens." *Greek, Roman and Byzantine Studies* 32 (1991): 15–50.

GREEN 1994
———. *Theatre in Ancient Greek Society.* London and New York: Routledge, 1994.

GREEN 1995
———. "Theatre Production: 1987–1995." *Lustrum* 37 (1995): 7–202.

GREEN 1999
———. "Tragedy and the Spectacle of the Mind: Messenger Speeches, Actors, Narrative and Audience Imagination in Fourth-Century BCE Vase Painting." In *The Art of Ancient Spectacle,* ed. B. Bergmann and C. Kondoleon, 37–63. Washington: Yale Univ. Press, 1999.

GREEN 2002
———. Review of Morelli 2001. *Bryn Mawr Classical Review.* http://ccat.sas.upenn.edu/bmcr/2002/2002-12-01.html.

GREEN 2003
———. *Ancient Voices, Modern Echoes: Theatre in the Greek World.* Exh. cat. Sydney: Nicholson Museum, Univ. of Sydney, 2003.

GREEN-HANDLEY 1995
———, and E. Handley. *Images of the Greek Theatre.* London: British Museum, 1995.

GRIFFITH 1983
Griffith, M. *Aeschylus: "Prometheus Bound."* Cambridge: Cambridge Univ. Press, 1983.

HALL 1989
Hall, E. *Inventing the Barbarian.* Oxford: Oxford Univ. Press, 1989.

HALL 2002
———. "The Singing Actors of Antiquity." In *Greek and Roman Actors: Aspects of an Ancient Profession,* ed. P. Easterling and E. Hall, 3–38. Cambridge: Cambridge Univ. Press, 2002.

HALL-MACINTOSH-TAPLIN 2000
———, F. Macintosh, and O. Taplin, eds. *Medea in Performance, 1500–2000.* Oxford: Legenda, European Humanities Research Center, 2000.

HAMBURG MUSEUM 1995
Bilder der Hoffnung: Jenseitserwartungen auf Prunkgefäßen Süditaliens. Hamburg: Museum für Kunst und Gewerbe, 1995.

HARDWICK 1999
Hardwick, N. "A Triglyph Altar of Corinthian Type in a Scene of *Medea* on a Lucanian Calyx-Crater in Cleveland." *NumAntCl* 28 (1999): 179–201.

HUFFMAN 2005
Huffman, C. A. *Archytas of Tarentum: Pythagorean, Philosopher and Mathematician King.* Cambridge: Cambridge Univ. Press, 2005.

HUGHES 1996
Hughes, A. "Comic Stages in Magna Graecia: The Evidence of the Vases." *TRI* 21 (1996): 95–107.

HUNTER 1983
Hunter, R. L., ed. *Eubulus: The Fragments.* Cambridge: Cambridge Univ. Press, 1983.

IMPERIO 2005
Imperio, O. "*Ouden pros ten polin?* Il teatro attico in Sicilia e in Italia meridionale." *Dioniso* 4 (2005): 280–93.

JEFFERY 1990
Jeffery, L. H. *The Local Scripts of Archaic Greece: A Study of the Origin of the Greek Alphabet and Its Development from the Eighth to the Fifth Centuries* BC. Rev. edn. Oxford: Clarendon Press, 1990.

JUNKER 2002
Junker, K. "Symposiongeschirr oder Totengefässe? Überlegungen zur Funktion attischer Vasen des 6. und 5. Jahrhunderts v. Chr." *AK* 45 (2002): 3–25.

JUNKER 2003
———. "Namen auf dem Pronomoskrater." *Mitteilungen des Deutschen Archäologischen Instituts, Athenische Abteilung* 118 (2003): 317–35.

KANNICHT 1991
Kannicht, R., ed. *Musa Tragica: Die griechische Tragödie von Thespis bis Ezechiel.* Göttingen: Vandenhoeck und Ruprecht, 1991.

KARAMANOU 2002–3
Karamanou, I. "An Apulian Volute-Crater Inspired by Euripides' *Dictys.*" *BICS* 46 (2002–3): 167–75.

KASSEL 1958
Kassel, R. *Untersuchungen zur griechischen und römischen Konsolationsliteratur.* Munich: Beck, 1958.

KEULS 1978
Keuls, E. "The Happy Ending: Classical Tragedy and Apulian Funerary Art." *Mededelingen van het Nederlandsch Historisch Institut te Rome* 40 (1978): 83–91.

KEULS 1990
———. "Clytemnestra and Telephus in Greek Vase-Painting." In Descoeudres 1990, 87–94.

KEULS 1997
———. *Painter and Poet in Ancient Greece: Iconography and the Literary Arts.* Stuttgart and Leipzig: Teubner, 1997.

KNOEPFLER 1993
Knoepfler, D. *Les imagiers de l'Orestie: Mille ans d'art antique autour d'un mythe grec.* Zurich: Akanthus, 1993.

KNOX 1979
Knox, B. *Word and Action: Essays on the Ancient Theater.* Baltimore and London: Johns Hopkins Univ. Press, 1979.

KOSSATZ-DEISSMANN 1978
Kossatz-Deissmann, A. *Dramen des Aischylos auf westgriechischen Vasen.* Mainz: von Zabern, 1978.

KOVACS 2001
Kovacs, D. *Euripides I: Cyclops, Alcestis, Medea.* Cambridge, MA, and London: Harvard Univ. Press, 2001.

KRAUS ET AL. (forthcoming)
Kraus, C., J. Elsner, H. Foley, and S. Goldhill, eds. *Visualising the Tragic: Essays for Froma Zeitlin.* Oxford: Oxford Univ. Press, forthcoming.

KRUMEICH 2002
Krumeich, R. "Euaion ist schoen." In Moraw and Nölle 2002, 141–45.

KRUMEICH-PECHSTEIN-SEIDENSTICKER 1999
———, N. Pechstein, and B. Seidensticker, eds. *Das griechische Satyrspiel.* Darmstadt: Wissenschaftliche Buchgesellschaft, 1999.

LCS
Trendall, A. D. *The Red-Figured Vases of Lucania, Campania and Sicily.* Oxford: Oxford Univ. Press, 1967.

LCS supp 2
———. *The Red-Figured Vases of Lucania, Campania and Sicily: Second Supplement.* BICS, 1973.

LCS supp 3
———. *The Red-Figured Vases of Lucania, Campania and Sicily: Third Supplement (Consolidated).* BICS, 1983.

LESKY 1966
Lesky, A. "Der Ablauf der Handlung in der *Andromache* des Euripides." Reprinted in *Albin Lesky, Gesammelte Schriften: Aufsätze und Reden zu antiker und deutscher Dichtung und Kultur*, ed. W. Kraus, 144–55. Bern and Munich: Francke, 1966.

LIMC
Lexicon Iconographicum Mythologiae Classicae. Volumes 1–8. Zurich and Munich: Artemis, 1981–1997.

LISSARRAGUE 1990
Lissarrague, F. "Why Satyrs are Good to Represent." In Winkler-Zeitlin 1990, 228–36.

LLOYD 1994
Lloyd, M. *Euripides: "Andromache."* Warminster: Aris & Phillips, 1994.

LLOYD-JONES 1996
Lloyd-Jones, H. *Sophocles III: Fragments.* Cambridge, MA, and London: Harvard Univ. Press, 1996.

LO PORTO 1991
Lo Porto, F. G. "Vasi apuli da una tomba di Irsina nel Materano." *Meditarch* 4 (1991): 91–97.

MACLEOD 1982
Macleod, C. W. *Homer: "Iliad" Book 24.* Cambridge: Cambridge Univ. Press, 1982.

MARCH 1989
March, J. "Euripides' *Bakchai*: A Reconsideration in the Light of Vase-Paintings." *BICS* 36 (1989): 33–65.

MARSHALL 2001
Marshall, C. W. "A Gander at the Goose Play." *Theater Journal* 53 (2001): 53–71.

MASTRONARDE 2002
Mastronarde, D. J. *Euripides: "Medea."* Cambridge: Cambridge Univ. Press, 2002.

MAYO 1982
Mayo, M. E., ed. *The Art of South Italy: Vases from Magna Graecia.* Richmond: Virginia Museum of Fine Arts, 1982.

MERCIER 1995
Mercier, C. "A Representation of Action from a *Ransom of Hector*." *AJA* 99 (1995): 314–15.

METZGER 1951
Metzger, H. *Les représentations dans la céramique attique du IVe siècle.* Paris: de Boccard, 1951.

METZGER 1965
———. *Recherches sur l'imagerie.* Paris: de Boccard, 1965.

MICHELAKIS 2002
Michelakis, P. *Achilles in Greek Tragedy.* Cambridge: Cambridge Univ. Press, 2002.

MITENS 1988
Mitens, K. *Teatri greci e teatri ispirati all'architettura greca in Sicilia e nell'Italia meridionale c. 350–50 a.C.: Un catalogo.* Rome: "L'Erma" di Bretschneider, 1988.

MORAW AND NÖLLE 2002
Moraw, S., and E. Nölle. *Die Geburt des Theaters in der griechischen Antike.* Mainz: von Zabern, 2002.

MORELLI 2001
Morelli, G. *Teatro attico e pittura vascolare: Una tragedia di Cheremone nella ceramica italiota.* Hildesheim: Olms, 2001.

MORET 1972
Moret, J. M. "Le départ de Bellérophon sur un cratère campanien de Genève." *AK* 15 (1972): 95–106.

MORET 1975
———. *L'Ilioupersis dans la cèramique italiote: Les mythes et leur expression figurée au IVe siècle.* Geneva: Institut Suisse de Rome, 1975.

MORET 1979
———. "Un ancêtre du phylactère: Le pilier inscrit des vases italiotes." *RA*, 1979: 3–34, 235–58.

MORET 1984
———. *Oedipe, la Sphinx et les Thébains: Essai de mythologie iconographique.* Geneva: Institut Suisse de Rome, 1984.

MORET 1993
———. "Les départs des Enfers dans l'imagerie apulienne." *RA*, 1993, 293–351.

MORETTI 1993
Moretti, J. C. "Les débuts de l'architecture théatrâle en Sicile et en Italie méridionale (Ve–IIIe s.)." *Topoi* 3.1 (1993): 72–100.

MOSSMAN 1995
Mossman, J. *Wild Justice: A Study of Euripides' "Hecuba."* Oxford: Oxford Univ. Press, 1995.

NEILS 2003
Neils, J., and J. H. Oakley. *Coming of Age in Ancient Greece: Images of Childhood from the Classical Past.* New Haven and London: Yale Univ. Press, 2003.

OAKLEY 1991
Oakley, J. H. "'The Death of Hippolytus' in South Italian Vase-Painting." *NumAntCl* 20 (1991): 63–83.

PADGETT ET AL. 1993
Padgett, J. M., M. B. Comstock, J. J. Hermann, and C. C. Vermeule. *Vase-Painting in Italy: Red-figure and Related Works in the Museum of Fine Arts, Boston.* Boston: Museum of Fine Arts, 1993.

PAGE 1938
Page, D. L. *Euripides: Medea.* Oxford: Clarendon Press, 1938.

PANVINI 2003
Panvini, R. *Caltanissetta: Il Museo Archeologico.* Exh. cat. Caltanissetta: Regione Siciliana, Assessorato dei Beni Culturali e Ambientali e P.I., 2003.

Para²
Beazley, J. D. *Paralipomena, Additions to Attic Black-Figure Vase-Painters and to Attic Red-Figure Vase-Painters.* 2nd edn. Oxford: Oxford Univ. Press, 1971.

PARKER 1983
Parker, R. *Miasma.* Oxford: Oxford Univ. Press, 1983.

PCG
Kassel, R., and C. Austin. *Poetae Comici Graeci*, I–VII. Berlin: de Gruyter, 1984–2003.

PELAGATTI-VOZA 1973
Pelagatti, P., and G. Voza, eds. *Archeologia nella Sicilia sud-orientale.* Naples: Centre Jean Bérard, 1973.

PhV²
Trendall, A. D. *Phlyax Vases.* 2nd edn. London: Institute of Classical Studies (Bulletin Supplement 19), 1967.

PICKARD-CAMBRIDGE 1968
Pickard-Cambridge, A. *The Dramatic Festivals of Athens.* 2nd edn. Revised by J. Gould and D. M. Lewis. Oxford: Clarendon Press, 1968.

PINGIATOGLOU 1992
Pingiatoglou, S. "Eine Komödiendarstellung auf einer Choenkanne des Benaki-Museums." In Froning-Hölscher-Mielsch 1992, 292–300.

POLACCO 1981
Polacco, L. *Teatro di Siracusa* I. Rimini: Maggioli, 1981.

POLACCO 1990
———. *Teatro di Siracusa* II. Padova: Programma, 1990.

PRAG 1985
Prag, A. J. N. W. *The "Oresteia": Iconographic and Narrative Tradition.* Warminster: Aris & Phillips, 1985.

PURCELL 1994
Purcell, N. "South Italy in the Fourth Century B.C." In *The Fourth Century B.C.*, ed. D. M. Lewis, 381–403. Vol. 6 of *Cambridge Ancient History.* Cambridge: Cambridge Univ. Press, 1994.

RASMUSSEN-SPIVEY 1991
Rasmussen, T., and N. Spivey, eds. *Looking at Greek Vases.* Cambridge: Cambridge Univ. Press, 1991.

RAU 1967
Rau, P. *Paratragodia: Untersuchung einer komischen Form bei Aristophanes.* Munich: Beck, 1967.

REVERMANN 2005
Revermann, M. "The 'Cleveland Medea' Calyx Crater and the Iconography of Ancient Greek Theatre." *TRI* 30 (2005): 3–18.

ROBERT 1881
Robert, C. *Bild und Lied: Archäologische Beiträge zur Geschichte der griechischen Heldensage*. Berlin: Weidmann, 1881.

ROBERTSON 1988
Robertson, M. "Sarpedon Brought Home." In Betts-Hooker-Green 1988, 109–20.

ROBINSON 1990
Robinson, E. G. D. "Workshops of Apulian Red-figure Outside Taranto." In Descoeudres 1990, 179–93.

RVAp
Trendall, A. D., and A. Cambitoglou. *The Red-Figured Vases of Apulia I/II*. Oxford: Oxford Univ. Press, 1978/1982.

RVAp supp 1
———. *First Supplement to The Red-Figured Vases of Apulia*. London: Institute of Classical Studies (Bulletin Supplement 42), 1983.

RVAp supp 2
———. *Second Supplement to The Red-Figured Vases of Apulia*. London: Institute of Classical Studies (Bulletin Supplement 60), 1991.

RVP
Trendall, A. D. *The Red-Figured Vases of Paestum*. Rome: British School at Rome, 1987.

RVSIS
———. *Red Figure Vases of South Italy and Sicily: A Handbook*. London: Thames and Hudson, 1989.

SALADINO 1979
Saladino, V. "Nuovi vasi apuli con temi euripidei (Alcesti, Crisippo, Andromeda)." *Prometheus* 5 (1979): 97–116.

SCHADEWALDT 1999
Schadewaldt, W., trans. With appendix by M. Flashar. *Sophocles Philoctet*. Frankfurt: Insel, 1999.

SCHAUENBERG 1988
Schauenberg, K. "Kreusa in Delphi." *Archäologischer Anzeiger*, 1988, 633–51.

SCHEFOLD 1976
Schefold, K. "Sophokles' *Aias* auf einer Lekythos." *AK* 19 (1976): 71–78.

SCHEFOLD-JUNG 1989
———, and F. Jung. *Die Sagen von den Argonauten, von Theben und Troia in der klassischen und hellenistischen Kunst*. Munich: Hirmer, 1989.

SCHMIDT 1960
Schmidt, M. *Der Dareiosmaler und sein Umkreis*. Mainz: von Zabern, 1960.

SCHMIDT 1967
———. "Herakliden: Illustrationen zu Tragödien des Euripides und Sophokles." In *Gestalt und Geschichte: Festschrift Karl Schefold*, 174–85. Bern: Freunde Antiker Kunst, 1967.

SCHMIDT 1970a
———. Review of *LCS. Gnomon* 44 (1970): 822–30.

SCHMIDT 1970b
———. "Makaria." *AK* 13 (1970): 71–73.

SCHMIDT 1979
———. "Ein Danaidendrama (?) und der euripideische Ion auf unteritalischen Vasenbildern." In Cambitoglou 1979, 159–69.

SCHMIDT 1982
———. "Oidipous und Teiresias." In *Praestant Interna: Festschrift für Ulrich Hausmann*, ed. B. von Freytag, D. Mannsberger, and F. Prayon, 236–43. Tübingen: Wasmuth, 1982.

SCHMIDT 1986a
———. Review of *RVAp* and *RVAp supp 1*. *JHS* 106 (1986): 253–57.

SCHMIDT 1986b
———. "Medea und Herakles: Zwei tragische Kindermörder." In *Studien zur Mythologie und Vasenmalerei: Festschrift für Konrad Schauenberg*, ed. E. Böhr and W. Martini, 169–74. Mainz : von Zabern, 1986.

SCHMIDT 1990
———. "Lydische Harmonie." In Descoeudres 1990, 221–26.

SCHMIDT 1992
———. "Daidalos und Ikaros auf Kreta." In Froning-Hölscher-Mielsch 1992, 306–11.

SCHMIDT 1995
———. "Tes ges ouch haptomenos: Nochmals zum Choenkanne Vlastos aus Anavyssos." *Museum Helveticum* 52 (1995): 65–70.

SCHMIDT 1998
———. "Komische Arme Teufel und andere Gesellen auf der griechischen Komödienbühne." *AK* 41 (1998): 17–32.

SCHMIDT-TRENDALL-CAMBITOGLOU 1976
———, A. D. Trendall, and A. Cambitoglou. *Eine Gruppe apulischer Grabvasen in Basel: Studien zu Gehalt und Form der unteritalischen Sepulkralkunst*. Basel: Archäologischer Verlag, 1976.

SCHULZE 1998
Schulze, H. *Ammen und Pädagogen: Sklavinnen und Sklaven als Erzieher in der antiken Kunst und Gesellschaft*. Mainz: von Zabern, 1998.

SÉCHAN 1926
Séchan, L. *Études sur la tragédie grecque dans ses rapports avec la céramique*. Paris: Champion, 1926.

SEECK 1979
Seeck, G. A., ed. *Das griechische Drama*. Darmstadt: Wissenschaftliche Buchgesellschaft, 1979.

SHAPIRO 1994
Shapiro, H. A. *Myth into Art: Poet and Painter in Classical Greece*. London: Routledge, 1994.

SHAPIRO-PICÓN-SCOTT 1995
———, C. A. Picón, and G. D. Scott, eds. *Greek Vases in the San Antonio Museum of Art*. San Antonio, TX: San Antonio Museum of Art, 1995.

SHEFTON 1956
Shefton, B. B. "Medea at Marathon." *AJA* 60 (1956): 159–63.

SICHTERMANN 1966
Sichtermann, H. *Griechische Vasen in Unteritalien aus der Sammlung Jatta in Ruvo*. Tübingen: Wasmuth, 1966.

SIEBERT 1998
Siebert, G. "La céramique lucanienne décorée." In *Trésors d'Italie du Sud: Grecs et Indigènes en Basilicate*, 100–119. Exh. cat. Milan: Skira, 1998.

SIMON 1982a
Simon, E. *The Ancient Theatre*. Trans. C. F. Vafopoulou-Richardson. London and New York: Methuen, 1982.

SIMON 1982b
———. "Satyr Plays on Vases in the Time of Aeschylus." In *The Eye of Greece: Studies in the Art of Athens*, ed. D. C. Kurtz and B. A. Sparkes, 123–48. Cambridge: Cambridge Univ. Press, 1982.

SIMON 1996
———. "Philoktetes: Ein kranker Heros." In *Geschichte, Tradition, Reflexion: Festschrift für Martin Hengel II*, ed. H. Cancik, 15–39. Tübingen: Mohr (Paul Siebeck), 1996.

SMALL 2003
Small, J. P. *The Parallel Worlds of Classical Art and Text*. Cambridge: Cambridge Univ. Press, 2003.

SOMMERSTEIN 1989
Sommerstein, A. H. *Aeschylus, Eumenides*. Cambridge: Cambridge Univ. Press, 1989.

SOURVINOU-INWOOD 1997
Sourvinou-Inwood, C. "Medea at a Shifting Distance: Images and Euripidean Tragedy." In *Medea: Essays on Medea in Myth, Literature, Philosophy and Art*, ed. J. J. Clauss and S. I. Johnston, 253–96. Princeton Univ. Press, 1997.

SNODGRASS 1998
Snodgrass, A. *Homer and the Artists: Text and Picture in Early Greek Art*. Cambridge: Cambridge Univ. Press, 1998.

SPARKES 1988
Sparkes, B. "A New Satyr-Mask." In Betts-Hooker-Green 1988, 133–36.

STEPHANIS 1988
Stephanis, I. E. *Dionysiakoi technitai: Symboles sten prosopographia tou theatrou kai tes mousikes ton archaion Ellenon*. Herakleion: Panepistemiakes Ekdoseis Kretes, 1988.

TAPLIN 1977
Taplin, O. *The Stagecraft of Aeschylus*. Oxford: Oxford Univ. Press, 1977.

TAPLIN 1978
———. *Greek Tragedy in Action*. London: Routledge, 1978.

TAPLIN 1986
———. "Fifth-Century Tragedy and Comedy: A Synkrisis." *JHS* 106 (1986): 163–74.

TAPLIN 1993
———. *Comic Angels and Other Approaches to Greek Drama through Vase-Painting*. Oxford: Oxford Univ. Press, 1993.

TAPLIN 1997
———. "The Pictorial Record." In Easterling 1997, 69–90.

TAPLIN 1998
———. "Narrative Variation in Vase-Painting and Tragedy: The Example of Dirke." *AK* 41 (1998): 33–39.

TAPLIN 1999
———. "Spreading the Word through Performance." In *Performance Culture and Athenian Democracy*, ed. S. Goldhill and R. Osborne, 33–57. Cambridge: Cambridge Univ. Press, 1999.

TAPLIN 2004
———. "A Disguised Pentheus Hiding in the British Museum?" *Meditarch* 17, Festschrift in Honour of J. R. Green (2004): 237–41.

TAPLIN (forthcoming A)
———. "Aeschylus' *Persai*: The Entry of Tragedy into the Celebration Culture of the 470s?" In *Dionysalexandros, Essays in Honour of Alexander F. Garvie*, ed. D. Cairns and A. Liapis, 1–10. Cardiff: Univ. of Wales Press, forthcoming.

TAPLIN (forthcoming B)
———. "A New Pair of Pairs?" In Kraus et al., forthcoming.

THOMAS 1992
Thomas, R. *Literacy and Orality in Ancient Greece*. Cambridge: Cambridge Univ. Press, 1992.

TODISCO 1982
Todisco, L. "L'Aiace di Sofocle nei frammenti di un cratere apulo." *Archeologia Classica* 34 (1982): 180–89.

TODISCO 2002
———. *Teatro e spettacolo in Magna Grecia e in Sicilia: Testi, immagini, architettura*. Milan: Longanesi, 2002.

TOMPKINS 1983
Tompkins, J. F., ed. *Wealth of the Ancient World: The Nelson Bunker Hunt and William Herbert Hunt Collections*. Fort Worth, TX: Kimbell Art Gallery, 1983.

TRENDALL 1938
Trendall, A. D. *Frühitaliotische Vasen*. Leipzig: Keller, 1938.

TRENDALL 1970
———. "Three Apulian Kraters in Berlin." *Jahrbuch der Berliner Museen* 12 (1970): 151–90.

TRENDALL 1972
———. "The Mourning Niobe." *RA* (1972): 309–16.

TRENDALL 1984
———. "Medea at Eleusis on a Volute Krater by the Darius Painter." *Record of the Art Museum, Princeton University* 43.1 (1984): 5–17.

TRENDALL 1985
———. "An Apulian Loutrophoros Representing the Tantalidae." *Greek Vases in the J. Paul Getty Museum* 2 (1985): 129–44.

TRENDALL 1986
———. "Two Apulian Calyx-Kraters with Representations of Amphion and Zethos." In *Enthousiasmos: Essays on Greek and Related Pottery Presented to J. M. Hemelrijk*, ed. H. A. Brijder, A. A. Drukker, and C. W. Neeft, 157–66. Amsterdam: Allard Pierson Series 6, 1986.

TRENDALL 1988
———. "Masks on Apulian Red-Figured Vases." In Betts-Hooker-Green 1988, 137–54.

TRENDALL 1990
———. "Two Bell Kraters in Melbourne by the Tarporley Painter." In Descoudres 1990, 211–15.

TRENDALL 1991
———. "Farce and Tragedy in South Italian Vase-Painting." In Rasmussen-Spivey 1991, 151–82.

TRENDALL-WEBSTER 1971
———, and T. B. L. Webster. *Illustrations of Greek Drama*. London: Phaidon, 1971.

TrGF 1–5.2
Tragicorum Graecorum Fragmenta. Vols. 1–5.2. (Vol. 1, *Minor Tragedians*, ed. B. Snell, 1971. Vol. 2, *Adespota* [i.e., author unknown], ed. R. Kannicht and B. Snell, 1981. Vol. 3, *Aeschylus*, ed. S. Radt, 1985. Vol. 4, *Sophocles*, ed. S. Radt, 1977. Vols. 5.1 and 2, *Euripides*, ed. R. Kannicht, 2004.) Göttingen: Vandenhoeck & Ruprecht, 1971–2004.

VERMEULE 1979
Vermeule, E. T. "More Sleeping Furies." In *Studies in Classical Art and Archaeology: A Tribute to Peter Heinrich von Blanckenhagen*, ed. G. Kopcke and M. B. Moore, 185–88. New York: Augustin, 1979.

VERMEULE 1987
———. "Baby Aigisthos and the Bronze Age." *Proceedings of the Cambridge Philological Society* New Series 33 (1987): 122–52.

VERNANT AND VIDAL-NAQUET 1972
Vernant, J. P., and P. Vidal-Naquet. *Mythe et tragédie en Grèce ancienne*. Paris: Maspero, 1972.

VERNANT AND VIDAL-NAQUET 1986
———. *Mythe et tragédie en Grèce ancienne*, vol. 2. Paris: Maspero, 1986.

WALTERS 1896
Walters, H. B. *Catalogue of the Greek and Etruscan Vases in the British Museum*. Vol. 4, *Vases of the Latest Period*. London: British Museum, 1896.

WEBSTER 1967
Webster, T. B. L. *Monuments Illustrating Tragedy and Satyr Play*. 2nd edn. London: Institute of Classical Studies (Bulletin Supplement 20), 1967.

WILSON 1996
Wilson, P. "Tragic Rhetoric: The Use of Tragedy and the Tragic in the Fourth Century." In *Tragedy and the Tragic*, ed. M. S. Silk, 310–31. Oxford: Oxford Univ. Press, 1996.

WILSON 2000
———. *The Athenian Institution of the Khoregia: The Chorus, the City, and the Stage*. Cambridge: Cambridge Univ. Press, 2000.

WILSON-TAPLIN 1993
———, and O. Taplin. "The Aetiology of Tragedy in the *Oresteia*." *Proceedings of the Cambridge Philological Society* 39 (1993): 139–80.

WINKLER-ZEITLIN 1990
Winkler, J., and F. Zeitlin, eds. *Nothing to Do with Dionysos? Athenian Drama in Its Social Context*. Princeton, NJ: Princeton Univ. Press, 1990.

WUILLEUMIER 1939
Wuilleumier, P. *Tarente des origines à la conquête romaine*. Paris: Boccard, 1939.

XANTHAKIS-KARAMANOS 1980
Xanthakis-Karamanos, G. *Studies in Fourth-Century Tragedy*. Athens: Akademia Athenon, 1980.

ZEITLIN 1996
Zeitlin, F. *Playing the Other: Gender and Society in Classical Greek Literature*. Chicago: Univ. of Chicago Press, 1996.

PHOTO CREDITS

No. 62. J. Paul Getty Museum, Los Angeles. Photo: Ellen Rosenbery.

No. 63. J. Paul Getty Museum, Los Angeles. Photo: Penelope Potter [detail], Louis Meluso [whole pot].

No. 64. From Andreassi 1996, p. 54.

No. 65. © Bildarchiv Preußischer Kulturbesitz/Art Resource, NY. Photo: Johannes Laurentius.

No. 66. G. Geddes collection, Melbourne. Photograph courtesy of A. D. Trendall.

No. 67. © 1989 Trustees of Princeton University.

No. 68. Courtesy of the Michael C. Carlos Museum, Emory University. Photo: Bruce White.

No. 69. Soprintendenza Archeologici delle province di Napoli e Caserta, Naples.

No. 70. © Copyright the Trustees of The British Museum, London.

No. 71. Soprintendenza per i Beni Archeologici del Lazio—Sezione Etruria Meridionale. Neg. no. 2011.

No. 72. Henry Lillie Pierce Fund. Photograph © 2007 Museum of Fine Arts, Boston.

No. 73. From Aellen 1994, pl. 1.

No. 74. From *Wealth of the Ancient World* (Fort Worth, TX, 1983), no. 15.

No. 75. Bildarchiv Preußischer Kulturbesitz/Art Resource, NY. Photo: Gudrun Stenzel.

No. 76. © The Cleveland Museum of Art, 2003. Leonard C. Hanna, Jr., Fund.

No. 77. San Antonio Museum of Art. Gift of Gilbert M. Denman, Jr.

No. 78. From *RVSIS*, p. 256.

No. 79. Soprintendenza Archeologici delle province di Napoli e Caserta, Naples.

No. 80. Sam Noble Oklahoma Museum of Natural History, Department of Ethnology, University of Oklahoma.

No. 81. © Bildarchiv Preußischer Kulturbesitz/Art Resource, NY. Photo: Johannes Laurentius.

No. 82. © Bildarchiv Preußischer Kulturbesitz/Art Resource, NY.

No. 83. J. Paul Getty Museum, Los Angeles. Photo: Ellen Rosenbery.

No. 84. Musei Vaticani, Archivio fotografico neg. no. VII.15.17.

No. 85. Soprintendenza archeologica della Lombardia.

No. 86. Archäologisches Institut und Akademisches Kunstmuseum der Universität Bonn. Photo: Wolfgang Klein.

No. 87. © Musée d'art et d'histoire, Ville de Genève, dépôt de l'Association Hellas et Roma.

No. 88. Martin von Wagner-Museum der Universität Würzburg. Photo: K. Oehrlein. © Wagner-Museum.

No. 89. J. Paul Getty Museum, Los Angeles. Photo: Ellen Rosenbery.

No. 90. From Alexander Cambitoglou and Jacques Chamay, *Céramique de Grande Grèce: La Collection de fragments Herbert A. Cahn* (Zurich, 1997), p. 223.

No. 91. Francis Bartlett Donation of 1900. Photograph © 2007 Museum of Fine Arts, Boston.

No. 92. Soprintendenza Archeologici delle province di Napoli e Caserta, Naples.

No. 93. © The Cleveland Museum of Art. Leonard C. Hanna, Jr., Fund.

No. 94. © 1990 Trustees of Princeton University.

No. 95. Collection of Shelby White and Leon Levy and Gift of the Jerome Levy Foundation. © 2007 Museum of Fine Arts, Boston.

No. 96. © Collection M. G. N., Geneva. On loan to Musée d'Art et d'Histoire, Ville de Genève.

No. 97. Antikenmuseum Basel und Sammlung Ludwig. Photo: Dieter Widmer.

No. 98. From *Bilder der Hoffnung: Jenseitserwartungen auf Prunkgefässen Süditaliens* (Hamburg, 1995), pl. 24.

No. 99. © Musée d'art et d'histoire, Ville de Genève, dépôt de l'Association Hellas et Roma. Photo: Yves Siza.

No. 100. © Réunion des Musées Nationaux/Art Resource, NY. Photo: Hervé Lewandowski.

No. 101. © Bildarchiv Preußischer Kulturbesitz/Art Resource, NY. Photo: Ingrid Geske.

No. 102. Staatliche Antikensammlungen und Glyptothek München.

No. 103. Museo Archeologico Regionale Eoliano «L. Bernabò Brea» di Lipari.

No. 104. Museo Archeologico Regionale Eoliano «L. Bernabò Brea» di Lipari.

No. 105. By permission of the Assessorato dei Beni Culturali e Ambientali e della Pubblica Istruzione della Regione Siciliana, Caltanissetta. All rights reserved.

No. 106. From *Annali della Scuola Normale Superiore di Pisa,* Serie 3, vol. 22.4 (Pisa, 1982), pl. 55.

No. 107. © Skulpturensammlung, Staatliche Kunstsammlungen Dresden. Photo: Jürgen Karpinski.

No. 108. © Musée d'art et d'histoire, Ville de Genève, dépôt de l'Association Hellas et Roma.

No. 109. J. Paul Getty Museum, Los Angeles. Photo: Ellen Rosenbery.

154, 156, 159–60; on Orestes-at-Delphi vases, 66; shrine of, 152

Assteas: 19, 143–45, 203–4, 209

Astydamas, 186, 220, 225; *Hektor*, 253, 254, 260

Atalante, 196, 198, 224

Athamas, 215, 217

Athena, 85, 217, 221, 227, 231, 233, 236, 256; and Athens, 133, 195–96, 240; and Diomedes, 163, 164; and the Erinyes, 66, 67; garland held by, 80–81; as god from the machine, 99, 146, 150, 176, 185; and Herakles, 143; and Hippolytos scenes, 137, 138, 196; and Ion, 146; and Odysseus, 164; and Orestes, 49, 66, 67; as a protective force, 127; and Rhesos, 165; statue of, 67

Athenianness, 6, 222

Athenian tragedy: in Apulia, 9–15; emergence of, 4; Euripides' role in, 108–9; spread of, 5–9, 32, 35; and variety of pottery, 20. *See also specific plays*

Athenian vase-painting. *See* Attic vase-painting

Atreus, 105–6, 241, 242–43, 245, 264

attendants, 39, 227

Attic Greek dialect, 13–14, 42–43, 215, 229, 230, 234, 255

Attic tragedy. *See* Athenian tragedy

Attic vase-painting: 15, 16, 28–30, 32–34, 50; Achilles in, 84–85; Andromeda in, 175–76, 181; Aphrodite in, 185; Apollo in, 209; Atalante in, 196; Athena in, 221; children-at-the-tomb iconography of, 50; Demeter and Ploutos in, 230; Hypnos and Thanatos in, 72; Iphigeneia in, 152; Kerch style, 155; "kneeling on the altar" poses in, 206; Lykourgos in, 68–69; Medeia in, 114–15; Niobids' massacre in, 75; Orestes in, 40, 56, 59, 60; Pentheus in, 156; Philoktetes in, 99; Phineus in, 82; Priam and Hektor in, 85; satyr masks in, 33–34; tragedy in performance in, 29

audiences, 4, 5, 9, 14, 22, 43, 109, 120, 121, 204

Aulis, 10, 133–34, 149, 159–60, 266

*aulos player, 29, 30, 31–32

B

Bacchai (Euripides), 156–58

Black Fury Painter, 61, 87, 221

Black Sea, 8, 125, 149–50, 154

*boots: Erinyes', 81, 137, 230, 233; fancy/ornate, 94, 98, 100, 123, 137, 193, 196, 207, 209, 210; of heroic nudes, 248; *kothornos*, 38; and the maenads, 158; of paidagogos figure, 40, 90, 112, 193, 238; tragic, 38, 78, 188, 215, 248, 256, 259, 262; traveler's, 38, 52, 53, 63, 127, 154; winged, 87, 179

bow: of Apollo, 61, 139; of Artemis, 154; of Herakles, 80, 143, 145; of Philoktetes, 37, 98, 99

C

Caivano Painter, 20, 264–67

Campanian pottery/vases, 20–21, 135, 149, 155–56, 170, 188, 220, 264–66

Canosa, 8, 18, 21, 22, 169

Capodarso Painter, 90, 261–62

caves: under the Acropolis, 146; Andromeda in, 174, 178; Philoktetes' cave, 37, 98, 99–100, 188; plays set before, 18–19; rocky arches of, 39, 80, 99, 178, 188, 247. *See also* rocky arches

Chairemon, 220; *Achilles*, 233–34

chariot, 104; Amphiaraos', 237; Artemis', 154; chariot races, 199–200, 218; dragon, 117–25, 257; four-horse chariot scenes, 218, 266, 267; Hektor's, 253; Hippolytos', 130, 135, 152; Medeia's, 73, 114, 117, 119, 120, 121, 123, 124–25, 256

Cheiron, 194–95, 214

child carers: 39–40, 111, 215, 218, 225. *See also* nurse, paidagogos

children: dead, 214, 250; exploitation of, 207; Herakles', 126–30, 143, 145; Medeia's, 45, 114–16, 117, 119, 120, 121, 123; Niobe's, 45, 74, 78; at the tomb, 20, 49, 50

Children of Herakles (Euripides), 126–30

*chorus: in *Andromeda*, 175–76, 178, 179; in *Antiope*, 191; of Argonauts, 82; Athenian, 7, 30; in *Bacchai*, 158; of Carians, 72; in *Diktys*, 192; of Edonians, 68; of Erinyes, 64, 67; female, 30, 104; in *Herakleidai*, 126; in *Hippolytos*, 131; in *Iphigeneia*, 152;

of Kreousa's attendants, 103, 148; in *Libation Bearers*, 53, 54–55; in lyric poetry, 296; masks of, 29, 294, 296; in *Medeia*, 121; in *Meleagros*, 198; of Myrmidons, 83; of Nereids, 84; offstage, 30, 32; of Phrygians, 245; in *Rhesos*, 161, 163, 164; of satyrs, 32, 35, 297; in tragedy, 29, 63, 109, 236, 242–43, 294; of Trojans, 84, 245; as witness, 39

columns: Andromeda bound to, 175; at Delphi, 61; of porticos, 297; sacred spaces represented by, 226–27, 253; on Sicilian vases, 39, 257

comedy: absurdity in, 45; Alkmene in, 170; distortion/ugliness in, 260; as metatheatrical, 27; and phlyakes, 10, 296; popularity of, 14; and saved-from-danger tragedies, 149; tragicomedy, 145, 149, 228, 260

comic vases: bearing of, 13–15; Dionysos on, 44; distribution of, 21; in graves, 44; in relation to performance, 26–28; as scene specific, 262; size/uses of, 44; stages on, 10, 19, 28, 90, 154, 261; theatricality of, 27–28

consolation, 22, 44–46, 86, 102, 179, 214, 229

Corinth: Medeia at, 114, 115, 117, 240; in *Oedipus*, 91–92

costume: of Andromeda, 33, 175, 182; of the aulos player, 29; barbarian, 125, 175, 178–79; of the chorus, 29, 294; of Erinyes, 63, 64; huntress, 196; Oriental, 33, 72, 86, 152, 218, 245, 256; ornate/theatrical, 82, 87, 103, 104, 117, 129, 143, 148, 150, 152, 165, 177, 203, 209, 210, 262; in Paestum, 209; of the paidagogos, 193, 224, 235, 238, 256; of satyrs, 11; Thracian, 104; tragic, 5, 38, 46, 104, 165, 167, 172, 185, 192, 199, 204, 215, 222, 223, 226, 234, 237, 241, 259, 263, 264

crowns, 96, 176, 178, 179, 195, 200, 240, 256

cults: of Apollo, 139, 147, 206, 294; of Artemis, 150, 154; in Attica, 230; of Demeter, 230, 238, 240; of Dionysos, 44, 187, 192; hero-cult, 100; mysteries, 44, 230, 238; Panhellenic, 8

Hieron, 48

Hippolytos: and Antiope, 246; and Artemis, 246; chariot of, 130, 135, 152; scenes, and Athena, 137, 138, 196

Hippolytos (Euripides), 43, 109, 126, 130–38, 149, 169, 183, 203, 246

Homonoia, 183, 184

Hypsipyle (Euripides), 149, 211–14, 250–51, 262

I

iconocentric approach, 23–26, 141

Ilioupersis Painter, 17, 115, 139, 150, 159, 192, 223–24

inscriptions, 45, 245; Agamemnon's tomb identified by, 52; and *Aias*, 89; and *Antigone*, 186; Aphrodite identified by, 183; on Apulian vases, 13, 19, 21–22, 230; on comic vases, 13; Daidalos identified by, 230; Diomedes identified by, 163; Doric form "Thersitas" in, 234; Elektra identified by, 50, 52; Euaion named in, 33, 175; Herakles identified by, 185; *heta* in, 42; Homonoia identified by, 183; and *Kreousa,* 102; name labels in Attic dialect, 42–43, 229, 230, 255; and *Oinomaos,* 198, 200; on Paestan vases, 19; Parthenopaios identified by, 224; and *Rhesos,* 163, 165; tomb scene identified by, 50

Iolaos, 126, 129, 130, 143, 145

Ion: and Apollo, 148; and Athena, 146; birth of, 196; and Ionia, 196; and Kreousa, 146, 148, 196

Ion (Euripides), 103–4, 146–48, 149, 196

Iphigeneia: and Agamemnon, 149–50, 159–60; and Artemis, 149, 150, 152, 154–56, 159–60; in Attic vase-painting, 152; fetched from Aulis, 133, 134; and Orestes, 25, 150–51, 152, 154; rescue of, 44, 149–50

Iphigeneia (among the Taurians) (Euripides), 10, 20, 25, 33, 109, 146, 149–56, 202

Iphigeneia (at Aulis) (Euripides), 10, 149, 159–60, 266

K

Kapaneus, 213, 266, 267

Karkinos, 220, 240

Kassandra, 45, 253, 254

Kassiepeia, 175–76, 179, 183

Kepheus, 174, 175–76, 178–79, 181, 182, 183

kerykeion, 53, 127, 134, 188, 190

keys, 49–50, 61, 139, 150, 152, 154

Klytaimestra, 160; and Agamemnon, 49, 205–6, 207, 209; on the altar, 56, 206; bared breast of, 56–57; dream by, 36, 56, 58, 64; Erinyes summoned by, 54; and Kassandra, 45; and Orestes, 56–57, 58, 96, 139–40

Kreon, 93–94, 96, 100–101, 114, 115, 116, 172, 174, 185–86, 256

Kreousa: and Apollo, 103, 104, 146, 148; and Ion, 146, 148, 196

Kreousa (Sophocles), 102–4

L

lagobolon, 134, 138, 191, 227, 233, 245, 247–48. *See also* Pan

Laios, 45, 92, 218

laurel trees, 58, 61, 112, 139, 147, 150–51, 206

letter: from Iphigeneia, 25, 150–52, 154; in *Stheneboia,* 201–2, 203, 204

Libation Bearers: Orestes in, 49, 50–51, 52, 53, 54, 55–56, 57; tomb in, 49–50, 52–56, 85, 96, 97

Libation Bearers (Aeschylus), 50, 52

Lucania: vs. Apulia, 17–18; column-kraters of, 129; hydrias of, 73, 97; and Taras, 21; theater sites in, 9

Lycurgus Painter, 17, 70, 85, 146, 196, 224–26

Lydia, 75, 76–77, 200, 250

Lykia, 72, 204

Lykourgos, 7, 68–69, 70–71, 264

lyre, 8, 30, 103, 213, 249–50

Lyssa, 70, 71, 124, 137, 143, 145

M

maids, 39, 49, 92, 111, 115, 183, 192, 229–30, 242, 245

*masks: actors', 10, 11–12, 30, 32, 33, 130, 137; Erinyes', 64; Hippo's, 195; and number of actors in a scene, 262; with open mouths, 27, 261; satyrs', 11, 33–34; theater symbolized by, 6; tragic, 5, 10, 38

mechane, 70, 72–74, 189, 204. *See also* god from the machine

Medeia, 20, 41, 43, 45, 67, 73, 167, 207, 238, 240, 255–57

Medeia (anon.), 220, 255

Medeia (Euripides), 109, 114–25, 126, 192, 240, 256

Megara, 143, 145

Melanippe, 193–96, 255

Melanippe (in Fetters) (Euripides), 193–94

Melanippe (the Wise) (Euripides), 39, 193–94, 195

Meleagros (Euripides), 196–98

Menelaos, 139, 233, 234, 251

Merope, 78, 255–56

*messengers, 70, 169, 171, 190, 191, 205–6, 213, 230, 236; in *Andromache,* 37, 139–41; Hektor–Achilles duel reported by, 254; Herakles story told by, 143; in *Hippolytos,* 130, 135–38; in *Hypsipyle,* 262; in *Iphigeneia (at Aulis),* 158, 159–60; in *Medeia,* 115, 116; in *Oedipus,* 91; paidagogos as, 137, 190, 197, 213–14, 256; in *Rhesos,* 161; speeches of, 24, 73–74, 104, 115, 116, 125, 174, 175–76, 187, 197, 204, 257; Thersites' death reported by, 234

Metapontion, 9, 10, 15, 17

mourners, 44, 45, 53, 69, 76, 119, 179, 188

Myrmidons (Aeschylus), 32, 83

*mystery cults, 44, 230, 238

N

*name labels, 42–43, 229, 230, 255

Naples (Napoli, Neapolis), 8, 15, 20, 250, 266, 294

Nemea, 211, 213, 250

Neoptolemos, 7, 37, 99, 100, 139–40, 149

Nereids, 175, 179, 192, 296

Nereids (Aeschylus), 84, 85

Niobe, 45, 74–79, 152, 250

Niobe (Aeschylus), 74–77

*nurses/nursemaids, 185, 242; in *Hippolytos,* 130, 131–32, 133; in *Hypsipyle,* 211, 213, 262; and Kanake, 169; in *Medeia,* 123; in *Melanippe,* 193, 195; and Niobe, 75, 77, 78; of Orestes, 209; and paidagogos, 78, 123, 131; and Pasiphae, 231; in *Phrixos,* 215; in *Stheneboia,* 203; in tragedies, 40, 130, 133, 194, 231, 248, 250; white-haired, 40, 123, 131, 133, 193, 237, 253, 256

248; in mythological paintings, 20; Neoptolemos', 139; Odysseus', 37, 98, 99; Orestes', 37, 58, 59; suicide/ self-wounding by, 89, 168, 169, 241; Telephos', 206, 207, 209; Thyestes', 106, 224, 241

Syracuse, 6, 7, 8, 9, 90, 99–100, 109, 257

T

Tantalos, 75, 77, 248, 250

Taranto. *See* Taras

Taras (Taranto), 8, 17; culture of, 22; Doric dialect in, 13, 42; Gnathia painting at, 15; Plato at, 9; stability/ prosperity, 21; theater in, 9–10, 14–15, 19; vase-painting in, 18, 30, 94–95

Teiresias (Tiresias), 93, 172, 174, 209

Telephos (anon.), 210

Telephos (Euripides), 14, 33, 111, 205–9, 210

Tereus, 104–5, 264

Tereus (Sophocles), 104–5

theaters, 6, 7, 9–10, 14–15, 18, 19

Thebes: Amphion's tomb in, 78; founders of, 94, 187; gates of, 266; kings of, 100, 172; local myths of, 221; Niobe at, 75, 77, 80; Pentheus's death at, 156; Seven against, 48, 212, 213, 224, 237, 250, 258, 266, 267; walls of, 267

Thersites, 42, 233–34

Theseus, 45, 100–101, 130, 131, 135, 137, 167, 197–98, 246

Thessaly, 6, 89, 108–9, 111, 112, 139, 193

*Thrace, 68, 82, 141, 245, 246, 259–60

thrones, 72, 94, 100, 152, 183, 186, 241, 245

Thyestes, 45, 224, 241

Thyestes tragedies (Sophocles), 105–7, 243

tomb, 45, 231, 243, 256; excavations of tombs, 8, 73, 117; Greek artworks found in, 21–22; robbing of tombs, 16; tragedy-related art in tombs, 32, 44; Aeschylus', 6, 48, 68; Amphion's, 78; in *Antiope*, 188; "children at the tomb" scenes, 20, 49, 50; in *Libation Bearers*, 49–50, 52–56, 85, 96, 97; Niobe on, 74, 75, 78; Oedipus', 100; Orestes/ Elektra at, 19, 33, 44, 58, 61

torches, 112, 170, 263; Amphitryon's, 172; of Demeter/Kore cult, 240; Erinyes', 60, 81, 124, 137, 197, 223, 230, 256; Kapaneus', 266

Trachinians (Sophocles), 89–90

tragedy: in Apulia, 9–15; point of, 4–5; spread from Athens, 5–7; spread to Sicily and Greek West, 8–9; vases related to, 28–43. *See also specific tragedies*

traveling troupes, 6, 7, 10, 32, 262

*tripods, 30, 43; at Delphi, 43, 61, 139; and prophetic affinity with Apollo, 253; in temples/sacred spaces, 43, 58, 101, 226–27, 248; for victory in artistic competition, 43, 101, 134, 248, 256

Troy: Astyanax at, 251; Greek army at, 233; Helen at, 149; local myths of, 221; Philoktetes at, 99; sack of, 23, 139, 141; Sarpedon at, 72; Telephos at, 205; walls of, 244

trumpets, 134, 247–48

U

*Underworld, 63, 81–82, 248

Underworld Painter, 134, 190, 193, 210, 221, 253, 255–57

W

witness figures, 39–40, 197, 242

Women at the Thesmophoria (Aristophanes), 14, 149, 174

Z

Zeus, 236; in *Alkmene*, 170–72, 174; altar of, 143; in *Antiope*, 187, 188–89, 190; in *Europe*, 72; in *Hypsipyle*, 213; and Leda, 229; lightning bolts of, 230, 266, 267; Nemean Games in honor of, 212; in *Philoktetes*, 99; in *Phrixos*, 217; in *Prometheus (Released)*, 80; and Sarpedon, 72; statuette of, 129; temple of, 126, 127

Mark Greenberg, *Editor in Chief*

Abby Sider, *Manuscript Editor*
Benedicte Gilman, *Editorial Coordinator*
Sandy Bell, *Designer*
Elizabeth Chapin Kahn, *Production Coordinator*
David Fuller, *Cartographer*

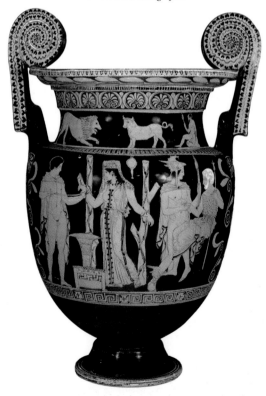